Volume Four

American Indian Art Series
Southern Pueblo Pottery
2,000 Artist Biographies

Featuring: Acoma, Cochiti, Isleta, Jemez and Pecos, Laguna,

Sandia, San Felipe, Santa Ana, Santo Domingo,

Tigua/Ysleta del Sur, Zia and Zuni

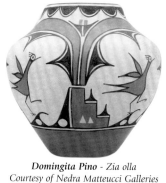

Domingita Pino - *Zia olla*
Courtesy of Nedra Matteucci Galleries

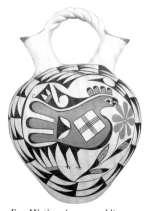

Eva Histia - *Acoma wedding vase*
Courtesy of Sunshine Studio

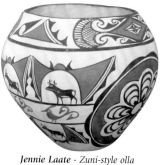

Jennie Laate - *Zuni-style olla*
Courtesy of John Blom

SPECIAL THANKS TO:

National Museum of the American Indian, Washington D.C.
Museum of Indian Art and Culture, Santa Fe, NM
Case Trading Post at the Wheelwright Museum of the American Indian, Santa Fe, NM
Heard Museum, Phoenix, AZ
Philbrook Museum of Art, Tulsa, OK
Red Earth, Inc., Oklahoma City, OK
SWAIA, Santa Fe, NM
Eight Northern Indian Pueblos, NM
Rio Grande Wholesale, Inc., Albuquerque, NM
Kennedy Indian Arts, NM & UT
Andrews Pueblo Pottery and Art Gallery, Albuquerque, NM
Gardner Lithograph, Buena Park, CA
Roswell Bookbinding, Phoenix, AZ

Cochiti cornmeal alter, unsigned
Frank Kinsel Collection, CA

Also a Collectors' Edition of 200 copies
bound in leather, signed and numbered.

First Edition
Published in 2002 by CIAC Press
(Center for Indigenous Arts & Cultures Press)
Copyright © 2002 by Gregory Schaaf
CENTER FOR INDIGENOUS ARTS & CULTURES
A division of Southwest Learning Centers, Inc.
a non-profit, educational organization est. 1972
P.O. Box 8627
Santa Fe, NM 87504-8627
Phone (505) 473-5375
Fax (505) 424-1025
email - Indians@nets.com
website - www.indianartbooks.com
Printed in U.S.A. by Gardner Lithograph
8332 Commonwealth
Buena Park, CA 90621-2591
Library of Congress Catalog Card Number 98-87933

Schaaf, Gregory
Southern Pueblo Pottery: 2,000 Artist Biographies
by Gregory Schaaf, Ph.D.
Graphic design by Angie Yan Schaaf
p. cm.
Incudes 1,000 illustrations, bibliographical references and
biographical index.
ISBN 0-9666948-5-6 (hardback)
ISBN 0-9666948-6-4 (Collectors' Edition)
1. Indians of North America – Art –Pottery.
2. Indians of North America – Biography.
3. Pueblo Indians – Pottery.
4. Pueblo Indians – Biography.
5. Indian Pottery – Collectors and Collecting – Southwest.
I. Schaaf, Gregory.
II. Center for Indigenous Arts & Cultures.
III. Title.

Volume Four

American Indian Art Series

Southern Pueblo Pottery

2,000 Artist Biographies

c. 1800-present

with Value/Price Guide

featuring over 20 years of auction records

by Gregory Schaaf, Ph.D.

with assistance by Angie Yan Schaaf

CIAC Press

Santa Fe, New Mexico

Acoma

Barbara & Joseph Cerno -
Nedra Matteucci Galleries

Acoma Pueblo, also called Sky City, is over 1,000 years old, one of the oldest living communities on Earth. Their four main Keresan villages are Acoma Pueblo, Acomita, San Fidel, and McCartys. Located about 50 miles west of Albuquerque, their quarter of a million acre territory features beautiful mesas, deep valleys and rolling hills covered with a variety of native plants, also homeland to deer, elk, antelope, bears, mountain lions, coyotes, rabbits, prairie dogs and hundreds of birds.

Traditional Acoma pottery is made from natural clays, minerals and plants found within their homeland. Many inherit family clay beds where they pray and sing songs to Mother Earth. Some collect many different types and colors of clay for paints and slips. Their main clay is naturally grey. To make their pottery strong, they mix ground pottery sherds or volcanic ash and water into the finely screened, dry powdered clay. Their white slip is made from Kaolin, a white chalky material formed millions of years ago by the sediment of microscopic organisms that once lived in an ancient sea covering the Great Southwest. Their black paint often is a mixture of an iron oxide mineral called Hematite and a vegetal paint brewed from wild spinach, Rocky Mountain bee weed, yucca fruit and other plants. Red, orange, yellow and other colors come mostly from natural clays, although some use non-traditional materials and molded pots.

Acoma potters have made over a dozen main styles of pottery. After the 1680 Pueblo Revolt for independence, prayer feather and cloud designs took on regional styles. During the 19th and early 20th centuries, the traditional style was orange & black-on-white. Their favorite shape was a water jar called an olla. Their designs included the Acoma parrot, clouds and rosettes. In the 1920's, fineline rain and black-on-white designs appeared in a revival of ancient pottery styles from their ancestors of the Anasazi Chacoan, Mogollon Tularosa and Mimbres regions. In the 1930s and 1940s, the first to sign their pots included: Lucy Lewis (Roadrunner Clan), Santana Cimmeron Cerno (Roadrunner Clan), Marie Z. Chino (Red Corn Clan), Jessie Garcia (Sun Clan), Sarah Garcia (Turkey Clan), Eva Histia (Roadrunner Clan), Ethel Shields (Yellow Corn Clan), Mary Histia and Frances Pino Torivio.

Today, over 500 Acoma artists from a dozen main clans sign their pots and take pride in passing on their family traditions to the coming generations. Top award winners of the 1980s to the present include: Barbara and Joseph Cerno, Melissa Antonio, Delores, John and Wanda Aragon, Debbie Brown, C. Maurus Chino, Grace and Rose Chino, Carolyn and Rachel Concho, Wilfred and Sandra Garcia, Goldie Hayah, Adrienne Roy Keene, Rebecca Lucario, Angela Medina, Charmae Natseway, Marilyn Ray, Patrick and Shawna Garcia-Rustin, Lilly Salvador, Dorothy Torivio, Jackie and Sandra Victorino.

Cochiti

Cochiti Pueblo is a small Keresan-speaking community located 25 miles southwest of Santa Fe. Many of their potters come from the Fox, Coyote, Turquoise and Shipewe clans. Their traditional pottery is painted with a vegetal or mineral black on a heavy cream slip with an orange base. Favorite designs include clouds, rain, animals and flowers.

Cochiti potters were known up through the 19th century for creating huge storage jars. By the 1880s, Cochiti became noted for their fine figural pottery. Circus performers, opera singers and tourists were portrayed in clay sculptures from two inches to two feet tall.

In 1964, Helen Cordero innovated a new figural form called the "Storyteller." Her model was her grandfather, Santiago Quintana, who used to tell stories to his many grandchildren. Singing Mother and child figures were remodeled into mothers and grandmothers covered with children and grandchildren. This theme expanded into Storytellers based on turtles, frogs, bears, coyotes, prairie dogs, cats, owls and more. Other Cochiti figural potters soon started making Storytellers: Felipa Trujillo (1965), Seferina Ortiz (1965), Frances Suina (1965), Dorothy Trujillo (1966), Aurelia Suina (1968), Josephine Arquero (1969). In 1971, Helen won "Best of Show" at Indian Market and was featured in a one-woman show at the Heard Museum.

During the 1970s the Storyteller makers were joined by Martha Arquero, Damacia Cordero, Ivan & Rita Lewis, Mary Martin, Louis & Virginia Naranjo, Snowflake Flower, Maria Priscilla Romero, Lucy, Judith, Louise & Ada Suina. The first twenty Cochiti Storyteller makers soon were joined by thirty from Jemez, a dozen from Acoma, and fifty more from other Pueblos. By the time Helen made the cover of *National Geographic Magazine* in 1982, perhaps a hundred Pueblo potters were part of the Storyteller movement and today the number has more than tripled.

From 1980 to the present, Seferina Ortiz and her children emerged as major award winners, including Mary Janice, Joyce, Inez and Virgil. He was featured in the 2000 Wheelwright Museum exhibit, the "Clay People," with his fantastic standing figures. Cochiti today continues to be a center for fine figural pottery.

Frances Suina -
Courtesy of Eason Eige, Albuquerque

Jemez

Southwest of Santa Fe, along the Jemez River in a beautiful mountain range, stands Walatow, pueblo of Jemez. Over a period of seven centuries, several Towa villages merged into one. In 1838, the last 17 survivors of their Pecos cousins arrived from the mountains above Santa Fe.

Today, with over 500 active potters, Jemez ranks second after Acoma for greatest number of artists working in clay. Of the ten main extended families making pottery at Jemez, the most numerous are the Corn, Fire, Sun and Oak Clans. To better understand their roots, family trees were constructed from some of the matriarchs of Jemez potters: Andrieta Shendo (Coyote Clan, b. 1884), Christina Sabaquie (Fire Clan, b. 1886), Juanita Fragua Yepa (Eagle Clan, b. 1890s), Persingula Fragua (Oak Clan, b. 1900), Perfectita Toya (Sun Clan, b. 1900s), Louisa Fragua Toledo (Sun Clan, b. 1903), Petra Chavez Romero (b. 1904, Fire Clan), Reyes S. Toya (Coyote Clan, b. 1907), Persingula Gachupin (Jemez/Zia, Corn Clan, b. 1910), Emilia Loretto (Eagle Clan, b. 1910s), Rufina Sandia Armijo (Oak Canyon Clan, b. 1910s); Loretta Cajero (Fire Clan, b. 1920), Juanita Yepa Gachupin (Sun Clan) and Carrie R. Loretto (Water Clan, b. 1920s).

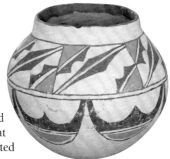

Mary Small

In the 20th century, several women potters from other Pueblos married into Jemez. They helped to foster a remarkable pottery revival: Refugia Moquino Toledo (Zia, b. 1884), Benigna Medina Madelena (Zia Corn Clan, b. 1880s), Filapeta Coriz Chavez (Tesuque Corn Clan, b. 1890s), Margaret Romero Sarracino (Laguna Fire Clan), Rita Magdalena Casiquito (Zia/Jemez Corn Clan, b. 1900), Benina Shije (Zia Corn Clan), Ruby Panana (Zia, b. 1954).

Contemporary Jemez pottery has advanced to new levels of quality, technique and form. Their figural pottery features Storytellers, Pueblo dancers, clowns and animals. Their pottery styles include matte polychrome with natural pigments on polished redware. Exquisite melon bowls and swirl pots are made in both polished redware and tanware. Top award-winners among Jemez Pueblo potters include: Aaron Cajero, Jr., Anita Cajero, Esther Cajero, Joe Cajero, Jr., Loretta Cajero, Teris Cajero, Lorraine Chinana, Felicia Fragua Curley, Dennis Daubs, Glendora Daubs, Mary Louis Eteeyan, Gordon Foley, Betty Jean Fragua, Juanita Fragua, Laura J. Fragua, Linda Lucero Fragua, Bertha Gachupin, Joseph Gachupin, Laura Gachupin, Wilma M. Gachupin, Helen Henderson, Estella Loretto, Fannie Loretto, Reyes Madelena, Alma Loretto Maestas, Reyes Panana, Carol Pecos, Rose Pecos-Sun Rhodes, Marie G. Romero, Pauline Romero, Geraldine F. Sandia, Caroline Sando, Mary Small, Vangie Tafoya, Benjamin & Geraldine Toya, Damian Toya, Judy Toya, Mariam Toya, Mary Ellen Toya, Maxine Toya, Emily Tsosie, Leonard Tsosie, Carol Vigil, Kathleen Wall, & Alvina Yepa.

Isleta

South of Albuquerque thirteen miles, along the Rio Grande, stands Isleta Pueblo, the largest settlement of Southern Tiwa speaking people. Their ancestors have lived in this vicinity for over 800 years. Their closest cousins are Sandia Pueblo and the Tigua at Ysleta del Sur in Texas, as well as the Northern Tiwa Pueblos, Taos and Picuris.

Before the 1880s, Isleta pots mostly were red-on-tan bowls, called "Bu-ru," and black-ware jars, "Pa-bu-ru." Early red-on-tan storage jars were prized. A third style of pottery, called "Isleta Polychrome," developed after the arrival in 1879 of Laguna pottery-making families at nearby Mesita. White slip, red and reddish brown clay paint were applied to new forms created after the arrival of the railroad in the 1880s. The most popular was a small clay basket with a twist handle. Water pitchers and vases also were sold at the train station. Dough bowls continued to be used for mixing flour and water to make bread.

Isleta olla, unsigned -
Frank Kinsel Collection, CA

Marcellina Jojolla (b. 1860s), Emilia Lente Carpio (b. 1880s) and Felicita Jojola (b. 1900s) made polychrome jars and bowls. Maria Lente (b. 1900s) made polychrome dough bowls up to 14" in diameter. Lula Lente (b. 1910s) did not coil her pots, but rather formed them with her hands and a paddle. Other Isleta potters distinguished themselves: Lupe Anselmo (b. 1890s), Lupe Anzara (b. 1890s), Maria Chiwiwi (b. 1890s), Felicita Jojola (b. 1900s), & Maria Montoya (b. 1920).

Contemporary Isleta potters create a range of pottery styles and figures. Fifth generation potters of the Teller family are known for their pastel colors. Some Jojolla family members make black & orange-on-whiteware jars, bowls, wedding vases and figures. Isleta top award winners also include: Lorenzo Baca, Caroline L. Carpio, Anthony Jojola, and Mary Lou Kokaly.

Laguna

Laguna Pueblo is located between Isleta and Acoma, 42 miles west of Albuquerque. Laguna people live mostly in and around several villages: Old Laguna, New Laguna, Mesita, Paraje, Casa Blanca, Puguate, Seama and Encinal. After the Pueblo Revolt, Old Laguna was founded in the early 17th century. Earlier glazeware was then being replaced with black & red-on-white polychrome pottery.

While Acoma and Laguna pottery often looks similar, Laguna pottery generally is characterized by being a little "thicker walled," and with "bolder" designs. Compositions on polychrome ollas often display a bold motif repeated four to six times around the belly of the pot. Traditional design elements include diamonds, diagonal parallelograms, plants and parrots.

Two 19th century Laguna potters also were attracted to Zuni designs — Arroh-ah-och (b. 1820s) and Dyamu (b. 1870s). Both were men who assumed the roles of women. They were honored as exceptional artists. In the late 19th century, Aroch-

ah-och painted fine ollas portraying Zuni-style deer with heartlines. Early 20th century Laguna potters included Benina Yuwai (b. 1900s), Carrie Reid (b. 1900s), Lucilla Mariano (b. 1910s) and Mabel Poncho (b. 1920s).

In the middle of the 20th century, pottery making almost died out at Laguna. Much of the credit for reviving Laguna pottery goes to Evelyn Cheromiah (Roadrunner Clan, b. 1928). She worked under a federal grant for a period, helping to teach over thirty Laguna people the art history and techniques of pottery making. She is respected for her contributions. Contemporary Laguna prize-winning potters include: Lee Ann Cheromiah, Max Early, Sally Garcia, Michael Kanteena, Harold Littlebird, Yvonne Lucas, Thomas Natseway, Andrew Padilla, Jr., Gladys Paquin, Michelle Pasquale, Dennis Rodriquez, Myron Sarracino, Sue Tapia and Mary Victorino.

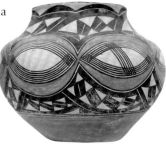

*Laguna olla, unsigned -
Frank Kinsel Collection, CA*

Sandia

About 45 miles south of Santa Fe, below the beautiful Sandia Peaks, the Southern Tiwa village of Sandia Pueblo rests on a sandy plain. The Sandia Reservation embraces 24,034 acres, but they seek to expand their jurisdiction to include the sacred mountains which rise between 5,000 feet up to 10,670 feet at Sandia Crest. Inside the tube-like Sandia Cave gracefully flaked stone points and tools were found dated to perhaps 10,000 years old.

Ancient clay beds exist in the foothills, and pottery sherds around Sandia Pueblo date back to 700 years old. Over time, perhaps twenty Southern Tiwa communities compressed into two: Sandia Pueblo and Isleta Pueblo. Some recognize Kuaua Pueblo at present-day Coronado State Monument as one of their ancestral sites. On the walls of their kiva were painted spiritual figures and Pueblo dancers bringing rain and fertility into the valley.

In 1617, the lives of the Sandia people changed with the establishment of the mission of San Francisco in their Pueblo. At the time of the Pueblo Revolt in 1680, they stood 3,000 strong. The Pueblo soon was abandoned, then reoccupied in 1748. Their numbers were reduced to 236 survivors by 1789. The 1910 U.S. Census totaled their population at 73, the low point from which the Sandia people have come back strong once again.

In the 19th century, Sandia artists were noted for their fine baskets and heavy stone-polished blackware cooking pots. In 1881, Sandia potters were making "black and white pottery." Early in the 20th century, their black & white-on-redware pots resembled Santa Ana pots with thicker walls. By 1930, only one Sandia potter remained active.

Late in the 20th century, a pottery revival commenced at Sandia. In the wake of tremendous popularity of Storyteller dolls, a Sandia husband-wife pottery making team emerged, J. & Trinnie Herrera Lujan. During the past decade, John Montoya has risen as a leading Sandia potter. One of his popular figural designs features a deer standing before Sandia Peak. Perhaps a dozen other artists are making pottery at Sandia, including B. Chavez, Christopher Chavez, Helen Garcia, D. Montoya, Robert Montoya, Gina Pecos, Angela Toribio and Deanna Trujillo.

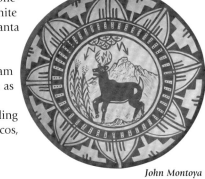

John Montoya

San Felipe

On the east side of the Rio Grande, about 35 miles south of Santa Fe, is the Eastern Keresan-speaking village of San Felipe Pueblo. Their 48,930 acre territory spans from the fertile river valley to the volcanic mesas of the Sandia and Jemez Mountains, covered with piñon and juniper trees.

Some of their clans once lived in the Anasazi regions around Chaco Canyon and Mesa Verde. Seven centuries ago, their ancestors moved into the Rio Grande Valley. Traditional stories recall how the Corn Mother Spirit helped guide their people to settle in this beautiful land. They agreed to "obey the laws of nature" and to live together in "unity" with leadership from their chief and elders. The strength of their sovereignty came from knowledge of nature and practice of a traditional way of life.

The people maintained their skills at making pottery. They adapted to local clays and native materials. Over the centuries, they traded more for pottery from their Santo Domingo cousins. By the late 1930s, pottery making almost died out at San Felipe. Pietra Sandoval helped keep the art alive. She made traditional ollas, jars, food bowls and cooking pots. One of her polychrome bowls, a polished redware bowl and an unpolished cooking pot are preserved at the Philbrook Art Center in Tulsa, Oklahoma. Other early San Felipe potters include: Marcelina Calabaza, Josefita Lucero, Mary Lucero and Marie R. Sandoval.

In the 1970s, when figural pottery became popular, Lenora Lupe Lucero from Jemez married into San Felipe and developed a style of matte red-on-tanware Storytellers, lizard effigy pots and figures. Her niece, Cecilia Valencia, also lives at San Felipe and makes Storytellers. Del Trancosa from San Felipe learned to make Storytellers from his mother-in-law, Helen Cordero.

In the 1980s, two potters emerged with new styles of pottery — Hubert Candelario and Daryl V. Candelaria. Hubert is noted for his orange micaceous "puzzle" pots. Daryl is popular for his "sherd" pots, meticulously painted in a mosaic of design motifs from various pueblos. In the 1990s, over a dozen artists joined the pottery revival at San Felipe.

*Daryl Candelaria -
King Galleries of Scottsdale, AZ*

Santa Ana

Elvira Montoya -
Courtesy of Allan & Carol Hayes

About 40 miles southwest of Santa Fe, between San Felipe and Zia, live the Santa Ana people who call themselves "Tamaya." Old Santa Ana Pueblo is located on the north bank of the Jemez River. Here on a sandy mesa, surrounded by volcanic mesas, the village is the center of their 17,360 acre territory.

Before the Pueblo Revolt of 1680, the ancestral pottery of Santa Ana and Zia Pueblo was a polychrome glazeware of reddish brown clay and crushed black basalt temper. Beginning in the 17th century, a transition began from glossy Kotyiti glazes to matte painted pottery dubbed Puname Polychrome, featuring mineral black outlines, buff oranges and reds, on a white, stone-polished slip. This style was carried forward into the 20th century by Santa Ana potters Victoriana Gallegos, Tonita Hilo and Crescencia Lujan.

Through the mid-20th century, Santa Ana pottery was preserved by Rose Armijo, Crescencia Martinez, Dora Montoya, Elvira Montoya, Eudora Montoya, Clara Paquin and Bertie Pasqual. Crescenciana Peña and her daughter, Lolita, along with Eudora Montoya used to sell their pottery at Coronado Monument in Bernallio, NM. By the 1960s, Eudora courageously held on to their pottery traditions.

In 1972, Eudora created a class to teach Santa Ana pottery making. She was encouraged by Nancy Winslow, a non-Indian woman from Albuquerque. Seventeen students participated the first year in the revival project. Their efforts helped to keep Santa Ana-style pottery alive.

Santo Domingo

Twenty-five miles southwest of Santa Fe, between Cochiti and San Felipe, the Pueblo of Santo Domingo is home to an active Keresan community. Known best for their jewelry, Santo Domingo potters still make some of the largest ollas and dough bowls. Much of their pottery is hand coiled, traditionally painted and fired outdoors in a pit.

From 1870-1910, six potters were most prominent at Santo Domingo. The American Museum of Natural History, Washington, D.C., collected pots by Rosita, Joseffa and Margarite Tenorio. Felipita Aguilar Garcia painted negative designs on her pots, including one preserved in the R. W. Corwin Collection, at the Taylor Museum, Colorado Springs, CO. The pottery of Felipita's sister, Asuncion Aguilar Cate, appears in a photograph at the Museum of New Mexico Archives, which includes pots by their sister-in-law, Mrs. Ramos Aguilar. One of her pots is in the collection of the Denver Art Museum, Denver, CO.

Unsigned olla, Courtesy of
John Beeder, Albuquerque

Early in the 20th century, other Santo Domingo potters included: Nescita Calabaza, Ines Cate, Andrea Ortiz, Raphaelita Pacheco, Reyes Quintana, Ventura Reano, and Reyes Tortolito. In the 1910s, Monica Silva (Santa Clara) married into Santo Domingo. She helped popularize black-on-blackware and red-on-redware pottery, and also created fine quality Santo Domingo-style polychrome, continued by her daughters, Clara Lovato Reano, Mary and Santana Rosetta. The blackware and redware styles were developed by Miguelita Aguilar, her daughter, Rafaelita Aguilar, and her nephews, Vidal, Robert and Darrin Aguilar, as well as Helen Bird, Olivia Coriz, Cheston Niles Garcia and Lonnie Lovato.

In the 1930s, museum director Kenneth M. Chapman gave sets of old Santo Domingo pottery designs to Juana Abeyta, Felicita Benavides, Maria Calabaza, Reyes Calabaza, Marie Coriz, Crucita Herrera and other prominent Santo Domingo potters, perhaps including Cecilia Nieto, Laurencita Pacheco and Lupe L. Tenorio. At that time, Maria Garcia began making large polychrome storage jars. Her daughter, Santana Melchor, emerged by the mid-20th century as a top, award-winning potter. Santana's daughters and granddaughters carry on the family tradition.

In 1924 and 1926, Felipa Aguilar and Tonita Quintana were award winners from Santo Domingo at Indian Market, in Santa Fe. The past two generations of award-winners include: Arthur & Hilda Coriz, Rosetta Kendrick, Charles Lovato, Manuelita Judy Lovato, Marvin Lovato, Crucita Melchor, Andrew Pacheco, Gilbert & Paulita Pacheco.

The greatest number of awards for excellence in fine pottery have been bestowed to Robert Tenorio. He is respected for his years of experience with different styles, clays, slips, designs and forms, from ancient times to the present. He continues to experiment, as he searches the countryside for special clays and natural paints.

Tigua at Ysleta Del Sur

During the Pueblo Revolt of 1680, some Tiwas from Isleta, Piros from Sevilleta and other refugees of the war re-settled near El Paso, Texas. They called themselves the "Tigua," and founded a new pueblo, Ysleta Del Sur, meaning "Isleta of the South." They secured a land grant from the King of Spain.

For over three centuries, they have maintained contact with their cousins from Isleta and Sandia. They also remain connected with the community of Tortugas, near Las Cruces, New Mexico, called a "daughter colony of Ysleta del Sur" founded after 1850. Furthermore, the

Lucila Robela - Allan & Carol Hayes

Tigua are inter-married with the Piro Pueblo of Senecu across the river in Mexico.

The Tigua have struggled to maintain their identity and legal rights. After the signing of the 1848 Treaty of Guadalupe Hildalgo, U.S. Indian agent James S. Calhoun recommended that their lands be protected. Much of their original lands were stolen in the process of incorporating the town of Ysleta. When the state created property taxes, more of their lands were taken for non-payment, even though the process was a violation of the 1790 Non-Intercource Act.

The Tigua miraculously have survived. Their tribal protector, "Awelo," continues as a masked being. Their buffalo masks are still ceremonially fed. They have struggled to maintain their culture. Pottery making almost died out in the 20th century. From the 1970s to the present, Gloria Lujan, Lucy F. Rodela and Tonia Zavala have preserved styles of polychrome whiteware & redware pottery. In the 1990s, Lus Duran and Angelita Pedraza joined them. Today, they form the core group of Tigua potters.

Zia

Sofia & Lois Medina -
Andrea Fisher Fine Pottery

Balanced on a mesa top, about 40 miles southwest of Santa Fe, the Keres Pueblo of Zia sits north of the Jemez River. Today, their territory totals over a hundred thousand acres, situated between Jemez to the north and Santa Ana to the south. Some Zia clans formerly lived at Mesa Verde and Pueblo Bonito, before moving into the Rio Grande Valley in the 13th century. They established five main pueblos, and their population grew to perhaps 20,000 strong at the time of European contact. Within a decade after the Pueblo Revolt, 300 survivors remained. Their population did not rise much above 500 until the present generation.

Zia pots are strong, because their temper is basalt, crushed black volcanic lava. Zia matte polychrome ollas, ca. 1750, feature mineral black outlines, buff oranges and reds, on a white, stone-polished slip. Most are globular with short, vertical, red-painted rims. By the 1830s, Zia potters generally painted the rims black. Beginning in the 19th century, one popular design features a diagonal row of star-like motifs capped with scrolls wrapped around three leaves. Dough bowls display flaring rims and bold designs. Early canteens include stirrup shapes, as well as globular forms with loop handles. Popular designs on 19th century Zia ollas include three-petaled flowers, birds, deer and even mountain lions, often framed in rainbow bands. By 1850, figures became more realistic. Fifteen 19th century Zia potters were identified by name: He-wee'-a, Augustina Aguilar, Reyes Aguilar, Lucia Gachupin, Luciana Medina, Rosalie Medina, Rosario Medina, Juanita Pecos, Ascenciona Pino, Lucrecia Pino, Juanita M. Salas, Rosita San Isidero, Dominga Shije, Reyes Shije and Rita Shije.

Early in the 20th century, over twenty-five additional Zia potters were active. In 1922, Isabel Torrebio became the first Zia potter to sign her name. Trinidad Medina is considered one of the best Zia potters in the first half of the 20th century. She was especially known for her large polychrome storage jars with unique designs. In 1928, she won 1st Prize at the New Mexico State Fair. She demonstrated at Chicago's 1933 Century of Progress Exposition and at San Francisco's 1939 Golden Gate International Exposition.

Roadrunners became the most popular 20th century Zia design. Some stand with head upstretched, while others run fast and low to the ground, as if being chased by "Wiley Coyote." Zia prize-winners from 1950 to the present include: Ralph Aragon, Serafina Bell, Irene Herrera, Diana Lucero, Elizabeth & Marcelus Medina, Lois Medina, J. D. Medina, Rafael & Sofia Medina, Ruby Panana, Eleanor Pino-Griego, Vicentita Pino and Eusebia Shije.

Zuni

Unsigned olla -
Frank Kinsel Collection, CA

Zuni Pueblo stands about 40 miles south of Gallup, NM. They call themselves "A'shiwi," and their language is spoken nowhere else on earth. At the time of first contact with Europeans, at least seven villages were known for excellent pottery, including Hawikuh and Matsaki. Before the Pueblo Revolt, Zuni potters made glazeware. In the 18th century, they gradually switched to iron oxide black paint and red clay on a white kaolin slip. Two main design bands around the neck and belly of their pots featured floral and geometric designs. As early as 1860, a Zuni pottery design of a deer with a red heartline first appeared, followed by scrolls, rosettes and birds. Frogs, tadpoles and Water Serpent designs soon were painted on pots, especially on cornmeal bowls with terraced rain cloud rims. Lautit Saluhsitsa and Nick Tinnaka were two late 19th century Zuni potters. Early in the 20th century, they were joined by We'wha, Kasinelu, La Wa Ta, Lonkeena, Myra Eriacho and Amy Westika.

From the 1920s-50s, pottery making at Zuni was carried forward by Tsayutitsa, Catalina Zunie, Mrs. Lahi , Eloise Westika, Josephine Nahohai and Nellie Bica. Figural pottery grew in popularity. Zuni owls became favorites among early collectors. Nellie Bica was perhaps the first to sign her owls.

In the 1960s-70s, classes were taught by Hopi-Tewa potter Daisy Nampeyo Hooee, who married into Zuni Pueblo. Beginning in 1979, Acoma potter Jennie Laate, who also married in, taught pottery classes at Zuni High School, followed by Noreen Simplicio. From 1990 to the present, Gabriel Paloma continues to serve as the pottery teacher. Others learned directly from Zuni matriarchs, such as Josephine Nahohai. Contemporary Zuni award-winning potters include: Marcus Homer, Jack & Quanita Kalestewa, Lydia Vicenti Lalio, Milford Nahohai, Randy Nahohai, Rowena Him Nahohai, Les & Jocelyn Quam Namingha, Agnes, Anderson and Priscilla Peynetsa, and Nelson Vicenti.

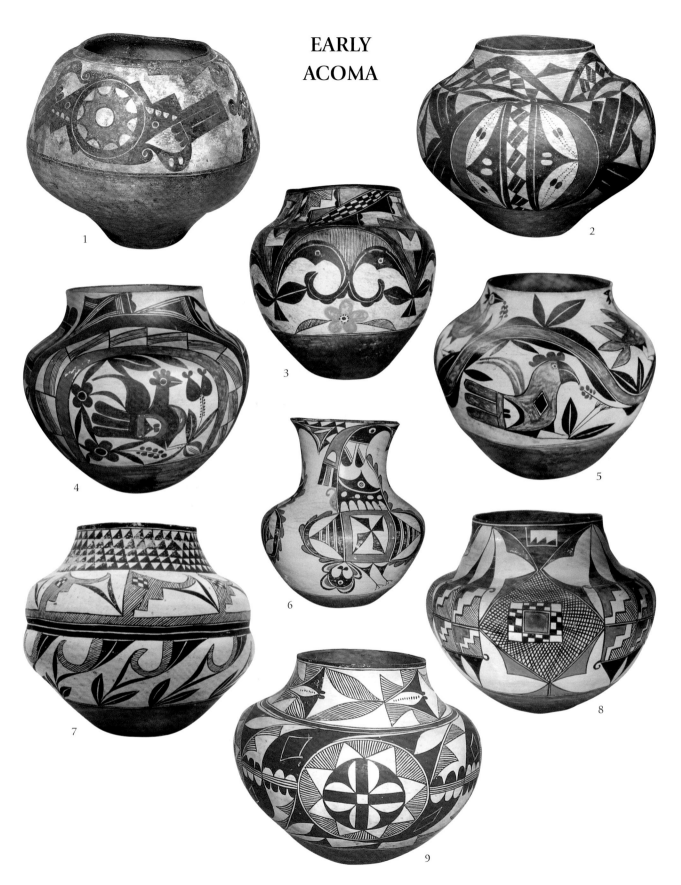

1. 'Ako' olla, ca. 1800, courtesy of Christopher Selser, Santa Fe. 2. McCartys polychrome jar, ca. 1875, courtesy of Adobe Gallery, Albuquerque & Santa Fe. 3. Olla, ca. 1890s, courtesy of Bob & Carol Berray, Santa Fe. 4. Olla, ca. 1890, courtesy of Christopher Selser, Santa Fe. 5. Olla, ca. 1890, courtesy of Christopher Selser, Santa Fe. 6. Vase, ca. 1910-1920, courtesy of Andrea Fisher Fine Pottery, Santa Fe. 7. Double-lobe geometric olla, ca. 1900, courtesy of Nedra Matteucci Galleries, Santa Fe. 8. Olla, ca. late 1900s, courtesy of Adobe Gallery, Albuquerque & Santa Fe. 9. Olla, courtesy of J. Mark Sublette, Medicine Man Gallery, Tucson & Santa Fe.

EARLY
ACOMA

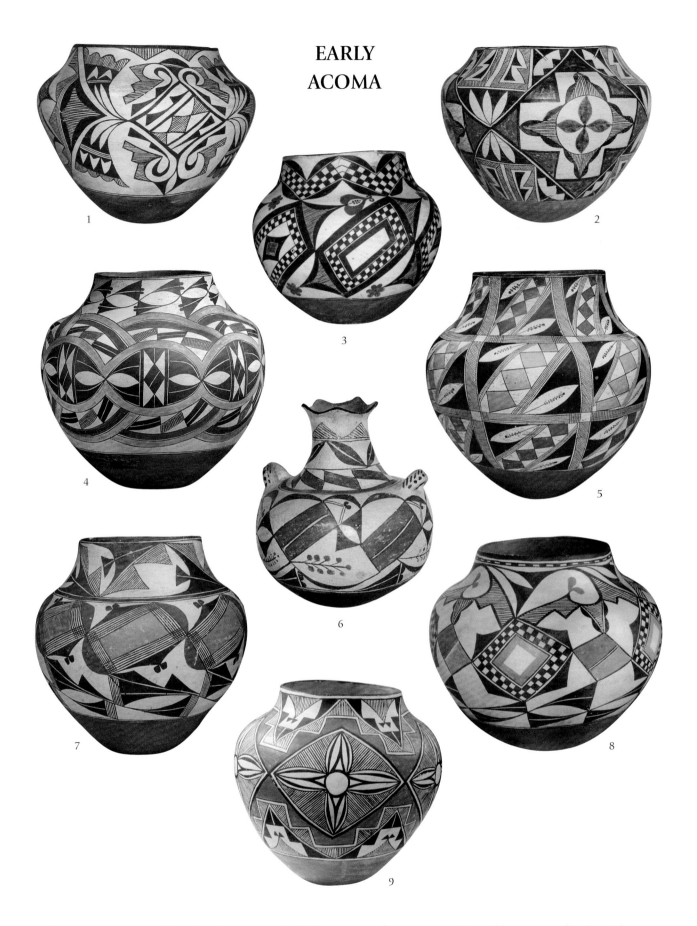

1. Olla, courtesy of Andrea Fisher Fine Pottery, Santa Fe. 2.Olla, courtesy of John Beeder, NM. 3. Olla, courtesy of Andrea Fisher Fine Pottery, Santa Fe. 4. Olla, courtesy of Phil Cohen, Native New Mexico, Inc. Santa Fe. 5. Olla, courtesy of Richard M. Howard. 6. Vase, courtesy of John Beeder, NM. 7 & 8. Ollas, courtesy of Richard M. Howard. 9. Olla, courtesy of Dr. Gregory & Angie Yan Schaaf.

EARLY
ACOMA

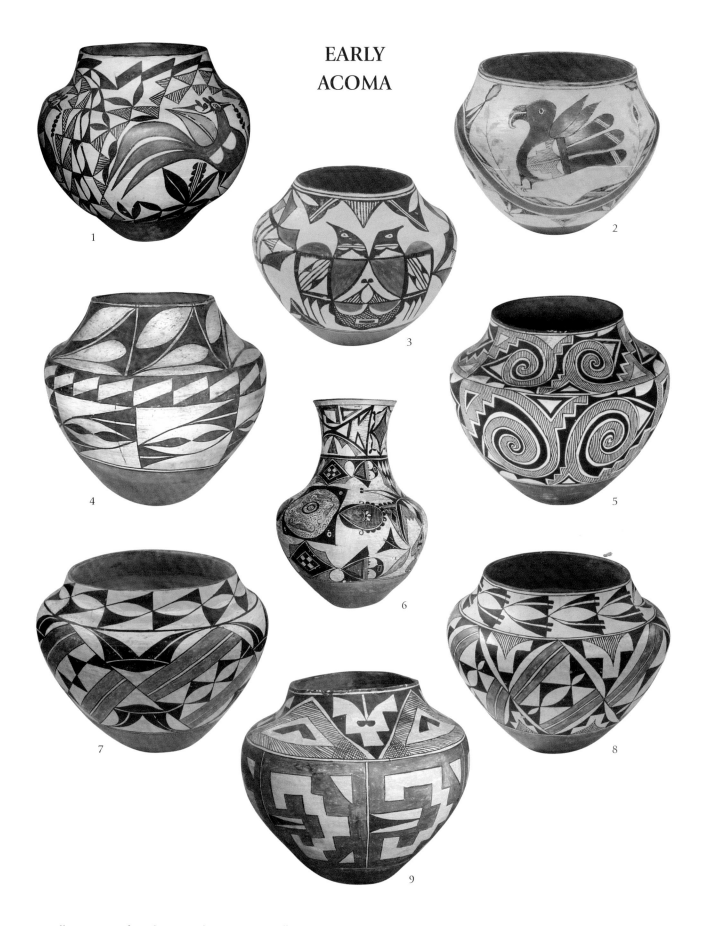

1. Olla, courtesy of Cowboys & Indians Antiques, Albuquerque, NM. 2 & 3. Ollas, courtesy of Dr. Gregory & Angie Yan Schaaf.
4. Olla, courtesy of J. Mark Sublette, Medicine Man Gallery, Inc., Tucson & Santa Fe. 5. Olla, courtesy of Don & Lynda Shoemaker,
Santa Fe. 6. Vase, courtesy of John Beeder, NM. 7, 8, & 9. Ollas, courtesy of Dr. Gregory & Angie Yan Schaaf.

EARLY
ACOMA

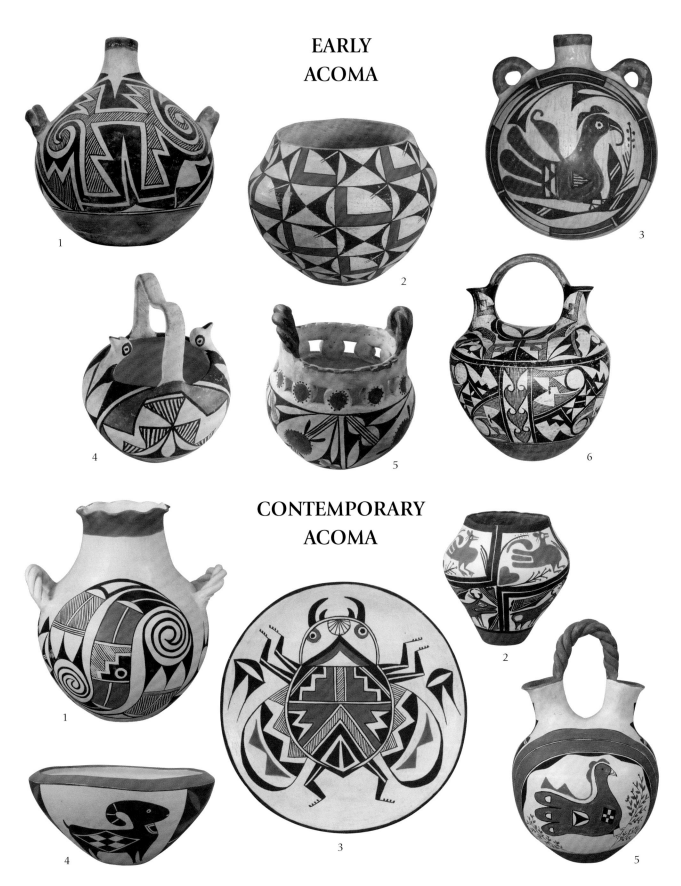

CONTEMPORARY
ACOMA

EARLY ACOMA: 1. Canteen, Tularosa Revival, ca. 1940s, courtesy of Frank Kinsel, CA. 2. Olla, ca. 1930s. 3. Canteen, Parrot design, ca. 1940s. 4. Clay basket, bird effigy, ca. 1940s. 5. Open work jar, ca. 1930s. 6. Wedding vase, courtesy of John Beeder, NM.
CONTEMPORAY ACOMA: 1. Vase with handles by Eva Histia, Rainbird design. 2. Jar by D. J. Aragon, bird & deer with heartline design. 3. Plate by Frances Torivio, Mimbres flying beetle design. 4. Bowl by Oliver Garcia, Mimbres Bighorn sheep design. 5. Wedding vase by Doris Patricio, bird design.

CERNO FAMILY of ACOMA

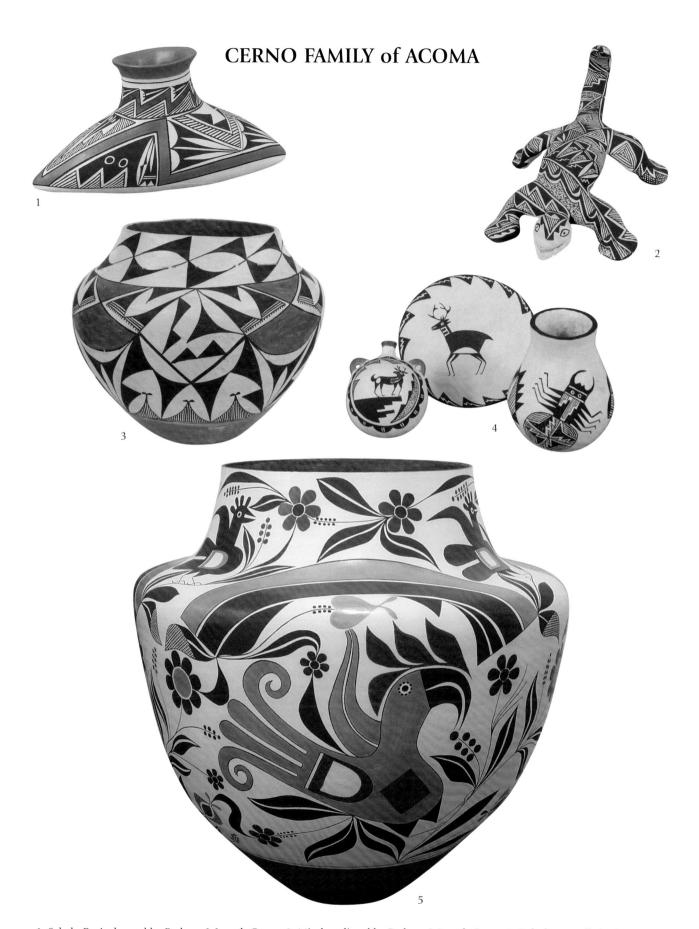

1. Salado Revival vessel by Barbara & Joseph Cerno. 2. Mimbres lizard by Barbara & Joseph Cerno. 3. Polychrome olla by Santana Cimmeron Cerno, mother of Joseph Cerno. 4. Miniatures by Barbara & Joseph Cerno. 5. Huge polychrome storage jar (24 x 24″) by Barbara & Joseph Cerno.

CONTEMPORARY
ACOMA

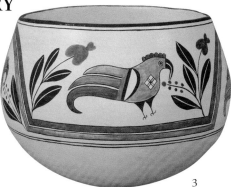

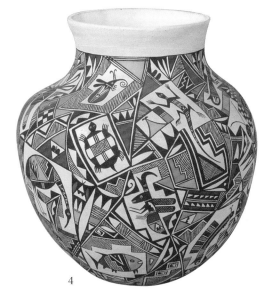

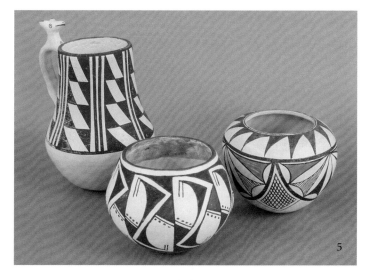

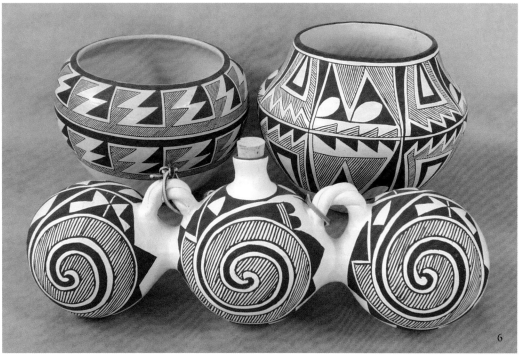

1. Orangeware bowl by Pat Iule, Mimbres lizard design. 2. Seed pot by Rebecca Lucario, Mimbres turkey design, courtesy of Charlotte Schaaf, Santa Fe. 3. Bowl by Carmel Lewis Haskaya, parrot design. 4. Jar by Rebecca Lucario, 23 Mimbres animals, birds & other creatures. 5. (Left to right): Mesa Verde mug by Anita Lowden; jar by Virginia Lowden; jar by Joyce Leno.
6. (Front row): Tularosa triple canteen by Juana Leno. (Back row left to right): Anasazi Revival jar by Sarah Garcia, Anasazi Revival olla by Rose Chino Garcia.

CONTEMPORARY
ACOMA

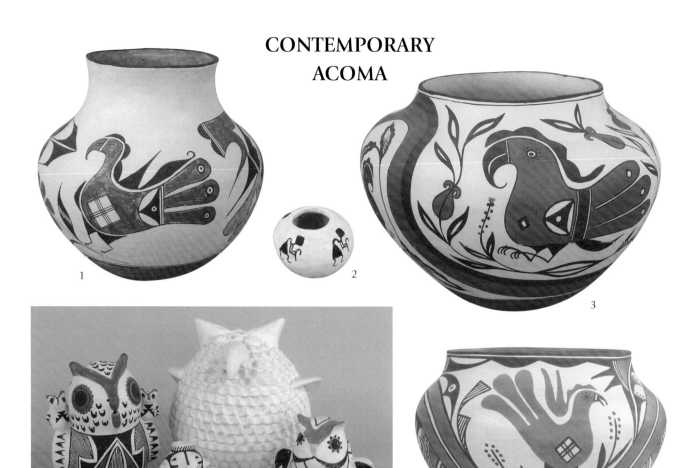

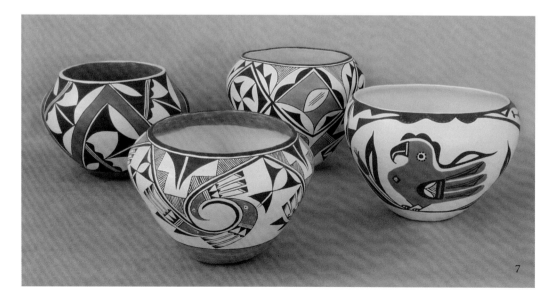

1. Olla by Linda Juanico, parrot design. 2. Miniature pot by Dolores Lewis Garcia, Kokopelli design, courtesy of Charlotte Schaaf, Santa Fe. 3. Olla by Darla Davis, parrot design. 4. (Left to right): Owl Storyteller by Marie S. Juanico; Hohocom Revival figure by Wanda Aargon, Corrugated owl by Jackie Shutiva; Owl by E. R. Vallo. 5. Olla by Loretta Joe, parrot design. 6. Cow pitcher by Mabel Brown. 7. (Left to right): Olla by Rose Poncho; Olla by Jessie Louis; Olla by Sarah Garcia; Olla by Darla Davis.

CONTEMPORARY ACOMA

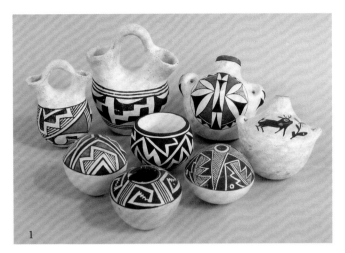

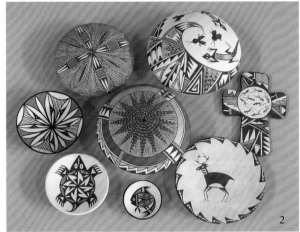

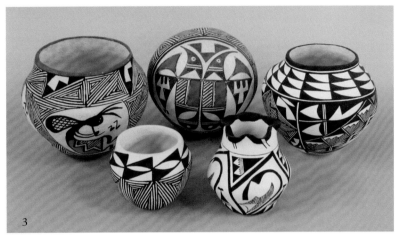

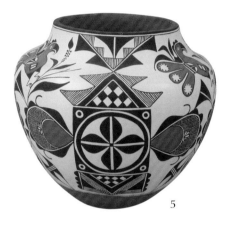

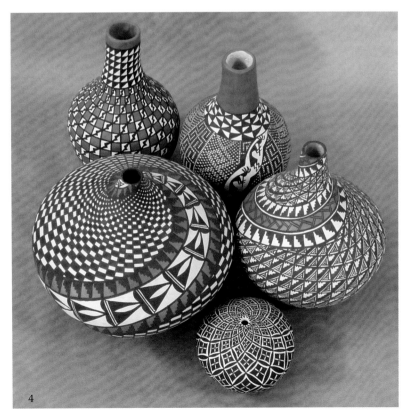

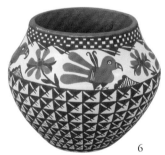

1. Miniatures (clockwise from 1 o'clock): Canteen by Monroe F. Victorino, Carrie Chino, Rebecca Lucario, Marie Z. Chino, Grace Chino, Grace Chino, Frances Torivio, and Emma Lewis (center).

2. Miniatures (clockwise from 1 o'clock): Carolyn Concho, Judy Lewis, Barbara & Joseph Cerno, Divine Reano, Bear Routzen, Divine Reano, Rebecca Lucario, and Rebecca Lucario (center).

3. (Back row left to right): Felice, Joyce Leno, and Karen Fernando. (Front row left to right): B. Louis, Harriett Garcia.

4. Optical designs (Clockwise from 1 o'clock): Melissa Antonio, Sandra Victorino, Dorothy Torivio, Sandra Victorino, & Mildred Antonio.

5. Olla by Rachel Aargon. 6. Olla by Mildred Antonio, parrots with optical design.

EARLY COCHITI

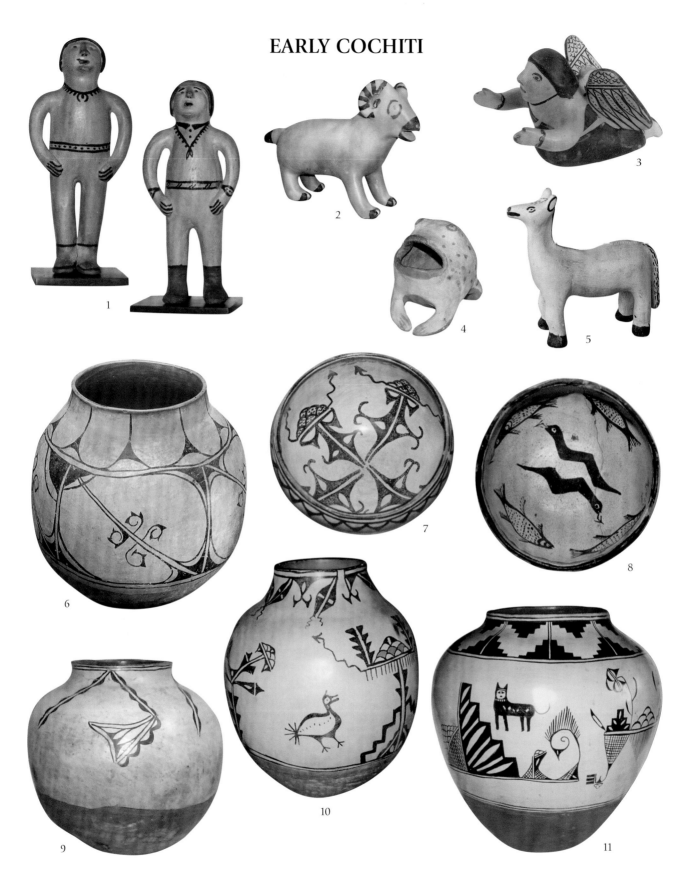

1. Standing figures, courtesy of Don & Lynda Shoemaker, Santa Fe. 2. Sheep, courtesy of J. Mark Sublette, Medicine Man Gallery, Inc., Tucson & Santa Fe. 3. Angel, ca. 1930s. 4. Frog, ca. 1920s. 5. Animal figure, courtesy of Eason Eige, Albuquerque. 6. Large storage jar, ca. 1880. courtesy of Adobe Gallery, Albuquerque & Santa Fe. 7 & 8. Ceremonial bowls, ca. 1920s, courtesy of Christopher Selser, Santa Fe. 9. Large storage jar, 19th century, courtesy of J. Mark Sublette, Medicine Man Gallery, Inc., Tucson & Santa Fe. 10. Large storage jar, 19th century, courtesy of Cowboys & Indians Antiques, Albuquerque. 11. Large storage jar, courtesy of Don & Lynda Shoemaker, Santa Fe.

CONTEMPORARY COCHITI

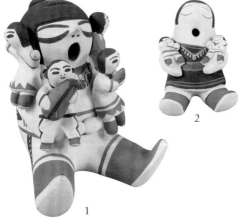

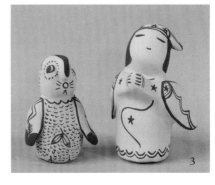

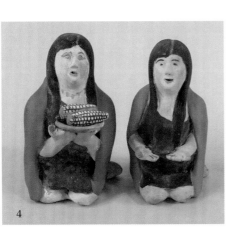

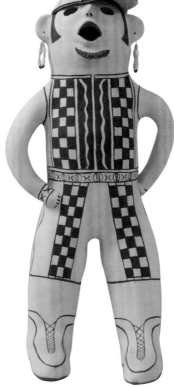

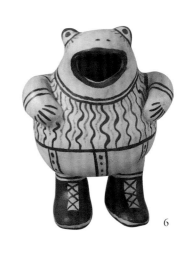

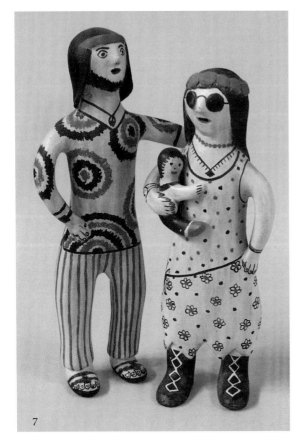

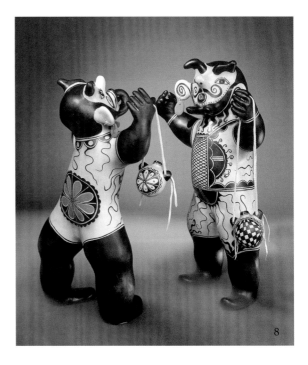

1. Storyteller by Judith Suina. 2. Storyteller by Joanne Trujillo. 3. Owl and Angel by Snowflake Flower. 4. Kneeling figures by Ben Eustace. 5. Large baseball player by Martha Arquero. 6. Singing frog by Guadalupe Ortiz. 7. Hippies by Joyce Ortiz. 8. Circus figures by Vigil Ortiz, Courtesy of Adobe Gallery, Albuquerque & Santa Fe.

CONTEMPORARY COCHITI

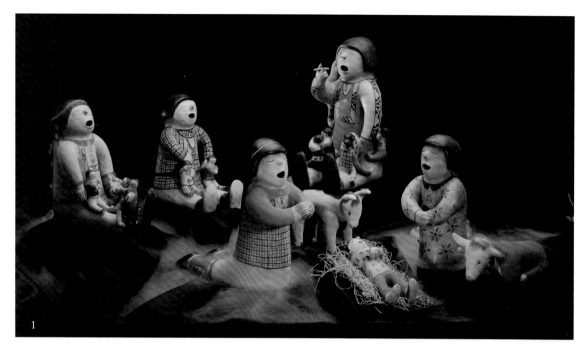

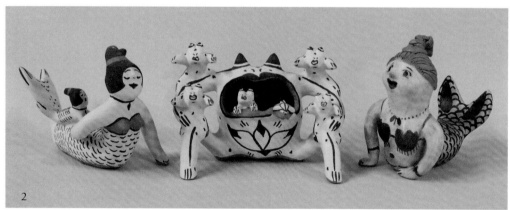

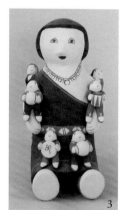

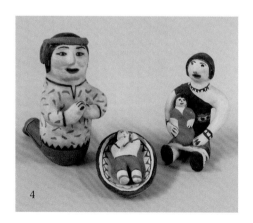

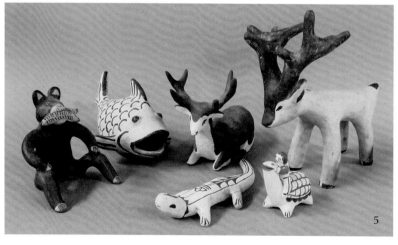

1. A collection of figures by Helen Cordero, including a Nativity and Storytellers, courtesy of Adobe Gallery, Albuquerque & Santa Fe. 2. (Left to right): Mermaid and Frog Storyteller by Martha Arquero, Mermaid by Juanita Inez Ortiz. 3. Storyteller by Annette Romero. 4. Nativity by Seferina Ortiz. 5. (Left to right): Bear with fish by Martha Arquero, big fish, unsigned, kneeling deer by Delfina Herrera, standing deer by Elizabeth Trujillo, Lizard and turtle by Juanita Inez Ortiz.

CONTEMPORARY COCHITI

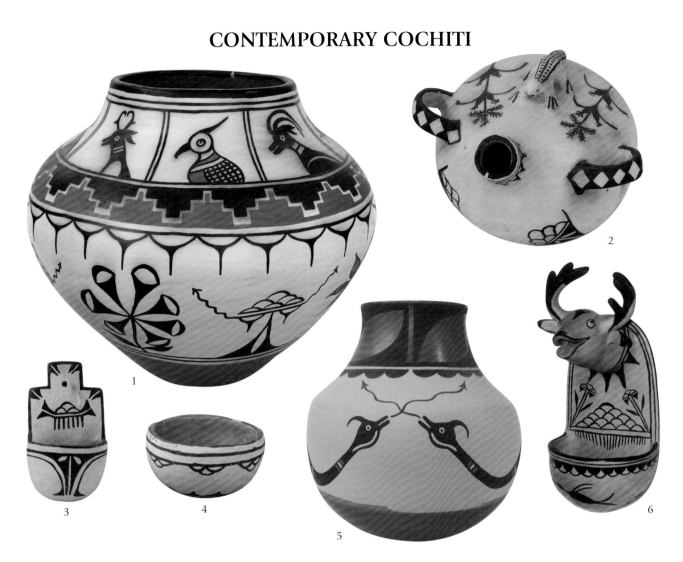

CONTEMPORARY ISLETA

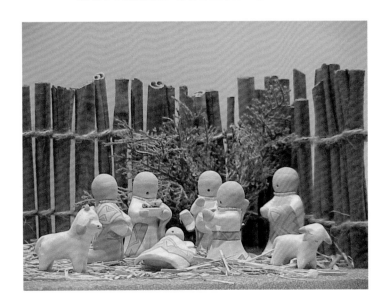

CONTEMPORARY COCHITI: 1. Large traditional olla by Vigil Ortiz. 2. Canteen by Seferina Ortiz, lizard effigy design. 3. Small cornmeal alter, unsigned, rain cloud design. 4. Bowl by Damacia Cordero, cloud design. 5. Large vase by Joseph B. Suina, Water Serpent design. 6. Cornmeal alter, unsigned, deer design, courtesy of Don & Lynda Shoemaker, Santa Fe.
CONTEMPORARY ISLETA: Nativity scene by Stella Teller, courtesy of Walton-Anderson.

CONTEMPORARY
JEMEZ

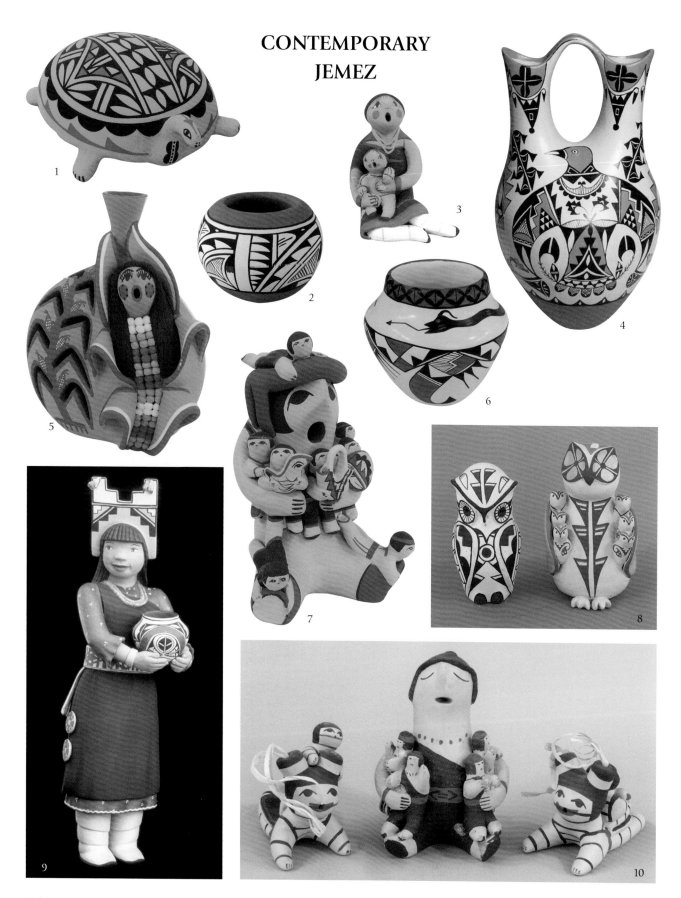

CONTEMPORARY JEMEZ: 1. Turtle by Anna Chinana & Marie Waquie. 2. Small pot by J. Shendo. 3. Singing Mother by Mary Lucero. 4. Unsigned Thunderbird wedding vase, courtesy of John Isaac Antiques, Albuquerque. 5. Corn Maiden vase by Cindy Fragua. 6. Water Serpent olla by Flo & Sal Yepa. 7. Storyteller by Judy Toya. 8. (Left to right): Owl by F. C. Gachupin, Owl Storyteller by Carol Pecos. 9. Maiden Dance Figure by Kathleen Wall, courtesy of the artist. 10. Storyteller by Judy Toya, Clown figure by Marie Toya.

CONTEMPORARY JEMEZ

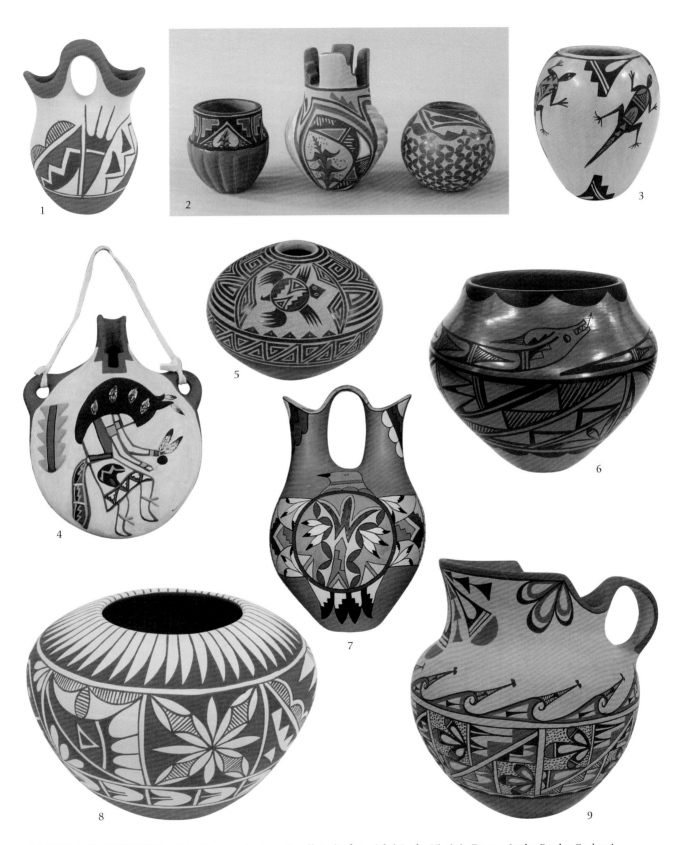

CONTEMPORARY JEMEZ: 1. Wedding vase by Mary Small. 2. (Left to right):Jar by Virginia Fragua, Jar by Bertha Gachupin, Sgraffito pot by Carol Vigil. 3. Vase by Juanita Fragua. 4. Canteen by Carol Pecos. 5. Sgraffito seed pot by Dennis Daubs. 6. Olla by Donald Chinana. 7. Unsigned wedding vase, courtesy of Andrea Fisher Fine Pottery, Santa Fe. 8. Jar by Mary Small. 9. Pitcher signed Yepa, courtesy of Frank Kinsel, CA.

EARLY LAGUNA

CONTEMPORARY
LAGUNA

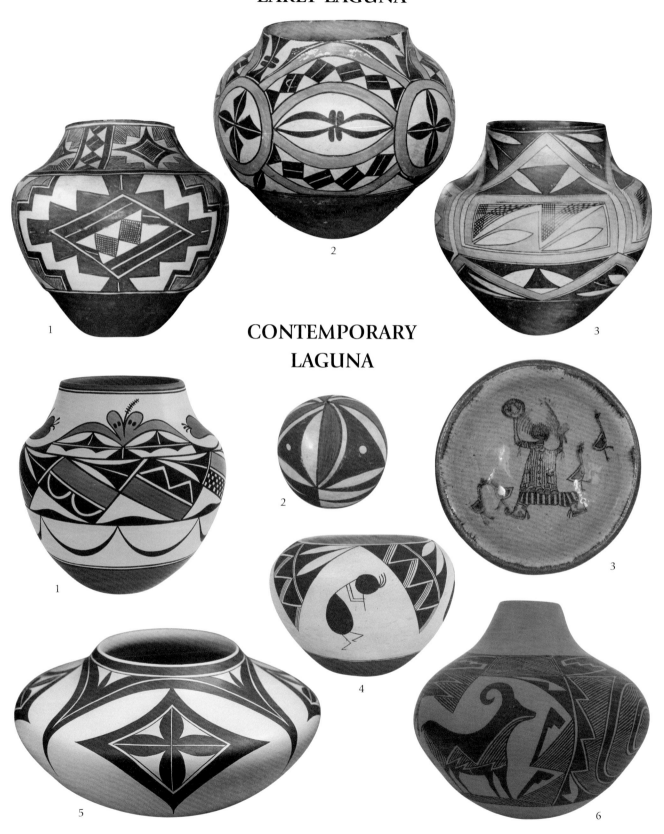

EARLY LAGUNA: 1. Olla, ca. 1885, courtesy of Christopher Selser, Santa Fe. 2. Olla, ca. 1890, courtesy of Christopher Selser, Santa Fe. 3. Olla, ca. 1900, courtesy of Christopher Selser, Santa Fe. **CONTEMPORARY LAGUNA:** 1. Olla by Gladys Paquin, courtesy of Jill Giller, Native American Collections, photograph by Bill Bonebrake. 2. Seed pot by Gladys Paquin. 3. Stoneware bowl by Harold Littlebird. 4. Jar with Kokopelli design by Mary Cheromiah. 5. Jar by Yvonne Lucas, courtesy of Case Trading Post at the Wheelwright Museum of the American Indian, photograph by Tony Molina. 6. Tularosa Revival redware vase by Myron Sarracino.

SANDIA

1

SANTA ANA

1

SAN FELIPE

1

2

3

SANDIA: 1. Plate by John Montoya, Sandia Peaks and deer design.
SANTA ANA: 1. Olla by Eudora Montoya, ca. 1969.
SAN FELIPE: 1. Storyteller by Leonora Lucero. 2. Puzzle Pot by Hubert Candelario, courtesy of Jill Giller, Native American Collections, photograph by Bill Bonebrake . 3. Jar by Daryl Candelaria, Sherd design, courtesy of Jill Giller, Native American Collections, photograph by Bill Bonebrake

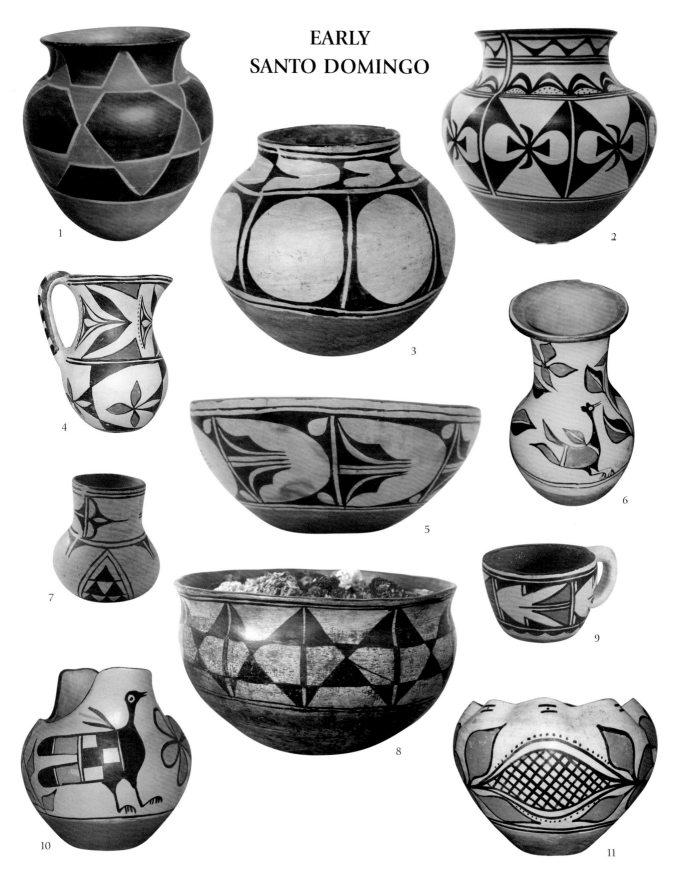

EARLY
SANTO DOMINGO

1

2

3

4

5

6

7

8

9

10

11

1. Olla, courtesy of Richard M. Howard. 2. Olla, courtesy of Joseph & Janet Marchiani Collection, 3. Olla, courtesy of Eason Eige, Albuquerque, NM. 4.Pitcher, courtesy of J. Mark Sublette, Medicine Man Gallery, Inc., Tucson & Santa Fe. 5. Dough bowl, courtesy of Nedra Matteucci Galleries, Santa Fe. 6. Vase, courtesy of Cowboys & Indians Antiques, Albuquerque, NM. 7. Vase, courtesy of Angie Yan Schaaf. 8. Dough bowl, ca. 1860, courtesy of Christopher Selser, Santa Fe. 9. Cup, courtesy of Angie Yan Schaaf. 10 & 11. Jars, courtesy of Dr. Sally Archer & Dr. Al Waterman Collection, Yardley, PA.

ROBERT TENORIO and FAMILY of SANTO DOMINGO

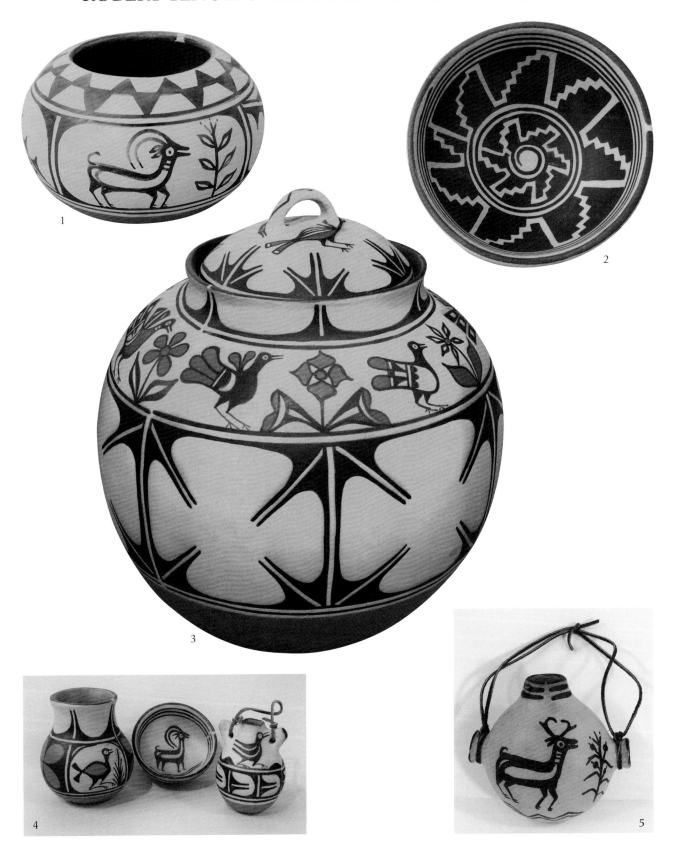

1. Jar by Robert Tenorio, Bighorn sheep design. 2. Bowl made by Hilda Coriz and painted by Robert Tenorio, negative terrace design. 3. Huge lidded storage jar (20″ x 19″) by Robert Tenorio. 4. (Left to right): Vase by Arthur & Hilda Coriz, Bowl by Robert Tenorio, Canteen by Hilda Coriz. 5. Canteen by Robert Tenorio.

MELCHOR FAMILY of SANTO DOMINGO

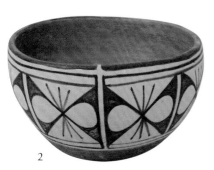

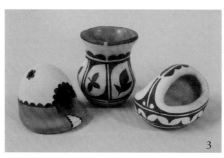

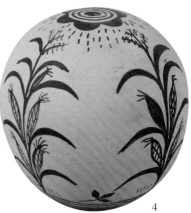

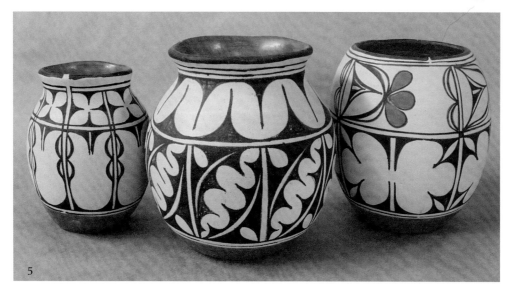

1. (Left to right): Olla by Crucita Melchor, Jar by Santana Melchor, Olla by Crucita Melchor. 2. Chili bowl by Crucita Melchor.
3. (Left to right): Bread oven by James Melchor, Jr., Olla & Clay basket by Dolorita Melchor. 4. Seed pot by Crucita Melchor.
5. Ollas by Crucita Melchor.

25

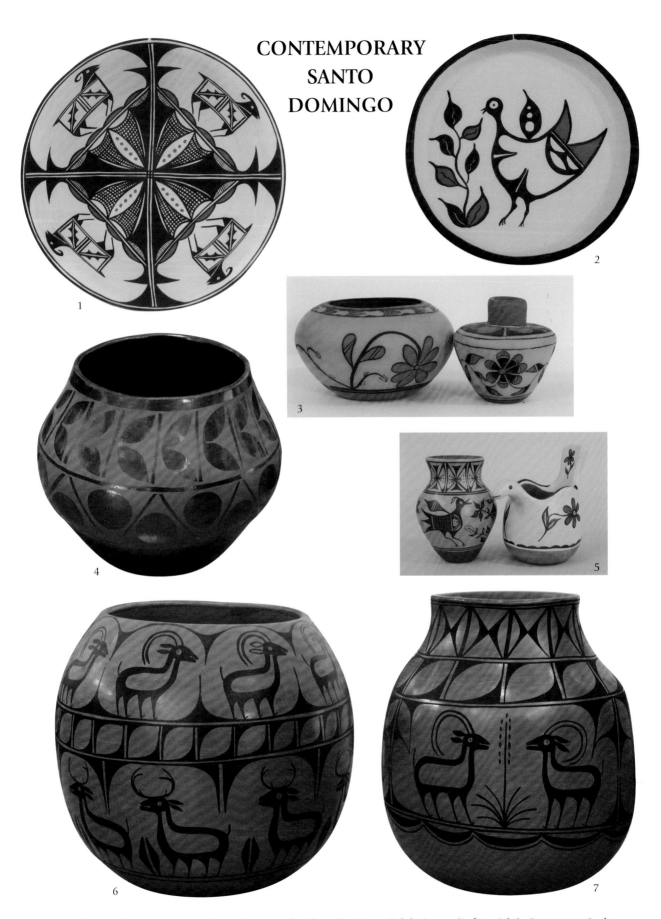

CONTEMPORARY SANTO DOMINGO

1. Bowl by Thomas Tenorio, Bighorn Sheep design. 2. Plate by Josie Nieto, Bird design. 3. (Left to right): Orangeware Jar by Florence Pajarito, Jar by Andrew Garcia. 4. Blackware olla by Rafaelita Aguilar. 5. (Left to right): Miniature olla by Thomas Tenorio, Bird pot by Del Mar Tenorio & Trini Peña. 6. & 7. Black-on-red storage jars by Vidal Aguilar.

CONTEMPORARY SANTO DOMINGO

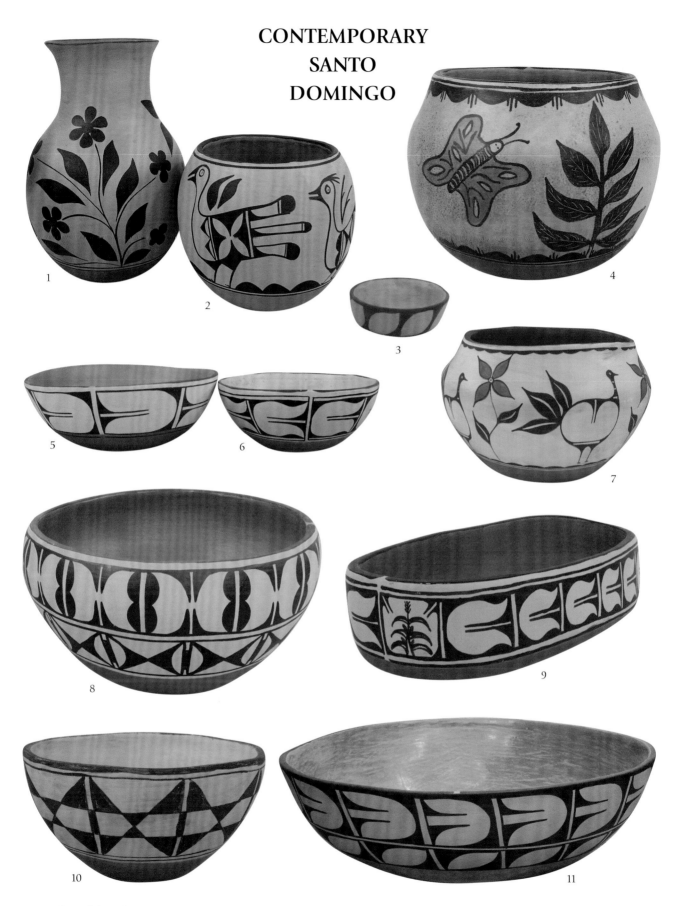

1. Vase by Vidal Aguilar. 2. Jar by Vidal Aguilar. 3. Pinch pot by Shumaal Lucero (age 2 1/2). 4. Jar by Alvina Garcia. 5. Stew bowl by Genevieve Garcia. 6. Unsigned Stew bowl. 7. Jar by Del Mar Tenorio & Trini Peña. 8. Feast bowl by Andrew & Vicky T. Calabaza. 9. Oval bowl by Alvina Garcia. 10. Chili bowl by Cecilia Nieto. 11. Dough bowl by Robert Aguilar.

EARLY
ZIA

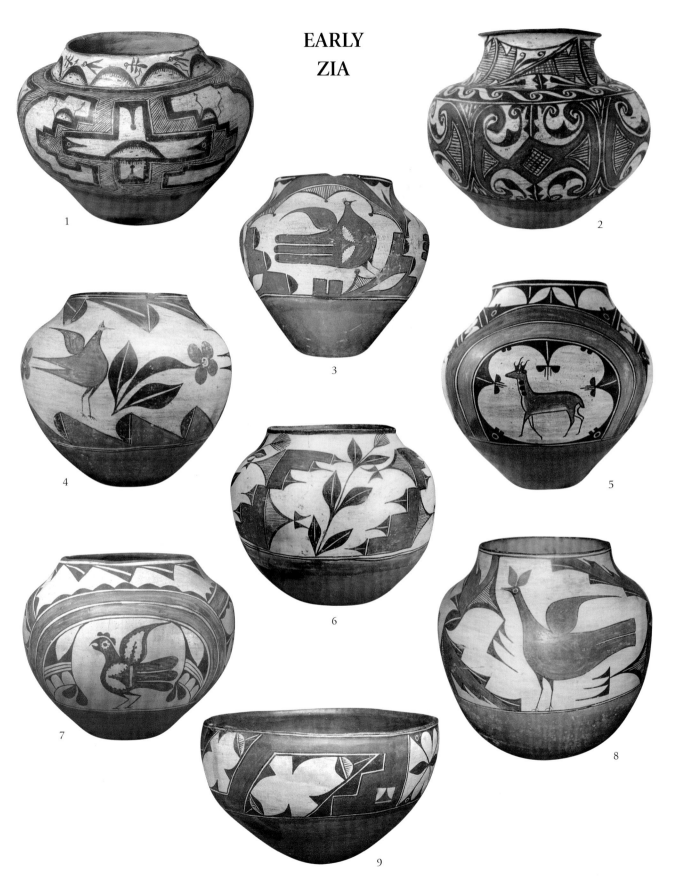

1. Olla, ca. 1865, courtesy of Christopher Selser. 2. Olla, ca. 1890, courtesy of Joseph & Janet Marchiani. 3. Olla, ca. 1900, courtesy of Ron & Doris Smithee, OK. 4. Olla, ca. 1910, courtesy of Lyn A. Fox Fine Historic Pottery. 5. Olla, ca. 1890, courtesy of Joseph & Janet Marchiani. 6. Olla, ca. 1880-1890s, courtesy of Lyn A. Fox Fine Historic Pottery. 7. Olla, courtesy of Phil Cohen, Native New Mexico, Inc. Santa Fe. 8. Olla, ca. 1910, courtesy of Richard M. Howard. 9. Dough bowl, ca. 1900-1920, courtesy of Lyn A. Fox Fine Historic Pottery.

EARLY
ZIA

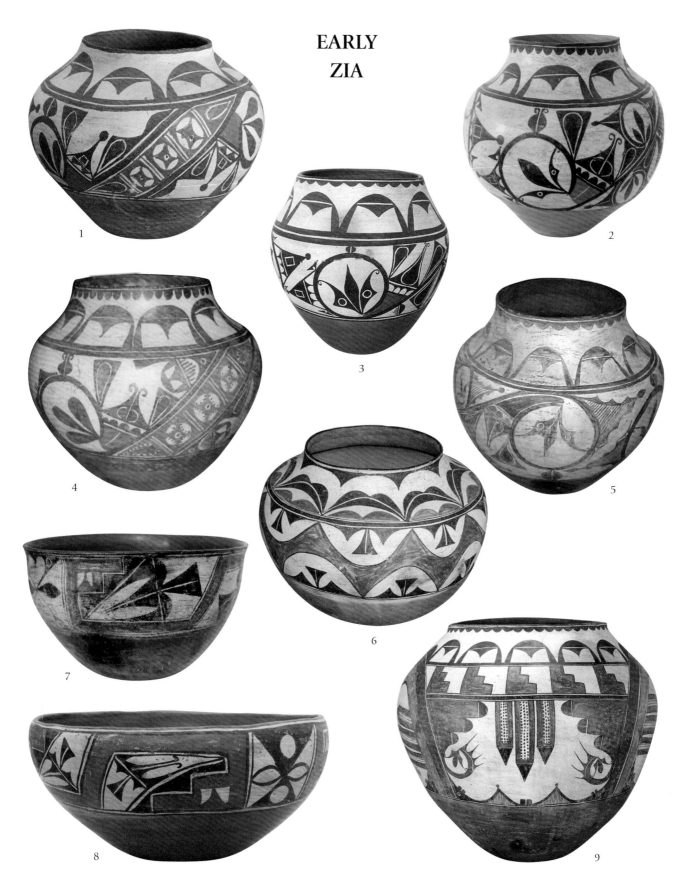

1. Olla, ca. 1900. 2. Olla, ca. 1880s, courtesy of Christopher Selser, Santa Fe. 3. Olla, ca. 1940, courtesy of Eason Eige, Albuquerque. 4. Olla, courtesy of Cowboys & Indians Antiques, Albuquerque. 5. Olla, courtesy of J. Mark Sublette, Medicine Man Gallery, Inc., Tucson & Santa Fe. 6. Olla (16 x 21″), ca. 1930s, courtesy of Terry Schurmeier & John Beeder, Albuquerque. 7. Dough bowl (9 x 16″), ca. 1890, courtesy of Christopher Selser. 8. Dough bowl (8 x 17″), ca. 1920s, courtesy of Nedra Matteucci Galleries, Santa Fe. 9. Olla (18 1/2 x 21 1/2″), courtesy of Butterfields, attributed to Trinadad Medina sold at Butterfields in November 1999 for $34,500.

CONTEMPORARY ZIA

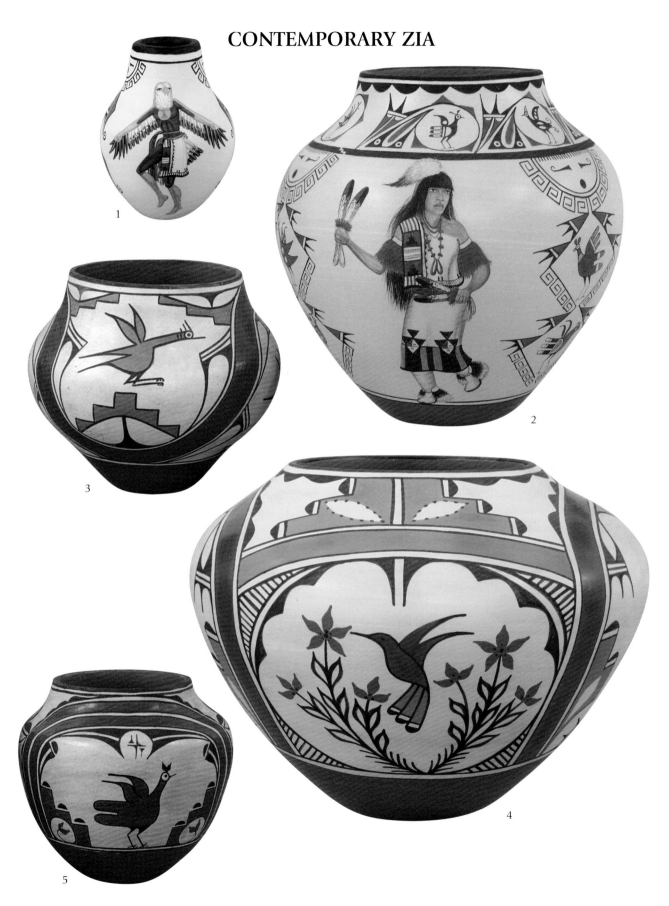

1. Miniature olla by Marcellus & Elizabeth Medina, Eagle dancer design. 2. Olla by Marcellus & Elizabeth Medina, Maiden dancer & buffalo dancer on verso. 3. Olla by Dominguita Pino, Roadrunner design. 4. Large olla by Ruby Panana, Hummingbird & roadrunner on verso. 5. Olla by Eusebia Shije, Roadrunner design.

CONTEMPORARY ZIA

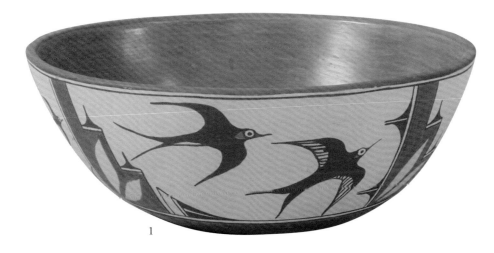

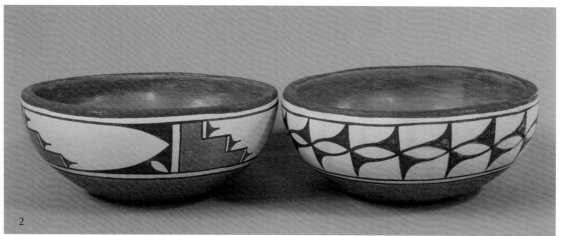

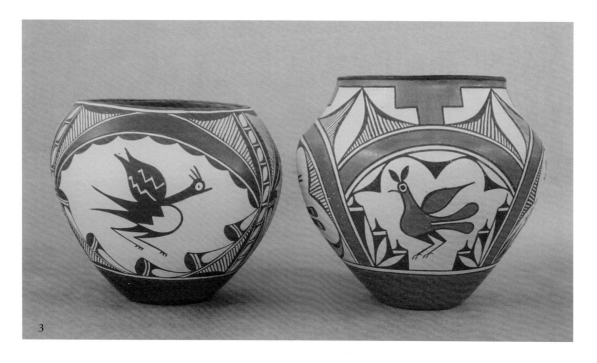

1. Dough bowl by Eleanor Pino-Griego, Swallow design. 2. Chili bowls by Sofia Medina. 3. (Left to right): Olla by Irene Herrera, Roadrunner design, Unsigned olla, Roadrunner design, courtesy of Robert Fisher.

CONTEMPORARY ZIA

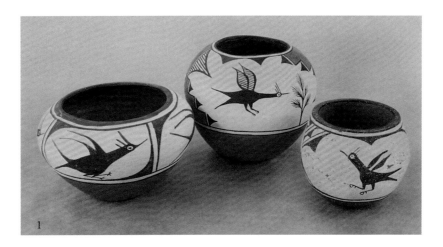

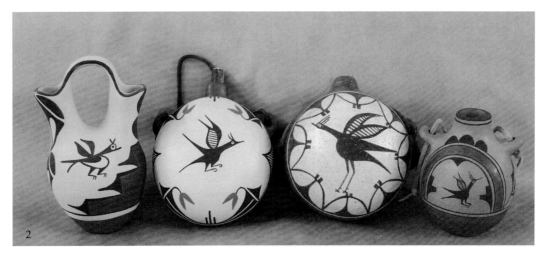

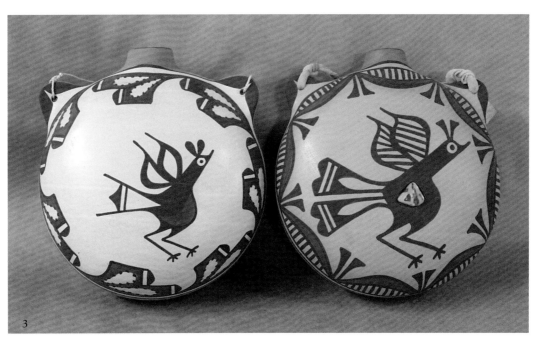

1. (Left to right): Jar by Serafina Bell, Jar by Vicentita S. Pino, Jar by Petra Lucero. 2. (Left to right): Wedding vase by Rebecca Gachupin, Canteen by Diana Lucero, Canteen by Angelina Herrera, Canteen by Vicentita S. Pino. 3. Two canteens by Ruby Panana

EARLY
ZUNI

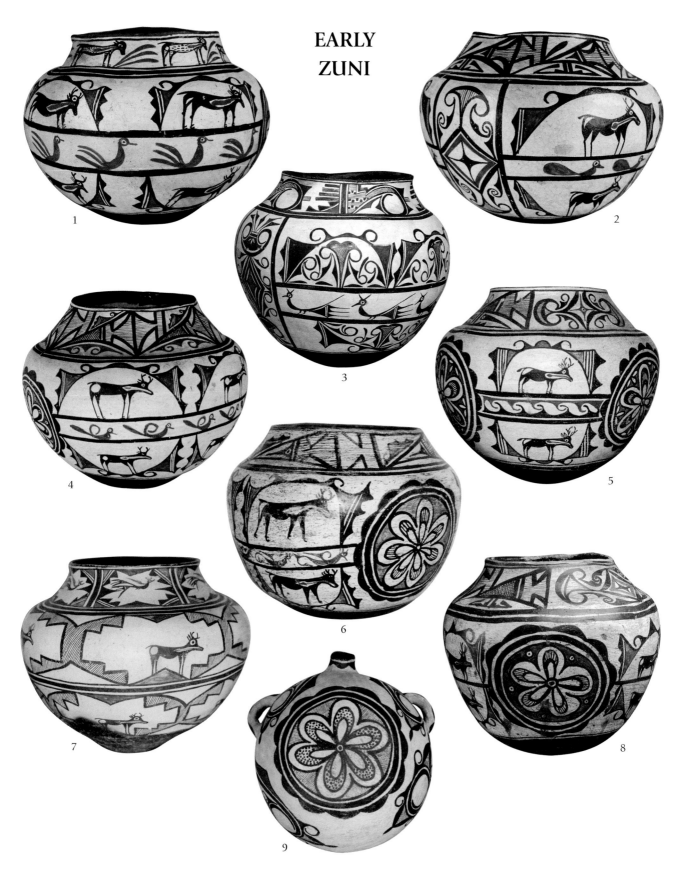

1. Olla, ca. 1880-1900, courtesy of Michael & Matthew Maxwell, Matthew Chase Ltd., Santa Fe. 2. Olla, ca. 1880-1900, courtesy of Michael & Matthew Maxwell, Matthew Chase Ltd., Santa Fe. 3. Olla (12 x 13"), ca. 1900, courtesy of Christopher Selser, Santa Fe. 4. Olla, courtesy of Don & Lynda Shoemaker, Santa Fe. 5. Olla, ca. 1890-1900, courtesy of Bob & Carol Berray, Santa Fe. 6. Olla, courtesy of John Beeder, Albuquerque. 7. Olla (10 1/2 x 12"), ca. 1890, courtesy of Christopher Selser, Santa Fe. 8. Olla, ca. 1880-1890, photograph by Addison Doty, courtesy of Phil Cohen, Native New Mexico, Inc. Santa Fe. 9. Canteen (9 x 12"), ca. 1880-1900, courtesy of Michael & Matthew Maxwell, Matthew Chase Ltd., Santa Fe.

EARLY ZUNI

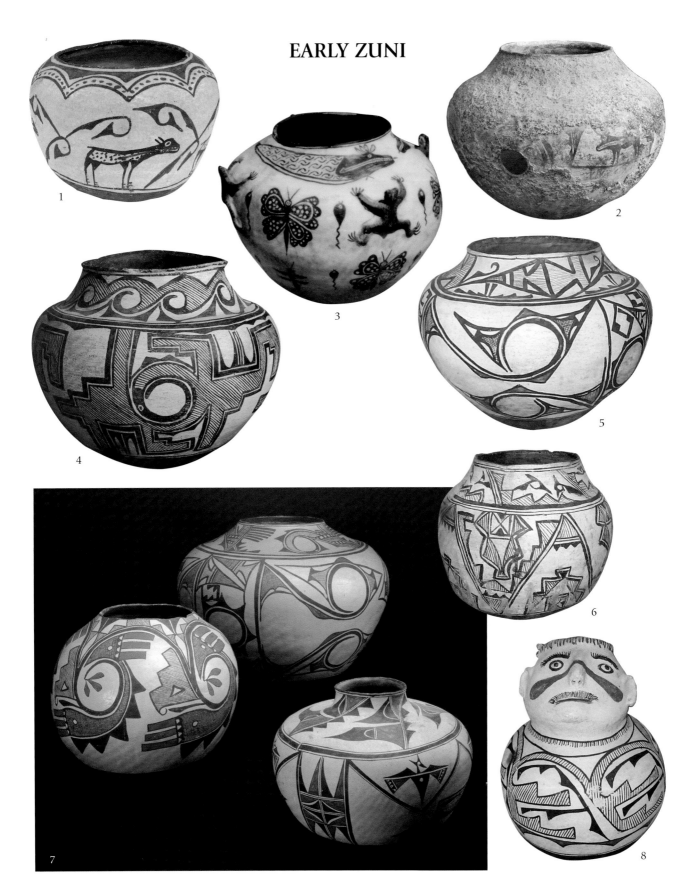

1. Olla, ca. 1880-1890, deer with heartline design. 2. Olla, ca. 1890, courtesy of Christopher Selser, Santa Fe. 3. Frog Jar, ca. 1910, courtesy of Richard M. Howard, Santa Fe. 4. Olla (10 x 12"), ca. 1880s, courtesy of Christopher Selser, Santa Fe. 5. Olla, courtesy of J. Mark Sublette, Medicine Man Gallery, Inc., Tucson & Santa Fe. 6. Olla, ca. 1880, courtesy of J. Mark Sublette, Medicine Man Gallery, Inc., Tucson & Santa Fe. 7. Three ollas, ca. early 20th century, courtesy of Adobe Gallery, Albuquerque & Santa Fe. 8. Human effigy pot, courtesy of J. Mark Sublette, Medicine Man Gallery, Inc., Tucson & Santa Fe.

EARLY ZUNI

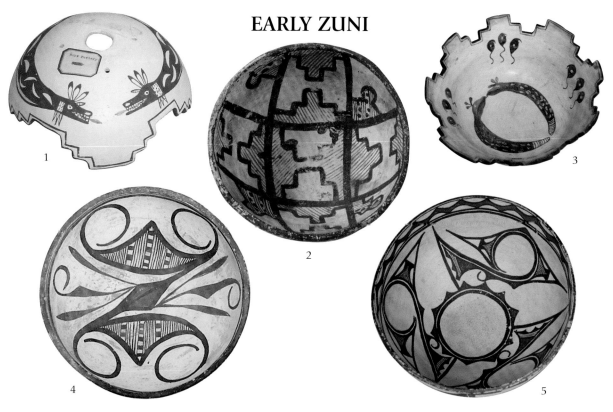

CONTEMPORARY ZUNI

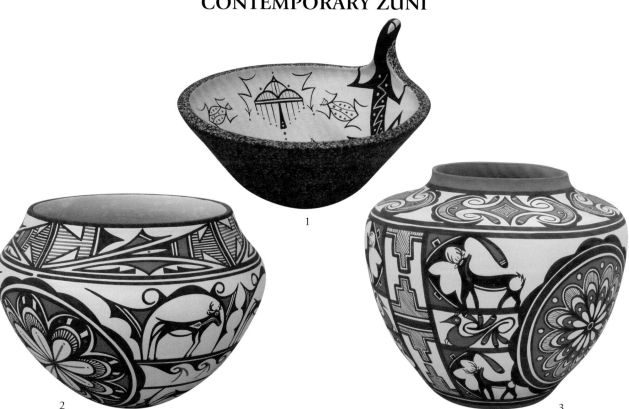

EARLY ZUNI: 1. Cornmeal Bowl converted into a lampshade, ca. 1900-10, courtesy of J. Mark Sublette, Medicine Man Gallery, Inc., Tucson & Santa Fe. 2. Chili bowl, ca. 1880-90, fineline rain design. 3.Cornmeal bowl, Water Serpent and tadpole designs, courtesy of John Beeder, Albuquerque. 4. Stew bowl, ca. 1890, courtesy of J. Mark Sublette, Medicine Man Gallery, Inc., Tucson & Santa Fe. 5. Bowl, ca. 1890, courtesy of Michael & Matthew Maxwell, Matthew Chase Ltd., Santa Fe.
CONTEMPORARY ZUNI: 1. Lizard effigy bowl by Priscilla Peynetsa. 2. Olla by Gabriel Paloma, Deer-in-His-House & rosette designs. 3. Olla by Noreen Simplicio, Deer with heartline & rosette designs.

CONTEMPORARY ZUNI

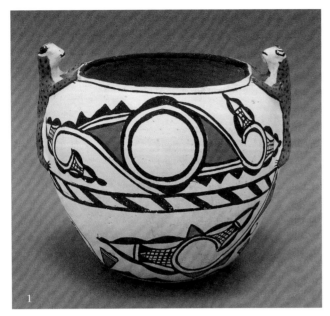

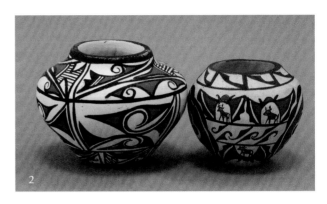

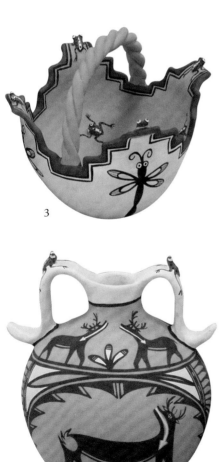

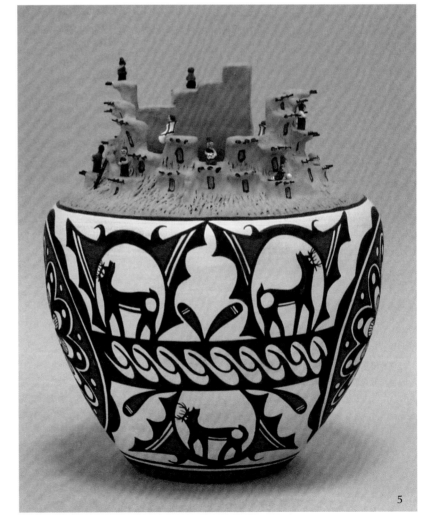

1. Frog jar by Sadie Tsipa. 2. (Left to right): Miniature olla by D. Bobelu, Miniature olla Jennie Laate. 3. Cornmeal bowl by Noreen Simplicio. 4. Frog effigy canteen by Noreen Simplicio, Deer-in-His-House design. 5. Olla with Pueblo village scene by Noreen Simplicio.

CONTEMPORARY
ZUNI

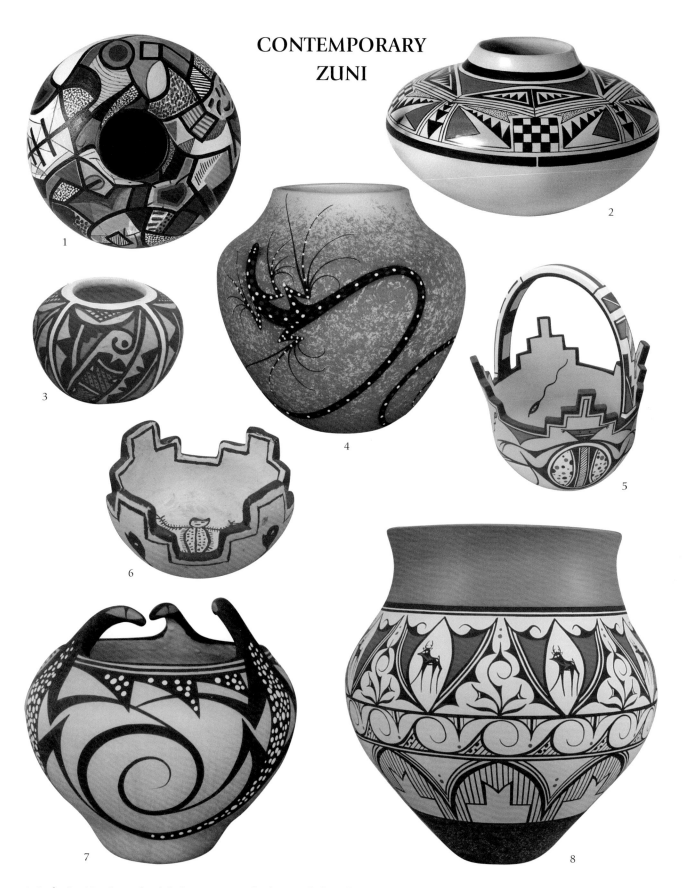

1. Jar by Les Naminga, sherd design, courtesy of Robert Nichols Gallery. 2. Jar by Jocelyn Naminga, Hopi style, courtesy of Robert Nichols Gallery. 3. Seed pot by Alton Chavez. 4. Lizard effigy jar by Deldrick Cellicion, courtesy of Jill Giller, Native American Collections, photograph by Bill Bonebrake. 5. Cornmeal bowl by Gabriel Paloma. 6. Cornmeal bowl by Effa Boone. 7. Lizard effigy jar by Anderson Peynetsa, courtesy of Jill Giller, Native American Collections, photograph by Bill Bonebrake. 8. Olla by Priscilla Peynetsa, deer with heartline design.

CONTEMPORARY ZUNI

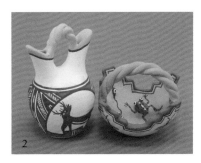

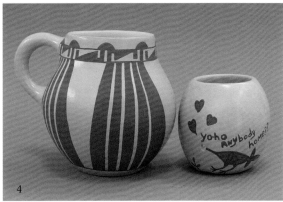

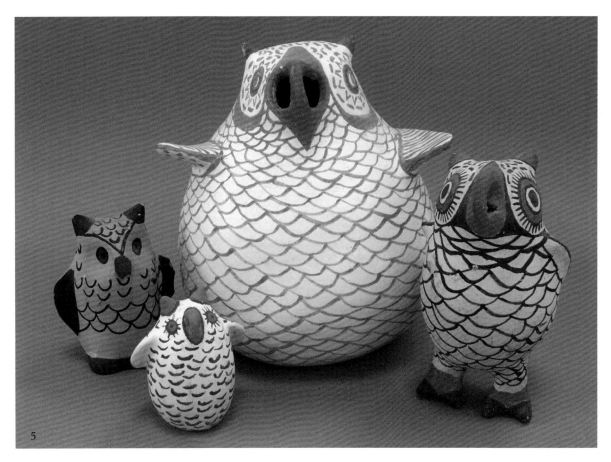

1. Miniature traditional bowl by Gabriel Paloma. 2.Miniature wedding vase and cornmeal bowl by Noreen Simplicio. 3. Miniature traditional bowl by Gabriel Paloma. 4. (Left to right): Cup by Josephine Nahohai, Turkey love cup by Kalestewa family. 5. (Left to right): Unsigned owl, Baby owl by Kenneth Earl Epaloose, Momma owl by Myra Eriacho, Standing owl by Nellie Bica.

Acknowledgments

This book would not be possible without the cooperation of Pueblo potters and their families. We recognize and honor the many Pueblo people who shared their lives and family traditions. Many of the matriarchs helped us construct family tree charts and told us who deserved special recognition for their unique contributions. They taught us that making pottery is traditionally a family affair.

This book was created as a joint effort between myself and Angie Yan Schaaf. She and I worked side-by-side, often starting before sunrise and working sometimes until late into the night. Angie also did much of the photography and digital scans, processing over 1,000 images. The graphic design is solely her creation. We fell in love creating this series. On December 23, 2000, we were happily married in a ceremony conducted by a Pueblo Indian elder at our home in Santa Fe.

Certain institutions share our commitment in compiling biographical information for Indian artists. Laura Holt, librarian at the Museum of Indian Arts and Culture, has worked for decades to computerize a state of the art facility. She has been assisted by volunteers Marlene Dallo and Hope Marrin. We thank Director Duane Anderson and the museum staff who maintain MIAC's remarkable collections.

Jonathan Batkin and Robb Lucas from the Wheelwright Museum of the American Indian provided lists of Pueblo potters and important research in the field. At the Heard Museum, Associate Archivist James T. Reynolds sent computer print-outs of their inventories and artist database. Bruce McGee and the staff of the Museum Shop have been very supportive.

We thank Bruce Bernstein and our friends at the National Museum of the American Indian for your strong support. President of the Indian Arts & Crafts Association, Susan Pourian, Colleen Reeks and staff at the Indian Craft Shop provided their collection inventory. The Philbrook Museum also kindly offered the inventory of their fine Pueblo pottery collection. Heather Companiott shared information on potters who have demonstrated their art at Idyllwild Arts. Records of demonstrations and exhibits were shared by the producers of Indian Market, Red Earth Festival, Albuquerque Indian Market, Inter-tribal Indian Ceremonial, Jemez Red Rock Arts & Crafts Show, Santo Domingo Arts & Crafts Show, San Felipe Arts & Crafts Show, Bein Mur Indian Market, Eight Northern Indian Pueblos Arts & Craft Show.

Over a thousand photographs were contributed for this book. John D. Kennedy & Georgia Kennedy Simpson at Kennedy Indian Arts gave historic portrait photographs from their family collection. Jason Esquibel of Rio Grande Wholesale, Inc. and Eason Eige of Andrews Pueblo Pottery and Art Gallery earned our high praise not only for their excellent photographs, but also for helping to collect biographical information directly from the artists. Thank you to the following collectors who provided photographs of pottery from their collections: Dr. Sally Archer & Dr. Al Waterman, John Beeder, Dr. Fred Belk, Bob & Carol Berry, Peter Carl, Bill & Jane Buchsbaum, Candace Collier, Janie & Paul K. Conner, Gloria Couch, Mary Dwyer, Charles Gideon, Cindy Hale, Allan & Carol Hayes, Richard M. Howard, Drs. Judith & Richard Lasky, Dave & Lori Kenney, Frank Kinsel, Johanna Leibfarth, Jewell Lynch, Dr. Gerald & Laurette Maisel, Joseph & Janet Marchiani, Brooks & Wanda Price, Dick & Karin Roth, Ed Samuels, Don & Lynda Shoemaker, Ron & Doris Smithee, Michael Snodgrass, Walton - Anderson Collection, Christopher Webster, John Wright and Shannon McCray.

Thank you to the following galleries who provided photographs of pottery and other information: Al Anthony & Ken at Adobe Gallery, Bien Mur, Blue Thunder Fine Indian Art, Robb Lucas of Case Trading Post at the Wheelwright Museum of American Indian, Michael & Matthew Maxwell at Matthew Chase Ltd., Terry Schurmeier at Cowboys & Indians, Enchanted Village, Andrea Fisher Fine Pottery, Carol Waters at Hoel's Indian Shop, Bill & Marilyn Knox at Indart Inc., Wanda & Ralph Campbell at Indian Art Unlimited, Isa & Dick Diestler of Isa Fetish, Jemez Mountain Trading Co., Charles King at King Galleries, Nedra Matteucci Galleries, Dr. J. Mark Sublette at Medicine Man Gallery, Inc., Jill Giller at Native American Collections, Phil Cohen at Native New Mexico, Inc., Robert Nichols Gallery, Joe Zeller of River Trading Post, Christopher Selser, and Sunshine Studio.

The Indian Art Collector's Circle of Santa Fe were the first to see early drafts of the manuscript. Thank you for your expertise: Jan Duggin, Blanche Brody, Bill Hawn, Bo Hunter, Toby Johnson, Nancy Lehrhaupt & Joseph Newman, Harriet Levine, Georgia Loloma, Fabrizia Marcus, Alan & Valerie McNown, John & Mary Schroeder, Susan Swift, Mark Winter, and others.

Several auction houses contributed their records, including: Sotheby's, Christie's, Butterfield & Butterfield, R. G. Munn Auction, Allard Auctions, and Ron Milam Auctions.

The directors of Southwest Learning Centers deserve recognition: Seth Roffman, Radford Quamahongnewa, James Berenholtz, and Mazatl Galindo. Jeffrey Bronfman's vision and support inspires us all.

Our team of proofreaders deserve much applause including: Donald Krier, Pat & Garet Ten Cate, Charlotte Schaaf, Dave & Lori Kenney. Others offered editorial suggestions, including Luella Schaaf, Kim Schaaf, Tony Chiboucas, Lori & Kelli Felix. Finally, we would like to thank our other friends and family members who encouraged us in this good work.

Introduction

This volume introduces potters of the past two centuries from Pueblos located south of Santa Fe: Acoma, Cochiti, Isleta, Jemez & Pecos, Laguna, Sandia, San Felipe, Santa Ana, Santo Domingo, Tigua/Ysleta del Sur, Zia and Zuni. The oldest potters in the book lived to be over a hundred. The youngest potter is 2 1/2-years-old. The goal was to record all known potters from past to present.

This book is organized alphabetically like a telephone book. Looking up a particular artist takes only seconds. The volume actually features 2,150 potters from almost a hundred clans, representing twelve Puebloan groups who speak four main languages: Keres, Tiwa, Towa and Zuni. Pueblo Indians collectively represent one of the oldest living cultures on Earth. Some of their communities are over 1,000 years old, and their ancient history stretches back to the emergence into the American Southwest and beyond.

Because Pueblo pottery making is a family tradition, their biographical history reveals how different forms, techniques and designs were passed down from generation-to-generation. This book is intended to help readers distinguish between different Pueblo styles. Certain potters maintain the old traditional 19th century styles. Some revive ancient Anasazi, Tularosa and Mimbres designs. Other contemporary artists innovate new styles and forms, sometimes with exciting results.

After acquiring this book, the desire to collect Pueblo pottery may become overwhelming. You may soon find yourself calling galleries, ordering auction catalogs, searching the Internet or even traveling to the Pueblos and getting your book autographed by the artists. Children's pots often cost less than $50. The highest price ever paid for a single pot reportedly was $325,000 for a large, classic Acoma olla. At whatever price, collecting Pueblo pottery and meeting Indian artists can bring much joy and beauty to one's life. Being a patron to Indian artists also may bring to them some added measure of freedom. Through our efforts may we help to keep traditional arts alive for the benefit of coming generations.

Map of the Southern Pueblos

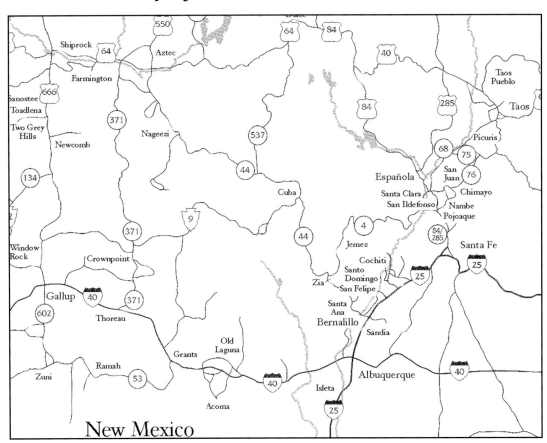

J. A. *(see Josephine Arquero)*

M.S.A.

(Jemez, active ?: polychrome-on-buff bowls, jars)
COLLECTIONS: Wright Collection, Peabody Museum, Harvard University, Cambridge, MA
FAVORITE DESIGNS: butterflies, corn
PUBLICATIONS: *Arizona Highways* May 1974 50(5):22; Babcock 1986; Drooker & Capone 1998:57, 138.

Andy Abeita

(Isleta, active ?-present)
GALLERIES: Arlene's Gallery, Tombstone, AZ

Burgess P. Abeita-James

(Acoma, Sun Clan, active 1988-present: traditional & contemporary sgraffito, polychrome jars, bowls)
BORN: June 13, 1979
FAMILY: son of Augustine & Tamra Abeita
PUBLICATIONS: Painter 1998.9.

Frances Abeita

(Acoma, active ca. 1930s-?: traditional polychrome jars, bowls)
BORN: ca. 1910
FAMILY: daughter of Dolores Stein; mother of Jennie Laate & Louise Amos; m. grandmother of Maggie Laate

Gloria A. Abeita

(Isleta, active ca. 1993-present: traditional & ceramic polychrome jars, bowls)
BORN: March 19, 1948
FAMILY: daughter of Jose & Dora Jojola
TEACHER: Dora Jojola
PUBLICATIONS: Berger & Schiffer 2000:97.

Richard Abeita

(Zuni/Isleta, active ?-present: traditional polychrome jars, bowls)
GALLERIES: Keshi, Santa Fe

Tamra L. Abeita *(Tamra Lea Abeita), (signs T. Abeita, Acoma N.M.)*

(Acoma, Sun Clan, active ca. 1980-present: traditional & contemporary polychrome jars, bowls, Storytellers, Nativities, wall art - spirit horses)
BORN: April 7, 1959; RESIDENCE: Albuquerque, NM
FAMILY: m. granddaughter of Frank & Alice P. White; daughter of Jimmy P. James and Rachael White James; sister of Gilbert R. James, Darla K. Davis, Tracey D. Chalan, Hope Taylor, Dewey M. James & Melody L. James; wife of Augustine D. Abeita; mother of Darius L. James, Burgess P. Abeita-James, Marlissa Kraft, David C. Mahoney
AWARDS: Indian Market, Santa Fe; Inter-tribal Indian Ceremonial, Gallup; 1st, 2nd, 3rd, New Mexico State Fair, Albuquerque; 2nd, High Country Show, Picuris Pueblo, NM; 3rd, Eight Northern Indian Pueblos Arts & Crafts Show; Excellence in Arts Award, Longview College, Faber, VA

Tamra L. Abeita - Courtesy of the artist

EXHIBITIONS: 1990, Casa Grande Winter Market, Phoenix; 1990-2001, Heard Museum Show, Phoenix; 1994-present, Eight Northern Indian Pueblos Arts & Crafts Show; 1996-present, Santa Fe Indian School Christmas Show; 2000-present, Albuquerque Indian Market, Albuquerque; 2000-present, Zia Arts & Crafts Show; 1990-present, Santo Domingo Arts & Crafts Show; ?-present, San Felipe Arts & Crafts Show; 1988-present, New Mexico State Fair, Albuquerque; ?-present, Albuquerque Ceramic & Doll Show; 2001, Indian Market, Santa Fe
DEMONSTRATIONS: Wheelwright Museum, Santa Fe; Indian Summerfest, Milwaukee, WI
FAVORITE DESIGNS: parrots, fineline rain, spirit horses
GALLERIES: The Indian Craft Shop, U.S. Department of Interior, Washington, D.C.; Jamestown Craft Shop, Williamsburg, VA; Buffalo Gallery, Alexandria, VA; Case Trading Post at the Wheelwright Museum, Santa Fe; Rio Grande Wholesale, Inc., Palms Trading Co., Albuquerque
PUBLICATIONS: Dillingham 1992:206-208; Reno 1995:4, 214; "Painter of the Month," *Positive Notes Magazine* Mar. 1996; Painter 1998:9; Berger & Schiffer 2000:97.

> Tamra L. Abeita shared her love for pottery making: "I enjoy experimenting with different shapes and forms and painting techniques. I also like to see people's faces when they make their purchases. I have the pleasure of meeting people from different places and countries."

> Tamra uses Acoma clay and natural paints. She fires pottery outdoors with manure in the old way. She is an excellent traditional potter.

Fernando Abenita

(Acoma, active ?-1990+: polychrome jars, bowls)
PUBLICATIONS: Dillingham 1992:206-208.

Juanita Abeyta
(Santo Domingo, ca. 1920s-1996: traditional polychrome jars, bowls)
EXHIBITIONS: 1995-96, Eight Northern Indian Pueblos Arts & Crafts Show
PUBLICATIONS: Batkin 1987:202, n. 83.
> Museum director Kenneth M. Chapman gave her a set of Santo Domingo pottery designs he had compiled in the 1930s. The designs also were shared with Felicita Benavides, Maria Calabaza, Reyes Calabaza, Santiago Calabaza's family, Marie Coriz, Crucita Herrera and two others.

Pauline Abeyta *(Abeita)*
(Acoma, active ?-1990+: polychrome jars, bowls)
PUBLICATIONS: Dillingham 1992:206-208; Reno 1995:5, 214.

Margaret Acencino
(Acoma, active ?-1975+: polychrome jars, bowls)
PUBLICATIONS: Minge 1991:195.

Aggie *(see Aggie Henderson-Poncho)*

Augustin Aguilar
(Zia, active 1910s-?)
BORN: ca. 1891
FAMILY: sister of Isuisuio? Aguilar
PUBLICATIONS: U.S. Census 1920, family 21.

Augustina Aguilar
(Zia, active ca. 1880s-1937: traditional polychrome ollas, jars, bowls)
BORN: ca. 1860s
FAMILY: daughter of He-wee'-a & Gaa-yo-le-nee; sister of Elisio Aguilar; mother of Manuelita Aguilar Salas; m. grandmother of Vicentita S. Pino; great-grandmother of John B. Pino, Ronald Pino & Diana Lucero

Darlene Aguilar *(collaborates sometimes with Rafaelita Aguilar, her mother), (signs Darlene Aguilar or Rafaelita & Darlene Aguilar, S.D.P.)*
(Santo Domingo, active ca. 1980s-present: black-on-black, black-on-red & black-on-cream large storage jars, ollas, dough bowls, pitchers, wedding vases, canteens)
BORN: August 15, 1960s
FAMILY: m. granddaughter of Juan and Miguelita Aguilar; daughter of Rafaelita Aguilar; related to Marie C. Aragon, Vidal E. Aguilar & Robert Aguilar
TEACHER: Rafaelita Aguilar, her mother
EXHIBITIONS: Santa Domingo Pueblo Arts & Crafts Show

Darrin Aguilar *(hallmark = moon and star)*
(Santo Domingo, active ca. 1995-present: redware and polychrome jars, bowls, canteens)
BORN: February 27, 1980
FAMILY: son of Joe & Helen Aguilar; brother of Vidal & Robert Aguilar
PUBLICATIONS: Berger & Schiffer 2000:97.

Felipa Aguilar
(Santo Domingo, active ca. 1910s-?: traditional polychrome ollas, jars, bowls)
AWARDS: 1924, 2nd, Indian Market, Santa Fe; 1926, 2nd, Indian Market, Santa Fe
PUBLICATIONS: Toulouse 1977:53.
> In 1924 and 1926, Felipa Aguilar and Tonita Quintana were award winners from Santo Domingo at Indian Market in Santa Fe.

Filipita Aguilar *(see Filipita Aguilar Garcia)*

Marie Aguilar *(collaborates with Martin Aguilar), (signs Marie & Martin Aguilar)*
(Santo Domingo, active ca. 1960s-present: black-on-black jars, bowls, jewelry)
BORN: ca. 1940
FAMILY: daughter of Reyes Calabaza & Santiago L. Calabaza; sister of Genevieve Garcia & Andrea; grandmother of Cheston Niles Garcia
COLLECTIONS: Candace Collier, Houston, TX

Martin Aguilar *(collaborates with Marie Aguilar), (signs Marie & Martin Aguilar)*
(Santo Domingo, active ca. 1960s-present: black-on-black jars, bowls, jewelry)
BORN: ca. 1940
COLLECTIONS: Candace Collier, Houston, TX

Miguelita Aguilar

(Santo Domingo, active ca. 1920s-?: traditional polychrome, black-on-black, black-on-red & black-on-cream large storage jars, ollas, dough bowls, pitchers, wedding vases, canteens)
BORN: ca. 1906
FAMILY: wife of Juan Aguilar; mother of Rafaelita Aguilar; m. grandmother of Darlene Aguilar; related to Marie C. Aragon, Vidal E. Aguilar & Robert Aguilar
STUDENT: Rafaelita Aguilar, her daughter

Rachel Aguilar

(Santa Domingo, active ?: pottery, jewelry)
PUBLICATIONS: Margaret Cesa, "The World of Flower Blue."

Rafaelita Aguilar *(collaborates sometimes with Darlene Aguilar, her daughter), (signs Rafaelita Aguilar or Rafaelita & Darlene Aguilar, S.D.P.)*

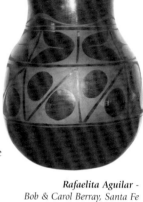

(Santo Domingo, active ca. 1953-present: black-on-black, black-on-red & black-on-cream large storage jars, ollas, dough bowls, pitchers, wedding vases, canteens, Jewelry)
BORN: August 15, 1936
FAMILY: daughter of Juan and Miguelita Aguilar; sister of Joe Aguilar; mother of Darlene Aguilar; aunt of Marie C. Aragon, Vidal E. Aguilar & Robert Aguilar
TEACHER: Miguelita Aguilar, her mother
STUDENT: Darlene Aguilar, her daughter
EXHIBITIONS: 1994, Eight Northern Indian Pueblos Arts & Crafts Show; ?-present, Santo Domingo Pueblo Arts & Crafts Show
COLLECTIONS: Roger & Marilyn Peterson, Williams Bay, WI; Dr. Gregory & Angie Yan Schaaf, Santa Fe
FAVORITE DESIGNS: birds, four petal flowers, leaves, clouds, rain
GALLERIES: Rio Grande Wholesale, Palms Trading Co., Albuquerque
PUBLICATIONS: Hayes & Blom 1996:146; Berger & Schiffer 2000:97.

Rafaelita Aguilar -
Bob & Carol Berray, Santa Fe

 Rafaelita Aguilar makes some of the largest black-on-black pottery in the Southwest. She also creates redware and other styles of pottery. Her pots feature a high gloss stone polish and are traditionally fired in a pit with manure. The black carbon from the smoke infuses into the clay making it black. The technique was popularized in the 1930s at Santo Domingo Pueblo by the famous Santa Clara potter, Monica Silva, who married into Santo Domingo. She was a contemporary of Rafaelita's mother, Miguelita Aguilar, who surely observed Monica's black-on-black and polished redware pots. Santo Domingo did make utilitarian blackware earlier.

 Rafaelita may be considered a relatively undiscovered master potter. Because she rarely entered her pots at Indian art shows, her work has not won ribbons. However, the quality of her work is commendable.

Mrs. Ramos Aguilar

(Santo Domingo, active ca. 1890s-1915: traditional polychrome ollas, jars, bowls)
FAMILY: sister-in-law of Felipita Aguilar Garcia & Asuncion, Aguilar Cate
COLLECTIONS: Denver Art Museum, Denver, CO
PUBLICATIONS: Douglas 1941; Batkin 1987:99.
PHOTOGRAPHS: Aguilar Style Pottery, ca. 1921, Museum of New Mexico Archives, neg. #23393.

Robert Aguilar -
Bob & Carol Berray, Santa Fe

Reyes Aguilar

(Zia, active ca. 1870s-?: traditional polychrome jars, bowls)
BORN: ca. 1854
FAMILY: mother of Toribio Aguilar & Andres Aguilar; grandmother of Tomas Aguilar
PUBLICATIONS: U.S. Census 1920, family 7.

Robert Aguilar -
Janie & Paul K. Conner Collection

Robert Aguilar

(Santo Domingo, active ca. 1970s-present: polychrome ollas, dough bowls, vases)
BORN: May 30, 1968
FAMILY: m. grandson of Lorencita Pacheco; son of Joe & Helen Aguilar; brother of Vidal, Shirley & Darrin Aguilar
EXHIBITIONS: Santo Domingo Pueblo Arts & Crafts Show
COLLECTIONS: Janie & Paul K. Conner, Bob & Carol Berray, Dr. Gregory & Angie Yan Schaaf, Santa Fe
FAVORITE DESIGNS: deer, antelope, big horn sheep, birds, flowers, clouds

 Robert Aguilar makes pottery in the Aguilar family tradition. He creates large polychrome jars, ollas, and bowls using natural clay and mineral paints. His work is classic in form and design.

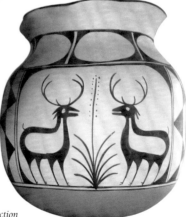

Robert Aguilar - Janie & Paul K. Conner Collection

Vidal Aguilar

(Santo Domingo, active ca. 1970s-present: polychrome and black-on-black, black-on-red & black-on-cream large storage jars, ollas, dough bowls, canteens)
BORN: May 24, 1972
FAMILY: m. grandson of Lorencita Pacheco; son of Joe & Helen Aguilar; brother of Darrin Aguilar, Shirley & Robert Aguilar
EXHIBITIONS: 1994-96, Indian Market, Santa Fe; 1994, Eight Northern Indian Pueblos Arts & Crafts Show; ?-present, Santo Domingo Pueblo Arts & Crafts Show
COLLECTIONS: Candace Collier, Houston, TX; Dr. Gregory & Angie Yan Schaaf, Santa Fe
FAVORITE DESIGNS: deer, antelope, big horn sheep, birds, flowers, clouds
PUBLICATIONS: Berger & Schiffer 2000:97.

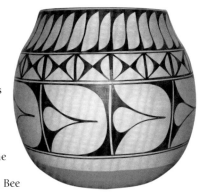

Vidal Aguilar -
Bob & Carol Berray, Santa Fe

Vidal Aguilar makes some of the largest polychrome ollas at Santo Domingo in the Aguilar family tradition. His pottery is hand coiled and polished. His black paint is a mineral pigment used centuries ago, rather than the typically used Guaco or Mountain Bee plant. His red & white paints are natural clay. He fires his pottery in a pit.

Vidal's designs include deer, antelope and big horn sheep. He also paints attractive flowers and birds. He has been inspired by looking at 19th and early 20th century designs, like those illustrated by museum director Kenneth Chapman.

Vidal continues the Aguilar family tradition of making large storage jars and ollas. They deserve much credit for their monumental work.

Lyndon Ahiyite *(signs L. Ahiyite)*

(Zuni, active ca. 1990s-present: polychrome jars, bowls)
FAVORITE DESIGNS: rain clouds

Juana Ahmie

(Laguna, active ?: pottery)
ARCHIVES: Laboratory of Anthropology Library, Santa Fe; lab. file.

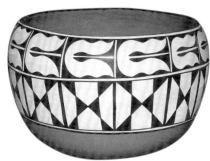

Vidal Aguilar -
Hoel's Indian Shop, Oak Creek Canyon, AZ

Cedric Albert

(Acoma, active ?-1990+: polychrome jars, bowls)
PUBLICATIONS: Dillingham 1992:206-208.

Donna Allapowa

(Zuni, active ca. 1980s-present: polychrome jars, bowls, owls)
PUBLICATIONS: Hayes & Blom 1998:49.

Alma *(see Alma Maestas)*

Emily Alonzo

(Laguna, active ca. 1973-?: traditional polychrome jars, bowls)
EDUCATION: 1973, Laguna Arts & Crafts Project participant

Louise Amos *(Louise Willie)*

(Acoma, active ca. 1962-present: polychrome jars, bowls, kiva bowls, clay bowls with handles, owls, Storytellers)
BORN: November 3, 1946
FAMILY: granddaughter of Dolores Stein; daughter of Lorenzo and Frances Abeita; sister of Jenny Laate
AWARDS: New Mexico State Fair, Albuquerque
COLLECTIONS: John Blom
PUBLICATIONS: Dillingham 1992:206-208; Berger & Schiffer 2000:98.

Mariano Amugereado

(Acoma, active ?-1880s: traditional polychrome ollas, jars, bowls)
PUBLICATIONS: Bandelier 1966-84, 1:826; Batkin 1986:20.

In the 1880s, early anthropologist Adolph F. Bandelier recorded that he met Mariano Amugereado, a man who dressed as a woman. There were then three of *qo-qoy-mo*, who were treated kindly and accepted in their roles as women.

Deana Amy

(Acoma, active ca. 1990s-present: pottery)
FAMILY: great-granddaughter of Lucy M. Lewis; m. granddaughter of Margaret Lewis Lim; daughter of Wanda Lim Amy; sister of Kateri & Theresa Amy

Kateri Amy

(Acoma, active ca. 1990s-present: pottery)
FAMILY: great-granddaughter of Lucy M. Lewis; m. granddaughter of Margaret Lewis Lim; daughter of Wanda Lim Amy; sister of Deana & Theresa Amy

Theresa Amy

(Acoma, active ca. 1990s-present: pottery)
FAMILY: great-granddaughter of Lucy M. Lewis; m. granddaughter of Margaret Lewis Lim; daughter of Wanda Lim Amy; sister of Deana & Kateri Amy

Alberta Analla

(Acoma, active ?-present: Anasazi Revival black-on-white, traditional polychrome ollas, jars, bowls, vases, miniatures)
COLLECTIONS: Candace Collier, Houston, TX

Calvin Analla, Jr. *(Anaya)*

(Laguna, active ca. 1980s-present: traditional polychrome ollas, jars, bowls, canteens)
EXHIBITIONS: 1998-present, Indian Market, Santa Fe
COLLECTIONS: Jane & Bill Buchsbaum, Santa Fe
FAVORITE DESIGNS: Rainbirds, clouds, split leaves
GALLERIES: Native American Collections, Inc., Denver, CO
PUBLICATIONS: Tucker 1998: plate 110.

Kathryn Analla *(Katherine Analla)*

(Acoma, active ?-1990+: polychrome jars, bowls)
BORN: ca. 1910s
FAMILY: daughter of Teofila Torivio; sister of Frances Pino Torivio, Juanita Keen, Lolita Concho, Concepcion Garcia
PUBLICATIONS: Dillingham 1992:206-208.

Lupy Andres

(Acoma, active ca. 1860s-1910s+: polychrome jars, bowls)
BORN: ca. 1850; RESIDENCE: McCartys in ca. 1910
PUBLICATIONS: Leopold Bibo, "13th Annual U.S. Census" (1910), New Mexico State Archives, Call T624, Roll 919; in Dillingham 1992:205.

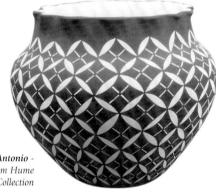

Calvin Analla, Jr. -
Andrea Fisher Fine Pottery, Santa Fe

Calvin Analla, Jr. - *Photograph by Bill Bonebrake*
Courtesy of Jill Giller
Native American Collections, Denver, CO

Jennifer Andrew

(Jemez, Oak Clan, active ca. 1990s-present: matte polychrome & stone polished black-on-redware)
BORN: ca. 1980s
FAMILY: m. granddaughter of Anacita Chinana; daughter of Christine Tosa; sister of Maxine T. Yepa
PUBLICATIONS: Berger & Schiffer 2000:32, 98.

Maxine Andrews

(Jemez, active ?)
PUBLICATIONS: *Indian Trader* Nov. 1999 30(11):10.

Lupe Anselmo

(Isleta, active ca. 1910s-?: traditional polychrome jars, bowls)
PUBLICATIONS: *El Palacio* Oct. 16, 1922 8(9):94; Parsons 1932:351; Batkin 1987:191.
　　　Anthropologist Elsie Clews Parsons stated that in the 1920s, Lupe Anselmo was the best potter at Isleta.

Laura Guadalupe Ansera

(San Felipe/Isleta, active ca. 1970s-present: pottery)
BORN: September 2, 1948; RESIDENCE: Santa Fe
FAMILY: daughter of Laura Duran (San Felipe) & Fidel Ansera (Isleta)

A. B. Antonio

(Acoma, active ?-present: black-on-white ollas, jars, bowls)
COLLECTIONS: Drs. Judith & Richard Lasky, New York City, NY

Adrian Antonio

(Acoma, active ca. 1992-present: polychrome jars, bowls, sgraffito)
BORN: July 28, 1961
FAMILY: daughter of Rafalita
PUBLICATIONS: Berger & Schiffer 2000:98.

A. B. Antonio -
Photograph by Adam Hume
Drs. Judith & Richard Lasky Collection

Blanche Antonio *(Blanche Pasqual), (collaborated sometimes with Juana C. Pasqual)*

(Acoma, active ca. 1949s-90s+: polychrome jars, bowls, wedding vases, figures, Storytellers)
BORN: May 10, 1927; RESIDENCE: San Fidel, NM
FAMILY: granddaughter of Juana Concho; daughter of Juana C. Pasqual; sister of Mary Lukee
EXHIBITIONS: 1976-96, Indian Market, Santa Fe
PUBLICATIONS: *SWAIA Quarterly* Fall 1976:12; *Indian Market Magazine* 1985, 1988, 1989, 1994, 1995, 1996:63; Babcock 1986:10, 55, 98, 135; Dillingham 1992:206-208; Reno 1995:9, 214.

C. Antonio

(Laguna, active ca. 1990s-?: traditional polychrome jars, bowls)
PUBLICATIONS: Hayes & Blom 1996:88.

Daniel Antonio

(Acoma, active ?-1990+: polychrome jars, bowls)
PUBLICATIONS: Dillingham 1992:206-208.

Deidra Antonio *(signs DSA, Acoma, NM) (collaborates sometimes with Steven Antonio)*

(Acoma, active ca. 1988-present: polychrome jars, bowls, sgraffito)
BORN: November 10, 1963
FAMILY: daughter of Ann Romero; sister of Gregory Romero
PUBLICATIONS: Dillingham 1992:206-208; Berger & Schiffer 2000:98.

Dora Antonio

(Acoma, active ?-1990+: polychrome jars, bowls, cups)
PUBLICATIONS: The Pottery of Acoma Pueblo 1991:11; Dillingham 1992:206-208.

Earlene Antonio *(signs E. Antonio, Acoma, NM)*

(Acoma, active ca. 1990-present: polychrome jars, bowls)
BORN: October 19, 1968
FAMILY: daughter of Alfred and Rafaelita Romero
EXHIBITIONS: 1995-present, Eight Northern Indian Pueblos Arts & Crafts Show
GALLERIES: The Indian Craft Shop, U.S. Department of Interior, Washington, D.C.; Rio
Grande Wholesale, Inc., Palms Trading Co., Albuquerque
PUBLICATIONS: Berger & Schiffer 2000:98.

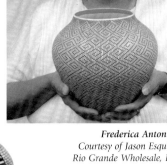

Frederica Antonio *(signs F. V. Antonio, Acoma, N.M.) (collaborates sometimes with Randy Antonio)*

(Acoma, active ca. 1986-present: traditional & ceramic polychrome & black-on-white fineline jars, bowls)
BORN: September 17, 1968; RESIDENCE: San Fidel, NM
FAMILY: daughter of Earl and Florina Vallo; wife of Randy Antonio; cousin of Melissa Antonio
TEACHER: Mildred Antonio, her mother-in-law
AWARDS: 1st, H.M., New Mexico State Fair, Albuquerque; H.M., Inter-tribal Indian Ceremonial, Gallup
COLLECTIONS: John Blom; Gerald & Laurette Maisel, Tarzana, CA
FAVORITE DESIGNS: eyedazzlers, Kokopelli
GALLERIES: Rio Grande Wholesale, Inc., Palms Trading Co., Albuquerque
PUBLICATIONS: Hayes & Blom 1996:54-55; Berger & Schiffer 2000:98.

*Frederica Antonio -
Courtesy of Jason Esquibel
Rio Grande Wholesale, Inc.*

*Frederica Antonio -
King Galleries of Scottsdale, AZ*

Frederica Antonio is an exceptional painter. Her fineline black-on-white jars display detailed eyedazzler designs. Some of her patterns have been described as resembling "crossword puzzle grids."

Hilary Antonio

(Acoma, Red Corn/Small Eagle Clans, active ca. 2000-present: black-on-white jars, bowls)
BORN: September 28, 1992; RESIDENCE: McCartys, NM
FAMILY: great-granddaughter of Santana Antonio; granddaughter of Richard & Mildred Antonio, Lillie Concho; daughter of Daniel & Melissa Antonio; sister of Clarissa, Derek Antonio

Hilary Antonio, at the age of nine, said of pottery making: "It is fun. I like watching my mother make different shapes of pottery. I want to continue the tradition and be able to go to Indian Market with her."

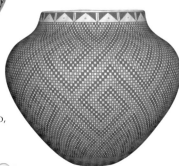

*Frederica Antonio -
Courtesy of Jason Esquibel
Rio Grande Wholesale, Inc.*

Hilda Antonio *(signs H.A. or H. Antonio Acoma NM)*

(Acoma, Roadrunner Clan, active ca. 1943-present; traditional polychrome jars, bowls, Storytellers 1958-, Storyteller owls)
BORN: August 7, 1938
FAMILY: m. granddaughter of Helice Vallo; p. granddaughter of Juanalita Histia; daughter of Eva Histia; niece of Lucy Lewis & Elizabeth Wocanda; sister of Rose Torivio; wife of David Antonio; mother of Mary J. Garcia, Jose M. Antonio
TEACHER: Eva Histia, her mother

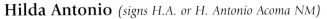

*Hilda Antonio -
Dr. Fred Belk Collection*

STUDENTS: Mary J. Garcia, her daughter
AWARDS: 1976, 1st, Indian Market, Santa Fe
GALLERIES: Rio Grande Wholesale, Inc., Palms Trading Co.,
Albuquerque; Kennedy Indian Arts, Bluff, UT
PUBLICATIONS: *SWAIA Quarterly* Fall 1976:12; Babcock
1986:55, 135-36, 138; Minge 1991:195; Dillingham
1992:206-208; Berger & Schiffer 2000:98, 118.

 Hilda Antonio learned to make traditional Acoma
pottery from her mother, Eva Histia. Hilda is best
known for her Storytellers. She said, "My paternal grand-
mother, Juanalita Histia, was the storyteller I remember
best."

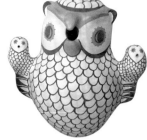

Hilda Antonio - Courtesy of
Georgiana Kennedy Simpson
Kennedy Indian Arts, Bluff, UT

Hilda Antonio -
Courtesy of John D. Kennedy and
Georgiana Kennedy Simpson
Kennedy Indian Arts

Jose M. Antonio *(J. Antonio)*

(Acoma, Roadrunner Clan, active ca.1989-present: traditional
& contemporary polychrome jars, bowls, owls)
BORN: March, 13, 1966; RESIDENCE: Acomita, NM
FAMILY: m. great-grandson of Helice Vallo; p. great-grandson of Juanalita Histia; grandson of
Eva Histia; son of Hilda & David Antonio, Sr.; husband of Earlene Antonio; father of Michael,
Katrina, Nicole
TEACHERS: Eva Histia, his grandmother; Hilda Antonio, his mother
EXHIBITIONS: 1995-present, Eight Northern Indian Pueblos Arts & Crafts Show; Indian
Market, Santa Fe
COLLECTIONS: Allan & Carol Hayes
FAVORITE DESIGNS: four directions, four seasons
PUBLICATIONS: Hayes & Blom 1998:49; Painter 1998:9.

Josephine Antonio

(Acoma, active ca. 1972-present: traditional & ceramic polychrome jars, bowls)
BORN: January 19, 1936
FAMILY: daughter of Jose and Mary Antonio
TEACHER: Mary Antonio
GALLERIES: Rio Grande Wholesale, Inc., Palms Trading Co., Albuquerque
PUBLICATIONS: Dillingham 1992:206-208; Berger & Schiffer 2000:98.

Juana Antonio

(Acoma, active ca. 1850s-1910s+: polychrome jars, bowls)
BORN: ca. 1840
PUBLICATIONS: Leopold Bibo, "13th Annual U.S. Census" (1910), New Mexico State
Archives, Call T624, Roll 919; in Dillingham 1992:205.

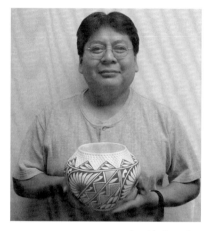

Jose M. Antonio -
Courtesy of Jason Esquibel
Rio Grande Wholesale, Inc.

Juana Maria Antonio

(Acoma, active ca. 1880s-1910s+: polychrome jars, bowls)
BORN: ca. 1865; RESIDENCE: Acomita in ca. 1910
PUBLICATIONS: Leopold Bibo, "13th Annual U.S. Census" (1910), New Mexico State Archives, Call T624, Roll 919; in Dillingham
1992:205.

L. Antonio

(Acoma, active ?-present)
COLLECTIONS: John Blom
GALLERIES: Arlene's Gallery, Tombstone, AZ

Louis Antonio

(Acoma, active ?-1990+: polychrome jars, bowls)
PUBLICATIONS: Dillingham 1992:206-208.

Lucille M. Antonio *(signs Lucille Antonio, Acoma N.M.)*

(Acoma, ca. 1994-present: traditional & ceramic polychrome jars, bowls)
BORN: December 23, 1955; RESIDENCE: San Fidel, NM
FAMILY: daughter of Lupe Louis
TEACHER: Lupe Louis, her mother
PUBLICATIONS: Berger & Schiffer 2000:98.

Maria Antonio

(Acoma, active ca. 1940)
PUBLICATIONS: Minge 1991:195.

Maria Beuina Antonio

(Acoma, active ca. 1850s-1910s+: polychrome jars, bowls)
BORN: ca. 1835; RESIDENCE: Acomita in ca. 1910
PUBLICATIONS: Leopold Bibo, "13th Annual U.S. Census" (1910), New Mexico State Archives, Call T624, Roll 919; in Dillingham 1992:205.

Mary Antonio

(Acoma, active ca. 1930s-?: traditional polychrome jars, bowls)
BORN: ca. 1920
FAMILY: wife of Jose Antonio; mother of Josephine Antonio
PUBLICATIONS: Berger & Schiffer 2000:98.

Melissa Concho Antonio *(signs M. C. Antonio), (sometimes works with Mildred Antonio), (see color illustration)*

(Acoma, Red Corn & Sun Clans, active ca. 1988-present: traditional & ceramic polychrome jars, bowls, vases, seed pots)
BORN: October 15, 1965; RESIDENCE: San Fidel, NM
FAMILY: g. daughter of Santana Antonio; daughter of Gilbert & Lillie Concho; daughter-in-law of Mildred Antonio; wife of Daniel Antonio; mother of Clarissa, Derek, & Hilary
TEACHER: Lillie Concho and Mildred Antonio
AWARDS:

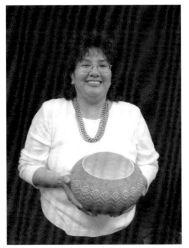

Melissa Antonio -
Courtesy of Jason Esquibel
Rio Grande Wholesale, Inc.

1992	1st, 2nd, New Mexico State Fair, Albuquerque
1993	3rd, New Mexico State Fair, Albuquerque
1994	Best of Show, 1st, New Mexico State Fair, Albuquerque; 1st, Inter-tribal Indian Ceremonial, Gallup
1995	1st, New Mexico State Fair, Albuquerque; 2nd, Inter-tribal Indian Ceremonial, Gallup
1996	1st, Eight Northern Indian Pueblos Arts & Crafts Show; 2nd, 3rd, HM, Inter-tribal Indian Ceremonial, Gallup
1997	2nd, New Mexico State Fair, Albuquerque
2001	3rd, New Mexico State Fair, Albuquerque; 2nd, Eight Northern Indian Pueblos Arts & Crafts Show

EXHIBITIONS: 1994-present, Eight Northern Indian Pueblos Arts & Crafts Show; 1997-present, Heard Museum Show, Phoenix
COLLECTIONS: City Hall, Phoenix
FAVORITE DESIGNS: Kokopelli, animals, optical black-on-white patterns
PUBLICATIONS: Dillingham 1992:206-208; Painter 1998:9; Berger & Schiffer 2000:98.

Mildred Antonio *(signs M. Antonio, Acoma N.M.), (sometimes works with Melissa Antonio)*

(Acoma, Eagle Clan, active ca. 1953-present: traditional polychrome fineline jars, bowls, wedding vases)
BORN: March 22, 1937; RESIDENCE: San Fidel, NM
FAMILY: daughter of Joe & Mrs. Torivio; daughter-in-law of Santana Antonio; niece of Marie Torivio; mother of Randy Antonio; mother-in-law of Melissa Antonio & Frederica Antonio
TEACHER: Auntie Marie Torivio
STUDENTS: Frederica Antonio & Melissa C. Antonio, her daughters-in-law
AWARDS: 1991, 2nd, New Mexico State Fair, Albuquerque
EXHIBITIONS: 1994-present, Eight Northern Indian Pueblos Arts & Crafts Show
COLLECTIONS: City Hall, Phoenix
FAVORITE DESIGNS: deer & bears with heartlines, diagonal swirl patterns, flowers, antelope
GALLERIES: Rio Grande Wholesale, Inc., Palms Trading Co., Albuquerque; River Trading Post, East Dundee, IL; Sunshine Studio at www.sunshinestudio.com
PUBLICATIONS: Minge 1991:195; Dillingham 1992:206-208; Painter 1998:9; Berger & Schiffer 2000:98.

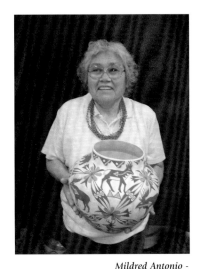

Mildred Antonio -
Courtesy of Jason Esquibel
Rio Grande Wholesale, Inc.

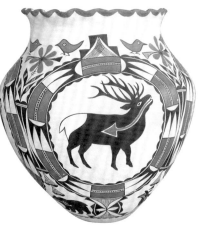

Mildred Antonio -
Courtesy of Joe Zeller
River Trading Post, East Dundee, IL

Randy Antonio *(collaborates with Frederica Antonio)*

(Acoma, active ?-1990+: polychrome jars, bowls)
BORN: ca. 1960s; RESIDENCE: San Fidel, NM
FAMILY: son of Mildred Antonio; husband of Frederica Antonio
PUBLICATIONS: Dillingham 1992:206-208.

Mildred Antonio -
Courtesy of Sunshine Studio

Rebecca Antonio

(Acoma, active ?-present: contemporary black-on-white, polychrome ollas, jars, vases)
FAVORITE DESIGNS: checkerboard, crossword puzzle, frets
GALLERIES: Nedra Matteucci Galleries, Santa Fe

Santana Antonio

(Acoma, active ca. 1920s-1990s: traditional polychrome jars, bowls)
BORN: ca. 1915
FAMILY: mother of Irma Maldonado, Richard Antonio; grandmother of Iona K. Chino, Daniel Antonio; great-grandmother of Hilary Antonio
PUBLICATIONS: Minge 1991:195; Dillingham 1992:206-208; Berger & Schiffer 2000:107.

Rebecca Antonio -
Nedra Matteucci Galleries, Santa Fe

Stephanie Antonio

(Acoma, active ca. 1994-present: sgraffito jars, bowls)
BORN: April 8, ?
TEACHER: her sister
GALLERIES: Rio Grande Wholesale, Inc., Palms Trading Co., Albuquerque
PUBLICATIONS: Berger & Schiffer 2000:99.

Steven Antonio *(collaborates with Diedra Antonio) (signs DSA, Acoma, N.M.)*

(Acoma, active ca. 1988-present: ceramic polychrome jars, bowls)
BORN: March 5, 1965
TEACHER: Diedra Antonio
PUBLICATIONS: Dillingham 1992:206-208.

Toni Antonio

(Acoma, active ?-1990+: polychrome jars, bowls)
PUBLICATIONS: Dillingham 1992:206-208.

Lupe Anzara

(Isleta, active ca. 1910s-?: traditional polychrome jars, bowls)
PUBLICATIONS: *El Palacio* Oct. 16, 1922 8(9):94.

Alica Aragon

(Acoma, active ?-1990+: polychrome jars, bowls)
PUBLICATIONS: Dillingham 1992:206-208.

Angelina Aragon

(Acoma, active ca. 1960s-?: polychrome jars, bowls)
BORN: ca. 1940s
FAMILY: daughter of Helen R. Vallo; wife of Wilbert Aragon, Sr.; mother of Wilbert Aragon, Jr., Deborah A. Aragon & Robyn Romero
GALLERIES: Rio Grande Wholesale, Inc., Palms Trading Co., Albuquerque
PUBLICATIONS: Berger & Schiffer 2000:99.

Bernadette Aragon

(Acoma, active ?-1990+: polychrome jars, bowls)
PUBLICATIONS: Dillingham 1992:206-208.

Bernie Aragon

(Acoma, active ?-1990+: polychrome jars, bowls)
PUBLICATIONS: Dillingham 1992:206-208.

Clarise Marie Aragon *(Clarice)*

(Acoma, active ca. 1982-present: figures, hot air balloons, bread-baking scenes, hummingbirds, miniature human figures)
BORN: August 5, 1972, Acoma Pueblo, NM; RESIDENCE: Albuquerque, NM
FAMILY: m. granddaughter of Frances Pino Torivio; daughter of Wanda Aragon & Marvis Aragon, Sr.; sister of Marvis Aragon, Jr., Heather Aragon
AWARDS: 1986, 2nd, 3rd, Indian Market; 1988, 3rd, Inter-tribal Indian Ceremonial, Gallup, NM
EXHIBITIONS: 1982-present, Indian Market, Santa Fe; 1988-?, Inter-tribal Indian Ceremonial, Gallup, NM; 1995-present, Eight Northern Indian Pueblos Arts & Crafts Show
COLLECTIONS: Wright Collection, Peabody Museum, Harvard University, Cambridge, MA; John Blom
PUBLICATIONS: *Indian Market Magazine* 1982, 1985, 1988, 1989, 1994, 1995, 1996, 1998; Dillingham 1992:206-208; Reano 1995:11; Nichols 1995:14-15; Peaster 1997:11-13; Drooker & Capone 1998:45, 138; Hayes & Blom 1998:6; Painter 1998:9.

Clarice Aragon's pottery bread oven was collected by William R. Wright, an object now in the Peabody Museum. Art historian Patricia Capone stated that Clarice is "known for her eccentric and experimental pieces." (Drooker & Capone 1998:45) The annual Hot Air Balloon Festival in Albuquerque, NM inspired her pottery hot air balloons.

Claudia Chavez Aragon *(Claudia Chavez)*

(San Felipe/Laguna, active ca. 1940s-?: traditional polychrome jars, bowls)
FAMILY: wife of James Aragon; sister-in-law of Mary V. Chavez; mother of Ralph Aragon; mother-in-law of Joan Gachupin Aragon; grandmother of Leslie Aragon & Kim Aragon

D. J. Aragon

(Acoma, active ?-1990s: pottery)
GALLERIES: White Horse Gallery, Boulder, CO

Daisy Aragon

(Acoma, active ?-1990+: polychrome jars, bowls)
PUBLICATIONS: Dillingham 1992:206-208.

Deborah Aragon *(Shri'My' to Wi), (signs D. Aragon)*

(Acoma, active ca. 1978-present: ceramic sgraffito horsehair jars, bowls, vases, wedding vases, bear fetishes)
BORN: 1963
FAMILY: granddaughter of Helen R. Vallo; daughter of Angelina & Wilbert Aragon, Sr.; sister of Robyn Romero, Deborah A. Aragon
TEACHER: Helen R. Vallo, her grandmother
AWARDS: 1998, 3rd, 1999, 2nd, New Mexico State Fair, Albuquerque

Deborah Aragon - Courtesy of Jason Esquibel
Rio Grande Wholesale, Inc.

Delores Aragon *(Dolores, D. J. Aragon)*

(Acoma, active ca. 1974-present: traditional polychrome & fineline ollas, jars, bowls, animal figures, miniatures)
BORN: ca. 1969
FAMILY: m. granddaughter of Delores Sanchez; daughter of Marie S. Juanico; daughter-in-law of Wanda Aragon; wife of Marvis Aragon, Jr.; mother of Marvis Aragon, III
AWARDS: 1996, 1st, 3rd (2); 1997, 1st, 3rd; 1998, 2nd, 3rd (2); 2000, 1st, 2nd, Acoma Jars, Indian Market, Santa Fe
EXHIBITIONS: 1994-present, Indian Market, Santa Fe; 1994-present, Eight Northern Indian Pueblos Arts & Crafts Show
COLLECTIONS: John Blom
FAVORITE DESIGNS: Kokopelli, deer with heartlines, lizards, birds, rain, frets
GALLERIES: Robert Nichols Gallery, Nedra Matteucci Galleries, Andrea Fisher Fine Pottery, Santa Fe
PUBLICATIONS: Focus/Santa Fe April 1993:18-19; *Indian Market Magazine* 1994-2000; Dillingham 1992:206-208; Brown 1993:18-19; Reano 1995:11.

*This group of pottery is by **Delores Aragon** -*
Andrea Fisher Fine Pottery, Santa Fe

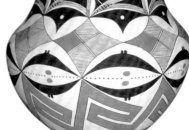

Delores M. Aragon is named after her grandmother, Delores Sanchez, a respected potter who lived to the age of 103. The younger Delores began making clay animal figures at the age of five. She learned by watching her grandmother and mother, Marie S. Juanico. Her mother-in-law, Wanda Aragon, also reinforced traditional techniques in Acoma pottery making. Today, Delores is especially known for her fine miniatures.

The artist recognized her ancestors, "The old techniques of my ancestors have motivated me even more so to become a part of this tradition. By doing so, I too try different techniques. My grandmother and those before her were strong in keeping the spirit and tradition alive."

Delores believes strongly that you must feel the spirit of pottery deep in your heart. She shared the spiritual dimension of pottery: "They can be really sacred, if you believe in it. It makes me feel good — a part of our ancestors — to do it in the traditional way." (Brown 1993:19)

Diane Aragon *(collaborates with Wilbert Aragon, Jr.) (signs Jr./D. Aragon, Acoma N.M.)*

(Laguna, married into Acoma, active ca. 1988-present: ceramic sgraffito polychrome jars, bowls, vases, contemporary forms)
BORN: ca. 1965
FAMILY: daughter-in-law of Angelina & Wilbert Aragon, Sr.; wife of Wilbert Aragon, Jr.
GALLERIES: Rio Grande Wholesale, Inc., Palms Trading Co., Albuquerque
PUBLICATIONS: Berger & Schiffer 2000:11, 99.

According to Rio Grande Wholesale, Inc., Diane & her husband, Junior, work as a pottery-making team. "They specialize in handcrafting ceramic pottery using contemporary styles. They hand paint the pottery and etch designs. . .They fire their pottery in a kiln, Then, they airbrush the pottery with a beautiful glaze to give it that contemporary style they are famous for pioneering."

Edna Aragon

(Acoma, active ?-1990+: polychrome jars, bowls)
PUBLICATIONS: Dillingham 1992:206-208.

Emma Rachel Aragon

(Acoma, active ?-present)
EXHIBITIONS: 1999-present: Indian Market, Santa Fe

Florence B. Aragon *(signs F. Aragon), (works with Rachel & John Aragon)*

(Acoma, active ca. 1967-present: Tularosa Revival & polychrome ollas, jars, bowls)
BORN: May 31, 1929; RESIDENCE: San Fidel, NM
FAMILY: daughter of Lupe Aragon; sister of Rachel Aragon, Mary Trujillo; mother of
John F. Aragon
AWARDS: Indian Market, Santa Fe; New Mexico State Fair, Albuquerque; Inter-tribal
Indian Ceremonial, Gallup
EXHIBITIONS: 1985 present: Indian Market, Santa Fe
COLLECTIONS: John Blom
FAVORITE DESIGNS: parrots, rain, clouds, rosettes, plants, leaves, berries, checker-
board
PUBLICATIONS: *Indian Market Magazine* 1985-2000; Dillingham 1992:206-208; Hayes
& Blom 1996:54-55; Berger & Schiffer 2000:99.
 Florence Aragon makes large Tularosa Revival and classic polychrome ollas with
fineline black-on-white swirling designs. Her pots are quite attractive, and she has earned
respect as a top prizewinner at major Indian art shows.

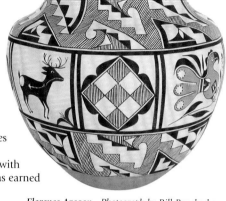

Florence Aragon - Photograph by Bill Bonebrake
Courtesy of Jill Giller
Native American Collections, Denver, CO

James Aragon

(Laguna/Acoma, active ca. 1990s-present: pottery)
AWARDS: 2nd, Student Division, miniatures, Indian Market, Santa Fe
EXHIBITIONS: 1999-present, Indian Market, Santa Fe

John F. Aragon *(works with Rachel and Florence Aragon)*

(Acoma, active ca. 1982-present; traditional polychrome ollas, jars, bowls)
BORN: November 24, 1962
FAMILY: grandson of Lupe Aragon; son of Florence Aragon; nephew of Rachel Aragon
TEACHER: Lupe Aragon, his grandmother
AWARDS: 1988, Best in Category, 1st, 3rd, Inter-tribal Indian Ceremonial, Gallup; 1989,
Best of Division, 1st, 2nd; 2000, 2nd, Bowls, Indian Market, Santa Fe; New Mexico State
Fair, Albuquerque
EXHIBITIONS: 1988-present, Indian Market, Santa Fe; 1988-?, Inter-tribal Indian
Ceremonial, Gallup
COLLECTIONS: John Blom
FAVORITE DESIGNS: parrots, Mimbres animals, birds & insects
PUBLICATIONS: *Indian Trader* September 1988:6-8; *Indian Market Magazine* 1988-2000;
Dillingham 1992:206-208; Reano 1995:11; Berger & Schiffer 2000:99.

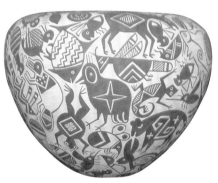

John F. Aragon - Courtesy of Jason Esquibel
Rio Grande Wholesale, Inc.

Karen J. Aragon *(signs K. Aragon, Acoma N.M.)*

(Acoma, active ca. 1984-present: fineline, polychrome and sgraffito jars, bowls, large
seed pots, figures, bears)
BORN: September 22, 1956; RESIDENCE: Grants, NM
FAMILY: daughter of Clifford & Alice Aragon
PUBLICATIONS: *Indian Market Magazine* 1988-2000; Dillingham 1992:206-208;
Berger & Schiffer 2000:99.

Kim Aragon

(Zia/San Felipe/Laguna, Water Clan, active ca. 1990s-present)
BORN: ca. 1970s
FAMILY: p. granddaughter of James & Claudia Chavez Aragon; daughter of Ralph
and Joan Aragon; sister of Leslie Aragon
TEACHER: Ralph Aragon, her father, and her grandmother

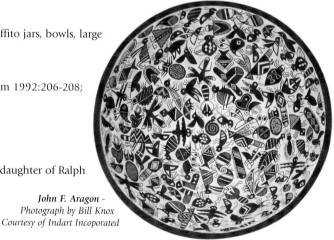

John F. Aragon -
Photograph by Bill Knox
Courtesy of Indart Incoporated

Leslie Aragon *(signs L. Aragon, Zia, N.M.)*

(Zia/San Felipe/Laguna, Water Clan, active ca. 1992-present)
BORN: December 27, 1973
FAMILY: p. granddaughter of James & Claudia Chavez Aragon; daughter of Ralph and Joan Aragon; sister of Kim Aragon
TEACHER: Ralph Aragon, her father, and her grandmother
EXHIBITIONS: 1995-present, Indian Market, Santa Fe; 1995-present, Eight Northern Indian Pueblos Arts & Crafts Show
PUBLICATIONS: Berger & Schiffer 2000:99.

Lupe Aragon

(Acoma, active ca. 1920s-1980s: traditional polychrome fineline jars, bowls)
BORN: ca. 1910
FAMILY: mother of Florence Aragon and Rachel Aragon; grandmother of John F. Aragon
EXHIBITIONS: 1977, "Indian Arts and Crafts Show," Heard Museum, Phoenix; 1979, "One Space: Three Visions," Albuquerque Museum, Albuquerque
GALLERIES: Rio Grande Wholesale, Inc., Palms Trading Co., Albuquerque
PUBLICATIONS: Minge 1991:195; Dillingham 1992:60; Berger & Schiffer 2000:99.

M. Aragon

(Acoma, active ?-1990+: polychrome jars, bowls)
PUBLICATIONS: Dillingham 1992:206-208.

M. L. Aragon

(Acoma, active ?-present: Anasazi & Mimbres Revival, fineline, polychrome ollas, jars, bowls)

Marie Aragon

(Acoma, active ?-1975+: polychrome jars, bowls)
PUBLICATIONS: Minge 1991:195.

M. L. Aragon -
Courtesy of Blue Thunder Fine Indian Art at
www.bluethunderarts.com

Marvis Joseph Aragon, Sr.

(Acoma, active ca. 1985-present: Anasazi Revival black-on-white and polychrome figures, bird effigy pots, animal figures)
BORN: November 3, 1947; RESIDENCE: Acoma, NM
FAMILY: husband of Wanda Aragon; father of Clarise Aragon, Marvis Aragon, Jr., Heather Aragon
AWARDS: 1992, 3rd, Indian Market, Santa Fe
EXHIBITIONS: 1992-present, Indian Market, Santa Fe; 1992, Heard Museum Show, Phoenix; 1994, Lawrence Indian Arts Museum, University of Kansas, Lawrence, KA; 1995-present, Eight Northern Indian Pueblos Arts & Crafts Show
COLLECTIONS: Allan & Carol Hayes
PUBLICATIONS: *Indian Market Magazine* 1992-2000; Nichols 1995:14-15; Hayes & Blom 1998:41; Painter 1998:9.

Marvis Aragon shared, "I am a traditional potter who grew up at Old Acoma with my grandparents. They taught me to respect all Mother Nature has given you so in return she will take care of you."

"My grandfather raised livestock, and my grandmother taught me about the art of pottery. I learned that everything the earth gives me was beautiful and that I could make it more beautiful through my artistic talents. I use natural clay and sand paints to create pre-historic [style] animals, birds, and humans which represent, to me, strength, happiness and continuation of life."

In 1985, after being laid off from working in a uranium mine, Marvis began making pottery full time. He began making small pots. In time, he became inspired to revive Anasazi style black-on-white animal figures and effigy jars.

Marvis Aragon, Sr. -
Courtesy of Allan & Carol Hayes

Marvis Aragon, Jr.

(Acoma, active ?-present: polychrome and black-on-white fineline figures, animals)
FAMILY: m. grandson of Frances Pino Torivio; son of Wanda & Marvis Aragon, Sr.; brother of Clarise & Heather Aragon; husband of Delores Aragon; father of Marvis Aragon, III
AWARDS: 1994, 3rd, 1999, Indian Market, Santa Fe
EXHIBITIONS: 1994-present, Indian Market, Santa Fe; 1995-present, Eight Northern Indian Pueblos Arts & Crafts Show
COLLECTIONS: John Blom
PUBLICATIONS: *Indian Market Magazine* 1994-2000; Hayes & Blom 1998:41.

Marvis Aragon, III

(Acoma, active ca. 1990s-present: polychome jars, bowls, figures)
AWARDS: 1994, 3rd, Pottery; 2000, 2nd, 3rd, Figures, Indian Market, Santa Fe
EXHIBITIONS: 2000-present, Indian Market, Santa Fe; 1995-present, Eight Northern Indian Pueblos Arts & Crafts Show
PUBLICATIONS: *Indian Market Magazine* 2000.

Marvis Aragon, Jr. -
Courtesy of John Blom

Mary Aragon

(Acoma, active ?-1990+: polychrome jars, bowls)
PUBLICATIONS: Dillingham 1992:206-208.

Nora Aragon

(Acoma, active ?-1975+: polychrome jars, bowls)
PUBLICATIONS: Minge 1991:195.

Rachel Aragon *(sometimes works with Florence & John Aragon)*

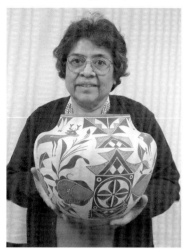

Rachel Aragon - Courtesy of Jason Esquibel Rio Grande Wholesale, Inc.

(Acoma, Eagle Clan, active ca. 1948-present: traditional polychrome & fineline ollas, jars, bowls)
BORN: October 27, 1938
FAMILY: daughter of Lupe Aragon; sister of Mary Trujillo, Florence Aragon; aunt of John Aragon
TEACHER: Lupe Aragon, her mother
AWARDS: 2nd, Indian Market, Santa Fe; 1st, 2nd, New Mexico State Fair, Albuquerque; Inter-tribal Indian Ceremonial, Gallup
EXHIBITIONS: 1985-present, Indian Market
FAVORITE DESIGNS: parrots, flowers, deer with heartlines, spirals
GALLERIES: Native American Collections, Denver, Co; Rio Grande Wholesale, Inc., Palms Trading Co., Albuquerque
PUBLICATIONS: *Indian Market Magazine* 1985-2000; Dillingham 1992:206-208; Berger & Schiffer 2000:99.

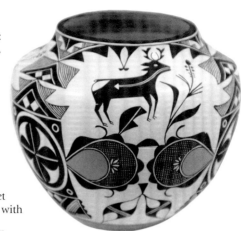

Rachel Aragon - Courtesy of Blue Thunder Fine Indian Art at www.bluethunderarts.com

Rachel is an outstanding potter. She makes large classic polychrome ollas with bold designs of parrots and deer with heartlines. Her work is quite popular among collectors.

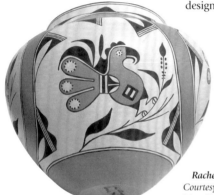

Rachel Aragon - Courtesy of Joe Zeller River Trading Post, East Dundee, IL

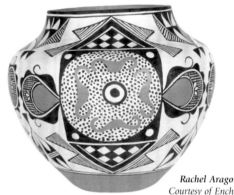

Rachel Aragon - Courtesy of Enchanted Village

Ralph Aragon *(signs R. Aragon, hallmark - kiva steps)*

Ralph Aragon - Courtesy of Jason Esquibel Rio Grande Wholesale, Inc.

(San Felipe/Laguna, Water Clan, married into Zia, active ca. 1967-present: contemporary polychrome pottery, gourds, shields, beadwork, paintings on leather)
BORN: August 24, 1944
FAMILY: son of James and Claudia Chavez Aragon; brother of Mary V. Chavez; husband of Joan Gachupin Aragon; father of Leslie Aragon & Kim Aragon; brother-in-law of Dora Tse-Pe
EDUCATION: 1965-66, Institute of American Indian Arts, Santa Fe
TEACHER: Candelaria Gachupin
AWARDS: 1980, 1st, New Mexico State Fair, Albuquerque; Inter-tribal Indian Ceremonial, Gallup; 1981, 1st, Eight Northern Indian Arts & Crafts Show; 1998, 2nd, Indian Market, Santa Fe; Heard Museum, Phoenix; 1998, "Reception for Ralph Aragon," Indian Pueblo Cultural Center, Albuquerque
EXHIBITIONS:

1965	Second Annual Invitational Exhibition of American Indian Paintings, U.S. Dept. of Interior, Washington, D.C. "Young American Indian Artists," Riverside Museum, NY
1975-81	Eight Northern Indian Pueblos Arts & Crafts Show
1980	"Nations of Nations," Institute of American Indian Arts
1980-	Indian Market, Santa Fe; New Mexico State Fair, Albuquerque; Heard Museum Show, Phoenix
1990	"One With the Earth," IAIA, Santa Fe; Many Horses Gallery, Palm Springs, CA
1991	"Rock Art Images," Pacific Western Traders, CA

COLLECTIONS: Institute of American Indian Arts, Santa Fe
FAVORITE DESIGNS: Kokopelli, rock art figures, handprints, corn plants, deer, antelope, rainbows, rain, speckled backgrounds
GALLERIES: Native American Collections, Denver, CO; Arlene's Gallery, Tombstone, AZ; Rio Grande Wholesale, Palms Trading Company, Albuquerque; Serendipity Trading Post
PUBLICATIONS: Snodgrass 1968:6; *Indian Market Magazine* 1985, 1989; Lester 1995:22; Hayes & Blom 1996:164-65; Berger & Schiffer 2000:99.

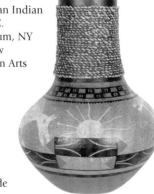

Ralph Aragon - Courtesy of Enchanted Village

Ralph Aragon was born at San Felipe, but married into Zia Pueblo. He is credited with creating a new style of painting Pueblo pottery. His designs employ a wide array of symbols, sometimes drawing from ancient rock art. He also uses a spatter technique reminiscent of Joe Herrera and Tony Da, two contemporaries of modern styles.

Ralph transcends his success as an easel painter by also painting pottery in his own unique way. His pots are easily recognizable. He uses bold colors and ancient designs to create fine art pieces that look both ancient and modern simultaneously. He is a true artist in his constant innovations, developing a myriad of variations on Southwest Indian symbolism. His work collectively represents a significant and unique contribution to the history of Southwest Indian pottery.

Ralph shared his personal feelings, "I love to make pottery and to paint them. I love painting traditional and contemporary designs. I will continue to paint, so I can hand down our traditions to my daughters, Kim and Leslie Aragon." We love the way Ralph dedicates his work to his daughters, the next generation, preserving their cultural continuity.

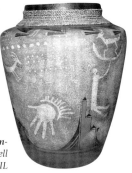

Ralph Aragon-
Courtesy of Wanda Campbell
Indian Art Unlimited, IL

Wanda A. Aragon *(Dzinats'ituwits'a), (signs W. Aragon, sometimes with rain cloud hallmark, Dzinats'ituwits'a)*

(Acoma, active ca. 1965-present: polychrome ollas, jars, bowls, wedding vases, bird effigy pots, owl figures, Nativities, canteens, human figures, miniatures, Storytellers, 1972-)
BORN: November 21, 1948
FAMILY: daughter of Frances Pino Torivio; sister of Marie Lilly [Lillian] Salvador & Ruth Paisano; wife of Marvis Aragon, Sr.; mother of Clarise Aragon; mother-in-law of Delores Aragon
AWARDS:

1975	1st, Indian Market, Santa Fe
1976	2nd, Indian Market, Santa Fe
1979	H.M., Heard Museum Show, Phoenix; 2nd, Indian Market
1980	2nd, 3rd, Indian Market, Santa Fe
1983	3rd, Indian Market, Santa Fe
1987	Best of Division, Indian Market, Santa Fe
1988	2nd, 3rd, Indian Market, Santa Fe
1989	Indian Arts Fund Award, 1st, Indian Market, Santa Fe; 1st, Native American Invitational, Sedona, AZ; 1st, Colorado Indian Market, Denver
1990	Miniatures Award, 2nd, Indian Market, Santa Fe
1991	3rd, Indian Market, Santa Fe; H.M., Heard Museum Show, Phoenix
1992	1st, H.M., Indian Market, Santa Fe; H.M., Heard Museum Show, Phoenix
1993	Merit Award, Lawrence Indian Arts Show, University of Kansas, Lawrence, KA; 2nd, Eiteljorg Museum Indian Market, Indianapolis, IN; 3rd, Indian Market
1994	Best of Class, 2nd, Eiteljorg Museum Indian Market, Indianapolis, IN; 1st, 2nd, Indian Market, Santa Fe; H.M., Southwest Museum Indian Market, LA
1995	3rd, Indian Market, Santa Fe
1996	1st, 2nd, Indian Market, Santa Fe
1997	1st, 3rd, Indian Market, Santa Fe
1998	1st (2), 3rd, H.M., Indian Market, Santa Fe; 1st, Heard Museum Show, Phoenix
2000	3rd, Traditional Jars, Indian Market, Santa Fe

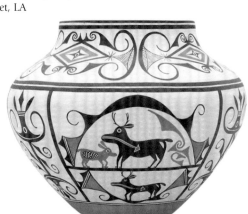

Wanda Aragon-
Courtesy of Charles Gideon, NM

EXHIBITIONS: 1974-present: Indian Market, Santa Fe; 1979-present, Heard Museum Show, Phoenix; 1979, "One Space: Three Visions," Albuquerque Museum, Albuquerque; 1995-present, Eight Northern Indian Pueblos Arts & Crafts Show
COLLECTIONS: Heard Museum, Phoenix; Philbrook Museum of Art, Tulsa, OK, jar, ca. 1980; Guy & Doris Monthan, Flagstaff, AZ; Charles Gideon, Edgewood, NM; Dr. Gregory & Angie Yan Schaaf, Santa Fe;
COLLECTIONS: Allan & Carol Hayes, John Blom
FAVORITE DESIGNS: parrots, rainbows, berry bushes, clouds
GALLERIES: Adobe Gallery, Albuquerque; Robert Nichols Gallery, Nedra Matteucci Galleries
PUBLICATIONS: *SWAIA Quarterly* Fall 1974:5; Fall 1975:4; Fall 1976:13; Fall 1982:11; *Indian Market Magazine* 1974-2000; Harlow 1977; Barry 1984:89; Babcock 1986:52, 53, 55, 135, 138; Indian Trader 1988:37; International Folk Art 1989; Minge 1991:195; Dillingham 1992:8-9, 64, 86, 105, 182, 185, 194-95, 200-01; 206-208; Reano 1995:11; Nichols 1995:14; Peaster 1997:11-15; Painter 1998:9; Anderson, et al. 1999; Congdon-Martin 1999:48.

Wanda Aragon-
Nedra Matteucci Galleries, Santa Fe

Wanda Aragon is an award-winning potter, daughter of the famous Frances Pino Torivio. In the 1960s, Wanda began making pottery owls. In the 1970s, she made her first Storyteller. She also makes Nativities and large canteens. She is a respected artist.

Wanda shared with Rick Dillingham, "You're always talking to the pot when you are making it — telling it your feelings — and when you finish a pot you blow life into it and it is given life." (Dillingham 1992:8)

Wanda added that they still continue the old custom of breaking pots over the deceased to be buried with them. That is the "end of a pot's life." The other way is when an area of a pot "pops off" in firing, indicating the spirit of the pot has left it lifeless.

Wilbert "Junior" Aragon, Jr. *(signs Jr./D. Aragon, Acoma N.M.) (collaborates with Diane Aragon)*

(Acoma, active ca. 1986-present: ceramic sgraffito jars, bowls)
BORN: May 5, 1966
FAMILY: m. grandson of Helen R. Vallo; son of Wilbert & Angelina Aragon; brother of Deborah A. Aragon & Robyn Romero; husband of Diane Aragon (Laguna)
TEACHER: Angelina Aragon, his mother
GALLERIES: Rio Grande Wholesale, Inc., Palms Trading Co., Albuquerque
PUBLICATIONS: Berger & Schiffer 2000:11, 99.

C. Armijo

(Jemez, active ?-present: matte polychrome Storytellers)
PUBLICATIONS: Congdon-Martin 1999:56.

Candace Armijo

(Jemez, Oak Canyon Clan, active ca. 1990s present: traditional polychrome Storytellers & Corn Maidens)
BORN: ca. 1950s
FAMILY: m. great-granddaughter of Mr. & Mrs. Manuel Sandia; p. great-granddaughter of Mr. & Mrs. Florencio Armijo; m. granddaughter of Rufina S. & Candido Armijo; daughter of Connie R. Armijo; sister of Christina Armijo
TEACHER: Connie R. Armijo

Christina Armijo

(Jemez, Oak Canyon Clan, active ca. 1990s-present: traditional polychrome Storytellers & Corn Maidens)
BORN: ca. 1950s
FAMILY: m. great-granddaughter of Mr. & Mrs. Manuel Sandia; p. great-granddaughter of Mr. & Mrs. Florencio Armijo; m. granddaughter of Rufina S. & Candido Armijo; daughter of Connie R. Armijo; sister of Candace Armijo
TEACHER: Connie R. Armijo

Connie R. Armijo

(Jemez, Oak Canyon Clan, active ca. late 1980s-present: traditional polychrome Storytellers & Corn Maidens)
BORN: ca. 1930s
FAMILY: m. granddaughter of Mr. & Mrs. Manuel Sandia; p. granddaughter of Mr. & Mrs. Florencio Armijo; daughter of Rufina S. & Candido Armijo; sister of Larry Anthony, Tim, Darlene, Laureen & Carlton Armijo; mother of Christina & Candace Armijo
EDUCATION: T-VI, Associate Degree in Accounting
TEACHERS: Rufina S. Armijo, her mother; Laureen Armijo, her sister & Kenny Sandia, her cousin
STUDENTS: Christina & Candace Armijo
CAREER: Datacom Sciences, Inc.
GALLERIES: Rio Grande Wholesale, Albuquerque; Jemez Pueblo Visitors' Center; Gus' Trading Post
 Connie R. Armijo shared, "It's a good feeling to know that people appreciate my work, and that they are willing to invest their money in it."
 She expressed her love for pottery making: "I also enjoy it because I'm passing on our tradition to my daughters, Christina & Candace Armijo."

Juanita Armijo

(Jemez, active ?)
ARCHIVES: Lab. File, Laboratory of Anthropology Library, Santa Fe

Laureen Armijo

(Jemez, Oak Canyon Clan, active ca. 1960s-?: traditional polychrome jars, bowls, Storytellers, Corn Maidens)
BORN: ca. 1930s
FAMILY: m. granddaughter of Mr. & Mrs. Manuel Sandia; p. granddaughter of Mr. & Mrs. Florencio Armijo; daughter of Rufina S. & Candido Armijo; sister of Larry, Anthony, Tim, Darlene, Connie R. & Carlton Armijo
TEACHER: Rufina S. Armijo, her mother
STUDENT: Connie R. Armijo, her sister

Phyliss Armijo

(Acoma, active ?-1990+: polychrome jars, bowls)
PUBLICATIONS: Dillingham 1992:206-208.

Rose Armijo

(Santa Ana, active ca. 1940s-90s?: polychrome jars, bowls)
BORN: ca. 1920s
FAMILY: grandmother of Rebecca Russell
PUBLICATIONS: Berger & Schiffer 2000:143.

Rufina Sandia Armijo

(Jemez, Oak Canyon Clan, active ca. 1930s-?: traditional polychrome jars, bowls, textiles)
BORN: ca. 1910s
FAMILY: daughter of Mr. & Mrs. Manuel Sandia; wife of Candido Armijo; mother of Connie R. Armijo, Larry Anthony Armijo, Tim Armijo, Darlene Armijo, Laureen Armijo & Carlton Armijo; m. grandmother of Christina & Candace Armijo
STUDENTS: Connie R. Armijo, Laureen Armijo
AWARDS: 1975, Eight Northern Indian Pueblos Arts & Crafts Show
PUBLICATIONS: Fox 1978:91; Schaaf 2001:279.

Rachel Arnold *(signs R. Arnold)*

(Acoma, active ca. 1975-present: polychrome Storytellers, pottery, sculptures)
BORN: March 10, 1930; RESIDENCE: Acoma, NM
FAMILY: daughter of Mannie Ortiz
EXHIBITIONS: 1985-present: Indian Market, Santa Fe
PUBLICATIONS: *Indian Market Magazine* 1985-2000; Dillingham 1992:206-208; The Pottery of Acoma Pueblo 1992:28; Tucker 1998: plate 88; Berger & Schiffer 2000:99.

April Arquero

(Cochiti, active ca. 1980s-present: polychrome jars, bowls, lidded clay boxes, miniatures)
FAVORITE DESIGNS: rosettes, feathers, clouds
COLLECTIONS: Allan & Carol Hayes
PUBLICATIONS: Hayes & Blom 1996:64-65; 1998:53.

Dominic Arquero *(collaborates sometimes with Imogene GoodShot Arquero)*

(Cochiti, active ca. 1970s-?: polychrome jars, bowls, figures, Storytellers, dolls, beadwork, hide paintings, watercolors & acrylic paintings)
BORN: August 8, 1957
FAMILY: husband of Imogene GoodShot Arquero
AWARDS: 1989, Overall Prize, 1st, painting; 1992, 1st, 2nd; 2nd, Indian Market, Santa Fe
EXHIBITIONS: pre-1980-present, Indian Market, Santa Fe; 1994, Heard Museum Show, Phoenix
COLLECTIONS: Heritage Center Collection, Red Cloud Indian School, Pine Ridge, SD
PUBLICATIONS: *SWAIA Quarterly* Spring 1980 15(1):1; *Indian Market Magazine* 1985, 1989; Lester 1997:25; *Northern New Mexico Today* Aug. 13, 1985:69; Kusel 1986:69; Congdon-Martin 1999:7; *Indian Trader* May 2000 31(4):11.

Ignacita Suina Arquero *(Ignacita Suina, Zuina)*

(Cochiti, Oak Clan, active ca. 1900s-1930s+: traditional polychrome & black-on-cream large storage jars with handles, bowls, bird effigy bowls with handles)
BORN: ca. 1879
FAMILY: sister of Pascual Suina; wife of Santiago Arquero; aunt of Tony Suina
COLLECTIONS: Buffalo Museum of Science, Buffalo, NY, pot with checkerboard design, exchanged in 1937 from the Denver Art Museum, #XCo-12; Taylor Museum, Colorado Springs, CO, black-on-cream bowl, ca. 1930, #1422; large storage jar, ca. 1920-1930, #6440.
FAVORITE DESIGNS: rain clouds, flowers
PUBLICATIONS: U.S. Census, New Mexico, 1920:, family 19, #80; *El Palacio* Oct. 16, 1922 8(8):94; *SWAIA Quarterly* Fall/Winter 1972 7(6):6; Batkin 1987:111, 114, 115, 202 n. 87.
PHOTOGRAPHS: Museum of New Mexico, Santa Fe, Photo Archives, neg. #2322.

 Ignacita Suina was born in 1879, before the train arrived. She attended school, learning to read and write English. She married Santiago Arquero. They owned their own home and farm, according to the 1920 U.S. Census.
 Jonathan Batkin, one of the most respected Southwest Indian pottery specialists, described Ignacita as "one of the best twentieth century potters of Cochiti."

Johnnie Arquero

(Cochiti, active ?-present, pottery, drums)
EXHIBITIONS: pre-1974-present, Indian Market, Santa Fe
PUBLICATIONS: *SWAIA Quarterly* Fall 1974 9(3):3; Fall 1983 17(3):13; Tucker 1998: plate 80.

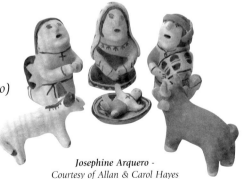

*Josephine Arquero -
Courtesy of Allan & Carol Hayes*

Josephine Arquero *(sometimes signs J. A.), (Mary Josephine Arquero)*

(Cochiti, active ca. 1970s-present: matte polychrome jars, bowls, animal & human figures, Storytellers, Nativities, deer)
BORN: December 31, 1928
FAMILY: daughter of Damacia Cordero & Santiago Cordero; sister of Martha Arquero, Marie Laweka & Gloria Herrera
TEACHER: Damacia Cordero, her mother
AWARDS: 1980, 3rd (3), Indian Market, Santa Fe
EXHIBITIONS: pre-1982-98, Indian Market, Santa Fe; 1999, Case Trading Post at the Wheelwright Museum, Santa Fe
COLLECTIONS: Allan & Carol Hayes, John Blom; Dr. Gregory & Angie Yan Schaaf, Santa Fe

FAVORITE DESIGNS: cowboys, tourists, priests, mother & children
PUBLICATIONS: Anthony 1982:12; *SWAIA Quarterly* Fall 1982 17(3):11; *American Indian Art Magazine* Spring 1983 8(2):36; Barry 1984:116; *Indian Market Magazine* 1985, 1988, 1989; Babcock 1986; Hayes & Blom 1998:37, 43; Tucker 1998: plate 79; Congdon-Martin 1999:6; Batkin 1999.

 Josephine Arquero is known for her Storytellers and figures in the tradition of her mother, Damacia Cordero, and the more famous Helen Cordero. Her grandmother and grandfather figures are covered with babies who sit in the laps and cling to their shoulders. She uses a lot of black paint to achieve bold effects.

Juanita C. Arquero

(Cochiti, Oak Clan, active ca. 1960s-80s: polychrome jars, dough bowls, figures)
BORN: ca. 1906
FAMILY: daughter of Santiago Cordero & Lorenza Cordero; sister of Ramona Cordero, Eluterio Cordero & Fred Cordero; sister-in-law of Helen Cordero
STUDENTS: Helen Cordero, Felicita Eustace
AWARDS: 1969, H.M., Heard Museum Show, Phoenix
EXHIBITIONS: 1969, Heard Museum Show, Phoenix; pre-1973-1998, Indian Market, Santa Fe; 1979, "One Space: Three Visions," Albuquerque Museum, Albuquerque
COLLECTIONS: Wright Collection, Peabody Museum, Harvard University, Cambridge, MA; Heard Museum, Phoenix; Rick Dillingham Collection, School of American Research, Santa Fe
FAVORITE DESIGNS: clouds, checkerboard
PUBLICATIONS: U.S. Census 1920, Cochiti Family 60; *SWAIA Quarterly* Fall 1973 8(3):3; *Arizona Highways* May 1974 50(5):41; Tanner 1976:121; *Southwest Art* June 1982 12(1):66; *American Indian Art Magazine* Spring 1983 8(2):30-32; Winter 1995 21(1):63; Dedera 1985:56; Trimble 1987:57; Hayes & Blom 1996:62; Drooker, et al., 1998:47, 138; *Indian Market Magazine* 1998:65; Berger & Schiffer 2000:113.

 Juanita Arquero was a great pottery teacher. She encouraged her sister-in-law, Helen Cordero, to try pottery making. They sold their pots together at Old Town in Albuquerque. They later taught pottery classes together at a school in Bernalillo. Helen went on to become Cochiti's most famous maker of Storytellers.

Margaret Arquero

(Cochiti, active ?-present: Storytellers)
PUBLICATIONS: Bahti 1988:43.

Maria Seferina Arquero *(Seferina Suina, Seferina Arquero)*

(Cochiti, active ca. 1890-?: traditional polychrome large storage jars, bowls, figures)
BORN: ca. 1857
FAMILY: wife of Juan José Suina; mother of Santana Suina; related to Frances Suina; grandmother of Mary Martin; great-grandmother of Gladys & Adrienne Martin
COLLECTIONS: Laboratory of Anthropology, Museum of New Mexico, Santa Fe; Taylor Museum, Colorado Springs, CO, large storage jar, 17" dia., #4308.
PUBLICATIONS: U.S. Census, 1920, family 69; Lange 1959:161-62; Batkin 1987:114.

 Maria Seferina Arquero is recognized as one of the first Cochiti potters to make large human figures out of clay. She began making them in the 1890s. (Lange 1959:161-62)

 In the 1920 U.S. Census, she was listed as Seferina Suina, wife, age 53. She spoke only Keres. Juan Suina is recorded as the head of household. Santana, the daughter, was born ca. 1896.

Martha Arquero *(see color illustrations)*

(Cochiti, active ca. 1977-present: polychrome jars, bowls, figures, human, frog & kangaroo Storytellers, Nativities, mermaids, bears, deer, ornaments)
BORN: May 15, 1944; RESIDENCE: Cochiti Pueblo
FAMILY: daughter of Damacia Cordero & Santiago Cordero; sister of Josephine Arquero, Marie Laweka & Gloria Herrera
COLLECTIONS: Allan & Carol Hayes, John Blom; Dr. Gregory & Angie Yan Schaaf
AWARDS: 1984, 1st, Indian Market, Santa Fe
EXHIBITIONS: pre-1982-present, Indian Market
GALLERIES: The Indian Craft Shop, U.S. Department of Interior, Washington, D.C.; Case Trading Post at the Wheelwright Museum, Santa Fe; Andrews Pueblo Pottery & Art Gallery, Palms Trading Company, Albuquerque
PUBLICATIONS: Anthony 1982:14; *SWAIA Quarterly* Fall 1982 17(3):11; Babcock 1986:42, 44, 128; Trimble 1987:58; Hayes & Blom 1996:62-63; 1998:1, 22, 51, 53; Congdon-Martin 1999:7-8; Berger & Schiffer 2000:79, 99.

 Martha Arquero learned pottery making from her mother, Damacia Cordero, who was

Martha Arquero -
Courtesy of
Georgiana Kennedy Simpson
Kennedy Indian Arts, Bluff, UT

Martha Arquero - Courtesy of Jason Esquibel
Rio Grande Wholesale, Inc.

famous for her traditional figures. Martha became popular with her whimsical mermaids and Frog Storytellers. She also makes miniature Nativity sets with baby lambs and angels.

We visited Martha in her home and bought some of her figures. We showed her the color catalog from the Wheelwright Museum exhibit, "The Clay People." We encouraged Martha to attempt some large standing figures. Some time passed when we received an exciting call from Martha, "I did it! I made two big ones!!!" She arrived soon thereafter. She made one tall baseball player figure and one tall Cochiti man with an old style outfit. The first went to our collection and the second was acquired by the Wheelwright Museum.

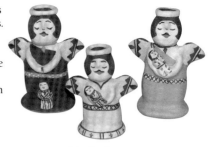

Martha Arquero -
Courtesy of
Georgiana Kennedy Simpson
Kennedy Indian Arts, Bluff, UT

Martha is on her way to becoming one of the great Cochiti pottery figure makers. She follows the tradition of her mother, Damacia, Helen Cordero and many more.

Martha perhaps is most famous for her Frog Storytellers. The frog is an important character in Cochiti story telling tradition. A 1931 Smithsonian Institution publication recorded the Cochiti tale, of the "Frog Wife," who before transforming into a frog, sings in the early morning:

Martha Arquero -
Photograph by Bill Knox
Courtesy of Indart Incoporated

> "Wa! Wa! (the frog's call)
> Down at the river are many lovers,
> For that I am homesick.
> Wa! Wa!" (Benedict 1931:140.)

Santiago Arquero

(Cochiti, active ca. 1900s-1930s+: traditional polychrome & black-on-cream large storage jars with handles, bowls, bird effigy bowls with handles)
BORN: ca. 1878
FAMILY: husband of Ignacita Suina Arquero
FAVORITE DESIGNS: rain clouds, flowers
PUBLICATIONS: U.S. Census, New Mexico, 1920:, family 19, #80; Batkin 1987:111, 114, 115, 202 n. 87.
PHOTOGRAPHS: Museum of New Mexico, Photo Archives, neg. #2322.

Santiago Arquero's wife, Ignacita, was one of the most respected Cochiti potters in the early 20th century. He probably helped her make pots and may have helped paint the designs.

Seferina Arquero *(see Maria Seferina Arquero)*

Arroh-ah-och *(Arroh-a-Och)*

(Laguna, active ca. 1840s-1900s: traditional polychrome ollas, jars, bowls)
LIFESPAN: ca. 1820-1900s
COLLECTIONS: Smithsonian Institution, olla, ca. 1880-1900, cat. #273442; Taylor Museum, Colorado Springs, CO, olla, ca. 1900, cat. #5705; School of American Research, Santa Fe, olla, ca. 1850-1900, collected in 1928 from Locario Chavez, , IAF. 1026; Museum of Northern Arizona, Flagstaff.
FAVORITE DESIGNS: deer with heartlines, Rainbirds, clouds, spirals; four design bands
PUBLICATIONS: Curtis, 1907-1930 XVI:242; Bunzel 1929; *American Indian Art Magazine* Winter 1979:33; Harlow 1977; Batkin 1987:150; Eaton 1990:25; Anderson, et al. 1999:38-39.

Arroh-ah-och was a famous man-woman, or berdache, a male who chose in childhood to live as a woman. Kenneth Chapman, the first curator of the Indian Arts Fund, attributed to Arroh-ah-och a polychrome olla now in the School of American Research Collection in Santa Fe.

Anthropologist Ruth Bunzel recounted that in the 19th century Arroh-ah-och visited Zuni. He was impressed with Zuni pottery. Soon thereafter, he began to paint a Zuni design of a deer with a heartline, called Deer-In-His-House on some of his pots.

Bernadette Ascencio

(Acoma, active ?-present: traditional polychrome & fineline ollas, jars, bowls, miniatures)
COLLECTIONS: Candace Collier, Houston, TX

Margaret Ascencio *(collaborates with Bernadette Victorino)*

(Acoma, active ?-1990+: polychrome jars, bowls)
PUBLICATIONS: Dillingham 1992:206-208.

Dolores Ascencion

(Acoma, ca. 1910s-30+: traditional Hawikuh glaze-on-red, black-on-red ollas, jars, bowls, canteens)
COLLECTIONS: Museum of New Mexico, olla, ca. 1930; School of American Research, Santa Fe, polychrome redware canteen, ca. 1930, IAF 1428.
PUBLICATIONS: Batkin 1987:139; Dillingham 1994:164, 167-68.

In 1928, Dolores Ascencion sold a glaze-on-red olla made in an earlier style called Hawikuh. She made a second black-on-red olla with a similar form and design that she sold in 1930 to the Museum of New Mexico in Santa Fe.

Ambroise Atencio

(Santo Domingo, active ?-present: traditional polychrome ollas,
jars, bowls)
COLLECTIONS: Richard M. Howard, Santa Fe; Candace
Collier, Houston, TX
FAVORITE DESIGNS: birds, flowers, sun, raindrops
EXHIBITIONS: 1988-95, Indian Market, Santa Fe
GALLERIES: Andrew's Pueblo Pottery, Albuquerque;
Richard M. Howard, Santa Fe

Frank Atencio *(jewelry hallmark: F A & arrow, jewelry)*

(Santo Domingo, active ?-present: pottery, jewelry)
EXHIBITIONS: 1996-present, Indian Market, Santa Fe;
1994-present, Eight Northern Indian Pueblos Arts & Crafts
Show; "Our Art, Our Voices"
PUBLICATIONS: Wright 1999:14.

Helen Atencio

(Santo Domingo, active ?: black-on-cream jars, bowls)
COLLECTIONS: Ronald Montoya, Santa Fe

Marie Atencio

(Santo Domingo, active ?-present: pottery, jewelry)
EXHIBITIONS: 1996-present, Indian Market, Santa Fe; 1994-present,
Eight Northern Indian Pueblos Arts & Crafts Show; "Our Art, Our
Voices"

Christopher Augustine *(Chris, Christopher Garcia)* *(signs Chris Augustine Acoma N.M.)*

(Acoma, active ca. 1979-present: traditional polychrome jars, bowls)
BORN: June 22, 1965
FAMILY: son of Elizabeth Garcia (Lewis)
GALLERIES: Rio Grande Wholesale, Inc., Palms Trading Co., Albuquerque
PUBLICATIONS: Dillingham 1992:206-208; Berger & Schiffer 2000:99.

James Augustine

(Acoma, active ca. 1980s-present: traditional polychrome jars, bowls, seed pots)
BORN: ca. 1960; RESIDENCE: Acoma Pueblo, NM
FAMILY: son-in-law of Rebecca & Harold Pasquale; husband of Marcella Augustine
COLLECTIONS: Johanna Leibfarth, South Carolina

Marcella Augustine

(Acoma, active ca. 1987-present: polychrome jars, bowls, seed pots)
BORN: November 11, 1960; RESIDENCE: Acoma Pueblo, NM
FAMILY: daughter of Rebecca & Harold Pasquale; wife of James
Augustine
COLLECTIONS: Johanna Leibfarth, South Carolina; Allan &
Carol Hayes, John Blom
GALLERIES: Rio Grande Wholesale, Inc., Palms Trading Co.,
Albuquerque
PUBLICATIONS: Hayes & Blom 1996; Berger & Schiffer
2000:97.

N. B. *(see Nellie Bica)*

T. B. *(see Tammy Bellson)*

Evangeline Baca *(signs Evangeline, with bear paw)*

(Jemez/Santa Clara, Bear Clan, active ca. 1995-present: traditional polychrome and sgraffito jars, bowls)
BORN: August 3, 1964
FAMILY: daughter of Ruby C. Waquiue
PUBLICATIONS: Berger & Schiffer 2000:100.

Josephine Baca

(Jemez, active ?-present: polychrome jars, bowls)

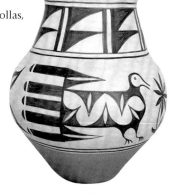

Ambroise Atencio -
Andrews Pueblo Pottery and Art Gallery
Albuquerque, NM

Ambroise Atencio -
Courtesy of
Richard M. Howard, Santa Fe

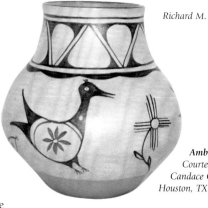

Ambroise Atencio -
Courtesy of
Candace Collier
Houston, TX

James Augustine -
Johanna Leibfarth Collection, SC

Marcella Augustine -
Johanna Leibfarth Collection, SC

Lenore Baca

(Jemez, ca. 1920s-60s+: traditional polychrome ollas, jars, bowls)
AWARDS: 1924, 1st, 2nd, Indian Fair [Market], Santa Fe
COLLECTIONS: Philbrook Museum of Art, Tulsa, OK, bowl, ca. 1953, bowl, ca. 1960
PUBLICATIONS: Batkin 1987:187; "Sharing the Heritage" no page numbers; Lab. File, Laboratory of Anthropology Library, Santa Fe.

 Lenore Baca is credited with helping to revive pottery making at Jemez before 1924. In that year, she won the 1st and 2nd prize ribbons, so she must have been working for some years to develop such praiseworthy pottery. She reportedly was the first woman to make pottery at Jemez in "150 years." However, she had other contemporaries, including Benigna Madelena and Rufugia Toledo, two Zia potters who married into Jemez.

 Lenore's award-winning pots were purchased in 1924 by the Indian Arts Fund in Santa Fe.

Lorenzo Baca

(Isleta/Mescalero Apache, active ca. 1960s-present: pottery, jewelry, metal sculpture, woodcarving, jewelry, sandcast, overlay, oil, acrylics, watercolors, illustrations, furniture, bull roars, poetry, music, acting)
BORN: September 9, 1947 in Morenci, AZ
EDUCATION: 1972, B.A., California State University, Long Beach; 1974, California State University, Turlock; 1974, Silversmithing, Institute of American Indian Arts, Santa Fe
AWARDS: 1979, Judges Choice, Heard Museum Show, Phoenix; 1986, Honorable Mention, Columbia College Art Show, Columbia, CA; National Endowment for the Arts grant, many more in other media
EXHIBITIONS: 1975, "Great American Face," California Museum of Science and Industry, Los Angeles; 1975-?, Scottsdale National Indian Arts Exposition, Scottsdale, AZ; 1977-?, Heard Museum Show; 1978, Potcarrier Gallery, Burlingame, CA; 1980, Spirit of the Earth, Native American Center for the Living Arts, Niagara, Falls, NY; 1981, "Lorenzo Baca," C. N. Gorman Gallery, University of California, Davis; 1987-88, American Indian Festival and Market, Los Angeles; 1988, American Indian Trade Fair, San Francisco; 1993, "Rain," Heard Museum, Phoenix., and many more.
PUBLICATIONS: New 1980; Lester 1995:35.
FILMS: 1977, "Jim Bridger," NBC-MOW; "Alex and the Gypsy," United Artists; 1978, "Ishi," NBC-MOW; "Return of the Apple Dumpling Gang," Disney Studios; 1980, "Sawyer and Finn," Columbia Pictures; "Joe Dancer," Filmways Productions.

Veronica Pino Baca

(Zia, Tobacco/Coyote/Arrow Clans, active ca. 1950s-present: traditional polychrome jars, bowls, also cross-stitch embroidery, aprons & pillowcases)
BORN: August 15, 1934
FAMILY: m. granddaughter of Santiago Shije & Joseffa Galvan; p. granddaughter of Peter Pino & Carlotta Pino; daughter of Refugia Galvan Shije & Santiago Shije; sister of Juan D. Pino, Ramon Pino, Florence Pino & Moses Pino; wife of Tony Baca (Jemez); mother of Timothy Pino, Samuel Pino & Anthony Baca; aunt of Randy Moquino
EDUCATION: 1948, Santa Fe Indian School; advanced medical training
TEACHER: Katherine Pino
CAREER: 34 years, Anesthesia Technician, University Hospital, Albuquerque
COLLECTIONS: Peru, South America; Chicago, IL
FAVORITE DESIGNS: roadrunner, flowers, clouds, tear drops

 We shared Easter dinner with Veronica Pino Baca, her brother, Moses Pino, her sister-in-law, Dolores Pino and other family members at their home on the Plaza. Over a hundred singers and dancers appeared on the Plaza that day in 2001. We found the family when searching for the family of Randy Moquino, one of the top embroidery artists.

 Veronica showed one of her polychrome jars. She explained that she was just getting back into pottery making after retiring from 34 years working as a medical technician at University Hospital. She expressed delight in the pottery-making process: "It is so interesting how it is made. You start with a small ball of clay, and it becomes a large pot. I also enjoy painting birds, flowers and clouds."

Vida Baca *(collaborates with Joseph Baca)*

(Zuni, married into Santa Clara, active ca. 1992-present: Santa Clara style carved blackware)
BORN: August 25, 1964
FAMILY: daughter of Terry & Janice Wyaco; wife of Joseph Baca
TEACHER: Mida Tafoya
AWARDS: Best of Show, 1st, 2nd, 3rd, Eight Northern Indian Pueblos Arts & Crafts Show
EXHIBITIONS: 1996-present, Eight Northern Indian Pueblos Arts & Crafts Show
PUBLICATIONS: Berger & Schiffer 2000:100

Wilma L. Baca *(New Wheat), (signs with Corn Hallmark)*

(Jemez, active ca. 1987-present: contemporary sgraffito polished redware jars, bowls, vases, wedding vases, seed pots)
BORN: September 1, 1967
FAMILY: granddaughter of Marie Reyes Shendo; daughter of John & Linda Baca; cousin of Carol Vigil & Imogene Shendo; related to Mildred Shendo
TEACHER: Marie Reyes Shendo, her grandmother
GALLERIES: Rio Grande Wholesale, Inc., Palms Trading Co., Albuquerque
PUBLICATIONS: Berger & Schiffer 2000:100.

Wilma Baca - Courtesy of Jason Esquibel
Rio Grande Wholesale, Inc.

Rita Banada *(see Rita Lewis)*

Joyce Barreras *(see Joyce Leno-Berreras)*

Seferina Bell *(hallmark - bell shaped outline), (see Zia color illustrations)*
(Zia, Coyote Clan, active ca. 1940s-?; traditional polychrome jars, bowls & canteens)
BORN: ca. 1930s
FAMILY: daughter of Joe Pino & Ascenciona Galvan Pino; sister of Katherine Pino, Laura Pino, Tomasita Pino & Filamino Pino; mother of Ruby Panana, Eleanor Griego, Reyes Pino
TEACHER: Ascenciona Galvan Pino, her mother
STUDENT: Ruby Panana, her daughter
COLLECTIONS: Dr. Paul K. & Janie Conner, Richard M. Howard, Angie Yan Schaaf, Santa Fe; Candace Collier, Houston, TX
FAVORITE DESIGNS: roadrunner, rainbows, clouds
VALUES: On December 2, 1998, a large polychrome olla (11.75 x 15.5"), sold for $6,325, at Sotheby's, #253.
 On May 19, 1998, a large polychrome olla (14.5 x 20"), est. $12,000-18,000, at Sotheby's, #447.
 On May 21, 1996, an olla (10 1/2" dia.), est. $1,500-1,800, at Sotheby's, #261.
PUBLICATIONS: Barry 1984:102, 104-05; Hayes & Blom 1996:162-63.
 Seferina Bell is recognized as one of the finest Zia potters of the mid-20th century. She made beautiful ollas, bowls and unique canteens. Her shapes are graceful. Her pottery-making techniques are refined. Best of all, she was an excellent painter. Her roadrunners were sleek and speedy. She painted both double loop and sharp tipped tails. Her talent comes out in her delicate details.

Tammy Bellson *(signs T. B. Zuni N.M.)*
(Zuni, Eagle Clan, active ca. 1990-present, polychrome, black & white on redware, jars, bowls, miniatures)
BORN: October 14, 1966
FAMILY: daughter of Eva & William Nashboo; sister of Yvonne Nashboo
TEACHER: her grandmother
FAVORITE DESIGNS: lizards
GALLERIES: Keshi, Santa Fe
PUBLICATIONS: Hayes & Blom 1998:53; Berger & Schiffer 2000:101.

Ascencion Chavez Benada *(Ascencion Benada Chavez)*
(Cochiti, active ca. 1920s-50s+: large polychrome ollas)
FAMILY: mother of Rita Lewis; mother-in-law of Ivan Lewis (son of Lucy Lewis from Acoma); m. grandmother of Ronald, Alvin, James, Elver & Patricia Lewis; great-grandmother of Kevin Lewis & Vanessa Lewis Sanchez
COLLECTIONS: Heard Museum, Phoenix
PUBLICATIONS: Shepard 1936:457; Lange 1959:162; Reano 1995:99.
 In October 1933, Ascencion Chavez Benada fired some pottery and allowed researcher Anna O. Shepard to observe the process. (Shepard 1936:457; Lange 1959:162) Ascencion is recognized as one the few Cochiti potters who made large ollas in the 20th century.

Felicita Benavides
(Santo Domingo, ca. 1920s-?: traditional polychrome jars, bowls)
PUBLICATIONS: Batkin 1987:202, n. 83.
 Museum director Kenneth M. Chapman gave her a set of Santo Domingo pottery designs he had compiled in the 1930s.

Soledad Berendo
(Acoma, active ca. 1860s-1910s+: polychrome jars, bowls)
BORN: ca. 1850; RESIDENCE: Acomita in ca. 1910
PUBLICATIONS: Leopold Bibo, "13th Annual U.S. Census" (1910), New Mexico State Archives, Call T624, Roll 919; in Dillingham 1992:205.

Nellie Bica *(signed N.B., Nellie Bica or Mrs. S. Bica), (collaborated sometimes with Erma Jean Homer and Jack Kalestewa), (see Zuni color illustrations)*
(Zuni, active ca. 1917-90s, polychrome jars, bowls, owl figures, owl Storytellers, three-lobed bowls with a handle, weaving, traditional dance outfits)
BORN: ca. 1904
FAMILY: mother of Quanita Kalestewa; mother-in-law of Jack Kalestewa; grandmother of Erma Jean Homer, Rowena Lemention, Connie Yatsayte
TEACHER: mother's youngest sister
STUDENTS: Quanita Kalestewa, her daughter; Jack Kalestewa, her son-in-law; Erma Jean Homer, Rowena Lemention, Connie Yatsayte, her granddaughters
COLLECTIONS: Wright Collection, Peabody Museum, Harvard University, Cambridge, MA; Dave & Lori Kenney, Dr. Gregory & Angie Yan Schaaf, Santa Fe
FAVORITE DESIGNS: owls, frogs, Deer-in-His-House, deer with heartlines
PUBLICATIONS: Rodee & Ostler 1986:24, 27, 32-33, 37; Babcock 1986:155; Trimble 1987:84; Nahohai & Phelps 1995:13; Hayes & Blom 1996:168; 1998:49; Bahti 1996:39; Peaster 1997:155; Drooker & Capone 1998:69, 83,140; Congdon-Martin 1999:48.
 Nellie Bica is considered one of the most famous Zuni potters of the mid-20th Century.

Nellie Bica - Courtesy of Dave & Lori Kenney Santa Fe

She is especially noted for her pottery owl figures. She was prolific and respected for her fine artistry.

In 1917, Nellie learned to make pottery: "My mother's youngest sister taught me when I was in my teens. Owls were the first potteries I made. That's the way they taught them in those days. I always put babies on my owls. I think I was none of the first to make owls with legs. Now my daughter and three granddaughters make them, too."

After the passing of Tsayutitsa and Catalina Zunie, Nellie Bica helped keep pottery making alive at Zuni. Quanita Kalestewa, her daughter, said that Nellie used to fire her pottery early in the morning, "just when the sun rises." Nellie taught her daughter to pray when gathering clay and making pottery.

Nellie made pottery when not working at their family sheep ranch. She was asked to teach pottery at Zuni, but explained that she was too busy with family responsibilities. She was a respected master potter.

Lores Bicente

(Acoma, active ca. 1860s-1910s+: polychrome jars, bowls)
BORN: ca. 1850; RESIDENCE: Acomita in ca. 1910
PUBLICATIONS: Leopold Bibo, "13th Annual U.S. Census" (1910), New Mexico State Archives, Call T624, Roll 919; in Dillingham 1992:205.

Helen Bird

(Santo Domingo, active ?-present: stone polished redware jars, bowls)
TEACHERS: She learned to polish redware at San Ildefonso Pueblo.
EXHIBITIONS: 1995-present, Indian Market, Santa Fe
PUBLICATIONS: Hayes & Blom 1996:146.

Shirley Blatchford

(Cochiti, active ?-1990s: Storytellers, animal & frog figures, miniatures, beadwork, clothing, leatherwork)
EXHIBITIONS: 1990, Heard Museum Show, Phoenix
COLLECTIONS: Heard Museum, Phoenix

Blooming Flower *(see Esther Suina)*

Nicol Blythe

(Isleta, active ?-present: pottery)
GALLERIES: The Indian Craft Shop, U.S. Department of Interior, Washington, D.C.

Ramona Blythe *(see Mona Teller)*

D. Bobelu

(Zuni, active ?-present: ollas, jars, bowls, miniatures)

Alice L. Bonham *(sometimes signs A. L. Bonham)*

(Cochiti, active ?-present: Rabbit Storytellers, Frog Storytellers)
PUBLICATIONS: Congdon-Martin 1999:47.

Effa Boone

(Zuni, active ?-1970s+: traditional polychrome jars, bowls)
COLLECTIONS: Wright Collection, Peabody Museum, Harvard University, Cambridge, MA; Dr. Gregory & Angie Yan Schaaf, Santa Fe
PUBLICATIONS: *Arizona Highways* May 1974:27; Drooker & Capone 1998:69, 140.

Lena Boone -
Courtesy of Sunshine Studio

Evalena Boone *(Evalina)*

(Zuni, active ca. 1980s-present: polychrome jars, cornmeal bowls with handles, fetishes)
BORN: ca. 1970
FAMILY: great-granddaughter of Teddy Weakie; daughter of Lena Boone
TEACHER: Jennie Laate
EXHIBITIONS: 1988-present, Indian Market, Santa Fe
FAVORITE DESIGNS: frogs, tadpoles, terraced clouds, dragonflies, bees
PUBLICATIONS: *Indian Market Magazine* 1988, 1989; Rodee & Ostler 1986:86.

Lena Boone

(Zuni, active ?-present: fetish jars)
COLLECTIONS: Sunshine Studio (www.sunshinestudio.com)

Ruth Boren

(Acoma, active ?-1990+: polychrome jars, bowls)
RESIDENCE: Grants, NM
COLLECTIONS: Jewell Lynch, Oklahoma City, OK
PUBLICATIONS: Dillingham 1992:206-208.

Ruth Boren - Jewell Lynch Collection
Oklahoma City, OK

Helen Bradley

(Acoma, active ca. 1970s-present: pottery)
EXHIBITIONS: 1994-present, Eight Northern Indian Pueblos Arts & Crafts Show
COLLECTIONS: Wright Collection, Peabody Museum, Harvard University, Cambridge, MA
PUBLICATIONS: Dillingham 1992:206-208; Drooker & Capone 1998:138.

Maria Bridgett *(Maria Bridgett Toribio)*

(Zia, Coyote Clan, active ca. 1910s-?: traditional polychrome ollas, jars, bowls)
BORN: ca. 1890
FAMILY: daughter of Rosalea Medina Toribio; sister of Juanita Toribio Pino; mother of
Candelaria Gachupin; m. grandmother of Dora Tse-Pe, Frances Gachupin, Irene Gachupin,
Joan Aragon, Steven Gachupin & Bernard Gachupin
PUBLICATIONS: Dillingham 1996:106.

Cyndee Sandia Brophy *(New Snow)*, *(signs Cyndee Sandia Brophy Toledo or Cyndee S. Brophy)*

(Jemez/Tesuque, Sun Clan, active ca. 1967-present:
traditional matte polychrome jars, bowls, seed pots,
wedding vases, miniatures)
BORN: November 20, 1957
FAMILY: daughter of Arthur & Rose Sandia
TEACHERS: grandmother & parents
AWARDS: 1978, 1979, 1981, H.M., Towa Arts Show,
Jemez Pueblo
FAVORITE DESIGNS: eagles, bears with heartlines,
butterflies, feathers, feathers-in-a-row, Rainbirds,
rainbows, rain clouds, lightning
GALLERIES: The Indian Craft Shop, U.S. Department
of Interior, Washington, D.C.; Andrews Pueblo Pottery
and Art Gallery, Albuquerque
PUBLICATIONS: Schiffer 1991d:49; Berger & Schiffer
2000:100.

Helen Bradley -
Photograph by Michael E. Snodgrass
Denver, CO

Cyndee Brophy -
Courtesy of Jason Esquibel
Rio Grande Wholesale, Inc.

Debbie G. Brown *(Debbie Garcia Brown)*

(Acoma, Turkey/Sun Clans, active ca. 1979-present: traditional
polychrome & plainware ollas, jars, bowls, seed pots, plates,
canteens, miniatures, corrugated pots)
BORN: December 12, 1962, Albuquerque, NM;
RESIDENCE: Acoma
FAMILY: great-granddaughter of Juana Garcia; m. grand-
daughter of Maria Trujillo, Laguna; p. granddaughter of
Jessie Garcia; daughter of Sarah Garcia; sister of Goldie
Hayah, Donna Chino, Oliver Garcia, Chester Garcia; wife of
Gerard Brown; mother of Gabrielle, Cecelia, Dwight &
Emilio Brown
TEACHERS: Sarah Garcia & Jessie Garcia
AWARDS: 1994, 2nd, 3rd; 1996, 1st; 1997, 3rd; 1998, 1st, 3rd;
H.M., 1999; 2000, 1st, 2nd, Plainware, Indian Market, Santa Fe
EXHIBITIONS: 1969-present: Indian Market, Santa Fe; 1996-
present, Eight Northern Indian Pueblos Arts & Crafts Show
FAVORITE DESIGNS: parrots, deer, turtles, bears, bees, flowers
PUBLICATIONS: Dillingham
1992:206-208; Painter 1998:9;
Berger & Schiffer 2000:102.

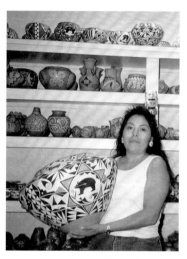

Debbie G. Brown -
Courtesy of John D. Kennedy and
Georgiana Kennedy Simpson
Kennedy Indian Arts

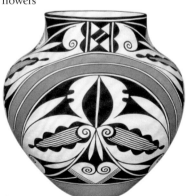

Debbie G. Brown -
Courtesy of Wanda Campbell
Indian Art Unlimited, IL

Debbie Brown comes
from an important Acoma
pottery-making family. She
commented, "I grew up
seeing pottery made all the
time. As a kid, I never
thought I had the talent
to make such beautiful
pottery. I started making
pottery full time, when I
turned eighteen. Ever since,
I've been making
pottery to this day."

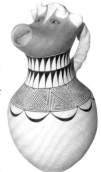

Debbie G. Brown - Courtesy of
Georgiana Kennedy Simpson
Kennedy Indian Arts, Bluff, UT

Debbie G. Brown -
Andrea Fisher Fine Pottery, Santa Fe

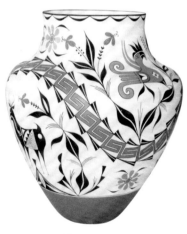

Debbie G. Brown -
Candace Collier Collection, Houston, TX

Fae Brown
(Acoma, active ?-1990+: polychrome jars, bowls)
PUBLICATIONS: Dillingham 1992:206-208.

Juanalita Brown
(Acoma, ca. 1930s-?: traditional polychrome jars, bowls)
COLLECTIONS: Philbrook Museum of Art, Tulsa, OK, jar, ca. 1939

Mabel Brown
(Acoma, active ca. 1950s-present: traditional & contemporary polychrome jars, bowls, cow pitchers)
PUBLICATIONS: Dillingham 1992:206-208; Reano 1995:24-25.

 Mabel Brown is noted for her popular cow pitchers, formed with a cow's head from which milk or cream is poured. One Colorado collector proudly showed us a picture of one of his shelves filled with cow pitchers. We met Mabel Brown when she and her family attended the Albuquerque Indian Art Show produced by Cowboys & Indians at the State Fairgrounds. We bought one of Mabel's cow pitchers, as did several of our friends. They're fun!

Rose M. Brown
(Cochiti/San Ildefonso, active ca. 1984-present: polychrome jars, bowls, Storytellers)
BORN: March 12, 1959
TEACHER: Marie P. Romero
EXHIBITIONS: 1997, Eight Northern Indian Pueblos Arts & Crafts Show
COLLECTIONS: John Blom
GALLERIES: Tribal Arts Zion, Springdale, UT; Adobe Gallery, Albuquerque
PUBLICATIONS: Hayes & Blom 1998:35, 51; Congdon-Martin 1999:7; Berger & Schiffer 2000:102; Schaaf 2000.

Mary Jane Buck
(Jemez, Corn Clan, active ca. 1950s-?: traditional polychrome jars, bowls)
BORN: ca. 1930s
FAMILY: granddaughter of Juan R Chavez (Jemez) & Filapeta Coriz Chavez (Tesuque); daughter of Juan I. & Lucy C. Toledo; sister of Marie Chavez, Jimmy Chavez, Charlie Chavez, Joseph Chavez, Reyes Collaque; wife of Juan I. Toledo

A. C. *(see Anthony Concho or Anthony Chosa)*

C. C. *(see Celina Chavez, Clara Chosa or Cyrus Concho)*

D. Y. C. *(see Dorina Y. Chinana)*

E. C. *(see Erna Choza)*

G. C.
(Jemez, active ca. 1990s-present: Storytellers)
GALLERIES: Wind River Trading Company, Santa Fe
PUBLICATIONS: Congdon-Martin 1999:56.

I. C. *(see Iva A. Colaque)*

J. M. C.
(Acoma, ca. 1990s-present: polychrome jars, bowls)
COLLECTIONS: John Blom

L. C. *(see Lorianne Concho)*

M. C. *(see Monica Chino)*

P. C. *(see Peggy Chinana or Patricia Chosa)*

P. M. C.
(Jemez, active ?: pottery)
PUBLICATIONS: Hotham, 6th ed.:198.

R. C. *(see Ramona Chino, Acoma)*

R. C.
(Jemez, active ?-present: pottery, miniatures)
PUBLICATIONS: Schiffer 1991d.

S. C. *(see Shirley Chino or Sheila Chavez Smith)*

V. C.
(Acoma, active ca. 1980s-present: polychrome jars, bowls)
COLLECTIONS: John Blom

V. C. *(see Virginia Chinana, Jemez)*

Aaron Cajero, Jr.

(Jemez, Sun Clan, active ca. 1994-present: contemporary carved and stone polished jars, bowls, bows, arrows, flint knapping)
BORN: December 5, 1987 in Las Vegas, NM
FAMILY: great-grandson of John & Loretta Cajero and Joe & Juana Pecos; grandson of Esther & Joe Cajero, Sr.; son of Anita & Aaron Cajero, Sr.; brother of Teris Cajero
TEACHERS: Anita & Aaron Cajero, Sr., his parents
AWARDS: 1996, Youth Award of Merit, Arizona State Museum, Tucson, AZ; 1998, Best of Division, Best of Class, 1st, Bow & Arrow Set, Indian Market, Santa Fe;1st, H.M., Southwestern Indian Art Show; 1999, 1st, Carved Bear Pot, Indian Market, Santa Fe; 2000, 1st, Bear Spirit Pot, 2nd (2), (ages 12 & under), Indian Market, Santa Fe; H.M., Wheelwright Museum Show, Santa Fe; 2001, 2nd, Indian Market, Santa Fe

Aaron Cajero, Jr. - Courtesy of the artist

EXHIBITIONS: 1995, Eight Northern Indian Pueblos Arts & Crafts Show; 1995-present, Indian Market, Santa Fe
FAVORITE DESIGNS: Water Serpents, bears, bear claws, kiva steps
PUBLICATIONS: *Indian Artist Magazine* Winter 1999:24.

Aaron Cajero, Jr. is a rising star among Southwest Pueblo Indian potters. He already has been awarded 1st prize at Indian Market. He learned pottery making from his parents. He explained that his focus as an artist is "to continue the long lived family traditions of pottery making."

Aaron Cajero, Sr.

(Jemez, Fire Clan, active ca. 1992-present: contemporary carved and stone polished jars, bowls)
BORN: May 28, 1966
FAMILY: grandson of John & Loretta Cajero and Joe & Juana Pecos; son of Esther & Joe Cajero, Sr.; brother of Joe Cajero, Jr.; husband of Anita Cajero; father of Aaron Cajero, Jr. & Teris Cajero
EDUCATION: B. A., physical education/coaching/administration/health
TEACHERS: Esther & Joe Cajero, Sr., Anita Cajero
STUDENTS: Aaron Cajero, Jr.

Aaron Cajero, Sr. - Courtesy of the artist

AWARDS: 2000, 1st, Indian Market, Santa Fe; other years, 2nd, 3rd, H.M.
FAVORITE DESIGNS: bears, eagles, feathers
GALLERIES: Wala-towa Visitor Center, Jemez Pueblo, NM; Rio Grande Wholesale

(Left to right): Anita Cajero, Aaron Cajero, Sr., Teri Cajero, Aaron Cajero, Jr. - Courtesy of the artists

Aaron Cajero explained that he enjoys creating pottery because "it's an expression of how I feel about beauty in nature. I create Native American arts and crafts using all natural materials."

Anita Cajero

(Jemez, Sun Clan, active ca. 1984-present: Storytellers, Nativities, figures, kiva pots, friendship pots, jars, bowls)
BORN: March 16, 1965
FAMILY: great-granddaughter of Juanita Yepa Gachupin; granddaughter of Leonora Toledo; daughter of Teresita Loretto & John Carrillo (Isleta); sister of Julie & Felecia Loretto; wife of Aaron Cajero, Sr.; mother of Teris & Aaron Cajero, Jr.
EDUCATION: 1983, studied Business Administration, New Mexico Highlands University, Las Vegas, NM
TEACHERS: Leonora Toledo, her grandmother; Teresita Loretto, her mother; Felecia Loretto, her sister & Esther Cajero
STUDENTS: Teris & Aaron Cajero, Jr.
AWARDS: 1994, 3rd, jars; 1996, 3rd, figures; 2001, 3rd, Nativities, Indian Market, Santa Fe; Eight Northern Indian Pueblos Arts & Crafts Show; Pueblo Grande Show, Phoenix, AZ
DEMONSTRATIONS: 1998, Pecos Pathways Project
AWARDS: 2001, 3rd, Nativity Set, Indian Market, Santa Fe
EXHIBITIONS: 1984-present, Indian Market, Santa Fe; Southwest Indian Art Fair, Arizona State Museum, Tucson; Pueblo Grande Show, Phoenix; New Mexico State Fair, NM
COLLECTIONS: Dave & Lori Kenny, Santa Fe
FAVORITE DESIGNS: corn, sun, feather, kiva steps, clouds
GALLERIES: Dancing Bear, IL; Heartlines, Atlanta, GA
PUBLICATIONS: Painter 1998:59; Congdon-Martin 1999:56-57; Berger & Schiffer 2000:32, 79.

Anita Cajero - Courtesy of the artist

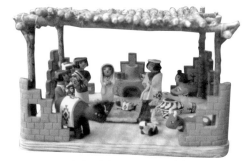

Anita Cajero - Courtesy of the artist

Anita pointed out how her traditional designs help "show Pueblo culture. I can show the Pueblo way of life with the type of pottery that I create: Storytellers, kiva pots, friendship pots and more."

One of her innovative designs depicts women dance figures with tabletas sitting on the steps of a wooden ladder emerging from a kiva pot. Her Storytellers position their legs forward or gracefully to the side. Her babies show expressions of awe.

Anita explained the tradition of Friendship Pots: "During rainy days, before running water, Pueblo people would take clay pots outside to collect water. Children would gather to see how much water collected in the pot. The turtle represents water and good life for the children around the pot. Friendship pots commemorate this tradition."

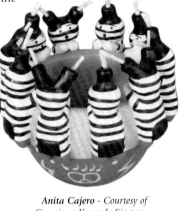

Anita Cajero - Courtesy of Georgiana Kennedy Simpson Kennedy Indian Arts, Bluff, UT

Bryant Cajero

(Jemez, active 1990s-present: figures)
AWARDS: 2000, 3rd, figures (ages 12-under), Indian Market, Santa Fe

Candelaria Cajero

(Acoma, active ca. 1850s-1910s+: polychrome jars, bowls)
BORN: ca. 1833; RESIDENCE: Acomita in ca. 1910
PUBLICATIONS: Leopold Bibo, "13th Annual U.S. Census" (1910), New Mexico State Archives, Call T624, Roll 919; in Dillingham 1992:205.

Esther H. Cajero *(Bird image hallmark), (signs E. Cajero)*

(Jemez, Fire Clan, active ca. 1985-present: polychrome Storytellers, Nativities, figures, jars, bowls, various Puebloan styles)
BORN: November 19, 1944
FAMILY: m. granddaughter of Petra C. Romero; daughter of Joe & Juana Pecos; wife of Joe Cajero, Sr.; mother of Loretta M. Cajero, Joetta Cajero, Aaron Cajero, Sr., Joe V. Cajero, Jr.; aunt of Gabriel Cajero
TEACHER: Petra C. Romero, her m. grandmother
STUDENTS: Joetta Cajero, Aaron Cajero, Sr., Joe V. Cajero, Jr., Anita Cajero, many more
AWARDS: 1990, 2nd, Nativities; 1991, 3rd, Nativities; 1993, 1st, Nativities; 1994, 1st, Storytellers; 1996, 1st; 1998, 2nd; 2000, 2nd, Storytellers, 3rd, Sets, Indian Market, Santa Fe; Heard Museum Show, Phoenix; Colorado Indian Market, Denver; Red Earth Indian Market, Oklahoma City; Santa Monica Indian Market, CA; Texas Indian Market
EXHIBITIONS: 1985-present, Indian Market, Santa Fe; University of Arizona, Tucson; Eight Northern Indian Pueblos Arts & Crafts Show
PUBLICATIONS: *Indian Market Magazine* 1997:99; Tucker 1998: plate 75; Congdon-Martin 1999:57-58.

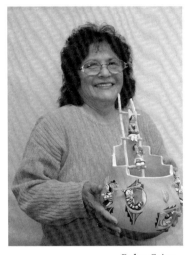

Esther Cajero - Courtesy of Jason Esquibel Rio Grande Wholesale, Inc.

Esther Cajero began her experience with pottery making around 1985. She is especially known for her fine Storytellers and other figures. She gives her Storytellers and figures individual names, such as "Cornflower," "Sunflower," "Far Star," or "Corn Dancer."

Esther experiments with different clays, slips, natural paints and firing techniques. To expand her knowledge and appreciation, she has made pottery in the styles of different Pueblos.

Collector Ed Samuels commented, "Esther developed the Friendship Pots. Her Storytellers have umbrellas. Her Corn Maidens are all dressed up with miniature pots. Some have tabletas or Butterfly whorls. She is one of the most creative potters. She also has taught many people to make pottery. She excels at being a teacher of pottery at her Pueblo."

Esther also holds additional community responsibilities as the wife of Joe Cajero, Sr., present Governor of Jemez Pueblo (ca. 2001). Esther kindly called and offered her assistance in collecting information to help the potters and other artists from Jemez Pueblo. We thank her sincerely for her help.

Gabriel P. Cajero

(Jemez, active ca. 1970-present: redware sgraffito jars, bowls, vases, sculpture)
BORN: May 16, 1961
FAMILY: son of Loretta Cajero; nephew of Esther & Joe Cajero, Sr.
TEACHER: Loretta Cajero
AWARDS: New Mexico State Fair, Albuquerque; Inter-tribal Indian Ceremonial, Gallup, NM
EXHIBITIONS: 1988-present, Indian Market, Santa Fe; Eight Northern Indian Pueblos Arts & Crafts Show
FAVORITE DESIGNS: feathers, rain clouds, Kokopelli, butterflies, corn plants, turtles
GALLERIES: Bien Mur, Albuquerque
PUBLICATIONS: Babcock 1996; *Indian Artist Magazine* 1996 2(1):23; Walatowa Pueblo of Jemez, "Pottery of Jemez Pueblo" (1999); Berger & Schiffer 2000:103.

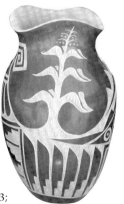

Gabriel P. Cajero - Courtesy of the artist

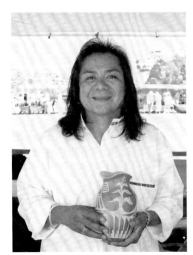

Gabriel P. Cajero - Photograph by Angie Yan Schaaf

Joe V. Cajero, Jr. *(Joseph)*

(Jemez, Fire Clan, active ca. 1974-present: Storytellers, Koshare clown figures, sculptures, animal figures - bears, paintings, drawings)
BORN: ca. 1971
FAMILY: great-grandson of Petra C. Romero; grandson of John & Loretta Cajero; son of Esther & Joe Cajero, Sr.
EDUCATION: A.F.A. degree, Institute of American Indian Arts, Santa Fe
TEACHERS: Esther Cajero, Felix Vigil
AWARDS: 1988, 3rd (ages 18 & under); 1990, 1st, figures; 1991, 1st, 2nd, figures; 1992, 2nd, sets; 1993, Robert and Dorothy Walker Fellowship, SWAIA; 1993, Katherine & Miguel Otero Award for Creative Excellence, 1st, Storytellers, 2nd, figures; 1994, 1st, 2nd, Nativities, 2nd, figures; 1998; 1st; 2000, Indian Market, Santa Fe; Best of Class, 1st, Inter-tribal Indian Ceremonial, Gallup, NM

EXHIBITIONS: 1988-present, Indian Market, Santa Fe
GALLERIES: Tanner-Chaney Gallery, Albuquerque; Kennedy Indian Arts
PUBLICATIONS: *New Mexico Magazine* Aug. 1998 77(8):63;; Tucker 1998: plate 74; *Indian Artist Magazine* Fall 1998 4(4):3, 89; *New Mexico Magazine* Aug. 1999 77(8):59; *Native Peoples Magazine* Feb./Mar. 2000 13(2):84.

Joe V. Cajero, Jr. has emerged as a respected Pueblo Indian artist, masterful in many forms of art — pottery, paintings and sculptures. He was only 17 years old when he became an Indian Market participant. He worked his way up to be recognized as a prizewinner.

In 1993, Joe won the prestigious Robert and Dorothy Walker Fellowship, awarded by SWAIA, producers of Indian Market. He responded, "My sculptures reflect the strength of our Pueblo traditions, with intimate details and expressions of joy, song, and dance."

In 1996, at the age of 25, Joe was selected for the Indian Market "Masters Show." This was a distinguished honor for an artist so young. His fame has attracted leading magazines including *New Mexico Magazine, Indian Artist, Cowboys & Indians,* and *Native Peoples.*

Joe is especially known for his lively Koshare clown figures. The artist commented, "'The medicine of the Koshares stand for happiness. They talk all the anguish away and bless you with positive energy."

Joseph Cajero, Jr. - Courtesy of John D. Kennedy and Georgiana Kennedy Simpson Kennedy Indian Arts

Joe Cajero, Jr. - Gerald & Laurette Maisel Collection, CA

Loretta Cajero *(1)*

(Jemez, Fire Clan, active ca. 1940s-?: traditional polychrome jars, bowls)
BORN: ca. 1920
FAMILY: wife of John Cajero; mother of Esther Cajero; grandmother of Gabriel Cajero, Joe Cajero, Jr., Joetta Cajero, Loretta Cajero & Aaron Cajero, Sr.; great-grandmother of Aaron Cajero, Jr. & Teris Cajero
STUDENTS: Gabriel Cajero

Loretta Cajero *(2)*

(Jemez, Fire Clan, active ca. 1980s-present: Storytellers, figures, jars, bowls, miniatures, embroidery)
BORN: 1975
FAMILY: m.granddaughter of Loretta Cajero (1); daughter of Esther & Joe Cajero, Sr.; sister of Joe Cajero, Jr., Joetta Cajero, Loretto & Aaron Cajero, Sr.; mother of Gabriel Cajero
AWARDS: 1986, 2nd, 3rd, pottery (ages 12 & under); 1989, 2nd, miniatures, 3rd, figures (ages 18 & under); 1990, 2nd, figures (ages 18 & under); 1991, 2nd, figures; 1993, 2nd, figures (ages 18 & under), Indian Market, Santa Fe
PUBLICATIONS: Schaaf 2001:281.

Teris Cajero *(Teri)*

(Jemez, Sun Clan, active ca. 1990s-present: Storytellers, figurines, kiva pots)
BORN: September 4, 1984
FAMILY: great-granddaughter of John & Loretta Cajero; granddaughter of Teresita Loretto & John Carillo (Isleta); p. granddaughter of Esther & Joe Cajero, Sr.; daughter of Anita & Aaron Cajero, Sr.; sister of Aaron Cajero, Jr.
TEACHERS: Anita & Aaron Cajero, Sr.
AWARDS:

1996	1st, Pottery Figurine, Indian Market, Santa Fe
	Youth Merit Award, Southwest Indian Art Fair
1997	1st, Kiva Pot, Indian Market, Santa Fe
1998	2nd, Kiva Pot, Indian Market, Santa Fe
	Youth Award, Southwest Indian Art Fair
1999	Storyteller, Youth Award, Southwest Indian Art Fair
2000	1st, Storyteller, Indian Market, Santa Fe
	Storyteller, Youth Award, Southwest Indian Art Fair
2001	2nd, Nativity, Indian Market, Santa Fe

Teris Cajero - Courtesy of the artist

Teris Cajero - Courtesy of the artist

Abel Calabaza *(collaborates sometimes with Carol Calabaza)*
(Santo Domingo, active ?-present: polychrome bowls, plates, jewelry)
EXHIBITIONS: 1988-present, Indian Market, Santa Fe; 1994-present, Eight Northern Indian Pueblos Arts & Crafts Show

Andrew Calabaza *(collaborates with Vicky Tenorio Calabaza)*
(Santo Domingo, active ca. 1980s-present: polychrome, jars, dough bowls)
FAMILY: husband of Vicky T. Calabaza
PUBLICATIONS: Hayes & Blom 1998:11.

Antonita Quintana Calabaza *(perhaps the same as Tonita Quintana)*
(Santo Domingo, active ?: pottery, jewelry)
PUBLICATIONS: Toulouse 1977.

Avelino Jay Calabaza
(Santo Domingo, active ca. 1960s-present: pottery, jewelry)
BORN; August 25, 1948
FAMILY: father of Denelle Rose Calabaza
EXHIBITIONS: 1980, 1995, Eight Northern Indian Pueblos Arts & Crafts Show
PUBLICATIONS: Schaaf 2001:281.

Carol Calabaza *(1), (collaborates sometimes with Abel Calabaza)*
(Santo Domingo, active ?-present: polychrome bowls, plates, jewelry)
EXHIBITIONS: 1989-present, Indian Market, Santa Fe

Carol Calabaza *(2)*
(Acoma, active ?-present: pottery)
EXHIBITIONS: 1988-1992, Indian Market, Santa Fe; 1995-present, Eight Northern Indian Pueblos Arts & Crafts Show

David Calabaza
(Santo Domingo, active ?-present: pottery, jewelry)
EXHIBITIONS: 1994, Eight Northern Indian Pueblos Arts & Crafts Show

Denelle Rose Calabaza
(Santo Domingo, active ca. 1990s-present: pottery, jewelry, textiles, beadwork)
BORN: May 28, 1976
FAMILY: daughter of Avelino Jay Calabaza
PUBLICATIONS: Schaaf 2001:281.

Jacob Calabaza
(Santo Domingo, active ?: pottery)

Joseph Calabaza *(collaborates with Genevieve Garcia)*
(Santo Domingo, active ?-present: polychrome, black-on-cream jars, bowls, jewelry)
BORN: ca. 1940s

Laurencita Calabaza
(Santo Domingo, active ca. 1970s-present: polychrome jars, bowls, canteens)
LIFESPAN: ca. 1940s - ?
FAMILY: sister of Vivian Sanchez, Gilbert Pacheco, Trinidad Pacheco; mother of Santana Calabaza
PUBLICATIONS: Dillingham 1994:136.

Marcelina Calabaza
(San Felipe, active ?: pottery)
ARCHIVES: Laboratory of Anthropology Library, Santa Fe, lab file.

Maria Calabaza *(Marie)*
(Santo Domingo, ca. 1920s-?: traditional polychrome jars, bowls)
PUBLICATIONS: Batkin 1987:202, n.83.
 Museum director Kenneth M. Chapman gave her a set of Santo Domingo pottery designs he had compiled in the 1930s.

Nescita Calabaza
(Santo Domingo, ca. 1910-?, traditional polychrome ollas, jars, dough bowls)
BORN: ca. 1890s
FAMILY: wife of Clemente Calabaza; mother of Juanita Calabaza Tenorio; m. grandmother of Robert Tenorio, Paulita Pacheco, Mary Edna Tenorio & Hilda Coriz

COLLECTIONS: Heard Museum, Phoenix

Grandson Robert Tenorio said of Nescita Calabaza, "She was a great potter. She made large dough bowls and ollas. She was noted for her traditional circle design. One of her pots was illustrated on a Heard Museum poster. Some of her pots are still with families at San Felipe and Cochiti Pueblo."

Reyes Calabaza

(Santo Domingo, ca. 1920s-?: traditional polychrome jars, bowls)
FAMILY: wife of Santiago L. Calabaza; mother of Genevieve Garcia, Marie Aguilar, Andrea
PUBLICATIONS: Batkin 1987:202, n. 83.

Museum director Kenneth M. Chapman gave her a set of Santo Domingo pottery designs he had compiled in the 1930s.

Santana Calabaza

(Santo Domingo, active ca. 1970s-present: polychrome jars, bowls, canteens)
BORN: ca. 1960s
FAMILY: daughter of Laurencita Calabaza
PUBLICATIONS: Dillingham 1994:136.

Mrs. Santiago Calabaza

(Santo Domingo, ca. 1920s-?: traditional polychrome jars, bowls)
PUBLICATIONS: Batkin 1987:202, n. 83.

Museum director Kenneth M. Chapman gave her a set of Santo Domingo pottery designs he had compiled in the 1930s.

Vicky T. Calabaza *(Victoria Tenorio) (hallmark - Six dots in a triangle) (collaborates with Andrew Calabaza)*

(Santo Domingo, active ca. 1983 - present: traditional polychrome, jars, bowls, jewelry)
BORN: April 1, 1959
FAMILY: granddaughter of Lupe L. Tenorio; daughter of Emiliano & Petra G. Tenorio; sister of 6 brothers and 1 sister; wife of Andrew Calabaza; mother of 3 children
TEACHER: Lupe L. Tenorio, her grandmother
EXHIBITIONS: Santo Domingo Pueblo Arts & Crafts Show
COLLECTIONS: Dr. Gregory & Angie Yan Schaaf, Santa Fe
PUBLICATIONS: Hayes & Blom 1998:11; Berger & Schiffer 2000:103.

Daryl V. Candelaria *(Wa-Na-Kee-Kuai, Mosaic Sea Shell; Sra-Au-iits, Water Serpent)*

Daryl Candelaria -
Courtesy of Jill Giller
Native American Collections, Denver, CO

(San Felipe, active ca. 1980s-present: multiple styles, Mimbres & Anasazi revival, traditional & contemporary polychrome jars, bowls, miniatures, embroidery, dancing, writing)
BORN: April 14, 1970
AWARDS: 1996, 3rd; 1998, 2nd; 1999; 3rd, 2000, Indian Market, Santa Fe
EXHIBITIONS: 1994-present, Eight Northern Indian Pueblos Arts & Crafts Show; 1996-present, Indian Market, Santa Fe
COLLECTIONS: Bill & Jane Buchsbaum, Santa Fe;
GALLERIES: Native American Collections, Denver, CO; King Galleries, Scottsdale, AZ
PUBLICATIONS: *Indian Market Magazine* 1996:59; *Indian Artist* Winter 1996:15; School of American Research, *Annual Report* 1000:17-18; *Pasatiempo, New Mexican* August 18, 2000:50.

Daryl Candelaria -
Bill & Jane Buchsbaum Collection

Diane Candelaria

(San Felipe, active ca. 1990s-present: pottery)
EXHIBITIONS: 1999, Eight Northern Indian Pueblos Arts & Crafts Show

Roger Candelaria

(San Felipe, active ca. 1990s-present: pottery)
EXHIBITIONS: 1995-present, Eight Northern Indian Pueblos Arts & Crafts Show

Daryl Candelaria - King Galleries of Scottsdale, AZ

Hubert Candelario

(San Felipe, active ca. 1987-present: polished redware (early) & traditional micaceous orangeware jars, bowls, swirl pots, puzzle pots, miniatures)
BORN: November 2, 1965; RESIDENCE: Algodones, NM
FAMILY: son of Phillip & Angelina Candelario
EDUCATION: Bernalillo High School (1984); Phoenix Institute of Technology (Architectural Drawing)
STUDENTS: Kevin Trancosa
AWARDS: 2000, 2nd, 3rd; Best of Show, Indian Market, Santa Fe; New Mexico State Fair, Albuquerque; Inter-tribal Indian Ceremonial, Gallup
COLLECTIONS: Denver Art Museum, Denver, CO; Indart, Inc.
GALLERIES: Tribal Arts Zion, Springdale, UT; Case Trading Post at the Wheelwright Museum, Santa Fe; Native American Collections, Denver, CO; King Galleries of Scottsdale, AZ; Andrea Fisher Fine Pottery, Santa Fe
PUBLICATIONS: Schiffer 1991d:46; Hayes & Blom 1996; *The Messenger,* Wheelwright Museum Spring 1996: inside cover; Fall-Winter 1996:6, 10; Tucker 1998: plate 99; Berger & Schiffer 2000:50,103; *Native Peoples* Nov. Dec. 20000 14(1):76.

Hubert Candelario -
Andrea Fisher Fine Pottery, Santa Fe

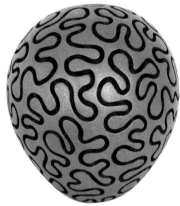

Hubert Candelario -
Photograph by Bill Bonebrake
Courtesy of Jill Giller
Native American Collections, Denver, CO

Hubert Candelario -
Andrea Fisher Fine Pottery, Santa Fe

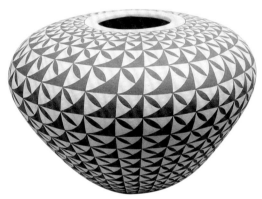

Hubert Candelario -
Photograph by Tony Molina
Case Trading Post at the Wheelwright Museum
of the American Indian, Santa Fe

Hubert Candelario confided, "I found myself through pottery." The collectors also have found him, as his popularity is soaring. He makes some of the most attractive micaceous pots in the Southwest. He credits Maria Martinez and Nancy Youngblood as his original inspirations. Maria encouraged him personally. He was influenced directly by Nancy's swirl pots which have become so popular.

Three years after graduating from Bernalillo High School, Hubert began in 1987 making polished redware. By 1990, he switched to using an orange micaceous slip. He set out to create a new style and succeeded: "I like to see what I can do differently with the designs. I like to get a new look." His most distinctive styles are the melon swirl pots and his orangeware with incised black outlines.

Hubert pushes the art form forward with his puzzle pots which are painted with outlines that fit together like pieces of a puzzle. He also creates what he calls "holey" pots with sharp rounded ridges and cut-outs.

Hubert is emerging as one of the top Pueblo Indian potters of the 21st century. People respond positively to his pottery, "So many say they love my pieces. It makes me feel so good that people like my work."

Caroline L. Carpio *(Caroline Lucero-Carpio, Thud-Bese, Sun Tablita)*

(Isleta, active ca. 1982-present: polished whiteware and orangeware melon bowls, corn meal bowls, vases, clay & bronze sculptures, some decorated with coral, turquoise and other natural materials, lamps, graphic art)
BORN: October 19, 1962
FAMILY: daughter of Sosten Clovis Lucero & Katherine Maria Lucero
AWARDS:

1984	1st, Mescalero Arts & Crafts Show, Mescalero, NM
1986	Best of Show, Colorado Indian Market, Denver, CO
1994	3rd, Inter-tribal Indian Ceremonial, Gallup, NM
1995	Best of Show, New Mexico State Fair, Albuquerque
1997	Best of Division, Heard Museum Show, Phoenix; Best of Division, Red Earth Festival, Oklahoma City, OK
2000	Fellowship, SWAIA, Santa Fe

EXHIBITIONS: 1993-present, Indian Market, Santa Fe; 1994-present, Eight Northern Indian Pueblos Arts & Crafts Show; 1994, Inter-tribal Indian Ceremonial, Gallup, NM; Mescalero Arts & Crafts Show, Mescalero, NM; ?-present, Indian Arts & Crafts Association Show, Albuquerque
GALLERIES: Arlene's Gallery, Tombstone, AZ
PUBLICATIONS: *Indian Market Magazine* 1998:99; *Cowboys & Indians* Dec. 1999:78; *Navajo Times* Aug. 10, 2000:6.

Caroline L. Carpio is respected as a top prize-winning artist in clay, bronze and other media. She is one of a few artists who have created a mold around their clay works to form fine art, limited edition bronzes. Caroline also is to be commended for the artistic design in her color brochure in which she stated in part:

"We all have different ways to pay homage to our Creator for our existence, and my means of paying the honor is to create something beautiful that comes from Mother Earth, from which we all came."

"The corn portrayed on my pottery personifies the female. The tableta (terraced cloud) design, often seen on my pottery, depicts Father Sky. At times, the Clay Mother wants to be of simplicity and elegance, and other times she wants to emerge as a human form."

Caroline further stated: "The representation of my people, and the contemporary expression of who I am is voiced through the creations of my art. It guides us to the past and to the future."

Caroline L. Carpio -
Courtesy of John Blom

Deborah Ann Casiquito *(Deborah or Debbie Gachupin)*
(Jemez, active ca. 1985-present: pottery, textiles)
AWARDS. 1998, Indian Market, Santa Fe
EXHIBITIONS: 1985-present, Indian Market, Santa Fe; 1998-present, Eight Northern Indian Pueblos Arts & Crafts Show
PUBLICATIONS: *Indian Market Magazine* 1985, 1988, 1989; Schaaf 1997b.

Jeronima F. Casiquito
(Jemez, active ca. 1980s-present: pottery, textiles)
EXHIBITIONS:1985-present, Indian Market, Santa Fe; 1994-present, Eight Northern Indian Pueblos Arts & Crafts Show
PUBLICATIONS: *Indian Market Magazine* 1985, 1988, 1989; Schaaf 2001:282.

Persingula M. Casiquito
(Pecos/Jemez, active ca. 1970s-?: Pecos polychrome glazeware jars, bowls)
PUBLICATIONS: Barry 1984:134.

Persingula M. Casiquito and Evelyn Vigil helped revive Pecos glazeware, the historic style of pottery made by their ancestors at Pecos Pueblo near Santa Fe. In the 19th century, the final group at Pecos moved to live with their cousins at Jemez Pueblo.

Regina Annette Casiquito
(Jemez, active ca. 1990s-present: pottery, textiles)
AWARDS: 1998, Indian Market, Santa Fe
EXHIBITIONS: 1995-present, Indian Market, Santa Fe
PUBLICATIONS: Schaaf 2001:282.

Rita Casiquito *(Rita Magdelena) (1)*
(Jemez/Zia, Corn Clan, active ca. 1930s-?: polychrome jars, bowls)
BORN: ca. 1900
FAMILY: mother of Juanita C. Fragua & Jeronina Shendo; grandmother of Clifford Fragua, Glendora Daubs Fragua & Barbara Jean Chavez Fragua
STUDENTS: Juanita Fragua & Jeronina Shendo
PUBLICATIONS: Peaster 1997:62.

Rita Casiquito *(2)*
(Jemez, active ca. 1920s-?)
BORN: ca. 1900
FAMILY: wife of Vidal Casiquito; mother of Rebecca & Josefina Casiquito
PUBLICATIONS: U.S. Census 1920, family 51.

Irene Castillo
(Acoma, active ?-1990+: polychrome Storytellers, jars, bowls, miniatures)
PUBLICATIONS: Dillingham 1992:206-208; Painter 1998:9.

Myrtle Chavarillo Cata
(San Felipe/San Juan, active ca. 1980s-present: micaceous jars, melon bowls, wedding vases)
EXHIBITIONS: 1994-present, Eight Northern Indian Pueblos Arts & Crafts Show; 1995-present, Indian Market, Santa Fe
COLLECTIONS: micaceous jar, ca. 1995, School of American Research, Santa Fe
FAVORITE DESIGNS: terraced rain cloud appliques, corn, fluted rims
PUBLICATIONS: Hayes & Blom 1996:126; Anderson 1999:167; Schaaf 2000:240, 272.

Rosalind Montoya Cata
(San Felipe/Isleta/San Juan, active ca. 1990s-present: micaceous ollas, jars, bowls)
EXHIBITIONS: 1994-present, Eight Northern Indian Pueblos Arts & Crafts Show
FAVORITE DESIGNS: terraced rain cloud appliques, fluted rims
PUBLICATIONS: Schaaf 2000:241.

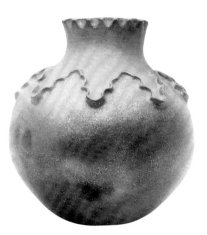

Rosalind M. Cata -
Nedra Matteucci Galleries, Santa Fe

Asuncion Aguilar Cate

(Santo Domingo, active ca. 1890s-1915: traditional polychrome ollas, jars, bowls)
FAMILY: sister of Felipita Aguilar Garcia, sister-in-law of Mrs. Ramos Aguilar
PUBLICATIONS: Batkin 1987:99.
PHOTOGRAPHS: Aguilar Style Pottery, ca. 1921, Museum of New Mexico Archives, neg. #23393.

Ines Cate *(Mrs. Juan Cate)*

(Santo Domingo, active ca. 1900-?: pottery)
BORN: ca. 1879
FAMILY: wife of Juan Cate; mother of Balintin, Reyes, Petro, Juan Reyes, Josefa, Catalina, Anselmo, Martin & Pascual Cate
PUBLICATIONS: U.S. Census 1920, Santo Domingo, family 110; Laboratory of Anthropology Library, Lab file, Santa Fe.

Deldrick Cellicion *(collaborates with Lorenda Cellicion)*

(Zuni, active ?-present, polychrome jars, bowls, effigy pots, wedding vases)
COLLECTIONS: Judy Johnson, Ralph Singleton and Frances Snyder
FAVORITE DESIGNS: lizards, salamanders, frogs, rosettes, feathers, scrolls
GALLERIES: Native American Collections, Denver, CO; King Galleries of Scottsdale, AZ;
Running Bear Zuni Trading Post, Zuni, NM; Case Trading Post at the Wheelwright Museum of the American Indian, Santa Fe
INTERNET: www.sunshinestudio.com
PUBLICATIONS: Bassman 1996:25; Hayes & Blom 1998:25.

Deldrick & Lorenda Cellicion -
Photograph by Tony Molina
Case Trading Post at the Wheelwright Museum
of the American Indian, Santa Fe

Lorenda Cellicion *(Lorinda), (collaborates with Deldrick Cellicion)*

(Zuni, active ?-present: polychrome jars, bowls, effigy pots, wedding vases)
COLLECTIONS: Judy Johnson, Ralph Singleton and Frances Snyder; Gerald & Laurette Maisel , CA
FAVORITE DESIGNS: lizards, salamanders, frogs, rosettes, feathers, scrolls
GALLERIES: Running Bear Zuni Trading Post, Zuni, NM
INTERNET: www.sunshinestudio.com
PUBLICATIONS: Bassman 1996:26; Hayes & Blom 1998:25.

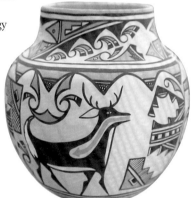

Lorenda Cellicion -
Gerald & Laurette Maisel Collection, CA

Deldrick & Lorenda Cellicion -
Courtesy of Jason Esquibel
Rio Grande Wholesale, Inc.

Alice Celo

(Jemez, active ca. 1990s-present: pottery)
EXHIBITIONS: 1994-present, Eight Northern Indian Pueblos Arts & Crafts Show

Mrs. Juan Celo *(see Susanita Celo)*

Manuelita Celo

(Jemez, active ca. 1930s-?: pottery)
BORN: ca. 1920
FAMILY: daughter of Juan P. & Susanita Celo; sister of Andrea C. Tsosie
PUBLICATIONS: U.S. Census 1920, family 101.

Mary Celo

(Jemez, active ca. 1950s-?: traditional polychrome jars, bowls)
BORN: ca. 1935
FAMILY: mother of Patricia Valencia
STUDENT: Patricia Valencia, her daughter

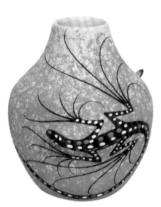

Deldrick & Lorenda Cellicion -
King Galleries of Scottsdale, AZ

Susanita Celo

(Jemez, active ca. 1920s-?: traditional polychrome jars, bowls)
BORN: ca. 1901
FAMILY: wife of Juan Celo; mother of Manuelita Celo & Andrea Tsosie; m. grandmother of Rebecca Tsosie, Irene Herrera & Leonard Tsosie; m. great-grandmother of Caroline Sando
PUBLICATIONS: U.S. Census 1920, family 101.

Annie Cerno *(see Santana Cimmeron Cerno)*

Barbara Cerno *(Barbara Hayah Cerno), (signs B & J Cerno), (collaborates with Joseph Cerno)*

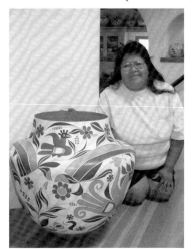

Barbara Cerno -
Photograph by Angie Yan Schaaf

(Acoma/Hopi, Eagle/Antelope Clans, active ca. 1969-present: Mimbres & Anasazi Revival & large traditional polychrome storage jars, ollas, jars, bowls, miniature seed pots - both Acoma & Hopi styles)

BORN: October 20, 1951, Albuquerque; RESIDENCE:Grants, NM

FAMILY: m. granddaughter of John & Maria Gunn; p. granddaughter of Willie & Kate Sennie; daughter of Esther Gunn Hayah & William Hayah; sister of Isaac Hayah, Zelda Chaplan, Melvin Chaplan, Stanless Hayah, John Hayah & Meldon Hayah; wife of Joseph Cerno, Sr.; mother of Joseph, Jr., Jolene, Joan, Jeorgette, Merle

TEACHER: Annie Cerno

AWARDS:

1971-01	collaborations - see listed with Joseph Cerno, Sr.
1988	Best of Division, 1st, Indian Market, Santa Fe
1989	2nd, Indian Market, Santa Fe
1990	2nd, Indian Market, Santa Fe
1991	1st, Indian Market, Santa Fe
1992	2nd, 3rd, Indian Market, Santa Fe
1994	1st, Indian Market, Santa Fe
1996	2nd, Indian Market, Santa Fe
2000	3rd (2) Acoma Jars, Indian Market

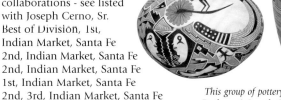

This group of pottery is by
Barbara & Joseph Cerno -
Courtesy of the artists

EXHIBITIONS: 1979, "One Space: Three Visions," Albuquerque Museum, Albuquerque; 1982-present: Indian Market, Santa Fe; 1995-present, Eight Northern Indian Pueblos Arts & Crafts Show; Inter-tribal Indian Ceremonial, Gallup; New Mexico State Fair, Albuquerque

DEMONSTRATIONS: Crow Canyon Archaeological Center, Cortez, CO

COLLECTIONS: Heard Museum, Phoenix; Allan & Carol Hayes; Gerald & Laurette Maisel, Tarzana, CA; Dr. Gregory & Angie Yan Schaaf, Santa Fe

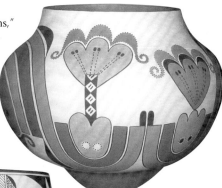

Barbara & Joseph Cerno -
Nedra Matteucci Galleries, Santa Fe

FAVORITE DESIGNS: parrots, rainbows, flowers, leaves, some Mimbres designs, lizards, bugs, birds

VALUES: On May 17, 2000, a polychrome olla, signed Barbara & Joseph Cerno, (16 x 19"), sold for $6,600, at Sotheby's, #539.

GALLERIES: The Indian Craft Shop, U.S. Department of Interior, Washington, D.C; Andrea Fisher Fine Pottery, Santa Fe

PUBLICATIONS: *SWAIA Quarterly* Fall 1982:10; Barry 1984:89; *American Indian Art Magazine* Autumn 1987:24; Spring 1992:32; Southwest Art Sept. 1988:58; Mar. 1989:106; *Arizona Highways* Nov. 1988:27; *Indian Market Magazine* 1988-2000; Schiffer 1991d:50; Dillingham 1992:206-208; Reano 1995:28; Peaster 1997:16-17; Marmor & Ravin 1997:152; *Cowboys & Indians* Nov. 1999:95; Sept. 2000:94; Berger & Schiffer 2000:103.

Barbara & Joseph Cerno -
Courtesy of the artists

Barbara and Joseph Cerno are a husband and wife pottery-making team. They make some of the largest traditional polychrome ollas. Their pots are made from traditional materials, hand coiled and fired outdoors.

Barbara's mother, Esther Gunn Hayah, was of the Acoma Eagle & Antelope Clans. Barbara's father, William David Hayah was of the Hopi Rabbit & Tobacco Clans and was from Polacca, AZ. Barbara is related to Marcella Kahe & Bessie Namoki, two prominent Hopi potters at First Mesa.

Barbara first learned pottery making from her husband's mother, Santana Cimmeron Cerno. Barbara also went to Hopi and consulted her Aunt Blanche Dewakuku, as well as Mark Tahbo. Barbara made some Hopi style pottery which looks similar in appearance with the work of Grace Chapella, Marcella Kahe & Karen Charlie. Barbara's Acoma style pottery, made mostly in collaboration with her husband, is classic in shape, color and form.

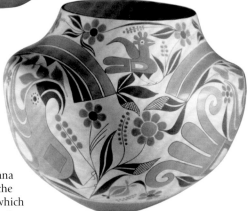

Barbara Cerno -
Courtesy of Blue Thunder Fine Indian Art at
www.bluethunderarts.com

Bernice Cerno

(Acoma, active ?-present: Mimbres & Anasazi Revival black-on-white & traditional polychrome jar, bowls, seed pots)
FAVORITE DESIGNS: Mimbres animals, lightning, fineline rain clouds
COLLECTIONS: John Blom
PUBLICATIONS: Hayes & Blom 1996:54-55.

Brenda L. Cerno *(see Brenda L. Garcia)*

Connie O. Cerno

(Acoma, active ca. 1930-90: traditional polychrome jars, bowls)
BORN: ca. 1915
FAMILY: mother of Margaret Garcia; grandmother of Shyatesa White Dove
PUBLICATIONS: Dillingham 1992:206-208; Reano 1995:27-28.

Gail S. Cerno *(see Gail S. Garcia-Cerno)*

Joseph Cerno, Sr. *(Dai-you-why, the Lucky One, Merle Joseph Martin Cerno), (signs B & J Cerno), (collaborates with Barbara Cerno)*

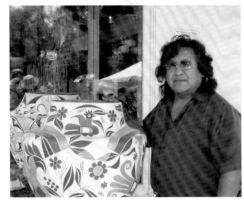

Joseph Cerno, Sr. - Photograph by Angie Yan Schaaf

(Acoma, Roadrunner Clan, active ca. 1970-present: Mimbres & Anasazi Revival & large traditional polychrome ollas, jars, bowls, miniature seed pots, plates)
BORN: January 30, 1947, McCartys, NM; RESIDENCE: Grants, NM
FAMILY: grandson of Luis Cimmeron & Marie Santiago; son of George & Santana Cimmeron Cerno; brother of Frank Cerno, Linda Wilkey, Rachel Concho, Matthew Cerno, Mary Cerno, Eloise Cerno; husband of Barbara Cerno; father of Joseph Cerno, Jr., Jolene A. Cerno, Joan M. Cerno, Jeorgett Cerno & Merle Cerno; grandfather of Nicole, Madeline, Tristan, Breanna, & Brennan Cerno, Elijah Riley
TEACHER: Santana Cerno
AWARDS:

1971	1st, Inter-tribal Indian Ceremonial, Gallup, NM
1978	Best Craftsman, 1st, Indian Ceremonial, Santa Monica, CA 2nd, Indian Market, Santa Fe
1979	Certificate of Merit, Inter-tribal Indian Ceremonial, Gallup, NM 2nd, Southwest Indian Market, Santa Fe
1981	1st (2), 2nd, 3rd, Indian Market, Santa Fe
1982	Special Award, Ruth L. Elam Memorial Award, 1st (3), Heard Museum Show, Phoenix; 2nd (2), Indian Market, Santa Fe
1983-87	unrecorded - Their ribbons were destroyed in a fire.
1988	Best of Division, Best of Category, 1st, Inter-tribal Indian Ceremonial, Gallup, NM; 1st, Indian Market, Santa Fe
1989	Best of Class, Best of Category (2), 1st (3), 2nd, Inter-tribal Indian Ceremonial, Gallup, NM; Honorable Mention, Indian Market
1990	2nd (2), Honorable Mention, Indian Market, Santa Fe; 3rd, O'Odham Tash, Casa Grande, AZ
1991	Best of Show, Grand Prize, 1st, Eight Northern Indian Pueblos Arts & Crafts Show; Best of Class, Best of Category, 1st (2), 2nd (3), Inter-tribal Indian; Ceremonial, Gallup, NM; 1st, Indian Market, Santa Fe
1992	1st, 2nd, 3rd, Indian Market, Santa Fe
1993	2nd (2), H.M. (2), Indian Market, Santa Fe
1994	1st, 2nd, 3rd, Eight Northern Indian Pueblos Arts & Crafts Show 2nd 3rd, Inter-tribal Indian Ceremonial, Gallup, NM; 1st, 3rd, Indian Market, Santa Fe
1995	Best of Category (2), Inter-tribal Indian Ceremonial, Gallup, NM 1st, 2nd, 3rd, Indian Market, Santa Fe
1996	2nd, Indian Market, Santa Fe
2000	1st, Inter-tribal Indian Ceremonial, Gallup, NM; 3rd, Acoma Jars, Indian Market, Santa Fe
2001	Best of Pottery, 1st, 2nd, New Mexico State Fair, Albuquerque

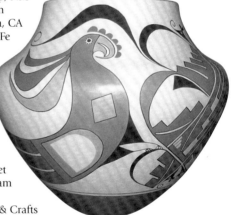

This group of pottery is by
Barbara & Joseph Cerno *- Courtesy of the artists*

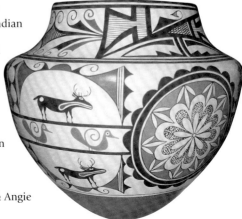

EXHIBITIONS: 1979, "One Space: Three Visions," Albuquerque Museum, Albuquerque; 1981-present: Indian Market, Santa Fe; 1995-present, Eight Northern Indian Pueblos Arts & Crafts Show; Inter-tribal Indian Ceremonial, Gallup; New Mexico State Fair, Albuquerque
DEMONSTRATIONS: Crow Canyon Archaeological Center, Cortez, CO
COLLECTIONS: John Blom; Gerald & Laurette Maisel, Tarzana, CA; Dr. Gregory & Angie Yan Schaaf, Santa Fe; Bill & Jane Buchsbaum, Santa Fe

FAVORITE DESIGNS: parrots, rainbows, flowers, leaves, Mimbres lizards, bugs, birds
GALLERIES: The Indian Craft Shop, U.S. Department of Interior, Washington, D.C.; Andrea
Fisher Fine Pottery, Santa Fe; Nedra Matteucci Galleries, Santa Fe
PUBLICATIONS: *SWAIA Quarterly* Fall 1982:10; Barry 1984:89; *American Indian Art Magazine*
Autumn 1987:24; Spring 1992:32; *Southwest Art* Sept. 1988:58; Mar. 1989:106; *Arizona
Highways* Nov. 1988:27; *Indian Market Magazine* 1988-2000; Schiffer 1991d:50;
Dillingham 1992:206-208; Reano 1995:28; Peaster 1997:16-17; Marmor & Ravin
1997:152; *Cowboys & Indians* Nov. 1999:95; Sept. 2000:94; Berger & Schiffer 2000:103.

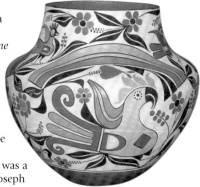

Barbara & Joseph Cerno -
Andrea Fisher Fine Pottery, Santa Fe

Joseph & Barbara Cerno are a husband and wife pottery-making team. They create some of the largest and finest traditional polychrome ollas in the Pueblo world. They use natural clay, mineral & vegetal paints and fire their pottery outdoors. They are well-recognized masters, honored as top award-winning artists.

Joseph learned pottery making from his mother, Santana Cimmeron Cerno, who was a respected potter. She won 1st prize for pottery in 1926 at Indian Market in Santa Fe. Joseph followed in her footsteps. He was her youngest child, and they enjoyed an especially close relationship. Barbara Cerno also learned from Joseph's mother. [See Santana Cimmeron Cerno's profile for her teachings.]

In the 1950s, Joseph devoted much time assisting his mother, who was a traditional medicine woman. He joined her on her frequent journeys to gather medicinal herbs. She taught him many songs and stories. Joseph learned that making pottery was a spiritual process. His mother taught him a series of songs for each step.

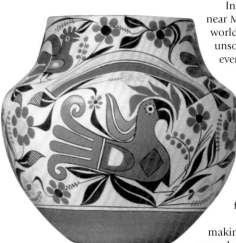

Barbara & Joseph Cerno -
Bill & Jane Buchsbaum Collection

In the late 1950s and early 1960s, he sold pottery for his mother along Route 66 near Malpais, site of an ancient lava flow. He enjoyed meeting tourists from around the world and let them take his photograph for 25 cents. Joseph confided that he hid the unsold pots in caves every night, so he wouldn't have to carry them home each evening.

After graduating from Grants High School, Joseph enlisted in the United States Marine Corps. He served two terms in Viet Nam, where he was wounded several times. After the war, he returned to Acoma and to Barbara, his wife.

In 1969, Joseph and Barbara made their first pottery. They started with miniatures, then created larger and larger pots. In 1971, they won their first of a long list of awards - 1st Prize in the Inter-tribal Ceremonial at Gallup, NM.

Joseph emphasizes the importance of being patient, step-by-step, when making pottery. Their traditional process requires over a year. He lets the clay age for at least 6 months. For large ollas, he lets them dry for 3 to 4 months before firing them.

Joseph is both a traditionalist and an innovator in the development of pottery making. While he follows his mother's teachings, he also came up with new ideas. For example, when he decided to attempt to create the largest Acoma ollas possible, several challenges confronted him. One problem was how to keep the fire from collapsing and crushing the pot. He welded together a re-bar frame and piled the manure around it, thus creating a stronger construction.

Joseph Cerno, Jr.

(Acoma/Hopi, Eagle/Roadrunner Clans, active ca. 1980s-present: pottery)
BORN: May 28, 1972; RESIDENCE: McCartys, NM
FAMILY: p. grandson of Santana Cimmeron Cerno & George Cerno; son of Barbara & Joseph Cerno, Sr.; brother of Jolene A. Cerno, Joan M. Cerno, Jeorgette Cerno, Merle Cerno, and Lisa Concho; father of Nicole, Madeline & Tristan Cerno
FAVORITE DESIGNS: parrots, rainbows, flowers, leaves, geometric patterns
PUBLICATIONS: *Southwest Art* Nov. 1990:25; Peaster 1997.

Joseph Cerno, Jr. explained how he learned pottery making: "It was passed on to me by my Grandmother [Santana Cimmeron Cerno] and my father [Joseph Cerno, Sr.]. It has been in my family for as long as I can remember. I look forward to passing it on to my children and grandchildren in the future."

Merle James Cerno

(Acoma/Hopi, Eagle/Roadrunner Clans, active ca. 1990s-present: traditional polychrome ollas, jars, bowls, figures - cats, miniatures)
BORN:1980s; RESIDENCE: McCartys, NM
FAMILY: p. grandson of Santana Cimmeron Cerno & George Cerno; son of Barbara & Joseph Cerno, Sr.; brother of Jolene A. Cerno, Joan M. Cerno, Jeorgette Cerno, Joseph Cerno, Jr., and Lisa Concho
AWARDS: 1993, 1st, Juvenile, Indian Market, Santa Fe
FAVORITE DESIGNS: parrots, rainbows, flowers, leaves, geometric patterns

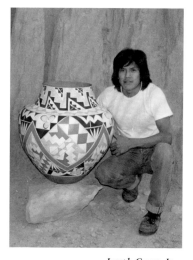

Joseph Cerno, Jr. -
Courtesy of the artist

Barbara Cerno recalled the beginnings of Merle James Cerno's pottery-making career: "When Merle James was four, he got into his daddy's paints. He painted one of his daddy's big pots with bold strokes."

By 1993, Merle was winning awards in the Juvenile division at Indian Market in Santa Fe.

Santana Cimmeron Cerno *(Annie Cerno)*

(Acoma, Roadrunner Clan, active ca. 1910s-80s: traditional polychrome ollas, jars, bowls)
BORN: July 2, 1907
FAMILY: m. granddaughter of Maria Santiago & Kahhaikia; daughter of Marie Santiago & Luis Cimmeron; wife of George Cerno; mother of Joseph Cerno, Sr., Linda Wilkey, Matthew Cerno, Mary Cerno, Eloise Cerno & Rachel Concho; grandmother of Joseph Cerno, Jr., Jolene A. Cerno, Joan M. Cerno, Jeorgette Cerno, Merle Cerno, and Lisa Concho
STUDENTS: Barbara & Joseph Cerno, Sr., Joseph Cerno, Jr.
AWARDS: 1926, 1st, Indian Market, Santa Fe
EXHIBITIONS: 1926-?, Indian Market, Santa Fe; 1979, "One Space: Three Visions," Albuquerque Museum, Albuquerque
FAVORITE DESIGNS: parrots, Mimbres bugs, clouds, rain
PUBLICATIONS: Minge 1991:195; Dillingham 1992:206-208; Peaster 1997:16-17; Berger & Schiffer 2000:103.

(Left to right): **Santana Cerno, Joseph Cerno, Sr., Mrs. Sandoval & son** - *Courtesy of Barbara & Joseph Cerno*

Son Joseph Cerno, Sr., spoke lovingly of his mother, Santana Cimmeron Cerno, who generally was known as Annie Cerno. He described his mother as a respected medicine woman and master potter: "My earliest memory is of watching my mother making pottery. When I was a little older, I used to go with her to gather medicine.

"One day, I asked her, 'Is there a song for making pottery?'"

"She replied, 'Yes, there are many songs. There is a song for when to go to get the clay; one sang while giving corn meal; one sang when coming back home; one sang while mixing the clay; one song for forming the pot, and songs sang during the firing.'"

One of her favorite designs was the Acoma parrot, according to her son Joseph who commented, "When making a parrot pot, my mother said, 'The last thing you paint is their eyes, then they'll wake up. Then you wash their faces and bless them with corn meal before we go to the Market.'"

Erika Chalan

(Acoma, Sun Clan, active ca. 1990s-present: traditional & contemporary polychrome jars, bowls)
BORN: ca. 1980s
FAMILY: m. great-granddaughter of Alice Pancho White & Frank Zieu White; granddaughter of Rachel White James & Jimmy P. James; daughter of Tracy D. Chalan; sister of Terrance & Maury Chalan

Maggie Chalan

(Cochiti, active ca. 1930s-?: traditional polychrome jars, bowls)
BORN: 1910s
FAMILY: mother of Marie Priscilla Romero (2); grandmother of Mary Eunice Ware
STUDENT: Marie Priscilla Romero (2), her daughter
PUBLICATIONS: Babcock 1986:130.

Mary O. Chalan

(Cochiti, active ca. 1955-present: polychrome jars, bowls, Storytellers, turtles, bears, frogs)
BORN: August 21, 1939
FAMILY: daughter of Raymond & Barbarita Herrera
AWARDS: Honorable Mention, New Mexico State Fair, Albuquerque
GALLERIES: Bien Mur, Albuquerque; Wind River Trading Company, Santa Fe
PUBLICATIONS: Congdon-Martin 1999:9; Berger & Schiffer 2000:104.

Maury Chalan

(Acoma, Sun Clan, active ca. 1990s-present: traditional & contemporary polychrome jars, bowls)
BORN: ca. 1980s
FAMILY: m. great-grandson of Alice Pancho White & Frank Zieu White; grandson of Rachel White James & Jimmy P. James; son of Tracy D. Chalan; brother of Terrance, Erika Chalan

Terrance Chalan

(Acoma, Sun Clan, active ca. 1990s-present: traditional & contemporary polychrome jars, bowls)
BORN: ca. 1980s
FAMILY: m. great-grandson of Alice Pancho White & Frank Zieu White; grandson of Rachel White James & Jimmy P. James; son of Tracy D. Chalan; brother of Erika & Maury Chalan

Tracy D. Chalan

(Acoma, Sun Clan, active ca. 1983-present: traditional & contemporary polychrome jars, bowls)
BORN: November 4, 1961
FAMILY: m. granddaughter of Alice Pancho White & Frank Zieu White; daughter of Rachel White James & Jimmy P. James; sister of Gilbert R. James, Darla K. Davis, Tamara L. Abeita, Hope Taylor, Dewey M. James, Melody James; mother of Terrance, Erika & Maury Chalan
STUDENTS: Terrance, Erika & Maury Chalan
EXHIBITIONS: New Mexico State Fair, Albuquerque

Virginia Chama
(Jemez, active ?: pottery)
ARCHIVES: vertical file, Laboratory of Anthropology, Santa Fe

Daisy Chapa *(signs Chapa, Isleta)*
(Isleta, active ca. 1992-present: Storyteller necklaces, human figures with clay hats formed as flutes)
BORN: May 11, 1943
FAMILY: daughter of Marian Montoya
AWARDS: 2nd, New Mexico State Fair, Albuquerque
PUBLICATIONS: Hayes & Blom 1998:26-27; Berger & Schiffer 2000:104.

Ann Charlie *(A. Charlie)*
(Acoma, active ?-1990+: polychrome jars, bowls, miniatures)
FAMILY: m. granddaughter of Marie Z. Chino; daughter of Carrie C. Chino; sister of Isabel & Corine Charlie
EXHIBITIONS: 1991-present, Indian Market, Santa Fe
PUBLICATIONS: Schiffer 1991d; Dillingham 1992:206-208; 1996:82; Peaster 1997:18; *Indian Market Magazine* 1998-2000.

Brenda Charlie
(Acoma, active ca. 1987-present: traditional & ceramic polychrome jars, bowls)
BORN: January 28, 1963
FAMILY: granddaughter of Margaret Charlie; daughter of Patrick & Emmalita C. Chino; sister of Monica C. Chino
TEACHER: Emmalita C. Chino, her mother
COLLECTIONS: John Blom
GALLERIES: Rio Grande Wholesale, Inc., Palms Trading Co., Albuquerque
PUBLICATIONS: Berger & Schiffer 2000:104.

Carrie Chino Charlie *(Carrie Chino)*
(Acoma, active ca. 1940s-present: traditional & contemporary polychrome, black-on-white fineline, whiteware jars, bowls)
BORN: ca. 1925; RESIDENCE: San Fidel, NM
FAMILY: daughter of Marie Z. Chino; sister of Rose Chino Garcia, Grace Chino, Vera Chino Ely, Gilbert Chino, Patrick Chino & Jody Chino; mother of JoAnne Chino Garcia, Isabel Chino, Ann Chino & Corinne Louis
AWARDS: 1978, 3rd; 1980, 3rd; 1992, 3rd; 1993, 2nd, Indian Market, Santa Fe
EXHIBITIONS: 1974, "Seven Families in Pueblo Pottery," Maxwell Museum, University of New Mexico, Albuquerque; 1979, "One Space: Three Visions," Albuquerque Museum, Albuquerque; 1983-present: Indian Market, Santa Fe
COLLECTIONS: Allan & Carol Hayes
PUBLICATIONS: Barsook, et al. 1974: 2-8; Tanner 1976:123; Harlow 1977; Dedera 1985:42; Dillingham 1994:82; Reano 1995:29; Hayes & Blom 1996:50; Painter 1998:10.

Corine Charlie
(Acoma, active ca. 1970s-present: traditional & contemporary polychrome & black-on-white fineline jars, bowls)
BORN: ca. 1950s
FAMILY: m. granddaughter of Marie Z. Chino; daughter of Carrie C. Chino; sister of Isabel & Ann Charlie
PUBLICATIONS: Peaster 1997:18.

Isabel Charlie *(Isabel Chino)*
(Acoma, active ca. 1970s-present: polychrome jars, bowls)
FAMILY: m. granddaughter of Marie Z. Chino; daughter of Carrie C. Chino; sister of Corine & Ann Charlie
EXHIBITIONS: 1991-?, Indian Market, Santa Fe
PUBLICATIONS: Dillingham 1992:206-208; 1996:82; Peaster 1997:18.

LaVerne Charlie
(Acoma, active ?-1990+: polychrome jars, bowls)
PUBLICATIONS: Dillingham 1992:206-208.

Wayne Chavarillo
(San Felipe, active ca. 1990s-present: pottery, jewelry)
BORN: January 27, 1969; RESIDENCE: Albuquerque, NM

Agapita Chavez
(Cochiti, active ?: pottery)
ARCHIVES: Laboratory of Anthropology Library, Santa Fe, Lab. File.

Alissa Chavez
(Santo Domingo, active ?: pottery)
ARCHIVES: Laboratory of Anthropology Library, Lab file, Santa Fe

Alton Chavez
(Zuni, active ?-present: polychrome jars, bowls)

B. Chavez
(Sandia, active ca. 1990s-present: pottery)
GALLERIES: Adobe Gallery, Albuquerque

B. J. or Betty Jean Chavez *(see Betty Jean Fragua)*

Bernard Chavez *(B. Chavez)*
(San Felipe, active ca. 1990s-present: pottery, jars, figures, sculpture)
RESIDENCE: Algodones, NM
COLLECTIONS: Allan & Carol Hayes
PUBLICATIONS: Hayes & Blom 1996:110.

Celina Chavez *(signs C.C. Jemez N.M.)*
(Jemez, active ca. 1967-present: traditional polychrome jars, bowls)
BORN: December 21, 1949
FAMILY: mother of Sheila Chavez Smith
TEACHER: her mother
STUDENT: Sheila Chavez Smith, her daughter
PUBLICATIONS: Berger & Schiffer 2000:105.

Christopher Chavez
(Sandia, active 1990s-present: polychrome & micaceous)
BORN: ca. 1970s; RESIDENCE: Sandia Pueblo

Clara H. Chavez
(Acoma, active ?-1990+: polychrome jars, bowls, sewing)
EXHIBITIONS: ?-1985, Indian Market, Santa Fe
ARCHIVES: Artist File, Heard Museum Library, Phoenix
PUBLICATIONS: Dillingham 1992:206-208.

Claudia Chavez *(see Claudia Chavez Aragon)*

Cynthia Chavez
(San Felipe, active ca. 1980s-present: pottery, sculpture)
AWARDS: 1988, 2nd, pottery, 3rd, miniatures, Indian Market, Santa Fe
EXHIBITIONS: 1988-present, Indian Market, Santa Fe

Elvira Chavez
(Acoma, active ?-1990+: polychrome jars, bowls)
PUBLICATIONS: Dillingham 1992:206-208.

Filapeta Coriz Chavez
(Tesuque, Corn Clan, married into Jemez, active ca. 1910s-?: traditional polychrome jars, bowls, Rain Gods)
BORN: ca. 1890s
FAMILY: wife of Juan R Chavez (Jemez); mother of Lucy C. Toledo, Mary Jane Buck, Jimmy Chavez, Marie Chavez, Charlie Chavez, Joseph Chavez, Reyes Collaque; grandmother of Elsie Yepa, Mary Virginia Tafoya, Joseph Brophy Toledo

Gloria Chavez
(Zuni, active ca. 1980s-present: polychrome jars, bowls, frogs)
PUBLICATIONS: Hayes & Blom 1998:51.

Ilene N. Chavez *(signs I. Chavez)*
(Acoma, active ca. 1989-present: traditional & ceramic, fineline jars, bowls)
BORN: July 20, 1970
GALLERIES: Rio Grande Wholesale, Inc., Palms Trading Co., Albuquerque
PUBLICATIONS: Berger & Schiffer 2000:105.

Lupe Chavez
(Acoma, active ca. 1920s-?: traditional polychrome ollas, jars, bowls)
BORN: ca. 1900
FAMILY: grandmother of Virginia Lowden; great-grandmother of Patricia M. Lowden
COLLECTION: Peter B. Carl, Oklahoma City, OK
ARCHIVES: Laboratory of Anthropology Library, Santa Fe; lab. file.

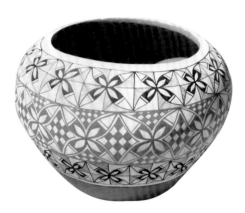

B. Chavez - Courtesy of Allan & Carol Hayes

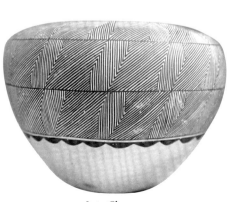

Lupe Chavez -
Peter B. Carl Collection, Oklahoma City, OK

Lupita Chavez

(Cochiti, active ?: pottery)
VALUES: On April 12, 1986, a polychrome dough bowl by Lupita Chavez (14″ dia.), sold for $1,320, at Skinner's, #341.
PUBLICATIONS: *American Indian Art Magazine* Autumn 1986 11(4):73.

Luther Chavez

(Acoma?, active ?: contemporary slip-cast pottery)
PUBLICATIONS: Dillingham 1992:178-79.
 Luther Chavez owned a shop for making slip-cast pottery at Cubero, NM. Dillingham's text is not clear whether or not Luther is from Acoma.

Mrs. Luciano Chavez

(Acoma, active ca. 1940)
PUBLICATIONS: Minge 1991:195.

Marie Chavez

(Jemez, Corn Clan, active ca. 1950s-?: traditional polychrome jars, bowls)
BORN: ca. 1930s
FAMILY: granddaughter of Juan R. Chavez (Jemez) & Filapeta Coriz Chavez (Tesuque); daughter of Juan I. & Lucy C. Toledo; sister of Mary Jane Buck, Jimmy Chavez, Charlie Chavez, Joseph Chavez, Reyes Collaque; wife of Juan I. Toledo

May Chavez

(Acoma, active ?-present: polychrome jars, bowls)
STUDENTS: Marquis Dann

Rose Leno Chavez *(see Rose Leno-Chavez)*

Roxanne Chavez

(Jemez, Corn Clan, ca. 1990s-present: pottery)
BORN: ca. 1982
FAMILY: m. great-granddaughter of Rita Magdalena Casiquito; granddaughter of Juanita Fragua; daughter of Betty Jean Fragua
PUBLICATIONS: Peaster 1997:62.

Ruby Chavez

(Acoma, active ?-1970s: pottery)
PUBLICATIONS: *Arizona Highways* May 1974:24.

Sam Chavez

(Acoma, active ?-1990+: polychrome jars, bowls)
PUBLICATIONS: Dillingham 1992:206-208.

Sheila Chavez *(see Sheila Chavez Smith)*

Vanessa Chavez

(Acoma, active ?-1990+: polychrome jars, bowls)
PUBLICATIONS: Dillingham 1992:206-208.

Elsie Chereposy

(Laguna, active ca. 1973-?: traditional polychrome jars, bowls)
EDUCATION: 1973, Laguna Arts & Crafts Project participant

Brooke Cheromiah *(see portrait picture with Lee Ann Cheromiah)*

(Laguna, Roadrunner Clan, active ca. 1990s-present: traditional polychrome jars, bowls)
FAMILY: m. great-granddaughter of Mariano Cheromiah; m. granddaughter of Evelyn Cheromiah; daughter of Lee Ann Cheromiah
PUBLICATIONS: Peaster 1997:80.

Elton Cheromiah

(Laguna, active ca. 1994-present: traditional polychrome jars, bowls)
BORN: August 20, 1975
FAMILY: son of Josephita Cheromiah
PUBLICATIONS: Berger & Schiffer 2000:105.

Evelyn Cheromiah *(signs E. Cheromiah)*

(Laguna, Roadrunner Clan, active ca. pre-1973-present: Anasazi Revival black-on-white, traditional polychrome, black-on-white fineline & corrugated whiteware ollas, jars, bowls, chicken figures)
BORN: August 20, 1928
FAMILY: daughter of Mariano Cheromiah; mother of Lee Ann Cheromiah, Mary Cheromiah & Wendy Cheromiah; aunt of Bertha Riley; m. grandmother of Brooke Cheromiah & Wendall Cheromiah
STUDENTS: Wendell Kowemy, Lee Ann Cheromiah, over 30 other students
AWARDS: 1977, Maria-Popovi Award, Special Award for Encouraging a Pottery Renaissance; 1981; 1991, 2nd, jars; 1992, 3rd, jars; 1993, 3rd, jars; 2000, 3rd, Indian Market, Santa Fe; New Mexico State Fair, Albuquerque; Inter-tribal Indian Ceremonial, Gallup
EXHIBITIONS: 1982-present, Indian Market, Santa Fe
COLLECTIONS: Gloria Couch, Coralles, NM; Candace Collier, Houston, TX
FAVORITE DESIGNS: Rainbirds, kiva steps, terraced clouds, fineline rain
VALUES: On May 17, 2000, a polychrome olla, signed E. Cheromiah, (11 x 14"), sold for $1,920, at Sotheby's, #542.
PUBLICATIONS: *SWAIA Quarterly* Fall 1975:4; Fall 1977:17; Fall 1982:81; Harlow 1977; Barry 1984:100; *Indian Market Magazine* 1985, 1988, 1989, 1996; Trimble 1987:81; Eaton 1990:25; *The Messenger,* Wheelwright Museum Autumn 1990:7; Dillingham 1992:9, 165, 171, 183, 190, 198-99; Hayes & Blom 1996; 1998; Peaster 1997:80-81; Berger & Schiffer 2000:105.

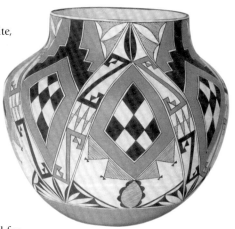

Evelyn Cheromiah -
Andrea Fisher Fine Pottery, Santa Fe

Evelyn Cheromiah, early in her career, was one of the few potters active in pottery making at Laguna. She worked under a federal grant for a period, helping to teach other Laguna people the art history and techniques of pottery making. She is respected for her contributions. She makes large polychrome ollas with delicate, fineline hatching. Her pottery is highly sought after by serious collectors.

Evelyn explained the reasons why pottery making declined at Laguna during the early 20th century. Laguna men were hired for cash wages when the railroad came. Beginning in the 1950s, they worked in the uranium mine and later at Omnitec. Laguna women could afford to buy cloth and commercial goods. They found it was easy to trade these goods for pottery and other handmade items.

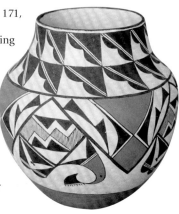

Evelyn Cheromiah -
Courtesy of Eason Eige, Albuquerque, NM

Evelyn was inspired to make larger ollas after watching Acoma potters with their large ollas at dances and feast days. The Acomas used to bring their big pots to trade at Laguna.

Rick Dillingham confided, "Laguna potters Evelyn and Lee Ann Cheromiah "talk" to deceased spirits of potters while making new pottery to guide them in their work." He also distinguished them, along with Gladys Paquin, as three "outstanding potters" who "are an inspiration to younger potters." (Dillingham 1992:9, 199)

Evelyn Cheromiah -
Courtesy of Gloria Couch, Corrales, NM

Josephita Cheromiah *(signed J. Cheromiah)*

(Laguna, active ca. 1970s-?: traditional polychrome jars, bowls)
EDUCATION: 1973, Laguna Arts & Crafts Project participant
COLLECTIONS: Wright Collection, Peabody Museum, Harvard University, Cambridge, MA
PUBLICATIONS: Drooker & Capone 1998:138.

June Pino Cheromiah

(Acoma/Laguna/Hopi, Eagle/Corn Clans, active ca. 1985-present: traditional polychrome jars, bowls)
BORN: June 21, 1963

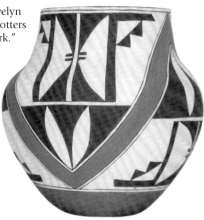

Evelyn Cheromiah -
Courtesy of Candace Collier, Houston, TX

FAMILY: granddaughter of Mary Antonio, John & Esther Gunn, William Hayah; daughter of James Pino & Zelda Chaplin Pino; sister of Erwin Pino, Melvin, Pino, Kim Pino, April Pino, Stacy Henry; mother of Christie, Sherrie & Kelly Cheromiah
TEACHERS: Rachel Concho, Paul Lucario, Goldie Hayah, Barbara & Joseph Cerno, Mildred Antonio
AWARDS: 1998, 1st, New Mexico State Fair, Albuquerque; Best of Show, Chairman's Award, White River, AZ
FAVORITE DESIGNS: parrots, rainbows, animals, checkerboard
COLLECTION: Candace Collier, Houston, TX; Gloria Couch, Corrales, NM; Eason Eige, Albuquerque, NM
GALLERIES: Andrea Fisher Fine Pottery, Packard's, Santa Fe; Rio Grande Wholesale, Albuquerque

June Pino Cheromiah commented, "I like working with my hands in clay. It gives me that feeling that I made something beautiful and that I created it. I enjoy painting beautiful designs and forming different shapes, both big and small."

Lee Ann Cheromiah *(signs L. A. Cheromiah, Old Laguna)*

(Left to right): Mary Cheromiah, Lee Ann Cheromiah and daughter Brook - Courtesy of Isa & Dick Diestler Isa Fetish, Cumming, GA

(Laguna, Roadrunner Clan, active ca. 1978-present: traditional polychrome jars, bowls, animal figures - rams)
BORN: June 24, 1954
FAMILY: m. granddaughter of Mariano Cheromiah; daughter of Evelyn Cheromiah; sister of Mary Cheromiah & Wendy Cheromiah Kowemy; mother of Brooke Cheromiah
TEACHER: Evelyn Cheromiah
EXHIBITIONS: 1985-present, Indian Market, Santa Fe
AWARDS: 1994, 3rd, jars, Indian Market, Santa Fe; New Mexico State Fair, Albuquerque; 2000, 1st, Laguna jars, Indian Market, Santa Fe
PUBLICATIONS: *Indian Market Magazine* 1985, 1996:59; Dillingham 1996:9, 44, 86, 88, 112, 183, 190, 199; Hayes & Blom 1996:88-89; Peaster 1997:80-81; Berger & Schiffer 2000:105.

Lee Ann Cheromiah learned pottery making from her mother, Evelyn Cheromiah, who helped revive pottery at Laguna.

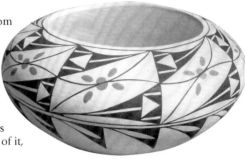

Lee Ann Cheromiah - Courtesy of John Blom

Lee Ann confided how they gathered their clay: "We mine the clay in a spiritual way, corn meal and food offerings are given. Clay is sacred for us. We ask for help and blessings from the clay."

She also shared her secret to creating beautiful pots, "If you take your time and put yourself wholeheartedly in it [making and designing], it makes it more beautiful. If you rush, it won't come out right. If you're in the spirit of it, it comes out right."

She talked about the Spirit of the Clay: "Sometimes the Clay will take over and do what She wants. If She doesn't like the design, it won't work."

M. W. or Mary Cheromiah *(see Mary Victorino)*

Cheykaychi
(Santo Domingo, active ?-present: polychrome ollas, dough bowls, jars)
COLLECTION: Wright/McCray, Santa Fe

Chinana *(see George Chinana, Georgia Chinana or Patrina Chinana)*

Alfreda Chinana *(see Alfreda Gachupin)*

Anacita Chinana

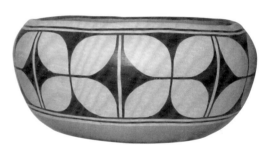

Cheykaychi - Wright/McCray Collection, Santa Fe

(Jemez, Oak Clan, active ca. 1940s-present: black-on-redware ollas, jars, bowls)
BORN: ca, 1920
FAMILY: daughter of Persingula Fragua; wife of Casmiro Toya; mother of Persingula Chinana, Marie Waquie, Donald R. Chinana, Christina Chinana Tosa, Marie Chinana, Georgia F. Chinana
STUDENTS: Donald Chinana, her son, & Georgia F. Chinana, her daughter

Anacita Chinana is a matriarch of the Oak Clan at Jemez Pueblo. She raised six children, many of whom are excellent potters. They are known for their beautiful, large stone polished black-on-redware ollas and jars.

Angela Chinana
(Jemez, Coyote Clan, active ca. 1988-present: sgraffito jars, bowls, traditional cooking pots)
BORN: December 6, 1976
FAMILY: great-great granddaughter of Juanito & Andrieta Shendo; great-granddaughter of Jose Maria Toya & Reyes Shendo Toya; m. granddaughter of Albert E. Vigil & Marie Toya Vigil; daughter of Tito & Lorraine Chinana
TEACHERS: Lorraine Chinana, her mother, Reyes Toya, her great-grandmother
AWARDS: 1994, 1st, Indian Market, Santa Fe
EXHIBITIONS: 1994-present, Indian Market, Santa Fe; 1997-present, Eight Northern Indian Pueblos Arts & Crafts Show; 2001, Jemez Pueblo Red Rocks Arts & Crafts Show
FAVORITE DESIGNS: clouds, feathers-in-a-row
PUBLICATIONS: Berger & Schiffer 2000:105.

When Angela Chinana was 12 years old, her great-grandmother, Reyes Toya, taught her how to make traditional cooking pots. Angela today creates grey and redware pots with sgraffito designs that allow the orange clay to emerge in the background. She experiments with natural materials.

Anna Chinana *(collaborates with Marie Waquie)*
(Jemez, active ?-present: matte polychrome jars, bowls, turtle effigies)
COLLECTIONS: Dr. Gregory & Angie Yan Schaaf, Santa Fe

Charles Chinana
(Jemez, active ?-present: polychrome jars, bowls)
GALLERIES: Kennedy Indian Arts, Bluff, UT

Christina Chinana *(see Christina Chinana Tosa)*

David G. Chinana *(signs D. Chinana)*
(Jemez, active ca. 1987-present: traditional polychrome jars, bowls)
BORN: November 22, 1961
FAMILY: son of Mary & Lizardo Chinana; brother of Alfreda Chinana, Martina Chinana, Patrina Chinana
PUBLICATIONS: Berger & Schiffer 2000:106.

D. Chinana *(collaborates with Marie M Chinana (2) (signs D. & M. Chinana)*
(Jemez, active ca. 1982-present: traditional polychrome jars, bowls)
BORN: ca. 1960
FAMILY: husband of Marie M. Chinana; son-in-law of Martha Toya
PUBLICATIONS: Berger & Schiffer 2000:106.

Diana Wade & Charles Chinana -
Courtesy of John D. Kennedy and
Georgiana Kennedy Simpson
Kennedy Indian Arts

Donald R. Chinana *(see Jemez color illustrations)*
(Jemez, Oak Clan, Pumpkin Kiva, active ca. 1983-present: stone polished black-on-redware jars, bowls)
BORN: November 5, 1963
FAMILY: grandson of Persingula Fragua; son of Anacita Chinana & Casimiro Toya; brother of Marie Chinana, Persingula Chinana Gonzales, Georgia F. Chinana, Marie Waquie, Ronnie Chinana & Christina Chinana Tosa
TEACHER: Anacita Chinana, his mother
STUDENTS: Anthony Chosa
COLLECTIONS: Dr. Gregory & Angie Yan Schaaf; Ed Samuels, Jemez Springs, NM; Bob & Carol Berray, Santa Fe
FAVORITE DESIGNS: clouds, rain, wind, kiva steps
GALLERIES: Jemez Mountain Trading Company, Jemez Springs, NM
PUBLICATIONS: Berger & Schiffer 2000:106.

Donald Chinana -
Photograph by Ed Samuels, Jemez Springs, NM

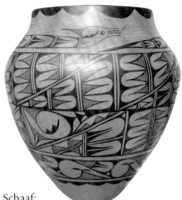

Donald Chinana -
Jemez Mountain Trading Co.
Jemez Springs, NM

Donald Chinana makes large, stone polished black-on-redware pottery. He shared, "My mother taught me all the old patterns of her family and their meanings. I love working in my family traditions."

Collector Ed Samuels commented, "Donald's work is big and bold. His stone polish is great. His painting is spontaneous, like breathing. To me, Donald is one of the best! His painting is so fresh. You can see his hand painting with confidence and lucidity."

Donald Chinana -
Bob & Carol Berray, Santa Fe

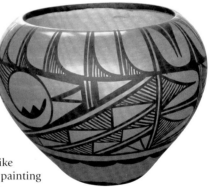

Donald Chinana -
Janice & Paul K. Conner Collection

Dorina Yepa Chinana *(signs D.Y.C. Jemez, NM)*
(Jemez, active ca. 1987-present: traditional polychrome jars, bowls)
BORN: August 29, 1962
FAMILY: daughter of George & Petra Yepa
TEACHER: Petra Yepa, her mother
PUBLICATIONS: Berger & Schiffer 2000:106.

Florinda Yepa Chinana *(Florinda Yepa), (signs Yepa)*
(Jemez, active ca. 1965-present: traditional polychrome jars, bowls, miniatures)
BORN: September 25, 1954
FAMILY: daughter of Lupe L. Yepa; sister of Virginia Chinana
TEACHER: Lupe L. Yepa
PUBLICATIONS: Berger & Schiffer 2000:106.

Genevieve Chinana

(Laguna/Jemez, Fire Clan, active ca. 1960s-present: polychrome jars, bowls)
BORN: ca. 1940s
FAMILY: m. granddaughter of Petra & Santiago Romero, Laguna; daughter of Margaret Romero Sarracino & Francisco Frank Sarracino, Jemez Roadrunner Clan; sister of Raphael Sarracino, Flo Yepa, Robert Sarracino & Sharon Sarracino
TEACHER: Sharon Sarracino, her sister

George Chinana *(signs Chinana)*

(Jemez, active ?-present: black-on-red micaceous jars, bowls, vases)
FAVORITE DESIGNS: clouds, rain, feathers-in-a-row
PUBLICATIONS: Berger & Schiffer 2000:33, 106.

Georgia F. Chinana *(signs Chinana)*

(Jemez, Oak Clan, active ca. 1987-present: black-on-red jars, bowls, wedding vases)
BORN: February 22, 1959
FAMILY: daughter of Anacita Chinana & Casimiro Toya; sister of Persingula Chinana, Marie Waquie, Donald R. Chinana, Christina Chinana Tosa, Marie Chinana
TEACHER: Anacita Chinana, her mother
FAVORITE DESIGNS: clouds
PUBLICATIONS: Berger & Schiffer 2000:32, 106.

Jacob Chinana

(Jemez, active ca. 1990s-present: pottery)
FAMILY: m. grandson of Anacita Chinana & Casimiro Toya; son of Persingula Chinana Gonzales & George Gonzales (Navajo/Cherokee); brother of Linda Chinana, Gabriel George Gonzales, Valentine Gonzales

Julia Chinana

(Jemez, Sun Clan, active ca. 1950s-present: pottery, paintings)
BORN: ca. 1940
FAMILY: daughter of Albenita Sando; wife of Mariano Chinana; mother of Marian L. Chinana; m. grandmother of Antoinette & Raymond Chinana
EXHIBITIONS: 1995-present, Eight Northern Indian Pueblos Arts & Crafts Show

Leo Chinana

(Jemez, active ca. 1990s-present: pottery)
EXHIBITIONS: 1994-present, Eight Northern Indian Pueblos Arts & Crafts Show

Linda Chinana

(Jemez, active ca. 1990s-present: pottery)
FAMILY: m. granddaughter of Anacita Chinana & Casimiro Toya; daughter of Persingula Chinana Gonzales & George Gonzales (Navajo/Cherokee); sister of Gabriel George Gonzales, Valentine Gonzales, Jacob Chinana

Lorraine Chinana

Lorraine Chinana -
Photograph by Angie Yan Schaaf

(Jemez, Coyote Clan, active ca. 1981-present: polychrome & sgraffito redware & grayware jars, bowls, oval vases, some with blue slips, figures, embroidery)
BORN: November 17, 1955
FAMILY: m. granddaughter of Reyes S. Toya; daughter of Albert & Marie Vigil; sister of Ida Yepa & Georgia Vigil-Toya; wife of Tito Chinana; mother of Angela Chinana
TEACHER: Reyes S. Toya, her grandmother
AWARDS: 1994, 2nd, 3rd, Red Sgraffito; 1996, 3rd, Sgraffito; 2000, 2nd, Red Sgraffito, Indian Market, Santa Fe; Eight Northern Indian Pueblo Arts & Crafts Show
EXHIBITIONS: 1992-present, Indian Market, Santa Fe; 1997-present, Eight Northern Indian Pueblos Arts & Crafts Show; 1998 "Walatowa Arts Tradition," South Broadway Cultural Center, Albuquerque; Heard Museum Show, Inter-tribal Indian Ceremonial, Gallup, NM
FAVORITE DESIGNS: radiating bands of clouds, rain and feather patterns, opticals
GALLERIES: Native American Collections, Inc., Denver, CO; Kennedy Indian Arts, Bluff, UT
PUBLICATIONS: Hayes & Blom 1996:82-83; *Indian Market Magazine* 1998; Walatowa Pueblo of Jemez, "Jemez Pottery" (1998); Berger & Schiffer 2000:33, 106.

Lorraine Chinana -
Photograph by Bill Bonebrake
Courtesy of Jill Giller
Native American Collections, Denver, CO

Lorraine Chinana has worked at perfecting her pottery techniques for over two decades. While she creates some polychrome ware, she is best known for her magnificent polished sgraffito redware and grayware pottery. Her optical designs are vibrant, radiating tremendous energy. The quality of her work has led her to become a prizewinner.

Lydia B. Chinana
(Jemez, active ?-present: polychrome jars & bowls, embroidery, clothing)
EXHIBITIONS: 1996, San Felipe Pueblo Arts & Crafts Show, NM
PUBLICATIONS: Schaaf 2001:282.

Marian L. Chinana
(Jemez, Sun Clan, active ca. 1976-present: matte polychrome jars, bowls, wedding vases, figures, snakes, bears)
BORN: August 28, 1959
FAMILY: granddaughter of Albanita Sando; daughter of Mariano & Julia Fragua Chinana; sister of Leo Chinana; mother of Antoinette & Raymond Chinana
EDUCATION: Riverside Indian School
TEACHER: Julia Fragua Chinana
EXHIBITIONS: 1970s-present, Eight Northern Indian Pueblos Arts & Crafts Show; 1990-present, Jemez Pueblo Red Rocks Arts & Crafts Show; Portal, Santa Fe Plaza
FAVORITE DESIGNS: eagle feathers, butterflies, kiva steps, rain, snow
GALLERIES: The Indian Craft Shop, U.S. Department of Interior, Washington, D.C.

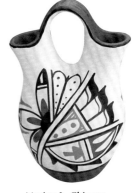

Marian L. Chinana -
Photograph by Angie Yan Schaaf
Courtesy of the artist

Marie Chinana *(1)*
(Jemez, active ?-present: polychrome jars, bowls, wedding vases, owls, ornaments)
FAVORITE DESIGNS: Kokopelli, feathers, rain clouds, sun faces, corn plants, daisies, butterflies, owls, water serpents, kiva steps
PUBLICATIONS: Walatowa Pueblo of Jemez, "Pottery of Jemez Pueblo" (1999).

Marie M. Chinana *(2) (signs D. & M. Chinana)*
(Jemez, active ca. 1982-present: traditional polychrome jars, bowls)
BORN: July 6, 1962
FAMILY: daughter of Martha Toya
TEACHER: Martha Toya, her mother
PUBLICATIONS: Berger & Schiffer 2000:106.

Marie Chinana *(3) (Maria)*
(Jemez, Oak Clan, active ca. 1980s-present: stone polished black-on-redware)
FAMILY: daughter of Anacita Chinana & Casimiro Toya; sister of Persingula Chinana, Marie Waquie, Donald R. Chinana, Christina Chinana Tosa, Georgia F. Chinana
TEACHER: Anacita Chinana, her mother

Martin Chinana
(Jemez, active ca. 1990s-present: pottery, beadwork)
EXHIBITIONS: 1995-present, Eight Northern Indian Pueblos Arts & Crafts Show

Martina Chinana *(signs M. Chinana, Jemez)*
(Jemez, active ca. 1987-present: polychrome jars, bowls, wedding vases)
BORN: October 25, 1963
FAMILY: daughter of Lizardo & Mary Chinana; sister of Alfreda Chinana, David Chinana, Patrina Chinana
TEACHER: Mary Chinana, her mother
GALLERIES: The Indian Craft Shop, U.S. Department of Interior, Washington, D.C.
PUBLICATIONS: Berger & Schiffer 2000:106.

Mary Chinana
(Jemez, active ca. 1960s-present: traditional polychrome jars, bowls)
BORN: 1940s
FAMILY: wife of Lizardo Chinana; mother of Alfreda Chinana, David Chinana, Martina Chinana, Patrina Chinana
STUDENTS: her children

Patrina Chinana *(Chinana, Jemez N.M.)*
(Jemez, active ca. 1991-present: traditional polychrome jars, bowls)
FAMILY: daughter of Lizardo & Mary Chinana; sister of Alfreda Chinana, David Chinana, Martina Chinana
TEACHER: Mary Chinana, her mother
PUBLICATIONS: Berger & Schiffer 2000:106.

Paul Chinana
(Jemez, active ca. 1960s-present: Storytellers, painting)
BORN: ca. 1946
EXHIBITIONS: American Indian Exposition, Chicago, IL
COLLECTIONS: National Museum of the American Indian, Smithsonian Institution, Washington, D.C.; Museum of New Mexico, Santa Fe
PUBLICATIONS: Lester 1997:108; Congdon Martin 1999.

Peggy Chinana *(signs P.C., Jemez N.M.)*

(Jemez, active ca. 1982-present: traditional polychrome jars, bowls, wedding vases, miniatures)
BORN: February 21, 1964
FAMILY: daughter of Virginia Chinana
TEACHER: Virginia Chinana, her mother
PUBLICATIONS: Berger & Schiffer 2000:106.

Percy or Persingula Chinana *(see Persingula Chinana Gonzales)*

Rita Y. Chinana

(Jemez, active ca. 1990s-present: pottery)
EXHIBITIONS: 1994-present, Eight Northern Indian Pueblos Arts & Crafts Show

Ronald Chinana

(Jemez, active ca. 1990-present: traditional polychrome jars, bowls)
BORN: September 13, 1961
TEACHER: his mother
PUBLICATIONS: Berger & Schiffer 2000:107.

Tito Chinana

(Jemez, active ca. 1990s-present: pottery)
PUBLICATIONS: *Indian Market Magazine* 1998:99.

Virginia Chinana *(signs V.C. Jemez N.M.)*

(Jemez, active ca. 1962-present: traditional polychrome jars, bowls, miniatures)
BORN: June 26, 1938
FAMILY: daughter of Lupe Yepa; sister of Florinda Yepa Chinana
TEACHER: Lupe Yepa, her mother
PUBLICATIONS: Berger & Schiffer 2000:107.

Chino *(see Corrine J. Chino or Edna G. Chino)*

Chino with Kokopelli drawing *(see Doris M. Chino)*

Becky Chino

(Acoma, active ?-1990+: polychrome jars, bowls)
PUBLICATIONS: Dillingham 1992:206-208.

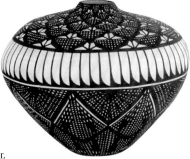

Brian A. Chino *(Kee-Yu-Wy-Sde-Wa), (signed B. Chino or Brian Chino)*

(Acoma, Eagle Clan, active ca. 1988-99: traditional fineline jars, bowls, vases, wedding vases, canteens, stirrup canteens, miniatures, clothing)
LIFESPAN: November 21, 1960 - July 21, 1999
FAMILY: m. grandson of Clifford L. & Lita L. Garcia; son of Elmer & Edna Chino; brother of Corrine J. Chino, Jay Vallo, Germaine Reed & Judy Shields
AWARDS: Eight Northern Indian Pueblos Arts & Crafts Show; 1st, 2nd, New Mexico State Fair, Albuquerque; 1st, Inter-tribal Indian Ceremonial, Gallup; 1st, Colorado Indian Market, Denver, CO; 1st, Texas Indian Market, Dallas
GALLERIES: Native American Collections, Denver, CO; Rio Grande Wholesale, Inc., Alb.
PUBLICATIONS: Schiffer 1991d:50; Berger & Schiffer 2000:107.

Brian Chino -
Photograph by Bill Bonebrake
Courtesy of Jill Giller
Native American Collections, Denver, CO

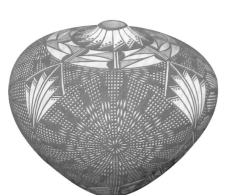

Brian Chino -
Courtesy of Jason Esquibel
Rio Grande Wholesale, Inc.

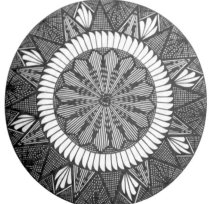

Brian Chino - Peter B. Carl Collection
Oklahoma City, OK

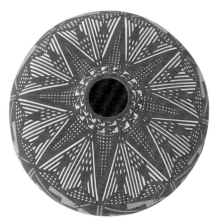

Brian Chino -
Johanna Leibfarth Collection, SC

C. Maurus Chino *(Maurus Chino, C. M. Chino, Kaiamiastiwa)*

(Acoma, Eagle/Sun Clan, active ca. 1976-present: pottery, animal figures, canteens, oil paintings, pastels, graphics)
BORN: January 28, 1954 in Albuquerque, NM; RESIDENCE: Corrales, NM
EDUCATION: Grants High School, NM, 1971; B.F.A., New Mexico State University, Las Cruces, 1980.
FAMILY: grandson of Mamie Torivio Ortiz & Joe L. Ortiz; son of Myrna Antonio and Elmer Chino; brother of Larry A. Chino, Debbie, Keith, Paula, Darlene
EDUCATION: BA, New Mexico State University, 1980

C. Maurus Chino - Courtesy of John Blom

CAREER: Forest firefighter, teacher, miner, illustrator, art consultant, potter; full-time painter since 1992.
AWARDS: 1994, 1st (2), Indian Market, Santa Fe; Judge's Merit Award, Colorado Indian Market, Boulder, CO; 1995, Best of Show, New Mexico State Fair, Albuquerque; 1st, Red Earth Festival, Oklahoma City; 1996, 1st (2), Inter-tribal Indian Ceremonial, Gallup, NM; 2nd, Indian Market, Santa Fe; 1998, H.M., Indian Market, Santa Fe; 1999, 1st, Inter-tribal Indian Ceremonial, Gallup, NM; 2000, Indian Market
EXHIBITIONS: 1992-present: Indian Market, Santa Fe, NM; 1994-96, Red Earth Festival, Oklahoma City, OK; 1994-96, Colorado Indian Market, Denver, CO; 1996-99, Inter-Tribal Indian Ceremonial, Gallup, NM; 1997, One Man Show, Wheelwright Museum, Santa Fe; Monterey Peninsula Museum of Art, Monterey, CA
COLLECTIONS: Heard Museum, Phoenix; John Blom
PUBLICATIONS: *Indian Trader* October 1987:27; Daniels 1991:8, 10, 19-20, 26; Dillingham 1992:206-208.; Lester 1995:109; Hayes & Blom 1996:52; Hayes & Blom 1998:23; *Indian Artist* Spring 1997:33; Winter 1997:8; *American Indian Art Magazine* Summer 1997:29; Tucker 1998: plate 86; *First Nations, First Peoples, First Voices* September 1998.

 C. Maurus Chino is applauded for keeping alive the old traditions. He has achieved a high level of mastery in both pottery and paintings. The artist explained his work, "One of the main focuses of the paintings on my pottery is reverence for the land. I always have respect for the land and its people. I always think of the people before me, my grandfather and grandmother, whose influence helped me, as well as other artists who worked in clay, stone, and pigments. All these materials are in my paintings. The symbols of rain and lightning are reflected in the realistic paintings also. I try to achieve a three-dimensional effect on my landscapes in pottery."

Carol Chino

(Acoma, active ca. 1980s-present: polychrome jars, bowls)
BORN: ca. 1971
FAMILY: m. granddaughter of Marie Z. Chino; daughter of Grace Chino; sister of Gloria Chino, Hubert Chino, Kevin (Chip) Chino, Chris Chino, Clarissa Chino
EXHIBITIONS: 1991-?, Indian Market, Santa Fe
PUBLICATIONS: Dillingham 1994:82; Peaster 1997:18.

Carrie Chino *(see Carrie Chino Charlie)*

Clarissa Chino *(Chris)*

(Acoma, active ca. 1980s-present: polychrome jars, bowls)
BORN: ca. 1970s
FAMILY: m. granddaughter of Marie Z. Chino; daughter of Grace Chino; sister of Gloria Chino, Hubert Chino, Kevin (Chip) Chino, Carol Chino
EXHIBITIONS: 1991-?, Indian Market, Santa Fe
PUBLICATIONS: Dillingham 1994:82; Peaster 1997:18.

Colleen Chino

(Acoma, active ?-1990+: polychrome jars, bowls)
PUBLICATIONS: Dillingham 1992:206-208.

Corrine J. Chino *(signs Chino or Corrine Chino)*

(Acoma, Eagle Clan, active ca. 1983-present: traditional & ceramic polychrome & black-on-white fineline jar, bowls)
BORN: May 17, 1957
FAMILY: m. granddaughter of Lita L. & Clifford L. Garcia; daughter of Elmer L. & Edna G. Chino; sister of Brian A. Chino, Judy Shields, Germaine Reed & Jay Vallo
FAVORITE DESIGNS: feathers-in-a-row, stars, clouds
PUBLICATIONS: Dillingham 1992:206-208; Berger & Schiffer 2000:107; *Guest Life New Mexico Magazine*, no date; Mary Laura, Southwestern Art Calendar, no date.
 Corrine J. Chino expressed, "I just love to paint; it brings balance to my life."

Corrine Chino - Courtesy of Jason Esquibel Rio Grande Wholesale, Inc.

Darrell Taliman Chino *(collaborates with Donna Chino)*

(Acoma/Santa Clara/San Juan/Navajo, active ca. 1990s-present: traditional & contemporary polychrome & sgraffito jars, bowls, plates, canteens)
BORN: August 19, 1959
AWARDS: 2nd, Eight Northern Indian Pueblos Arts & Crafts Show
EXHIBITIONS: 1998-present, Eight Northern Indian Pueblos Arts & Crafts Show
PUBLICATIONS: Painter 1998:10; Schaaf 2000:17.

Debbie Chino

(Acoma, active ?-1990+: polychrome jars, bowls)
PUBLICATIONS: Dillingham 1992:206-208.

Diana Chino

(Acoma, active ca. 1970s-present: traditional polychrome jars, bowls)
BORN: ca. 1950; RESIDENCE: Acomita, NM
FAMILY: wife of Sandy Chino; mother of Francine Chino
STUDENT: Francine Chino, her daughter
PUBLICATIONS: Berger & Schiffer 2000:107.

Diane Chino

(Acoma, active ?-present: traditional & contemporary polychrome jars, bowls)
PUBLICATIONS: Painter 1998:10.

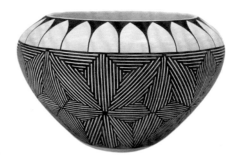

Donna G. Chino -
Photograph by Bill Knox
Courtesy of Indart Incorporated

Donna G. Chino *(Donna M. Garcia-Chino), (collaborates with Darrell Chino)*

(Acoma, Turkey Clan, active ca. 1990-present: polychrome, black-on-white fineline & sgraffito jars, bowls, plates, canteens)
BORN: ca. 1950s
FAMILY: m. granddaughter of Maria Trujillo; p. granddaughter of Jessie C. Garcia; daughter of Sarah Garcia & Chester W. Garcia, Sr.; sister of Debbie G. Brown, Goldie Hayah, & Chester W. Garcia, Jr.; wife of Darrell Chino; mother of Danielle Garcia, Devin Mariano
AWARDS: 1998, 2nd, Eight Northern Indian Pueblos Arts & Crafts Show
EXHIBITIONS: 1998-present, Eight Northern Indian Pueblos Arts & Crafts Show
COLLECTIONS: Maxwell Museum, Albuquerque; John Blom; Allan & Carol Hayes; Indart Incorporated
PUBLICATIONS: Dillingham 1992:206-208; Painter 1998:10; Schaaf 2000:17.

Doris M. Chino *(Chino with Kokopelli drawing)*

(Acoma, active ca. 1994-present: polychrome Storytellers, jars, bowls)
BORN: May 22, 1952
FAMILY: daughter of Fermin & Sarah Martinez
AWARDS: Tucson Women's Invitational, Tucson, AZ; Red Earth Festival, Oklahoma City; Laughlin Balloon Fiesta, Laughlin, NV
GALLERIES: Rio Grande Wholesale, Inc., Palms Trading Co., Albuquerque
PUBLICATIONS: Berger & Schiffer 2000:107.

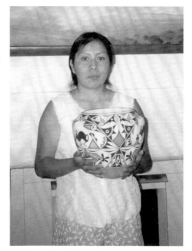

Donna G. Chino -
Courtesy of John D. Kennedy and
Georgiana Kennedy Simpson
Kennedy Indian Arts

Edna G. Chino *(signs E. Chino or Chino)*

(Acoma, Eagle Clan, active ca. 1950-present: traditional fineline polychrome jars, bowls)
BORN: June 13, 1935, McCartys, NM
FAMILY: daughter of Clifford L. & Lita L. Garcia; sister of Josephine Sanchez, Virginia Victorino & Maxine Sanchez; wife of Elmer L. Chino; mother of Corrine J. Chino, Germaine Reed, Judy Shields & Brian A. Chino
TEACHER: Frances Torivio
STUDENT: Corrine J. Chino, Brian, Jay, Germaine & Kevin Chino
AWARDS: 1st, New Mexico State Fair, Albuquerque; Bi-County Fair, NM
COLLECTIONS: Dr. Fred Belk, NM
GALLERIES: Rio Grande Wholesale, Inc., Palms Trading Co., Albuquerque
PUBLICATIONS: Minge 1991:195; Dillingham 1992:206-208; Berger & Schiffer 2000:107.

Edna Chino explained, "I like making my pottery and painting. I do all sizes of pottery."

Edna Chino -
Courtesy of John D. Kennedy and
Georgiana Kennedy Simpson
Kennedy Indian Arts

Elva L. Chino

(Acoma/Laguna, active ?: pottery, photography)
ARCHIVES: Artist File, Heard Museum Library, Phoenix

Edna Chino -
Dr. Fred Belk Collection

Emil Chino *(collaborates with Carmen Lewis)*

(Acoma, active ?-present: traditional & ceramic polychrome jars, bowls)
PUBLICATIONS: Painter 1998:10.

Emmalita C. Chino *(Emma Chino, signs E. Chino, Acoma N.M.)*

(Acoma, active ca. 1942-present: traditional & ceramic jars, bowls)
BORN: June 6, 1931
FAMILY: daughter of Margaret Charlie; daughter-in-law of Marie Z. Chino; wife of Patrick Chino; mother of Brenda Charlie & Monica Chino
TEACHER: Marie Z. Chino
STUDENTS: Brenda Charlie & Monica Chino, her daughters
AWARDS: numerous - art shows in New Mexico, Arizona & Utah
PUBLICATIONS: Minge 1991:195; Dillingham 1992:206-208; Nahohai & Phelps 1995:81.
 Emmalita C. Chino was complimented for her excellent designs by Zuni potter Marjorie Esalio, who said, "Emmalita Chino, she's my sister's mother-in-law. Her designs really interest me."

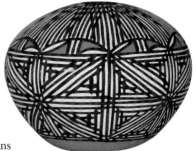

E. Chino - Wright/McCray Collection, Santa Fe

Evelyn L. Chino

(Acoma, Sun Clan, active ca. 1960s-?: traditional polychrome ollas, jars, bowls)
BORN: ca. 1940
FAMILY: wife of Ivan F. Chino; mother of Terrance M. Chino, Sr., Emil Chino, Ilona Chino, Colleen Mariano, Jeffrey Chino, Sr., Marlene Vallo, Jolene Mariano; grandmother of Terrance M. Chino, Jr., Jeffrey Chino, Jr.
COLLECTIONS: Allan & Carol Hayes, John Blom
FAVORITE DESIGNS: Kokopelli, Mimbres animals, feathers-in-a-row, kiva steps, terraced clouds
PUBLICATIONS: Hayes & Blom 1996:54-55.

Everett Chino

(Acoma, active ?-1990+: polychrome jars, bowls)
PUBLICATIONS: Dillingham 1992:206-208.

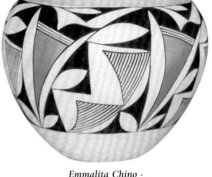

Emmalita Chino -
Dave & Lori Kenney Collection, Santa Fe

Francine Chino *(signs F. Chino, Acoma N.M.)*

(Acoma/Hopi, active ca. 1991-present: traditional polychrome, sgraffito jars, bowls)
BORN: August 30, 1970
FAMILY: daughter of Sandy & Diana Chino
TEACHER: Diana Chino, her mother
GALLERIES: Rio Grande Wholesale, Inc., Palms Trading Co., Albuquerque
PUBLICATIONS: Berger & Schiffer 2000:107.

Gilbert Chino

(Acoma, active ca. 1960s-present: traditional polychrome, black-on-white fineline jars, bowls)
BORN: ca. 1946
FAMILY: son of Marie Z. Chino; brother of Carrie Chino Charlie, Rose Chino Garcia, Grace Chino, Vera Chino Ely, Patrick Chino & Jody Chino
EXHIBITIONS: ?-1983, Indian Market, Santa Fe
FAVORITE DESIGNS: Kokopelli, optical fineline black & white patterns.
PUBLICATIONS: Harlow 1977; Dillingham 1994:82, 88-9; Reano 1995:31.
 Gilbert Chino expressed the importance of putting one's "spirit into pottery making," to preserve the art form.

Gloria Chino

(Acoma, active ca. 1970s-present: polychrome jars, bowls)
BORN: ca. 1955
FAMILY: m. granddaughter of Marie Z. Chino; daughter of Grace Chino; sister of Carol Chino, Hubert Chino, Kevin (Chip) Chino & Clarissa
EXHIBITIONS: 1991-?, Indian Market, Santa Fe
PUBLICATIONS: Dillingham 1994:82; Peaster 1997:18.

Grace T. Chino

(Acoma, active ca. 1950s-1994: traditional polychrome & black-on-white jars, bowls, seed pots, wedding vases, miniatures)
LIFESPAN: ca. 1929 - 1994
FAMILY: daughter of Marie Z. Chino; sister of Gilbert Chino, Carrie Chino Charlie, Rose Chino Garcia, Vera Chino Ely; mother of Hubert Chino, Gloria Chino, Kevin (Chip) Chino, Carol Chino & Chris Clarissa; grandmother of Tyler Wade Chavez
STUDENTS: her children and Carrie Chino Charlie, her niece
AWARDS: 1980, 1st, 3rd; 1981, 2nd, 3rd; 1983, 2nd; 1988, 2nd; 3rd; 1989, 3rd; 1990, 1st, 2nd,, 3rd; 1991, 1st, 2nd, 1992, 1st, 2nd, 3rd; 1993, 2nd, 3rd, Indian Market, Santa Fe; 1981 2nd, Southwest Indian Market
EXHIBITIONS: 1974, "Seven Families in Pueblo Pottery," Maxwell Museum, University of New Mexico, Albuquerque; 1979, "One Space: Three Visions," Albuquerque Museum, Albuquerque; 1982-1994, Indian Market, Santa Fe
COLLECTIONS: Wright Collection, Peabody Museum, Harvard University, Cambridge, MA; Albuquerque Museum, Albuquerque, NM; Allan & Carol Hayes; Dr. Gregory Schaaf, Santa Fe
FAVORITE DESIGNS: parrots, clouds, rain, optical four-petal pattern

GALLERIES: Adobe Gallery, Albuquerque
VALUES: On May 17, 2000, a black-on-white olla, signed Grace Chino, (13.75 x 14"), sold for $3,900, at Sotheby's, #547.

On December 2, 1998, a black-on-white bowl, signed Grace Chino, (10 1/4" dia.), sold for $4,600 at Sotheby's, lot #64.

PUBLICATIONS: Barsook, et al. 1974; Tanner 1976:123; *SWAIA Quarterly* Fall 1982:11; *Indian Market Magazine* 1982-1994; Barry 1984:89; Dedera 1985:42; Trimble 1987:74-79; Schiffer 1991d:52; Dillingham 1992:206-208; Reano 1995:31; Hayes & Blom 1996:48-49; Peaster 1997:18; Peterson 1997; Drooker & Capone 1998:45, 138; *American Indian Art Magazine* Autumn 1999:19.

Grace was respected for making large, well formed and beautifully painted traditional pottery. She did not repeat trademark designs, but rather believed that each pot should "decide" which design is most appropriate. Her innovative compositions are well balanced and artistic. Many potters speak of her with respect, choosing her as their favorite.

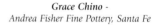
Grace Chino -
Andrea Fisher Fine Pottery, Santa Fe

Iona K. Chino *(signs I. Chino, Acoma N.M.)*
(Acoma, active ca. 1982-present: traditional and ceramic polychrome & fineline jars, bowls, pitchers)
BORN: November 26, 1956
FAMILY: granddaughter of Santana Antonio; daughter of Irma Maldonado
GALLERIES: Rio Grande Wholesale, Inc., Palms Trading Co., Albuquerque
PUBLICATIONS: Dillingham 1992:206-208; Berger & Schiffer 2000:12, 107.

Isabel Chino *(see Isabel Chino Charlie)*

J. M. Chino
(Acoma, active ?: polychrome jars, bowls)
COLLECTIONS: Heard Museum, Phoenix

Jeffrey Chino
(Acoma, Sun Clan, active ca. 1990-present: polychrome jars, bowls)
BORN: ca. 1965
FAMILY: son of Evelyn L. & Ivan F. Chino; brother of Terrance M. Chino, Sr., Emil Chino, Ilona Chino, Collene Mariano, Marlene Vallo, Jolene Mariano
PUBLICATIONS: Dillingham 1992:206-208.

JoAnne Chino *(see JoAnne Chino Garcia (2))*

Jodie Chino
(Acoma, active ?: pottery)
EXHIBITIONS: 1995-present, Eight Northern Indian Pueblos Arts & Crafts Show
PUBLICATIONS: Trimble 1987:11.

Jody Chino
(Acoma, active ca. 1960s-?: traditional polychrome & fineline black-on-white jars, bowls)
FAMILY: adopted daughter of Marie Z. Chino; sister of Gilbert Chino, Carrie Chino Charlie, Rose Chino Garcia, Vera Chino Ely, Grace Chino
PUBLICATIONS: Peaster 1997:18.

Juana Chino
(Acoma, active ca. 1930s-80s: traditional polychrome & fineline jars, bowls)
BORN: ca. 1910s
FAMILY: wife of Garcia Chino; mother of Terri Lukee

Juanita Chino
(Acoma, active ca. 1900s-1910s+: polychrome jars, bowls)
BORN: ca. 1890; RESIDENCE: Acomita in ca. 1910
PUBLICATIONS: Leopold Bibo, "13th Annual U.S. Census" (1910), New Mexico State Archives, Call T624, Roll 919; in Dillingham 1992:205.

Julian Chino *(signs J. Chino, Acoma N.M.)*
(Acoma, active ca. 1995-present: ceramic polychrome jars, bowls)
BORN: December 10, 1971
FAMILY: son of Matthew & Mary Chino
TEACHER: Mary Chino, his mother
GALLERIES: Rio Grande Wholesale, Inc., Palms Trading Co., Albuquerque
PUBLICATIONS: Berger & Schiffer 2000:107.

Keith Chino

(Acoma, Eagle/Sun Clans, active ca. 1980s-present: Anasazi Revival, traditional black-on-white fineline, contemporary sgraffito redware, some with blue-and-yellow highlights, seedpots, sculptures, graphic arts, serigraphs)
BORN: August 28, 1960; RESIDENCE: McCartys, NM
FAMILY: grandson of Mamie Torivio Ortiz & Joe L. Ortiz; son of Myrna Antonio Chino and Elmer Chino; brother of C. Maurus Chino, Debbie, Larry, Paula, Darlene; husband of Sharlyn Chino; father of Darris & Sidney
EDUCATION: Haskell Indian College, 1979-81; Fine Arts, SIPI, 1981-82
TEACHERS: Mamie Torivio Ortiz, Myrna Antonio Chino, Fernando Romero
AWARDS: 1990, 2nd; 1998, 1st, Indian Market, Santa Fe; 1998, 1st; 1999, 1st; 2000, 1st, New Mexico State Fair, Albuquerque; 2nd, Ohio Indian Market, OH
DEMONSTRATIONS: Smithsonian Institution, Washington, D.C.; Painted Desert Tours, NM
EXHIBITIONS: 1988-present, Indian Market, Santa Fe; 1998-present, New Mexico State Fair, Albuquerque; Colorado Indian Market, Denver, CO; Southwest Museum Show, Los Angeles, CA; Texas Indian Market
COLLECTIONS: John Blom; William E. Brodersen, Architectural Continuity, Inc.
FAVORITE DESIGNS: rain, lizards, feathers-in-a-row
GALLERIES: Whitehorse Gallery, Boulder, CO; Pueblo Pottery Gallery, Acoma, NM; Bien Mur, Albuquerque, NM; Sandia Casino, Sandia Pueblo, NM; Santa Fe Trails, Sarasota, FL; Monongye Gallery, Old Oraibi, AZ
PUBLICATIONS: *Indian Market Magazine* 1988-2000; Dillingham 1992:206-208; Reano 1995:31.

Keith Chino -
Courtesy of the artist

Keith Chino -
Johanna Leibfarth Collection, SC

 Keith Chino comes from a talented family of artists. He is experienced in sculpture and graphic arts, as well as pottery. He enjoys creating artwork, because "it gives me a sense of relaxation and satisfaction to produce a high quality piece of art that people appreciate."

Larry Antonio Chino *(Kie-Stee)*

(Acoma, Eagle/Sun Clans, active ca. 1970-present: traditional & contemporary polychrome jars, bowls)
BORN: November 20, 1958
FAMILY: grandson of Mamie Torivio Ortiz & Joe L. Ortiz; son of Myrna Antonio and Elmer Chino; brother of C. Maurus Chino, Debbie, Keith, Paula, Darlene; husband of Geri Pino (deceased); step-father of Tanya Tallieman
EDUCATION: Grant's High School; Albuquerque Technical Vocational Institute; Haskell Indian Junior College, Lawrence, KA
TEACHERS: Mamie T. Ortiz & Myrna Chino
STUDENT: Ka-Ste-Ma [Daniel L. Chino], grand-nephew
EXHIBITIONS: 1988-present, Indian Market, Santa Fe; Eight Northern Indian Pueblos Arts & Crafts Show; 2001, Santo Domingo Arts & Crafts Show
FAVORITE DESIGNS: hummingbirds, whirlwinds
PUBLICATIONS: *Indian Market Magazine* 1988-2001; Tucker 1998: plate 85.

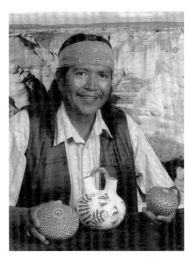

Larry A. Chino -
Courtesy of the artist

 In the summer of 2001, we met Larry Chino at the Santo Domingo Arts & Crafts Show. He said that he enjoyed creating pottery, because "it makes me feel good to know the people who collect and appreciate my work. I am blessed with a talent that keeps me close to the land and people. My art makes me feel proud and other people feel good, so everybody feels good!"

Laura V. Chino

(Acoma, active ?-1990+: polychrome jars, bowls)
PUBLICATIONS: Dillingham 1992:206-208.

Lita L. Chino *(see Lita L. Garcia)*

Lupe Chino

(Acoma, active ca. 1880s-1910s+: polychrome jars, bowls)
BORN: ca. 1867
PUBLICATIONS: Leopold Bibo, "13th Annual U.S. Census" (1910), New Mexico State Archives, Call T624, Roll 919; in Dillingham 1992:205.

Maria Antonia Chino

(Acoma, active ca. 1850s-1910s+: polychrome jars, bowls)
BORN: ca. 1835; RESIDENCE: Acomita in ca. 1910
PUBLICATIONS: Leopold Bibo, "13th Annual U.S. Census" (1910), New Mexico State Archives, Call T624, Roll 919; in Dillingham 1992:205; *El Palacio* Oct. 16, 1922:94.

Marie Z. Chino *(Marie Zieu Chino)*

(Acoma, Red Corn Clan, active ca. 1920s-1982: Mimbres, Anasazi, Tularosa Revival, traditional polychrome & black-on-white fineline ollas, jars, bowls, seed pots, vases, wedding vases, miniatures)

LIFESPAN: May 10, 1907 - November 28, 1982

FAMILY: sister of Santana Sanchez; mother of Carrie Chino Charlie, Rose Chino Garcia, Grace Chino, Vera Chino Ely; Patrick Chino & Jody Chino; grandmother of JoAnne Chino, Isabel, Ann, Corinne Louis, Tena Garcia, Hubert Chino, Gloria Chino, Kevin (Chip) Chino, Carol Chino, Chris Clarissa, Deborah Marie, Mark Lorenzo, Luke Bear

STUDENTS: Carrie Chino Charlie, Rose Chino Garcia, Grace Chino, Vera Chino Ely; Patrick Chino, Jody Chino, JoAnne Chino, Isabel, Ann, Corinne Louis, Tena Garcia, Hubert Chino, Gloria Chino, Kevin (Chip) Chino, Carol Chino, Chris Clarissa, Deborah Marie, Mark Lorenzo, Luke Bear, Emmalita C. Chino

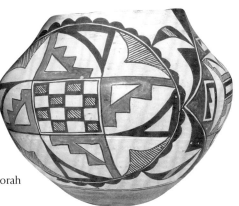

Marie Z. Chino -
Dr. Fred Belk Collection

AWARDS:

1922	Indian Market, Santa Fe
1970	1st, Indian Market, Santa Fe
1974	Best Traditional Pottery, 1st, Indian Market, Santa Fe
1975	1st (3), Indian Market, Santa Fe
1977	Forest Fenn Award for Best Traditional Pottery, Indian Market, Santa Fe
1978	2nd (2), 3rd (2), Indian Market, Santa Fe
1979	Richard M. Howard Award for Best Traditional Acoma Pottery
1980	Best of Class, Best of Division, 1st (3), 2nd (2), Indian Market
1981	Best of Division, 1st, Indian Market, Santa Fe
1982	Excellence Award, Southwest Indian Market; Inter-tribal Indian Ceremonial, Gallup, New Mexico State Fair, Albuquerque

Marie Z. Chino -
Peter B. Carl Collection, Oklahoma City, OK

EXHIBITIONS: 1922-1982, Indian Market, Santa Fe; 1974, "Seven Families in Pueblo Pottery," Maxwell Museum, University of New Mexico, Albuquerque; 1979, "One Space: Three Visions," Albuquerque Museum, Albuquerque; 1997, "Recent Acquisitions from the Herman and Claire Bloom Collection," Heard Museum, Phoenix

COLLECTIONS: Wright Collection, Peabody Museum, Harvard University, Cambridge, MA; Philbrook Museum of Art, Tulsa, OK, jar, ca. 1952; Allan & Carol Hayes, John Blom

FAVORITE DESIGNS: Mimbres animals, Tularosa swirls, Acoma parrots, rainbows, bushes with berries, leaves, rain, clouds, lightning, fineline snowflakes

VALUES: On October 31, 2000, a black-on-white bowl, signed Marie Z. Chino (4 x 10"), sold for $2,645 at Butterfields, #4250.

On December 2, 1998, a black-on-white storage jar, signed Marie Z. Chino (20" dia.), sold for $10,350 at Sotheby's, #63.

On December 2, 1998, a black-on-white plate, signed Marie Z. Chino (11.5" dia.), sold for $2,185 at Sotheby's, #65.

On December 2, 1998, a black-on-white wedding vase, signed Marie Z. Chino (12.25" h.), sold for $2,587 at Sotheby's, #66.

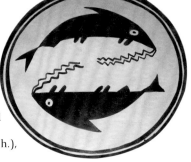

Marie Z. Chino -
Courtesy of Joe Zeller
River Trading Post, East Dundee, IL

On December 2, 1998, a black-on-white vase, signed Marie Z. Chino (10.5" h.), sold for $2,300 at Sotheby's, #68.

On December 2, 1998, a black-on-white seed jar, signed Marie Z. Chino (11" dia.), sold for $2,587 at Sotheby's, #66.

On December 10, 1996, a polychrome olla, signed Marie Z. Chino (8.25 x 10.75"), sold for $1,150, at Butterfield & Butterfield, #614.

PUBLICATIONS: *El Palacio* Oct. 16, 1922:94; *SWAIA Quarterly* Fall 1971:8; Fall 1972:4; Fall 1973:3; Fall 1974:3; Fall 1975:4; Fall 1976:12; Fall 1982:10-14; Barsook, et al. 1974; *Arizona Highways* May 1974:14, 26, 40; Explorations 1974:21; Tanner 1976:106-07, 122-23; Dillingham 1977:50, 84; Toulouse 1977:81; *American Indian Art Magazine* Autumn 1977:84; Spring 1989:28; Summer 1999:28; Autumn 1999:19; *Fourwinds* Spring 1980:42; Spring 1981:32; Spring 1989:30; *Indian Market Magazine* 1983-85, 1991, 1997-2000; Dedera 1985:42; Trimble 1987:77-79; *Southwest Art* Nov. 1988:42; Eaton 1990:23; Minge 1991:195; Dillingham 1992:206-208; 1996:82-4; Hayes & Blom 1996:23, 46, 48, 50-51, 54; 1998:43; Peaster 1997:18; Peterson 1997:202; Drooker & Capone 1998:138; *Native Peoples* Fall 1998:94.

In 1922, Marie Z. Chino was only 15 years old when she won her first award at Indian Market in Santa Fe. Marie is considered one of the highly respected matriarchs of an important pottery-making family at Acoma. She, Lucy Lewis, Sarah Garcia and others led the revival of ancient pottery forms including the Mimbres, Tularosa, and various cultures in the region called Anasazi, in the Four Corners area. This movement exhibited a profound impact, spreading to hundreds of potters who accepted the old styles and innovated variations of style and form.

Marie shared her knowledge and techniques with laudable

Marie Z. Chino -
Nedra Matteucci Galleries, Santa Fe

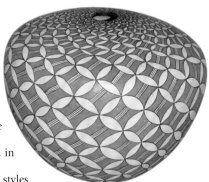

Marie Z. Chino -
Andrea Fisher Fine Pottery, Santa Fe

generosity, helping to teach her children, grandchildren and her in-laws. She was patient, as some of her descendants acknowledge that it took time to perfect the delicate process of fine pottery making.

Marie is especially known for fineline black-on-white pottery. She sometimes encouraged her daughter, Carrie Chino Charlie, and others to paint her pots. They began by "helping her fill in her painting." Eventually, each earned the right to make pots from start to finish.

Marie took her family with her to many Indian art shows, including Indian Market in Santa Fe. They enjoyed the opportunity to meet the many people from around the world who loved to collect the Chino family pottery. A sense of pride and unity grew throughout the whole family, who has maintained the family tradition for fine pottery, since Marie passed over to the other side.

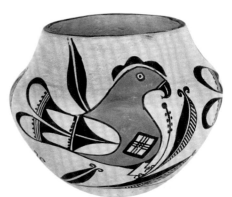

Marie Z. Chino -
King Galleries of Scottsdale, AZ

Mary Chino

(Acoma, active ca. 1960s-present: polychrome jars, bowls)
BORN: ca. 1950
FAMILY: wife of Matthew Chino; mother of Julian Chino
STUDENTS: Julian Chino, her son
GALLERIES: Rio Grande Wholesale, Inc., Palms Trading Co., Albuquerque
PUBLICATIONS: Berger & Schiffer 2000:107.

Mary W. Chino

(Acoma, active ca. 1920s-30s?: traditional polychrome jars, bowls, plates)
FAVORITE DESIGNS: Rainbirds, fineline rain, clouds

Maurus Chino *(see C. Maurus Chino)*

Mimi Chino

(Acoma, active ca. 1960s-70s: traditional polychrome jars, bowls)
AWARDS: 1974, 1st, Indian Market, Santa Fe
EXHIBITIONS: ?-1974, Indian Market, Santa Fe
PUBLICATIONS: *SWAIA Quarterly* Fall 1973:3.

Monica C. Chino *(signs M.C. or Monica Chino, Acoma N.M.)*

(Acoma, active ca. 1990-present: traditional & ceramic polychrome & black-on-white fineline jars, bowls)
BORN: December 4, 1970
FAMILY: p. granddaughter of Marie Z. Chino; m. granddaughter of Margaret Charlie; daughter of Patrick Chino & Emmalita Charlie Chino; niece of Marie Torivio, Loretta Garcia & Rose Chino; sister of Brenda Charlie
TEACHER: Emmalita C. Chino, her mother
GALLERIES: Rio Grande Wholesale, Inc., Palms Trading Co., Albuquerque
PUBLICATIONS: Berger & Schiffer 2000:107.

Monica Chino -
Courtesy of Jason Esquibel
Rio Grande Wholesale, Inc.

Myra Chino

(Acoma, active ca. 1980-present: polychrome & black-on-white fineline jars, bowls, large ollas)
BORN: ca. 1965
FAMILY: sister of Victoria Sarracino; sister-in-law of Carla Vallo
FAVORITE DESIGNS: starbursts, eyedazzlers
GALLERIES: The Indian Craft Shop, U.S. Department of Interior, Washington, D.C.
PUBLICATIONS: Dillingham 1992:206-208.

Myrna Antonio Chino

(Acoma, active ca. 1950s-1999: Anasazi Revival, black-on-white, traditional polychrome jars, bowls)
BORN: ca. 1930s
FAMILY: daughter of Mamie Torivio; wife of Elmer Chino; mother of C. Maurus, Paula, Darlene, Debbie, Keith, & Larry A. Chino.
AWARDS: 1976, 3rd; 1978, 3rd; 1991, 3rd; 1993, 3rd, Indian Market, Santa Fe
EXHIBITIONS: 1974-98, Indian Market, Santa Fe
PUBLICATIONS: *Indian Market Magazine* 1974-1998; *SWAIA Quarterly* Fall 1976:14; Dillingham 1992:206-208; Tucker 1998: plate 84.

Myra Chino - Courtesy of Jason Esquibel
Rio Grande Wholesale, Inc.

Nellie Chino

(Acoma, active ?-1990+: polychrome jars, bowls)
PUBLICATIONS: Dillingham 1992:206-208.

Patrick C. Chino *(signs P. Chino, Acoma N.M.)*

(Acoma, ca. 1962-present: traditional & ceramic polychrome jars, bowls)
BORN: July 31, 1940
FAMILY: son of Marie Z. Chino; brother of Carrie Chino Charlie, Rose Chino Garcia, Grace Chino, Vera Chino Ely & Jody Chino; husband of Emmalita Charlie Chino; father of Monica C. Chino & Brenda Charlie
AWARDS: Grand Prize, 1st, 2nd, Inter-tribal Indian Ceremonial, Gallup; New Mexico State Fair, Albuquerque
EXHIBITIONS: 1983, Indian Market, Santa Fe
FAVORITE DESIGNS: Mimbres animals
PUBLICATIONS: Dillingham 1994:82; Peaster 1997:18.

Ramona Chino

(Acoma, active ca. 1988-present: ceramic polychrome jars, bowls)
BORN: February 7, 1964
FAMILY: daughter of Marvin & Theresa Lukee
TEACHER: Theresa Lukee, her mother
GALLERIES: Rio Grande Wholesale, Inc., Palms Trading Co., Albuquerque
PUBLICATIONS: Berger & Schiffer 2000:108.

Rose or Rosemary Chino *(see Rose Chino Garcia)*

S. Chino

(Acoma, active ?-present: Nativities)
GALLERIES: Palms Trading Co., Albuquerque
PUBLICATIONS: Congdon-Martin 1999:48.

Santana Chino

(Acoma, active ?-1980s: pottery)
EXHIBITIONS: ?-1985, Indian Market, Santa Fe
PUBLICATIONS: *Indian Market Magazine* 1985.

Shirley Chino *(signs S.C. Acoma)*

(Acoma, active ca. 1979-present: ceramic polychrome animal figures, jars, bowls)
TEACHER: her grandmother
GALLERIES: Rio Grande Wholesale, Inc., Palms Trading Co., Albuquerque
PUBLICATIONS: Berger & Schiffer 2000:108.

Terrance M. Chino, Sr. *(collaborated sometimes with Colleen Chino)*

(Acoma, Sun Clan, active ca. 1980-present: traditional polychrome jars, bowls, seed pots, vases)
BORN: April 27, 1965 at Albuquerque
FAMILY: son of Ivan F. & Evelyn L. Chino; brother of Emil Chino, Ilona Chino, Colleen Manano, Jeffrey Chino, Sr., Marlene Vallo & Jolene Marian; father of Terrance M. Chino, Jr.
TEACHERS: grandmother and Evelyn L. Chino, his mother
FAVORITE DESIGNS: Mimbres figures, checkerboard, Sunface
GALLERIES: Rio Grande Wholesale, Inc., Albuquerque
PUBLICATIONS: Dillingham 1992:206-208.

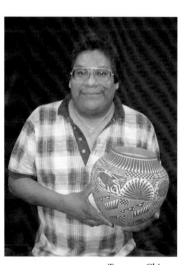

Terrance Chino -
Courtesy of Jason Esquibel
Rio Grande Wholesale, Inc.

Velma C. Chino

(Acoma, active ca. 1950s-present: polychrome jars, bowls, Storytellers)
BORN ca. 1931
TEACHER: her grandmother
AWARDS: 1998, 1st, Indian Market, Santa Fe
EXHIBITIONS: 1985-present: Indian Market, Santa Fe
PUBLICATIONS: *Indian Market Magazine* 1985-present; Chino 1992; Dillingham 1992:206-208; Painter 1998:10.
 Velma Chino not only is an excellent potter, she also is one of the few Acoma people who is the author of a book.
 Velma's book is entitled, *The Boy and the Turtle* (Spider Mountain Press, 1992). She explained, "This is the story of how the boy and the turtle save the people. This is the beautiful story that my grandfather used to tell me, and I've now shared it with you."

Vera Chino *(see Vera Chino Ely)*

Wanda F. Chino

(Acoma, active ?: pottery)
ARCHIVES: Artist's File, Heard Museum, Phoenix

Wilberta Chino-Guinn

(Acoma, active ?-1990s: pottery)
EXHIBITIONS: 1993-present, Indian Market, Santa Fe

Hollis Chitto
(Laguna/Choctaw, active ca. 1990s-present: figures)
FAMILY: related to Randall Chitto (Choctaw)
AWARDS: 2000, 1st, figures (ages 12 & under), Indian Market, Santa Fe

Randall Chitto
(Choctaw, married into Laguna, active ?-present: figures)
FAMILY: related to Hollis Chitto
AWARDS: 2000, 3rd, Indian Market, Santa Fe

Maria Chiwiwi
(Isleta, active ca. 1920s-?: traditional polychrome jars, bowls)
FAMILY: wife of a Laguna man
TEACHER: Benina Yuwai (Laguna)
COLLECTIONS: Denver Art Museum, Denver, CO, bowl, ca. 1926, #1926.48.
PUBLICATIONS: Parsons 1928:604; Batkin 1987:191, 205, n. 137; Weigle & Babcock:161, 216.
> Maria Chiwiwi was an excellent potter. She made pottery for tourists, as well as for village use. Her friend, Maurine Grammer, considers her one of the best Isleta potters of the 1920s-30s.

Kevin Chopito
(Zuni, active ?-present: traditional polychrome ollas, jars, bowls)
FAVORITE DESIGNS: deer with heartlines, turtle back
GALLERIES: Turquoise Village
PUBLICATIONS: Bassman 1996:21.

Anthony Chosa *(signs A.C. or Anthony Chosa Jemez)*
(Jemez/Hopi-Tewa, active ca. 1988-present: traditional polychrome jars, bowls)
BORN: March 6, 1961
FAMILY: son of Antonita Chosa Colateta (Hopi-Tewa)
TEACHER: Donald Chinana
PUBLICATIONS: Berger & Schiffer 2000:108.

Clara Chosa *(signs C.C. Jemez N.M.)*
(Jemez, active ca. 1952-present: traditional polychrome jars, bowls)
BORN: January 27, 1935
FAMILY: daughter of Sylvia & Francisco Chosa
TEACHER: Sylvia Chosa, her mother
STUDENT: Rachel L. Loretto
PUBLICATIONS: Berger & Schiffer 2000:108.

Erna Chosa *(Broom Flower), (signs E. C.)*
(Jemez/Hopi-Tewa, Sun Clan, active ca. 1978-present: traditional black & red-on-tanware jars, bowls, wedding vases, textiles)
BORN: April 6, 1959
FAMILY: granddaughter of Sarah Collateta; daughter of Antonita Chosa Colateta; sister of Anthony Chosa & Kathleen Collateta
AWARDS: 1988, 1989, 1991, Eight Northern Indian Pueblos Arts & Crafts Show; 1990, 1992, Jemez Pueblo Arts & Crafts Show; 1992-93, Santo Domingo Pueblo Art Show
EXHIBITIONS: 1977-present, Eight Northern Indian Pueblos Arts & Crafts Show
FAVORITE DESIGNS: Rainbirds, clouds, rain, fineline
GALLERIES: Rio Grande Wholesale, Palms Trading Company, Albuquerque
PUBLICATIONS: Fox 1978:91; Berger & Schiffer 2000:26, 108; Schaaf 2001:283.

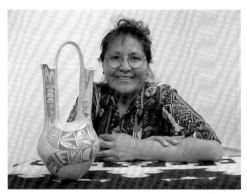

Erna Chosa - Courtesy of Jason Esquibel
Rio Grande Wholesale, Inc.

Patricia Chosa *(signs P.C. or P. Chosa, Jemez N.M.)*
(Jemez, active ca. 1977-present: traditional polychrome jars, bowls, Storytellers, figures, owls, quail)
BORN: January 26, 1948
EDUCATION: Santa Fe Indian School, Santa Fe
PUBLICATIONS: Congdon-Martin 1999:60-61; Berger & Schiffer 2000:108.

Sylvia Chosa
(Jemez, active ca. 1930-present: traditional polychrome jars, bowls)
BORN: ca. 1910s
FAMILY: wife of Francisco Chosa; mother of Clara Chosa
STUDENT: Clara Chosa, her daughter

Maria Cimmeron [Cimerone]

(Acoma, Roadrunner Clan, active ca. 1900s-20s+: traditional polychrome ollas, jars, bowls)
BORN: 1880s
FAMILY: daughter of Maria Santiago & Luis Cimmeron; wife of Luis Cimmeron; mother of Santana Cimmeron Cerno; m. grand-mother of Joseph Cerno, Sr., Frank Cerno, Linda Wilkey, Rachel Concho, Matthew Cerno, Mary, Eloise
PUBLICATIONS: *El Palacio*, Oct. 16, 1922.

Juana Cimmeron

(Acoma/Zuni, Bear Clan, active ca. 1910-47: traditional polychrome jars, bowls)
LIFESPAN: ca. 1890-1947
FAMILY: mother of Elizabeth Valles and Terresa Chino; mother-in-law of Joe Medina; m. grandmother of Angelina Medina, Vera Valles & Ira Valenzuela

> Juana Cimmeron's family was originally members of the Bear Clan from Zuni. When the Pueblo of Acoma needed them to re-strengthen the Bear Clan at Acoma, the family moved to Acoma where they were given a respected position within Acoma society.
> Angelina Medina recalled her maternal grandmother, Juana Cimmeron, "I remember watching my grandmother sitting with a board on her lap, rolling out clay for her pottery."

Santana Cimmeron *(see Santana Cimmeron Cerno)*

Goldie Colaque

(Jemez, active ca. 1970s-present: traditional polychrome jars, bowls)
BORN: ca. 1950s
FAMILY: mother of Iva A. Colaque

Iva A. Colaque *(signs I.C. Jemez)*

(Jemez, active ca. 1995-present: traditional polychrome jars, bowls)
BORN: November 24, 1977
FAMILY: daughter of Goldie Colaque
PUBLICATIONS: Berger & Schiffer 2000:108.

Reyes Colaque

(Jemez, Corn Clan, active ca. 1950s-?: traditional polychrome jars, bowls)
BORN: ca. 1930s
FAMILY: granddaughter of Juan R Chavez (Jemez) & Filapeta Coriz Chavez (Tesuque); daughter of Juan I. & Lucy C. Toledo; sister of Mary Jane Buck, Jimmy Chavez, Charlie Chavez, Joseph Chavez, Marie Chavez

Andrea Collateta

(Jemez, active ca. 1990s-present: Storytellers)
GALLERIES: Palms Trading Company, Albuquerque
PUBLICATIONS: Congdon-Martin 1999:62.

Kathleen Collateta *(Kathleen Collateta Sandia), (signs K. Collateta)*

(Jemez/Hopi, active ca. 1975-present: polychrome jars, bowls)
BORN: November 24, 1969
FAMILY: granddaughter-in-law of Sara Collateta & Taft Collateta, Sr.
PUBLICATIONS: *The Messenger*, Wheelwright Museum Summer 1995:inside cover; Schaaf 1999:42; Berger & Schiffer 2000:109.

V. Collateta

(Jemez, active ca. 1990s-present: Storytellers, Corn Maidens)
GALLERIES: Palms Trading Company, Albuquerque
PUBLICATIONS: Congdon-Martin 1999:62.

Alma Loretto Concha *(see Alma Loretto Maestas)*

Antoinette Concha *(signs A. Concha, Jemez N.M.)*

(Jemez/Taos, Water Clan, active ca. 1980-present: matte black & white on redware & blackware Mudhead Storytellers, Drummers, figures, some with feather attachments)
BORN: September 8, 1964
FAMILY: m. granddaughter of Louis & Carrie R. Loretto; daughter of Alma Maestas and Del Concha
TEACHER: Alma Maestas, her mother
GALLERIES: Wind River Trading Company, Santa Fe; Palms Trading Company, Albuquerque
PUBLICATIONS: Congdon-Martin 1999:108; Berger & Schiffer 2000:109.

> Antoinette Concha creates Mudhead Storytellers and figures. The Mudheads, sometimes called Koyemsi, are a spiritual society with ancient roots. They move slowly and communicate in their own language. They emerge from their kivas and appear in the plazas at Pueblos throughout the Southwest. Their deeper purpose is kept secret out of respect.

John Concha

(Jemez/Taos, Water Clan, active ca. 1989-present: figures, Mudheads, dogs, leatherwork)
BORN: May 18, 1970; RESIDENCE: Taos, NM
FAMILY: m. grandson of Louis & Carrie R. Loretto; son of Alma Maestas and Del Concha; father of Leandra & Alslinn
John Concha confided his personal feelings about making pottery, "it connects me to who I am as a Native American, opening the past in what I create today. There's nothing more satisfying than to see a creation from digging to firing."

J. R. Concha

(Acoma, active ? - present: Storytellers, Mudhead figures)
GALLERIES: Palms Trading Co., Albuquerque
PUBLICATIONS: Congdon-Martin 1999:49.

Adeline Concho

(Acoma, active ?-1990+: polychrome jars, bowls)
PUBLICATIONS: Dillingham 1992:206-208.

Angela Concho

(Acoma, active ?-1990+: polychrome jars, bowls)
PUBLICATIONS: Dillingham 1992:206-208.

Anthony Concho *(signs A.C. Acoma, N.M.)*

(Acoma, active 1991-present: sgraffito jars, bowls)
BORN: February 7, 1966
FAMILY: son of Harold & Laura Vallo; brother of Ergil F. Vallo, Sr. (Dalawepi)
GALLERIES: Rio Grande Wholesale, Inc., Palms Trading Co., Albuquerque
PUBLICATIONS: Berger & Schiffer 2000:109.

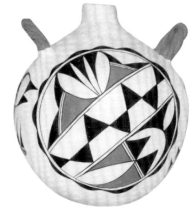

B. Concho -
Candace Collier Collection, Houston, TX

B. Concho

(Acoma, active ca. 1970s-?: traditional polychrome jars, bowls, canteens)
COLLECTIONS: Candace Collier, Houston, TX
FAVORITE DESIGNS: flowers, leaves, triangles, clouds

Carolyn Concho *(Carolyn Lewis, E-ya-tsa), (signs C. Concho, Acoma N.M.)*

(Acoma, Yellow Corn Clan, active ca. 1984-present: traditional & contemporary polychrome & black-on-white seedpots, jars, bowls, miniatures)
BORN: September 15, 1961; RESIDENCE: Acomita, NM
FAMILY: m. granddaughter of Toribio & Dolores S. Sanchez; daughter of Katherine & Edward Lewis; sister of Rebecca Lucario, Marilyn Lewis Ray, Judy M. Lewis, Diane M. Lewis & Bernard Lewis; sister-in-law of Sharon Lewis
AWARDS: 1984, 3rd; 1988, 3rd; 1989, 1st, 2nd; 1992, 2nd, 3rd; 1993, 3rd; 1996, 1st; 1998, 3rd; 2000, 2nd, 3rd, Indian Market, Santa Fe; 1st, Heard Museum Show, Phoenix; 1st, 2nd, 3rd, New Mexico State Fair, Albuquerque; 1999, 2nd, Indian Market, Santa Fe; H.M., Inter-tribal Indian Ceremonial, Gallup; Eight Northern Indian Pueblos Arts & Crafts Show
EXHIBITIONS: 1985-present, Indian Market, Santa Fe; 1995-present, Eight Northern Indian Pueblos Arts & Crafts Show
COLLECTIONS: Wright Collection, Peabody Museum, Harvard University, Cambridge, MA; John Blom; Dr. Gregory & Angie Yan Schaaf; Ed Samuels, Jemez Springs, NM
FAVORITE DESIGNS: Mimbres animals, lizards, Kokopelli
GALLERIES: The Indian Craft Shop, U.S. Department of Interior, Washington, D.C.; Tribal Arts Zion, Springdale, UT; Arlene's Gallery, Tombstone, AZ; Rio Grande Wholesale, Inc., Palms Trading Co., Albuquerque
PUBLICATIONS: *Indian Market Magazine* 1985-2000; *The Messenger*, Wheelwright Museum Spring 1987:3; Winter 1997:14; Jacka 1988; *Southwest Art* Sept. 1988:57, 62; *American Indian Art Magazine* Summer 1990:74; Spring 1992:91; Dillingham 1992:206-208; Reano 1995:35; Drooker & Capone 1998:138; Hayes & Blom 1996:54-55;1998:51; Painter 1998:10; Berger & Schiffer 2000:109.

Carolyn Concho -
Courtesy of Jason Esquibel
Rio Grande Wholesale, Inc.

Carolyn Concho -
Courtesy of Sunshine Studio

Carolyn Concho - Courtesy of
Georgiana Kennedy Simpson
Kennedy Indian Arts, Bluff, UT

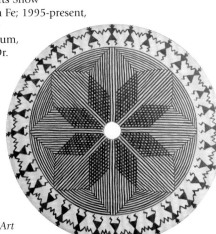

Carolyn Concho - Photograph by Bill Bonebrake
Courtesy of Jill Giller
Native American Collections, Denver, CO

Celeste Concho

(Acoma, active ?-1990+: polychrome jars, bowls)
PUBLICATIONS: Dillingham 1992:206-208.

Cyrus Concho *(signs LC/CC Acoma N.M.)* *(collaborates with Lorianne Concho)*

(Acoma, active ca. 1985-present: ceramic polychrome & sgraffito jars, bowls)
BORN: February 25, 1944
FAMILY: related to Lorianne Concho
GALLERIES: Rio Grande Wholesale, Inc., Palms Trading Co., Albuquerque
PUBLICATIONS: Berger & Schiffer 2000:109.

Daisy Concho

(Acoma, active ?-1990+: polychrome jars, bowls)
PUBLICATIONS: Dillingham 1992:206-208.

Elaine Concho

(Acoma, active ?-present: pottery)
EXHIBITIONS: 1999-present, Eight Northern Indian Pueblos Arts & Crafts Show

Eva G. Concho *(signs E. Concho, Acoma N.M.)*

(Acoma, active ca. 1994-present: Mimbres Revival black-on-white, fineline, traditional & ceramic polychrome jars, bowls, seed pots)
BORN: March 28, 1966; RESIDENCE: Acomita, NM
FAMILY: daughter of Floyd & Angela Concho
TEACHER: her grandmother & in-laws
COLLECTIONS: Johanna Leibfarth, South Carolina; John Blom
FAVORITE DESIGNS: Mimbres animals, lizards, bugs, clouds, lightning, rain
GALLERIES: Rio Grande Wholesale, Inc., Palms Trading Co., Albuquerque
PUBLICATIONS: Schiffer 1991d:53; Berger & Schiffer 2000:110.

*E. Concho -
Johanna Leibfarth Collection, SC*

Frances Patricio Concho *(Frances Patricio, Frances M. Concho), (signs Frances Concho Acoma), (collaborates with Isidore Concho)*

(Acoma, active ca. 1957-present: traditional polychrome jars, bowls)
BORN: July 15, 1947 or July 16, 1948; RESIDENCE: San Fidel, NM
FAMILY: daughter of Jose & Helen Patricio; wife of Isidore Concho; mother of Marietta P. Juanico & Norbert L. Patricio
TEACHERS: Jose & Helen Patricio, her parents
STUDENTS: Marietta P. Juanico, her daughter
AWARDS: Best of Show, New Mexico State Fair, Albuquerque
GALLERIES: The Indian Craft Shop, U.S. Department of Interior, Washington, D.C.; Rio Grande Wholesale, Inc., Palms Trading Co., Albuquerque
PUBLICATIONS: Dillingham 1992:206-208; Painter 1998:10; Berger & Schiffer 2000:110.

Isidore Concho *(collaborates with Frances Patricio Concho)*

(Acoma, active ca. 1960s-present: traditional polychrome jars, bowls)
BORN: ca. 1940s; RESIDENCE: San Fidel, NM
FAMILY: husband of Frances Patricio Concho; father of Marietta P. Juanico & Norbert L. Patricio
PUBLICATIONS: Dillingham 1992:206-208; Painter 1998:10.

John Concho *(signs John C. Acoma N.M.)*

(Acoma, active ca. 1996-present: ceramic polychrome jars, bowls)
BORN: April 9, 1964
FAMILY: son of Domingo Concho
TEACHER: his mother

Juana Concho

(Acoma, active ca. 1900-?: traditional polychrome jars, bowls)
BORN: ca. 1880
FAMILY: mother of Juana Pasqual; grandmother of Blanche Antonio
PUBLICATIONS: Reno 1995:9.

Lehta Concho

(Acoma, active ?: pottery)
GALLERIES: River Trading Post, East Dundee, IL

Lillian Concho

(Acoma, active ca. 1975-1990)
PUBLICATIONS: Minge 1991:195; Dillingham 1992:206-208.

*Lehta Concho -
Courtesy of Joe Zeller
River Trading Post, East Dundee, IL*

Lillie Concho
(Acoma, active ?-present: polychrome jars, bowls)
FAMILY: wife of Gilbert Concho; mother of Melissa C. Antonio

Lilly Concho
(Acoma, active ?-present: black-on-redware jars, bowls, seed pots)
FAVORITE DESIGNS: lizards

Lisa Concho
(Acoma, active ?: pottery)
PUBLICATIONS: Peaster 1997:16.

Lolita Concho *(sometimes signs L. Concho)*
(Acoma, active ca. 1930s-76+: traditional polychrome & Tularosa Revival, black-on-white fineline, jars, bowls, vases, canteens)
BORN: ca. 1910s
FAMILY: sister of Frances Pino Torivio, Juanita Keen, Katherine Analla, Concepcion Garcia; mother of Peter Concho & Shirley Concho; mother-in-law of Dorothy Torivio
STUDENTS: Dorothy Torivio, her daughter-in-law
AWARDS: 1970, 1st; 1976, 2nd; 1978, 3rd; 1980, 3rd; 1983, 1st, Indian Market, Santa Fe
COLLECTIONS: Philbrook Museum of Art, Tulsa, OK, jar, ca. 1984; Rick Dillingham Collection, School of American Research, Santa Fe; Sunshine Studio
EXHIBITIONS: 1973-88, Indian Market, Santa Fe; 1979, "One Space: Three Visions," Albuquerque Museum, Albuquerque
FAVORITE DESIGNS: parrots, flowers, berry bushes, frets, fineline rain
VALUES: On May 26, 1999, a large polychrome olla (15 1/2" dia.), signed L. Concho, sold for $3,450, at Sotheby's, #57.
PUBLICATIONS: *Indian Market Magazine* 1973-1988; *SWAIA Quarterly* Fall 1973:2; Fall 1976:13; Fall 1982:10; *Arizona Highways* May 1974:40; Tanner 1976:123, 207; Dillingham 1977:50, 84; Barry 1984:89; Coe 1986:207; Minge 1991:195; Cohen 1993:122; Dillingham 1992:206-208.

*Lolita Concho -
Courtesy of Sunshine Studio*

Lolita Concho was a respected, prize-winning potter. Since her own daughter, Shirley, decided not to be a full time potter, Lolita's polishing stone, four base bowls & her red paint were inherited by her daughter-in-law, the famous Dorothy Torivio.

Art historian Roberta Bennett related a time when Dorothy and sister Juanita Keene, along with Lolita, all went to the Wheelwright Museum to examine old Pueblo pottery. Lolita identified old design elements: "the sawtooth representing the mesas, the red dots and lines representing rain and snow." (Cohen 1993:122)

Rick Dillingham collected one of her pots, a five-color polychrome olla with a parrot design made in 1976. He illustrated it in his 1977 article, "The Pottery of Acoma Pueblo," *American Indian Art Magazine.*

Lolita Concho - Courtesy of Sunshine Studio

Lorianne Concho *(Loriane, L. Concho), (collaborates with Cyrus Concho), (signs LC/CC Acoma N.M.)*
(Acoma, active ca. 1985-present: ceramic polychrome, sgraffito jars, bowls, clay sculptures)
BORN: November 22, 1964; RESIDENCE: Milan, NM
PUBLICATIONS: Dillingham 1992:206-208.

Lupe Concho
(Acoma, Yellow Corn Clan, active ca. 1940s-80s+: traditional polychrome jars, bowls)
BORN: ca. 1920s
FAMILY: daughter of Pueblo & Maria Garcia; wife of John Concho; mother of Rita Malie, Florence Waconda, Ruby Shrulote, Doris Patricio; grandmother of Beverly Victorino, Tanya, Denise, Darcy Malie, Tyler Malie
STUDENTS: Florence Waconda & Rita Malie, her daughters; Beverly Victorino, her granddaughter

Pablita Concho
(Acoma, active ca. 1975-1990)
GALLERIES: Rio Grande Wholesale, Inc., Palms Trading Co., Albuquerque
PUBLICATIONS: Minge 1991:195; Dillingham 1992:206-208; Berger & Schiffer 2000:110.

Pat Concho
(Acoma, active ?-1990+: polychrome jars, bowls)
PUBLICATIONS: Dillingham 1992:206-208.

Rachel Concho *(Rachael, Rose), (signs R. Concho, Acoma)*

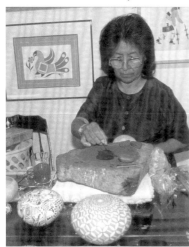

(Acoma, Roadrunner/Eagle Clan, active ca. 1958-present: black-on-white jars, bowls, plates, seed pots, fineline)
BORN: January 1, 1936; RESIDENCE: San Fidel, NM
FAMILY: daughter of Santana Cimmeron Cerno; sister of Joseph Cerno, Sr.; mother of Lisa Concho
AWARDS: Best of Show, Indian Market, Santa Fe; 2000, Best of Traditional Pottery,1st, 2nd & 3rd, Eight Northern Indian Pueblos Arts & Crafts Show
EXHIBITIONS: 1972-present, Indian Market, Santa Fe; 1971-present, Eight Northern Indian Pueblos Arts & Crafts Show
DEMONSTRATIONS: Wheelwright Museum, Case Trading Post, Santa Fe
COLLECTIONS: Sunshine Studio; John Blom; Gerald & Laurette Maisel, Tarzana, CA; Dr. Gregory & Angie Van Schaaf
FAVORITE DESIGNS: Mimbres animals, four petal opticals
GALLERIES: Rio Grande Wholesale, Inc., Palms Trading Co., Albuquerque
PUBLICATIONS: *Indian Market Magazine* 1985-1996; *The Messenger,* Wheelwright Museum Summer 1990:cover, 2; Fall 1994:11; Dillingham 1992:206-208; Hayes & Blom 1996:52-53; *Indian Artist* Summer 1996:73; Peaster 1997:16-17; *Santa Fean* Aug. 1998:74; *Cowboys & Indians* Nov. 1999:93; Berger & Schiffer 2000:110; *Southwest Magazine* August 2001

Rachel Concho -
Courtesy of Sunshine Studio

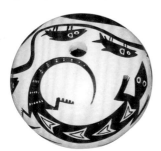

Rachel Concho -
Courtesy of Paula McDonald
Kiva Fine Arts, Santa Fe

For over four decades, Rachel Concho has created some of the thinnest Acoma pottery. Her work is very fine. Her painting features Mimbres animal designs. In 1992-93, Rachel Concho was commissioned to make 450 pots for the Coca-Cola corporation. She is prolific.

Rachel exhibited at Indian Market before 1985. Her contributions to Pueblo Indian pottery have been published in many books and magazines.

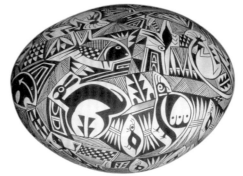

Rachel Concho -
Dr. Sally Archer &
Dr. Al Waterman Collection
Yardley, PA

Rachel Concho -
Andrea Fisher Fine Pottery, Santa Fe

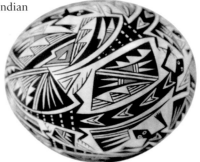

Rachel Concho -
Courtesy of Blue Thunder Fine Indian Art at
www.bluethunderarts.com

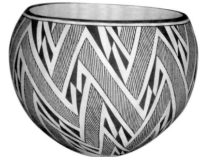

Rachel Concho -
Andrea Fisher Fine Pottery, Santa Fe

Rebecca Concho

(Acoma, active ?-1990+: polychrome jars, bowls)
PUBLICATIONS: Dillingham 1992:206-208.

Santana Concho

(Acoma, active ?-1990+: polychrome jars, bowls)
PUBLICATIONS: Dillingham 1992:206-208.

Sheila Concho

(Acoma, active ?-present: traditional & contemporary polychrome jars, bowls)
PUBLICATIONS: Dillingham 1992:206-208; Reano 1995:35.

Sheila Concho has experimented with adding painted designs after firing some pottery. She also makes traditional black-on-white pots.

Erika Cooeyate

(Zuni, active ca. 1990s-present: traditional polychrome ollas, jars, bowls)
FAVORITE DESIGNS: deer-in-his-house, flowers, rain

Maria Coowai

(Acoma, active ca. 1880s-1910s+: polychrome jars, bowls)
BORN: ca. 1865; RESIDENCE: Acomita in ca. 1910
PUBLICATIONS: Leopold Bibo, "13th Annual U.S. Census" (1910), New Mexico State Archives, Call T624, Roll 919; in Dillingham 1992:205.

Maria Cooyaitie

(Acoma, active ca. 1860s-1910s+: polychrome jars, bowls)
BORN: ca. 1845; RESIDENCE: Acomita in ca. 1910
PUBLICATIONS: Leopold Bibo, "13th Annual U.S. Census" (1910), New Mexico State Archives, Call T624, Roll 919; in Dillingham 1992:205.

Maria Corai

(Acoma, active ca. 1880s-1910s+: polychrome jars, bowls)
BORN: ca. 1865; RESIDENCE: Acomita in ca. 1910
PUBLICATIONS: Leopold Bibo, "13th Annual U.S. Census" (1910), New Mexico State Archives, Call T624, Roll 919; in Dillingham 1992:205.

Lorencita Cordera *(see Lorenza Cordero)*

Antonita Cordero *(see Toni Suina)*

Berina Cordero *(Berena Herrera)*

(Cochiti, Fox Clan, active ca. 1930s-?: traditional polychrome jars, bowls, figures)
BORN: December 13, 1911
FAMILY: daughter of Juan & Estefanita Herrera; sister of Felipa Trujillo, Tonita, Candelaria & Santiago Herrera; wife of Elutero Cordero; mother of Ada Suina, Snowflake Flower, Polly Cordero, Mary Cordero, Joe Cordero & Frances Cordero
PUBLICATIONS: U.S. Census 1920, family 42.

Buffy Cordero *(Elizabeth Buffy Cordero-Suina, Elizabeth M. Suina)*

(Cochiti, active ca. 1985-present: traditional polychrome Storytellers, figures, drummers, animals, turtles, jars, bowls)
BORN: November 28, 1969
FAMILY: great-great granddaughter of Magdelena & Santiago Quintana; p. great-granddaughter of Santiago & Lorenza Cordero; m. granddaughter of Fred & Helen Cordero; daughter of George Cordero & Kathy Cordero
TEACHERS: Helen Cordero, her grandmother, & George Cordero, her father
EXHIBITIONS: pre-1988-present, Indian Market, Santa Fe
PUBLICATIONS: Babcock 1986; *American Indian Art Magazine* Autumn 1986 11(4):73; *The Messenger*, Wheelwright Museum Fall 1992:9; Bahti 1996:2, 34; Peaster 1997:25; Peterson 1997; *Native Peoples* Aug./Oct. 1997 10(4):78; Congdon-Martin 1999:33.

 Buffy Cordero learned to make pottery from her famous grandmother, Helen Cordero, and her father. George Cordero. She strongly influenced her family's style and techniques. Buffy was a good student who became an excellent potter in her own right.

Buffy Cordero -
Courtesy of John D. Kennedy and
Georgiana Kennedy Simpson
Kennedy Indian Arts

Damacia Cordero

(Cochiti, active ca. 1920s-?: traditional polychrome jars, bowls, figures, effigies, dinosaur figures)
BORN: ca. 1905
FAMILY: daughter of Lucinda Suina; 2nd wife of Santiago Cordero (1876-?); mother of Josephine Arquero, Gloria Herrera, Marie Laweka, Martha Arquero
STUDENTS: Martha Arquero, Josephine Arquero, Marie Laweka & Dorothy Trujillo
EXHIBITIONS: 1999, "Clay People," Wheelwright Museum, Santa Fe
COLLECTIONS: Allan & Carol Hayes, John Blom; Dr. Gregory & Angie Yan Schaaf, Santa Fe
GALLERIES: Adobe Gallery, Albuquerque & Santa Fe; Cowboy & Indians, Albuquerque; Case Trading Post at the Wheelwright Museum, Santa Fe
PUBLICATIONS: Arnold 1982:cover, 599; *American Indian Art Magazine* Spring 1983 8(2):30-31, 36, 42; Babcock 1986; Trimble 1987:59-60; Hayes & Blom 1996:60-61; 1998:43, 53; Batkin 1999:83; Congdon-Martin 1999:10.

Damacia Cordero -
Eason Eige, Albuquerque

George Cordero *(collaborated sometimes with Helen Cordero)*

(Cochiti, Fox Clan, active ca. 1970s-90: polychrome jars, bowls, Storytellers (ca. 1982-90), drummers, figures, turtles)
LIFESPAN: September 24, 1944 - 1990
FAMILY: great-grandson of Santiago Quintana Magdelena Quintana; grandson of Caroline Pecos, son of Helen Cordero; brother of Toni Suina; husband of Kathy Cordero; father of Buffy Cordero
EXHIBITIONS: pre-1985-1989, Indian Market, Santa Fe
VALUES: On October 10, 1997, a polychrome Turtle signed Helen & George Cordero (5 x 8 x 5"), sold for $3,025 at R. G. Munn, #1272.
PUBLICATIONS: *Indian Market Magazine* 1985, 1988, 1989; *The Messenger*, Wheelwright Museum Summer 1990:2; *American Indian Art Magazine* Autumn 1998 23(4):20; Congdon-Martin 1999:10.
George Cordero learned to make Storytellers and other figures from his mother, the famous Helen Cordero. His style is strongly influenced by his mother. Sometimes it is hard to tell them apart, until you look at the signature on the bottom.

George Cordero - Courtesy of Dave & Lori Kenney

Helen Cordero *(Helen Quintana Cordero)*

Helen Cordero

(Cochiti, Fox Clan, active ca. 1950s-?: polychrome jars, bowls,
Singing Mother figures (ca.1950s-1963), Storytellers (1964-1994),
Nativities, drummers, beadwork)
LIFESPAN: June 17, 1915 - July 24, 1994
FAMILY: p.granddaughter of Santiago Quintana & Magdelena
Quintana; daughter of Mr. Quintana & Caroline [Quintana]
Pecos; sister of Trinidad Herrera; wife of Fred Cordero; mother of
Dolores Peshlakai, Jimmy Cordero, Antonita "Toni" Suina, George
Cordero, Leonard Trujillo (adopted); grandmother of Buffy Cordero,
Tim Cordero, Tia Cordero, Kevin Peshlakai, Ivan Trujillo, Evon
Trujillo, Roberta Trujillo, Jeanette Trujillo, Del Trancosa
TEACHER: Juanita Arquero, her husband's cousin
AWARDS:

1964	1st, 2nd, 3rd, New Mexico State Fair, Albuquerque
1965	1st, Indian Market, Santa Fe
1968	1st, Heard Museum Show, Phoenix
1969	1st, 2nd, Heard Museum Show
1971	1st, Traditional Pottery, Indian Market, Santa Fe
	Best of Show, 1st, 2nd, Heard Museum Show
1974	Honorable Mention, 12th Annual Scottsdale National Indian Arts Show, Scottsdale
1981	1st (2), Indian Market, Santa Fe

*Helen Cordero -
Don & Lynda Shoemaker Collection*

1982	Governor's Award for Excellence and Achievement in the Arts - Pottery, Indian Market, Santa Fe
1986	National Endowment for the Arts, National Heritage Fellowship, Washington, D.C.
1987	John R. Bott Memorial Award, Best Cochiti Storyteller, Indian Market, Santa Fe
1988	1st, Storytellers, Indian Market, Santa Fe
1994	Timeless Impression Award, Heard Museum, Phoenix

EXHIBITIONS:

1960	Santo Domingo Feast Day, Santo Domingo Pueblo, NM
1965-71	Indian Market, Santa Fe
1969	Indian Arts and Crafts Exhibition," Heard Museum, Phoenix
1970	Heard Museum Indian Fair, Phoenix, AZ
1971	"Helen Cordero and Her Little People," Heard Museum, Phoenix
1973	"Helen Cordero," The Hand and the Spirit Gallery, Scottsdale, AZ; "What is Folk Art?" Museum of International Folk Art, Santa Fe
1974	"World Craft Council Exhibition," Toronto, Ontario; 12th Annual Scottsdale National Indian Arts Exhibition,"Scottsdale, AZ
1975	"Women's Work," The Hand and The Spirit Crafts Gallery, Scottsdale, AZ
1976	"Helen Cordero," Heard Museum, Phoenix
1978	"Clay," Heard Museum, Phoenix
1979	"One Space, Three Visions," Albuquerque
1979-83	"Storyteller Show," Adobe Gallery, Albuquerque
1980	"Helen Cordero," Gallery 10, Scottsdale, AZ
1981	"American Indian Art of the 1980s," Native American Center for the Living Arts, Niagara Falls, NY; Heard Museum Indian Fair, Phoenix
1982	"Tales for All Seasons," Wheelwright Museum, Santa Fe; "Cochiti Pueblo Storyteller," Adobe Gallery, Albuquerque
1985	"Helen Cordero, James Little" Lovena Ohl Gallery, Scottsdale, AZ; "Larry Golsh, Helen Cordero," Lovena Ohl Gallery, Scottsdale, AZ
1988	"American Indian Art: The Collecting Experience," Elvehjem Museum of Art, University of Wisconsin, Madison
1989	"The Galbraith Collection of Native American Art," Heard Museum, Phoenix
1991	"2,000 Years of Contemporary New Mexico Ceramics," Jonson Gallery, University of New Mexico, Albuquerque Heard Museum Show, Phoenix
1994	"Timeless Impressions," Heard Museum, Phoenix
1995	"American Indian Art Magazine 20th Anniversary Exhibit," Heard Museum, Phoenix; "Dancing Across Time: Indian Images of the Southwest," American Contemporary Arts, San Francisco
1997	"Recent Acquisitions from the Herman and Claire Bloom Collection," Heard Museum, Phoenix
1998	"The Legacy of Generations: Pottery by American Indian Women," Heard Museum, Phoenix

*Helen Cordero -
Andrea Fisher Fine Pottery, Santa Fe*

DEMONSTRATIONS: 1974, Pecos National Monument, Pecos, New Mexico; Idyllwild Arts, Idyllwild, California
COLLECTIONS: Smithsonian Institution, Washington, D.C.; Heard Museum, Phoenix; Museum of New Mexico, Museum of
International Folk Art, Santa Fe; Museum of Northern Arizona, Flagstaff, Storyteller,
ca. 1965; Dave & Lori Kenny, Santa Fe; Mr. & Mrs. James R. Rapp; Katherine H.
Rust Children's Collection; D & I Investment Company; Allan & Carol Hayes
VALUES: On May 17, 2000, a polychrome Storyteller, signed Helen Cordero,
(12.25″ h.), sold for $13,200, at Sotheby's, #555.
 On May 26, 1999, a polychrome Storyteller, signed Helen Cordero, N. Mex., (7″ h.),
sold for $10,350, at Sotheby's, #64.
 On May 26, 1999, a polychrome Storyteller, signed Helen Cordero, N. Mex., (7.5″ h.),
sold for $11,500, at Sotheby's, #66.
 On May 26, 1999, a polychrome Drummer, signed Helen Cordero, N. Mex., (8.25″ h.),

*Helen Cordero -
Andrea Fisher Fine Pottery, Santa Fe*

sold for $8,050, at Sotheby's, #67.

On November 23, 1998, a polychrome Storyteller, signed Helen Cordero, (5 x 7.5"), sold for $14,950, at Butterfield & Butterfield, #3106.

On October 3, 1998, a polychrome Storyteller, signed Helen Cordero, (9" h.), sold for $9,925, at Skinner, #16.

On October 10, 1997, a polychrome Storyteller signed Helen Cordero (12 x 8 x 11"), sold for $11,000 at R. G. Munn, #1269.

On June 10, 1997, a polychrome Storyteller, signed Helen Cordero, (10.5" h.), sold for $12,650, at Butterfield & Butterfield, #2023.

On Dec. 10, 1996, a polychrome Storyteller, signed Helen Cordero, (9" h.), sold for $5,750, at Butterfield & Butterfield, #597.

On Dec. 7, 1993, a polychrome Storyteller, signed Helen Cordero, (8.5" h.), sold for $8,625, at Butterfield & Butterfield, #247.

GALLERIES: Adobe Gallery, Albuquerque; Ray Dewey Galleries, Santa Fe; Andrea Fisher Fine Pottery

PUBLICATIONS: *Arizona Republic* 1971; *Sunset Magazine* April 1972: cover; *Arizona Highways* May 1974; *New York Times* 1974; Monthan 1975:16-27; 1977:72-76; 1979; Tanner 1976:120-21; Toulouse 1977:76-78; 1986:21-27; *American Indian Art Magazine* Autumn 1977 2(4):72-76; Autumn 1979 2(1):14; Spring 1980 5(2):27; Winter 1981 7(1):29; Spring 1983 8(2):30-32; Summer 1983 8(2):33; Winter 1983 9(1):21; Winter 1985 11(1):20; Autumn 1986 11(4):59; Spring 1987 12(2):62; Autumn 1987 12(4):51; Autumn 1990 15(4):19; Autumn 1992 17(4):27; Autumn 1993 18(4):28; Summer 1994 19(3):21; Winter 1994 20(1):81; Winter 1995 21(1):62-63; Autumn 1995 21(4):20; Summer 1997 22(3)19; Winter 1998 23(1):20; Autumn 1998 23(4):20; Spring 1999 24(2):21; Summer 1999 24(3):24; Autumn 1999 24(4):18; Winter 1999 25(1):24; Summer 2000 25(3):28; *Fourwinds* Winter 1981 2(3):82; Arnold 1982: cover, 599; *Indian Trader* Feb. 1982 13(2):16-18; April 1985 16(4):2, 3, 24; 1994 25(8):10; 1996 27(5):27; July 1997 28(7):27; Aug.1997 28(8):27; Feb. 1999 30(2):6; Babcock 1983:30-39; 1986; Barry 1984:115-16; Coe 1986:199-203; Trimble 1987; Gordon 1988; Eaton 1990:18, 20; Cohen 1993:46-51; Toyk 1993:158; Dillingham 1996:xiv; Bahti 1996:2, 8-9; Hayes & Blom 1996; 1998:33; Peterson 1997:92-99; Hoffman, in Matuz, ed., 1997:127-28; Peaster 1997:25; Schaaf 1998:128; Hoffman in Matuz, ed., 1998"127-28; *Indian Market Magazine* 1998:65; Congdon-Martin 1999:5-6, 10-12; *Native Peoples* Summer 1999 12(4); *Artfocus* Nov./Dec. 1999:10-11.

Helen Cordero -
Courtesy of Dave & Lori Kenney

Helen Cordero's paternal grandfather, Santiago Quintana, is given credit as the inspiration for Helen's famous Storytellers. He was born in 1865. Her grandmother, Magdelena, was born in 1871. They raised at least four children: Reyes T. Romero, Tonita Quintana, Manuel Quintana and Juan Rosario Quintana. Her mother, Caroline, was married first to a Mr. Quintana and later remarried a Mr. Pecos.

In 1932, at the age of 17, Helen Quintana married Fred Cordero, who then was 26. Fred was a drum maker who later inspired Helen's figures of the Drummer. Early in their marriage, they adopted two boys: Gabe Yellowbird Trujillo & Leonard Trujillo. Helen was 29, when she gave birth to George Cordero, and four years later was blessed with a girl, Antonita, who would become known as Toni Suina. Some references make note of another daughter, Anita Suina.

Helen Cordero began her artistic career by sewing beadwork on leather. She explained her beginnings as an artist, "Everyone around me was making beautiful things, and I wanted to do something too."

Helen's dear friend, Juanita Arquero, encouraged her to try her hand at pottery making. Helen started with bowls and jars, but found it was not so easy: "I just couldn't do it. My pots never looked right. I was so discouraged." She and Juanita taught pottery making for a while at a school in Bernalillo, between Cochiti and Albuquerque, where someone planted a seed of an idea by asking about the historic Cochiti figures.

Helen later began making figures in the old Cochiti tradition. She became known for her "Singing Mothers." The artist made a breakthrough, "Suddenly, it was just like a flower blooming. I knew that was what I was meant to do." During the late 1950s and early 1960s, Helen made small figures of animals and birds. She and her husband, Fred Cordero, sold them each summer at the Flagstaff Indian Powwow.

Helen today is credited as the originator of the Storyteller, a popular figure usually portraying a grandmother or grandfather telling stories to the grandchildren. Helen was encouraged to expand her mother and child figures by folk art collector Alexander Girard, who bought Helen's early figures for $7.50 apiece. Today, the same pieces would be valued at perhaps $10,000.

Courtesy of
Dave & Lori Kenney

Helen created her first Storyteller in 1964, inspired by her grandfather, Santiago Quintana, an important consultant on Cochiti oral tradition. The first Storyteller was purchased by Girard and is preserved in the Museum of International Folk Art in Santa Fe. Helen explained, "When people ask me what it is, I tell them it's my grandfather. His eyes are closed because he's thinking and his mouth is open because he's telling stories."

At first, Helen formed the babies by modeling the clay from the body of the main figure. Late in the 1960s, she began making her "little kids" individually, then attaching them to the grandmother or grandfather figure. She started signing her figures, initially with a pen or pencil, then later with a black or dark brown vegetal paint made from the Rocky Mountain Bee plant or wild spinach.

The more articles written on Helen Cordero, the more popular her Storytellers became. Demand grew quickly. Prices began soaring. A competition commenced among museums, collectors, and gallery owners. Top prizes awarded her from the art judges at Indian Market confirmed her prominent place among the best potters. In 1971, she both won Best of Show at Indian Market and was featured in a one-woman show at the Heard Museum in Phoenix. Helen was clearly in the spotlight.

Helen added a cast of characters to her forms: figures praying or smoking, drummers, water carriers, Hopi maidens, as well as owls and turtles covered with baby children. In 1971, she created a composition of several figures gathered around a grandfather telling stories. Helen called the set, "Children's Hour."

From 1977 to the present, Helen Cordero appeared or was mentioned in over 25 issues of *American Indian Art Magazine*. Her fame and recognition as a master artist are well attested. In 1982, one of Helen's Storytellers was illustrated on the cover of *National Geographic Magazine*.

No other American Indian artist ever received such a spotlight. Helen became known around the world.

In 1983, Helen commented, "To make good potteries, you have to do it the right way, the old way, and you have to have a special happy feeling inside. All my potteries come out of my heart. I talk to them. They're my little people. Not just pretty things that I make for money." (*American Indian Art Magazine*)

Over the past 35 years, perhaps more than two hundred potters have followed Helen's lead in creating Storytellers. Her influence first inspired her own family and neighbors at Cochiti. Storytellers soon spread to other Pueblos. Helen's biographer, Barbara Babcock, listed in 1986 Storyteller makers from Acoma, Hopi, Isleta, Jemez, Nambe, San Felipe, San Ildefonso, San Juan. Santo Domingo, Santa Clara, Taos, Tesuque, Zia and Zuni. In later life, Helen concluded, "I guess I really started something."

Lorenza Cordero *(Lorencita Cordero, Cordera)*
(Cochiti, active ca. 1890s-?: traditional polychrome jars, bowls)
BORN: ca. 1874
FAMILY: wife of Santiago Cordero; mother of Ramona Cordero, Eluterio Cordero, Juanita Arquero, Fred Cordero; sister-in-law of Nicanor Cordero; mother-in-law of Helen Cordero & Berina Herrera Cordero; p. grandmother of Ada Suina, Snowflake Flower, Polly Cordero, Mary Cordero, Joe Cordero, Frances Cordero, Anita Suina, Antonita Suina & George Cordero
PUBLICATIONS: U.S. Census 1920, page 417, family 60, #75; *El Palacio* Oct. 16, 1922 8(8):111; Batkin 1987:111.

Seraphina Cordero *(Cordova)*
(Cochiti, ca. 1920s-?: traditional polychrome ollas, jars, bowls)
COLLECTIONS: Philbrook Museum of Art, Tulsa, OK, jar, ca. 1930

Tim Cordero
(Cochiti, active ca. 1980s-present: Storytellers)
BORN: August 25, 1963
FAMILY: great-great grandson of Magdelena & Santiago Quintana; grandson of Fred & Helen Cordero; nephew of George Cordero & Antonita Suina

Toni or Tony Cordero *(see Toni Suina)*

Angel Annette Coriz *(signs A. Coriz), (sometimes collaborates with Ralph Bailon)*
(Santo Domingo/Jemez, active ca. 1992-present: Storyteller necklaces)
BORN: December 5, 1968
FAMILY: daughter of Luciano & Marie Edna Coriz (Jemez)
TEACHER: Marie Coriz
AWARDS: 2nd, New Mexico State Fair, Albuquerque
COLLECTIONS: John Blom
GALLERIES: Bien Mur, Albuquerque
PUBLICATIONS: Babcock 1986:138; Berger & Schiffer 2000:110.

Angelita B. Coriz
(Santo Domingo, active ca. 1940s-present: polychrome jars, bowls)
BORN: ca. 1924
FAMILY: daughter of Diego & Mrs. Beinevieadas; sister of Luciano Beinevieadas, Johnnie Beinevieadas, Reyes Garcia; wife of Raymond S. Coriz (jeweler - Thunderbird necklaces); mother of Anita Harrington, Nancy Chavarria, Bernadette Coriz & Norman Coriz
COLLECTIONS: Wright Collection, Peabody Museum, Harvard University, Cambridge, MA
PUBLICATIONS: Drooker, et al. 1998:67, 139.

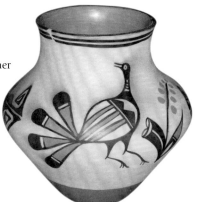

Angelita R. Coriz
(Santo Domingo, active ca. pre-1985-?: polychrome jars, bowls, jewelry, heishi)
EXHIBITIONS: pre-1985-present, Indian Market, Santa Fe
PUBLICATIONS: *Indian Market Magazine* 1985, 1989, 1998:99.

Arthur Coriz *(collaborates with Hilda Coriz) (signs Arthur and Hilda Coriz)*
(Santo Domingo, active 1968-present: traditional polychrome jars, bowls, canteens, jewelry)
LIFESPAN: October 21, 1948 - 1998
FAMILY: husband of Hilda Coriz; father of Ione Coriz
AWARDS: 1992, 2nd, traditional jars; 1993, 2nd, traditional bowls, 3rd, traditional jars; 1996, 3rd; 1998, 2nd, Indian Market, Santa Fe
EXHIBITIONS: pre-1985-1998, Indian Market, Santa Fe; 1994-98, Eight Northern Indian Pueblos Arts & Crafts Show
FAVORITE DESIGNS: deer, bighorn sheep, birds, clouds, flowers
VALUES: On October 16, 1998, a polychrome jar signed Arthur & Hilda (18 x 18"), sold for $1,100 at R. G. Munn, #1024.
GALLERIES: Hoel's Indian Shop, Oak Creek Canyon, AZ
PUBLICATIONS: *Indian Market Magazine* 1985, 1988, 1989; *Southwest Art* Nov. 1990:25; Dillingham 1994:136; Mercer 1995:30, 44; Hayes & Blom 1996:148; 1998; Peaster 1997:144-48; Berger & Schiffer 2000:70, 110; *Native Peoples Magazine* Aug. 2000:87.

Arthur & Hilda -
Courtesy of Hoel's Indian Shop
Oak Creek Canyon, AZ

Arthur learned by watching his wife, Hilda, and her brother, Robert Tenorio. In the beginning, Robert painted his pots. However, within two years, Arthur was painting his own pots and those of his wife.

They made pottery in the traditional way, using natural clays and wild spinach and honey for their black paint. Arthur passed away in 1998, and Hilda continues to make traditional pottery.

Demacia Coriz *(Damacia)*

(Cochiti, active ?: pottery)
ARCHIVE: Laboratory of Anthropology Library, Santa Fe, Lab file.

Edna Coriz

(Jemez/Laguna; married into Santo Domingo, active ca. 1970s-?: polychrome jars, bowls, Nativities)
BORN: ca. 1930s
FAMILY: daughter of Louis Loretto (Jemez) and Carrie Reid (Laguna); sister of Alma Concha & Dorothy Trujillo
PUBLICATIONS: Monthan 1979:86.

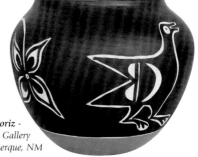

Arthur & Hilda Coriz -
Andrews Pueblo Pottery and Art Gallery
Albuquerque, NM

Hilda Tenorio Coriz *(collaborated with Arthur Coriz) (signed Arthur and Hilda Coriz, now Hilda Coriz)*

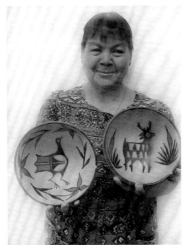

Hilda Coriz -
Courtesy of Jason Esquibel
Rio Grande Wholesale, Inc.

(Santo Domingo, active ca. 1968-present: traditional polychrome jars, bowls, canteens, ornaments, miniatures, jewelry)
BORN: February 7, 1949
FAMILY: m. granddaughter of Clemente & Nescita Calabaza; p. granddaughter of Andrea Ortiz; daughter of Juanita Tenorio; sister of Paulita Pacheco, Robert Tenorio, Mary Edna Tenorio; wife of Arthur Coriz; mother of Ione Coriz
AWARDS: 1983, 3rd; 1984, 1st, canteens; 1988, Best of Class, Best of Division, 1st, 3rd; 1989, 2nd, jars; 1990, Large Pottery Award, Best Traditional Jar or Bowl 15" or larger; 1991, 2nd, traditional jars; 1993, 2nd, traditional bowls, 3rd, traditional jars; 1998, Indian Market, Santa Fe
EXHIBITIONS: pre-1984-present, Indian Market, Santa Fe; 1994-present, Eight Northern Indian Pueblos Arts & Crafts Show
COLLECTIONS: Janie & Paul K. Conner, Santa Fe
FAVORITE DESIGNS: birds, clouds, animals
GALLERIES: Native American Collections, Inc., Denver, Co; Hoel's Indian Shop, Oak Creek Canyon, AZ; Kennedy Indian Arts, Bluff, UT

Hilda Coriz -
Janie & Paul K. Conner Collection

PUBLICATIONS: *Indian Market Magazine* 1985, 1988, 1989; *Southwest Art* Nov. 1990:25; Dillingham 1994:136; Mercer 1995:30, 44; Hayes & Blom 1996:148; 1998; Peaster 1997:144-48; Tucker 1998: plates 104, 105; Berger & Schiffer 2000:70, 110; *Native Peoples Magazine* Aug. 2000:87.

Ione Coriz

(Santo Domingo, active ca. 1990s-present: polychrome ollas, jars, bowls, canteens)
BORN: ca. 1973
FAMILY: m. great-granddaughter of Clemente & Nescita Calabaza; p. great-granddaughter of Andrea Ortiz; granddaughter of Juanita Tenorio; daughter of Arthur & Hilda Coriz
AWARDS: 1988, 3rd, pottery (ages 18 & under); 1989, 2nd, pottery (ages 18 & under), Indian Market, Santa Fe
EXHIBITIONS: 1989-present, Indian Market, Santa Fe; 1995-present, Eight Northern Indian Pueblos Arts & Crafts Show
GALLERIES: Nedra Matteucci Galleries, Santa Fe
PUBLICATIONS: Dillingham 1994:136, 143; Hayes & Blom 1996:148; *The Messenger,* Wheelwright Museum Spring 1996:12; Peaster 1997:147; Tucker 1998: plate 105.

Arthur & Hilda Coriz -
Courtesy of Joe Zeller
River Trading Post, East Dundee, IL

Joseph Coriz

(Santo Domingo, active ?-present: pottery)
EXHIBITIONS: 1997, Eight Northern Indian Pueblos Arts & Crafts Show

Ione Coriz - Courtesy of
Georgiana Kennedy Simpson
Kennedy Indian Arts, Bluff, UT

Juanita R. Coriz

(Santo Domingo, active ca. 1954-present: pottery, embroidery, cross-stitch, jewelry)
BORN: ca. 1939
EXHIBITIONS: 1954, Arts & Crafts Show, Santa Fe Indian School, Santa Fe; pre-1985-present, Indian Market, Santa Fe
PUBLICATIONS: Santa Fe Indian School, *Teguayo* 1954, 1956:89; *Indian Market Magazine* 1985, 1988, 1989, 1998:99; Schaaf 2001:281.

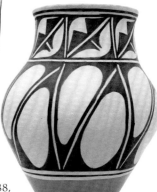

Ione Coriz -
Nedra Matteucci Galleries, Santa Fe

Lupe T. Coriz
(Santo Domingo, active ?-1980s: pottery, beadwork, jewelry)
EXHIBITIONS: ?-1985, Indian Market, Santa Fe

Marcus Coriz
(Santo Domingo, active ca. 1950s-?: traditional polychrome jars, bowls, figures of tourists with cameras)
COLLECTIONS: Philbrook Museum of Art, Tulsa, OK, bowl, figure of tourist with camera, ca. 1960

Marie D. Coriz *(1)*
(Santo Domingo, ca. 1920s-?: traditional polychrome jars, bowls, textiles, woven belts)
COLLECTIONS: School of American Research, Santa Fe, sash, ca. 1948, #T689.
PUBLICATIONS: *American Indian Art Magazine* Autumn 1985 10(4):31; Batkin 1987:202, n. 83; Schaaf 2001:281.
> Museum director Kenneth M. Chapman gave her a set of Santo Domingo pottery designs he had compiled in the 1930s.

Marie Edna Coriz *(2)* *(Marie Edna Loretto)*
(Jemez, married into Santo Domingo, ca. 1970s-present: Storytellers, traditional polychrome jars, bowls)
BORN: February 3, 1946
FAMILY: daughter of Louis & Carrie R. Loretto; sister of Mary Toya, Alma Maestas Concha, Leonora Lupe L. Lucero, Fannie Loretto & Dorothy Trujillo; wife of Luciano Coriz; mother of Angel Annette Coriz
PUBLICATIONS: Babcock 1986:57, 58, 61, 91, 138-44, 147-49; Eaton 1990:21; *Indian Artist* Winter 1996 2(1):53, 55; Congdon-Martin 1999:63; Berger & Schiffer 2000:110.
> Marie Edna Coriz expressed what Storytellers mean to her: "Storytellers show that Indian people have a lot of character and would like to share their humanity and pride with all people. Stories are important to us because that is our way of life. . ." (Babcock 1986:58)

Martin Leo Coriz
(Santo Domingo, active ca. 1990s-present: polychrome jars, bowls)
BORN: July 3, 1988
FAMILY: great-grandson of Reyes & Ventura Reano; grandson of Tonita R. Lovato & Ike Lovato, Sr.; son of Corine Lovato; brother of Merlinda Coriz

Mary J. Coriz
(Santo Domingo, active ?-1980s: pottery, jewelry)
EXHIBITIONS: pre-1982-1985, Indian Market, Santa Fe
PUBLICATIONS: *SWAIA Quarterly* Fall 1982 17(3):9; *Indian Market Magazine* 1985.

Merlinda Coriz
(Santo Domingo, active ca. 1990s-present: polychrome jars, bowls)
BORN: July 1, 1992
FAMILY: great-granddaughter of Reyes & Ventura Reano; granddaughter of Tonita R. Lovato & Ike Lovato, Sr.; daughter of Corine Lovato; sister of Martin Leo Coriz

Olivia Coriz
(Santo Domingo, active ca. 1994-present: blackware jars, vases, pitchers, seed jars, jewelry, quillwork)
BORN: November 5, 1974
TEACHERS: Robert Tenorio, Preston Duwyenie, Diego Romero
EXHIBITIONS: 1999-present, Indian Market, Santa Fe

Cornstalk hallmark *(see Glendora Fragua)*

Andrea Corpus
(Acoma, active ?: pottery)
ARCHIVES: Artist File, Heard Museum Library, Phoenix
PUBLICATIONS: *Indian Trader* Feb. 1996:13.

Prudy Correa
(Acoma, active 1980s-present: polychrome jars, bowls, sculptures)
AWARDS: 1998, 1999, Indian Market, Santa Fe
EXHIBITIONS: 1992-present, Indian Market, Santa Fe; 1994-present, Eight Northern Indian Pueblos Arts & Crafts Show
PUBLICATIONS: Dillingham 1992:206-208; Painter 1998:10.

Coyote *(Tim Smith)*
(Laguna/Hopi, active ca. 1977-present, traditional pottery)
BORN: November 4, 1954
FAMILY: son of Dennis & Katherine Smith
PUBLICATIONS: Berger & Schiffer 2000:148.

Terecita Crespin

(Santo Domingo, active ?-present: pottery, jewelry, sewing)
EXHIBITIONS: pre-1985-present, Indian Market, Santa Fe
PUBLICATIONS: *Indian Market Magazine* 1985, 1988, 1998.

Felicia Fragua Curley *(Felicia Fragua, Wallowing Bull), (signs F. Fragua or Felicia A. Curley)*

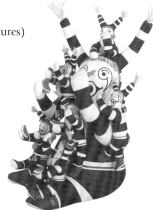

(Jemez, Eagle Clan, active, ca. 1978-present: polychrome jars, bowls, Storytellers - Mudheads, humans, animals, figures, Nativities, bowls, miniatures)
BORN: October 23, 1964
FAMILY: m. granddaughter of Emilia & Carmelito Loretto; daughter of Felix & Grace Loretto Fragua; sister of Rose T. Fragua; wife of Mike J. Curley; mother of Ardina Fragua, Tarasina Wallowing Bull, Loren Wallowing Bull
TEACHERS: Bonnie Fragua, Rose Fragua & Grace Fragua, her mother
AWARDS: 2000, 1st, 2nd; 1999, 3rd, Eight Northern Indian Pueblos Arts & Crafts Show
FAVORITE DESIGNS: Mudheads, dogs, Mice
GALLERIES: The Indian Craft Shop, U.S. Department of Interior, Washington, D.C.; Andrews Pueblo Pottery & Art Gallery; Turquoise Lady
PUBLICATIONS: Babcock 1986; Peaster 1997:69, 72; Congdon-Martin 1999:64; Hayes & Blom 1998:35; Schiffer 1999d; Berger & Schiffer 2000:82, 114.

Felicia Fragua - Courtesy of Kennedy Indian Arts, UT

> Felicita Fragua proclaimed her main goal, "Keeping the Pueblo way of life alive and strong!!!"
> She explained that pottery making is a "family tradition." She pointed out that her pottery is all "handmade" and her materials were "all natural from the Earth." She spoke with pride for being "self-employed" as a potter since age fifteen.

Dalawepi *(see Ergil F. Vallo)*

Tony Dallas

(Hopi, married into Cochiti, active ca. 1982-present: Mudhead & Clown Storytellers, figures, sculptures)
BORN: March 23, 1956
FAMILY: grandson-in-law of Helen Cordero; son of Patrick & Marietta Dallas
TEACHER: Lucy Suina, his mother-in-law
GALLERIES: Bien Mur, Albuquerque; Andrews Pueblo Pottery and Art Gallery, Albuquerque

Marquis Dann *(Lente)*

(Laguna/Hopi, Water/Kachina Clan, active ca. 1986-present: polychrome pottery)
BORN: August 23, 1970; RESIDENCE: Keams Canyon, AZ
FAMILY: daughter of Floyd Dann, Jr., Sandra J. Lente
TEACHER: Preston Duwyenie (Hopi), May Chavez (Acoma)

> Marquis Dann shared, "I enjoy working with the clay and painting my pots. It makes me happy! I enjoy meeting people who like my work."

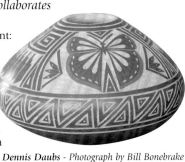

Theresa Darnell

(Acoma, active ?-present: polychrome jars, bowls)
EXHIBITIONS: ?-present: Indian Market, Santa Fe

*Tony Dallas -
Andrews Pueblo Pottery and Art Gallery
Albuquerque, NM*

Dennis Daubs *(Oboweya - Early morning runner before the Kachina Dance), (collaborates sometimes with Glendora Daubs)*

(Jemez/San Ildefonso, Eagle Clan, active ca. 1978-present: stone polished redware sgraffito jars, bowls, seed pots, miniatures)
BORN: December 15, 1960
FAMILY: son of Gerri Gachupin Daubs; brother of Patricia & Steve Daubs
TEACHER: Juanita Fragua
AWARDS: 1979, Art Mart, Denver; 1982, 1984, 1st, 3rd, sgraffito, Indian Market, Santa Fe; 1986, Eight Northern Indian Pueblos Arts & Crafts Show; 1987, Las Vegas Art Show; Heard Museum Show, Phoenix; New Mexico State Fair, Albuquerque
COLLECTIONS: Charlotte Schaaf, Santa Fe
FAVORITE DESIGNS: Mimbres animals, beetles, feathers-in-a-row, spirals, frets, zigzags
GALLERIES: Native American Collections, Inc., Denver, CO; Turquoise Tortoise, Sedona, AZ
PUBLICATIONS: *American Indian Art Magazine* Spring 1984 9(2):72; Schiffer 1991d:49; Hayes & Blom 1996:82-83; Berger & Schiffer 2000:110.

*Dennis Daubs - Photograph by Bill Bonebrake
Courtesy of Jill Giller
Native American Collections, Denver, CO*

*Dennis Daubs - Courtesy of Jason Esquibel
Rio Grande Wholesale, Inc.*

> Dennis Daubs is a dynamic pottery artist who specializes in polished redware and blackware with sgraffito designs. The quality of his carving is exceptional. His compositions are complex and his eye for small details sets his work apart. His work is unique.
> Dennis explained, "I use a different design on every piece of pottery that I make and each one is a challenging and rewarding one to complete."

Gerri Daubs

(Jemez, active ?-present: pottery)
GALLERIES: Rio Grande Wholesale, Inc. Albuquerque, NM

Glendora Fragua Daubs *(Glendora Fragua), (signs Cornstalk hallmark), (collaborates sometimes with Dennis Daubs)*

(Jemez, Corn Clan, active ca. 1976-present: redware & tanware sgraffito jars, bowls)
BORN: September 12, 1958
FAMILY: daughter of Manuel & Juanita Fragua
AWARDS: 1984, 1st, 3rd, sgraffito; 1988, 2nd, sgraffito; 1989, 2nd, sgraffito; 1990, 2nd, other sgraffito, 3rd, sgraffito with stones; 1992, 1st, 2nd, sgraffito; 1993, 2nd, sgraffito; 1999, Indian Market, Santa Fe; New Mexico State Fair, Alb.; Inter-tribal Indian Ceremonial, Gallup
EXHIBITIONS: 1985-present, Indian Market, Santa Fe; 1997-present, Eight Northern Indian Pueblos Arts & Crafts Show
COLLECTIONS: Philbrook Museum of Art, Tulsa, OK, jar, ca. 1985; Gerald & Laurette Maisel, Tarzana, CA
FAVORITE DESIGNS: lizards, flowers, corn plants, feathers, butterflies
GALLERIES: The Indian Craft Shop, U.S. Department of Interior, Washington, D.C.; Turquoise Tortoise, Sedona, AZ (ca. 1984-?); Case Trading Post at the Wheelwright Museum , Santa Fe; Adobe Gallery
PUBLICATIONS: *American Indian Art Magazine* Spring 1984 9(2):72; Summer 1984 9(3):25; Winter 1998 24(1):86; Trimble 1987:67; Gussie Fauntleroy, "Potter tells it was meant to be: Daubs follows tradition — with twist," *New Mexican* (August 20, 1992); Hayes & Blom 1996:82-83; Peaster 199761-64; *Cowboys & Indians* Nov. 1999:95; Sep. 2000 8(4):94; Berger & Schiffer 2000:82, 114.

> Glendora Fragua Daubs is respected "at the top of the ladder among Jemez potters." Her polished redware sgraffito pottery has won numerous awards. Her style finds its roots among her Tewa cousins, Tony Da, Camillio Tafoya, Joseph Lonewolf and Grace Medicine Flower. Glendora's work draws more from Jemez traditions, giving her work a unique character.

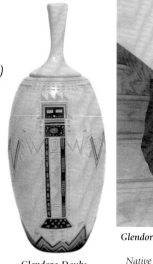

Glendora Daubs - King Galleries of Scottsdale

Glendora Daubs - Photo by Bill Bonebrake Courtesy of Jill Giller Native American Collections, Denver, CO

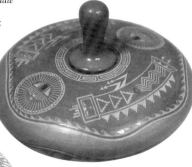

Glendora Daubs - Courtesy of Blue Thunder Fine Indian Art at www.bluethunderarts.com

Manuel Daubs

(Jemez, Corn Clan, active ca. 1990s-present: figures, snakes)
BORN: ca. 1980s
FAMILY: m. grandson of Juanita Fragua; son of Glendora Daubs
PUBLICATIONS: Peaster 1997:62-63.

Glendora Daubs - Photograph by Bill Bonebrake Courtesy of Jill Giller Native American Collections, CO

Patricia Daubs

Patricia Daubs - Courtesy of Jason Esquibel Rio Grande Wholesale, Inc.

(Jemez/San Ildefonso, Eagle Clan, active ca. 1975-present: stone polished tanware & redware sgraffito jars, bowls, seed pots, plates, miniatures)
BORN: ca. 1963
FAMILY: great-granddaughter of Maria Sanchez; granddaughter of Elvira Gachupin; daughter of Gerri Gachupin Daubs; sister of Dennis & Steve Daubs
TEACHER: Steve Daubs, her brother
FAVORITE DESIGNS: Kachinas, Water Serpent, feathers-in-a-row, waves
EXHIBITIONS: 1998-present, Eight Northern Indian Pueblos Arts & Crafts Show
GALLERIES: Native American Collections, Inc., Denver,CO; Rio Grande Wholesale, Albuquerque, NM
PUBLICATIONS: Hayes & Blom 1996

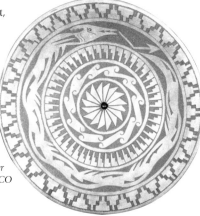

Patricia Daubs - Photograph by Bill Bonebrake Courtesy of Jill Giller Native American Collections, Denver, CO

Steve Daubs

(Jemez/San Ildefonso, Eagle Clan, active ca. 1978-present: stone polished tanware & redware sgraffito jars, bowls, seed pots, miniatures)
LIFESPAN: pre-1960 - ?
FAMILY: great-grandson of Maria Sanchez; grandson of Elvira Gachupin; son of Gerri Gachupin Daubs; brother of Patricia & Dennis
STUDENTS: Patricia Daubs, his sister

Darla K. Davis

(Acoma, Sun Clan, active ca. 1978-present: traditional & contemporary polychrome ollas, jars, bowls)
BORN: August 3, 1960
FAMILY: m. granddaughter of Alice Pancho White & Frank Zieu White; daughter of Rachael & James White; sister of Gilbert R. James, Tamara L. Abeita, Tracy D. Chalan, Hope Taylor, Dewey M. James, Melody J. James; mother of Alicia Kelsey
TEACHERS: Rachael White, her mother, and her grandmother
AWARDS: 1st, Arizona Arts & Crafts Show; 2nd, Navajo Nation Fair, Window Rock; 3rd, Native American Art Show; Indian Market, Santa Fe; Inter-tribal Indian Ceremonial, Gallup, NM
COLLECTIONS: Dr. Gregory & Angie Yan Schaaf, Santa Fe
FAVORITE DESIGNS: Acoma parrots, rainbows, leaves
GALLERIES: The Indian Craft Shop, U.S. Department of Interior, Washington, D.C.; Rio Grande Wholesale, Inc., Palms Trading Co., Albuquerque
PUBLICATIONS: Dillingham 1992:206-208; Painter 1998:10; Berger & Schiffer 2000:111.

Miriam Ortiz Davis *(signs M. Davis, Laguna, N.M.)*

(Laguna, Big Badger/Little Roadrunner Clans; active ca. 1983-present: traditional polychrome jars, bowls)
BORN: December 3, 1952
FAMILY: daughter of Mark Ortiz & Marie Yepa
AWARDS: 1st, 2nd, Colorado Indian Market, Denver
FAVORITE DESIGNS: rain, clouds, stars
GALLERIES: Rio Grande Wholesale, Palms Trading Co., Albuquerque
PUBLICATIONS: Berger & Schiffer 2000:111.

Byran DeLorme

(Acoma, active ?-1990+: polychrome jars, bowls)
PUBLICATIONS: Dillingham 1992:206-208.

Arlan Dempsey *(A. Dempsey)*

(Laguna/Navajo, active ca. 1990s-present: white or grey clay masks, painted with orange clay highlights, feather attachments, dance figures)
EXHIBITIONS: 1994-present, Eight Northern Indian Pueblos Arts & Crafts Show
FAVORITE DESIGNS: Ye'ii Bicheii
GALLERIES: Tanner's Indian Arts, Gallup
PUBLICATIONS: Hayes & Blom 1996:104; Bassman 1996.

Rose DeVore

(Laguna/Jemez?, active ?-present: Storytellers, figures)
GALLERIES: Adobe Gallery
PUBLICATIONS: Bahti 1996:20; Congdon-Martin 1999:127.

Marie Domingo

(Santo Domingo, active ?: Storytellers, pottery)
ARCHIVES: artist file, Heard Museum Library, Phoenix.

Paula Dominguez

(Acoma, active 1990s-present: polychrome jars, bowls)
EXHIBITIONS: 1996-present: Indian Market, Santa Fe
PUBLICATIONS: *Indian Market Magazine* 1996-2000; Painter 1998:10.

Dominguita

(Santo Domingo, active early 20th century: large polychrome ollas, storage jars, bowls)
FAVORITE DESIGNS: deer, antelope, flowers, six pointed stars
GALLERIES: Andrea Fisher Fine Pottery, Santa Fe

Mary Duncan

(Laguna, active ca. 1973-?: traditional polychrome jars, bowls)
EDUCATION: 1973, Laguna Arts & Crafts Project participant

Lus Duran

(Tigua/Ysleta del Sur, active ca. 1990s-?: polychrome jars, bowls)
PUBLICATIONS: *New Mexico Magazine* Dec. 1997:55-57, 60.

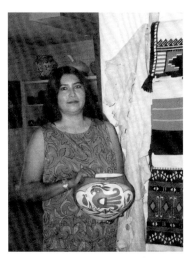

Darla Davis -
Courtesy of John D. Kennedy and
Georgiana Kennedy Simpson
Kennedy Indian Arts

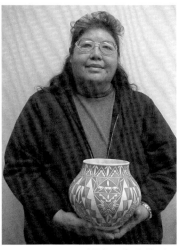

Miriam Ortiz Davis -
Courtesy of Jason Esquibel
Rio Grande Wholesale, Inc.

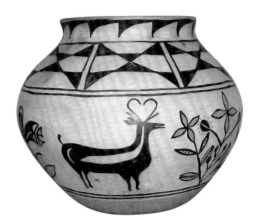

Dominguita -
Andrea Fisher Fine Pottery, Santa Fe

Dyamu

(Laguna, Chaparral Cock Clan, active 1890s?-1920s?: traditional polychrome jars, bowls)
PUBLICATIONS: Parsons 1923:237.

Dyamu was a man-woman or Kokwimu. He lived with his mother in the old Laguna Village before moving to Paraje.

K. E. (see Kimberly Eteeyan)

M. L. E. (see Mary Louise Eteeyan)

Y. E.

(Acoma, active ?-present: black-on-white fineline jars, bowls)
FAVORITE DESIGNS: feather, fineline

Delores Earle

(Laguna, active ca. 1973-?: traditional polychrome jars, bowls)
EDUCATION: 1973, Laguna Arts & Crafts Project participant

Alan Early

(Laguna, active ca. 1990s-present: pottery)
BORN: ca. 1990
FAMILY: great-grandson of Clara Acoya Encino; son of Max & Bertha Martin Early (Cochiti); brother of Maria Rose and David
EXHIBITIONS: 1998-present, Indian Market, Santa Fe

Bertha Martin Early (sometimes collaborates with Max Early)

(Cochiti, active ca. 1991-present: polychrome jars, bowls, canteens, effigy pots, Storytellers)
BORN: November 23, 1964
FAMILY: m. granddaughter of Juanita Arquero; daughter of Mary Martin; formerly wife of Max Early (Laguna); mother of Maria Rose, David and Alan
AWARDS: 1994, 3rd, Storytellers; 1998, Indian Market, Santa Fe
EXHIBITIONS: 1994-present, Indian Market, Santa Fe
PUBLICATIONS: Tucker 1998: plate 108.

Bertha Early reflected, "Looking back, Mother Clay has always been a part of my life and family. My mother, Mary Martin, and grandmother, Juanita Arquero, are both established potters. They are my inspiration. My husband, Max, is from Laguna Pueblo. . .My storytellers have both Cochiti and Laguna designs. They are unique in form and spirit. I look forward to passing this tradition to my own children."

David Early

(Laguna, active ca. 1990s-present: pottery)
BORN: ca. 1990
FAMILY: great-grandson of Clara Acoya Encino; son of Max & Bertha Martin Early (Cochiti); brother of Maria Rose and Alan
AWARDS: 1998, Indian Market, Santa Fe
EXHIBITIONS: 1998-present, Indian Market, Santa Fe

Maria Rose Early

(Laguna, active ca. 1990s-present: pottery)
BORN: ca. 1990
FAMILY: great-granddaughter of Clara Acoya Encino; daughter of Max & Bertha Martin Early (Cochiti); sister of David and Alan
AWARDS: 1998, Indian Market, Santa Fe
EXHIBITIONS: 1998-present, Indian Market, Santa Fe

Max Early (sometimes collaborates with Bertha Martin Early)

(Laguna, Turkey Clan, married into Cochiti, active ca. 1991-present: polychrome jars, bowls, canteens, effigy pots, drums, moccasins)
BORN: August 8, 1963
FAMILY: grandson of Clara Acoya Encino; son of Turkey Clan mother and Bear Clan father; formerly husband of Bertha Martin Early (Cochiti); father of Maria Rose, David and Alan
TEACHERS: Clara Acoya Encino, his grandmother, and Gladys Paquin
AWARDS: 1994, Fellowship Artist, SWAIA; 1998, H.M., Indian Market, Santa Fe; 1995, 4th premium, New Mexico State Fair, Albuquerque
COLLECTIONS: Cincinnati Art Museum, Cincinnati, OH; San Diego Museum of Man, CA; Museum of Indian Art & Culture, Santa Fe; Indian Pueblo Cultural Center, Albuquerque
GALLERIES: Andrea Fisher Fine Pottery, Robert Nichols Gallery, Santa Fe; Rio Grande Wholesale, Inc., Albuquerque
PUBLICATIONS: New Mexico Magazine 1994; Eddington & Makov 1995; Mercer

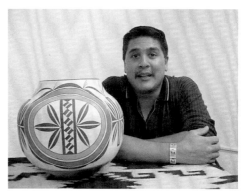

Max Early - Courtesy of Jason Esquibel
Rio Grande Wholesale, Inc.

1995:4, 18-19, 44; *Indian Artist* 1995:22; *SWAIA American Indian News* July 1995; Dillingham 1996; Hayes & Blom 1996:88-89; *Indian Market Magazine* August 1998; Painter 1998:202; Tucker 1998: plate 108.

Max Early was born into the Turkey Clan of his mother and Bear Clan of his father at Laguna Pueblo. He grew up with his grandfather and grandmother, Clara Acoya Encino. Through his teenage years, he painted some of his grandmother's pots. He refined his technique to a personal touch, while maintaining traditional Laguna design symbols and composition. He learned other traditional Pueblo arts including moccasin and drum-making.

Max made few pots in the 1980s, while he attended college. After a decade long interlude, he returned to pottery making. He set a goal for himself to make a large olla. He gathered natural clay and prepared it with great care. He formed the olla coil by coil, scraping and sanding it gently, as he had seen his grandmother do many times. Upon the smooth surface, he painted a traditional Laguna design. Then he called on master potter Gladys Paquin to help teach him how to fire the large pot. He followed her advice, and the great olla successfully survived the fire, "a sign that he was destined to become an artisan."

Max continued to make Laguna style pottery after marrying into Cochiti Pueblo. He and his wife, Bertha Martin Early, have three children: Maria Rose, David and Alan. Max and Bertha are passing their knowledge of pottery making onto their children.

From 1994 to the present, Max continues to be honored as a top prize-winning pottery artist at Indian Market in Santa Fe. He maintains the highest standards of pottery making, helping to preserve and expand Laguna style of form and design. His work is admired and appreciated for the finest in quality. Max concluded, "My life's ambition is to keep this tradition enduring for my children and my people."

Jodi Edaakie

(Zuni, active ?: polychrome jars, bowls, effigy duck pots)
GALLERIES: Kennedy Indian Arts, Bluff, UT

Rita Edaakie

(Zuni, born into the Sand Crane Clan, active ca. 1980s-present, polychrome jars, bowls, owls)
PUBLICATIONS: Hayes & Blom 1998:49.

Jodi Edaakie - Courtesy of Georgiana Kennedy Simpson Kennedy Indian Arts, Bluff, UT

Robert A. Edaakie *(signs R. A. Edaakie)*

(Zuni/Isleta, active ca. 1982-present: polychrome jars, bowls)
BORN: May 16, 1956
FAMILY: son of Ted & Tillie Edaakie
FAVORITE DESIGNS: Kachina faces
PUBLICATIONS: Berger & Schiffer 2000:112.

H. Edwards

(Acoma, active ?-1990+: polychrome jars, bowls)
PUBLICATIONS: Dillingham 1992:206-208.

Josie Edwards

(Acoma, active ?-1990+: polychrome jars, bowls)
PUBLICATIONS: Dillingham 1992:206-208.

Juanita Edwards

(Acoma, active ca. 1940s-?: traditional polychrome pottery)
PUBLICATIONS: *El Palacio* Jan. 1947:13.

Maria Edwards

(Acoma, active ca. 1940s-?: traditional polychrome pottery)
PUBLICATIONS: *El Palacio* Jan. 1947:13.

Rosita Edwards

(Acoma, active ca. 1890s-1910s+: polychrome jars, bowls)
BORN: ca. 1875; RESIDENCE: Acomita in ca. 1910
PUBLICATIONS: Leopold Bibo, "13th Annual U.S. Census" (1910), New Mexico State Archives, Call T624, Roll 919; in Dillingham 1992:205.

Vera Chino Ely *(Vera Chino), (collaborated with Marie Z. Chino)*

(Acoma, active ca. 1960s-?: traditional polychrome & black-on-white fineline jars, bowls, Storytellers)
BORN: ca. 1943
FAMILY: daughter of Marie Z. Chino; sister of Gilbert Chino, Carrie Chino Charlie, Rose Chino Garcia, Grace Chino; mother of Deborah Marie, Mark Lorenzo & Luke Bear
TEACHER: Marie Z. Chino
EXHIBITIONS: 1979, "One Space: Three Visions," Albuquerque Museum, Albuquerque
COLLECTIONS: Wright Collection, Peabody Museum, Harvard University, Cambridge, MA
PUBLICATIONS: Dillingham 1992:206-208; 1994:82.

In the late 1970s, Vera Chino Ely did fineline painting on pots formed by her grandmother, Marie. Z. Chino.

Jerilyn A. Lowden Emanuel *(Gerri, Jerilyn Lowden)*

(Acoma, Sun Clan, active ca. 1980s-present: polychrome jars, bowls, vases, animal figures)
BORN: November 1, 1959
FAMILY: granddaughter of Jessie Garcia; daughter of Anita Garcia Lowden; step-daughter of Elvina Lowden;
sister of Patricia Lowden
PUBLICATIONS: Dillingham 1992:206-208.

Tina Garcia Engle

(Acoma, active ?-1990+: traditional polychrome & black-on-white jars, bowls, vases)
COLLECTIONS: John Blom; Sunshine Studio
FAVORITE DESIGNS: swirling leaves, spirals, flowers
PUBLICATIONS: Dillingham 1992:206-208; Hayes & Blom 1996:54-55.

Kenneth Earl Epaloose

(Zuni, Child of an Eagle/Coyote Clans, active ca. 1998-present: pottery, jewelry)
BORN: March 15, 1994
FAMILY: son of George Epaloose & Noreen Simplicio
EXHIBITIONS: Heard Museum Show, Phoenix, AZ; Indian Market, Santa Fe;
Eight Northern Indian Pueblos Arts & Crafts Show
COLLECTIONS: Museum of Man, San Diego, CA; Dr. Gregory & Angie Yan Schaaf
 Kenneth Epaloose is one of the most successful Pueblo Indian child
artists. He sold out at a recent Heard Museum Show. His mother is the
famous potter, Noreen Simplicio. Kenneth is one of the family's rising stars.

Margaret Eriacho

(Zuni, active ?: pottery)
PUBLICATIONS: *Pueblo Horizons* Fall 1996:6; *Messenger* - Wheelwright Museum
Fall 2000.

Myra Eriacho

(Zuni, active ca. 1930s-?: traditional polychrome jars, bowls, cornmeal bowls, owls)
BORN: ca. 1910s
FAMILY: sister of La Wa Ta, Lonkeena; aunt of Josephine Nahohai
AWARDS: 1972, 2nd, Inter-tribal Indian Ceremonial, Gallup
EXHIBITIONS: 2000, "Rain," Heard Museum, Phoenix, AZ
COLLECTIONS: Wright Collection, Peabody Museum, Harvard University, Cambridge, MA; Heard Museum, Phoenix, AZ
FAVORITE DESIGNS: Deer-in-His-House, deer with heartlines, rosettes, rain, clouds; Kolowisi [Water Serpent], dragonflies
PUBLICATIONS: Babcock 1986:155; Nahohai & Phelps 1995:23; Drooker & Capone 1998:69, 84, 140; *Plateau Journal* Winter
1999:24; Marshall 2000:67.

Marie Erija

(Acoma, active ca. 1900s-?: traditional polychrome jars, bowls)
COLLECTIONS: Philbrook Museum of Art, Tulsa, OK, bowl, ca. 1914

Marjorie Esalio

(Zuni, active ca. 1977-present: polychrome orangeware and tanware ollas, jars, dough bowls, frog effigy canteens, oil paintings, furniture)
FAMILY: mother of five children
TEACHERS: Jennie Laate, Daisy Hooee, Alex Seowtewa, Eileen Yatsattie, Gabriel Paloma
EXHIBITIONS: 1998-present, Indian Market, Santa Fe
 FAVORITE DESIGNS: clouds, rain, Rainbirds, Deer-in-His-House, hummingbirds, swirls
 GALLERIES: Turquoise Village, Zuni, NM
 PUBLICATIONS: Nahohai & Phelps 1995:cover, 78-83; Bassman 1996:28.
 Marjorie Esalio was one of the many students of Jennie Laate. Marjorie also visited with former teacher Daisy
Hooee. She also learned oil painting from Alex Seowtewa at the Learning Center, an alternative high school in the
1970s.
 Marjorie returned to pottery making in the 1980s. Eileen Yatsattie helped her get started again. She and
Marjorie gathered clay at Pia Mesa since 1989. She became especially talented at making big dough bowls up to
18" in diameter.

Ron Esalio *(collaborates with Diane Wade - Isleta/Lakota)*

 (Zuni, active ?-present: polychrome & black-on-red jars, bowls, fetishes)
 FAMILY: son of Randy & Geraldine Esalio
FAVORITE DESIGNS: Kachinas, tadpoles, dragonflies, butterflies, bears

Beatrice Esquibel

(Jemez, active ? -present: Storytellers)

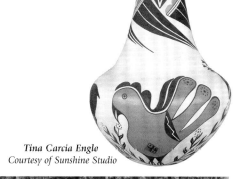

Tina Garcia Engle
Courtesy of Sunshine Studio

Kenneth Earl Epaloose -
Photograph by Michael E. Snodgrass, Denver, CO

Beatrice Esquibel - Andrews Pueblo Pottery and Art Gallery, Albuquerque, NM

Bessie Esquibel *(signs B. Esquibel)*

(Jemez, Corn Clan, active ca. 1988-present: Storytellers, figures)
BORN: September 23, 1947
FAMILY: daughter of Abel Sando & Anita T. Sando; wife of Louis Esquibel
TEACHER: her sister
PUBLICATIONS: Berger & Schiffer 2000:112.

Berleen Estevan *(signs B. Estevan Acoma, New Mexico)*

(Acoma, active ca. 1992-present: traditional & ceramic polychrome jars, bowls)
BORN: October 5, 1975
FAMILY: granddaughter of Lucy Juanico; daughter of Charlene Estevan; niece of Dorothy Torivio
TEACHER: Lucy Juanico, her grandmother
GALLERIES: Rio Grande Wholesale, Inc., Palms Trading Co., Albuquerque
PUBLICATIONS: Berger & Schiffer 2000:112.

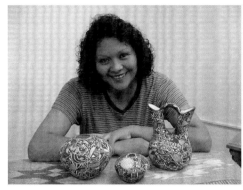

*Berleen Estevan - Courtesy of Jason Esquibel
Rio Grande Wholesale, Inc.*

Charlene Estevan

(Acoma, active ca. 1970s-present: traditional polychrome & black-on-white jars, bowls, clay baskets, effigy pots, baskets)
BORN: ca. 1950s
FAMILY: daughter of Lucy Juanico; mother of Berleen Estevan
FAVORITE DESIGNS: spotted birds, flowers, clouds
COLLECTIONS: John Blom
GALLERIES: Rio Grande Wholesale, Inc., Palms Trading Co., Albuquerque
PUBLICATIONS: Dillingham 1992:206-208; Hayes & Blom 1996:54-55; Painter 1998:11; Berger & Schiffer 2000:112.

Jennifer Estevan *(signs J. Estevan, Acoma, N.M.), (collaborates with Michael Patricio, Jr.)*

(Acoma, active ca. 1977-present: traditional & ceramic black-on-white jars, bowls, vases with handles, ollas)
BORN: June 15, 1963
FAMILY: daughter of Virginia Estevan; sister of Yvonne Estevan & Joe Estevan
TEACHER: Virginia Estevan, her mother
AWARDS: 2nd, Inter-tribal Indian Ceremonial, Gallup; New Mexico State Fair, Albuquerque
COLLECTIONS: Allan & Carol Hayes, John Blom
FAVORITE DESIGNS: eyedazzlers, lightning
GALLERIES: King Galleries of Scottsdale, AZ; Arlene's Gallery, Tombstone, AZ; Rio Grande Wholesale, Inc., Palms Trading Co., Albuquerque
PUBLICATIONS: Hayes & Blom 1996:iv; Berger & Schiffer 2000:113.

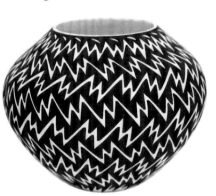

*Jennifer Estevan -
King Galleries of Scottsdale, AZ*

Juanita Delores Estevan

(Acoma, active ca. 1880s-1910s+: polychrome jars, bowls)
BORN: ca. 1870; RESIDENCE: Acomita in ca. 1910
PUBLICATIONS: Leopold Bibo, "13th Annual U.S. Census" (1910), New Mexico State Archives, Call T624, Roll 919; in Dillingham 1992:205.

Marcia Estevan

(Acoma, active ca. 1994-present: traditional & ceramic jars, bowls)
BORN: May 14, 1964
FAMILY: daughter of Patsy Mike; sister of Paula Estevan
TEACHER: Patsy Mike, her mother
GALLERIES: Rio Grande Wholesale, Inc., Palms Trading Co., Albuquerque
PUBLICATIONS: Berger & Schiffer 2000:113.

Maria Estevan

(Acoma, active ?-1975+: polychrome jars, bowls)
PUBLICATIONS: Minge 1991:195.

Paula Estevan *(signs P. Estevan, Acoma N.M.)*

(Acoma, active ca. 1986-present: traditional & ceramic jars, bowls)
BORN: September 19, 1967
FAMILY: daughter of Patsy Mike; sister of Marcia Estevan
GALLERIES: Rio Grande Wholesale, Inc., Palms Trading Co., Albuquerque
PUBLICATIONS: Berger & Schiffer 2000:113.

Virginia Estevan *(sometimes signs V. G. Estevan)*

(Acoma, active ca. 1960s-present: traditional polychrome jars, bowls)
BORN: ca. 1940s
FAMILY: mother of Jennifer Estevan, Joe Estevan & Yvonne Estevan
STUDENTS: Jennifer Estevan, her daughter
FAVORITE DESIGNS: parrots, deer with heartlines
GALLERIES: Rio Grande Wholesale, Inc., Palms Trading Co., Albuquerque
VALUES: On Dec. 2, 1987, a polychrome olla (21″ h.), signed V. G. Estevan, est. $1,500-1,800, at Sotheby's, lot 294A.
PUBLICATIONS: Berger & Schiffer 2000:113.

Kimberly G. Eteeyan *(Kim)*, *(signs K. E. Jemez)*

(Jemez/Potowatomie, active ca. 1984-present: polychrome jars, bowls, Storytellers, figures, miniatures)
BORN: June 11, 1964
FAMILY: granddaughter of Anna Marie Shendo; daughter of William & Mary Louise Eteeyan
TEACHER: Mary Eteeyan, her mother
AWARDS: H.M., New Mexico State Fair, Albuquerque; Inter-tribal Indian Ceremonial, Gallup
GALLERIES: Adobe Gallery, Albuquerque; Rio Grande Wholesale, Inc. Albuquerque
PUBLICATIONS: Congdon Martin 1999:64; Berger & Schiffer 2000:113.

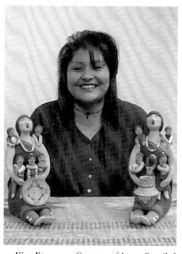

*Kim Eteeyan - Courtesy of Jason Esquibel
Rio Grande Wholesale, Inc.*

Kimberly Eteeyan expresses herself well in making beautiful polychrome Storytellers and singing figures. Often covered with babies, her figures appear with a miniature drum, canteen, plate or olla. Her exceptionally tall figures are attached to a circular clay disk for balance and stability.

Kimberly's pottery style features a matte surface with three primary colors of clay paint - cream, orange and a charcoal grey. Some of her grandmotherly figures wear black mantas with painted embroidery. Kimberly's mastery as a sculptor comes through in her figures donning long flowing wearing blankets formed with delicate and graceful folds. Her figures are especially tall and slender, their faces looking up, usually singing, to the heavens.

Mary Louise Eteeyan *(sometimes signs M.L.E.)*

(Jemez, active ca. 1978-present: matte polychrome & polished red-ware ollas, jars, lidded bowls, wedding vases, seed jars)
BORN: ca. 1942
FAMILY: daughter of Anna Marie Shendo; wife of William Eteeyan; mother of Kimberly Eteeyan
STUDENT: Kimberly Eteeyan, her daughter
AWARDS: 1st, New Mexico State Fair, Albuquerque; 1st, Eight Northern Indian Pueblo Arts & Crafts Show; Inter-tribal Indian Ceremonial, Gallup
FAVORITE DESIGNS: butterflies, flowers
GALLERIES: The Indian Craft Shop, U.S. Department of Interior, Washington, D.C.;

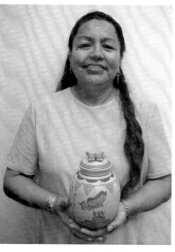

*Mary Louise Eteeyan -
Courtesy of Jason Esquibel
Rio Grande Wholesale, Inc.*

*Mary Louise Eteeyan -
Photograph by Bill Bonebrake. Courtesy of Jill Giller
Native American Collections, Denver, CO*

Native American Collections, Inc., Denver, CO; Hoel's Indian Shop, AZ; Arlene's Gallery, Tombstone, AZ; Rio Grande Wholesale, Inc.
PUBLICATIONS: Hayes & Blom 1996:84; *Southwest Magazine*

Mary Louise Eteeyan is respected for her excellent painting. Her butterfly bowls are especially popular, featuring a sculptural butterfly 3 or 4 inches across poised atop her lidded bowls. She paints the butterfly wings with a myriad of different patterns.

Mary's pots feature areas of polished redware surfaces. She polishes these places well to a high gloss finish. This demonstrates her true mastery of traditional techniques. She has passed her knowledge onto her daughter, Kimberly Eteeyan, who is known for her figures and Storytellers.

Albert Eustace

(Zuni, active ca. 1970s-80s+: polychrome jars, bowls)
COLLECTIONS: Smithsonian Institution, Museum of Natural History, Washington, D.C.
FAVORITE DESIGNS: birds, butterflies

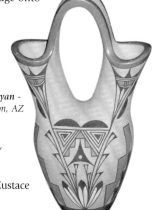

*Mary Louise Eteeyan -
Hoel's Indian Shop, Oak Creek Canyon, AZ*

Ben Eustace *(collaborates sometimes with Felicita Eustace)*, *(Eagle hallmark in the 1950s)*

(Zuni, married into Cochiti, Ant Clan, active ca. 1940s-present: Cochiti-style polychrome Storytellers, figures, jewelry, paintings)
BORN: ca. 1920s
FAMILY: husband of Felicita Eustace; father of Christina Eustace, Nelson Eustace; grandfather of Julius Eustace
EXHIBITIONS: 1985-present, Indian Market, Santa Fe
COLLECTIONS: Dave & Lori Kenny, Dr. Gregory & Angie Yan Schaaf, Santa Fe
PUBLICATIONS: *Indian Market Magazine* 1985, 1988, 1989; Wright 1989:49; Bassman 1992:16.

Felicita Eustace *(collaborates sometimes with Ben Eustace, her husband), (jewelry hallmark - F.E.)*
(Cochiti, active ?-present: polychrome jars, bowls, Storytellers, ca. 1956-present, animals, human figures, jewelry)
BORN: August 7, 1927
FAMILY: daughter or sister of Seferina Herrera; wife of Ben Eustace (Zuni); mother of Christine Alice Eustace, James Eustace, Nelson Eustace, Linda Eustace, Joseph Eustace; mother-in-law of Charlotte Eustace
TEACHER: Juanita Arquero
AWARDS: Inter-tribal Indian Ceremonial, Gallup; Indian Market, Santa Fe
EXHIBITIONS: pre-1985-present, Indian Market, Santa Fe
GALLERIES: Rainbow Man, Santa Fe; Adobe Gallery, Albuquerque & Santa Fe
PUBLICATIONS: *Indian Market Magazine* 1985, 1989; Wright 1989, 2000:65; *The Messenger*, Wheelwright Museum Winter 1995-96:12; Hayes & Blom 1996:62; 1998:53; Congdon-Martin 1999:13; Berger & Schiffer 2000:113.

Joseph Eustace *(Joe), (jewelry hallmark - JE)*
(Cochiti, active ca. 1970s-present: polychrome jars, bowls, Storytellers, jewelry)
BORN: ca. 1950s
FAMILY: son of Felicita Eustace (Cochiti) & Ben Eustace (Zuni); brother of Christine Alice Eustace, James Eustace, Nelson Eustace, Linda Eustace
EXHIBITIONS: 1989-1992, Indian Market, Santa Fe

Felicita Eustace -
Photograph by Tony Molina
Case Trading Post at the
Wheelwright Museum of the American Indian
Santa Fe

Lorqura Eustace
(Cochiti, active ?: human figures, bow hunters)
COLLECTION: Candace Collier, Houston, TX
FAVORITE DESIGNS: standing figures with wooden bows & arrows

Evening Star *(see Caroline Garcia-Sarracino)*

A. V. F. *(see Andrea V. Fragua)*

C. R. F. *(see Cheryl Fragua)*

L. G. F. or Leonora F. *(see Leonora G. Fragua)*

M. F. *(see Mabel Fragua)*

Conception Faustin *(Funny Lady)*
(Acoma, active ca. 1930s-present: polychrome jars, bowls)
BORN: ca. 1910s
PUBLICATIONS: Dillingham 1992:206-208.
PHOTOGRAPH: M. James Slack, staff photographer, Historic American Building Survey (WPA), 1934, in collection of John Beeder

Karen Fernando -
Photograph by Bill Bonebrake
Courtesy of Jill Giller
Native American Collections, Denver, CO

Karen Fernando
(Acoma, active ?-present: polychrome jars, bowls)
GALLERIES: Native American Collections, Inc., Denver, CO

Felipa *(see Felipa Trujillo)*

Benina Foley *(Benina Fley)*
(Jemez/Otoe-Missouria, Corn Clan, active ca. 1984-present: polychrome jars, melon bowls, figures, owls)
BORN: April 7, 1982
FAMILY: great-granddaughter of Persingula & Joe Gachupin; granddaughter of Marie Romero; daughter of Laura Gachupin & James Foley; sister of Gordon Foley
EDUCATION: Santa Fe Indian School, Santa Fe Community College
TEACHER: Laura Gachupin, her mother
AWARDS: 1992, 1st, polished redware or blackware (ages 12 & under); 1999, Indian Market
EXHIBITIONS: Heard Museum Show, Phoenix; Indian Market, Santa Fe; Eight Northern Indian Pueblos Arts & Crafts Show
GALLERIES: Dancing Corn Gallery
PUBLICATIONS: Peaster 1997:66-67.

 Benina Foley was born into a major pottery-making family. She began playing with clay at the age of two and formed her first pots. She commented, "I enjoy carrying on my family tradition."

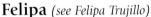

Benina Foley - Courtesy of Jason Esquibel
Rio Grande Wholesale, Inc.

Gordon Foley

(Jemez/Oto-Missouria, Corn Clan, active ca. 1980s-present: polished cream melon bowls, swirl pots, jars, bowls, clay sculptures)
BORN: ca. 1975
FAMILY: great-grandson of Persingula & Joe Gachupin; grandson of Marie Romero; son of Laura Gachupin & James Foley; brother of Benina Foley
AWARDS: 1984, 1st, 2nd (ages 12 & under); 1986, 2nd (ages 12 & under); 1993, 1st, Indian Market; 1997, Inter-tribal Indian Ceremonial, Gallup; 1999, 3rd, 4th, New Mexico State Fair
PUBLICATIONS: Peaster 1997:66-67.

 Gordon Foley makes elegant polished cream melon bowls with more narrow ribs when compared with Helen Shupla. His swirl pots are beautiful in polished cream colored natural clay. Gordon follows traditional techniques, uses natural materials and fires his pots with cedar wood in a pit. The results are quite attractive, earning his place among a family of excellent potters.

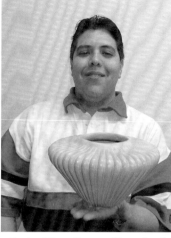

Gordon Foley - Courtesy of Jason Esquibel Rio Grande Wholesale, Inc.

Tonia Fontenelle *(Fontelle)*

(Zuni, active ?-present: pottery)
GALLERIES: Rio Grande Wholesale, Inc. Albuquerque

Maria Charlie Forbio

(Acoma, active ?: pottery)
PUBLICATIONS: *Art of Native America.*

Amy Fragua

(Jemez, active ca. 1990s-present: Storytellers)
FAMILY: p. great-granddaughter of Emilia Loretto; p. granddaughter of Grace L. Fragua; daughter of Philip Fragua; sister of Chisalyn Fragua
PUBLICATIONS: Peaster 1997:69.

Tonia Fontenelle - Courtesy of Jason Esquibel Rio Grande Wholesale, Inc.

Andrea Vigil Fragua *(signs A.V.F. Jemez N.M.)*

(Jemez, active ca. 1973-present: traditional polychrome & Pecos Revival Glazeware jars bowls, textiles)
BORN: March 31, 1948
FAMILY: daughter of Evelyn M. Vigil
TEACHER: Evelyn M. Vigil, her mother
AWARDS: Museum of New Mexico, Santa Fe
EXHIBITIONS: 1976-?, Indian Market, Santa Fe
PUBLICATIONS: Fox 1978:90; Trimble 1987:70-71; Berger & Schiffer 2000:114; Schaaf 2001:285.

Azhane'e Fragua - Candace Collier Collection, Houston, TX

Ardina Fragua *(signs A. Fragua)*

(Jemez, active ca. 1990-present: traditional polychrome tanware jars, bowls, figures)
BORN: October 16, 1980
FAMILY: m. great-granddaughter of Emilia Loretto; m. granddaughter of Felix & Grace L. Fragua; daughter of Felicia Fragua
FAVORITE DESIGNS: turtles, children, terraced clouds, kiva steps and rain symbols
GALLERIES: The Indian Craft Shop, U.S. Department of Interior, Washington, D.C.; Turquoise Lady, Palms Trading Company, Albuquerque
PUBLICATIONS: Peaster 1997:69; Congdon-Martin 1999:66; Berger & Schiffer 2000:81, 114.

 Ardina Fragua's turtle and children figures - made when she was only 10 years old - were so good they were chosen for publication by Douglas Congdon-Martin. Her figures are well-formed into thoughtful compositions. Her painting is confident. Her facial features are whimsical. She adds terraced clouds, kiva steps and rain symbols.

Azhane'e Fragua

(Jemez, active ?-present: figural scenes)
COLLECTIONS: Candace Collier, Houston, TX
FAVORITE DESIGNS: Saguaro Cactus, snakes, clouds

Benjamin Fragua *(signs B. Fragua)*

(Jemez, active ca. 1995-present: Storytellers, Kokopelli, animal figures, polychrome jars, bowls)
BORN: March 26, 1961
FAMILY: m. grandson of Emilia Loretto; son of Felix & Grace L. Fragua; brother of Bonnie, Rose, Felecia Fragua & Emily F. Tsosie
TEACHERS: Bonnie & Rose Fragua
GALLERIES: The Indian Craft Shop, U.S. Department of Interior, Washington, D.C.; Kennedy's Indian Arts, Bluff, UT
PUBLICATIONS: Peaster 1997:69; Berger & Schiffer 2000:114.

Ben Fragua - Courtesy of John D. Kennedy and Georgiana Kennedy Simpson Kennedy Indian Arts

Betty Jean Fragua *(B. J. Chavez, Betty Fragua Chavez), (signs B. J. Fragua)*

(Jemez, Corn Clan, active ca. 1980-present: traditional polychrome & stone polished sgraffito redware & matte tanware jars bowls)
BORN: October 10, 1962
FAMILY: m. granddaughter of Rita Magdalena Casiquito; daughter of Manuel & Juanita Fragua; sister of Clifford Fragua (1), Glendora Fragua; mother of Roxanne Fragua Chavez
TEACHER: Juanita Fragua, her mother
AWARDS: 1984, 3rd, jars; 1988, 1st, non-traditional jars; 1994, 1st; 1998, 2nd, Indian Market, Santa Fe; Inter-tribal Indian Ceremonial, Gallup, NM
EXHIBITIONS: ca. 1985-present, Indian Market, Santa Fe, 1997-present, Eight Northern Indian Pueblos Arts & Crafts Show
FAVORITE DESIGNS: lizards, flowers, corn plants, feathers
GALLERIES: Turquoise Tortoise, Sedona, AZ (ca. 1984); Native American Collections, Inc., Denver, CO
PUBLICATIONS: *American Indian Art Magazine* Spring 1984 9(3):72; Winter 1993 19(1):29; Hayes & Blom 1996:82-83; Peaster 1997:61-64; *Cowboys & Indians* Nov. 1999:95; Sept. 2000 8(4):94; Berger & Schiffer 2000:35, 114.

B. J. Fragua -
King Galleries of Scottsdale, AZ

B. J. Fragua -
Photograph by Bill Bonebrake
Courtesy of Jill Giller
Native American Collections, Denver, CO

Bonnie Fragua

(Jemez, active ca. 1983-present: polychrome Storytellers, figures)
BORN: March 26, 1966
FAMILY: m. granddaughter of Emilia Loretto; daughter of Felix & Grace L. Fragua; sister of Chris Fragua, Emily Fragua Tsosie, Clifford Kim Fragua (2), Felicia Fragua, Carol Fragua; mother of Jonathan Fragua
STUDENTS: Benjamin Fragua, Felicia Fragua
AWARDS: 1984, 3rd, pottery (ages 18 & under); Eight Northern Indian Pueblos Arts & Crafts Show
FAVORITE DESIGNS: figures with children
PUBLICATIONS: Peaster 1997:69; Walatowa Pueblo of Jemez, "Pottery of Jemez Pueblo" 1999; Berger & Schiffer 2000:114.

Brandon Pecos Fragua

(Jemez, Corn Clan, active ca. 1999-present: pottery)
BORN: July 2, 1993; RESIDENCE: Jemez Pueblo, NM
FAMILY: grandson of Joe R. & Persingula Gachupin, Moses & Leonora G. Fragua; son of M. Pecos & Virginia Fragua; brother of Clarinda Fragua & Marlinda Pecos

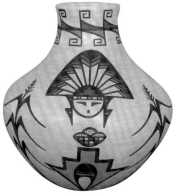

Bonnie Fragua - Andrews Pueblo Pottery &
Art Gallery, Albuquerque, NM

B. J. Fragua -
Photograph by Bill Bonebrake
Courtesy of Jill Giller
Native American Collections, Denver, CO

C. Fragua

(Jemez, active ca. 1990s-present: matte polychrome Storytellers)
BORN: ca. 1985
GALLERIES: Foutz Trading Company, Shiprock
PUBLICATIONS: Congdon-Martin 1999:64.

C. K. Fragua

(Jemez, active ca. 1990s-present: matte polychrome Storytellers, Clowns)
BORN: ca. 1985
GALLERIES: Wind River Trading Company, Santa Fe
PUBLICATIONS: Congdon-Martin 1999:64.

Carmellie Fragua

(Jemez, active ca. 1990s-present)
FAMILY: m. great-granddaughter of Emilia Loretto; m. granddaughter of Felix & Grace L. Fragua; daughter of Cindy Fragua
PUBLICATIONS: Peaster 1997:69.

Carol Fragua *(see Carol Fragua Gachupin (1))*

Cheryl Fragua *(sometimes signs C.R.F.)*

(Jemez, active ca. 1988-present: polychrome Storytellers, figures, sets of "See no evil. Hear no evil. Speak no evil.")
BORN: January 20, 1970
FAMILY: daughter of Christino & Vera Fragua
TEACHERS: Rose Fragua & Emily Tsosie
PUBLICATIONS: Hayes & Blom 1998:33-35; Berger & Schiffer 2000:114.

Cheryl Fragua -
Courtesy of Allan & Carol Hayes

Chris Fragua *(collaborates sometimes with Vera Fragua)*

(Jemez, active ca. 1985-present: polychrome Storytellers, figures, clowns, cats)
BORN: January 10, 1943
FAMILY: m. granddaughter of Emilia Loretto; daughter of Felix & Grace L.
Fragua; sister of Bonnie Fragua, Emily Fragua Tsosie, Clifford Kim Fragua (2),
Felicia Fragua, Bonnie Fragua, Carol Fragua; mother of Sheryl Fragua
TEACHER: Grace L. Fragua, her mother
GALLERIES: The Indian Craft Shop, U.S. Department of Interior,
Washington, D.C.; Kennedy Indian Arts, Bluff, UT
PUBLICATIONS: Bahti 1996:2, 16; Peaster 1997:69; Hayes & Blom 1996;
1998:34; Berger & Schiffer 2000:114.

*Chris Fragua - Courtesy of
Georgiana Kennedy Simpson
Kennedy Indian Arts, Bluff, UT*

Chrislyn Fragua *(Chrisalyn)*

(Jemez, Corn Clan, active ca. 1988-present: sgraffito jars, bowls, Storytellers, figures)
BORN: November 14, 1973
FAMILY: p. great-granddaughter of Emilia Loretto; p. granddaughter of Grace L. Fragua; m. granddaughter of Jose & Rebecca Lucero;
daughter of Phillip M. Fragua & Linda M. Lucero Fragua; sister of Amy Fragua, Loren Wallowing Bull; mother of Anissa Tsosie (b.
1994)
TEACHER: Linda M. Lucero Fragua, her mother
AWARDS: 1990 2nd, Eight Northern Pueblo Indian Arts & Crafts Show
FAVORITE DESIGNS: Sun & corn stalk, figures with children
PUBLICATIONS: Peaster 1997:69.

> At the age of 15, Chrislyn Fragua inherited her family's pottery-making tradition passed on by her mother, Linda M.
> Lucero Fragua, and her grandmother, Rebecca Lucero. After learning the basics, Chrislyn followed her mother's footsteps in cre-
> ating Storytellers. Chrislyn explained her joy in pottery making: "I like to form them and come up with other creative styles.
> The best part is painting the Storytellers."

Cindy Fragua *(1)*

(Jemez, active ca. 1980s-present)
FAMILY: m. granddaughter of Emilia Loretto; daughter of Felix & Grace L. Fragua; mother of Carmellie Fragua
PUBLICATIONS: Peaster 1997:69.

Cindy Fragua *(2)*, *(see Jemez color illustration)*

(Jemez, active ca. 1985-present: matte polychrome Storytellers, figures, Corn Maidens, angels, Santa Claus)
BORN: March 4, 1963
FAMILY: daughter of Grace L. Fragua
TEACHERS: Rose T. Fragua & Emily Fragua
AWARDS: 1994, 3rd, New Mexico State Fair, Albuquerque; Eight Northern Indian Pueblos Arts & Crafts Show
EXHIBITIONS: Eight Northern Indian Pueblos Arts & Crafts Show
COLLECTIONS: Dr. Gregory & Angie Yan Schaaf, Santa Fe
FAVORITE DESIGNS: Corn Maidens
PUBLICATIONS: Walatowa Pueblo of Jemez, "Pottery of Jemez Pueblo" (1999); Berger & Schiffer 2000:114.

> Cindy Fragua is an exceptional figural clay artist. Her work has a sculptural quality. She displays a strong sense of color
> and design. She merged Corn Maiden figures into her contemporary vases to create unique compositions. Her growth as an
> artist places her as an emerging new talent.

Clarinda Fragua

(Jemez, Corn Clan, active ca. 1981-present: polychrome jars, bowls)
BORN: March 6, 1978; RESIDENCE: Jemez Pueblo, NM
FAMILY: granddaughter of Joe R. & Persingula Gachupin, Moses & Leonora G. Fragua; daughter of Virginia Fragua; sister of Brandon
Pecos Fragua & Marlinda Pecos Fragua

Clifford Fragua *(1)*

(Jemez, Corn Clan, active ca. 1970-present: sgraffito jars, bowls, figures, sculptures)
FAMILY: son of Manuel & Juanita Fragua; brother of Glendora Fragua, Barbara Jean Chavez Fragua; father of Tablita Fragua,
Stardancer Swope & Northbear Fragua
EDUCATION: Institute of American Indian Arts, Santa Fe; San Francisco Art Institute, San Francisco
TEACHER: Juanita Fragua, his mother
AWARDS:

1974	Best of Show, Jemez Pueblo Indian Art Expo, Jemez Pueblo
1977	Best of Class, Best of Division, 1st, Indian Market, Santa Fe
1980	Best of Class, Best of Division, 1st, Indian Market, Santa Fe
1981	Wheelwright Museum Award for Most Promising Sculptor/Carver, Indian Market, Santa Fe; 1st, Indian Market
1982	Best of Class, Inter-tribal Indian Ceremonial, Gallup
1983	Best of Class, Best of Division, 1st, Indian Market, Santa Fe
1991	1st, Indian Market, Santa Fe
1992	1st, Indian Market, Santa Fe

1993	1st, Indian Market, Santa Fe
1995	Wheelwright Museum Award for Excellence in Sculpture, 1st, Indian Market, Santa Fe
1996	1st, Indian Market, Santa Fe
1997	Best in Category, Indian Arts & Crafts Association Show, Denver, CO
1998	Best of Show, Native American Artist Invitational, Fountain Hills, AZ; Indian Market, Santa Fe
1999	Indian Market, Santa Fe

EXHIBITIONS: 1977-present, Indian Market, Santa Fe; 1981, "Indian Art of the 1980s," Native American Center for the Living Arts, Niagara Falls, NY; 1996-present, Eight Northern Indian Pueblos Arts & Crafts Show; 1998 "Walatowa Arts Tradition," South Broadway Cultural Center, Albuquerque; Albuquerque Museum of Art, Albuquerque; Santa Fe Festival of the Arts, Santa Fe
COLLECTIONS: Albuquerque International Airport, Albuquerque; City of Phoenix Mayor's Office, Phoenix; Albuquerque Museum, Albuquerque; Indian Pueblo Cultural Center, Albuquerque; Oklahoma Heritage Hall of Fame; American Indian Hall of Fame, Peninsula, OH
GALLERIES: Singing Stone Studio, Jemez Pueblo, NM; Ray Tracey Gallery, Santa Fe; Four Winds Gallery, Pittsburgh, PA and Sarasota, FL; Elk Ridge Art Company, Evergreen, CO; Windrush Gallery, Sedona, AZ
PUBLICATIONS: *Indian Market Magazine* 1985; *Arizona Highways* May 1986 62(5):28; Lester 1995:184; *Southwest Art Magazine* Feb. 1989:123; May 1989:142; *American Indian Art Magazine* Spring 1995 20(2):17; Winter 1995 21(1):34; Winter 1996 22(1):82; Summer 1997 22(3):17; Peaster 1997:63, 69; *Masters of Indian Market Exhibition Guide* 1997:11; 1998:7; Tucker 1998: plate 70; *Santa Fean* Aug. 1998 26(7):56-57; *Indian Trader* Jun. 1999 30(6):20; Dec. 1999 30(12):18; Dec. 2000 31(12):24, 26; *Cowboys & Indians* Dec. 1999/Jan. 2000 7(6):76, 78; Sep. 2000 8(4):94, 114-116; Berger & Schiffer 2000:114; *Native Peoples* Feb./Mar. 2000 13(2):84; Mar./Apr. 2001:18.

Clifford Fragua is famous more as a sculptor than as a potter. He is included here out of respect for his powerful importance as an artist. His beginnings may be found in the clay, although his new works are mostly in marble, alabaster and bronze.

Clifford Kim Fragua *(2)*

(Jemez, active ca. 1970-present: Storytellers, Koshari clown figures, Nativities, Corn Maidens, children on horse figures, red-on-white and black-on-white jars, bowls, vases, ornaments)
BORN: ca. 1957
FAMILY: m. grandson of Emilia Loretto; son of Felix & Grace L. Fragua; brother of Emily Fragua-Tsosie, Bonnie Fragua & Carol Fragua Gachupin
AWARDS: 1992, 1st, Inter-tribal Indian Ceremonial, Gallup; 2nd 3rd, Totah Farmington Festival, Farmington, NM
GALLERIES: Bien Mur, Albuquerque; Rio Grande Wholesale, Inc., Albuquerque

Clifford Kim Fragua creates unique polychrome pottery figures and Storytellers. His figural compositions are ever changing. Children in his groupings occasionally carry miniature teddy bears. Sometimes he attaches figures of children around his tall-necked vases with corn leaf rims. His pots often feature fineline hatching on split leaves, feathers and cloud patterns, giving the contemporary work a traditional flair. His largest Storyteller is 24" tall with 217 children, for which he won first prize, 1992 Inter-tribal Indian Ceremonial, Gallup, New Mexico.

Clifford K. Fragua - Courtesy of Jason Esquibel
Rio Grande Wholesale, Inc.

Cynthia Fragua

(Jemez, active ?-present: pottery)
EXHIBITIONS: 1995-present, Eight Northern Indian Pueblos Arts & Crafts Show

E. B. Fragua

(Jemez, active ?-present: polychrome Storytellers, figures)
FAVORITE DESIGNS: Mudhead figures with children

Edwina Fragua

(Jemez, active ?-present: pottery)
ARCHIVES: Laboratory of Anthropology Library, Santa Fe

Emily Fragua *(see Emily Fragua Tsosie)*

Felicia Fragua *(see Felicia Fragua Curley)*

Glendora Fragua *(see Glendora Daubs)*

Grace Loretto Fragua *(Grace L. Fragua)*

(Jemez, active ca. 1940s-present: polychrome traditional & poster paint Storytellers, jars, bowls, figures, miniature bread ovens)
LIFESPAN: ca. 1920s - ?
FAMILY: daughter of Carmilito & Emilia Loretto; wife of Felix Fragua; mother of Chris Fragua, Rose T. Fragua, Felicia Fragua, Emily F. Tsosie, Clifford Kim Fragua (2); Bonnie Fragua, Benjamin Fragua, Cindy Fragua & Caroline Fragua Gachupin
STUDENTS: Chris Fragua, Felicia Fragua, Emily F. Tsosie, her daughters
PUBLICATIONS: Babcock 1986; Peaster 1997:69; Congdon-Martin 1999:66.

Grace L. Fragua is a matriarch of many Jemez figural potters. She gave birth to 13 children, 10 of whom are potters. They are known mostly for their excellent Storytellers.

J. Fragua

(Jemez, active ?-present: bear Storytellers)
GALLERIES: Arlene's Gallery, Tombstone, AZ; Turquoise Lady, Albuquerque
PUBLICATIONS: Congdon-Martin 1999:66.

J. L. Fragua *(see Joseph L. Fragua)*

Jan Fragua

(Jemez, active ca. 1980s-present: Storytellers)
GALLERIES: Turquoise Lady, Albuquerque
PUBLICATIONS: *The Messenger*, Wheelwright Museum Spring 1996:12; Congdon-Martin 1999:67.

Janeth A. Fragua *(name & arrow hallmark)*

(Jemez, active ca. 1985-present: matte polychrome Storytellers, figures, clowns, some with corn husk tassels)
BORN: May 9, 1964
FAMILY: m. great-granddaughter of Emilia Loretto; m. granddaughter of Grace L. Fragua; daughter of Rose T. Fragua
TEACHER: Rose T. Fragua, her mother
EXHIBITIONS: Eight Northern Indian Pueblos Arts & Crafts Show
FAVORITE DESIGNS: figures with children
GALLERIES: The Indian Craft Shop, U.S. Department of Interior, Washington, D.C.; Jemez Visitor's Center, Jemez Pueblo; Palms Trading Company, Albuquerque
PUBLICATIONS: Peaster 1997:69; Congdon-Martin 1999:67; Walatowa Pueblo of Jemez, "Pottery of Jemez Pueblo" (1999); Berger & Schiffer 2000:114.

Jonathan Fragua

(Jemez, active ca. 1990s-present: pottery)
BORN: ca. 1980s
FAMILY: m. great-grandson of Emilia Loretto; m. grandson of Grace L. Fragua; son of Bonnie Fragua
PUBLICATIONS: Peaster 1997:69.

Joseph L. Fragua *(1)*

(Jemez, active ca. pre-1980: polychrome jars, bowls, plates, figures - Storytellers, Clowns, Santa Claus)
BORN: ca. 1940s
COLLECTIONS: Wright Collection, Peabody Museum, Harvard University, Cambridge, MA
GALLERIES: Kennedy Indian Arts, Bluff, UT; Wind River Trading Company, Santa Fe; Palms Trading Company, Albuquerque
PUBLICATIONS: Drooker & Capone 1998:57, 138; Hayes & Blom 1998:35; Congdon-Martin 1999:67.

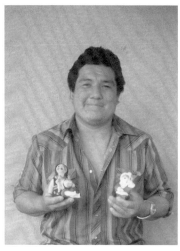

Joseph L. Fragua (1) -
Courtesy of John D. Kennedy and
Georgiana Kennedy Simpson
Kennedy Indian Arts

Joseph L. Fragua's pottery in the Peabody Museum is described as a "polychrome plate set in a raised, modeled Koshare clown against a Pueblo background, a traditional scene on a contemporary form."

Joseph Fragua *(2)*

(Jemez, ca. 1990s-present: Storytellers, jars, bowls, black & yellow on redware wedding vases)
BORN: June 1, 1977
FAMILY: great-grandson of Juan & Reyes Toya; grandson of Margaret Toya & Frank Toya; related to Lorraine Toledo & Rosalie Toya
TEACHER: Margaret Toya, his grandmother
STUDENT: Diane Lucero
COLLECTIONS: Winona State University
FAVORITE DESIGNS: hummingbirds, butterflies
GALLERIES: Rio Grande Wholesale, Albuquerque

Joseph Fragua comes from a lineage of excellent potters. He explained why he makes pottery: "I enjoy doing all the work for pottery I've created. I also like to see the reactions and expressions on people's faces when they look at my pottery."

Josephine Fragua

(Jemez, ca. 1990s-present: pottery)
EXHIBITIONS: 1995-present, Eight Northern Indian Pueblos Arts & Crafts Show

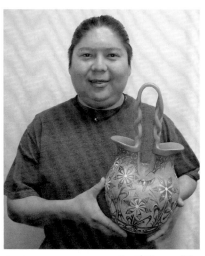

Joseph Fragua (2) -
Courtesy of Jason Esquibel
Rio Grande Wholesale, Inc.

Juanita C. Fragua

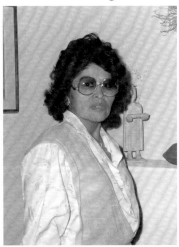

Juanita Fragua -
Courtesy of John D. Kennedy and
Georgiana Kennedy Simpson
Kennedy Indian Arts

(Jemez, Corn Clan, active ca. 1950s-present: traditional polished redware & tanware, some sgraffito jars, bowls, cornmeal bowls, vases, wedding vases, embroidery)
BORN: March 15, 1935
FAMILY: daughter of Rita Magdalena (Zia/Jemez); sister of Jeronina Shendo; wife of Manuel Fragua; mother of Clifford Fragua, Glendora Fragua Daubs, Betty Jean Chavez Fragua
EDUCATION: Santa Fe Indian School
TEACHERS: Rita Magdalena, her mother, Al Momaday (Kiowa); Lorencita Bird, Stephania Toya
STUDENTS: Clifford Fragua, Dennis Daubs, Betty Jean Fragua, Theresa Tsosie
AWARDS: 1980, 2nd; 1983, 1st, 3rd; 1990, 1st, jars; 1991, 1st, bowls, 2nd, jars; 1992, 1st, wedding vases; 1993, 3rd, wedding vases; 1994, 1st, 3rd, jars, 2nd, wedding vases; 1996, 1st, 3rd (2), Indian Market, Santa Fe
EXHIBITIONS: ca. 1982-present, Indian Market, Santa Fe
COLLECTIONS: Angie Yan Schaaf, Santa Fe
FAVORITE DESIGNS: lizards, flowers, corn plants, feathers, kiva steps

Juanita Fragua -
Andrea Fisher Fine Pottery, Santa Fe

GALLERIES: Mike Kokin, Sherwood's Spirit of America, Santa Fe; Matthew Chase Ltd., Santa Fe; Andrea Fisher Fine Pottery, Santa Fe; Native American Collections, Inc., Denver, CO; Kennedy Indian Arts, Bluff, UT; Turquoise Tortoise, Sedona, AZ (ca. 1984); Blue Thunder Fine Indian Art at www.bluethunderarts.com
PUBLICATIONS: Santa Fe Indian School Yearbook, eds., *Teguayo* 1954; *American Indian Art Magazine* Spring 1984 9(3):72; Summer 1984 9(3):25, 27; Summer 1988 24(1):67; Winter 1998 24(1):86; Barry 1984:120; Trimble 1987:68; *Indian Artist Magazine* Winter 1996 2(1):23; *Indian Trader* Feb. 1996 27)2):19; Peaster 1997:62-63; Tucker 1998: plate 71; Walatowa Pueblo of Jemez, "Jemez Pottery" (1998); *Cowboys & Indians* Nov. 1999:95; Sep. 2000 8(4):94; *Native Peoples* Apr./May 2000 13(3):58; Schaaf 2001:285.

Juanita Fragua recognized Benina Shije, her sister Corn Clan member from Zia Pueblo, as being important in helping the pottery revival at Jemez Pueblo. Juanita herself has made a significant contribution in promoting the arts at Jemez. Her children are top artists including, Clifford Fragua, Glendora Fragua and Barbara Jean Chavez Fragua.

Juanita studied early Jemez pottery at the museums in Santa Fe. She observed their simple lines. Then she decided to develop her own designs, inspired mostly by her Corn Clan heritage. She concluded, "It's all up here in my head."

Juanita Fragua - Courtesy of
Michael & Matthew Maxwell
Matthew Chase Ltd., Santa Fe

Juanita became known for her stone polished tanware melon swirl pots, some with polychrome designs of corn plants, flowers and other elements. She explained her technique: "The big ones I push out from inside and groove them on the outside. . .I have a new one I call my 'oval melon,' grooved only on one side."

Al Momaday (Kiowa painter), father of Pulitzer Prize winning author N. Scott Momaday, played an important part in Juanita's painting techniques. She acknowledged that he taught her "how to draw, how to mix paints." (Trimble 1987:68)

Juanita chooses to use a black mineral paint that gives her uniform solid lines and jet-black areas of design. She prizes her black paint and keeps her source a secret.

Juanita Fragua -
Photograph by Bill Bonebrake
Courtesy of Jill Giller
Native American Collections, Denver, CO

Juanita Sabaquie Fragua

(Jemez, Fire Clan, active ca. 1920s-?: traditional polychrome jars, bowls)
BORN: May 20, 1911
FAMILY: daughter of Christina Sabaquie & Abran Sabaquie; sister of Petra Chavez Romero, Lupita, Dulcinea, Lucy Rogers, Epifanio, Juan Chavez
ARCHIVES: U.S. Census, Jemez Pueblo, ca. 1920, family 26.

Laura J. Fragua *(Wa-pa-wa-gie, Laura J. Fragua-Cota)*

(Jemez/Pecos, active ca. 1970s-present: Storytellers, non-traditional stoneware, paintings, sculptures)
BORN: ca. 1960s
EDUCATION: 1984, Institute of American Indian Arts, Santa Fe
AWARDS: 1983, Aplan Award, Red Cloud Indian Show, Heritage Center, Pine Ridge, SD; 1984, Wheelwright Museum Award for Best Young & Promising Sculptor; 1991, 1st, wedding vases; 1994, 2nd, Storytellers; 2000, 3rd, Stoneware, Indian Market, Santa Fe 1988, 1st, Cherokee National Museum, Talaquah, OK
EXHIBITIONS: 1988-present, Indian Market, Santa Fe; Wheelwright Museum, Santa Fe
PUBLICATIONS: *Southwest Art Magazine* Mar. 1989:90; *New Mexico Magazine* August 1991 69(8):76-80; *Art Talk* Feb. 1995; Lester 1995:184.

Leonora G. Fragua *(signs L.G.F. or Leonora F. Jemez N.M.)*

Leonora Fragua -
Photograph by Angie Yan Schaaf

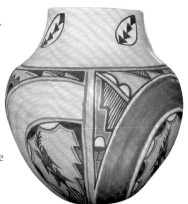

Leonora Fragua -
Photograph by Angie Yan Schaaf
Courtesy of the artist

(Jemez, Corn Clan, active ca. 1955-present: traditional matte polychrome & red-on-tanware jars, bowls, owls)
BORN: April 18, 1938
FAMILY: daughter of Joe R. & Persingula Gachupin; sister of Marie G. Romero; wife of Moses Fragua; mother of Virginia Ponca Fragua, Bertha Gachupin, Matthew Fragua, Elmer Fragua, Virgil Fragua & Loren Fragua
TEACHER: Persingula Gachupin, her mother
AWARDS: 1998, 2nd (2), Indian Market, Santa Fe
EXHIBITIONS: 1985-present, Indian Market, Santa Fe
PUBLICATIONS: Exxon 1973 12(2):n.p.; Barry 1984:126; Babcock 1986; *Indian Market Magazine* 1996:60; Peaster 1997:65, 67; Berger & Schiffer 2000:35, 84, 115.

Linda Lucero Fragua *(L. L. Fragua, Linda Lucero) (collaborates with Phillip M. Fragua)*

(Jemez, Corn Clan, active ca. 1975-present: polychrome jars, bowls, Storytellers, Clown Storytellers, figures)
BORN: November 28, 1954
FAMILY: daughter of Jose & Rebecca Lucero; wife of Phillip M. Fragua; mother of Chrislyn Fragua, Amy Fragua, Loren Wallowing Bull; grandmother of Anissa Tsosie (b. 1994)
TEACHER: Rebecca Lucero, her mother
STUDENT: Chrislyn Fragua, her daughter
AWARDS: 1990 1st, Dallas Indian Art Show, Dallas, TX; 3rd, Jemez Red Rock Indian Art Show, Jemez; 3rd, Eight Northern Pueblo Indian Arts & Crafts Show; 1998, 3rd; 2000, 2nd, Storytellers, 3rd, Figures, Indian Market, Santa Fe
DEMONSTRATIONS: Bandelier National Park, NM
EXHIBITIONS: 1995-present, Eight Northern Indian Pueblos Arts & Crafts Show; 1997-present, Indian Market, Santa Fe
FAVORITE DESIGNS: Sun, eagle & corn stalks, figures with children
GALLERIES: Crosby Collection, Park City, UT; Palms Trading Company, Albuquerque
PUBLICATIONS: *American Indian Art Magazine* Spring 1986 11(2):75; Summer 1986 11(3):21; Congdon-Martin 1999:68; Berger & Schiffer 2000:83, 115.

In expressing her uniqueness as an artist, Linda Lucero Fragua explained: "I like to be different from other people and have a different style of Storyteller."

Mabel Fragua *(signs M. F. Jemez N.M.)*

(Jemez, active ca. 1960-present: traditional polychrome jars, bowls, miniatures)
BORN: March 27, 1947
FAMILY: daughter of Josephine Loretto; wife of Robert Fragua; mother of Raylene Fragua
PUBLICATIONS: Schiffer 1991d; Berger & Schiffer 2000:115.

Manuelita Fragua

(Jemez, active ca. 1970s-present: pottery, textiles)
EXHIBITIONS: 1975-?, Eight Northern Indian Pueblos Arts & Crafts Show; 1976-?, Indian Market, Santa Fe
PUBLICATIONS: *SWAIA Quarterly* Fall/Winter 1976 11(3-4):15; Fox 1978:90; Schaaf 2001:285.

Marlinda Pecos Fragua -
Photograph by Angie Yan Schaaf

Marlinda Pecos Fragua

(Jemez, Corn Clan, active ca. 1997-present: bowls, miniature bread ovens, kivas)
BORN: March 17, 1992; RESIDENCE: Jemez Pueblo, NM
FAMILY: granddaughter of Joe R. & Persingula Gachupin, Moses & Leonora G. Fragua; daughter of M. Pecos & Virginia Fragua; sister of Brandon Pecos Fragua & Clarinda Pecos Fragua

Matthew E. Fragua *(signs M. Fragua, Jemez)*

(Jemez, active ca. 1978-present: polychrome Koshare clown Storytellers, figures on horseback)
BORN: ca. 1963
FAMILY: great-grandson of Persingula M. Gachupin; nephew of Marie Romero; cousin of Laura Gachupin & Maxine Toya
TEACHER: Persingula M. Gachupin, his great-grandmother
AWARDS: New Mexico State Fair, Albuquerque

Matthew Fragua - Courtesy of Jason Esquibel
Rio Grande Wholesale, Inc.

Melinda Toya Fragua

(Jemez, active ca. 1982-present: polychrome Storytellers)
BORN: March 18, 1959
FAMILY: daughter of Mary E. Toya & Casimiro Toya, Sr.; sister of Melissa Toya, Mary Ellen Toya (2), Judy Toya , Yolanda Toya, Casimiro Toya, Jr., Etta Toya Gachupin & Anita Toya
TEACHER: Mary E. Toya, her mother
AWARDS: 1st, 2nd, 3rd, Eight Northern Indian Pueblos Arts & Crafts Show
EXHIBITIONS: 1985-present, Indian Market, Santa Fe; 1995-present, Eight Northern Indian Pueblos Arts & Crafts Show
GALLERIES: The Indian Craft Shop, U.S. Department of Interior, Washington, D.C.
PUBLICATIONS: *Indian Market Magazine* 1985, 1988, 1989; Babcock 1986; Berger & Schiffer 2000:115.

P. Fragua *(see Virginia Ponca Fragua)*

Persingula Fragua

(Jemez, Oak Clan, active ca. 1920s-?: traditional pottery)
BORN: ca. 1900
FAMILY: mother of Anacita Chinana; m. grandmother of Marie Chinana, Persingula Chinana Gonzales, Georgia F. Chinana, Marie Waquie, Ronnie Chinana & Christina Chinana Tosa

Phillip M. Fragua *(collaborates with Linda Lucero Fragua)*

(Jemez, active ca. 1970s-present: polychrome Storytellers, figures)
BORN: 1950s
FAMILY: m. grandson of Emilia Loretto; son of Felix & Grace L. Fragua; husband of Linda Lucero Fragua; father of Chrislyn Fragua, Amy Fragua, Loren Wallowing Bull; grandfather of Anissa Tsosie (b. 1994)
EXHIBITIONS: 1995-present, Eight Northern Indian Pueblos Arts & Crafts Show
PUBLICATIONS: Peaster 1997:69; Congdon-Martin 1999:68; Berger & Schiffer 2000:83, 115.

R. Fragua

(Jemez, active ?-present: Turtle Storytellers)
GALLERIES: Indian Traders West, Santa Fe
PUBLICATIONS: Congdon-Martin 1999:68.

Raylene Fragua

(Jemez, active ca. 1995-present: polychrome Storytellers, figures)
BORN: October 22, 1978
FAMILY: granddaughter of Josephine Loretto; daughter of Robert & Mabel Fragua
PUBLICATIONS: Berger & Schiffer 2000:115.

Rose T. Fragua

(Jemez, active ca. 1960s-present: polychrome Storytellers, drummers, figures)
BORN: May 7, 1946
FAMILY: m. granddaughter of Emilia Loretto; daughter of Grace L. Fragua; mother of Janeth Fragua
STUDENTS: Benjamin Fragua, Cheryl Fragua, Janeth Fragua, Felicia Fragua
EXHIBITIONS: 1985-?, Indian Market, Santa Fe; 1994-present, Eight Northern Indian Pueblos Arts & Crafts Show
FAVORITE DESIGNS: figures with children
GALLERIES: The Indian Craft Shop, U.S. Department of Interior, Washington, D.C.; Jemez Visitor's Center, Jemez Pueblo
PUBLICATIONS: *Indian Market Magazine* 1985, 1988, 1989; Babcock 1986; Peaster 1997:69; Congdon-Martin 1999:68; Walatowa Pueblo of Jemez, "Pottery of Jemez Pueblo" (1999); Berger & Schiffer 2000:83, 114.

Sheryl Fragua

(Jemez, active ca. 1980s-present, Storytellers)
BORN: ca. 1960s
FAMILY: m. great-granddaughter of Emilia Loretto; m. granddaughter of Grace L. Fragua; daughter of Chris Fragua
PUBLICATIONS: Peaster 1997:69.

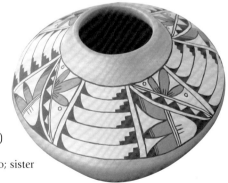

Tablita Fragua -
Photograph by Angie Yan Schaaf
Courtesy of the artist

Tablita Fragua

(Jemez, Turtle Clan, active ca. 1991-present: traditional matte polychrome jars, bowls)
BORN: December 17, 1980
FAMILY: p. granddaughter of Juanita Fragua; daughter of Cliff Fragua & Christine Otto; sister of Stardancer Swope & Northbear Fragua
TEACHER: Juanita Fragua, her p. grandmother
AWARDS: 1993, 2nd, pottery (ages 12 & under), Indian Market, Santa Fe
EXHIBITIONS: 2001, Jemez Pueblo Red Rocks Indian Arts & Crafts Show
FAVORITE DESIGNS: turtles & lizards

 Tablita Fragua spoke respectfully, "My family's generation are very talented. I enjoy creating pottery, because I love to hang on to clay and feel so close to my Mother Nature. I have learned to do pottery, so I can pass it on to my generation."

Teresita B. Fragua

(Jemez, Sun Clan, active ca. 1947-present: Storytellers, friendship pots, wedding vases, turtles, canoes, jars, bowls, embroidery)
BORN: February 27, 1937
FAMILY: wife of Pasqual Fragua; mother of Frances Toledo; grandmother of Bertha Danielson, Lorain Thomas, Elizabeth Fahey, Michael Toledo, Jr., Harold Toledo, Marie Romero & Earl Toledo

Vera C. Fragua *(collaborates sometimes with Chris Fragua)*

(Jemez, active ca. 1985-present: polychrome figures, clowns, cat & dog Storytellers)
BORN: November 25, 1942
FAMILY: wife of Christino Fragua; mother of Cheryl Fragua
PUBLICATIONS: Bahti 1996:7, 19, 53; Berger & Schiffer 2000:115.

Virginia Ponca Fragua *(signs V. P. Fragua, Ponca Flower)*

Virginia Fragua - Courtesy of Jason Esquibel Rio Grande Wholesale, Inc.

(Jemez, Corn Clan, active ca. 1977-present: traditional buff polychrome on polished red-ware jars, bowls, melon bowls, Storytellers)
BORN: September 25, 1961
FAMILY: granddaughter of Joe R. & Persingula Gachupin; daughter of Moses & Leonora G. Fragua; sister of Bertha Gachupin, Matthew Fragua, Elmer Fragua, Virgil Fragua & Loren Fragua; mother of Charinda Fragua, Marlinda Fragua & Brandon Fragua
TEACHERS: Persingula Gachupin, her grandmother, and Leonora Fragua, her mother
AWARDS: 1990, New Mexico State Fair, Albuquerque; 2001, 2nd, Jemez Pueblo Red Rocks Arts & Crafts Show
FAVORITE DESIGNS: corn, corn plants, feathers-in-a-row, terraced clouds, lightning, melons, rainbows, clouds, kiva steps, swirls
GALLERIES: The Indian Craft Shop, U.S. Department of Interior, Washington, D.C.
PUBLICATIONS: *Indian Market Magazine* 1985, 1989; Peaster 1987:67; *Indian Market Magazine* 1996:60; Congdon Martin 1999:68; Berger & Schiffer 2000:115.

Virginia Ponca Fragua learned pottery making from her grandmother, Persingula Gachupin. Virginia also painted some of the pottery by her mother, Leonora G. Fragua. Virginia developed her skills to a highly refined manner in each step of pottery making. She now creates pottery of an exceptional high quality.

Virginia is noted for her high-necked vases, some with terraced cloud rims. She combines highly polished redware and creamware melon and swirl forms with matte polychrome designs. Her style is distinctive and attractive. Most of her pots incorporate her Corn Clan symbols.

A. G. *(see Amelia Galvan)*

G. G. *(see Genevieve Garcia)*

M. A. G. or M. J. G. *(see Mary J. Garcia)*

M. F. G. *(see M. F. Gachupin)*

M. W. G. *(see Mark Wayne Garcia)*

R. G. *(see Rebecca T. Gachupin)*

Virginia P. Fragua - Photograph by Angie Yan Schaaf Courtesy of the artist

Alfreda Gachupin *(earlier signed Chinana, Jemez N.M.)*

(Jemez, active ca. 1990-present: traditional polychrome jars, bowls)
BORN: May 12, 1968
FAMILY: daughter of Lizardo & Mary Chinana; sister of Patrina Chinana, David Chinana, Martina Chinana
GALLERIES: Santa Fe Décor, Inc.
PUBLICATIONS: Berger & Schiffer 2000:105.

Alice Gachupin

(Jemez, active ?-present: pottery)
GALLERIES: The Indian Craft Shop, U.S. Department of Interior, Washington, D.C.

Andrea Gachupin

(Zia, active ca. 1920s-?: traditional polychrome jars, bowls)
BORN: ca. 1902
FAMILY: wife of Jose Gachupin; mother of Manuelita Gachupin (b. 1919)
PUBLICATIONS: U.S. Census 1920, family 9.

Antonia Gachupin

(Jemez, active ca. 1980s-present: polychrome jars, bowls)
BORN: ca. 1970s
FAMILY: mother of Kiana, Kajzia & Okoya Gachupin

Ardina Gachupin

(Jemez, active ca. 1990s-present: sgraffito jars, bowls)
AWARDS: 2000, 3rd (2), (ages 12 & under), Indian Market, Santa Fe
EXHIBITIONS: 1998-present, Indian Market, Santa Fe

Benian Gachupin

(Jemez, Corn Clan, active ca. 1990s-present: matte polychrome on stone polished redware jars, bowls)
FAMILY: m. great-granddaughter of Persingula Gachupin; m. granddaughter of Marie Romero; daughter of Laura Gachupin; sister of Gordon Gachupin
PUBLICATIONS: Peaster 1997:66-67.

Bertha Gachupin *(Thunder Flower)*

*Bertha Gachupin - Courtesy of Jason Esquibel
Rio Grande Wholesale, Inc.*

(Jemez, Corn Clan, active ca. 1970s-present: matte polychrome on polished redware & creamware jars, bowls, melon swirl pots, owls, ornaments)
BORN: April 11, 1954
FAMILY: m. granddaughter of Joe R. & Persingula M. Gachupin; daughter of Leonora G. Fragua & Moses Fragua; niece of Marie G. Romero; sister of Virginia Ponca Fragua, Matthew Fragua, Elmer Fragua, Virgil Fragua & Loren Fragua; grandmother of Kajzia Gachupin, Taryn Gachupin & Kiana Gachupin
AWARDS: 1994, 4th, New Mexico State Fair, Albuquerque; 1995, 2nd, New Mexico State Fair, Albuquerque; 2001, 2nd, Jemez Pueblo Red Rocks Arts & Crafts Show
EXHIBITIONS: 1985-present, Indian Market, Santa Fe; ?-2001, Jemez Pueblo Red Rocks Arts & Crafts Show
FAVORITE DESIGNS: feathers, rain clouds, terraced clouds, terraced diamonds, corn plants, lightning

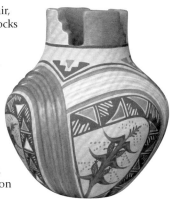

*Bertha Gachupin -
Photograph by Angie Yan Schaaf
Courtesy of the artist*

PUBLICATIONS: *Arizona Highways* May 1974 50(5):22; Barry 1984:131; *Indian Market Magazine* 1985, 1989, 1996:60; Peaster 1997:67; Walatowa Pueblo of Jemez, "Pottery of Jemez Pueblo" (1999).

Bertha Gachupin is admired and respected for her exceptional pottery. She and her sister, Virginia Ponca Fragua, share similar styles in blending polished redware and creamware melon and swirl forms with areas of matte polychrome designs. Both draw strongly on their Corn Clan symbols.

Candelaria Gachupin

(Zia, Coyote Clan, active ca. 1920s-?: traditional polychrome jars, dough bowls)
BORN: 1908
FAMILY: granddaughter of Rosalea Medina Toribio; daughter of Maria Bridgett; wife of Antonio Gachupin; mother of Dora Gachupin Tse-Pe (married into San Ildefonso), Frances Gachupin, Irene Gachupin, Joan Aragon, Steven Gachupin, Bernard Gachupin
STUDENTS: Dora Tse-Pe, her daughter, Ralph Aragon, her son-in-law
EXHIBITIONS: pre-1973-present, Indian Market, Santa Fe; 1974, "Seven Families in Pueblo Pottery," Maxwell Museum of Anthropology, Albuquerque; 1979, "One Space: Three Visions," Albuquerque Museum, Albuquerque
FAVORITE DESIGNS: rain, clouds
PUBLICATIONS: *SWAIA Quarterly* Fall 1973:3; Barry 1984:102; Batkin 1986:18; Trimble 1987:67; Dillingham 1996:106; Peaster 1997:97; Peterson 1997; *Indian Market Magazine* 1999:44.

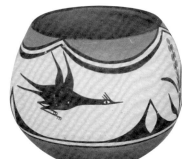

*Candelaria Gachupin -
Andrews Pueblo Pottery and Art Gallery
Albuquerque, NM*

Carla C. Gachupin *(signs C. Gachupin)*

(Jemez, active ca. 1991-present: Storytellers, polychrome jars, bowls)
BORN: August 13, 1970
FAMILY: daughter of Matthew & Genevieve Gachupin
TEACHER: Genevieve Gachupin, her mother
PUBLICATIONS: Congdon-Martin 1999:68; Berger & Schiffer 2000:116.

Carmelita Gachupin *(signs C. Gachupin)*

(Jemez, active ca. 1975-present: contemporary polychrome, black-on-buff jars, bowls, vases)
BORN: May 3, 1951
FAMILY: daughter of Gerry Daubs
TEACHER: Vangie Tafoya
FAVORITE DESIGNS: feathers-in-a-row, flowers, clouds
PUBLICATIONS: Berger & Schiffer 2000:36, 116, 131.

Carol or Caroline Fragua Gachupin *(1)* *(signs C. F. Gachupin)*

(see portrait with husband Joseph R. Gachupin, Sr.)

(Jemez, active ca. 1980s-present: matte polychrome Storytellers, Cat Storytellers, jars, bowls)
BORN: ca. 1960s
FAMILY: daughter of Felix & Grace L. Fragua; sister of Chris Fragua, Emily Fragua Tsosie, Clifford Kim Fragua (2), Felicia Fragua, Bonnie Fragua; wife of Joseph Gachupin, Sr.; mother of Joseph E. Gachupin, Jr.
EXHIBITIONS: 1985-present, Indian Market, Santa Fe; 1994-present, Eight Northern Indian Pueblos Arts & Crafts Show
GALLERIES: Kennedy Indian Arts, UT; Adobe Gallery, Albuquerque & Santa Fe
PUBLICATIONS: Babcock 1986; Peaster 1997:61, 69, 73; Congdon-Martin 1999:70.

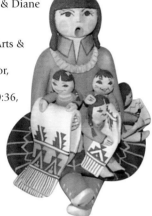

*Carol Lucero-Gachupin (2) -
Georgiana Kennedy Simpson
Kennedy Indian Arts, Bluff, UT*

Carol G. Lucero-Gachupin *(2)* *(signs Lucero-Gachupin with kiva step hallmark)*

(Jemez, active ?-present: polychrome Storytellers, jars & bowls)
BORN: November 19, 1958
FAMILY: daughter of Margarita Lucero; sister of Mary R. Lucero; cousin of Mary I. Lucero, Virginia A. Lucero; related to Marie Romero & Diane Lucero
TEACHER: Marie Romero
EXHIBITIONS: 1996-present, Eight Northern Indian Pueblos Arts & Crafts Show
GALLERIES: The Indian Craft Shop, U.S. Department of Interior, Washington, D.C.; Arlene's Gallery, Tombstone, AZ
PUBLICATIONS: Hayes & Blom 1998:35; Berger & Schiffer 2000:36, 116.

Carol Lucero-Gachupin was inspired to make pottery by her relative, Marie Romero. Carol specializes in forms with Hopi, Pueblo, or Navajo styles of hair and dress. Her figures wear painted turquoise nugget necklaces; some with pendants. Her babies are intelligent, reflected by the fact that many of them are reading books at an early age. Their blankets flutter and skirts flare out, creating the effect of motion.

Carol Lucero-Gachupin (2)

*Carol Lucero-Gachupin (2) - Courtesy of
Georgiana Kennedy Simpson
Kennedy Indian Arts, Bluff, UT*

Clara Gachupin

(Jemez, Coyote Clan, active ca. 1970-present: polychrome jars, bowls, wedding vases)
BORN: November 30, 1948
FAMILY: m. granddaughter of Andrieta & Juanita Shendo; daughter of Jose Maria & Reyes S. Toya; sister of Paul Toya, Ralph Toya, Mike Toya, Allen Toya, Johnny Toya, Marie Toya Vigil
TEACHER: Reyes S. Toya, her mother
AWARDS: 1998, 1st, Indian Market, Santa Fe
EXHIBITIONS: 1995-present, Indian Market, Santa Fe; 1995-present, Eight Northern Indian Pueblos Arts & Crafts Show
FAVORITE DESIGNS: clouds, feathers
PUBLICATIONS: Walatowa Pueblo of Jemez, "Jemez Pottery" (1998); Berger & Schiffer 2000:36, 116.

Corrie Gachupin

(Jemez, active ca. 1990s-present: sgraffito jars, bowls, pots)
AWARDS: 1992, 3rd, sgraffito (ages 12 & under), Indian Market, Santa Fe

Deborah A. Casiquito Gachupin

(Jemez, active ca. 1990s-present: pottery, textiles)
EXHIBITIONS: 1992-present, Indian Market, Santa Fe
PUBLICATIONS: Schaaf 2001:285.

Delia J. Gachupin

(Jemez, active ?-present: polychrome jars, bowls, ornaments, bread ovens)
EXHIBITIONS: 1994-present, Eight Northern Indian Pueblos Arts & Crafts Show
FAVORITE DESIGNS: feathers, rain clouds, corn plants, Kokopelli, cradleboard, bears
PUBLICATIONS: Walatowa Pueblo of Jemez, "Pottery of Jemez Pueblo" (1999).

Dora Gachupin *(see Dora Tse-Pe in Schaaf 2000)*

Etta Toya Gachupin

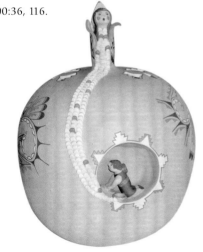

(Jemez, active ca. 1970s-present: pottery)
FAMILY: daughter of Mary E. Toya & Casimiro Toya; sister of Melinda Toya Fragua, Mary Ellen Toya (2), Judy Toya (2), Yolanda Toya, Casimiro Toya, Jr., Etta Toya Gachupin & Anita Toya; wife of Jimmy Gachupin

F. Gachupin

(Jemez, active ?-present: contemporary matte polychrome forms with human figures, corn kernel appliques)

*F. Gachupin -
Candace Collier Collection, Houston, TX*

Genevieve Gachupin *(signs G. Gachupin, Jemez)*

(Jemez, active ca. 1968-present: Storytellers, polychrome jars, bowls)
BORN: January 12, 1948
FAMILY: wife of Matthew Gachupin; mother of Carla C. Gachupin
STUDENT: Carla C. Gachupin, her daughter
AWARDS: 2nd, Youngbrook Show
EXHIBITIONS: 1997-present, Eight Northern Indian Pueblos Arts & Crafts Show
PUBLICATIONS: Berger & Schiffer 2000:84, 116.

Gloria Gachupin

(Zia, active ca. 1970s-?: traditional polychrome ollas, jars & bowls)
EXHIBITIONS: 1979, "One Space: Three Visions," Albuquerque Museum, Albuquerque; pre-1985-88, Indian Market, Santa Fe
COLLECTIONS: Candace Collier, Houston, TX
FAVORITE DESIGNS: roadrunners, plants, rainbows, clouds
PUBLICATIONS: Hayes & Blom 1996:162-63; 1998.

Helen Gachupin

(Zia, active ca. 1950s-90s: polychrome ollas, vases, jars, bowls, canteens)
BORN: ca. 1930
EXHIBITIONS: 1979, "One Space: Three Visions," Albuquerque Museum, Albuquerque; 1985-87, Indian Market, Santa Fe
COLLECTIONS: Wright Collection, Peabody Museum, Harvard University, Cambridge, MA; Dave & Lori Kenney, Santa Fe
FAVORITE DESIGNS: roadrunners, birds, yucca, rainbows
VALUES: On February 4, 2000, a polychrome jar signed Helen Gachupin (16 x 13"), sold for $1,100 at R. G. Munn, #233.
 On February 4, 2000, a polychrome dough bowl signed Helen Gachupin (8 x 17"), sold for $1,100 at R. G. Munn, #829.
 On February 4, 2000, a polychrome jar signed Helen Gachupin (14 x 14"), sold for $1,100 at R. G. Munn, #233.
 On February 6, 1998, a polychrome dough bowl signed Helen Gachupin (9 x 16"), sold for $1,210 at R. G. Munn, #742.
PUBLICATIONS: Barry 1984:102; *Indian Market Magazine* 1985, 1988; Trimble 1987:67; *Indian Trader* May 1997:27; Drooker & Capone 1998:139.

Henrietta Toya Gachupin

(Jemez, active ca. 1980s-present: matte polychrome Storytellers)
BORN: ca. 1963
AWARDS: 2000, 3rd, Storytellers, Indian Market, Santa Fe
EXHIBITIONS: 1985-present, Indian Market, Santa Fe
GALLERIES: Palms Trading Company, Albuquerque
PUBLICATIONS: *Indian Market Magazine* 1985, 1988, 1989; Babcock 1996; Congdon-Martin 1999:71.

J. Gachupin

(Jemez, active ca. 1980s-present: matte polychrome jars, bowls, Mudhead effigy seed pots)
GALLERIES: Adobe Gallery, Albuquerque & Santa Fe

Joseph R. Gachupin, Sr. *(signs J. R. Gachupin, Jemez)*

*Joseph R. Gachupin, Sr. & Caroline Gachupin (1) -
Courtesy of the artists*

(Jemez, active ca. 1976-present: traditional & contemporary matte polychrome Corn Maidens, corn sculptures, jars, bowls)
BORN: December 14, 1953
FAMILY: son of Irene Gachupin; husband of Caroline Gachupin; father of Joseph E. Gachupin, Jr.
TEACHERS: Caroline Gachupin, his wife; and Emily Tsosie, his sister-in-law
AWARDS: 1st, Eight Northern Indian Pueblos Arts & Crafts Show; 2nd, Colorado Indian Market, Denver; 1st, 2nd, New Mexico State Fair, Albuquerque; Dallas Arts & Crafts Show, Dallas, TX
EXHIBITIONS: 1988-present, Eight Northern Indian Pueblos Arts & Crafts Show; 1989-present, Indian Market
GALLERIES: Kennedy Indian Arts, Bluff, UT; Rio Grande Wholesale, Palms Trading Company, Albuquerque
PUBLICATIONS: Peaster 1997:69, 73; Congdon-Martin 1999:72; Berger & Schiffer 2000:84, 116.

 Joseph R. Gachupin is an award-winning potter. He molds his matte polychrome Corn Maidens and other figures by hand. His figures seem to emerge from the surface of his pottery. Joseph's designs are bold and beautiful. He fires his figures outdoors with cedar chips.

*Joseph R. Gachupin, Sr. -
Courtesy of Jason Esquibel
Rio Grande Wholesale, Inc.*

Joseph E. Gachupin, Jr.

(Jemez, active ca. 1990s-present: pottery, figures)
BORN: ca. 1980
FAMILY: p. grandson of Irene Gachupin; son of Caroline Gachupin & Joseph Gachupin, Sr.

Juan Gachupin

(Jemez, active ca. 1920s-?: pottery, paintings)
COLLECTIONS: Museum of New Mexico, Santa Fe; Minneapolis Institute of Arts, MN; Museum of Northern Arizona, Flagstaff; Southwest Museum, Los Angeles
PUBLICATIONS: Fawcett & Callander 1982; Lester 1995:190.

Kajzia Gachupin

(Jemez, Zia Corn Clan, active ca. 1990s-present: pottery)
BORN: June 15, 1991
FAMILY: granddaughter of Moses & Leonora Fragua, Bertha Gachupin; daughter of Albert Yepa & Antonia Gachupin; sister of Kiana, Okoya Gachupin

Kiana Gachupin

(Jemez, Zia Corn Clan, active ca. 1990s-present: pottery)
BORN: May 21, 1993
FAMILY: granddaughter of Moses & Leonora Fragua, Bertha Gachupin; daughter of Albert Yepa & Antonia Gachupin; sister of Kajzia, Okoya Gachupin

Laura Gachupin *(Corn Plant hallmark)*

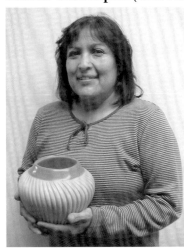

Laura Gachupin - Courtesy of Jason Esquibel Rio Grande Wholesale, Inc.

(Jemez, Zia Corn Clan, active ca. 1978-present: traditional matte polychrome, polished red-ware and buffware jars, melon bowls, kiva bowls, turtle bowls, effigy jars, vases, wedding vases, seed pots, Kiva bowls, animal & human figures, Pueblo dancers, owls, miniatures)
BORN: November 4, 1954
FAMILY: m. granddaughter of Joe R. & Persingula M. Gachupin; p. granddaughter of Benina Medina; daughter of Marie G. Romero; sister of Maxine Toya; wife of James Foley; mother of Benina & Gordon Foley
EDUCATION: Institute of American Indian Arts, Santa Fe
TEACHER: Persingula M. Gachupin
STUDENTS: Benina Foley, Leonora G. Fragua, her daughters
AWARDS: 1979, 1st (2), jar with figural lid, kiva bowl; 1981, 2nd; 1984, 1st, jars; 2nd, melon bowls, 3rd, plates; 1988, 1st, melon bowls; 1989, 1st, jars; 1990, 1st, melon bowls; 1992, 2nd, traditional bowls, Indian Market, Santa Fe; Heard Museum Show, Phoenix; Eight Northern Indian Pueblos Arts & Crafts Show; New Mexico State Fair, Albuquerque; Inter-tribal Indian Ceremonial, Gallup
EXHIBITIONS:1981, "Indian Art of the 1980s," Native American Center for the Living Arts, Niagara Falls, NY; 1984-present, Indian Market, Santa Fe
DEMONSTRATIONS: Idyllwild Arts, Idyllwild, CA; Cleveland Museum of Art, OH
COLLECTIONS: Albuquerque International Airport, Albuquerque, NM; Museum of Northern Arizona, Flagstaff
FAVORITE DESIGNS: Pueblo dancers, corn plants, ears of corn, clouds, rain, turtles, kiva steps
GALLERIES: The Indian Craft Shop, U.S. Department of Interior, Washington, D.C.; Kennedy Indian Arts, Bluff, UT; Crosby Collection, Park City, UT, Andrew's Pueblo Pottery, Rio Grande Wholesale, Wright's Gallery, Pueblo Loft, Albuquerque
PUBLICATIONS: Barry 1984:119-26; Babcock 1986; Trimble 1987:68-69; Wright 1989, 2000:250; Eaton 1990:13; Schiffer 1991d:49; Hayes & Blom 1996; 1998:48; *Southwest Art Magazine* Nov. 1996 26(6):50; Peaster 1997:61, 65-67, 157; Congdon-Martin 1999:72; *Cowboys & Indians* 1999:95; Sep. 2000 8(4):94; Berger & Schiffer 2000:36, 116.

Laura Gachupin - Courtesy of Blue Thunder Fine Indian Art at www.bluethunderarts.com

Laura Gachupin is a top prize winning pottery artist. She is multi-talented and has experimented with many styles. She learned traditional pottery techniques from her family. She also learned many forms of art as a student at the Institute for American Indian Arts in Santa Fe. Laura explained her personal feelings, "I was born into an art family. I feel at peace with myself when I do my clay work. I love it!"

Laura's owls are unique. She forms each feather in red clay, portraying a small red baby owl in a round ball of plumes. She digs her clay and makes beautiful traditional polished redware and buff melon and swirl jars. She taught her daughter, Benina Foley, to carry on the family tradition.

Lucero Gachupin *(see Carol Lucero-Gachupin)*

Lucia Gachupin

(Zia, active ca. 1890s-?: traditional polychrome jars, bowls)
BORN: ca. 1874
FAMILY: wife of Juan de Jesus Gachupin; mother of Antonio, Reyes & Nicholas Gachupin
PUBLICATIONS: U.S. Census 1920, family 11.

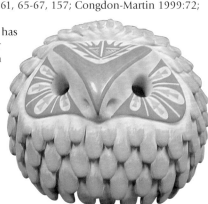

Laura Gachupin - Courtesy of Jason Esquibel Rio Grande Wholesale, Inc.

M. F. Gachupin *(signs M.F.G.)*
(Jemez, active ?-present: polychrome matte tanware jars, bowls, wedding vases)
FAVORITE DESIGNS: terraced clouds, flowers, rain
PUBLICATIONS: Berger & Schiffer 2000:36, 116.

Manuelita Gachupin *(1)*
(Jemez, active ca. 1990s-present: pottery)
EXHIBITIONS: 1994-present, Eight Northern Indian Pueblos Arts & Crafts Show

Manuelita Gachupin *(2)*
(Zia, active ?-present: pottery)
EXHIBITIONS: ?-1985, Indian Market, Santa Fe; 1998-present, Eight Northern Indian Pueblos Arts & Crafts Show
PUBLICATIONS: *Indian Market Magazine* 1985.

Mary Gachupin
(Zia, active ca. 1970s-?: polychrome pottery)
PUBLICATIONS: Hayes & Blom 1996:160-61.

Maxine Gachupin
(Jemez, active ca. 1963-?: pottery, paintings)
BORN: ca. 1948
EXHIBITIONS: Indian Market 1984-?
PUBLICATIONS: Fawcett & Callander 1982:20, 68, 80; Lester 1995:190; *New Mexico Magazine* Aug. 2000 78(8):12.

P. Gachupin
(Jemez, active ca. 1980s-present: stone polished polychrome Storytellers)
PUBLICATIONS: Congdon-Martin 1999:72.

Persingula M. Gachupin
(Jemez/Zia, Corn Clan, active ca. 1930s-80s+: traditional matte polychrome & black-on-white redware & tanware Storytellers, figures, owls, Nativities, jars, bowls)
LIFESPAN: ca. 1910 - 1994
FAMILY: daughter of Ramon Madelena & Benigna Medina Madelena (Zia Corn Clan); sister of Elcina Madelena & Josephita Madelena; wife of Joe R. Gachupin; mother of Marie G. Romero, Leonora G. Fragua; grandmother of Bertha Gachupin, Matthew Fragua, Elmer Fragua, Virgil Fragua, Loren Fragua, Laura Gachupin, Maxine Toya & Virginia Ponca Fragua; great-grandmother of Charinda Fragua, Marlinda Fragua, Brandon Fragua, Benina Foley, Gordon Foley & Damian Toya
STUDENTS: Leonora G. Fragua & Bertha Gachupin, her daughters, Laura Gachupin, Benina Foley
EXHIBITIONS: pre-1984-94, Indian Market, Santa Fe
FAVORITE DESIGNS: terraced clouds, kiva steps, fineline rain
GALLERIES: Adobe Gallery, Albuquerque & Santa Fe
PUBLICATIONS: U.S. Census 1920, family 77; *Arizona Highways* May 1974 50(5):22-24; Barry 1984:131; Babcock 1986; Peaster 1997:61, 63, 65; Congdon-Martin 1999:73; Berger & Schiffer 2000:142.

Persingula Gachupin was the daughter of Ramon Madalena from Jemez Pueblo and Benigna Medina Madalena from Zia Pueblo. Persingula married Joe R. Gachupin. They raised two daughters, Marie G. Romero and Leonora G. Fragua, who became fine potters. In the 1960s, Persingula and her daughter, Marie Romero, were the first potters at Jemez Pueblo to introduce Storytellers and Nativities. They also are known for making fine matte polychrome on polished redware pottery.

Rebecca T. Gachupin *(signs R. G.)*
(Jemez/Zia, active ca. 1987-present: Zia style polychrome jars, bowls)
BORN: November 17, 1955
FAMILY: m. granddaughter of Juan & Susanita Celo; daughter of Hubert & Andrea C. Tsosie; sister of Irene Herrera, Leonard Tsosie & Joanne Toribio
COLLECTIONS: Angie Yan Schaaf, Santa Fe
FAVORITE DESIGNS: Roadrunners, rainbows, clouds
GALLERIES: The Indian Craft Shop, U.S. Department of Interior, Washington, D.C.
PUBLICATIONS: Hayes & Blom 1996:162-63; 1998; Berger & Schiffer 2000:116.

Taryn Gachupin -
Photograph by Angie Yan Schaaf

Reyes Gachupin
(?Zia, active ?: pottery)
ARCHIVES: Laboratory of Anthropology Library, Santa Fe, lab. file.

Taryn Gachupin
(Jemez, Corn Clan, active ca. 1990s-present: pottery)
BORN: December 8, 1992
FAMILY: granddaughter of Moses & Leonora Fragua, Bertha Gachupin; daughter of Melanie Gachupin

Wilma M. Gachupin *(Sacred Rock Basket)*, *(signs W. Gachupin)*

(Jemez, active ca. 1985-present: Storytellers)
BORN: July 30, 1957
FAMILY: daughter of Lawrence Sando & J. Gonzales; sister of Kenneth Sando;
mother of Megan Gachupin & Kayla Gachupin
TEACHER: Kenneth Sando
AWARDS: 1999, 3rd, New Mexico State Fair, Albuquerque; Eight Northern
Indian Pueblos Arts & Crafts Show; Towa Arts & Crafts Show, Jemez, NM
EXHIBITIONS: Smithsonian Institution, Washington, D.C.
GALLERIES: The Indian Craft Shop, U.S. Department of Interior, Washington,
D.C.; Arlene's Gallery, Tombstone, AZ; Rio Grande Wholesale, Inc., Albuquerque
PUBLICATIONS: Congdon-Martin 1999:73; Berger & Schiffer 2000:85, 117.

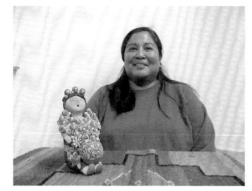

Wilma Gachupin - Courtesy of Jason Esquibel
Rio Grande Wholesale, Inc.

Mary Gaithia

(Laguna, active ?-present: traditional polychrome jars, bowls)
FAMILY: grandmother of Bertha Riley; great-grandmother of Stuart Riley, Jr.

Edna Medina Galiford *(Guliford, Edna Medina)*

(Zia, Coyote Clan, active ca. 1980s-present: contemporary polychrome jars, bowls, paintings on matte board & wood)
BORN: 1957
FAMILY: great-granddaughter of Rosalea Medina Toribio; granddaughter of Juanita Toribio Pino; daughter of
Sofia and Rafael Medina; sister of Marcellus Medina, Rachel Medina, Samuel Medina, Lois Medina, Herman
Medina & Fred Medina.
TEACHERS: Sofia & Rafael Medina
STUDENTS: Gallup Public School, Christian School, Gallup; Portales Public School
PUBLICATIONS: Dillingham 1994:106, 113; *Indian Trader* Sept. 1999:7.

 Edna Medina Galiford calls her pottery an "in-between style." She experiments with mixing old and
new techniques. Her painting style is influenced by her father, Rafael Medina. Her mother, Sofia Medina,
is one of the Zia masters in making large polychrome ollas.

JoAnne G. Gallegos *(JoAnne Garcia)*

(Acoma, active ca. 1984-present: traditional & ceramic polychrome jars, bowls)
BORN: September 24, 1957
FAMILY: daughter of Elizabeth Garcia
TEACHERS: Elizabeth Garcia, her mother, and Mary Lewis
GALLERIES: Rio Grande Wholesale, Inc., Palms Trading Co., Albuquerque
PUBLICATIONS: Berger & Schiffer 2000:117.

Wilma Gachupin -
Courtesy of Jason Esquibel
Rio Grande Wholesale, Inc.

Victoriana Gallegos

(Santa Ana, active ca. 1900-?: pottery)
BORN: ca. 1884
FAMILY: wife of Rafael; mother of Coliqni, Tonita, Rumalda
ARCHIVES: U.S. Census Santa Ana 1920, family 13; Laboratory of Anthropology Library, Santa Fe, lab file.

Viola Gallegos

(Acoma, active ?-1990+: polychrome jars, bowls)
PUBLICATIONS: Dillingham 1992:206-208.

Amelia Galvan *(signs A. G. Jemez N.M.)*

(Jemez, active ca. 1962-present: traditional polychrome jars, bowls)
BORN: May 10, 1940
TEACHER: her mother
PUBLICATIONS: Berger & Schiffer 2000:117.

Ascencion Herrera Galvan

(Zia, Tobacco Clan, active ca. 1920s-40s+: traditional polychrome ollas, jars, bowls)
BORN: ca. 1900
FAMILY: daughter of Reyes Arsala Herrera & Juan Pedro Herrera; mother of Dolorita Galvan Pino, Harveana Helen Medina, Pablita
Galvan Lucero; grandmother of Teresita Mellon, Stanley Pino, Harry Pino, Antonita Pino; great-grandmother of Travis Mellon
ARCHIVES: Laboratory of Anthropology Library, Santa Fe, lab. file.

Francisca Galvan

(Zia, active ca. 1910s-?: traditional polychrome jars, bowls)
BORN: ca. 1888
FAMILY: wife of Antonio Galvan; mother of Augusta, Ray, Savin, Abelina
PUBLICATIONS: U.S. Census 1920, family 3.

Joseffa Galvan *(see Joseffa Galvan Shije)*

Rufina Galvan
(Zia, active ca. 1900s-?: traditional polychrome jars, bowls)
BORN: ca. 1882
FAMILY: wife of Celestino Galvan
PUBLICATIONS: U.S. Census 1920, family 1.

Teresita Galvin
(Zia, active ca. 1980s-present: polychrome jars, bowls)
FAMILY: sister of Eusebia Shije
PUBLICATIONS: Peaster 1997:151.

Garcia *(see Cyres Garcia)*

Aaron M. Garcia
(Acoma, active ?-1990+: polychrome jars, bowls)
PUBLICATIONS: Dillingham 1992:206-208.

Alvina Garcia
(Santo Domingo, active ca. 1960s-?: polychrome & black-on-cream jars, vases, dough bowls)
COLLECTIONS: Wright Collection, Peabody Museum, Harvard University, Cambridge, MA; Dr. Gregory & Angie Yan Schaaf
FAVORITE DESIGNS: leaves, butterflies, deer
PUBLICATIONS: Hayes & Blom 1996; Drooker et al. 1998:139.

Andrew Garcia
(Santo Domingo, active ? - present: polychrome, jars, bowls)
COLLECTIONS: Dr. Gregory & Angie Yan Schaaf, Santa Fe

Arlene Garcia
(Acoma, active ?-1990+: polychrome jars, bowls)
PUBLICATIONS: Dillingham 1992:206-208.

Beatrice Garcia *(signs Bea Garcia) (collaborates sometimes with Elliot Garcia, Sr.)*
(Acoma, active ca. 1977-present: ceramic fineline & polychrome jars, bowls)
BORN: January 16, 1953
FAMILY: m. granddaughter of Santana & Siome Sanchez; daughter of Gladys & Lorenzo P. Garcia; mother of Shawna Garcia-Rustin, Elliott Garcia Jr., Lynette Garcia, Janet Garcia & Terrance Garcia
TEACHER: Santana Sanchez, her grandmother
GALLERIES: Rio Grande Wholesale, Inc., Palms Trading Co., Albuquerque
PUBLICATIONS: Dillingham 1992:206-208; Berger & Schiffer 2000:13, 117.

Bert Garcia
(Acoma, active ?-1990+: polychrome jars, bowls)
PUBLICATIONS: Dillingham 1992:206-208.

Beverly Victorino Garcia *(see Beverly Victorino)*

Brenda L. Garcia *(formerly Brenda L. Cerno)*
(Acoma, active ca. 1976: polychrome jars, bowls)
BORN: May 3, 1959
FAMILY: daughter of Daisy & Stan Leon
TEACHER: her grandmother
AWARDS: New Mexico State Fair, Albuquerque
PUBLICATIONS: Dillingham 1992:206-208; Berger & Schiffer 2000:102.

Candy Garcia
(Santo Domingo, active ?-present: pottery, jewelry)
EXHIBITIONS: 1992, Indian Market, Santa Fe

Caroline Garcia-Sarracino *(Caroline Sarracino, Evening Star)*
(Acoma, active ca. 1990s-present: traditional & contemporary polychrome jars, bowls)
BORN: December 26, 1960; RESIDENCE: San Fidel, NM
EXHIBITIONS: 1995-present, Eight Northern Indian Pueblos Arts & Crafts Show
PUBLICATIONS: Painter 1998:15.

Cheston Niles Garcia *(collaborated with Marie Aguilar)*
(Santo Domingo, active ca. 1994-present: blackware jars, bowls, wedding vases, animal figures
BORN: ca. 1991
FAMILY: grandson of Marie Aguilar

Christopher and Loretta Garcia
(Acoma, active ?-1990+: polychrome jars, bowls)
PUBLICATIONS: Dillingham 1992:206-208.

Claudia Garcia
(Acoma, active ca. 1977-present: traditional & ceramic polychrome jars, bowls)
BORN: April 26, 1952
FAMILY: daughter of Ruth Garcia
GALLERIES: Rio Grande Wholesale, Inc., Palms Trading Co., Albuquerque
PUBLICATIONS: Berger & Schiffer 2000:117.

Concepcion Garcia
(Acoma, active ca. 1930s-?: traditional polychrome jars, bowls)
BORN: ca. 1920s
FAMILY: daughter of Teofila Torivio; sister of Frances Pino Torivio, Juanita Keene (1), Katherine Analla, Lolita Concho

Connie Garcia
(Acoma, active ?-1990+: polychrome jars, bowls)
PUBLICATIONS: Dillingham 1992:206-208.

Corrine Garcia *(signs C. Garcia, Acoma N.M.)*
(Acoma, active ca. 1979-present: corrugated storybowls, polychrome and whiteware jars, bowls, Storyteller turtles, miniatures)
BORN: February 17, 1960
FAMILY: daughter of Fermin & Sarah Martinez
TEACHER: her grandmother
COLLECTIONS: John Blom
FAVORITE DESIGNS: human figures, turtles, lizards
GALLERIES: Rio Grande Wholesale, Inc., Palms Trading Co., Albuquerque
PUBLICATIONS: Schiffer 1991d:50; Dillingham 1992:206-208; Congdon-Martin 1999:49; Painter 1998:11; Berger & Schiffer 2000:117.

Cyres Garcia *(signs Garcia, Acoma)*
(Acoma, active ca. 1994-present: polychrome jars, bowls)
BORN: December 17, 1955
FAMILY: child of Albert Garcia
GALLERIES: Rio Grande Wholesale, Inc., Palms Trading Co., Albuquerque
PUBLICATIONS: Berger & Schiffer 2000:117.

D. J. Garcia *(see Janet Garcia)*

Danielle Garcia
(Acoma, active ?-present: pottery)
EXHIBITIONS: 1998-present, Eight Northern Indian Pueblos Arts & Crafts Show

Dolores Lewis Garcia *(1), (signs Dolores Lewis, Acoma N.M.)*
(Acoma, Road Runner Clan, active ca. 1953-1998: Anasazi Revival black-on-white & polychrome ollas, jars, bowls, wedding vases, canteens, mugs, miniatures, jewelry)
BORN: July 25, 1938 or 1939; RESIDENCE: San Fidel, NM
FAMILY: daughter of Lucy M. Lewis & Toribio Lewis; mother of Kathleen Garcia, Adam Garcia, Chris Garcia & Merle Garcia; grandmother of Todd James, Chad David, Jason Garcia & Manuel Garcia
TEACHER: Lucy M. Lewis, her mother
AWARDS: 1979, 3rd (2); 1981, 3rd, Indian Market, Santa Fe
EXHIBITIONS:

1960-91	Indian Market, Santa Fe
1974	"Seven Families in Pueblo Pottery," Maxwell Museum, University of New Mexico, Albuquerque
1979	"One Space: Three Visions," Albuquerque Museum, Albuquerque
1987	Native American Rights Fund Event, Boulder, CO
1993	Taipei International Exhibition of Traditional Arts & Crafts, Taipei Fine Arts Museum, Taipei, Taiwan

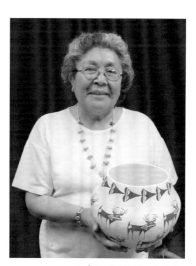

Dolores Lewis Garcia (1) -
Courtesy of Jason Esquibel
Rio Grande Wholesale, Inc.

1997 "The Legacy of Generations," National Museum of Women in the Arts, Washington, D.C.
1999-2000 Very Special Arts, Albuquerque, NM
DEMONSTRATIONS/WORKSHOPS:
 1979-88 One week ceramic workshop, Idyllwild Arts, Idyllwild, CA
 1990 Indiana University Institute for Advanced Study, Bloomington, IN
 1991 One week ceramic workshop, Minnesota State University, Mankato, MN
 1997-2001 One week ceramic workshop, University of Santa Cruz, Santa Cruz, CA
 1998-2001 One week ceramic workshop, Taos Art Institute, Taos, NM
 1999 U.S.-Canadian Arts Exchange, Toronto, Hamilton, Dundas, Ontario,
 Canada; One week ceramic workshop, Cushing Academy, Boston, MA
 2000 One week ceramic workshop, Kalamazoo Institute of Art,
 Kalamazoo, MI

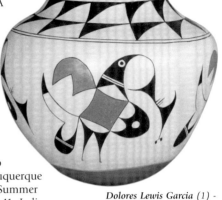

Dolores Lewis Garcia (1) -
Dave & Lori Kenney Collection

COLLECTIONS: Wright Collection, Peabody Museum, Harvard University,
Cambridge, MA; Albuquerque Museum, Albuquerque; Maxwell Museum of
Anthropology, Albuquerque; Brooklyn Museum of Arts, Brooklyn, NY; San Diego
Museum of Man, San Diego, CA; Southwest Museum, Los Angeles, CA; Volunteer Park
Museum, Seattle, WA; Candace Collier, Houston, TX; Dave & Lori Kenney, Santa Fe
FAVORITE DESIGNS: deer, Rainbirds, parrots, clouds, rain
GALLERIES: The Indian Craft Shop, U.S. Department of Interior, Washington, D.C.; Rio
Grande Wholesale, Inc., Palms Trading Co., Andrews Pueblo Pottery & Art Gallery, Albuquerque
PUBLICATIONS: Barsook, et al. 1974; Tanner 1976:123; *American Indian Art Magazine* Summer
1979:21; Peterson 1984; 1997:10, 44, 77, 132-35, 138-39; Barry 1984:89; Dedera 1985:41; *Indian
Market Magazine* 1985-91; Trimble 1987:2, 12, 19, 77, 79; Schiffer 1991d:51; Dillingham
1992:206-208; 1996:93, 102; Mercer 1995:7; Reano 1995:58; Hayes & Blom 1996:48-49;
Indian Trader Apr. 1996:14; Oct. 1997; Peaster 1997:157; Peterson 1997; Drooker &
Capone 1998:138; Painter 1998:13; Anderson, et al. 1999:32; Berger & Schiffer
2000:117, 127.

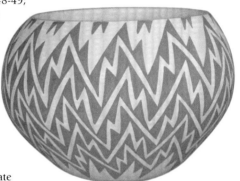

Dolores Lewis Garcia (1) -
Dave & Lori Kenney Collection

 Dolores Lewis Garcia is the daughter of Lucy M. Lewis, one of the
respected matriarchs of Acoma potters. Delores praised her mother for
teaching her how to make pottery. However, she credited her ancient
ancestors, the Anasazi, as their "greatest inspiration. . .Generation to
generation, we keep the pottery rolling." (Dillingham 1994:102.)

Dolores Garcia *(2)*
(Acoma, active ca. 1880s-1910s+: polychrome jars, bowls)
BORN: ca. 1869; RESIDENCE: McCartys in ca. 1910
PUBLICATIONS: Leopold Bibo, "13th Annual U.S. Census" (1910), New Mexico State
Archives, Call T624, Roll 919; in Dillingham 1992:205.

Dolores Garcia *(3)*
(Acoma, active ?-present: polychrome jars, bowls)
PUBLICATIONS: Reano 1995:58.

Donna M. Garcia-Chino *(see Donna G. Chino)*

Elizabeth Garcia *(1) (Elizabeth Lewis)*
(Acoma, active ca. 1960s-1990s: polychrome jars, bowls)
FAMILY: mother of Christopher Augustine
PUBLICATIONS: Minge 1991:195; Dillingham 1992:206-208.

Elizabeth Garcia *(2)*
(Acoma, active ca. 1950s-90s: traditional & ceramic polychrome jars, bowls)
BORN: 1930s
FAMILY: mother of JoAnne G. Gallegos
GALLERIES: Rio Grande Wholesale, Inc., Palms Trading Co., Albuquerque
PUBLICATIONS: Berger & Schiffer 2000:117.

Elizabeth Garcia *(3)*
(Acoma, Red Corn Clan, active ca. 1950s-?: traditional polychrome jars, bowls)
BORN: ca. 1940
FAMILY: mother of Sharon Lewis

Elliott Garcia, Jr.
(Acoma, Red Corn Clan, active ca. 1990s-present: ceramic sgraffito & polychrome jars, bowls)
BORN: February 24, 1971
FAMILY: son of Beatrice & Elliott Garcia, Sr.; brother of Shawna Garcia-Rustin, Lynette Garcia, Janet Garcia & Terrance Garcia

Elliott Garcia, Sr. *(signs drawing of a Sunrise hallmark), (collaborates sometimes with Zelda Garcia), (They sign Zel Sun Rise followed by a Sunrise hallmark)*

(Acoma, Sun Clan, active ca. 1977-present: molded ceramic white jars, bowls, wedding vases, vases with raised bears and cutouts of pueblo village outlines)
BORN: July 24, 1947
FAMILY: brother of Wilfred Garcia, Mary Garcia Seymour; father of Shawna Garcia, Elliott Garcia, Jr., Lynette Garcia, Janet Garcia & Terrance Garcia
STUDENTS: Janet, Shawna & Elliott Garcia, Jr., his children
FAVORITE DESIGNS: Sunfaces, pueblo village scenes, bears
GALLERIES: Rio Grande Wholesale, Inc., Palms Trading Co., Albuquerque
PUBLICATIONS: Berger & Schiffer 2000:117.

*Elliott Garcia, Sr. & Zelda Garcia -
Courtesy of Jason Esquibel, Rio Grande Wholesale, Inc.*

Evelyn Garcia

(Acoma, active ?-present: polychrome figures, redware bears, dogs)
PUBLICATIONS: Hayes & Blom 1998:41, 45.

Evelyn Garcia makes wonderful animal figures. She creates realistic images; her dogs have carefully modeled hair and life-like expressions.

Felipa Garcia *(possibly Felipita Aguilar Garcia)*

(Santo Domingo, active ca. 1880s-30s: pottery)
BORN: ca. 1867
FAMILY: wife of Santiago Garcia; mother of Sanjuanito Garcia
PUBLICATIONS: U.S. Census, Santo Domingo, 1920, family 41; School of American Research, Kenneth M. Chapman collection, box III, folder 2; Batkin 1987:202, n. 80.

Felipita Aguilar Garcia

(Santo Domingo, active ca. 1890s-1930s: traditional polychrome, black-on-cream & black-on-red ollas, jars, dough bowls, pitchers)
FAMILY: sister of Asuncion Aguilar Cate; sister-in-law of Mrs. Ramos Aguilar
COLLECTIONS: R. W. Corwin Collection, Taylor Museum, Colorado Springs, CO, on loan from The Colorado College, pitcher ca. 1900-1910, #6468, Frank Applegate Collection, dough bowl, ca. 1900-1920, #4382; Joe Marchiani, Canyon City, CO.
PUBLICATIONS: Batkin 1987:99, 107.
PHOTOGRAPHS: Aguilar Style Pottery, ca. 1921, Museum of New Mexico Archives, neg. #23393; Toulouse 1977:41; *American Indian Art Magazine* Winter 1991 17(1):87..

Felipita Aguilar Garcia was known for making negative designs with a solid black background. She made beautifully formed ollas. Five of her ollas were photographed in 1921 at the Bernalillo Mercantile Company.

She may be the same Felipita Garcia who was visited in 1933 by museum director Kenneth Chapman. (School of American Research, Kenneth Chapman Papers, box III, folder 2)

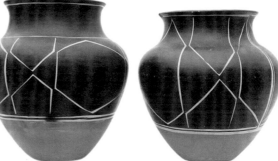

*Felipita Aguilar Garcia -
Nedra Matteucci Galleries
Santa Fe*

Gail S. Garcia-Cerno

(Acoma, active ?-1990+: polychrome jars, bowls)
RESIDENCE: Acoma Pueblo, NM
PUBLICATIONS: Dillingham 1992:206-208.

Genevieve Garcia *(signs G. G.), (collaborates with Joseph Calabaza & Shumaal Lucero)*

(Santo Domingo, active ca. 1960s-present: polychrome bowls, figures, angels, Nativities)
BORN: July 25, 1942
FAMILY: daughter of Reyes Calabaza & Santiago L. Calabaza; wife of Joseph Calabaza; sister of Marie Aguilar & Andrea; grandmother of Shumaal Lucero
TEACHER: Reyes Calabaza, her mother
STUDENT: Shumaal Lucero
GALLERIES: Genny's Pottery & Jewelry Shop, Santo Domingo Pueblo
EXHIBITIONS: 2001, Santo Domingo Arts & Crafts Show

Gladys Garcia

(Acoma, Red Corn Clan, active ca. 1940s-?: traditional polychrome jars, bowls)
BORN: ca. 1920
FAMILY: daughter of Santana & Siome Sanchez; sister of James & Elliott Sanchez; wife of Lorenzo Garcia; mother of Lena Garcia Aragon, Geraldine Garcia, Marie Garcia Vallo, Alan "Thunder Cloud" Garcia & Beatrice Garcia; m. grandmother of Shawna Garcia-Rustin, Elliott Garcia, Jr., Lynette Garcia, Janet Garcia & Terrance Garcia; m. great-grandmother of Wade, Natalie & Patrick Rustin

Glenda Garcia

(Acoma, active ca. 1970s-present: pottery)
ARCHIVES: Artist File, Heard Museum, Phoenix

Harriett Garcia

(Acoma, active ? - present: polychrome, jars, bowls)
COLLECTIONS: Dr. Gregory & Angie Yan Schaaf, Santa Fe

Helen Garcia *(1) (H. Garcia)*

(Sandia, active ca. 1960s-70s: polychrome jars, chili bowls)
PUBLICATIONS: Hayes & Blom 1996:108-09.

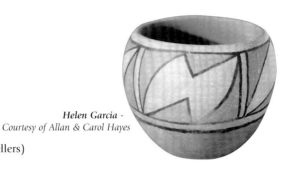

Helen Garcia -
Courtesy of Allan & Carol Hayes

Helen Sando Garcia *(2)*

(Jemez, married into Santo Domingo, active ca. 1980s-present: Storytellers)
COLLECTIONS: Pat & Garet Ten Cate

Janet Garcia *(signs DJ Garcia, Acoma N.M.)*

(Acoma, Red Corn Clan, active ca. 1995-present: ceramic fineline effigy jars with lizards)
BORN: December 24, 1975
FAMILY: daughter of Beatrice & Elliott Garcia, Sr.; sister of Shawna Garcia, Elliott Garcia, Jr.,
Lynette Garcia & Terrance Garcia
TEACHERS: Elliott & Beatrice Garcia, her parents
PUBLICATIONS: Berger & Schiffer 2000:118.

Jessie C. Garcia

(Acoma, Sun Clan, active ca. 1930s-90: traditional polychrome, Anasazi Revival black-on-white &
corrugated ollas, jars, bowls, vases, wedding vases, figures, turtles, turkeys, owls, Storytellers)
LIFESPAN: ca. 1910s - 1990s
FAMILY: daughter of Juana Garcia; mother of Chester W. Garcia, Marcus Garcia, Lori Garcia, Tina
Garcia, Anita Garcia Lowden, Stella Shutiva; mother-in-law of Sarah Garcia; p. grandmother of
Debbie G. Brown, Goldie Hayah; m. grandmother of Sandra Shutiva, Jacqueline Shutiva Histia,
Jerilyn Emanuel, Patricia Lowden

Jessie Garcia -
Andrea Fisher Fine Pottery, Santa Fe

EXHIBITIONS: 1961-72 Indian Market, Santa Fe
COLLECTIONS: Smithsonian Institute, Washington, D.C.; School of American Research, Santa Fe, cat. #IAF 2147, #IAF 2842; Allan
& Carol Hayes; Candace Collier; Gloria Couch; Dave & Lori Kenney
FAVORITE DESIGNS: frogs, lightning, rain, clouds, flowers
VALUES: On August 15, 1999, a polychrome jar, signed Jessie Garcia (17 x 17.5"), sold for $1,210, at Allard Auctions, #151.
 On June 5, 1998, a double-lobed polychrome jar signed Jessie Garcia (19 x 11"), sold for $1,210 at R. G. Munn, #823.
PUBLICATIONS: *SWAIA Quarterly* Fall 1972:6; *Arizona Highways* May 1974:40; Tanner 1976:123; Dillingham 1977:84; Harlow
1977; Trimble 1987:78; Minge 1991:195; Dillingham 1992:51, 107, 169, 171, 206-208, 228-30.

Jessie Garcia is recognized as one of the three most important
Acoma potters in the mid-20th Century, along with Lucy M.
Lewis and Marie Z. Chino. (Dillingham 1992:169)
 In 1941, one of her black-on white seed jars
was donated by museum director Kenneth
Chapman to the Indian Arts Fund collection. The
design featured "fineline square spirals."
 In 1961, Mrs. William J. Lippincott bought a
bowl by Jessie Garcia at Indian Market. The
black-on-white seed jar displayed four Mimbres-
style grasshoppers hopping around the shoulder of
the pot. The piece was purchased from Mrs. Lippincott by
the administrators of the Indian Arts Fund. Rick Dillingham
illustrated the pot in his book, *Acoma and Laguna Pottery*.
 In 1966, the Indian Arts Fund made a direct purchase of a
black-on-white bowl from Jessie at Indian Market. The artist
painted "two opposing Mimbres style fish motifs" in the
center of the bowl. Her work is similar to works by
Lucy Lewis and Marie Z. Chino representing "contemporary seed jars inspired
by pre-historic designs." Dillingham also recognized important contributions to
the revival style by Anita Lowden, Juana Leno, Lolita Concho and Frances
Torivio. (Dillingham 1992:171) Jessie expanded traditional polychrome pottery,
but also is credited with reviving corrugated pottery. The style is carried forward
by her daughter, Stella Shutiva, and granddaughter, Jackie Shutiva Histia.

Jessie Garcia -
Candace Collier Collection

Jessie Garcia -
Gloria Couch Collection, Corrales

JoAnne Garcia *(1) (Gallegos)*

(Acoma, active ca. 1984-present: traditional polychrome jars, bowls)
BORN: September 24, 1957
FAMILY: daughter of Mary Recus
TEACHERS: her grandmother and uncle
AWARDS: 1993, New Mexico State Fair, Albuquerque
PUBLICATIONS: Berger & Schiffer 2000:119.

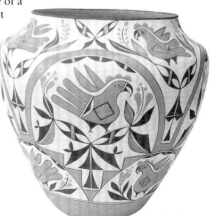

Jessie Garcia -
Gloria Couch Collection, Corrales, NM

JoAnne Chino Garcia *(2)* *(JoAnne Chino)*
(Acoma, active ca. 1970s-present: polychrome, black-on-white jars, bowls)
BORN: ca. 1961
FAMILY: m. granddaughter of Marie Z. Chino; daughter of Carrie Chino Charlie; sister of Gloria Chino, Hubert Chino, Kevin (Chip) Chino & Chris Clarissa; wife of Lawrence Garcia, Sr.; mother of Lawrence Garcia, Jr., Zachary Garcia & Trystyn Garcia
EXHIBITIONS: 1974, "Seven Families in Pueblo Pottery," Maxwell Museum, University of New Mexico, Albuquerque
COLLECTIONS: Rick Dillingham, Santa Fe
PUBLICATIONS: Barsook, et al. 1974:2, 6; Dillingham 1992:206-08; 1996:82; Reano 1995:59.

 JoAnne Chino was raised by her Grandmother Marie Z. Chino, one of the great matriarchs of Acoma pottery. JoAnne's pottery was collected by the late Rick Dillingham, potter and author of Fourteen *Families in Pueblo Pottery.* She especially admires the pottery of her Aunt Grace Chino.

JoAnne Garcia *(3)* *(see JoAnne Gallegos)*

Josephine Garcia
(Acoma, active ca. 1960s-80s: traditional polychrome jars, bowls, canteens)
AWARDS: 1976, 1st, Indian Market, Santa Fe
PUBLICATIONS: *SWAIA Quarterly* Fall 1976:12; Minge 1991:195; Dillingham 1992:206-208.

Mrs. Juan E. Garcia
(Acoma, active ca. 1940: traditional polychrome jars, bowls)
PUBLICATIONS: Minge 1991:195.

Juana Garcia
(Acoma, Sun Clan, active 1898-1988: traditional polychrome ollas, jars, bowls, vases)
LIFESPAN: ca. 1890-1988
FAMILY: daughter of Antonio & Lupita Garcia; wife of Jose Garcia; mother of James Garcia, Jessie Louis, Margaret Seymour, David Garcia & Ray Garcia; m. grandmother of Chester W. Garcia, Marcus Garcia, Lori Garcia, Tina Garcia, Anita Garcia Lowden, Stella Shutiva

Kathleen Garcia
(Acoma, active ?: pottery)
EXHIBITIONS: 1991-present, Indian Market, Santa Fe
PUBLICATIONS: *Indian Market Magazine* 1991; Peaster 1997:9.

Mrs. L. P. Garcia
(Acoma, active ca. 1930s-?: traditional polychrome jars, bowls)
COLLECTIONS: Philbrook Museum of Art, Tulsa, OK, jar, ca. 1939

Lena Garcia
(Santa Ana, active 1972-present: polychrome jars, bowls, canteens, embroidery, sewing)
TEACHER: Eudora Montoya & Nancy Winslow
EXHIBITIONS: ca. 1979-present Indian Market, Santa Fe
GALLERIES: Ta-Ma-Ya Arts and Crafts Co-op, Santa Ana
PUBLICATIONS: Barry 1984:108; Eddington & Makov 1995; Hayes & Blom 1996:128-29; 1998:23; Tucker 1998, plate 103; *Indian Market Magazine* 2000:80; Schaaf 2001:286.

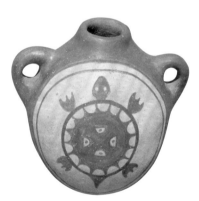

Lena Garcia -
Courtesy of Allan & Carol Hayes

Leslie M. Garcia *(signs L. Garcia)*
(Acoma, active ca. 1996-present: traditional polychrome jars, bowls)
BORN: June 5, 1978
FAMILY: m. granddaughter of Marie Torivio; daughter of Loretta & Chris Garcia
TEACHERS: Loretta Garcia, her mother, & her grandmother
PUBLICATIONS: Berger & Schiffer 2000:118.

Lita L. Garcia
(Acoma, Eagle Clan, active ca. 1930-1990: traditional polychrome jars, bowls)
BORN: ca. 1910
FAMILY: wife of Clifford L. Garcia; mother of Virginia Victorino, Josephine Sanchez, Edna G. Chino & Maxine Sanchez; grandmother of Greg P. Victorino, Corrine J. Chino & Brian A. Chino
STUDENTS: Virginia Victorino, her daughter
GALLERIES: Rio Grande Wholesale, Inc., Palms Trading Co., Albuquerque
PUBLICATIONS: Minge 1991:195; Dillingham 1992:206-208; Berger & Schiffer 2000:107.

Lolita Garcia
(Acoma, Bear Clan, active ca. 1930s-80s+: traditional polychrome jars, bowls)
BORN: ca. 1910
FAMILY: mother of Rose Stevens; m. grandmother of Sharon Stevens, Manuel Steven & Virgie Garcia (1)

Loretta Garcia *(U-Wi-Nit), (signs L. Garcia)*
(Acoma, active ca. 1972-present: traditional & ceramic polychrome & black-on-white jars, bowls, effigy seed pots)
BORN: January 7, 1956
FAMILY: daughter of Marie Torivio; sister of Mary Torivio & Nelda Lucero; mother of Leslie M. Garcia
TEACHERS: Marie Torivio, her mother
AWARDS: 2nd, New Mexico State Fair, Albuquerque
PUBLICATIONS: Berger & Schiffer 2000:118.
　　　　Loretta Garcia expressed, "I am proud to be able to continue the tradition, that my ancestors began many years ago. It brings peace to my mind knowing that I am contributing to their legacy."

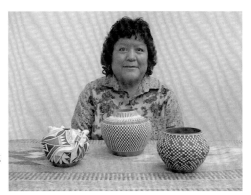

Loretta Garcia -
Courtesy of Jason Esquibel, Rio Grande Wholesale, Inc.

Lori Garcia *(Lorrie Garcia)*
(Acoma, Sun Clan, active ca. 1986-present: traditional polychrome jars, bowls)
BORN: May 27, 1957
FAMILY: daughter of Jessie Garcia; sister of Tina Garcia & Marcus Garcia
PUBLICATIONS: Berger & Schiffer 2000:118.

Lupita Garcia
(Acoma, Sun Clan, active ca. 1890-?: traditional polychrome jars, bowls)
FAMILY: wife of Antonio Garcia; mother of Juana Garcia

Lynette Garcia *(signs L. Garcia)*
(Acoma, active ca. 1992-present: polychrome jars, bowls)
BORN: May 8, 1972
FAMILY: m. great-granddaughter of Santana & Siome Sanchez; m. granddaughter of Gladys & Lorenzo P. Garcia; daughter of Beatrice Garcia & Elliott Garcia, Sr.; sister of Shawna Garcia, Elliott Garcia, Jr., Janet Garcia & Terrance Garcia
PUBLICATION: Berger & Schiffer 2000:118.

Mrs. Lucian Garcia
(Acoma, active ?-1975+: polychrome jars, bowls)
PUBLICATIONS: Minge 1991:195.

Manuelita Garcia
(Santo Domingo, active ?: pottery)
ARCHIVES: Laboratory of Anthropology Library, Santa Fe

Marcus Garcia *(Red Corn Child), (collaborates with Virginia Garcia), (They sign V. Garcia, Acoma, NM)*
(Acoma, Sun Clan, active ca. 1954-present: traditional & ceramic black-on-buffware jars, bowls, ollas with handles)
BORN: ca. 1937; RESIDENCE: San Fidel, NM
FAMILY: son of Jessie Garcia; brother of Tina Garcia (1) & Lori Garcia; husband of Virginia Garcia; father of Shelly R. Garcia
AWARDS: 1989, 1st, 2nd, New Mexico State Fair, Albuquerque; 1992, 1st, Red Rock Arts & Crafts Show, Jemez Pueblo, NM; 1995, 2nd, Inter-tribal Indian Ceremonial, Gallup
FAVORITE DESIGNS: lizards, spirals
PUBLICATIONS: Painter 1998:11.

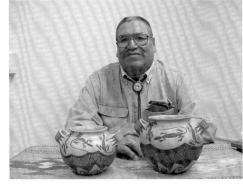

Marcus Garcia -
Courtesy of Jason Esquibel, Rio Grande Wholesale, Inc.

Margaret Garcia *(1)*
(Acoma, active ca. 1950s-?: traditional polychrome jars, bowls)
BORN: ca. 1930
FAMILY: daughter of Connie Cerno; wife of James Garcia; mother of Shyatesa White Dove

Margaret Peggy Garcia *(2) (see Peggy Garcia)*

Margaret Garcia *(3)*
(Acoma, active ?-present: traditional & contemporary polychrome jars, bowls, Storytellers)
PUBLICATIONS: Painter 1998:11.

Maria Garcia *(1)*
(Santo Domingo, active ca. 1930s-78: polychrome large storage jars, bowls, jewelry)
LIFESPAN: ca. 1910 - 1978
FAMILY: mother of Santana Melchor; m. grandmother of Crucita, Ray and Dolorita; m. great-grandmother of Michael, JoAnn, Marlene, Darlene & Irene (René) Melchor
PUBLICATIONS: Dillingham 1994:130-31.

Maria Garcia (2)

(Santo Domingo, active ?-present: pottery)
EXHIBITIONS: 1999, Indian Market, Santa Fe
PUBLICATIONS: *Indian Market Magazine* 1999:58.

Maria Garcia (3)

(Acoma, Yellow Corn Clan, active ca. 1920s-?: traditional polychrome jars, bowls)
BORN: ca. 1900s
FAMILY: wife of Pueblo Garcia; mother of Lupe Concho; m. grandmother of Rita Malie, Florence Waconda, Ruby Shrulote, Doris Patricio; great-grandmother of Beverly Victorino, Tanya, Denise, Darcy Malie, Tyler Malie

Marie Garcia

(Acoma, active ca. 1975-1990)
PUBLICATIONS: Minge 1991:195; Dillingham 1992:206-208.

Mark Wayne Garcia *(signs MWG)*

(Santo Domingo, active ?-present: black-on-red jars, dough bowls, canteens)
EXHIBITIONS: 1998-present, Eight Northern Pueblos Arts & Crafts Show
PUBLICATIONS: Hayes & Blom 1996:146-47.

Marty M. Garcia *(signs M. M. Garcia, Acoma N.M.)*

(Acoma, active ca. 1991-present: traditional & ceramic polychrome jars, bowls)
BORN: September 3, 1961
FAMILY: grandson of Paul Lucario, Sr.; son of Richard & Sally Garcia
GALLERIES: Rio Grande Wholesale, Inc., Palms Trading Co., Albuquerque
PUBLICATIONS: Berger & Schiffer 2000:118.

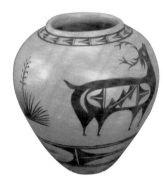

Mark Wayne Garcia -
Courtesy of John Blom

Mary J. Garcia (1), *(Mary Antonio Garcia), (signs M.J.G. or M.A.G. Acoma N.M.)*

(Acoma, Roadrunner Clan, active ca. 1977-present: polychrome jars, bowls)
BORN: December 29, 1962
FAMILY: m. granddaughter of Eva Histia; daughter of David & Hilda Antonio
TEACHERS: Hilda Antonio, her mother, and Eva Histia, her grandmother
EXHIBITIONS: 1993-present: Indian Market, Santa Fe; 1995-present, Eight Northern Indian Pueblos Arts & Crafts Show
GALLERIES: Rio Grande Wholesale, Inc., Palms Trading Co., Albuquerque
PUBLICATIONS: *Indian Market Magazine* 1993-2000; Berger & Schiffer 2000:118.

Mary Lewis Garcia (2), *(Mary Lewis, Mary Delores Lewis Garcia)*

(Acoma, Roadrunner Clan, active ca. 1950s-present: traditional polychrome, black-on-black Mimbres & Anasazi revival ollas, jars, bowls, canteens)
BORN: 1933
FAMILY: daughter of Lucy M. Lewis & Toribio Haskaya; wife of David Histia, Sr. (1st husband), Marvin Garcia (2nd husband); mother of David Histia, Victoria Histia Garcia, Stephanie Histia, Margaret Histia, Bernadette Histia, Carmelita Histia, Albert Histia, Antonia Histia, Aaron M. Garcia, Amelia Garcia & Anna Marie Garcia
TEACHER: Lucy M. Lewis
AWARDS: 1st, Indian Market, Santa Fe
EXHIBITIONS: 1974, "Seven Families in Pueblo Pottery," Maxwell Museum, University of New Mexico, Albuquerque; 1988-present: Indian Market, Santa Fe
FAVORITE DESIGNS: Mimbres animals, deer, lightning, fineline rain
PUBLICATIONS: Barsook, et al. 1974:10, 12; Harlow 1976; Peterson 1984; Barry 1984:89; Dedera 1985:41; Dillingham 1992:206-208; 1994:93; Mercer 1995:1, 9, 44; Hayes & Blom 1996:48-49; Peaster 1997:9.

Mary J. Garcia (1) -
Courtesy of John D. Kennedy and
Georgiana Kennedy Simpson
Kennedy Indian Arts

Mary Lewis Garcia is the daughter of Lucy M. Lewis, a famous matriarch of Acoma pottery. Mary raised eleven children. In 1974, for the catalog of the "Seven Families in Pueblo Pottery" exhibition, Mary said, "I enjoy making the pottery for others to enjoy. I'm glad I still have my mother to encourage me and to show me how."

Mary Ann Garcia Seymour (3) *(see Mary Seymour)*

Melinda Garcia *(collaborates sometimes with Irvin Lucero)*

(Santo Domingo, active ?-present: traditional polychrome ollas, jars, dough bowls)
FAVORITE DESIGNS: hummingbirds, flowers, plants, banded compositions
GALLERIES: Andrea Fisher Fine Pottery, Santa Fe

Nellie Garcia

(Acoma, active ca. 1960s-90+: polychrome jars, bowls)
PUBLICATIONS: *Arizona Highways* May 1974:14; Dillingham 1992:206-208.

Nina Garcia
(Acoma, active ?-1990+: polychrome jars, bowls)
PUBLICATIONS: Dillingham 1992:206-208.

Oliver Garcia *(signs O. Garcia)*
(Acoma, active ? - present: black-on-white jars, bowls)
FAVORITE DESIGNS: deer with heartlines, bighorn sheep

Paulina Garcia
(Acoma, active ca. 1960s-present: polychrome jars, bowls)
BORN: ca. 1940s
FAMILY: mother of Verna Garcia

Pauline Garcia
(Acoma, active ?-1990+: polychrome jars, bowls)
PUBLICATIONS: Dillingham 1992:206-208.

Peggy Garcia *(Margaret Peggy Garcia (2))*
(Acoma, active 1980s-present: polychrome Storytellers, jars, bowls, wooden carved bultos & retablos)
RESIDENCE: McCartys, NM
EXHIBITIONS: 1988-present: Indian Market, Santa Fe
PUBLICATIONS: Dillingham 1992:206-208; Bahti 1996:29; Peaster 1997:7, 157.

Petra G. Garcia
(Santo Domingo, active ca. 1970s-present: polychrome jars, vases)
COLLECTIONS: Wright Collection, Peabody Museum, Harvard University, Cambridge, MA
EXHIBITIONS: 2000, Indian Market, Santa Fe
PUBLICATIONS: Mercer 1995:30, 44; Drooker et al. 1998:139.

Regina Garcia
(Acoma, active ?-1990+: polychrome jars, bowls)
PUBLICATIONS: Dillingham 1992:206-208.

Reyes Marie Garcia *(Reyes Garcia)*
(Santo Domingo, active ?-present: pottery, jewelry)
EXHIBITIONS: pre-1985-present, Indian Market, Santa Fe
PUBLICATIONS: *Indian Market Magazine* 1985, 1988.

Reyes T. Garcia
(Zia, active ca. 1950s-?: traditional polychrome jars, dough bowls)
VALUES: On Nov. r 6, 1997, a dough bowl (18″ dia.) by Reyes T. Garcia, dated 5/31/58, sold for $5,520 at Christie's in New York.
PUBLICATIONS: *American Indian Art Magazine* Summer 1998 23(3):20.

Robert Garcia
(Acoma, active ?-1990+: polychrome jars, bowls)
PUBLICATIONS: Dillingham 1992:206-208.

Roque Garcia
(Santo Domingo, active ca. pre-1985-1990s: pottery, textiles, jewelry)
EXHIBITIONS: pre-1985-1992, Indian Market, Santa Fe
PUBLICATIONS: *Indian Market Magazine* 1985, 1988; Schaaf 2001:281.

Rose Chino Garcia *(Rose Chino, Rosemary Chino Garcia)*
(collaborated sometimes with Tena Garcia)
(Acoma, active ca. 1967-90s: traditional polychrome & black-on-white fineline jars, bowls,
seed pots, vases, wedding vases, plates, turtle effigy canteens)
BORN: February 8, 1928; RESIDENCE: San Fidel, NM
FAMILY: daughter of Marie Z. Chino; sister of Gilbert Chino, Carrie Chino Charlie, Vera
Chino Ely, Grace Chino, Patrick Chino & Jody Chino; mother of Tena Garcia
TEACHER: Marie Z. Chino, her mother
STUDENT: Tena Garcia, her daughter
AWARDS: 1975, 1st; 1976, 3rd; 1977, SWAIA Award for Most Creative Design, 1st; 1978, 1st
(2), 2nd; 1979, 2nd; 1979, 2nd; 3rd; 1980, Richard M. Howard Award for Best Traditional
Acoma Pottery, 1st (3), 2nd; 1981, 2nd, 3rd; 1983, 1st; 1984, Indian Arts Fund Award for Overall
Excellence; 1990, 3rd; 1991, 1st; 1993, 1st, Indian Market, Santa Fe; Inter-tribal Indian
Ceremonial, Gallup

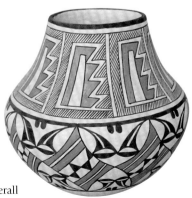

Rose Chino Garcia -
Courtesy of Eason Eige, Albuquerque

EXHIBITIONS: 1967-present, Indian Market, Santa Fe; 1974, "Seven Families in Pueblo Pottery," Maxwell Museum, University of New Mexico, Albuquerque; 1979, "One Space: Three Visions," Albuquerque Museum, Albuquerque; 1997, "Recent Acquisitions from the Herman and Claire Bloom Collection," Heard Museum, Phoenix

COLLECTIONS: Wright Collection, Peabody Museum, Harvard University, Cambridge, MA; Heard Museum, Phoenix; Philbrook Museum of Art, Tulsa, OK, jar, ca. 1981; Allan & Carol Hayes; Candace Collier, Houston, TX; Dr. Gregory & Angie Yan Schaaf

FAVORITE DESIGNS: deer with heartlines, parrots, flowers, rain, clouds, potsherds, frets, lightning, snowflakes

VALUES: On October 31, 2000, a black-on-white vase, signed Rose Chino (8.5 x 5.25"), sold for $1,983 at Butterfields, #4251.

On Dec. 2, 1998, a black-on-white wedding vase, signed Rose Chino Garcia (12" h.), sold for $1,265 at Sotheby's, lot #67.

On May 19, 1998, a polychrome olla, signed Rose Chino Garcia (11.5 x 14.75"), sold for $1,955, at Sotheby's, #427.

PUBLICATIONS: *SWAIA Quarterly* Fall 1972:4; Fall 1973:3; Fall 1982:10; Barsook, et al. 1974;2-6; *Arizona Highways* May 1974:22, 31, 40; *SWAIA Quarterly* Fall 1975:3; Fall 1976:12, 14; Fall 1977:14; Tanner 1976:123; Harlow 1976; Barry 1984:89; Trimble 1997:75; Dedera 1985:42; *Indian Market Magazine* 1985-2000; Dillingham 1992:206-208; 1994:82; Mercer 1995:8; Hayes & Blom 1996:50; Peaster 1997:18; Drooker & Capone 1998:138; Anderson, et al. 1999.

Rose Chino Garcia learned pottery making from her mother, Marie Z. Chino, one of the honored matriarchs of Acoma pottery. Rose began by using Marie's designs. However, Rose is proud that she has innovated some new designs and shapes from her own creativity.

Rose Chino Garcia - Courtesy of John D. Kennedy and Georgiana Kennedy Simpson Kennedy Indian Arts

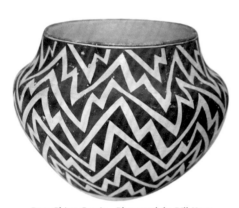

Rose Chino Garcia - Photograph by Bill Knox Courtesy of Indart Inc.

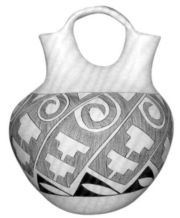

Rose Chino Garcia - Andrea Fisher Fine Pottery, Santa Fe

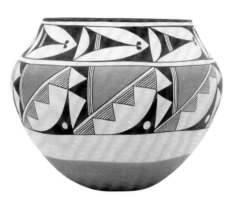

Rose Chino Garcia - Nedra Matteucci Galleries, Santa Fe

Rosita Garcia

(Acoma, active ca. 1890s-1910s+: polychrome jars, bowls)
BORN: ca. 1875; RESIDENCE: Acomita in ca. 1910
PUBLICATIONS: Leopold Bibo, "13th Annual U.S. Census" (1910), New Mexico State Archives, Call T624, Roll 919; in Dillingham 1992:205.

Ruth Garcia

(Acoma, active ca. 1950s-80s?: traditional polychrome jars & bowls)
BORN: ca. 1930
FAMILY: mother of Claudia Garcia
PUBLICATIONS: Berger & Schiffer 2000:117.

Sally R. Garcia *(Gah-Wee-Nah-Zah, Running Brook)*

(Acoma/Laguna, active ca. 1959-present: carved ceramics, horsehair pottery)
BORN: ca. 1940
FAMILY: granddaughter of Santana Antonio; daughter of Paul Lucario, Sr.; niece of Mildred Antonio; sister of Paul Lucario, Jr. & Arthur Lucario; wife of Richard Garcia; mother of Veronica Garcia; aunt of Darren Pasquale
STUDENTS: Arthur Lucario, her brother; Veronica Garcia, her daughter
AWARDS: 1979, 1st, New Mexico State Fair, Albuquerque; 1980, 1st, New Mexico State Fair, Albuquerque; 1981, 1st, New Mexico State Fair, Albuquerque
PUBLICATIONS: Dillingham 1992:206-208; Hayes & Blom 1996; Berger & Schiffer 2000:119.

Sally Garcia - Courtesy of Jason Esquibel, Rio Grande Wholesale, Inc.

Sally Garcia is considered the innovator of an unique style of carved ceramics, sometimes called "etching." She began in 1959, the earliest known date for carved Acoma or Laguna pottery. She uses no stencils to carve intricate designs freehand with a knife. Her pottery often depicts scenes from nature. More recently, she has been experimenting with carving horsehair pottery. Many Acoma and Laguna artists have been influenced by Sally and followed her lead in carving ceramics.

Sandra Shutiva Garcia (see Sandra Shutiva)

Sarah Garcia (Sara Garcia)

Sarah Garcia - Courtesy of John D. Kennedy and Georgiana Kennedy Simpson, Kennedy Indian Arts

(Acoma/Laguna, Turkey Clan, active ca. 1932-present: traditional polychrome & Mimbres, Anasazi & Tularosa Revival black-on-white ollas, jars, bowls, figures, owls, mugs with human faces)
BORN: December 6, 1928
FAMILY: daughter of Maria Trujillo (Laguna); mother of Debbie G. Brown & Goldie Hayah
TEACHER: her grandmother (Laguna)
STUDENTS: Debbie G. Brown, her daughter
AWARDS: Indian Market, Santa Fe; Eight Northern Indian Pueblos Arts & Crafts Show
COLLECTIONS: Heard Museum, Phoenix; John Blom; Candace Collier, Houston, TX; Dr. Gregory & Angie Yan Schaaf, Santa Fe
FAVORITE DESIGNS: deer with heartlines, parrots, fish, clouds, rain, lightning
PUBLICATIONS: Barry 1984:95; Minge 1991:195; Dillingham 1992:206-208, 229; Hayes & Blom 1998:49; Berger & Schiffer 2000:102, 118.

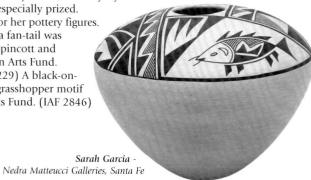

Sarah Garcia - Courtesy of Don & Lynda Shoemaker, Santa Fe

Sarah Garcia is one of the most prolific potters in the history of Acoma, along with Jessie Garcia, Lucy Lewis and Marie Z. Chino. These women helped to revive Anasazi and Tularosa styles, especially black-on-white pottery. Sarah's pottery comes in many styles and shapes. Her large ollas are especially prized.

Sarah also is well known for her pottery figures. One of her turkey figures with a fan-tail was collected by Mrs. William J. Lippincott and purchased in 1962 by the Indian Arts Fund. (IAF 2844, in Dillingham 1992:229) A black-on-white bowl with a Mimbres-style grasshopper motif also was purchased by the Indian Arts Fund. (IAF 2846)

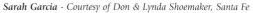

Sarah Garcia - Courtesy of Don & Lynda Shoemaker, Santa Fe

Sarah Garcia - Nedra Matteucci Galleries, Santa Fe

Sharon Garcia

(Acoma, active ?-present: polychrome jars, bowls)
COLLECTIONS: Allan & Carol Hayes, John Blom
PUBLICATIONS: Dillingham 1992:206-208.

Shawna Garcia-Rustin *(collaborates with Patrick Rustin), (signs S. Garcia, Acoma N.M.)*

(Acoma, Red Corn Clan, active ca. 1991-present: traditional polychrome jars, bowls)
BORN: December 31, 1969
FAMILY: great-granddaughter of Sime & Santana Sanchez; granddaughter of Tony & Lucy Garcia; daughter of Beatrice & Elliott Garcia, Sr.; sister of Lynette, Janet, Elliot, Jr. & Terrace Garcia; wife of Patrick Rustin (Apache); mother of Wade, Natalie & Patrick, Jr.
TEACHERS: Beatrice & Elliott Garcia, Sr., her parents
AWARDS:

1997	3rd, New Mexico State Fair, Albuquerque	
1998	Best of Show, New Mexico State Fair, Albuquerque	
2000	Best of Show, Best Pottery, 1st, New Mexico State Fair, Albuquerque	

DEMONSTRATIONS: 1997 - Utility Shack (Indian art gallery), Albuquerque
COLLECTIONS: Gerald & Laurette Maisel, Tarzana, CA
GALLERIES: Bien Mur, Sandia Pueblo; Adobe Gallery, Skip Maesel's, Albuquerque
FAVORITE DESIGNS: birds, kiva steps, Sun Clan, rain, clouds, mountains
PUBLICATIONS: Berger & Schiffer 2000:118.

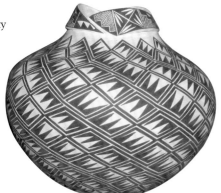

Shawna Garcia-Rustin - Courtesy of Jason Esquibel, Rio Grande Wholesale, Inc.

Shawna Garcia learned pottery making from her mother and father in Acomita. She is one of the best contemporary Acoma painters of pottery. Like her father, Shawna uses a traditional yucca brush.

Her husband, Patrick Rustin (San Carlos Apache), forms and fires the pottery, noted for fine, thin-walled whiteware as light as bone china. Together, Shawna and Patrick are a successful husband and wife pottery-making team. Their pottery has been judged Best of Show for two years at the New Mexico State Fair.

Shawna visited the Center for Indigenous Arts & Cultures in the winter of 2001, while her husband, Patrick, took care of their baby inside their warm car. She brought a sample of their work, an exquisite vase with a fineline optical design. A masterpiece!

Shawna explained how their careers as artists benefited from becoming award-winning potters: "After being recognized and receiving awards, it inspires us to make the next pot even more beautiful. We feel encouraged by new ideas for making and painting contemporary pottery."

Shelly R. Garcia *(signs Shelly Garcia with a bear claw hallmark)*

(Acoma, Sun Clan, active ca. 1995-present: traditional polychrome jars, bowls)
BORN: April 6, 1982; RESIDENCE: San Fidel, NM
FAMILY: p. granddaughter of Jessie C. Garcia; daughter of Marcus & Virginia Garcia
TEACHERS: Marcus & Virginia Garcia
GALLERIES: Rio Grande Wholesale, Inc., Palms Trading Co., Albuquerque
PUBLICATIONS: Berger & Schiffer 2000:118.

Sheryl Garcia

(Acoma, active ?-present: traditional & contemporary polychrome jars, bowls)
PUBLICATIONS: Painter 1998:11.

Tena Garcia *(Tena Chino Garcia), (collaborated sometimes with Rose Chino Garcia, Marie Z. Chino)*

(Acoma, active 1980s-present: traditional polychrome, Mimbres & Anasazi Revival black-on-white ollas, jars, bowls, seed pots, miniatures, undecorated wedding vases)
BORN: December 19,1964; RESIDENCE: San Fidel, NM
FAMILY: m. granddaughter of Marie Z. Chino; daughter of Rose Chino Garcia; sister of Joanne Garcia
TEACHERS: Rose Chino Garcia & Marie Z. Chino
AWARDS: 1989, 1st, Indian Market, Santa Fe
EXHIBITIONS: 1974, "Seven Families in Pueblo Pottery," Maxwell Museum, University of New Mexico, Albuquerque; 1985-present: Indian Market, Santa Fe
COLLECTIONS: Wright Collection, Peabody Museum, Harvard University, Cambridge, MA
FAVORITE DESIGNS: Mimbres animals
PUBLICATIONS: Barsook, et al. 1974:2, 6; Drooker & Capone 1998:138; Dillingham 1994:82, 84; Berger & Schiffer 2000:118.

Theresa R. Garcia-Salvador *(Theresa R. Garcia), (signs T. Garcia or T. Salvador, Acoma N.M.)*

(Acoma, Red Corn Clan, active ca. 1989-present: traditional polychrome jars, bowls)
BORN: September 5, 1964
FAMILY: daughter of Mr. & Mrs. A. Garcia; sister of Vivian Seymour
TEACHER: Vivian Seymour, her sister
GALLERIES: Rio Grande Wholesale, Inc., Palms Trading Co., Albuquerque
PUBLICATIONS: Berger & Schiffer 2000:119.

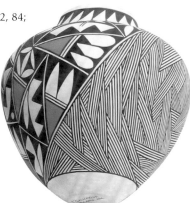

Theresa Garcia-Salvador -
Courtesy of Joe Zeller
River Trading Post, East Dundee, IL

Tina Garcia *(1) (Lady Clay), (signs Tina Garcia, Acoma)*

(Acoma, Sun Clan, active ca. 1967-present: traditional polychrome jars, bowls, sewing)
BORN: March 29, 1950
FAMILY: daughter of Jessie Garcia; sister of Lori Garcia & Marcus Garcia
AWARDS: New Mexico State Fair, Albuquerque
EXHIBITIONS: 1997, Indian Market, Santa Fe
GALLERIES: The Indian Craft Shop, U.S. Department of Interior, Washington, D.C.; Rio Grande Wholesale, Inc.
PUBLICATIONS: *Southwest Profile* Fall 1987:49; Berger & Schiffer 2000:119.

Tina Garcia *(2) (signs Tina Garcia, San Juan, SC), (see Schaaf 2000)*

Tony Garcia, Jr.

(Acoma, active ?: pottery)
RESIDENCE: San Fidel, NM

Verna Garcia

(Acoma, active ca. 1991-present: polychrome jars, bowls)
BORN: March 24, 1967
FAMILY: daughter of Paulina Garcia
TEACHER: Paulina Garcia, her mother
GALLERIES: Rio Grande Wholesale, Inc., Palms Trading Co., Albuquerque
PUBLICATIONS: Berger & Schiffer 2000:119.

Tina Garcia (1) - Courtesy of
John D. Kennedy and
Georgiana Kennedy Simpson
Kennedy Indian Arts

Veronica Garcia *(signs V. Garcia, Laguna)*

(Laguna, active ca. 1992-present: carved ceramics)
BORN: December 31, 1963
FAMILY: daughter of Sally Garcia
TEACHER: Sally Garcia, her mother
AWARDS: First, New Mexico State Fair, Albuquerque
PUBLICATIONS: Berger & Schiffer 2000:119.

Victoria Histia Garcia

(Acoma, Roadrunner Clan, active ca. 1970s-?: polychrome jars, bowls, canteens)
BORN: ca. 1950s
FAMILY: m. granddaughter of Lucy M. Lewis & Toribio Haskaya; daughter of David Histia, Sr. & Mary Lewis Garcia (2); sister of David Histia, Stephanie Histia, Margaret Histia, Bernadette Histia, Carmelita Histia, Albert Histia, Antonia Histia, Aaron M. Garcia, Amelia Garcia & Anna Marie Garcia
AWARDS: 1975, H.M., Scottsdale National Indian Arts Exhibition, AZ
GALLERIES: The Indian Craft Shop, U.S. Department of Interior, Washington, D.C.

Virgie Garcia *(Virginia Garcia (1))*

(Acoma, Bear Clan, active ca. 1982-present: traditional polychrome jars, bowls)
BORN: December 10, 1947
FAMILY: m. granddaughter of Lolita Garcia; daughter of Rosita Stevens; sister of Sharon Stevens & Manuel Stevens
TEACHER: Lolita Garcia, her grandmother
AWARDS: New Mexico State Fair, Albuquerque
GALLERIES: Rio Grande Wholesale, Inc., Palms Trading Co., Albuquerque
PUBLICATIONS: Dillingham 1992:206-208; Berger & Schiffer 2000:119.

Virginia Garcia *(2)*

(Acoma, Sun Clan, active ca. 1980s-present: traditional polychrome jars, bowls)
BORN: ca. 1960; RESIDENCE: San Fidel, NM
FAMILY: wife of Marcus Garcia; mother of Shelly R. Garcia
AWARDS: 1989, 1st, 2nd, New Mexico State Fair, Albuquerque; 1992, 1st, Red Rock Arts & Crafts Show, Jemez Pueblo, NM; 1995, 2nd, Inter-tribal Indian Ceremonial, Gallup
FAVORITE DESIGNS: lizards, spirals
GALLERIES: Rio Grande Wholesale, Inc., Albuquerque
PUBLICATIONS: Dillingham 1992:206-208.

Virginia Garcia *(3)*, Santa Clara/San Juan *(see Schaaf 2000)*

Vivian Garcia

(Acoma, Red Corn Clan, active ca. 1980s-present: traditional polychrome jars, bowls)
BORN: ca. 1960s
FAMILY: daughter of Mrs. & Mrs. A. Garcia; sister of Clovis Garcia & Theresa R. Garcia

Wilfred Garcia *(collaborates with Sandra Shutiva), (signs W. Garcia)*

Wilfred Garcia -
Courtesy of Jason Esquibel
Rio Grande Wholesale, Inc.

Sandra Shutiva Garcia & Wilfred Garcia -
Courtesy of John D. Kennedy and
Georgiana Kennedy Simpson, Kennedy Indian Arts

(Acoma, Sun Clan, active 1982-present: whiteware with Mesa Verde style cliff dwellings & applique ears of corn, jars, bowls, paintings)
BORN: March 30, 1954
FAMILY: son of Tony & Lucy Garcia; brother of Elliott Garcia, Sr., Mary Garcia Seymour; husband of Sandra Shutiva Garcia
TEACHER: Stella Shutiva
AWARDS: 1990, 1st; 1992, 2nd; 1994, 3rd, jars; 1996, 1st, 2nd; 1998, 1st, Indian Market, Santa Fe; Heard Museum Show, Phoenix; Best of Show, Best in Contemporary Pottery, New Mexico State Fair, Albuquerque; Inter-tribal Indian Ceremonial, Gallup
EXHIBITIONS: 1989-present, Indian Market, Santa Fe; 1995-present, Eight Northern Indian Pueblos Arts & Crafts Show

COLLECTIONS: John Blom
GALLERIES: Rio Grande Wholesale, Inc., Blue Thunder Fine Indian Art at www.bluethunderarts.com
PUBLICATIONS: Jacka 1988:122; *Southwest Art* Dec. 1990:135; Dillingham 1992:206-208; Hayes & Blom 1996:52-53; Painter 1998:11; *American Indian Art Magazine* Winter 1997:96; *Indian Artist* Winter 1998:63; Berger & Schiffer 2000:119.

Wilfred Garcia & Sandra Shutiva are best known for their large white jars with appliqued ears of corn and carved scenes of cliff dwellings. Wilfred also makes oval vases with appliqued faces of Kachinas. They are gracefully formed. The spiritual form emerges from the surface like a cameo. Light and shadow interplay on the pure white surfaces.

Wilfred calls his art, "A Vision of Dreams" that comes to him through Mother Earth. He further shared, "I actually started as a painter, but was inspired by my mother-in-law, Stella Shutiva, to try pottery. She told me my hands were meant to work with clay, not oils and acrylics. . .My art plays an important role in how I feel about life. I enjoy making people happy."

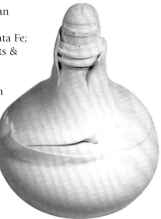

Wilfred Garcia -
Blue Thunder Fine Indian Art at
www.bluethunderarts.com

William Garcia
(Acoma, active ?: polychrome, black-on-white ollas, jars, bowls)
FAVORITE DESIGNS: deer with heartlines, fineline

Zelda Garcia *(collaborates with Elliott Garcia, Sr.), (signs Zel Sun Rise, followed by a sunrise hallmark)*
(Acoma, Parrot Clan, active ca. 1980s-present: traditional & ceramic polychrome & black-on-white jars, vases, wedding vases, contemporary forms)
BORN: ca. 1967
FAVORITE DESIGNS: Sunfaces, bears, pueblo village scenes, snowflakes
GALLERIES: Rio Grande Wholesale, Inc., Palms Trading Co., Albuquerque

Dianna Lim Garry
(Acoma, active ?-present: pottery)
FAMILY: m. granddaughter of Lucy M. Lewis; daughter of Margaret Lewis Lim; mother of Aspen Garry & Andrew Garry

Rose Gasper *(Rosie)*
(Zuni, active ca. 1930s-?: traditional polychrome ollas, jars, bowls)
FAMILY: wife of Harold Gasper; mother of Angelina Lonjose
STUDENTS: Angelina Lonjose, her daughter
PHOTOGRAPHS: School of American Research
PUBLICATIONS: Rodee & Ostler 1986:40.
> Rose Gasper was a participant in the Zuni dance group, the Olla Maidens, who performed throughout the Southwest. They were especially popular at the Inter-tribal Indian Ceremonial parade in Gallup.

Celestina R. Gchachu
(Jemez, Sun Clan, active ca. 1980s-present: polychrome jars, bowls, jewelry, paintings)
BORN: November 22, 1971
FAMILY: daughter of Celestino & Clanta Romero; wife of Vincent Gchachu
EDUCATION: Institute of American Indian Arts, Santa Fe
TEACHERS: Felix Vigil, Laura Fragua, Connie Tsosie-Gaussoin, David Garcia
EXHIBITIONS: 1997-present, Indian Market, Santa Fe
> Celestina shared her beginnings as an artist: "I'm learning my talents that I didn't know I had. I'm learning more — every time I make a piece — to be creative and to be open-minded. I'm learning to create the unexpected. I amaze myself sometimes with the finished product."

Faylene Gchachu
(Zuni, active ?-present: pottery)
GALLERIES: The Indian Craft Shop, U.S. Department of Interior, Washington, D.C.

Dora Gonzales
(Zia, active ?: pottery)
ARCHIVES: Laboratory of Anthropology Library, Santa Fe, lab. file.

Gabriel George Gonzales
(Jemez, Oak Clan, active ca. 1976-present: traditional carved jars, melon bowls)
BORN: May 6, 1971
FAMILY: grandson Anacita Chinana; son of Persingula Chinana Gonzales (Jemez), & George Gonzales (Navajo and Cherokee); brother of Linda Chinana, Valentine Gonzales, Jacob Chinana
TEACHERS: Persingula Chinana Gonzales, George Gonzales, Nancy Youngblood
EDUCATION: University of New Mexico, Taos
AWARDS: 1st, 2nd, 3rd, Eight Northern Indian Pueblos Arts and Crafts Show; 1999, Indian Market, Santa Fe; Show in Grand Junction, CO; Show in Portland, OR
EXHIBITIONS: Heard Museum Guild Indian Fair and Market, Phoenix
GALLERIES: King Galleries of Scottsdale, AZ
PUBLICATIONS: *American Indian Art Magazine* Winter 1998 23(1):96; Spring 1998 23(2):29; *Indian Artist Magazine* Summer 1998:66; *Cowboys & Indians* Nov. 1999:95; Sep. 2000 23(2):29; Berger & Schiffer 2000:37, 119.
> Gabriel G. Gonzales wrote his own biographical statement: "Gabriel comes from a family of Jemez Pueblo potters. Almost every relative makes pottery currently. He learned the art of pottery from his mother, Persingula (Chinana) Gonzales. Gabriel has been making pottery from the age of five and has pursued the art seriously since the age of fifteen.
> "Although he was not born and raised at Jemez Pueblo, he spent the summers of his youth with his family at the Pueblo, and has participated in the traditional life there to this day. Gabriel, while maintaining a full schedule of pottery making, also pursues higher education in the fields that interest him: Early Childhood Development, Cosmetology, and Interior Design."

William Garcia -
Courtesy of John D. Kennedy and
Georgiana Kennedy Simpson, Kennedy Indian Arts

Gabriel Gonzales -
King Galleries of Scottsdale, AZ

Persingula Chinana Gonzales *(Percy Chinana), (signs P. Chinana)*

(Jemez, Oak Clan, active ca. 1967-present: traditional polychrome, buff tanware, black-on-redware jars, bowls, wedding vases)
BORN: July 10, 1946
FAMILY: daughter of Anacita Chinana & Casimiro Toya; sister of Christina Tosa, Donald R. Chinana, Marie Chinana (3), Georgia F. Chinana & Marie Waquie; wife of George Gonzales (Navajo and Cherokee), traditional potter; mother of Linda Chinana, Gabriel G. Gonzales, Valentine Gonzales & Jacob Chinana
TEACHER: Anacita Chinana, her mother
PUBLICATIONS: Berger & Schiffer 2000:34, 106.

Valentine Gonzales

(Jemez, Oak Clan, active ca. 1990s-present: pottery)
FAMILY: m. grandson of Anacita Chinana & Casimiro Toya; son of Persingula Chinana Gonzales & George Gonzales (Navajo/Cherokee); brother of Linda Chinana, Gabriel George Gonzales, Jacob Chinana

Candace Grayson

(Laguna, active ca. 1990s-?: pottery)
EXHIBITIONS: 1999-present, Eight Northern Indian Pueblos Arts & Crafts Show

Johan Grayson

(Laguna, active ca. 1990s-?: pottery)
EXHIBITIONS: 1999-present, Eight Northern Indian Pueblos Arts & Crafts Show

Yvonne Shije Grayson *(Yvonne S. Grayson)*

(Zia/Acoma, ?-present: polychrome jars, bowls, double spouted jars)
BORN: September 17, 1961
FAMILY: daughter of Juanita C. Shije; sister of Cornelia J. Shije
EXHIBITIONS: 1997-present, Eight Northern Indian Pueblos Arts & Crafts Show

Daniel Sebastian Griego

(Zia, Sagebrush Clan, active ca. 1998-present: pottery)
BORN: March 31, 1978
FAMILY: great-grandson of Joe Pino & Ascencion Galvan Pino; grandson of Laura Pino; son of Eleanor Pino-Griego & Felix Griego; brother of Gabriel, Carolyn, Candice Griego; father of Angel, Star Griego
AWARDS: 2nd, San Felipe Pueblo Indian Art Show, NM
EXHIBITIONS: 1997-present, Indian Market, Santa Fe

Yvonne Shije Grayson -
Photograph by Michael E. Snodgrass, Denver

Eleanor Griego *(see Eleanor Pino-Griego)*

Edna Guliford *(see Edna Medina Galiford)*

Lola Gunn

(Acoma, active ?-1975+: polychrome jars, bowls)
PUBLICATIONS: Minge 1991:195.

Joe Val Gutierrez

(Santo Domingo/Santa Clara: active ca. 1973-present: pottery, basketry)
EXHIBITIONS: 1988-89, Indian Market, Santa Fe
PUBLICATIONS: *Indian Market Magazine* 1988, 1989; *The Messenger*, Wheelwright Museum July/Aug. 1998 2(4):2; *Native Peoples Magazine* Autumn 1998 11(4):50-53; School of American Research, *Annual Report* 1999:21; Schaaf 2000:37.

C. H. *(see Cecilia Hepting)*

M. B. H. *(collaborates with Ke'shra)*

(Cochiti, active ?-present: Storytellers)
GALLERIES: Palms Trading Company, Albuquerque
PUBLICATIONS: Congdon-Martin 1999:17.

M. F. H. *(see Mary Francis Herrera (1))*

P. H.

(Jemez, active ca. 1980s-?: Storytellers)
GALLERIES: Palms Trading Company, Albuquerque
PUBLICATIONS: Congdon-Martin 1999:74.

V. H. *(see Victoria Hepting)*

Alvin Haloo

(Zuni, active ?-present, polychrome jars, bowls)
FAVORITE DESIGNS: Eagle dancers, Kokopelli

Claudine Haloo

(Zuni, active ?-present: polychrome jars, bowls)
GALLERIES: Isa Fetish, Cumming, GA

Mary Ann Hampton

(Acoma, active ca. 1960s-present: polychrome & black-on-white jars, bowls)
COLLECTIONS: John Blom
PUBLICATIONS: *Arizona Highways* May 1974:40; Harlow 1976: Tanner 1976:123;
Trimble 1987:79.

Mary Ann Hampton is known for her fineline, eye-dazzler designs. She
has to paint them a little at a time, because "I start getting cross-eyed."

*Claudine Haloo & Isa Diestler -
Courtesy of Isa Fetish, Cumming, GA*

Anne Lewis Hansen *(Anne Lewis)*

(Acoma, Roadrunner Clan, active 1940s-present: polychrome jars, bowls)
BORN: ca. 1925; RESIDENCE: Antelope, CA
FAMILY: daughter of Lucy M. Lewis & Toribio Haskaya; mother of Andrew, Joseph, Ivan, Vincent Lewis Hansen, Anthony Hansen,
Diana Lim Garry
AWARDS: 1992, 3rd; 1996, 2nd, Indian Market, Santa Fe
EXHIBITIONS: 1950s-present: Indian Market, Santa Fe; 1974, "Seven Families in Pueblo Pottery," Maxwell Museum, University of
New Mexico, Albuquerque.
COLLECTIONS: Heard Museum, Phoenix; John Blom
FAVORITE DESIGNS: Acoma parrots, flowers with leaves, rainbows
PUBLICATIONS: Barsook, et al. 1974:9-16; Harlow 1977; Barry 1984:89; *Indian Market Magazine* 1985-2000; Dillingham 1992:92,
206-208; 1996:92, 98; Hayes & Blom 1996:48-49; Peaster 1997:9; Anderson, et al. 1999:32.

At the age of ten, Anne Lewis Hansen began selling pottery next to Route 66 with her now famous mother, Lucy M. Lewis.
She initially helped her mother by grinding pottery sherds used to temper the clay. She eventually graduated to forming small
pots from her mother's clay.

When Anne was 19, she moved to California. She graduated from San Jose State as a history major. Anne is noted for giv-
ing classes and presentations on pottery making. She lives today in Antelope, CA. Anne continues to return home every year,
attending Indian Market in Santa Fe.

Gloria Hansen *(see Gloria Lewis)*

Vincent Lewis Hansen *(hummingbird hallmark)*

(Acoma, Roadrunner Clan, active ?-present: polychrome animal figures, turtles, lizards, jars, bowls)
FAMILY: grandson of Lucy M. Lewis; son of Anne Hansen; brother of Gloria Lewis, Andrew, Joseph, Ivan, Vincent Lewis Hansen,
Anthony Hansen, Diana Lim Garry
COLLECTIONS: John Blom
PUBLICATIONS: Hayes & Blom:53.

Carmel Lewis Haskaya *(Carmel Lewis, Carmel Lewis Garcia), (signs Carmel Lewis, sometime with date)*

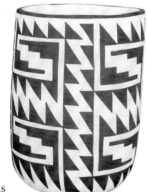

(Acoma, Roadrunner Clan, active ca. 1952-present: Anasazi, Mimbres & Tularosa Revival
polychrome, black-on-white & black-on-orange jars, bowls, seed pots, canteens, miniatures)
BORN: September 5, 1947; RESIDENCE: San Fidel, NM
FAMILY: daughter of Lucy M. Lewis & Toribio Haskaya Lewis;
mother of Katerina Haskaya Lukee
TEACHER: Lucy M. Lewis, her mother
AWARDS: Indian Market, Santa Fe; New Mexico State Fair,
Albuquerque; Inter-tribal Indian Ceremonial, Gallup, NM
EXHIBITIONS: 1979, "One Space: Three Visions,"
Albuquerque Museum, Albuquerque; 1997, "The Legacy of
Generations," National Museum of Women in the Arts,
Washington, D.C.
COLLECTIONS: Rick Dillingham Collection, Santa Fe; Dr.
Gregory & Angie Yan Schaaf Collection, Santa Fe
FAVORITE DESIGNS: parrots eating berries from a bush,
clouds, rain, lightning
GALLERIES: The Indian Craft Shop, U.S. Department of
Interior, Washington, D.C.; Rio Grande Wholesale, Inc., Palms
Trading Co., Alb.; Native American Collections, Denver, CO
PUBLICATIONS: Peterson 1984; 1997:132-35, 140-41;
Barry 1984:89; Dedera 1985:41; Schiffer 1991d:53;
Dillingham 1992:206-208; Dillingham 1994:93, 103;

*Carmel Lewis Haskaya -
Courtesy of Jason Esquibel
Rio Grande Wholesale, Inc.*

*Carmel Lewis Haskaya -
Photograph by Bill Bonebrake
Courtesy of Jill Giller
Native American Collections, Denver, CO*

Hayes & Blom 1996:48-49; Peaster 1997:9, 10, 157; Peterson 1997; Painter 1998:13; Berger & Schiffer 2000:126.

Carmel Lewis Haskaya is the youngest of Lucy M. Lewis' daughters. Lucy taught Carmel and her other children how to make pottery. Carmel excelled and is respected today as one of the best Southwest potters. Her pots are known for their thin walls and elegant painting style.

Carmel is deeply involved in her study of ancient Puebloan designs. She actively participates in the revival of Anasazi, Mimbres and Tularosa style pottery. She still gathers clay and uses the old traditional techniques of her ancestors.

Carmel collects many natural pigments for her paints including various mineral oxides. She grinds her pigments in a metate and paints with a yucca brush. She creates pottery while maintaining her family responsibility to take good care of the family, as well as tending the family's herd of cattle. (Peterson 1997:135)

Carmel Lewis Haskaya -
Photograph by Bill Bonebrake
Courtesy of Jill Giller
Native American Collections, Denver, CO

Mrs. Torivio Haskaya
(Acoma, active ca. 1940)
PUBLICATIONS: Minge 1991:195.

Consepsion Haskea
(Acoma, active ca. 1870s-1910s+: polychrome jars, bowls)
BORN: ca. 1860; RESIDENCE: Acomita in ca. 1910
PUBLICATIONS: Leopold Bibo, "13th Annual U.S. Census" (1910), New Mexico State Archives, Call T624, Roll 919; in Dillingham 1992:205.

Pam Lujan Hauer
(Zuni, active ?-present, polychrome jars, bowls)
PUBLICATIONS: Hayes & Blom 1998:53.

Concepcion Haweya
(Acoma, active ?: pottery)
ARCHIVES: Laboratory of Anthropology Library, Santa Fe; lab. file.

Angela Hayah
(Acoma, active ?-1990+: polychrome jars, bowls)
PUBLICATIONS: Dillingham 1992:206-208.

Goldie A. Hayah *(Shro Te Ma, Goldie Garcia)*
(Acoma, Turkey Clan, active ca. 1962-present: polychrome jars, large ollas, vases)
BORN: July 18, 1956, Acomita Village
FAMILY: m. granddaughter of Maria Trujillo, Laguna; p. granddaughter of Jessie Garcia (Sun Clan); daughter of Sarah J. Garcia & Chester W. Garcia, Sr.; sister of Debbie G. Brown, Donna Chino, Chester W. Garcia, Jr.; wife of John B. Hayah, Sr., mother of Juliet Hayah & 3 others
TEACHERS: Jessie Garcia, Sarah J. Garcia
STUDENTS: John B. Hayah, Sr., her husband, and Juliet Hayah, her daughter
AWARDS: 1996, Best of Pottery Division, Inter-tribal Indian Ceremonial, Gallup; 1997, Best Large Pot, New Mexico State Fair, Albuquerque; 1998, 1st, New Mexico State Fair, Albuquerque; 1998, Best Large Pot, Inter-tribal Indian Ceremonial, Gallup; Indian Market, Santa Fe

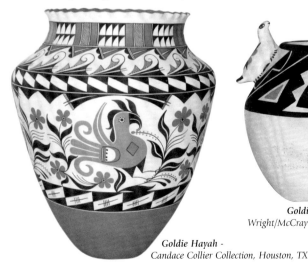

Goldie Hayah -
Courtesy of John D. Kennedy and
Georgiana Kennedy Simpson, Kennedy Indian Arts

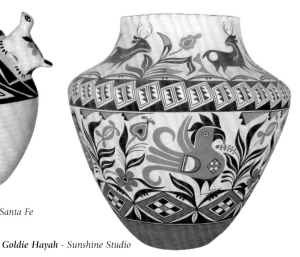

Goldie Hayah -
Wright/McCray Collection, Santa Fe

Goldie Hayah -
Candace Collier Collection, Houston, TX

Goldie Hayah - Sunshine Studio

EXHIBITIONS: Indian Market, Santa Fe
FAVORITE DESIGNS: deer with heartlines, bears, antelope, parrots, birds, flowers, vines
GALLERIES: Andrews Pueblo Pottery & Art Gallery, Rio Grande Wholesale, Palms Trading Company, Albuquerque; Packard's, Wind River, Santa Fe, Sunshine Studio at www.sunshinestudio.com
PUBLICATIONS: Berger & Schiffer 2000:121.

 Goldie Hayah enjoyed the benefit of two of the best Acoma pottery teachers: her paternal grandmother, Jessie Garcia (Sun Clan) and her mother, Sarah J. Garcia (Turkey Clan). These ladies are renowned masters of traditional pottery.

 Goldie shared, "I grew up watching my Grandma make pottery. How beautiful they came out after their firing! My mother's pottery was very nice too. I like making pottery. I especially enjoy shaping them out through hand coiling."

Goldie Hayah - Courtesy of Eason Eige, Albuquerque, NM

John B. Hayah, Sr.

(Acoma, active ca. 1996-present: polychrome jars, bowls)
BORN: December 17, 1949
FAMILY: husband of Goldie Hayah; father of Juliet Hayah
TEACHER: Goldie Hayah, his wife
GALLERIES: Rio Grande Wholesale, Inc., Palms Trading Co., Albuquerque
PUBLICATIONS: Berger & Schiffer 2000:121.

Juliet Hayah

(Acoma, Turkey Clan, active ca. 1996-present: polychrome jars, bowls)
BORN: November 4, 1980
FAMILY: m. granddaughter of Sarah Garcia; daughter of Goldie & John B. Hayah, Sr.
GALLERIES: Rio Grande Wholesale, Inc., Palms Trading Co., Albuquerque
PUBLICATIONS: Berger & Schiffer 2000:121.

Mavis Hayah

(Acoma, active 1990s-present: polychrome jars, bowls, seed pots)
EXHIBITIONS: 1999-present: Indian Market, Santa Fe
PUBLICATIONS: Dillingham 1992:206-208; Painter 1998:11.

Aggie Henderson-Poncho *(Aggie Poncho, Christine Henderson-Poncho),* *(signs Aggie Acoma, N.M.)*

(Acoma, active ca. 1985-present: polychrome Storytellers, figures)
BORN: August 6, 1973
FAMILY: daughter of Christine S. & Ted Martinez; sister of Crystal Poncho & Tina Poncho; niece of Yolanda Paytiamo
TEACHER: Marilyn Ray-Henderson, her mother-in-law
AWARDS: 2nd, Inter-tribal Indian Ceremonial, Gallup; New Mexico State Fair, Albuquerque
GALLERIES: Arlene's Gallery, Tombstone, AZ; Rio Grande Wholesale, Inc., Palms Trading Co.
PUBLICATIONS: Berger & Schiffer 2000:140.

Aggie Christine Poncho - Courtesy of John D. Kennedy and Georgiana Kennedy Simpson Kennedy Indian Arts

Helen Henderson *(H. Henderson, H. Tafoya Henderson, Helen Marie Henderson Tafoya)*

(Jemez/San Ildefonso, active ca. 1987-present: polychrome & sgraffito jars & bowls)
BORN: June 11, 1961
FAMILY: great-granddaughter of Maria Sanchez Colaque; daughter of David & Vangie Tafoya; sister of Brenda Tafoya & Tyron Tafoya
AWARDS: 1988; 1998, 3rd, Indian Market, Santa Fe; 1st (4), 2nd (2), New Mexico State Fair, Albuquerque; Inter-tribal Indian Ceremonial, Gallup
EXHIBITIONS: 1992-present, Indian Market, Santa Fe; 1994-present, Eight Northern Indian Pueblos Arts & Crafts Show
FAVORITE DESIGNS: clouds, hummingbirds, lizards
GALLERIES: The Indian Craft Shop, U.S. Department of Interior, Washington, D.C.; Kennedy Indian Arts, Bluff, UT
PUBLICATIONS: *Native Peoples Magazine* Feb./Mar./Apr. 1997 10(2):28; *Indian Market Magazine* 1998:99; Walatowa Pueblo of Jemez, "Pottery of Jemez Pueblo" (1998); *Native Artists Magazine* Summer 1999 1(1):22; Schaaf 2000:184; Berger & Schiffer 2000:121.

 H. Tafoya Henderson creates handmade, hand painted and stone polished pottery. Many of her pots have sgraffito designs.

Helen T. Henderson - Courtesy of John D. Kennedy and Georgiana Kennedy Simpson Kennedy Indian Arts

Katherine Henderson

(Cochiti, active ca. 1998-present: pottery)
BORN: ca. 1990
EXHIBITIONS: 1999-present, Indian Market, Santa Fe

Helen T. Henderson - Courtesy of Georgiana Kennedy Simpson Kennedy Indian Arts, Bluff, UT

Krystal Henderson
(Cochiti, active ca. 1990s-present: traditional pottery, figures)
BORN: ca. 1987
FAMILY: great-great-great-granddaughter of Santiago & Magdelena Quintana; great-great-granddaughter of Vicente & Reyes T. Romero; great-granddaughter of Nestor & Laurencita Herrera; granddaughter of Seferina & Guadalupe Ortiz; daughter of Juanita Inez Ortiz; sister of Lisa Holt, Katherine Ortiz
TEACHER: Juanita Inez Ortiz, her mother
PUBLICATIONS: Dillingham 1994:120.

M. Henderson
(Acoma, active ?-present: black-on-white fineline vases, some covered in human figures of children climbing up the vase)
PUBLICATIONS: Congdon-Martin 1999:49.

Marilyn Henderson *(see Marilyn Ray)*

Cecelia Hepting *(signs C.H., Acoma N.M.)*
(Acoma, active ca. 1950s-present: traditional & ceramic polychrome jars, bowls)
BORN: April 19, 1938
FAMILY: daughter of Lucita R. Vallo; wife of John Hepting; mother of Victoria Hepting
PUBLICATIONS: Dillingham 1992:206-208; Berger & Schiffer 2000:121.

Victoria Hepting *(signs V.H., Acoma N.M.)*
(Acoma, active ca. 1975-present: traditional & ceramic polychrome jars, bowls)
BORN: October 25, 1959
FAMILY: granddaughter of Lucita R. Vallo; daughter of Cecelia & John Hepting
TEACHERS: Lucita R. Vallo & Cecelia Hepting
GALLERIES: Rio Grande Wholesale, Inc., Palms Trading Co., Albuquerque
PUBLICATIONS: Dillingham 1992:206-208; Berger & Schiffer 2000:121.

Barbara Herrera
(Cochiti, active ca. 1930s-?: polychrome jars, bowls)
FAMILY: wife of Raymond Herrera; mother of Mary O. Chalan
PUBLICATIONS: Berger & Schiffer 2000:104.

Christina L. Herrera
(Cochiti, active 1980s-present: contemporary stoneware)
AWARDS: 1990, 2nd, Indian Market, Santa Fe

Cruzita Herrera *(Crucita Herrera)*
(Santo Domingo, active ca. 1920s-?: traditional polychrome jars, bowls)
PUBLICATIONS: Batkin 1987:202, n. 83.
 Museum director Kenneth M. Chapman gave her a set of Santo Domingo pottery designs he had compiled in the 1930s.

Dorothy Herrera

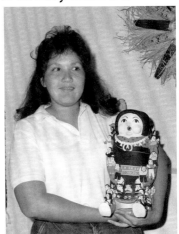

(Cochiti, active ca. 1980s-present: polychrome jars, bowls, Storytellers, frogs, bears)
BORN: ca. 1970
FAMILY: m. granddaughter of Laurencita & Nestor Herrera; daughter of Mary Frances Herrera; sister of Edwin & Mary Ramona Herrera
COLLECTIONS: John Blom
GALLERIES: The Indian Craft Shop, U.S. Department of Interior, Washington, D.C.; Arlene's Gallery, Tombstone, AZ; Andrews Pueblo Pottery & Art Gallery, Albuquerque; Crosby Collection, Park City, UT; Kennedy Indian Arts, Bluff, UT
PUBLICATIONS: Hayes & Blom 1996:62-63; Bahti 1996:31, 56; Peaster 1997:27-27; Congdon-Martin 1999:14.

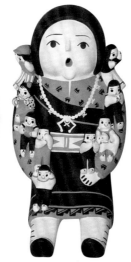

Dorothy Herrera - Courtesy of John D. Kennedy and Georgiana Kennedy Simpson Kennedy Indian Arts

Dorothy Herrera - Courtesy of Georgiana Kennedy Simpson Kennedy Indian Arts, Bluff, UT

E. Herrera
(Cochiti, active ?: polychrome jars, bowls)
PUBLICATIONS: Hayes & Blom 1998:41.

Edwin Herrera *(Ie-yoo-ris), (signs E H Cochiti, N.M.)*
(Cochiti, active ca. early 1980s-present: polychrome jars, bowls, Storytellers, Bear Storytellers, bears, Nativities, fetishes)
BORN: June 6, 1966
FAMILY: m. grandson of Laurencita & Nestor Herrera; son of Mary Francis Herrera; nephew of Dorothy Herrera
TEACHER: Mary Francis Herrera, his mother
GALLERIES: The Indian Craft Shop, U.S. Department of Interior, Washington, D.C.; Rio Grande Wholesale, Andrews Pueblo Pottery & Art Gallery, Albuquerque; Crosby Collection, Park City, UT
INTERNET: www.sunshinestudio.com
PUBLICATIONS: Hayes & Blom 1996; Peaster 1997:26-27; Congdon-Martin 1999:16; Berger & Schiffer 2000:121.

 Edwin Herrera learned traditional Cochiti pottery making from his mother, Mary Frances Herrera. He gathers clay in the hills of Cochiti and fires his pottery with cedar chips.

 Edwin creates popular bear figures, bear Storytellers and bear Nativities. His deer, big horn sheep and antelope figures are poised resting. His traditional polychrome on cream jars are beautiful in form and design. His rain clouds, with lightning bolts flashing upward, appear before the Sun Spirit.

Estefanita Arquero Herrera *(Estefana Herrera, Estephanita, Stephanita, Stefanita Herrera, Estafana Herrera), (signed S.A.H.)*
(Cochiti, Fox Clan, Turquoise Kiva, active ca. 1900s-pre-1965: large polychrome storage jars, ollas, jars, dough bowls, pitchers with lizard spouts, lizard effigy ollas, lizards, pigs, owls, turtle pots, textiles)
LIFESPAN: March 18, 1889 - pre-1965
FAMILY: wife of Juan Herrera (Cottonwood Clan); mother of Felipa Trujillo (b. 1909), Toñita (b. 1911), Berena (b. 1912), Santiago Herrera (b. 1914), Candelaria Herrera (b. 1918), Verna Herrera, Issesio Herrera, Alberto Herrera; grandmother of Ada Suina, Snowflake Flower, Polly Cordero, Mary Cordero, Joe Cordero, Frances Cordero, Angel Quintana; Stephanie Rhodes, Arnold Herrera
EXHIBITIONS: 1979, "One Space: Three Visions," Albuquerque Museum, Albuquerque
COLLECTIONS: Museum of Indian Art & Culture, Santa Fe; Philbrook Museum of Art, Tulsa, OK, olla, ca. 1910, bowl, ca. 1939, lizard, owl, 1947, lizard jar, figure, pig, 1955, turtle pot, ca. 1957; School of American Research, Santa Fe, olla with lizard effigies, ca. 1951; Frank Kinsel Collection, CA; Don & Lynda Shoemaker Collection, Santa Fe
FAVORITE DESIGNS: lizards, pigs, owls, turtles, rain clouds, lightning
PUBLICATIONS: U.S. Census, New Mexico, 1920, family 42; Goldfrank 1927:n.33, genealogical chart, personal ID #+216; Lange 1959:162, 511; Toulouse 1977:32; Monthan 1979:33, 40; Babcock 1986; Batkin 1987:111; *Southwest Profile* Oct. 1989 12(9):31; Schaaf 2001:288.

Estefanita Herrera -
Don & Lynda Shoemaker Collection

 Estefanita Arquero Herrera was known for her large storage jars. She was active in the ceremonial life of the Pueblo. Lange recorded her as a member of the Ku-sha'li [Clown] Society.

 Her granddaughter, Ada Suina commented, "She did great big pots — dough pots, we call them — and pitchers with lizard spouts. Her work is in museums." In her dough bowl, the rim flared out with a central band featuring up to 14 design elements, with a black band underneath and two thin lines before the red clay base.

 Her style of lizard effigy ollas influenced other Cochiti potters, including Seferina Ortiz with her lizard canteens and Martha Arquero with her frogs. Small lizards, frogs and other animal figurines continue to be favorite early choices of Cochiti children making their first clay pieces. They're fun and fast to create. Children play with the animal figures, which are reinforced in traditional Cochiti animal stories. Animal tales often teach important personal growth themes of benefit for children's early development.

Estefanita Herrera -
Frank Kinsel Collection, CA

Evelyn Herrera
(Cochiti, active ?-present: pottery)
COLLECTIONS: John Blom

Felipa Herrera *(Filipa)*
(Cochiti, Coyote Clan, Turquoise Kiva, active ca. 1930s-?: traditional polychrome jars, bows, Storytellers)
BORN: ca. 1909
FAMILY: daughter of Juan & Estefanita Arquero Herrera
TEACHER: Estefanita Arquero Herrera, her mother
PUBLICATIONS: U.S. Census, New Mexico, 1920, family 42; Lange 1959:162, 511; Barry 1984:118.

Irene Herrera *(Apple Flower)*, *(signs I. Herrera - Zia)*

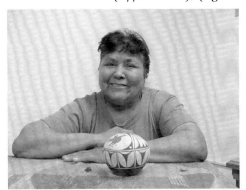

Irene Herrera - Courtesy of Jason Esquibel
Rio Grande Wholesale, Inc.

(Zia/Jemez, active ca. 1950-present: polychrome Storytellers, wedding vases, ollas, jars, bowls)
BORN: August 4, 1942
FAMILY: m. granddaughter of Juan & Mrs. Celo; daughter of Hubert & Andrea Tsosie (Jemez); sister of Leonard Tsosie, Rebecca Tsosie-Gachupin & Joanne Tsosie-Toribio
TEACHER: Andrea Tsosie
AWARDS: Best of Show, 2nd, Eight Northern Indian Pueblos Arts & Crafts Show
FAVORITE DESIGNS: roadrunners, rainbows, feathers-in-a-row, terraced clouds, rain, leaves
GALLERIES: Rio Grande Wholesale, Palms Trading Co., Albuquerque
PUBLICATIONS: Berger & Schiffer 2000:121.

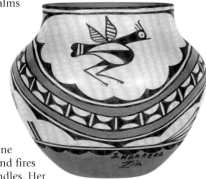

Irene Herrera -
Courtesy of Enchanted Village

Irene Herrera was only 8 years old when she "sparked an interest in pottery making." By age 12, she was painting her own pots. For half a century, Irene Herrera has continued to make traditional polychrome, Zia style pottery.

Irene shared her personal feelings, "I enjoy making pottery because it comes from within my heart. It's a gift to make my pottery."

Irene learned from her mother, Andrea Tsosie, who is from Jemez. However, Irene chose to create Zia-style pottery. She is an excellent potter. She gathers natural clay and fires her pottery outdoors. Her wedding vases are distinctive with their terraced cloud handles. Her roadrunners have two rounded tail feathers with openwork wings filled with dots or circles.

J. Herrera

(Zia, active ca. 1970s-?: polychrome jars, miniature ollas)
PUBLICATIONS: Barry 1984:104.

Juana Maria Herrera

(Cochiti, active ?: pottery)
ARCHIVES: Laboratory of Anthropology Library, Santa Fe, Lab file.

Laurencita Herrera

(Cochiti, active ca. 1920s-1984: polychrome jars, bowls, figures, Storytellers, canteens)
LIFESPAN: ca. 1912 - 1984
FAMILY: daughter of Vicente & Reyes T. Romero; sister of Pelaria, Catalina, Porfilia, Lucy R. Suina; wife of Nestor Herrera (drummaker); mother of Mary Francis Herrera, Juanita James, Regina Herrera, Loretta Clark, Trini Lujan, Benny Herrera, Delphin Herrera, Florentino Herrera, Seferina Ortiz; grandmother of Joyce Lewis, Mary Janice Ortiz, Inez Ortiz, Virgil Ortiz, Leon Ortiz & Angie Ortiz
STUDENTS: Mary Francis Herrera & Seferina Ortiz
EXHIBITIONS: 1979, "One Space: Three Visions," Albuquerque Museum, Albuquerque
COLLECTIONS: Wright Collection, Peabody Museum, Harvard University, Cambridge, MA; Heard Museum, Phoenix; School of American Research, Cat. #IAF 2755 & 2756.
GALLERIES: Andrews Pueblo Pottery and Art Gallery, Albuquerque
PUBLICATIONS: *SWAIA Quarterly* Fall 1973 8(3):5; Tanner 1976:121; *American Indian Art Magazine* Spring 1983 8(2):37; Babcock 1986:19-20, 34, 40, 42, 130, 132; Dillingham 1994:120-23; Peaster 1997:24, 27; Drooker, et al., 1998:47, 138.

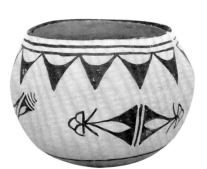

Laurencita Herrera -
Andrews Pueblo Pottery and Art Gallery
Albuquerque, NM

Mary Frances Herrera *(1)*, *(sometimes signs Mary F. Herrera or M.F.H.)*

(Cochiti, active ca. 1930s-1991: polychrome jars, bowls, Storytellers (1978-91), miniatures)
LIFESPAN: ca. 1935 - 1991
FAMILY: daughter of Nestor & Laurencita Herrera; sister of Seferina Ortiz & 7 others; mother of Dorothy Herrera, Ramona Herrera, Edwin Herrera & Mary Ramona Herrera (2)
GALLERIES: Rainbow Man, Santa Fe; Adobe Gallery, Albuquerque & Santa Fe; Kennedy Indian Arts, Bluff, UT
PUBLICATIONS: Tanner 1976:121; *American Indian Art Magazine* Spring 1983 8(2):37; Babcock 1986:32, 45, 48, 156; Trimble 1987:58; Dillingham 1994:120; Peaster 1997:26-27; Congdon-Martin 1999:13.

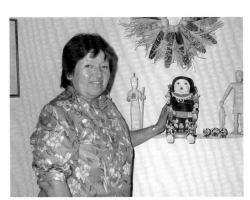

Mary F. Herrera - Courtesy of John D. Kennedy and
Georgiana Kennedy Simpson, Kennedy Indian Arts

Mary Ramona Herrera (2) *(Mona Herrera, signs Mary R. Herrera, M. Herrera or M. H., Cochiti N.M.)*
(Cochiti, active ca. 1991-present: polychrome jars, bowls, Storytellers)
BORN: August 29, 1970
FAMILY: m. granddaughter of Nestor & Laurencita Herrera; daughter of Mary Francis Herrera (1); sister of Dorothy Herrera, & Edwin Herrera
GALLERIES: The Indian Craft Shop, U.S. Department of Interior, Washington, D.C.
PUBLICATIONS: Peaster 1997:26-27; Berger & Schiffer 2000:122.

Mary Herrera (3) *(collaborates with Edwin Herrera)*
(Cochiti, active, ca. 1990s-present: polychrome jars, bowls, Storytellers)
FAMILY: wife of Edwin Herrera

Mavis B. Herrera *(signs Mavis, Cochiti)*
(Navajo, married into Cochiti, active ca. 1990-present: Storytellers)
BORN: June 19, 1941
TEACHER: her mother-in-law
PUBLICATIONS: Berger & Schiffer 2000:121.

Mona Herrera *(see Mary Ramona Herrera (2))*

Ramona Herrera *(see Mary Ramona Herrera (2))*

Mary Ramona Herrera (2) -
Dave & Lori Kenney, Santa Fe

Reyes Arsala Herrera
(Zia, Tobacco Clan, active ca. 1900-40s+: traditional polychrome jars, bowls)
BORN: ca. 1880s
FAMILY: wife of Juan Pedro Herrera; mother of Ascencion Herrera Galvan; m. grandmother of Dolorita Galvan Pino, Harveana Helen Medina, Pablita Galvan Lucero

Stephanita Herrera *(see Estephanita Herrera)*

Tim Herrera
(Cochiti, active 1982-present: pottery, animal figures, drums)

Trinidad Herrera *(Trini Herrera, Trinidad Quintana)*
(Cochiti, Fox Clan, active 1940s-?: traditional polychrome jars, bowls, figures)
FAMILY: daughter of Caroline Pecos; sister of Helen Cordero; wife of Alfred Herrera; mother of Leona, Connie, Isaac & Gabe Yellowbird Quintana (adopted)
ARCHIVES: Laboratory of Anthropology Library, Santa Fe, lab file.

Velino Shije Herrera *(Ma Pe Wi or Ma Pe We)*
(Zia, active ca. 1880s-?: traditional painted polychrome jars, bowls, watercolors, oil & tempera paintings)
BORN: October 22, 1902
FAMILY: son of Reyes Ancero Shije & Juan Pedro Shije; sister of Vivian Shije; cousin of Jose Rey Toledo
PUBLICATIONS: U.S. Census 1920, family 26.

He-wee'-a
(Zia, active ca. 1840s-1910s: traditional polychrome large storage jars, ollas, jars, bowls)
BORN: ca. 1820s
FAMILY: wife of Gaa-yo-le-nee; mother of Augustina Aguilar & Elisio Aguilar; m. grandmother of Manuelita Aguilar Salas; m. great-grandmother of Vicentita S. Pino; m. great-great-grandmother of John B. Pino, Ronald Pino & Diana Lucero
> He-wee'-a is one of the earliest known potters from Zia Pueblo. Her great-granddaughter, Vicentita S. Pino, recalled, "She made really big pots, over 18" in diameter. Some she used to store flour. One big one she filled with eggs and was carried to town in a horse and wagon by her son, Elisio Aguilar. He-wee'a often was seen making pottery, sitting outside her adobe home at Zia Pueblo.

Tonita Hilo or Hivo *(Mrs. Jose Reyes Hivo)*
(Santa Ana, active ca. 1880s-?: traditional polychrome jars, bowls)
BORN: ca. 1873
FAMILY: wife of Jose Reyes Hilo or Hivo; mother of Cristo Hilo or Hivo, Jose Reyes Leon Hilo or Hivo; mother-in-law of Crescencia; grandmother of Pedro Hilo or Hivo
ARCHIVES: U.S. Census, 1920, Santa Ana, family 26; Laboratory of Anthropology Library, Santa Fe, lab file.

Rowena Him *(see Rowena Him Nahohai)*

Mariontona Lola Hishi
(Acoma, active ca. 1880s-1910s+: polychrome jars, bowls)
BORN: ca. 1870; RESIDENCE: Acomita in ca. 1910
PUBLICATIONS: Leopold Bibo, "13th Annual U.S. Census" (1910), New Mexico State Archives, Call T624, Roll 919; in Dillingham 1992:205.

Bennett Greg Histia *(B. Greg Histia), (collaborates with Jackie Shutiva)*

(Acoma, active ?-present: traditional polychrome & corrugated jars, bowls)
BORN: September 3, 1953; RESIDENCE: San Fidel, NM
FAMILY: husband of Jacqueline Shutiva Histia
EXHIBITIONS: 1996-present, Eight Northern Indian Pueblos Arts & Crafts Show
PUBLICATIONS: Dillingham 1992:206-208: Painter 1998:12; Tucker 1998: plate 95.

Carmelita Histia

(Acoma, active ?: pottery)
FAMILY: related to the Garcia family
ARCHIVES: Artist File, Heard Museum Library, Phoenix

Daisy Histia

(Acoma, active ?-1990+: polychrome jars, bowls)
PUBLICATIONS: Dillingham 1992:206-208.

Eva Histia *(signs E. Histia)*

(Acoma, Roadrunner Clan, active ca. 1922-present: traditional polychrome jars, bowls, fluted vases with twist handles, lamps, owls)
BORN: ca. May 4, 1914
FAMILY: daughter of Helice Vallo; mother of Hilda Antonio, Rose Torivio & Ida Ortiz; grandmother of Mary J. Garcia & Lavine Torivio
TEACHER: Helice Vallo, her mother
STUDENTS: Lavine Torivio, Hilda Antonio, Rose Torivio and Mary J. Garcia
AWARDS: 1979, 2nd, Indian Market, Santa Fe; New Mexico State Fair, Albuquerque
EXHIBITIONS: pre-1972-present: Indian Market, Santa Fe
COLLECTIONS: Heard Museum, Phoenix; Dr. Gregory & Angie Yan Schaaf, Santa Fe
GALLERIES: Rio Grande Wholesale, Inc., Palms Trading Co., Albuquerque
PUBLICATIONS: *SWAIA Quarterly* Fall 1972:3; Fall 1973:3; Babcock 1986:135; Minge 1991:195; Dillingham 1992:206-208; Reno 1995:9; Berger & Schiffer 2000: 4, 16, 122.

*Eva Histia -
Andrews Pueblo Pottery and Art Gallery
Albuquerque, NM*

*Eva Histia -
Courtesy of Sunshine Studio*

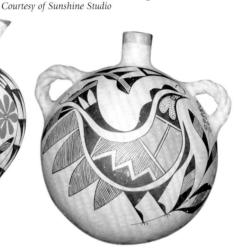

*Eva Histia - Courtesy of
Cowboys & Indians Antiques, Albuquerque*

Jackie Shutiva Histia *(Jacqueline Histia Shutiva, Jackie M. Histia, Jackie H. Shutiva, Shewaati), (signs J. Histia, Shutiva, Acoma N.M.), (collaborates sometimes with Bennett Greg Histia)*

(Acoma, Sun/Yellow Corn Child Clan, active ca. 1982-present: traditional corrugated whiteware jars, bowls, wedding vases, vases, seed pots with handles, Storytellers, owls, fetishes)
BORN: August 12, 1961; RESIDENCE: San Fidel, NM
FAMILY: great-granddaughter of Juana Garcia; m. granddaughter of Jessie Garcia; daughter of Ernest D. & Stella Shutiva; sister of Sandra Shutiva; wife of Bennett Greg Histia; mother of Shelly, Alicia & Lindsey
TEACHER: Stella Shutiva
AWARDS: 1989, 3rd; 1990, 3rd; 1991, 1st; 1996,2nd, 3rd, Indian Market, Santa Fe; Heard Museum Show, Phoenix; 1995, 3rd, Eight Northern Indian Pueblos Arts & Crafts Show; Inter-tribal Indian Ceremonial, Gallup; New Mexico State Fair
DEMONSTRATIONS: Portland Gallery, San Francisco
EXHIBITIONS: 1988-present: Indian Market, Santa Fe; 1989, Lawrence Indian Arts Show, Lawrence, KA; 1992, Heard Museum Show, Phoenix; 1995-present, Eight Northern Indian Pueblos Arts & Crafts Show
COLLECTIONS: John Blom
FAVORITE DESIGNS: ears of corn
GALLERIES: The Indian Craft Shop, U.S.

*Jackie Shutiva Histia -
Courtesy of Jason Esquibel
Rio Grande Wholesale, Inc.*

*Jackie Shutiva Histia - Courtesy of Jason Esquibel
Rio Grande Wholesale, Inc.*

Department of Interior, Washington, D.C.; Rio Grande Wholesale, Inc., Albuquerque
PUBLICATIONS: Trimble 1987:24, 75, 78, 79; Dillingham 1992:206-208; Hayes & Blom 1996:54-55; Peaster 1997:20; Tucker 1998: plate 96; Painter 1998-12; Berger & Schiffer 2000:122.

 Jackie Shutiva Histia comes from a prolific pottery-making family. Her grandmother, Jessie Garcia, was an important potter who helped advance Acoma pottery tradition. Her mother, Stella Shutiva, is well known for unique white corrugated pottery owls. Jackie continues making corrugated whiteware. Some of her designs, such as appliques of ears of corn, are reminiscent of similar works with smooth surfaces by Wilfred Garcia and Sandra Shutiva, her sister.

 Jackie said pottery making is "my way of expressing my creations — new and old. Through my mother, I'm carrying on the tradition. For me, it is a way of relaxation."

Juanalita Histia

(Acoma, ca. 1910s-40s+: traditional polychrome ollas, jars, bowls, owls)
BORN: ca. 1890s
FAMILY: mother-in-law of Eva Histia; grandmother of Hilda Antonio, Rose Torivio.
PUBLICATIONS: Babcock 1986:136.

Early in the 20th century, Juanalita Histia was a popular storyteller. Her granddaughter, Hilda Antonio, recalled: "When she came to our house, she would call all the little children to gather around her [and] would tell us stories about a long time ago, how she grew up, how our ancestors made pottery, and how, during the wars, the people of Acoma hired the owls to watch over the Pueblo at night." (Babcock 1986:136.)

Margaret Histia

(Acoma, active ?-1990+: polychrome jars, bowls)
PUBLICATIONS: Dillingham 1992:206-208.

Mary Histia *(Acoma Mary)*

(Acoma, active ca. 1890s-1973: polychrome-on-red, polychrome-on-white ollas, jars, bowls, animal figures, turtles, turkeys & owls)
LIFESPAN: 1881 - 1973
FAMILY: wife of San Juan Histia; mother of Dolores Histia Sanchez; m. grandmother of Cindy Sanchez Lewis; m. great-granddaughter of Alvin Lewis, Jr., Viola M. Ortiz
AWARDS:1930s Potter to the President of the United States
COLLECTIONS: Maxwell Museum of Anthropology, Albuquerque; School of American Research, Santa Fe, polychrome-on-red jar, ca. 1931; John Beeder, Albuquerque; John Blom
PUBLICATIONS: Harlow 1977; Batkin1987:138; Hayes & Blom 1996:46-47; 1998:51,
PHOTOGRAPHS: Adam Carl Vroman, "Acoma, Mary holding olla. 1900"; M. James Slack, staff photographer, Historic American Building Survey (WPA), 1934, in collection of John Beeder, Albuquerque.

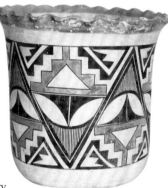

Mary Histia - Courtesy of John Beeder, Albuquerque, NM

Mary Histia was the most famous Acoma potter at the turn of the 20th Century. She traveled to Washington, D.C. and became popular as an unofficial potter to President Roosevelt. Her polychrome ollas soon decorated many government offices with the support of Secretary of Interior John Collier. (Batkin 1987:138)

A polychrome olla by Mary in the Maxwell Museum of Anthropology displays an eagle with wings spread and the initials "NRA," an abbreviation for the National Recovery Act, part of President Roosevelt's "New Deal."

Josef Hoffman

(Santo Domingo, active ?: pottery)
ARCHIVES: Heard Museum Library, Phoenix, artist file.

Anita Holleha

(Acoma, active ca. 1930s-?: traditional polychrome jars, bowls)
COLLECTIONS: Philbrook Museum of Art, Tulsa, OK, 2 jars, ca. 1939

Lisa Holt *(Liza)*

(Cochiti, active 1996-present: figures: bears, frogs, lizards)
BORN: March 21, 1980
FAMILY: granddaughter of Guadalupe & Seferina Ortiz; daughter of Juanita Ortiz; sister of Krystal, Katherine; mother of Dominique Leemoné Holt
TEACHER: Juanita Ortiz, her mother
EXHIBITION: Wheelwright Museum, Santa Fe
GALLERIES: The Indian Craft Shop, U.S. Department of Interior,

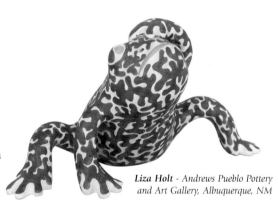

Liza Holt - Andrews Pueblo Pottery and Art Gallery, Albuquerque, NM

Washington, D.C.; Andrews Pueblo Pottery and Art Gallery, Albuquerque; Case Trading Post at the Wheelwright Museum of the American Indian; Robert Nichols Gallery, Santa Fe

Lisa Holt comes from a prominent pottery-making family. They are especially known for their figural pottery. Lisa carries on the tradition, making bears, frogs and lizards. Lisa shared how pottery making connects her with her mother, Juanita Ortiz: "It is very enjoyable and like my mom. Pottery making takes away your stress. The work can be done at your own pace. No one pressures you for the hours spent on one piece."

Lisa makes her pottery figures in the traditional way. She uses wild spinach for black and natural clay paints for red and white.

Erma Jean Homer *(collaborates with Fabian Homer, and sometimes with Nellie Bica)*

(Zuni, active ca. 1960s-?: traditional polychrome jars, bowls)
FAMILY: granddaughter of Nellie Bica; daughter of Jack & Quanita Kalestewa; sister of Roweena Lemention, Connie Yatsayte; wife of Fabian Homer
TEACHERS: Nellie Bica, Quanita & Jack Kalestewa
PUBLICATIONS: Rodee & Ostler 1986:24; Peaster 1997:155.

Erma Jean Homer comes from a family famous for their traditional pottery. They are noted for firing their pottery out of doors. She forms the pottery, and her husband, Fabian, sometimes paints them with polychrome designs.

Fabian Homer *(collaborates sometimes with Erma Jean Homer)*

(Zuni, active ca. 1960s-?: traditional polychrome jars, bowls, figures of bears with heartlines, fetishes)
FAMILY: husband of Erma Jean Homer
PUBLICATIONS: Rodee & Ostler 1986:24, 30; Peaster 1997:155.

Marcus Homer *(signs Marcus Homer or M. Homer with a bear paw hallmark)*

*Marcus Homer - Courtesy of Jason Esquibel
Rio Grande Wholesale, Inc.*

(Zuni, active ca. 1978-present, polychrome jars, bowls, kiva bowls, effigy pots, frog pots, seed pots, wedding vases, canteens, miniatures)
BORN: January 7, 1971
FAMILY: son of Bernard Homer, Jr.
AWARDS: 1994, 1st, Inter-tribal Indian Ceremonial, Gallup; Eight Northern Indian Pueblos Arts & Crafts Show; New Mexico State Fair, Albuquerque; Heard Museum, Phoenix; "Zuni Show," Museum of Northern Arizona, Flagstaff
FAVORITE DESIGNS: frogs, tadpoles, turtles, water serpents (Kolowisi), Corn Maidens, lizards, spotted salamanders, fineline hatched rain
GALLERIES: The Indian Craft Shop, U.S. Department of Interior, Washington, D.C.; Pueblo of Zuni Arts & Crafts, Zuni, NM; Rio Grande Wholesale, Albuquerque; Kennedy Indian Arts, Bluff, UT
INTERNET: www.sunshinestudio.com
PUBLICATIONS: Bassman 1996:23, 29; Berger & Schiffer 2000:122.

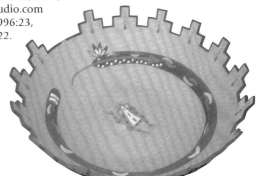

Marcus Homer creates unique cornmeal bowls, sometimes called kiva bowls. His bowls have up to 20 terraced clouds on the rim. From the surface of the bowl, appliques of Water Serpents and frogs emerge from the surface. The appealing effect makes the surface of his bowls simulate the surface of a pond. His spotted salamanders emerge from the belly of a canteen, reminiscent of M. C. Escher's lizards. Marcus also makes traditional, Classic Zuni ollas, brown-on-white fineline with diagonal hatching. His pottery is attractive and well made.

*Marcus Homer - Courtesy of Jason Esquibel
Rio Grande Wholesale, Inc.*

Robert Allen Homer

(Zia/Hopi, active ca. 1985-present: sgraffito jars, bowls)
BORN: October 6 or 22, 1956
FAMILY: son of Marie Moquino; nephew of Corn Moquino
TEACHER: Corn Moquino
AWARDS: 1995 Heard Museum Show, Phoenix
EXHIBITIONS: 1997-present, Indian Market, Santa Fe
PUBLICATIONS: Hayes & Blom 1996:74-75; 1998; Schaaf 1999:51; Berger & Schiffer 2000:122.

Daisy Hooee *(Daisy Hooee Nampeyo, Daisy Naha, Daisy Poblano)*

(Hopi-Tewa, married into Zuni, active ca. 1920s-90s: polychrome jars, bowls, frog figures, sculpture, stone carvings)
LIFESPAN: 1906 - November 29, 1994
FAMILY: m. granddaughter of Nampeyo; daughter of Annie & Willie Healing; sister of Rachel Namingha Nampeyo, Fletcher Healing, Lucy, Dewey Healing and Beatrice Naha; wife of Neil Naha, Leo Pablano (Zuni, 1939-47), then Sidney Hooee from 1948; mother of Shirley Benn (b. 1936), Louella Naha Inote, "Whiskey" and Raymond Naha (painter).
EDUCATION: L'Ecole de Beaux Arts, Paris, France
TEACHER: Nampeyo, her grandmother
EXHIBITIONS: 1960s-?, Inter-tribal Indian Ceremonial, Gallup; 1974, "Seven Families in Pueblo Pottery," Maxwell Museum of Anthropology, University of New Mexico, Albuquerque; 1997-98, "Recent Acquisitions," Heard Museum, Phoenix
DEMONSTRATIONS: 1974, Honolulu Academy of Arts, Hawaii
COLLECTIONS: Wright Collection, Peabody Museum, Harvard University, Cambridge, MA, frog figure; Museum of Northern Arizona, black and red on yellow jar, #E3347, 1950; black and red on yellow jar, #E7682, ca. 1920-30; Heard Museum, Phoenix, jar, #3487-1, ca. 1948
FAVORITE DESIGNS: migration, parrots, birds, frogs, clouds, rain
PUBLICATIONS: *Arizona Highways* May 1974:21, 40; Bell 1976:6; Toulouse 1977:81; Eaton 1990:29; *American Indian Art Magazine* Summer 1990:58; Dillingham 1996:14-15; Nahohai & Phelps 1995:10; Reano 1995:79; *Indian Trader* Feb. 1995:9-10; Hayes & Blom 1996:53; Bassman 1996:18; Kramer 1996:96-99, 107-08. 176; Drooker & Capone 1998:51, 138; Schaaf 1998:52, 89, 95, 97, 140; Blair 1999:87-90, 138, 194-98.

Daisy Hooee was the granddaughter of the famous Hopi potter Nampeyo. She confessed that she used to sneak some of her grandmother's clay to make little figures. Daisy recalled, "One day while my grandmother was sweeping, she found some of my small pieces hidden under the stove, and she encouraged me to keep working."

Daisy recalled going to school in 1913, at the age of 7, with her older sisters, Fannie and Rachel. The teacher first said she was too young, but she just kept coming with her sisters. The teacher finally gave her paper and pencil, letting her sit on the side. She quickly learned English and proved an exceptional student.

When Daisy was a child, she attended Phoenix Indian School. She developed a disease in her eyes that blurred her vision. She fell behind in her classes. A government teacher, who did not recognized Daisy's poor vision, impatiently beat her in front of the class. Daisy was horrified and traumatized by the terrible experience. She returned soon to Hopi, where she attended

Polacca Day School. Daisy soon left the reservation to receive eye surgery in California. The operation was a success! Her patroness, Annie Baldwin, arranged for her to stay with her and to attend Pasadena High School.

Daisy was proclaimed a talented artist by sculptor Emry Kopta. He recommended to Ms. Baldwin that Daisy should receive formal training. The wealthy philanthropist arranged for Daisy to study at the L'encole des Beaux Arts in Paris. Daisy excelled at fine art and learned to speak French. So promising was the young Hopi-Tewa artist, Ms. Baldwin arranged for her to study art in a worldwide tour.

Around 1930, Daisy returned to Hopi and began making pottery in the Hopi-Tewa's Sikyatki Revival style. She helped her grandmother Nampeyo, who then was going blind. Nampeyo formed the pots. Daisy and sister Fannie helped paint their grandmother's pots with traditional designs. Daisy was married a few years to Neil Naha, and gave birth to three children. From 1935 to 1939, she worked with the Peabody Museum's excavations of Awatovi village. She compiled a notebook filled with drawings of old pottery designs.

In 1939, Daisy married Zuni master jeweler, Leo Pablano, and moved to his pueblo. He taught her silversmithing and mosaic inlay. She made Hopi maidens of mosaic inlaid into silver boxes. Her work has a sculptural quality. Her husband, Leo, tragically was killed by a falling tree while fighting a forest fire. Daisy became a widow with three children.

In 1948, Daisy married Sidney Hooee, a Zuni jeweler noted for his needlepoint turquoise and channel inlay styles. Daisy returned to her pottery, but also made Zuni-style pots. She accepted Zuni traditions, and appeared in their Olla Maiden Dance at the Inter-tribal Indian Ceremonial in Gallup.

Daisy is respected for teaching pottery-making classes in the 1960s and 1970s at Zuni High School. She encouraged Zuni people to use traditional Zuni designs. She continued classes in her home. She also shared with them much knowledge of clan migration stories. Her role as pottery teacher was carried forward by Jennie Laate, an Acoma potter who also was married into Zuni.

Ventura Howeya
(Acoma, active ca. 1950s-present: polychrome jars, bowls)
BORN: ca. 1930
FAMILY: mother of Roberta H. Trujillo

Dru Ann Hughte
(Zuni, active ?: pottery)
PUBLICATIONS: Bassman 1996.

Phil Hughte
(Zuni, active ca. 1990s-present)
STUDENTS: Brian Tsethlikai, Yvonne Nashboo
Phil Hughte taught pottery in the 1990s at Zuni High School.

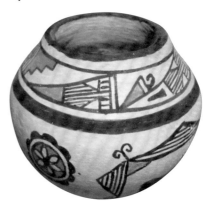

Daisy Hooee Nampeyo -
Courtesy of John Blom

Hu-u-ca
(Cochiti, active ?-present: figures, clowns)
PUBLICATIONS: Congdon-Martin 1999:17.

Hummingbird hallmark *(see Vincent Hansen or Tommy Lewis)*

Carmelita Ingersoll *(signs C. I. Jemez N.M.)*
(Jemez, active ca. 1972-present: traditional polychrome jars, bowls)
BORN: October 1, 1943
FAMILY: daughter of Manuel & Marie Fragua
TEACHER: Marie Fragua, her mother
AWARDS: Window Rock Arts & Crafts Show
PUBLICATIONS: Berger & Schiffer 2000:122.

Irene *(see Irene Quintana)*

Dora Isleta *(see Dora Jojola)*

Pat Iule *(signs P. Iule, Acoma N.M.)*
(Acoma, active ca. 1984-present: traditional & ceramic polychrome jars, bowls)
BORN: March 10, 1956
FAMILY: child of Robert & Pauline Iule
TEACHERS: grandmother and mother-in-law
EXHIBITIONS: 1985-present, Indian Market, Santa Fe
COLLECTIONS: Wright Collection, Peabody Museum, Harvard University, Cambridge, MA; Allan & Carol Hayes; John Blom; Dr. Gregory & Angie Yan Schaaf, Santa Fe
PUBLICATIONS: *Indian Market Magazine* 1985-89; Dillingham 1992:206-208; Drooker & Capone 1998:138; Berger & Schiffer 2000:122.

Burgess P. James
(Acoma, active ?: pottery)
RESIDENCE: Albuquerque, NM
ARCHIVES: Artist File, Heard Museum Library, Phoenix

Darius L. James

(Acoma, Sun Clan, active ca. 1988-present: traditional & contemporary polychrome, sgraffito jars, bowls)
BORN: May 24, 1977
FAMILY: son of Jimmy P. James & Rachel White James
PUBLICATIONS: Painter 1998:12.

Kenneth James

(Jemez, active ?-present: pottery)
GALLERIES: The Indian Craft Shop, U.S. Department of Interior, Washington, D.C.

Melody L. James

(Acoma, Sun Clan, active ca. 1970s-present: traditional & contemporary polychrome jars, bowls)
BORN: ca. 1960s
FAMILY: m. granddaughter of Alice Pancho White & Frank Zieu White; daughter of Rachel White James & Jimmy P. James; sister of Gilbert R. James, Darla K. Davis, Tamara L. Abeita, Tracy D. Chalan, Hope Taylor, Dewey M. James, Darius L. James

Patricia A. Jones

(Jemez, active ca. 1970-present: polychrome jars, bowls)
BORN: November 7, 1955
FAMILY: daughter of Reina L. Kohlmeyer (Waquiu)
TEACHER: Reina L. Kohlmeyer, her mother
PUBLICATIONS: Berger & Schiffer 2000:124.

Rachel White James

(Acoma, Sun/Little Bear Clans, active ca. 1950s-present: traditional & contemporary polychrome jars, bowls)
BORN: November 20, 1939
FAMILY: daughter of Alice Pancho White & Frank Zieu White; wife of Jimmy P. James; mother of Gilbert R. James, Darla K. Davis, Tamara L. Abeita, Tracy D. Chalan, Hope Taylor, Dewey M. James, Darius L. James & Melody L. James
EXHIBITIONS: New Mexico State Fair, Albuquerque; Navajo Nation Fair, Window Rock, AZ
PUBLICATIONS: Dillingham 1992:206-08; Painter 1998:12.

 Rachel White James spoke of natural abilities of Indian artists: "Creative arts in any form is instilled within us at birth. It's a natural thing for us Native American Indians." Rachel is well educated. She earned a Masters Degree in Elementary Education. She credits her mother, Alice Pancho White, as her pottery teacher. She taught her children and grandchildren to make pottery.

Priscilla Torivio Jim *(see Priscilla Torivio & James Torivio)*

Lawrence Joe *(collaborates with Loretta Joe)*

(Acoma, ca. 1980s-present: traditional jars, bowls)
BORN: ca. 1950s
FAMILY: husband of Loretta Joe

Loretta Joe *(signs L. J. or L. Joe Acoma N.M.), (collaborates with Lawrence Joe)*

(Acoma, Yellow Corn Clan, active ca. 1977-present: traditional large polychrome jars & bowls)
BORN: September 17, 1958
FAMILY: m. granddaughter of Lupe & John Concho; daughter of Florence & Fred Waconda; sister of Beverly Victorino; wife of Lawrence Joe
TEACHERS: Florence Waconda & Lupe Concho
AWARDS: New Mexico State Fair, Albuquerque
COLLECTIONS: Wright Collection, Peabody Museum, Harvard University, Cambridge, MA; John Blom; Dr. Gregory & Angie Schaaf
FAVORITE DESIGN: parrots, bears with heartlines, rainbows, flowers, plants, clouds
GALLERIES: The Indian Craft Shop, U.S. Department of Interior, Washington, D.C.; Rio Grande Wholesale, Inc., Albuquerque
PUBLICATIONS: Dillingham 1992:206-208; Drooker & Capone 1998:46, 138; Berger & Schiffer 2000:123.

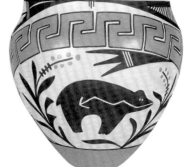

Loretta Joe - Courtesy of Sunshine Studio

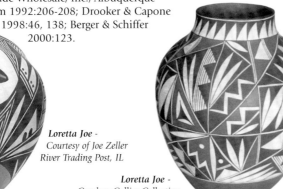

Loretta Joe - Courtesy of Joe Zeller River Trading Post, IL

Loretta Joe - Candace Collier Collection Houston, TX

Loretta Joe - Courtesy of Enchanted Village

Florence Johnson
(Acoma, active ca. 1975-1990)
PUBLICATIONS: Minge 1991:195; Dillingham 1992:206-208.

Juanita Johnson
(Acoma, active ca. 1900s-1910s+: polychrome jars, bowls)
BORN: ca. 1885; RESIDENCE: Acomita in ca. 1910
PUBLICATIONS: Leopold Bibo, "13th Annual U.S. Census" (1910), New Mexico State Archives, Call T624, Roll 919; in Dillingham 1992:205.

Lois Johnson
(Acoma, active ca. 1975-1990)
PUBLICATIONS: Minge 1991:195; Dillingham 1992:206-208.

Zyla Johnson
(Zuni, active ca. 1990s-present: polychrome jars, kiva bowls)
BORN: ca. 1985
AWARDS: 3rd, Zuni High School Art Show, Zuni Pueblo, NM (when in 9th grade)
FAVORITE DESIGNS: tadpoles, dragonflies, rain clouds

Anthony Jojola
(Isleta, active ?-present: pottery, glassware)
AWARDS: 1991, Katherine & Miguel Otero Award for Creative Excellence, Indian Market, Santa Fe

Berta Jojola *(collaborates with Vernon Jojola)*
(Isleta/Laguna, active ?, pottery, jewelry)

Deborah Jojola - Courtesy of
Allan & Carol Hayes

Deborah Jojola *(Deborah A. Jojola Sanchez), (signs Deb. Jojola)*
(Isleta, active ca. 1970s-present: contemporary white-on-redware sculptures, effigy vases, shell attachments)
AWARDS: 1991, 3rd, misc., Indian Market, Santa Fe
COLLECTIONS: Allan & Carol Hayes
FAVORITE DESIGNS: Water Serpents
GALLERIES: Bahti Indian Arts, Tucson, AZ

Dora Jojola *(signs Dora Isleta)*
(Isleta, active ca. 1980s-present: black-on-cream jars, bowls, miniature moccasins)
COLLECTIONS: Allan & Carol Hayes

Dora Jojola - Courtesy of
Allan & Carol Hayes

Felicita Jojola *(Ansera, Jojolla)*
(Isleta, active 1920s-?: traditional polychrome jars, bowls, figures)
BORN: ca. 1900s
FAMILY: m. granddaughter of Marcellina Jojola; daughter of Emilia Lente Carpio; wife of Rudy Jojolla; mother of Stella Teller; m. grandmother of Mona Teller, Chris Teller, Lynette Teller, Robin Teller
ARCHIVES: Laboratory of Anthropology Library, Santa Fe; Lab. File.
PUBLICATIONS: Babcock 1986: 79, 154.

Jesusita Jojola
(Isleta, active ca. 1920s-?: polychrome jars, bowls)
FAMILY: p. grandmother of Tony Jojola

Joe S. Jojola
(Isleta, active ?: traditional polychrome jars, bowls, cornmeal bowls)
AWARDS: 1972, 1st, Inter-tribal Indian Ceremonial, Gallup
COLLECTIONS: Wright Collection, Peabody Museum, Harvard University, Cambridge, MA.
FAVORITE DESIGNS: frogs, terraced clouds
PUBLICATIONS: Drooker & Capone 1998:56, 138.

Laguarda R. Jojola
(Isleta, active ?: pottery)
COLLECTIONS: Heard Museum, Phoenix

Louise Jojola *(Loise), (signs L. R. Jojola)*
(Isleta, active ?: traditional polychrome jars, bowls)
FAVORITE DESIGNS: lightning, kiva steps, leaves in stacked vertical bands
PUBLICATIONS: Hayes & Blom 1996:76-77.

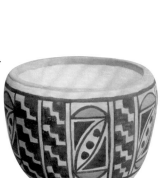

L. R. Jojola -
Courtesy of John Blom

Lucy R. Jojola *(L. R. Jojola)*
(Isleta, active ca. 1960s-?: polychrome jars, bowls, wedding vases, wind chimes)
COLLECTIONS: Wright Collection, Peabody Museum, Harvard University, Cambridge, MA, wind chimes; Museum of Northern Arizona, wedding vase, ca. 1972; John Blom
FAVORITE DESIGNS: birds, lightning, clouds, leaves
GALLERIES: Morning Star Traders, Tucson, AZ
PUBLICATIONS: Eaton 1990:14; Drooker & Capone 1998:56, 138.

Marcellina Jojola
(Isleta, active 1880s-?: traditional polychrome jars, bowls)
BORN: ca. 1860s
FAMILY: mother of Emilia Lente Carpio; m. grandmother of Felicita Jojolla; m. great-grandmother of Stella Teller; m. great-great-grandmother of Mona Teller, Chris Teller, Lynette Teller, Robin Teller
PUBLICATIONS: Babcock 1986: 79, 154.

P. Jojola
(Isleta, active ?-present: polychrome jars, bowls, miniature ollas)

Roberta Jojola *(1)*
(Isleta, active ?-present: sgraffito jars, bowls)
AWARDS: 1994, 2nd, sgraffito, Indian Market, Santa Fe

Roberta L. Jojola *(2)*
(Laguna/Navajo, active ca. 1990s-?: pottery)
EXHIBITIONS: 1988-present, Indian Market, Santa Fe
PUBLICATIONS: *Indian Market Magazine* 1988, 1989, 1996.

Tony Jojola
(Isleta, active ca. 1960s-present: polychrome jars, bowls, hand-blown glass, bronze)
FAMILY: p. grandson of Jesusita Jojola (pottery); m. grandson of Patricio Olguin (silversmith)
TEACHER: Dale Chihuly
STUDENTS: youth in Tacoma, WA, Hilltop artist-in-residence; teacher, Taos Glass Art and Education, Taos
EXHIBITIONS: 1978-present, Indian Market, Santa Fe; 2001, "Born of Fire," Wheelwright Museum, Santa Fe
COLLECTIONS: Denver Art Museum, Denver; New Mexico Museum of Fine Arts, Santa Fe; Institute for American Indian Arts, Santa Fe; Albuquerque Museum, Albuquerque; Contemporary Fine Arts Museum, Helsinki, Finland
PUBLICATIONS: Lesley Constable, "Jojola's hot shop," *Pasatiempo, New Mexican* (January 19-25, 2001):36-37.

Vernon Frederick Jojola *(collaborates with Berta Jojola)*
(Isleta/Laguna, active ca. 1970s-present: pottery, jewelry, painting)
BORN: April 18, 1949
EXHIBITIONS: 1988-present, Indian Market, Santa Fe; 1994, Heard Museum Show, Phoenix; 1995-present, Eight Northern Indian Pueblos Arts & Crafts Show; American Indian Art Festival and Market, Dallas, TX
PUBLICATIONS: Lester 1995:273.

Joseffa
(Santo Domingo, active ca. 1890s-1910s+: traditional polychrome jars, bowls)
COLLECTIONS: American Museum of Natural History, Washington, D.C., #50.0/5031-5037.
PUBLICATIONS: Batkin 1987:99.

L. Joyce
(Acoma, active ? - present: Nativities, human & animal figures)
GALLERIES: Palms Trading Co., Albuquerque
PUBLICATIONS: Congdon-Martin 1999:52.

Consepsion Juachonpino
(Acoma, active ca. 1860s-1910s+: polychrome jars, bowls)
BORN: ca. 1845; RESIDENCE: Acomita in ca. 1910
PUBLICATIONS: Leopold Bibo, "13th Annual U.S. Census" (1910), New Mexico State Archives, Call T624, Roll 919; in Dillingham 1992:205.

Lorencita Juachonpino
(Acoma, active ca. 1890s-1910s+: polychrome jars, bowls)
BORN: ca. 1875; RESIDENCE: Acomita in ca. 1910
PUBLICATIONS: Leopold Bibo, "13th Annual U.S. Census" (1910), New Mexico State Archives, Call T624, Roll 919; in Dillingham 1992:205.

Lorita Juachonpino

(Acoma, active ca. 1870s-1910s+: polychrome jars, bowls)
BORN: ca. 1855; RESIDENCE: Acomita in ca. 1910
PUBLICATIONS: Leopold Bibo, "13th Annual U.S. Census" (1910), New Mexico State Archives, Call T624, Roll 919; in Dillingham 1992:205.

Andy Juanico *(signs A. Juanico)*

(Acoma, active ca. 1974-present: pottery, Kachinas, artifacts)
BORN: September 10, 1954
FAMILY: son of Judy Juanico
GALLERIES: Rio Grande Wholesale, Inc., Palms Trading Co., Albuquerque
PUBLICATIONS: Berger & Schiffer 2000:125.

Brenda R. Juanico

(Acoma, active ca. 1960s-present: polychrome jars, bowls, paintings)
AWARDS: 1970, Heard Museum Show, Phoenix
EXHIBITIONS: 1995-present, Eight Northern Indian Pueblos Arts & Crafts Show
PUBLICATIONS: Dillingham 1992:206-208; Lester 1995:275..

D. M. Juanico

(Acoma, active ?-1990+: polychrome jars, bowls)
PUBLICATIONS: Dillingham 1992:206-208.

Georgia Juanico

(Acoma, active 1970s-80s: pottery)
EXHIBITIONS: 1985, Indian Market, Santa Fe
PUBLICATIONS: *Indian Market Magazine* 1985.

Linda Juanico

(Acoma, active ca. 1940s-1975+: traditional polychrome jars, bowls (1940s-), figures (1947-), polychrome Storytellers (1972-))
BORN: September 1, 1927
FAMILY: granddaughter of Teofila Torivio; daughter of Mamie Ortiz; sister of Rachael Arnold, Myrna Chino; mother of Carmen King
PUBLICATIONS: Babcock 1986:136-37; Minge 1991:195.

Linda Juanico made traditional Acoma pottery for thirty years before making her first Storyteller in 1972. She made her first clay figure in about 1947: "When I was twenty years old, I found a shard that was made like a figure, and I decided to make one like the one I found."

Linda explained how she makes figures, "I use native clay and paint from wild spinach and mineral rocks. I mold the clay with my hands — shaping, putting arms and legs on — using hands only, no tools."

Linda once also made jars and bowls, but now she makes exclusively figures and Storytellers. In 1986, she told University of Arizona professor, Barbara Babcock, "This is the only kind of pottery I work with, and I rely solely on touch, for I am totally blind." (Babcock 1986:137)

Lucy Juanico

(Acoma, active ca. 1940s-90s: traditional polychrome jars, bowls)
BORN: ca. 1930s
FAMILY: mother of Charlene Estevan; m. grandmother of Berleen Estevan
EXHIBITIONS: 1985, Indian Market, Santa Fe
PUBLICATIONS: *Indian Market Magazine* 1985; Dillingham 1992:206-208.

Marie R. Juanico

(Acoma, active ca. 1900s-1914+: traditional polychrome jars, bowls)
COLLECTIONS: Philbrook Museum of Art, Tulsa, OK, bowl, ca. 1914

Marie S. Juanico *(signs M. Juanico, Acoma N.M.)*

(Acoma, Yellow Corn Clan, active ca. 1962-present: traditional polychrome jars, bowls, owls)
BORN: September 17, 1937
FAMILY: granddaughter of Jose Sandoval; daughter of Toribio & Delores Sanchez; sister of Ethel Shields, Katherine Lewis; mother of Delores Aragon; mother-in-law of Marvis Aragon, Jr.
TEACHER: Delores Sanchez, her mother
STUDENT: Delores Aragon, her daughter
AWARDS: 2000, 3rd, Indian Market, Santa Fe; New Mexico State Fair, Albuquerque; Inter-tribal Indian Ceremonial, Gallup
COLLECTIONS: Allan & Carol Hayes, John Blom; Drs. Judith & Richard Lasky, New York
FAVORITE DESIGNS: Mimbres animals, parrots, rainbows, snowflakes
GALLERIES: The Indian Craft Shop, U.S. Department of Interior, Washington, D.C.; Adobe Gallery, Rio Grande Wholesale, Inc., Albuquerque; Robert Nichols Gallery, Santa Fe

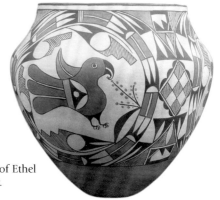

Marie Juanico -
Photograph by Adam Hume
Drs. Judith & Richard Lasky Collection
New York City

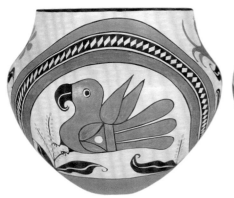
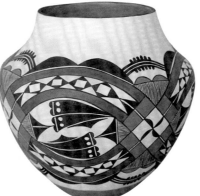
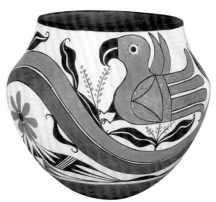

Marie Juanico -
Courtesy of Enchanted Village

Marie Juanico - Courtesy of
Eason Eige, Albuquerque, NM

Marie Juanico - Andrews Pueblo Pottery
and Art Gallery, Albuquerque, NM

PUBLICATIONS: Dillingham 1992:206-208; Brown 1993:18-19; Reano 1995:11, 92; Painter 1998:12; Congdon-Martin 1999:52; Berger & Schiffer 2000:124.

Marie S. Juanico learned pottery making from her mother, Delores Sanchez, who lived to the age of 103. Marie carries forward her mother's tradition of creating fine pottery in the old way. She has passed the tradition on to her daughter, Delores Aragon.

Marie enjoys doing her own "creative work from scratch." She said that she likes to "mix clay, make paint and mix different color earth pigments." Pottery making is her main source of income, but it's "what I want and like to do."

Marie feels that her pots take on their own desired forms naturally. If the shape comes out old style, she uses traditional Acoma designs. If the shape emerges in a contemporary style, she innovates her own patterns. She explained, "There's no two pots alike; they each have meaning." (Brown 1993:19)

Marietta H. Patricio Juanico *(signs M. P. Juanico, Acoma, N.M.)*

Marietta Juanico & husband Melvin Juanico -
Photograph by Michael E. Snodgrass, Denver, CO

(Acoma, active ca. 1973-present: traditional & contemporary polychrome jars, bowls, miniatures)
BORN: September 23, 1964; RESIDENCE: Acoma Pueblo, NM
FAMILY: daughter of Isidore & Frances Concho; sister of Norbert Patricio
TEACHER: Frances Concho, her mother
AWARDS: 1997, Collector's Choice Artist, "Phoenix Indian Center," Phoenix; 1998, 1st, Eight Northern Indian Pueblos Arts & Crafts Show
EXHIBITIONS: 1998-present, Indian Market, Santa Fe; 1996-present, Eight Northern Indian Pueblos Arts & Crafts Show
GALLERIES: The Indian Craft Shop, U.S. Department of Interior, Washington, D.C.; Rio Grande Wholesale, Inc., Palms Trading Co., Albuquerque
PUBLICATIONS: Painter 1998:12; Berger & Schiffer 2000:124.

Matt Juanico *(Matthew), (collaborates with Myra Juanico)*

(Acoma, active ?-present: pottery)
GALLERIES: The Indian Craft Shop, U.S. Department of Interior, Washington, D.C.

Melvin E. Juanico

(Acoma, active ?-present: polychrome jars, bowls)
EXHIBITIONS: 1998-present: Indian Market, Santa Fe

Myra Juanico *(collaborates with Matt Juanico)*

(Acoma, active ?-present: pottery)
GALLERIES: The Indian Craft Shop, U.S. Department of Interior, Washington, D.C.

Marietta Juanico -
Photograph by Adam Hume
Drs. Judith & Richard Lasky Collection
New York City

Norma Jean Juanico *(Norma Jean Ortiz, Poncho, Rambeau)*

(Acoma, active ca. 1970s-present: polychrome jars, bowls, Storytellers, turtles)
BORN: ca. 1955; RESIDENCE: Acoma, NM
PUBLICATIONS: Dillingham 1992:206-208.

Phyliss Juanico

(Acoma, active ?-1990+: polychrome jars, bowls)
PUBLICATIONS: Dillingham 1992:206-208.

Rita Juanico

(Acoma, active ?-1990+: polychrome jars, bowls)
PUBLICATIONS: Dillingham 1992:206-208.

J. K. *(see Jack Kalestewa)*

M. K. *(see Melville Kelsey)*

Evan Kalestewa - Andrews Pueblo Pottery and Art Gallery, Albuquerque, NM

C. Kalestewa *(signs C. K.)*

(Zuni, active ?: traditional polychrome jars, bowls, owls)
COLLECTIONS: Wright Collection, Peabody Museum, Harvard University, Cambridge, MA
PUBLICATIONS: Hayes & Blom 1998:49; Drooker & Capone 1998:140.
 The Kalestewa family continues to fire their pots traditionally outdoors.

Erma H. Kalestewa *(signs E. Kalestewa, Zuni)*

(Zuni, active ?-present: polychrome owls, jars, bowls, owls, miniatures)
COLLECTIONS: Gerald & Laurette Maisel, Tarzana, CA
GALLERIES: The Indian Craft Shop, U.S. Department of Interior, Washington, D.C.;
Pueblo of Zuni Arts & Crafts, Zuni, NM; Keshi, Santa Fe
PUBLICATIONS: Bassman 1996:24, 25, 29.

Jack Kalestewa - Courtesy of John Blom

Evan Kalestewa *(signs E. Kalestewa Zuni)*

(Zuni, active ca. 1980s-present: traditional polychrome jars, bowls, frog effigy pots, owls)
FAVORITE DESIGNS: frogs, tadpoles
PUBLICATIONS: Hayes & Blom 1996:168-69.
 The Kalestewa family continues to fire their pots traditionally outdoors.

Jack Kalestewa *(sometimes signs JK), (collaborates sometimes with Quanita Kalestewa)*

(Zuni, active ?-present: Hawikuh Revival and traditional polychrome jars, cornmeal bowls with frog effigies, frog pots, coffee cups, figures of bears with heartlines, jewelry)
FAMILY: son-in-law of Nellie Bica; husband of Quanita Kalestewa; father of Erma Jean Homer, Roweena Lemention, Connie Yatsayte
TEACHER: his great-grandmother
AWARDS: 1996, 2nd, Zuni Jars, Indian Market, Santa Fe
FAVORITE DESIGNS: Deer-in-His-House, frogs, Water Serpents (Kolowisi), butterflies, tadpoles, terraced clouds
GALLERIES: Turquoise Village, Pueblo of Zuni Arts & Crafts, Zuni, NM
PUBLICATIONS: Jacka, Pottery Treasures; Rodee & Ostler 1986:24, 28-29; Nahohai & Phelps 1995:back cover; Bassman 1996:20, 23, 25-26; Hayes & Blom 1998:41.
 The Kalestewa family continues to fire their pots traditionally outdoors. Jack does much of the family firings. He has constructed a special area for firing pottery at their sheep ranch. He uses sheep manure.
 Jack is known as an excellent potter in his own right. His cornmeal bowls feature frog and water serpent forms attached to the pots. He studied historic Hawikuh (ca. 1600) pottery from the School of American Research in Santa Fe. He was inspired to create several similar pots. He also studies photographs of pots in the collection of the Smithsonian Institution.

Quanita Kalestewa *(Juanita, Kalistewa), (QK - jewelry hallmark), (collaborates sometimes with Jack Kalestewa)*

(Zuni, active ca. 1940s-?: traditional polychrome jars, cornmeal bowls, effigy pots, frog pots, owls, Storytellers, jewelry, carvings)
FAMILY: daughter of Nellie Bica; wife of Jack Kalestewa; mother of Erma Jean Homer, Roweena Lention, Connie Yatsayte
AWARDS: 1991, 1st, 3rd, figures, 2nd, Storytellers; 1996, 2nd, figures, Indian Market, Santa Fe
EXHIBITIONS: 1982-present, Indian Market, Santa Fe; 1997-present, Eight Northern Indian Pueblos Arts & Crafts Show
COLLECTIONS: Indart Inc.
FAVORITE DESIGNS: Deer-in-His-House, rain, terraced clouds, frogs, tadpoles, lizards, plumed Water Serpents (Kolowisi)
GALLERIES: Turquoise Village, Pueblo of Zuni Arts & Crafts, Zuni, NM; Keshi, Santa Fe; Kennedy Indian Arts, Bluff, UT
PUBLICATIONS: SWAIA Quarterly Fall 1982:10; Indian Market Magazine 1985, 1988, 1989; Jacka, Pottery Treasures; Rodee & Ostler 1986:24-25, 28; Wright 1989, 2000:90; Nahohai & Phelps 1995:12-21; Bassman 1996:20, 23, 25; Hayes & Blom 1996; 1998:168; Peaster 1997:155; Congdon-Martin 1999; Whittle, Native American Fetishes.

Quanita Kalestewa - Courtesy of John D. Kennedy and Georgiana Kennedy Simpson

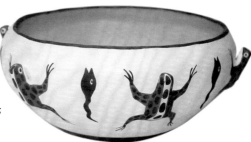

Quanita Kalestewa - Photograph by Bill Knox Courtesy of Indart Incorporated

 Quanita Kalestewa watched her mother, Nellie Bica, make pottery. However, Quanita did not get personally involved in pottery making until the 1940s.

Quanita and her husband, Jack Kalestewa, began by making jewelry. They later turned to pottery making because of the high price of silver, as well has health concerns over breathing dust from grinding shells. They collect clay at Nutria Mesa. Their red paint is made from yellow ochre (limonite). They form their pottery in a trailer behind their home. The Kalestewa family continues to fire their pots traditionally with sheep manure outdoors. They also are known for making very thin-walled pottery.

Michael Kanteena - Courtesy of Hoel's Indian Shop, Oak Creek Canyon, AZ

Michael Kanteena

(Laguna, active ca. 1990s-present: black-on-white Anasazi Revival jars, bowls, canteens, figures)
EXHIBITIONS: 1997-present, Indian Market, Santa Fe; 1996-present, Eight Northern Indian Pueblos Arts & Crafts Show
FAVORITE DESIGNS: Mimbres animals, human figures, deer
GALLERIES: Case Trading Post at the Wheelwright Museum, Santa Fe
PUBLICATIONS: *Indian Trader* Apr. 1996:13; Hayes & Blom 1996; 1998; *Indian Artist* Spring 1997:92; Winter 1997:36; Fall 1998:86; Tucker 1998: plate 100; *The Messenger,* Wheelwright Museum Summer 1998:3; *American Indian Art Magazine* Autumn 1998:94.

Michael Kanteena describes his pottery on his business card as, "Contemporary & Pre-Columbian Recreations in Clay." We met him on two occasions and found him to be a very personable young man. He expressed his sincere desire for his pottery to be accepted in a good way. His unique contribution is in his efforts to help revive ancient Pueblo pottery forms and styles. A growing circle of collectors are enthusiastic about his work.

Michael Kanteena - Courtesy of King Galleries of Scottsdale, AZ

Mrs. Torivio Kasario

(Acoma, active ?: pottery)
PUBLICATIONS: *Arizona Highways* May 1974:26.

Marie Kasero

(Laguna, active ca. 1973-?: traditional polychrome jars, bowls)
EDUCATION: 1973, Laguna Arts & Crafts Project participant

Kasinelu

(Zuni, active 1900-?: traditional polychrome jars, bowls)
PUBLICATIONS: Batkin 1987:20.

Kasinelu, along with We'wha, was a noted Zuni man-woman. They were both fine potters.

Michael Kanteena - Courtesy of Georgiana Kennedy Simpson Kennedy Indian Arts, Bluff, UT

Michael Kanteena - Courtesy of King Galleries of Scottsdale, AZ

Maria Katitse

(Zuni, active ?: pottery)
PUBLICATIONS: Art of the Native American

Katitse

(Zuni, active ?: pottery, musical instruments)
ARCHIVES: Laboratory of Anthropology Library, Santa Fe; lab. file.

Glorietta Katsenith

(Zuni, active ?: pottery)
PUBLICATIONS: *Pueblo Horizons* Fall 1996:6.

Adrienne Roy Keene - Photograph by Bill Bonebrake Courtesy of Jill Giller Native American Collections, Denver, CO

Adrienne Roy Keene *(Adrian Roy-Keene, Adrianne, Adrian Keene, Adrianna Teresa Ann Roy)*

(Acoma, active ca. 1970s-present: Mimbres & Anasazi Revival black-on-white & polychrome, jars, bowls, seed pots, corrugated ware, miniatures, non-traditional new forms, jewelry)
BORN: October 3, 1956; RESIDENCE: Tuba City, AZ
AWARDS: 1980, 1st; 1981, 2nd; 1983, 2nd; 1984, 2nd, 3rd; 1989, 1st; 3rd; 1995, Best of Division; 1996, 3rd, Indian Market, Santa Fe; 1997, Collector's Choice Award, 14th Annual Phoenix Indian Center Bola Tie Dinner and Awards Banquet; 1998, 2nd (2), 3rd, Indian Market, Santa Fe
EXHIBITIONS: 1981, "American Indian Art in the 1980s," Native American Center for the Living Arts, Niagara Falls, NY; 1982-present, Indian Market, Santa Fe; 1995-present, Eight Northern Indian Pueblos Arts & Crafts Show
FAVORITE DESIGNS: optical patterns, four petal flowers, rain, sun
COLLECTIONS: John Blom
PUBLICATIONS: New 1981:44, 75; Dillingham 1992:206-208; Hayes & Blom 1996:52-53.

Adrienne Roy Keene - King Galleries of Scottsdale, AZ

Gary Keene

(Acoma/Navajo, active ca. 1980s-present: pottery)
EXHIBITIONS: 1988, Indian Market, Santa Fe
PUBLICATIONS: *Indian Market Magazine* 1988.

Gus Keene, Sr. *(collaborated with Juanita Keene)*

(Acoma/Navajo, active ?-1975+: polychrome jars, bowls, jewelry)
FAMILY: husband of Juanita Keene; father of Gus Keene, Jr., Waya Gary Keene

Juanita Keene *(1), (Juanita Keen)*

(Acoma, active ca. 1930s-?: traditional polychrome jars, bowls)
FAMILY: daughter of Teofila Torivio; sister of Frances Pino Torivio, Katherine Analla, Lolita Concho, Concepcion Garcia

Juanita Keene *(2), (Juanita Keen), (collaborated with Gus Keene, Sr.)*

(Acoma, active ca. 1970s-present: polychrome, black-on-white & whiteware jars, bowls, pitchers, wedding vases, jewelry)
FAMILY: wife of Gus Keene, Sr.; mother of Gus Keene, Jr., Waya Gary Keene
AWARDS: 1979, 3rd; 1984, 3rd, wedding vases, Indian Market, Santa Fe
EXHIBITIONS: 1979-present: Indian Market, Santa Fe; 1995-present, Eight Northern Indian Pueblos Arts & Crafts Show
PUBLICATIONS: *Indian Market Magazine* 1979-present, *SWAIA Quarterly* Fall 1982:11; Barry 1984:89; Dillingham 1992:206-208; Minge 1991:195.

Mavis Keene

(Acoma, active ca. 1990s-present: polychrome jars, bowls)
EXHIBITIONS: 1999-present, Eight Northern Indian Pueblos Arts & Crafts Show

Ruby Keene

(Acoma, active ?-1975+: polychrome jars, bowls)
PUBLICATIONS: Minge 1991:195.

Alicia Kelsey *(Alice)*

(Acoma, active ca. 1994-present: traditional & ceramic fineline & polychrome jars, bowls)
BORN: June 27, 1979
FAMILY: granddaughter of Rachel James; daughter of Darla Davis; sister of Melville Kelsey
TEACHER: Darla Davis, her mother
AWARDS: 1996, 1st, 2nd, New Mexico State Fair, Albuquerque; 2nd, Navajo Nation Fair, Window Rock, AZ
FAVORITE DESIGNS: parrots, rainbows, fineline, deer
GALLERIES: The Indian Craft Shop, U.S. Department of Interior, Washington, D.C.; Rio Grande Wholesale, Inc., Palms Trading Co.
PUBLICATIONS: Berger & Schiffer 2000:125.

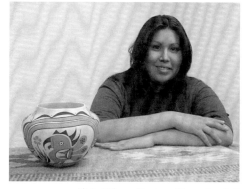

Alicia Kelsey - Courtesy of Jason Esquibel
Rio Grande Wholesale, Inc.

Melville Kelsey *(signs M.K. Acoma N.M.)*

(Acoma, active ca. 1983-present: traditional & ceramic polychrome jars, bowls)
BORN: ca. November 1, 1976
FAMILY: grandson of Rachel & James White; son of Darla K. Davis; brother of Alicia Kelsey
TEACHER: Darla Davis, his mother
AWARDS: New Mexico State Fair, Albuquerque; Inter-tribal Indian Ceremonial, Gallup
GALLERIES: Rio Grande Wholesale, Inc., Palms Trading Co., Albuquerque
PUBLICATIONS: Berger & Schiffer 2000:125.

Melvilla R. Kelsey

(Acoma, active ?-present: polychrome jars, bowls)
PUBLICATIONS: Painter 1998:12.

Rosetta Kendrick

(Santo Domingo, active ?-present: Storytellers, pottery)
AWARDS: 1998, 1999, 2000, Indian Market, Santa Fe
EXHIBITIONS: 1998-present, Indian Market, Santa Fe
PUBLICATIONS: *The Messenger*, Wheelwright Museum Fall 2000.

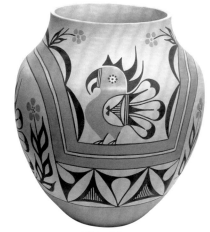

Alicia Kelsey -
Courtesy of Joe Zeller
River Trading Post, East Dundee, IL

Ke'Shra *(collaborates with M. B. H)*

(Cochiti, active ca. 1980s-present: Storytellers)
GALLERIES: Palms Trading Company, Albuquerque
PUBLICATIONS: Congdon-Martin 1999:17.

Josephine Kie

(Laguna, active ca. 1973-?: traditional polychrome jars, bowls)
EDUCATION: 1973, Laguna Arts & Crafts Project participant

Kim'a'aits'a

(Acoma, active ?-1990+: traditional & contemporary polychrome jars, bowls)
PUBLICATIONS: Dillingham 1992:206-208.

Lorrenda Kiyite

(Zuni, active ?: polychrome jars, bowls)
COLLECTIONS: Gerald & Laurette Maisel, Tarzana, CA

Dabina Kohlmeyer *(Dalaina)*

(Jemez, active ca. 1980s-present: animal figures)
AWARDS: 1990, 1st, pottery, (ages 12 & under); 1991, 1st, figures (ages 12 & under),
Indian Market, Santa Fe

Kris Kohlmeyer

(Jemez, active ca. 1980s-present: animal figures)
AWARDS: 1991, 3rd, figures (ages 18 & under), Indian Market, Santa Fe

Reina L. Kohlmeyer *(Reina Waquiu)*

(Jemez, active ca. 1950s-present: polychrome Storytellers, jars, bowls)
BORN: ca. 1930s
FAMILY: mother of Patricia A. Jones
STUDENT: Patricia A. Jones, her daughter
AWARDS: 1990, 3rd, Storytellers; 1996, 3rd, Storytellers, Indian Market, Santa Fe
PUBLICATIONS: Dillingham 1992:206-208.

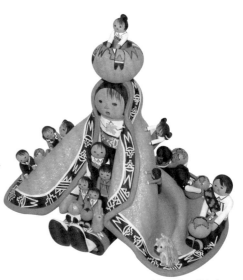

Mary Lou Kokaly -
Photograph by Angie Yan Schaaf. Courtesy of the artist

Mary Lou Kokaly *(Summer Flower, Thum-u-ya Povi, Marylou)*

(Isleta/San Juan, active ca. 1992-present: Storytellers, jewelry, bolos, pins)
BORN: May 4, 1943
FAMILY: daughter of Jose & Christine Povi Zuni; wife of Floyd J. Kokaly
AWARDS: 1994, 1st; 1998, 3rd; 1999, Indian Market, Santa Fe; 2001, Albuquerque Indian
Market, Albuquerque; 2001, Red Earth Festival, Oklahoma City, OK
EXHIBITIONS: 1992-present, Indian Market, Santa Fe; 1993, Heard Museum Show, Phoenix;
1994-present, Eight Northern Indian Pueblos Arts & Crafts Show; 2001, Albuquerque Indian
Market; Red Earth Festival, Tulsa
PUBLICATIONS: Schaaf 2000:245.

"I love to create Storytellers. Through stories we learn the lessons of life. As an art
teacher, I observe the creative art process and the joy of creating Storytellers. To me, the
Storyteller represent my personal life with family, friends and other people. Storytellers
help to promote appreciation of Native American culture and art."

Mary Lou Kokaly -
Photograph by Angie Yan Schaaf

Santana Koowakami

(Acoma, active ca. 1880s-1910s+: polychrome jars, bowls)
BORN: ca. 1870; RESIDENCE: Acomita in ca. 1910
PUBLICATIONS: Leopold Bibo, "13th Annual U.S. Census" (1910), New Mexico State
Archives, Call T624, Roll 919; in Dillingham 1992:205.

Wendell Kowemy *(signs W. Kowemy, Laguna N.M.)*

(Laguna, Roadrunner Clan, active ca. 1991-present: traditional polychrome, red-on-black,
black & white-on-orangeware jars, bowls, twist handles, fluted rims)
BORN: November 28, 1972
FAMILY: m. great-grandson of Mariano Cheromiah; m. grandson of Evelyn Cheromiah; son of
Kent Kowemy & Wendy Cheromiah Kowemy; brother of Arissa and Aerial Kowemy
TEACHER: Evelyn Cheromiah
EXHIBITIONS: 1994-present, Indian Market, Santa Fe
COLLECTIONS: Dave & Lori Kenney, Santa Fe
GALLERIES: Adobe Gallery, Rio Grande Wholesale,
Albuquerque
PUBLICATIONS: Berger & Schiffer 2000:125.

Wendell Kowemy shared the joy of
pottery making by saying simply, "It
makes me happy." He added, "I think it's
good to do artwork. Don't you?"

Wendell Kowemy -
Courtesy of Jason Esquibel
Rio Grande Wholesale, Inc.

R. Koyona

(Laguna, active ca. 1970s-?: polychrome, black-on-
white jars, bowls)
PUBLICATIONS: Hayes & Blom 1996:86.

Wendell Kowemy -
Courtesy of Dave & Lori Kenney, Santa Fe

Kuutimaits'a *(see Clara Santiago)*

A. L.
(Jemez, active ca. 1980s-?: Storytellers)
PUBLICATIONS: Congdon-Martin 1999:55.

A. M. L. *(see Anna Marie Loretto)*

D. L. *(see D. Loretto)*

D. S. L. *(see Deborah S. Loretto)*

J. L.
(Jemez, active ca. 1980s-?: Storytellers)
GALLERIES: Palms Trading Company, Albuquerque
PUBLICATIONS: Congdon-Martin 1999:74.

K. L. *(see Katherine Lewis)*

L. L. *(see Lynette Lukee)*

M. L. *(see Manuelita Judy Lovato)*

T. L.
(Jemez, active ca. 1980s-?: Storytellers)
GALLERIES: Palms Trading Company, Albuquerque
PUBLICATIONS: Congdon-Martin 1999:74.

Carlos Laate
(Zuni, active ?-present: traditional polychrome jars, bowls, pinch pots, wedding vases)
FAVORITE DESIGNS: Deer-in-His-House, rosettes
GALLERIES: Keshi, Santa Fe

Jennie Laate
(Acoma, married into Zuni, active ca. 1950s-?, polychrome jars, frog effigy ollas, bowls, cornmeal bowls, clay bowls with handles, owls, Storytellers: 1978-)
LIFESPAN: September 26, 1933 - ?
FAMILY: granddaughter of Dolores Stein; daughter of Frances Abeita; sister of Louise Amos; wife of Noel Laate (Zuni); mother of Maggie Laate
STUDENTS: Marjorie Esalio, Gabriel Paloma, Livia Roxie Panteah, Agnes Peynetsa, Anderson Peynetsa, Pricilla Peynetsa, Noreen Simplicio, Ruby Nastacio Toya and many more
AWARDS: 1977, 2nd, painted owl, Indian Market, Santa Fe
EXHIBITIONS: 1983-84, "Gifts of Mother Earth: Ceramics in the Zuni Tradition," Heard Museum, Phoenix (traveling exhibit); 1993, "Rain," Heard Museum, Phoenix (traveling Exhibit)
COLLECTIONS: Wright Collection, Peabody Museum, Harvard University, Cambridge, MA; Heard Museum, Phoenix; Roxanne & Greg Hofmann; Angie Yan Schaaf, Santa Fe
FAVORITE DESIGNS: tadpoles, frogs, Deer-in-His-House, deer with heartlines, swirls, birds, Rainbirds, rosettes; Kolowisi [Water Serpents]
PUBLICATIONS: Barry 1984:186, 189; Babcock 1986:81, 155; Rodee & Ostler 1986:66-69; Trimble 1987:84-85; Nahohai & Phelps 1995: back cover; Bassman 1996:18, 21, 25; Hayes & Blom 1996; 1998:29; Peaster 1997:156; Drooker & Capone 1998:71, 84, 140; Marshall 2000:78.

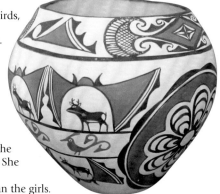

Jennie Laate -
Courtesy of John Blom

Jennie Laate was an Acoma woman who married into Zuni. She made pottery with another woman who had married into Zuni, Hopi-Tewa potter Daisy Hooee. Daisy taught pottery classes at Zuni High School. After Daisy, Jennie took over the pottery classes in 1975.

Jennie took her students out to gather clay and natural materials for paints. She taught them how to make black paint by boiling down wild spinach or bee weed. She offered beginning, intermediate and advanced courses.

She especially complimented her male students: "My boys turn out better than the girls. Girls get discouraged too fast." One of her top students was male potter Anderson Peynetsa. By 1986, Jennie's program grew to six classes with seventy-eight students.

She was the only artist making Zuni style pottery at the 1979 Indian Market in Santa Fe.

Gloria LaBelle

(Acoma, active ?-1990+: polychrome jars, bowls)
PUBLICATIONS: Dillingham 1992:206-208.

Victor Lahaleon

(Zuni, active ?-present: traditional polychrome effigy bowls, cornmeal bowls with frog effigies, wedding vases & Water Serpent handles)
COLLECTIONS: Candace Collier, Houston, TX; Dr. Fred Belk, NM
FAVORITE DESIGNS: frogs with 3-dimensional heads, Water Serpents

Mrs. Lahi *(Liha)*

(Zuni, active ca. 1920s-?: traditional polychrome jars, bowls)
COLLECTIONS: School of American Research, Santa Fe, jar, ca. 1929, #1325; Philbrook Museum, Tulsa, OK, jar, ca. 1920, #PO-319; Candace Collier, Houston, TX.
PUBLICATIONS: Batkin 1987:205, n. 130.

Filmer L. Lalio

(Zuni, active ?-present: pottery, jewelry)
FAMILY: husband of Lydia Vicenti Lalio
EXHIBITIONS: 1998-present, Indian Market, Santa Fe; 1994-present, Eight Northern Indian Pueblos Arts & Crafts Show

Victor Lahaleon -
Candace Collier Collection, Houston, TX

Lydia Vicenti Lalio

Lydia V. Lalio & husband Filmer Lalio -
Photograph by Michael E. Snodgrass, Denver, CO

(Zuni, active ca. 1992-present: traditional polychrome jars, bowls, miniatures, jewelry)
BORN: September 21, 1956
FAMILY: daughter of Cecil & Celicita V. Vicenti; wife of Filmer L. Lalio
AWARDS: 1998, Best of Class, Best of Division, West Valley Fine Art Show, Litchfield, AZ; 1998, 1st, Museum of Northern Arizona; 1998, Awards Banquet, Indian Health Service, Albuquerque
DEMONSTRATIONS: Pueblo Grande Museum, Phoenix; West Valley Museum, AZ
EXHIBITIONS: 1995-present, Eight Northern Indian Pueblos Arts & Crafts Show; Heard Museum Show; Zuni Show, Museum of Northern Arizona, Flagstaff; Sharlot Hall Museum, Prescott, AZ
GALLERIES: Keshi, Santa Fe; Heard Museum Shop, Phoenix
PUBLICATIONS: *Native Artists* Summer 1999:19; *Cowboys & Indians* Sept. 2000:94.

Lydia Vicenti Lalio carries forward traditional arts as a third generation Zuni potter. Her mother, the late Celecita Yawkia Vicenti, helped her develop the knowledge of traditional pottery making.

Lydia also is a well-educated professional. She earned a B.A. in Business Administration from New Mexico State University, Las Cruces. She further was awarded a certificate in Elementary Education. She is experienced both in education and banking. For three years, she taught as an elementary school teacher. She has several years' experience in retail banking and human resource management.

Lydia was honored for her beautiful pottery award plaques which she custom makes for the Indian Health Service in Albuquerque, Acoma, Canoncito, Laguna, Jicarilla Apache and in the regional area of Rockville, MD.

Lydia and her husband, Filmer, have three children. She spoke with pride of her family's artistic tradition, "I want to continue to pass it down to the next generation in our family. Pottery making is something that I enjoy very much."

Rudell Lanjose

(Zuni, active ?-present: polychrome owls)
PUBLICATIONS: Peaster 1997:158.

Alan Lasiloo

(Zuni, active ca. 1985-present, polychrome jars, ollas, bowls)
BORN: March 31, 1969
FAMILY: son of Angie and Marcus Lasiloo
EDUCATION: Institute of American Indian Arts, Santa Fe
EXHIBITIONS: Indian Market, Santa Fe
PUBLICATIONS: Berger & Schiffer 2000:125.

Joseph Latoma

(San Felipe, active ca. 1992-present: traditional artifacts and tools)
BORN: May 5, 1966
FAMILY: son of Joe Latoma
TEACHER: his great-grandfather
PUBLICATIONS: Berger & Schiffer 2000:125.

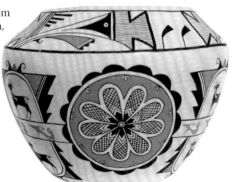

Lydia V. Lalio -
Courtesy of the artist

Dawn Laughlin

(Acoma, active ca. 1980s-present: pottery)
AWARDS: 1984, 2nd, pottery (ages 12 & under), Indian Market, Santa Fe

La Wa Ta

(Zuni, born into Eagle Clan, active 1900s-?: pottery)
BORN: ca. 1890s
FAMILY: sister of Lonkeena, Myra Eriacho; mother of Josephine Nahohai; m. grandmother of Randy Nahohai, Milford Nahohai, Irene Nahohai, Priscilla Tsethlikai

Marie Laweka

(Cochiti, active ca. 1960s-present: Storytellers, animal figures)
BORN: ca. 1930s
FAMILY: daughter of Damacia Cordero; sister of Josephine Arquero, Gloria Herrera & Martha Laweka
GALLERIES: Andrews Pueblo Pottery and Art Gallery, Albuquerque
FAVORITE DESIGNS: frogs, deer, turtles, snakes, cows, fish, birds, penguins, dogs & cats
PUBLICATIONS: Congdon-Martin 1999:17.

Maria Laweka -
Andrews Pueblo Pottery &
Art Gallery, Albuquerque

Maria Laweka -
Andrews Pueblo Pottery &
Art Gallery, Albuquerque

Maria Laweka - Courtesy of
Eason Eige, Albuquerque, NM

Juanarita Layo

(Acoma, active ca. 1870s-1910s+: polychrome jars, bowls)
BORN: ca. 1855; RESIDENCE: Acomita in ca. 1910
PUBLICATIONS: Leopold Bibo, "13th Annual U.S. Census"
(1910), New Mexico State Archives, Call T624, Roll 919; in Dillingham 1992:205.

Martha Redhorse Leeds

(Laguna/Pima: active ca. 1980s-present: pottery, textiles, paintings)
EXHIBITIONS: 1985-present, Indian Market, Santa Fe
PUBLICATIONS: *Indian Market Magazine* 1985, 1996:62,

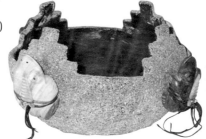

Edna Leki - Courtesy of
Don & Lynda Shoemaker
Santa Fe

Yamie Z. Leeds

(Laguna, active ?: pottery)
PUBLICATIONS: Harlow 1977.

Edna Leki

(Zuni, active ?-present, fetish jars covered with turquoise)
COLLECTIONS: Don & Lynda Shoemaker, Santa Fe
GALLERIES: Turquoise Village
PUBLICATIONS: Bassman 1996:21; Hayes & Blom 1998:168-69.

 Edna Leki is noted for her fetish pots covered with chip turquoise. Her fetishes are made of serpentine, alabaster, marble and other materials. She drills holes into the sides of her pots to attach the fetishes with leather. Bears are her most frequently used fetishes.

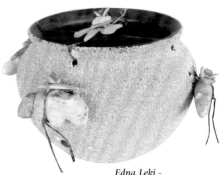

Fernandez Lemention *(collaborates with Roweena Lemention)*

(Zuni, active ca. 1960s-present: traditional polychrome jars, bowls)
FAMILY: husband of Roweena Lemention
PUBLICATIONS: Rodee & Ostler 1986:24.

Edna Leki -
Courtesy of Sunshine Studio

Roweena Lemention *(collaborates with Fernandez Lemention)*

(Zuni, active ca. 1960s-?: traditional polychrome jars, bowls)
FAMILY: granddaughter of Nellie Bica; daughter of Jack & Quanita Kalestewa; sister of Erma Jean Homer, Connie Yatsayte; wife of Fernandez Lemention
PUBLICATIONS: Rodee & Ostler 1986:24.

 Roweena Lemention comes from a family famous for their traditional pottery. They are noted for firing their pottery in a bonfire. Roween forms her pottery, and her husband, Fernandez, sometimes paints them with polychrome designs.

Bonnie Leno

(Acoma, active ?-1990+: polychrome jars, bowls, Storytellers)
BORN: ca. 1950s
FAMILY: m. granddaughter of Juana Pasqual (2); related to Blanche Antonio, Mary Lukee & Kimberly Pasqual
PUBLICATIONS: Dillingham 1992:206-208.

C. Leno

(Acoma, active ca. 1990s-present: polychrome jars, bowls)
COLLECTIONS: Allan & Carol Hayes

Elmer Leno

(Santa Ana, active ?-present: pottery, straw inlay)
TEACHER: Alfonso Garcia (straw inlay)
EXHIBITIONS: 1982-present, Indian Market, Santa Fe
PUBLICATIONS: *SWAIA Quarterly* 1982:12; Coe 1986:199-200; *Indian Market Magazine* 1985, 1988, 1989, 1996:62.

Filipita Leno *(see Phyllis Leno)*

G. Leno

(Acoma, active ?: polychrome ollas, jars)
COLLECTIONS: Wright Collection, Peabody Museum, Harvard University, Cambridge, MA; Heard Museum, Phoenix
GALLERIES: Andrews Pueblo Pottery & Art Gallery, Albuquerque
PUBLICATIONS: Drooker & Capone 1998:138.

Isabel Leno

(Acoma, active ca. 1960s-?)
BORN: ca. 1940s
FAMILY: p. great-granddaughter of Eulilia Vallo; granddaughter of Lupita and Jose Luis Vallo; daughter of Thomas & Juana Leno; sister of Rose, Phyllis, Marie, and Regina Leno
PUBLICATIONS: Monthan 1979:43-45.

J. Leno

(Acoma, active ?: figures, human busts)
COLLECTIONS: Don & Lynda Shoemaker, Santa Fe

Jeannie Leno *(see Regina Leno-Shutiva)*

Joseph Leno *(collaborates with Vina Leno)*
(Acoma, active ?-1990+: polychrome jars, bowls)
PUBLICATIONS: Dillingham 1992:206-208.

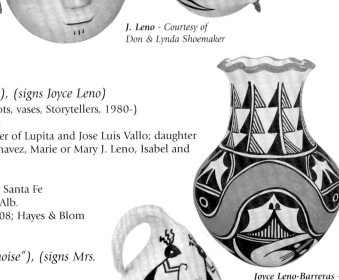

*J. Leno - Courtesy of
Don & Lynda Shoemaker*

Joyce Leno-Barreras *(Joyce Leno, Joyce Barreras), (signs Joyce Leno)*

(Acoma, active 1963-present: polychrome jars, bowls, seed pots, vases, Storytellers, 1980-)
BORN: October 17, 1952 or 1955; RESIDENCE: Cubero, NM
FAMILY: p. great-granddaughter of Eulilia Vallo; granddaughter of Lupita and Jose Luis Vallo; daughter of Thomas & Juana Leno; sister of Phyllis Leno, Rose Leno Chavez, Marie or Mary J. Leno, Isabel and Regina M. Leno Shutiva
EXHIBITIONS: 1985-present: Indian Market, Santa Fe
COLLECTIONS: John Blom; Dr. Gregory & Angie Yan Schaaf, Santa Fe
GALLERIES: Rio Grande Wholesale, Inc., Palms Trading Co., Alb.
PUBLICATIONS: Babcock 1986:136; Dillingham 1992:206-208; Hayes & Blom 1998; Congdon-Martin 1999; Berger & Schiffer 2000:125.

Juana Leno *(Juana Louis Vallo, Syo-ee-mee, "Turquoise"), (signs Mrs. Juana Leno, Acoma, NM or LENO, Acoma N.M.)*

(Acoma, active ca. 1937-2000: polychrome, Tularosa, Anasazi Revival, black-on-white jars, bowls, canteens, owls, duck pots, Nativities, Storytellers, 1976-)
LIFESPAN: March 4, 1917 at Acomita - 2000; RESIDENCE: Cubero, NM
FAMILY: p. granddaughter of Eulilia Vallo; daughter of Lupita and Jose Luis Vallo; wife of Thomas Leno; mother of Rose Leno Chavez, Phyllis, Marie or Mary J. Leno, Phyllis Leno, Isabel and Regina M. Leno-Shutiva and Joyce Leno-Barreras
TEACHER: Eulilia Vallo, her grandmother
AWARDS: Indian Market, Santa Fe; New Mexico State Fair, Albuquerque; Inter-tribal Indian Ceremonial, Gallup, NM
EXHIBITIONS: pre-1985-present, Indian Market, Santa Fe
COLLECTIONS: Heard Museum, Phoenix; Museum of Northern Arizona, Flagstaff;

*Joyce Leno-Barreras -
Andrews Pueblo Pottery &
Art Gallery, Albuquerque*

*Juana Leno -
Gloria Couch Collection
Corrales, NM*

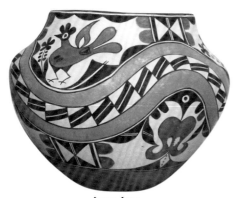

Juana Leno -
Bill & Jane Buchsbaum Collection, Santa Fe

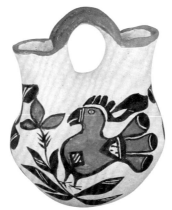

Juana Leno - Andrews Pueblo Pottery & Art Gallery

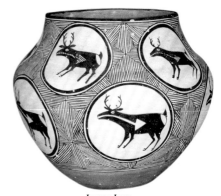

Juana Leno -
Andrea Fisher Fine Pottery, Santa Fe

Jane & Bill Buchsbaum, Angie Yan Schaaf, Santa Fe; Gloria Couch, Corrales, NM; Candace Collier, Houston, TX; Allan & Carol Hayes
VALUES: On December 2, 1998, a black-on-white effigy jar, (12" h.) sold for $2,587 at Sotheby's, lot #61.

On December 4, 1997, a black-on-white triple canteen (13 1/2" l.), signed Mrs. Juana Leno, Acoma N.M., sold for $920, at Sotheby's, #305.
GALLERIES: Andrea Fisher Fine Pottery, Santa Fe; Andrews Pueblo Pottery & Art Gallery, Albuquerque; Case Trading Post at the Wheelwright Museum of the American Indian, Santa Fe
PUBLICATIONS: *Arizona Highways* May 1974:14, 22; Tanner 1976:123; Jacka & Gill 1976:58; Harlow 1977; Dillingham 1977:84; Monthan 1979:43-45; Reano 1985:99; *Indian Market Magazine* 1985-2000; Babcock 1986:10, 55, 136-37; Trimble 1987:12+; Minge 1991:195; Dillingham 1992:206-208; Hayes & Blom 1998:25; Berger & Schiffer 2000:126.
PHOTOGRAPH: M. James Slack, staff photographer, Historic American Building Survey (WPA), 1934, in collection of John Beeder, Albuquerque

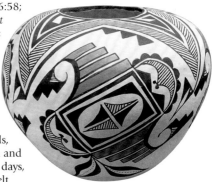

Juana Leno is best known for her black-on-white Tularosa and Anasazi Revival style of pottery. She also learned the traditional style from her grandmother, Eulilia Vallo and mother, Lupita Vallo. She made her pottery in the old village, because "it's so quiet and I can concentrate on my pottery and the designs."

To help perpetuate the reproduction and good health of domestic farm animals, Juana was observed by Doris Monthan "taking unfired animal figures to the church and placing them in a basket with wheat on the altar with the Nativity scene. After four days, the figures are taken home and buried in the corral." Juana explained that "they melt back into the earth from which they came." (Babcock 1986:10)

Juana Leno - Photograph by Tony Molina
Case Trading Post at the
Wheelwright Museum of the American Indian
Santa Fe

University of Arizona professor Barbara Babcock called Juana Leno, "one of Acoma's master potters who began as a child in the 1920s."

Juanita Leno

(Acoma, ca. 1940s-?: traditional polychrome ollas, large storage jars, bowls)
COLLECTIONS: Philbrook Museum of Art, Tulsa, OK, storage jar, ca. 1946

Marie Leno *(Mary J. Leno), (signs M. Leno Acoma)*

(Acoma, active ca. 1960s-?: polychrome fineline jars, bowls)
BORN: ca. 1940s
FAMILY: p. great-granddaughter of Eulilia Vallo; granddaughter of Lupita and Jose Luis Vallo; daughter of Thomas & Juana Leno; sister of Rose Leno Chavez, Phyllis Leno, Isabel and Regina Leno
PUBLICATIONS: Monthan 1979:43-45.

Miranda Leno

(Acoma, active ca. 1993-present: traditional polychrome jars, bowls)
BORN: March 16, 1960
FAMILY: daughter of Lloyd & Mrs. Aragon
TEACHER: Regina Shutiva, her sister-in-law
PUBLICATIONS: Berger & Schiffer 2000:126.

Marie Leno - Courtesy of Joe Zeller
River Trading Post, East Dundee, IL

Phyllis Leno *(Felipita Leno) (signs P. Leno)*

(Acoma, active ca. 1975-present: traditional polychrome jars, bowls, miniatures, animal figures, owls)
BORN: November 11, 1943
FAMILY: p. great-granddaughter of Eulilia Vallo; granddaughter of Lupita and Jose Luis Vallo; daughter of Thomas & Juana Leno; sister of Rose, Marie, Isabel and Regina Leno
TEACHER: Juana Leno, her mother
COLLECTIONS: Heard Museum, Phoenix; Allan & Carol Hayes
PUBLICATIONS: Monthan 1979:43-45; Berger & Schiffer 2000:125.

Regina Leno-Shutiva *(Jeannie Leno) (signs RLS, Acoma N.M.)*
(Acoma, active ca. 1967-present: traditional polychrome & black-on-white jars, bowls)
BORN: September 7, 1955
FAMILY: p. great-granddaughter of Eulilia Vallo; granddaughter of Lupita and Jose Luis Vallo; daughter of Thomas & Juana Leno; sister of Rose, Phyllis, Marie or Mary J. Leno, Joyce Leno-Barreras and Isabel Leno
TEACHER: Juana Leno, her mother
EXHIBITIONS: 1993-present: Indian Market, Santa Fe; 1994, Eight Northern Indian Pueblos Arts & Crafts Show
FAVORITE DESIGNS: repeated bands of geometric designs with red base
PUBLICATIONS: Monthan 1979:43-45; Dillingham 1992:206-208; Painter 1998:12; Berger & Schiffer 2000:126.

Rose Leno-Chavez *(Rose Leno Chavez)*
(Acoma, active ca. 1960s-?: traditional polychrome jars, bowls, figures, Storytellers (1982-))
BORN: November 18, 1943
FAMILY: p. great-granddaughter of Eulilia Vallo; granddaughter of Lupita and Jose Luis Vallo; daughter of Thomas & Juana Leno; sister of Phyllis, Marie (Mary J.), Isabel and Phyllis Leno, Regina Leno-Shutiva
EXHIBITIONS: 1977-97, Indian Market, Santa Fe
GALLERIES: The Indian Craft Shop, U.S. Department of Interior, Washington, D.C.
PUBLICATIONS: *SWAIA Quarterly* Fall 1977:15;Monthan 1979:43-45; *Indian Market Magazine* 1985-2000; Babcock 1986:136; Dillingham 1992:206-208; Capone-Drooker 1998:46, 138.

Vina Leno *(collaborates with Joseph Leno)*
(Acoma, active ?-1990+: polychrome jars, bowls)
PUBLICATIONS: Dillingham 1992:206-208.

Emily Lente
(Isleta, active ca. 1910s-?: traditional polychrome jars, bowls)
PUBLICATIONS: *El Palacio* Oct. 16, 1922 8(8):94; Harlow 1977.

Joe Lente
(Isleta, active ?: pottery painter)

Lule Lente
(Isleta, active ca. 1930s-?: traditional polychrome jars, bowls)
FAMILY: related to Maria Lente
COLLECTIONS: Southwest Museum, Los Angeles, 2 bowls, ca. 1941, #535-G-316, 535-G-318.
PUBLICATIONS: Batkin 1987:192
 Lule Lente continued an old technique of making pottery by the "paddle and anvil" technique, where the pottery was pounded into shape. This is in contrast with the more common coiling and scraping technique.

Maria Lente
(Isleta, active ca. 1920s-?: traditional polychrome jars, dough bowls)
FAMILY: related to Lule Lente
COLLECTIONS: Southwest Museum, Los Angeles, bowl, ca. 1931, #535-G-347.
PUBLICATIONS: Batkin 1987:192.
 Maria Lente was known for making dough bowls. She reportedly made some of the largest polychrome bowls at Isleta.

Mrs. Lente
(Isleta, active 1900s-40s: large ollas, jars, bowls)
 Mrs. Lente had daughters who were potters.

Julie Leon
(Acoma, active ?-1990+: polychrome jars, bowls)
PUBLICATIONS: Dillingham 1992:206-208.

June Leon
(Acoma, active ?-1990+: traditional polychrome jars, bowls)
COLLECTIONS: Candace Collier, Houston, TX
PUBLICATIONS: Dillingham 1992:206-208.

Philip Leon
(Acoma, active ?-1990+: polychrome jars, bowls)
PUBLICATIONS: Dillingham 1992:206-208.

S. Leon
(Laguna, active ?-present: fineline black-on-white jars, bowls)

Alvin Lewis, Jr.

(Acoma, active ?-present: polychrome jars, bowls)
FAMILY: m. great-grandson of Mary Histia; p. great-grandson of Lucy M. Lewis; m. grandson of Dolores Histia Sanchez; p. grandson of Ivan & Rita Lewis; son of Cindy Sanchez Lewis & Alvin Lewis, Sr.
PUBLICATIONS: Dillingham 1992:206-208.

 Alvin Lewis, Jr. is the descendant of two important pottery-making families. He is the great-grandson of Mary Histia and Lucy M. Lewis, both Acoma matriarchs. His grandparents were important potters: Dolores Histia Sanchez, as well as Ivan & Rita Lewis. Ivan was from Acoma, and Rita was from Cochiti.

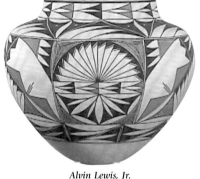

Alvin Lewis, Jr.

Andrew Haskaya Lewis, Jr.

(Acoma, active ca. 1982-present: traditional & non-traditional polychrome jars, bowls, drawings)
BORN: July 24, 1958
FAMILY: grandson of Lucy M. Lewis & Toribio H. Lewis; son of Andrew H. Lewis, Sr.
TEACHERS: Drew (Andrew H.) Lewis, Sr., his father and Lucy M. Lewis, his grandmother
AWARDS: 1988, 3rd; 1990, 3rd, Indian Market, Santa Fe
EXHIBITIONS: 1985-present: Indian Market, Santa Fe
GALLERIES: Rio Grande Wholesale, Inc., Palms Trading Co., Albuquerque
PUBLICATIONS: Dillingham 1992:206-208; Berger & Schiffer 2000:126.

Andrew H. Lewis, Sr. *(see Drew Lewis)*

Ann Lewis *(see Ann Lewis Hansen)*

Anne Lewis

(Acoma, active ca. 1980s-?: polychrome jars, bowls)
COLLECTIONS: John Blom

B. J. Lewis

(Acoma, active ca. 1990s-?: polychrome jars, bowls)
COLLECTIONS: John Blom

Bernard E. Lewis *(collaborates with Sharon Lewis)*

(Acoma, Yellow Corn Clan, active ca. 1980s-present: polychrome jars, bowls, canteens, figures)
BORN: December 23, 1957
FAMILY: grandson of Toribio & Dolores S. Sanchez; son of Kathleen & Edward Lewis; brother of Rebecca Lucario, Marilyn Lewis-Ray, Judy M. Lewis, Diane M. Lewis & Carolyn Lewis-Concho; husband of Sharon Lewis
AWARDS: 1998, 1st (2), 2nd; 2000, 1st, Canteens, 2nd, Figures, Indian Market, Santa Fe
EXHIBITIONS: 1994-present, Indian Market, Santa Fe; 1997-present, Eight Northern Indian Pueblos Arts & Crafts Show
PUBLICATIONS: Painter 1998:12.

Carmel Haskaya Lewis *(see Carmel Lewis Haskaya)*

Carmen Lewis *(collaborates with Emil Chino)*

(Acoma, active ?-present: polychrome jars, bowls)
ARCHIVES: Artist File, Heard Museum Library, Phoenix
PUBLICATIONS: Painter 1998:13.

Carolyn Lewis *(see Carolyn Lewis-Concho)*

Cindy Sanchez Lewis *(sometimes signs C.V.L.)*

(Acoma, active ca. 1940s-?: traditional polychrome jars, bowls, wedding vases)
BORN: ca. 1920s
FAMILY: m. granddaughter of Mary Histia; daughter of Dolores Histia Sanchez (2); wife of Alvin Lewis, Sr.; mother of Alvin Lewis, Jr.

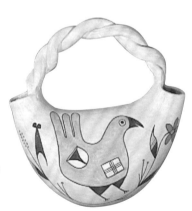

Cindy Lewis

Cynthia Lewis

(Acoma, active ?-1990+: polychrome jars, bowls)
PUBLICATIONS: Dillingham 1992:206-208.

Daisy R. Lewis

(Acoma, active ?-1990+: polychrome jars, bowls)
RESIDENCE: Acomita, NM
ARCHIVES: Artist File, Heard Museum Library, Phoenix
PUBLICATIONS: Dillingham 1992:206-208.

Delores Lewis (1), (Dolores)

(Acoma, active ca. 1920s-?: traditional polychrome jars, bowls)
BORN: ca. 1900
FAMILY: daughter of Lola Santiago; sister of Toribio Haskaya; sister-in-law of Lucy M. Lewis; great-aunt of Delores Lewis Garcia
PUBLICATIONS: Peterson 1985:42.

Delores Lewis may have been the namesake of Lucy Lewis' daughter, Delores Lewis Garcia. The younger Delores remembered her great-aunt: "Father had a sister named Dolores; she was a great potter. They used to make a lot, I mean a lot. . .I remember my aunt made a pot about three feet high and two feet wide, and they spread out a white manta [traditional dress] on the floor to carry the pot with. . ." (Peterson 1985:42)

Delores Lewis (2) (See Delores Lewis Garcia)

Diane Monica Lewis (Tsi-Ku-rai-tsa, Morning Dew), (signs D. Lewis)

(Acoma, Yellow Corn Clan, active ca. 1986-present: Mimbres Revival & traditional polychrome jars, bowls, seed pots, pitchers, canteens, miniatures)
BORN: May 26, 1959, Corcoran, CA; RESIDENCE: Acomita, NM
FAMILY: daughter of Edward & Kathleen Lewis; sister of Rebecca Lucario, Marilyn Lewis-Ray, Judy Lewis, Bernard Lewis & Carolyn Lewis-Concho
AWARDS: 1989, 2nd (2); 1991, 1st; 1992, 1st, 2nd, 3rd; 1993, 2nd; 1994, 2nd; 1996, 1st, 2nd, 3rd; 1998, 2nd, 3rd; 1999, 2nd, Indian Market, Santa Fe; Inter-tribal Indian Ceremonial, Gallup, NM; Heard Museum Show, Phoenix; Wheelwright Museum, Santa Fe; 1st, 2nd, 3rd, Eight Northern Indian Pueblos; 2000, 2nd, Canteens, Indian Market, Santa Fe
EXHIBITIONS: 1989-present, Indian Market, Santa Fe; 1995-present, Eight Northern Indian Pueblos Arts & Crafts Show
FAVORITE DESIGNS: Mimbres animals, lizards, bugs, fish, Kokopelli, rain, lightning, clouds
COLLECTIONS: John Blom; Gerald & Laurette Maisel, Tarzana, CA
GALLERIES: Rio Grande Wholesale, Inc., Palms Trading Co., Albuquerque
PUBLICATIONS: *The Messenger*, The Wheelwright Museum Spring 1987:3; Winter 1997:14; *American Indian Art Magazine* Summer 1990:91; Schiffer 1991d:52; Dillingham 1992:206-208; Hayes & Blom 1996:53-55; 1998:15, 53; Berger & Schiffer 2000:126.

Diane Lewis -
Courtesy of Jason Esquibel
Rio Grande Wholesale, Inc.

Drew Lewis (Andrew H. Lewis, Sr., War Paint)

(Acoma, Roadrunner Clan, active ca. 1980-present: Anasazi Revival black-on-white, traditional polychrome jars, bowls, pitchers, seed pots, canteens)
BORN: December 8, 1927; RESIDENCE: San Fidel, NM
FAMILY: son of Lucy M. Lewis and Toribio Haskaya Lewis; husband of Theresa Walking Eagle; father of Andrew H. Lewis, Jr.
AWARDS: 1984, 3rd, Indian Market, Santa Fe
EXHIBITIONS: 1984, Kerr Gallery, New York City; 1985-present, Indian Market, Santa Fe
COLLECTIONS: Allan & Carol Hayes, John Blom
GALLERIES: Kennedy Indian Arts, Bluff, UT; Rio Grande Wholesale, Inc., Albuquerque
PUBLICATIONS: *Indian Market Magazine* 1985-2000; Dillingham 1994:93; Hayes & Blom 1996:48-49; 1998:15, 22; Peterson 1997:10, 77; Berger & Schiffer 2000:126.

Edward Lewis (collaborates with Katherine Lewis)

(Acoma, ?-present: pottery)
FAMILY: husband of Katherine Lewis; father of Rebecca Lucario; Marilyn Lewis-Ray, Judy M. Lewis, Diane M. Lewis, Bernard Lewis & Carolyn Lewis Concho

Emma Lewis (See Emma Lewis Mitchell)

Drew Lewis -
Courtesy of John D. Kennedy and
Georgiana Kennedy Simpson
Kennedy Indian Arts

Gloria Ann Lewis (Gloria Hansen)

(Acoma, active, ca. 1980s-present: polychrome jars, bowls)
FAMILY: granddaughter of Lucy M. Lewis; daughter of Anne Hansen; sister of Andrew, Joseph, Ivan, Vincent Lewis Hansen, Anthony Hansen, Diana Lim Garry
EXHIBITIONS: 1985-96, Indian Market, Santa Fe
COLLECTIONS: John Blom
PUBLICATIONS: *Indian Market Magazine* 1985-1996.

Grace Lewis

(Acoma, active ?-1990+: polychrome jars, bowls)
PUBLICATIONS: Dillingham 1992:206-208.

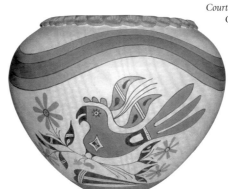

Drew Lewis -
Courtesy of Jason Esquibel
Rio Grande Wholesale, Inc.

Ivan H. Lewis *(collaborates sometimes with Rita Lewis)*

(Acoma/married into Cochiti, Roadrunner Clan, active ca. 1959-present: polychrome jars, dough bowls, Storytellers, Nativities, figures, mermaids)
BORN: ca. August 24, 1919; RESIDENCE: Cochiti Pueblo, NM
FAMILY: m. grandson of Martin Ortiz & Lola Santiago; son of Toribio Haskaya & Lucy M. Lewis; brother of Margaret Lewis Lim, Ann Lewis Hansen, Andrew Lewis, Emma Lewis Mitchell, Mary Lewis Garcia, Delores Lewis Garcia, Cecilia Marie Lewis & Carmel Lewis Haskaya; husband of Rita Banada Lewis; father of Ronald, Alvin, James, Elmer & Patricia Lewis; grandfather of Kevin Lewis & Vanessa Lewis Sanchez
TEACHERS: Lucy M. Lewis, his mother, and Rita Banada Lewis (his wife)
FAVORITE DESIGNS: drummers, deer, sheep, pigs, mermaids
AWARDS: 1984, 2nd 3rd; 1st; 1990, 1st, 3rd, Indian Market, Santa Fe
EXHIBITIONS: pre-1985-1997, Indian Market, Santa Fe
COLLECTIONS: Rick Dillingham Collection, School of American Research, Santa Fe; John Blom
GALLERIES: Adobe Gallery, Albuquerque
PUBLICATIONS: *Indian Market Magazine* 1985, 1988, 89; Babcock 1986; Coe 1986:203; Trimble 1987:57-60; Dillingham 1994:92, 96-97; Reano 1995:99-100; Hayes & Blom 1996; 1998:33, 55; Peaster 1997:24, 30-31; Peterson 1997:77; Congdon-Martin 1999:18-19; Batkin 1999.

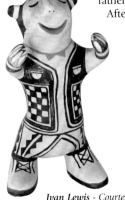

Ivan Lewis is the son of the famous Acoma pottery, Lucy M. Lewis. He never made Acoma style pottery, but rather practiced in the Cochiti tradition of his wife, Rita. They were married in 1944, while Ivan was in the service. After his honorable discharge in 1946, he returned to live with his wife at Cochiti.

Ivan and Rita did not begin to make pottery until 1959, after being encouraged by Rita's mother. He was inactive as a potter during the 12 years that he worked on the construction of Cochiti Dam. Finally, around 1977, Ivan & Rita became active potters. Ivan specialized in figures, especially cowboys and mermaids.

Ivan credits the late author and potter, Rick Dillingham, with commissioning him to make his first mermaid. However, Ivan tells a different story tongue-in-cheek: "I used to talk to the mermaids at Cochiti Lake. They would come out around midnight. I'm the only one who knows where they are." (Dillingham 1994:96)

Ivan Lewis - Courtesy of Don & Lynda Shoemaker

Joyce Ortiz Lewis - Andrews Pueblo Pottery & Art Gallery, Albuquerque

Jessie Lewis

(Acoma, active ?-1976+: traditional polychrome jars, bowls)
AWARDS: 1976, 1st, Indian Market, Santa Fe
PUBLICATIONS: *SWAIA Quarterly* Fall 1976:12; Minge 1991:195.

Joyce Ortiz Lewis *(Joyce Ortiz), (sometimes signs J. Ortiz)*

(Cochiti, Oak Clan, active ca. 1970s-present: polychrome jars, bowls, figures: mermaids, body builders, hippies, Nativities, miniatures)
BORN: ca. 1954
FAMILY: daughter of Seferina & Guadalupe Ortiz; sister of Mary Janice Ortiz, Inez Ortiz, Virgil Ortiz, Leon Ortiz & Angie Ortiz; mother of Leslie, Josy, Jamie & Joshua Lewis
EXHIBITIONS: ?-present, Indian Market, Santa Fe; 1999, "Ortiz Family," Robert Nichols Gallery, Santa Fe; 1999, "Clay People," Wheelwright Museum, Santa Fe;
COLLECTIONS: Dr. Gregory & Angie Yan Schaaf
GALLERIES: Robert Nichols Gallery, Santa Fe; Andrews Pueblo Pottery & Art Gallery, Albuquerque
PUBLICATIONS: Dillingham 1994:120; Native Peoples Fall 1997 11(1):35; *American Indian Art Magazine* Summer 1999 24(3):20.

Joyce Ortiz Lewis comes from a prominent pottery-making family who specialize in figures. She recalled, "I was probably in high school when I made my first piece. . .a little mermaid. . .I gave it to my godfather for Father's Day." Joyce is known for her great diversity of subjects and the fine quality of her traditional process. She has a wonderful sense of humor.

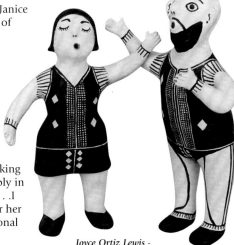

Joyce Ortiz Lewis - Andrews Pueblo Pottery & Art Gallery, Albuquerque

Judy Lewis *(1)*

(Acoma, active ca. 1950-?: traditional polychrome jars, bowls)
BORN: ca. 1920s
FAMILY: daughter of Toribio & Dolores S. Sanchez; sister of Ethel Shields & Katherine Lewis

Judy M. Lewis *(2)*

Judy Lewis - Courtesy of Jason Esquibel
Rio Grande Wholesale, Inc.

(Acoma, Yellow Corn Clan, active ca. 1986-present: polychrome Storytellers, seed pots, jars, bowls, wedding vases & canteens with twist handles)
BORN: ca. 1966; RESIDENCE: Albuquerque, NM
FAMILY: granddaughter of Toribio & Dolores S. Sanchez; daughter of Edward & Kathleen or Katherine Sanchez Lewis; sister of Marilyn Lewis-Ray, Diane M. Lewis, Sharon Lewis, & Carolyn Lewis-Concho
AWARDS: 1991, 1st; 1992, 2nd, Indian Market, Santa Fe; Inter-tribal Indian Ceremonial, Gallup; Eight Northern Indian Pueblos Arts & Crafts Show
EXHIBITIONS: 1994-present, Indian Market, Santa Fe; 1996-present, Eight Northern Indian Pueblos Arts & Crafts Show
FAVORITE DESIGNS: parrots, flowering plants, clouds
GALLERIES: The Indian Craft Shop, U.S. Department of Interior, Washington, D.C.; Arlene's Gallery, Tombstone, AZ; Hoel's Indian Shop, Oak Creek Canyon, AZ; Native American Collections, Denver, CO; Bien Mur; Rio Grande Wholesale, Inc., Albuquerque
PUBLICATIONS: *Indian Market Magazine* 1994-2000; Hayes & Blom 1996:53-55; 1998:35; *The Messenger*, Wheelwright Museum Winter 1997:14; Berger & Schiffer 2000:127.

Judy Lewis - Courtesy of
Hoel's Indian Shop,
Oak Creek Canyon, AZ

Judy Lewis -
Photograph by Bill Bonebrake
Courtesy of Jill Giller
Native American Collections, CO

Katherine Lewis *(Kathleen Sanchez Lewis, Kathy),*
(signs K.L. or K. Lewis Acoma N.M.), (collaborates with Edward Lewis)

(Acoma, Yellow Corn Clan, active ca. 1982-present: traditional and ceramic polychrome & black-on-red jars, bowls, some effigy pots, Storytellers, miniatures)
BORN: September 26, 1932; RESIDENCE: Acomita, NM
FAMILY: m. granddaughter of Josephita Sandoval & Joe A. Sandoval; daughter of Toribio & Dolores S. Sanchez; wife of Edward Lewis; mother of Rebecca Lucario; Marilyn Lewis-Ray, Judy M. Lewis, Diane M. Lewis, Bernard Lewis & Carolyn Lewis Concho
EXHIBITIONS: 1999-present, Eight Northern Indian Pueblos Arts & Crafts Show
FAVORITE DESIGNS: bears, clouds
GALLERIES: Kennedy Indian Arts, Bluff, UT; Rio Grande Wholesale, Inc., Palms Trading Co., Albuquerque
PUBLICATIONS: Schiffer 1991d:50; Dillingham 1992:206-208; Congdon-Martin 1999:52; Berger & Schiffer 2000:127.

On May 1, 2001, we met Katherine and her sister, Ethel Shields. They were showing their pottery at the San Felipe Pueblo Feast Day. Katherine displayed both traditional pottery jars and bowls, as well as an effigy pot with figures on top.

Katherine Lewis -
Courtesy of John D. Kennedy and
Georgiana Kennedy Simpson
Kennedy Indian Arts

Kevin Lewis *(signs Morning Star)*

(Cochiti/Acoma, active ca. 1989-present: polychrome jars, bowls, Storytellers, figures, big horn sheep)
FAMILY: great-grandson of Lucy M. Lewis & Toribio Haskaya; grandson of Ivan & Rita Lewis; son of Patricia Lewis; brother of Vanessa Lewis Sanchez
AWARDS: 1989, 1st, 3rd; 1900, 1st, Figures (ages 12 & under), Indian Market, Santa Fe; 1989-91, Student Artist, Heard Museum, Phoenix
PUBLICATIONS: *Southwest Art* Nov. 1990:25; Dillingham 1994:92; Peaster 1997:30.

Leslie Lewis

(Cochiti, active ca. 1990s-present: polychrome jars, bowls, figures)
FAMILY: m. granddaughter of Seferina & Guadalupe Ortiz; daughter of Joyce Lewis; sister of Josy & Jamie Lewis
PUBLICATIONS: Dillingham 1994:120.

Lorraine Gala Lewis

(Laguna/Hopi/Taos, active 1990s-present: pottery, sculpture, beadwork)
EXHIBITIONS: 1999-present, Indian Market, Santa Fe; 1996-present, Eight Northern Indian Pueblos Arts & Crafts Show
PUBLICATIONS: Schaaf 1999:63.

Lucy Martin Lewis *(Lucy M. Lewis)*

(Acoma, active ca. 1920-90: Mimbres & Anasazi Revival black-on-white & traditional poly-chrome ollas, jars, bowls, vases, pitchers, canteens, figures: turtles, lizards, snakes)

LIFESPAN: (ca. 1898 to 1900- March 12, 1992)

FAMILY: daughter of Lola Santiago & Martin Ortiz; niece of Helice Vallo; sister of Joseph Ortiz & Albert Ortiz; wife of Toribio Lewis (Luis/Haskaya); mother of Ivan Lewis, Margaret Lewis Lim; Ann Lewis Hansen, Andrew Lewis, Emma Lewis Mitchell, Mary Lewis Garcia, Dolores Lewis Garcia, Cecilia Marie Lewis Lucero (Belle), Carmel Lewis Haskaya; grandmother to 45 grandchildren, 46 great-grandchildren and 4 great-great grandchildren (as of 1992)

AWARDS:

1950	1st, Certificate of Merit, Inter-tribal Indian Ceremonial, Gallup
1956	Maria Martinez Special Award, Indian Market, Santa Fe
1958	1st, American Indian Art Exhibition, Los Angeles, CA
1960	1st, Indian Market, Santa Fe; 1st, Inter-tribal Indian Ceremonial, Gallup, NM
1961	1st, Indian Market, Santa Fe; Research Prize for Overall Excellence, Indian Arts Fund, School of American Research, Santa Fe
1967	1st (5), 2nd (5), 3rd (2), Inter-tribal Indian Ceremonial, Gallup
1972	1st, Scottsdale National Indian Arts Council, Scottsdale, AZ
1977	Lucy was honored at the White House, Washington, D.C.
1983	Governor of New Mexico Award for Outstanding Personal Contribution to the Art of the State, Santa Fe; Woman of Achievement Award, Northwood Institute, Houston, TX

(Left to right): Emma Lewis Mitchell, Lucy M. Lewis & Delores Lewis Garcia - Courtesy of John D. Kennedy and Georgiana Kennedy Simpson Kennedy Indian Arts

EXHIBITIONS:

1950-?	Inter-tribal Indian Ceremonial, Gallup
1960-91	Indian Market, Santa Fe
1972-?	Scottsdale National Indian Arts Council, Scottsdale, AZ
1974	"Seven Families in Pueblo Pottery, Maxwell Museum of Anthropology, University of New Mexico, Albuquerque
1975	"A Tribute to Lucy M. Lewis, Acoma Potter," Museum of North Orange County, Fullerton, CA
1979	"One Space: Three Visions," Albuquerque Museum, Albuquerque
1980	Master Pueblo Potters, ACA Gallery, New York
1982	Salute to Acoma Pottery: Lucy Lewis and Marie Chino,"Wheelwright Museum, Santa Fe; Traveling Exhibit to the Peoples' Republic of China, Organized by the Driscoll Gallery, Denver, CO
1983	Governor's Award, New Mexico; Northwood Institute, Houston, TX
1987	Honolulu Academy, Hawaii
1988	Montclair Museum, New Jersey

DEMONSTRATIONS: Idyllwild Arts, Idyllwild, California

COLLECTIONS: Smithsonian Institution, Washington, D.C.; Museum of the American Indian, Washington, D.C., black-on-white jar, #24.7772; Princeton University Art Museum, Princeton, NJ; Southwest Museum, Los Angeles; Driscoll Gallery, Denver, CO; Philbrook Museum of Art, Tulsa, OK, olla, jar, snake figure, ca. 1957; Idyllwild School of Music and Arts, Idyllwild, CA; Maxwell Museum of Anthropology, Albuquerque; Museum of New Mexico, Santa Fe; Museum of North Orange County, Fullerton, CA: Northwood Institute, Houston, TX; Wheelwright Museum, Santa Fe; Ron & Doris Smithee, Harrah, OK; Allan & Carol Hayes, John Blom

FAVORITE DESIGNS: rain, clouds, birds, parrots, deer with heartlines, turtles, snakes, turkeys, lizards

VALUES: On August 12, 2000, a black-on-white jar, signed Lucy Lewis (5 x 7"), sold for $1,100, at Allard Auctions, #971.

On May 17, 2000, a black-on-white fineline olla, signed Lucy Lewis 1969, (6 x 8.25"), sold for $5,700, at Sotheby's, #586.

Lucy M. Lewis - Courtesy of Andrea Fisher Fine Pottery, Santa Fe

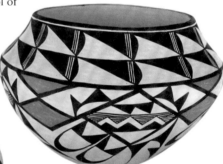

Lucy M. Lewis - Courtesy of King Galleries of Scottsdale, AZ

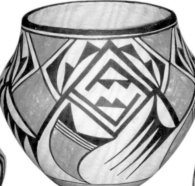

Lucy M. Lewis - Courtesy of Andrea Fisher Fine Pottery, Santa Fe

Lucy M. Lewis - Dave & Lori Kenney Collection

Lucy M. Lewis - Courtesy of Andrea Fisher Fine Pottery, Santa Fe

On February 4, 2000, a black-on-white jar signed Lucy M. Lewis (5 x 7"), sold for $1,430 at R. G. Munn, #660.

On February 4, 2000, a black-on-white jar signed Lucy M. Lewis (4 x 6"), sold for $1,980 at R. G. Munn, #1255.

On Dec. 11, 1999, a black-on-white bowl (4 x 4"), signed Lucy Lewis, est. $900-1,200, at National Indian Center's Auction, #394.

On October 15, 1999, a black-on-white jar signed Lucy Lewis (5 x 5.5"), sold for $1,210 at R. G. Munn, #505.

On October 15, 1999, a black-on-white jar signed Lucy Lewis (5.5 x 6.5"), sold for $3,190 at R. G. Munn, #1219.

On December 2, 1998, a black-on-white jar, signed Lucy M. Lewis (9" h.) sold for $3,162 at Sotheby's, lot #60.

On November 23, 1998, a polychrome jar, deer with heartline design (5" dia.) sold for $2,875 at Butterfield & Butterfield, #3108.

On October 16, 1998, a black-on-white jar signed Lucy Lewis (6 x 6.5"), sold for $1,705 at R. G. Munn, #753.

On October 16, 1998, a black-on-white jar signed Lucy Lewis (7 x 9.5"), restored, sold for $1,210 at R. G. Munn, #980.

On October 16, 1998, a black-on-white pitcher signed Lucy Lewis (9 x 9"), sold for $1,210 at R. G. Munn, #1180.

On October 16, 1998, a white corrugated vase signed Lucy Lewis (11 x 9"), sold for $1,210 at R. G. Munn, #1181.

On June 5, 1998, a black-on-white jar signed Lucy Lewis (7 x 7"), sold for $6,875 at R. G. Munn, #810.

On Feb. 6, 1998, a black-on-white jar signed Lucy Lewis (9 x 7"), some pitting and scratches, sold for $1,768 at R. G. Munn, #781.

On May 19, 1998, a white corrugated jar (6" h.), signed Lucy M. Lewis, sold for $1,495, at Sotheby's, #430.

On December 8, 1994, a black-on-white seed jar, signed Lucy M. Lewis, 1962, (5 x 7.5"), sold for $1,380, at Butterfield & Butterfield, #4800.

On Dec. 8, 1994, a black-on-white jar, signed Lucy M. Lewis, (5 x 6.5"), sold for $1,265, at Butterfield & Butterfield, #4801.

On Dec. 7, 1993, a black-on-white jar, signed Lucy M. Lewis, 1959, (5 x 8.25"), sold for $2,300, at Butterfield & Butterfield, #246.

On December 7, 1993, a black-on-white jar, signed Lucy M. Lewis, 1960, (5.75 x 8.75"), sold for $2,587, at Butterfield & Butterfield, #384.

On September 25, 1990, a black-on-black vase (7.75 dia.) sold for $2,200 at Sotheby's, #443.

On September 25, 1990, a polychrome jar, deer with heartline design (5" dia.) sold for $1,870 at Sotheby's, #444.

On No. 38, 1989, a polychrome jar, Anasazi Revival, interlocking fret design (7.75" dia.) sold for $1,980 at Sotheby's, #330.

On May 22, 1989, a polychrome jar, deer with heartline design (5.75" dia.) sold for $715 at Sotheby's, #183.

GALLERIES: Adobe Gallery, Albuquerque; Andrea Fisher Fine Pottery, Steve Elmore, Richard M. Howard, Santa Fe and many more

PUBLICATIONS: *SWAIA Quarterly* Summer 1966:5-8; Fall 1972:6; Fall 1974:13; Fall 1975:10; Fall 1982:11; Tanner 1968, 1975; Barsook, et al. 1974; *Arizona Highways* May 1974:40; Collins 1975; Manley 1975; Tanner 1976:122; Jacka 1976; Dillingham 1977:50, 84; Harlow 1977; Toulouse 1977:80; Ortiz, ed., 1979; *American Indian Art Magazine* Summer 1979:21; Summer 1984:27; Spring 1985:65; Summer 1985:14; Autumn 1985:65; Spring 1987:9; Winter 1987:139; Spring 1989:29; Winter 1995:34; Winter 1997:104; Winter 1998:68; Autumn 1999:18; Dittert & Plog 1980; Peterson 1980; Chauvenet 1983; Peterson 1984; 1997; Barry 1984:89, 91-92; Dedera 1985:40; Babcock 1986; *Indian Market Magazine* 1985-99; Trimble 1987:599, 72-23; 79; Eaton 1990:23; Minge 1991:195; Dillingham 1992:206-208; 1996:94-99; Reano 1995:100; Mercer 1995:9; *The Messenger*, Wheelwright Museum Spring 1995:9; Hayes & Blom 1996:48-49;1998:53-55; *Indian Artist* Summer 1996:73; Spring 1997:18; Winter 1998:47; Hill & Hill, eds. 1997:208-09; Peaster 1997:9, 10, 157; *Indian Trader* May 1997Anderson, et al. 1999:8, 14; *Native Peoples* Nov. 2000:76.

Lucy Lewis is perhaps the most famous potter in the history of Acoma Pueblo. She probably would have been the first to give others more credit, including Marie Z. Chino, Jessie & Sarah Garcia, Dorothy Torivio and many more. Together, these artists revived ancient Pueblo pottery styles, most notably Mimbres, Tularosa and Anasazi black-on-white. Collectively, their pottery is called the "Revival Style." Lucy is most noted for her fineline hatched designs.

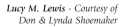

Lucy was born ca. 1898-1900. She didn't know her birthday, so she chose November 2nd as her day to celebrate. She is the daughter of Lola Santiago and Martin Ortiz, and the sister of Joseph and Albert. They grew up in the village of Acoma, and lived within the ceremonial cycles of the Pueblo.

Lucy acknowledged her Aunt Helice Vallo as a strong influence on her development as a potter. Lucy learned by watching Aunt Helice make pots. Helice was known for making large traditional ollas and storage vessels. Lucy remembered when she was about five or six, riding with Aunt Helice in a wagon up to the top of the mesa.

When Lucy was between 17 and 19, she married Toribio Lewis. Their first son, Ivan Lewis, was born in 1919. Eight more children followed: Margaret Lewis Lim; Ann Lewis Hansen, Andrew Lewis; Emma Lewis Mitchell, Mary Lewis Garcia, Dolores Lewis Garcia, Cecilia Marie Lewis Lucero (Belle), Carmel Lewis Haskaya. In total there were two sons and seven daughters.

Lucy M. Lewis - Courtesy of Don & Lynda Shoemaker

In 1928, the Indian Arts Fund in Santa Fe purchased their first Lucy Lewis pot. The polychrome bowl featured four orange and black scroll motifs of feathers in a spiral. Although not signed, the bowls later was identified by Lucy to be one of hers. (IAF #1120)

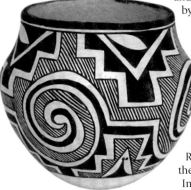

Up until the 1940s, Lucy did not sign her name on her pots, nor did any of the other Acoma potters. Lucy did paint on the bottom of some of her pots, "Acoma, N. Mex." Or "Sky City, N. Mex."

In 1950, Lucy decided to be the first Acoma potter to sign her name on the bottom of her pots. Lucy was honored with an "Award of Merit" by Inter-tribal Indian Ceremonial in Gallup, NM, and this may have encouraged her decision. The award attracted the attention of a long line of pottery collectors who began to search out Lucy to buy her pots and figures.

During the 1950s, Lucy produced not only fineline pottery jars and bowls, but also an extensive line of pottery animal figures. Her most popular included: owls, chickens, Roadrunners, turtles, lizards, snakes and many more. Collectors loved them and acquired them with a passion.

In 1958, Lucy was honored at Indian Market, winning the Outstanding Exhibit Award. Laura Gilpin, chair of the Indian Arts Fund, soon introduced Lucy to Museum of New Mexico Director Kenneth Chapman. He introduced her to designs of pottery from Mimbres, Anasazi, Tularosa and

Lucy M. Lewis - Courtesy of King Galleries of Scottsdale, AZ

other ancient cultural styles. In 1959, Lucy donated four pots to the Indian Arts Fund. One Tularosa Revival jar featured four hatched spirals with an orange based. A second was a small water jar with birds and flowers beneath a double rainbow band. The third was a 14″ shallow bowls with terraced clouds. The final pot was a seed jar with an Anasazi lightning design similar to those found at Chaco Canyon. Lucy later borrowed designs from Zuni, including the deer with a heartline.

Lucy continued to make friends with a growing number of collectors, dealers and museums. She won many awards at Indian Market, Inter-tribal Indian Ceremony and other shows. She also demonstrated pottery making for 19 years at Idyllwild School of Music and the Arts, in Southern California. Lucy's fame was spread even further with the publication of a monograph, a large hardback book with color illustrations, by Susan Peterson, *Lucy Lewis: American Indian Potter* (1984). The book was published and printed in Japan, expanding Lucy's fame in Asia. She gained respect worldwide.

Lupe Lewis

(Acoma, active ?-1975+: polychrome jars, bowls)
FAMILY: sister of Lucy M. Lewis and Dolores Lewis
PUBLICATIONS: Peterson 1985:42; Minge 1991:195.

M. Lewis

(Acoma, active ?-present: polychrome storytellers)
GALLERIES: Rio Grande Wholesale, Inc., Palms Trading Co., Albuquerque
PUBLICATIONS: Berger & Schiffer 2000:87, 127.

Marie Lewis *(sometimes signs M. Lewis)*

(Cochiti, active ?-present: polychrome Storytellers)
GALLERIES: Andrews Pueblo Pottery & Art Gallery, Albuquerque
PUBLICATIONS: Congdon-Martin 1999:20.

Mary Lewis *(1)*

(Acoma, active ?-present: polychrome jars, bowls, pitchers)
STUDENTS: JoAnne G. Gallegos
COLLECTIONS: John Blom
GALLERIES: Rio Grande Wholesale, Inc., Palms Trading Co., Albuquerque
PUBLICATIONS: Hayes & Blom 1998:15; Berger & Schiffer 2000:117.

Mary Lewis *(2)*

(Cochiti, active ca. 1980s-present: polychrome jars, bowls, Storytellers)
FAMILY: wife of Elmer Lewis; daughter-in-law of Ivan Lewis & Rita Banada Lewis
PUBLICATIONS: Babcock 1986:45, 129; *The Messenger*, Wheelwright Museum Summer 1990:15; Autumn 1990:7; Peaster 1997:30.

Patricia Lewis

(Cochiti/Acoma, active ca. 1980s-present: polychrome jars, bowls, Storytellers)
FAMILY: daughter of Ivan Lewis (Acoma) & Rita Banada Lewis (Cochiti); sister of Ronald, Alvin, James & Elmer Lewis; mother of Kevin & Vanessa Lewis Sanchez
PUBLICATIONS: Babcock 1986:45, 129; Dillingham 1994:92; Peaster 1997:30.

Rita Lewis *(Rita Banada), (collaborated sometimes with Ivan Lewis)*

(Cochiti, active ca. 1940s-91: polychrome jars, bowls, Storytellers, figures, Nativities)
LIFESPAN: ca. January 7, 1920 - 1991
FAMILY: daughter of Ascencion Banada; wife of Ivan Lewis (Acoma); mother of Patricia, Ronald & N. P. Elmer Lewis; grandmother of Kevin Lewis & Vanessa Lewis Sanchez
AWARDS: 1978, 3rd; 1979, 2nd; 1980, 1st (2), 2nd (2); 1988, John R. Bott Award for Best Cochiti Storyteller; 1990, 1st, 2nd (2), Indian Market, Santa Fe
EXHIBITIONS: 1979, "One Space: Three Visions," Albuquerque Museum, Albuquerque; pre-1979-91, Indian Market, Santa Fe
COLLECTIONS: Albuquerque Museum, Albuquerque, Storyteller, ca. 1978
FAVORITE DESIGNS: drummers, deer, sheep, mermaids
GALLERIES: Adobe Gallery, Albuquerque

Rita Lewis -
Don & Lynda Shoemaker Collection, Santa Fe

PUBLICATIONS: *American Indian Art Magazine* Spring 1983 8(2):37; *Indian Market Magazine* 1985, 1988, 1989; Babcock 1986:42, 45-48, 129; Trimble 1987:57-60; Dillingham 1994:92, 96; Reano 1995:99-100; Peaster 1997:30; Peterson 1997:77; Congdon-Martin 1999:18-19.

Rita Lewis is the daughter of noted potter Ascencion Banada. Rita married Ivan Lewis, the son of the famous Acoma potter, Lucy M. Lewis. She and Ivan sometimes worked as a husband-wife pottery-making team.

In 1973, Rita began making Storytellers. She also made figures of deer and other animals.

Ronald Lewis *(collaborates with Tomasita Lewis)*

(Cochiti/Acoma, active ca. 1990s-present: polychrome jars, bowls, Storytellers)
FAMILY: son of Ivan Lewis & Rita Banada Lewis; brother of Alvin, James, Elmer & Patricia Lewis; husband of Tomasita Lewis
PUBLICATIONS: Dillingham 1994:92; Peaster 1997:30.

Sharon Lewis *(signs S. Lewis), (collaborates with Bernard E. Lewis)*

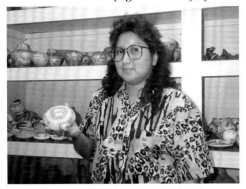

Sharon Lewis - Courtesy of John D. Kennedy and Georgiana Kennedy Simpson, Kennedy Indian Arts

(Acoma, Red Corn Clan, active ca. 1985-present: Mimbres Revival & traditional polychrome & black-on-white jars, bowls, seed pots, bird figures, canteens)
BORN: August 19, 1959, Los Angeles; RESIDENCE: Acoma Pueblo, NM
FAMILY: daughter of Elizabeth Garcia; wife of Bernard E. Lewis
AWARDS: 1988, 2nd; 1989, 1st; 1991, 3rd (2); 1992, 3rd; 1993, 3rd; 1994, 2nd, 3rd, Indian Market, Santa Fe; 1995, 1st, Red Earth Festival, Oklahoma City; 1996, 2nd; 1999,1st, 2nd, 3rd, Indian Market, Santa Fe; New Mexico State Fair, Albuquerque; Eight Northern Indian Pueblos Arts & Crafts Show
EXHIBITIONS: 1989-present, Indian Market, Santa Fe; 1995-present, Eight Northern Indian Pueblos Arts & Crafts
FAVORITE DESIGNS: Mimbres animals, quail, human figures holding hands, lizards, Kokopelli, fineline rain
GALLERIES: The Indian Craft Shop, U.S. Department of Interior, Washington, D.C.; Andrea Fisher Fine Pottery, Santa Fe; Native American Collections, Denver, CO
PUBLICATIONS: *Indian Market Magazine* 1989-2000; *American Indian Art Magazine* Summer 1990:74; Spring 1992:91; Dillingham 1992:206-208; Hayes & Blom 1996:54-55; 1998:47; Painter 1998:13; Berger & Schiffer 2000:127.

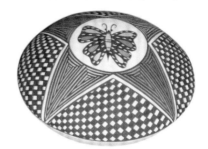

Sharon & Bernard Lewis - Photograph by Bill Bonebrake Courtesy of Jill Giller Native American Collections, Denver, CO

Suwimi Marie Lewis
(Acoma, Roadrunner Clan, active ca. 1980s-present: pottery)
BORN: September 24, 1981
FAMILY: great-granddaughter of Lucy M. Lewis; granddaughter of Anne Lewis Hanson; daughter of Gloria & Greg Lewis; sister of Dyaami Lewis
AWARDS: 1992, 1st (ages 12 & under); 1998, Indian Market, Santa Fe
EXHIBITIONS: 1991-present, Indian Market, Santa Fe

Tomasita Lewis
(Cochiti, active ca. 1990s-present: polychrome jars, bowls, Storytellers)
FAMILY: wife of Ronald Lewis; daughter-in-law of Ivan Lewis & Rita Banada Lewis
PUBLICATIONS: Peaster 1997:30.

Tommie Lewis *(signs with hallmark of Hummingbird)*
(Cochiti, active ca. 1987-present: polychrome Storytellers)
BORN: September 11, 1945
PUBLICATIONS: Berger & Schiffer 2000:127.

Vanessa Lewis *(see Vanessa Lewis Sanchez)*

Mrs. Liha *(see Mrs. Lahi)*

Sharon Lewis - Courtesy of Andrea Fisher Fine Pottery, Santa Fe

Emma Liptow
(Acoma, active ?-1990+: polychrome jars, bowls)
PUBLICATIONS: Dillingham 1992:206-208.

Harold Littlebird
(Laguna/Santo Domingo, Roadrunner Clan, active ca. 1960s-present: Mimbres Revival, Contemporary stoneware jars, bowls, vases, plates, canteens, shields, tiles, painting, drawing in ink and pencil, poetry, storytelling, singer)
BORN: May 28, 1951; RESIDENCE: Peralta, NM
FAMILY: son of Andrea Sarracino (Laguna) & Tony L. Bird (Santo Domingo); brother of Larry Littlebird, Charlie Bird & Gail Bird; father of Mateo & Maya
EDUCATION: Institute of American Indian Art, Santa Fe, 1966-69
TEACHERS: Ralph Pardington
AWARDS:

1969	1st, 3rd, Scottsdale National, Scottsdale, AZ; 2nd, Center for American Indian Art, Washington, D.C.
1970	Most Creative Design, 1st, "Jack's Bean Pot," Indian Market, Santa Fe; 1st, New Mexico Craftsman Exhibit, Albuquerque, NM
1971	Stoneware, Indian Market, Santa Fe
1975	1st, 2nd, Indian Market, Santa Fe; Popovi Da Memorial Award, 1st, Scottsdale National, Scottsdale, AZ
1976	1st, 2nd, Indian Market, Santa Fe
1977	Museum of New Mexico Purchase Award
1978	3rd, Indian Market, Santa Fe
1979	2nd, 3rd, Indian Market, Santa Fe

Harold Littlebird - Photograph by Angie Yan Schaaf

1980	Craftsman Fellowship, National Endowment for the Arts Most Creative New Design, Best of Division, 1st (2), 2nd, Indian Market
1981	Heard Museum Purchase Award, Phoenix, AZ; Millicent Rogers Museum Purchase Award, Taos, NM; 1st, 2nd, Indian Market, Santa Fe
1984	1st, 2nd, stoneware, Indian Market, Santa Fe
1988	2nd, non-traditional jars, 3rd, stoneware, Indian Market, Santa Fe
1993	Best of Division, 1st, 2nd, 3rd, stoneware, Indian Market, Santa Fe Best of Division, Heard Museum Show, Phoenix
1994	1st, 2nd, stoneware, Indian Market, Santa Fe
1995	2nd, 3rd, Indian Market, Santa Fe
1996	2nd, Eiteljorg Museum Show, Indianapolis, IN; 2nd, Jemez Red Rocks Indian Art Show, Jemez, NM; H.M., Heard Museum Show
1997	Best in Class, Phoenix Indian Center Awards, Phoenix; Best of Division, Heard Museum Show, Phoenix, AZ; Best of Painting, Collectors Choice Premier Indian Art Event, Scottsdale, AZ
1998	2nd, 3rd , stoneware, Indian Market, Santa Fe; Best of Division, Rover of Hope Indian Art Exhibition, Albuquerque; 1st, Indian Art Northwest, Portland, OR, Merit Award, Rezart, Scottsdale, AZ
2000	1st, 2nd, stoneware, Indian Market, Santa Fe
2001	1st, 2nd, 3rd, Indian Market, Santa Fe

Harold Littlebird -
2001, 1st Prize, Indian Market
Courtesy of the artist

EXHIBITIONS: 1969-76, Scottsdale National, Scottsdale, AZ; 1969-present, Indian Market, Santa Fe; "Southwest Craftsmen," Museum of International Folk Art, Santa Fe; Center for American Indian Art, Washington, D.C.; 1972, Eight Northern Indian Pueblos Arts & Crafts Show; 1979, "One Space: Three Visions," Albuquerque Museum, Albuquerque; 1981, "Indian Art of the 1980s," Native American Center for the Living Arts, Niagara Falls, NY
COLLECTIONS: Heard Museum, Phoenix; Museum of New Mexico, Santa Fe; School of American Research, Santa Fe
FAVORITE DESIGNS: Mimbres & Anasazi rock art symbols, shields, deer, human figures, hunters with bows & arrows, abstract
PUBLICATIONS: *SWAIA Quarterly* Fall 1975 10(3):4; Fall/Winter 1976 11(3/4):12-13; Fall 1982 17(3):10; Tanner 1976:131; *American Indian Art Magazine* Winter 1979:76; Winter 1996:82; Highwater 1980:135-36; New 1981; *Indian Market Magazine* 1985, 1988, 1989; *Arizona Highways* May 1986 62(5):9, 44; *Southwest Art* Sep. 1988 18(4):60, 63; *Southwest Profile* Mar. 1989 12(3):32; Aug. 1990 13(7):16; Hill 1992; School of American Research, *Annual Report* 1995:15; *Native Peoples* Fall 1994 8(1):55; Spring 1999 12(3):81; Feb./Mar. 2000 13(2):18; *Indian Artist Magazine* August 1998:3; *News from Indian Country* Sep. 2000 14(18):8B; Cirillo 49; *Sunstone Review Magazine.*

Harold Littlebird is an innovative artist who discovered pleasing ways of combining ancient symbols and traditions with contemporary techniques and concepts. As a student in 1966-69 at the Institute of American Indian Arts, his teacher, Ralph Pardington, offered a model for experimentation of clays, slips, paints, as well as the use of slab, pinch, coiling and a potter's wheel. Harold explored new forms of artistic expression. Harold praised his mentor Ralph Pardington, "He first showed me the wonder, stirred and directed the passion of clay and fire. I offer him my deepest gratitude."

While still an IAIA student, Harold acknowledged two particular potters — Christine McHorse (Dené) and Peter B. Jones (Onondaga/Seneca) — who "significantly influenced and encouraged me in my work with clay."

Harold recalled respectfully his profound educational experience at IAIA with Japanese master potter, Toshira Takezu. "She demonstrated her wheel throwing techniques. . .with precision and flair." He was amazed when she added clay balls that bounced around inside her large vessels during firing. They made a "resonating sound, as a part of its captivating beauty."

Harold's non-traditional pottery created quite a stir in 1972 at Eight Northern Indian Pueblos Arts & Crafts Show. While collectors were attracted to his new work, show organizers challenged him as to whether his work qualified as "Indian pottery?" Harold stood his ground stating, "You know me. I'm from Laguna and Santo Domingo Pueblos. I'm an Indian, so my work is Indian pottery." Around the same time, Joseph Lonewolf was being challenged at Santa Clara Pueblo over his sgraffito pottery. Both Littlebird and Lonewolf responded courageously in defense of their right as artists to innovate new styles and techniques.

Harold recognizes Cherokee potter Bill Glass as a kindred spirit. "He creatively continues to 'push the edge,' and himself with work/play." Both artists share a joyful approach to pottery making.

Harold credits Oregan potter Frank Boyleu for introducing to him Terra Sigilatta, an unique process that includes firing and re-firing pottery. Harold briefly immersed himself in the new techniques, before returning to stoneware. Harold also explored a myriad of techniques under the influence of Peruvian potter, Lucho Soler.

After pushing the limits in contemporary, non-traditional techniques, Harold turned to Margaret Tafoya, the matriarch of traditional Santa Clara pottery. Harold spoke with great respect for Margaret, "Through her quiet manner and wisdom, she reinstilled in me a reverence for the way clay teaches. I admired her respectful demeanor and subtle, prayerful voice, as she quietly addressed and gently touched natural clay, asking for permission to be used."

Mateo Littlebird

(Laguna, active ca. 1990s-present: animal figures)
FAMILY: son of Harold Littlebird & Barbara Perrin; brother of Maya Littlebird
AWARDS: 1994, 1st, 3rd, animal figures (ages 12 & under), Indian Market, Santa Fe

Angelina Lonjose

(Zuni, active ca. 1995-present: traditional polychrome jars, bowls)
BORN: December 11, 1972
FAMILY: daughter of Rosie & Harold Gasper
TEACHER: her grandmother
PUBLICATIONS: Berger & Schiffer 2000:128.

Leo Lonjose

(Zuni, active ?-present: pottery)
PUBLICATIONS: *Pueblo Horizons* Fall 1996:6.

Mrs. Lonkena

(Zuni, born into Eagle Clan, active ca. 1930s-?:
traditional polychrome ollas, jars, bowls)
BORN: ca. 1910s
FAMILY: sister of La Wa Ta; aunt of Josephine Nahohai

Looking Elk *(Ronald Martinez)*

(Isleta/Taos, active ca. 1990s-present: siennaware, contemporary sgraffito jars, bowls, plates, figures, sculptures, paintings)
AWARDS: 1997-98, Harvey W. Branigar, Jr., Native American Internship, School of American Research, Santa Fe; 2000, Challenge Award, Non-Traditional Pottery, Indian Market, Santa Fe
EXHIBITIONS: 1996-present, Indian Market, Santa Fe; 1998-present, Eight Northern Indian Pueblos Arts & Crafts Show
FAVORITE DESIGNS: Anasazi rock art, handprints, human figures, clouds, lightning
PUBLICATIONS: *Indian Artist* Winter 1996:15; Spring 1996:76; Spring 1998:24; Winter 1999:76; Anderson, et al. 1999:12.

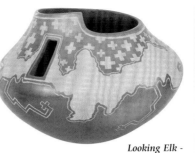

Looking Elk -
Photo by Bill Bonebrake. Courtesy of
Native American Collections, CO

Looking Elk -
Photograph by Bill Bonebrake
Courtesy of Jill Giller
Native American Collections, Denver, CO

Edith Lorenzo

(Laguna, active ca. 1973-?: traditional polychrome jars, bowls)
EDUCATION: 1973, Laguna Arts & Crafts Project participant

Frances Lorenzo

(Laguna, active ca. 1973-?: traditional polychrome jars, bowls)
EDUCATION: 1973, Laguna Arts & Crafts Project participant

Adrianna Loretto

(Jemez, active ca. 1990s-present: traditional polychrome jars, bowls)
BORN: December 21, 1978
FAMILY: daughter of Flo & Sal Yepa; sister of Miriam Brenda Loretto, Victor Loretto, Jr.; mother of Emmet Trevor Yepa
TEACHERS: Flo & Sal Yepa
STUDENT: Emmet Trevor Yepa

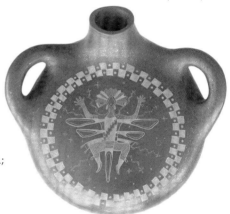

Looking Elk -
King Galleries of Scottsdale, AZ

Albenita Loretto

(Jemez, active ca. 1960s-80s?: polychrome jars, bowls)
FAMILY: wife of Joseph Loretto; mother of Estella and Glenda Loretto; grandmother of Fawn Loretto
STUDENTS: Estella and Glenda Loretto, her daughters
> Albenita's daughter, Estella Loretto, explained how her mother was her role model: "I try to do the things my mother would have done, the cooking, the communal roles, and I have come to appreciate her more. She was so giving."

Alma Concha Loretto *(see Alma Loretto Maestas)*

Andrea Loretto

(Jemez, active ca. 1950s-?: traditional polychrome jars, bowls)
BORN: ca. 1930s
FAMILY: wife of Napoleon Loretto; mother of Rachel L. Loretto
STUDENT: Rachel L. Loretto, her daughter
DEMONSTRATIONS: 1987, Museum of Indian Arts & Cultures, Santa Fe
PUBLICATIONS: *American Indian Art Magazine* Autumn 1988 13(4):47; Berger & Schiffer 2000:128.

Andreas Loretto

(Jemez, ca. 1930s-?: traditional cooking pots)
COLLECTIONS: Philbrook Museum of Art, Tulsa, OK, cooking pots, ca. 1942

Angie Loretto-Riley -
Courtesy of Jason Esquibel
Rio Grande Wholesale, Inc.

Angie Loretto-Riley *(Angie Loretto)*

(Jemez, active ca. 1967-present: matte polychrome Storytellers, Corn Maidens)
BORN: ca. 1955
FAMILY: daughter of Leonora Gachupin; sister of Lucy Toya & Bea Riley; aunt of Felecia Loretto & Angita Cajero
GALLERIES: The Indian Craft Shop, U.S. Department of Interior, Washington, D.C.; Rio Grande Wholesale, Albuquerque
> Angie Loretto-Riley fills her Storytellers with many babies. Some seem to be blowing kisses and singing. They are painted in matte polychrome. Her Corn Maidens hold bowls of corn. Her figures bring smiles to an admiring public.

Anita Loretto

(Jemez, active 1980s-present: Storytellers)
BORN: ca. 1960
FAMILY: daughter of Terry Loretto; sister of Julie & Felicia Loretto

Anthony Loretto *(signs A. Loretto)*

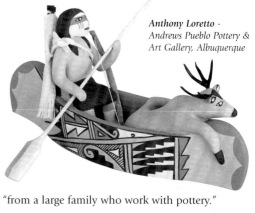
Anthony Loretto - Andrews Pueblo Pottery & Art Gallery, Albuquerque

(Jemez, Eagle Clan, active ca. 1990-present: figures: warriors in a canoe, horses)
BORN: August 6, 1969
FAMILY: grandson of Carmelito & Emilia Loretto; son of Angela Loretto; father of Dedric Toribio
FAVORITE DESIGNS: birds, horses, canoes, warriors
GALLERIES: Andrews Pueblo Pottery and Art Gallery, Albuquerque
 Anthony Loretto shared that he enjoyed "working with the clay" and "being an artist." He uses all natural clay and paints. He spoke of the importance of keeping the "tradition going." He expressed pride in coming "from a large family who work with pottery."

Arlene Loretto

(Jemez, active ca. 1990s-present: pottery)
EXHIBITIONS: 1997-present, Eight Northern Indian Pueblos Arts & Crafts Show

B. Loretto *(see Beatrice Loretto Riley)*

Barbara Madelena Loretto *(signs B.L. or B. Loretto, Jemez N.M.)*

(Jemez, active ca. 1982-present: Storytellers, traditional polychrome matte tan-ware jars, bowls)
BORN: June 28, 1952
FAMILY: daughter of Frank & Genevieve Madalena
FAVORITE DESIGNS: clouds, rain, feathers
PUBLICATIONS: Congdon-Martin 1999:74; Berger & Schiffer 2000:37, 128.

Beatrice Loretto

(Jemez, active ?-present: Storytellers)
GALLERIES: Rio Grande Wholesale, Albuquerque

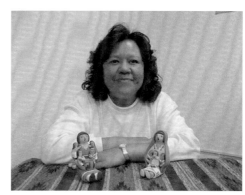
Beatrice Loretto - Courtesy of Jason Esquibel Rio Grande Wholesale, Inc.

Caroline G. Loretto *(Carol Loretto), (signs C. G. Loretto)*

(Jemez, active ca. 1977-present: polished cream & black-on-redware jars, bowls, miniatures)
BORN: April 20, 1953
FAMILY: daughter of Cecilia A. Loretto; sister of Mary H. Loretto, Geraldine Sandia; mother of Nanette Loretto
TEACHER: Cecilia A. Loretto, her mother
EXHIBITIONS: 1995-present, Eight Northern Indian Pueblos Arts & Crafts Show
GALLERIES: Isa Fetish, Cumming, GA
PUBLICATIONS: *American Indian Art Magazine* Spring 1990 15(2); Schiffer 1991d; Hayes & Blom 1996:82-83; Berger & Schiffer 2000:128.

(Left to right): Caroline Loretto, Mary Loretto & Shirley Loretto - Courtesy of Isa & Dick Diestler Isa Fetish, Cumming, GA

Carrie R. Loretto *(Carrie Reid Loretto)*

(Jemez/Laguna, active ca. 1940s-present: traditional polychrome jars, bowls)
BORN: ca. 1920s
FAMILY: wife of Louis Loretto; mother of Alma Maestas, Fannie Loretto, Mary Toya, Dorothy Trujillo, Leonora Lupe L. Lucero, Marie Edna Coriz; grandmother of Antoinette Concha, Adrian & Kathleen Wall, Cecilia Valencia
STUDENTS: Alma Maestas & Fannie Loretto, her daughters

Cecilia A. Loretto

(Jemez, active ca. 1950s-?: polished cream & black-on-redware jars, bowls)
BORN: ca. 1930
FAMILY: wife of Arthur Loretto; mother of Caroline G. Loretto, Geraldine Sandia & Mary H. Loretto
STUDENTS: Caroline G. Loretto, Geraldine Sandia & Mary H. Loretto, her daughters

D. Loretto *(signs. D. L.)*

(Jemez, active ?-present: matte polychrome jars, bowls, wedding vases, figures)
PUBLICATIONS: Berger & Schiffer 2000:37.

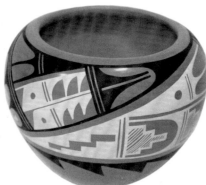
Caroline G. Loretto - Photograph by Bill Knox Courtesy of Indart Incorporated

Deborah Seonia Loretto *(Debbie S. Loretto), (signs DSL)*
(Jemez/Laguna, active ca. 1982-present: matte polychrome Storytellers, jars, bowls, figures)
BORN: April 16, 1956
GALLERIES: The Indian Craft Shop, U.S. Department of Interior, Washington, D.C.; Palms Trading Company, Albuquerque
PUBLICATIONS: Babcock 1986; Congdon-Martin 1999:78; Berger & Schiffer 2000:128.

Dorothy Loretto *(see Dorothy Loretto Trujillo)*

Emilia Loretto
(Jemez, Eagle Clan, active ca. 1930s-?: traditional polychrome jars, bowls)
BORN: ca. 1910s
FAMILY: wife of Carmalito Loretto; mother of Grace L. Fragua & Angela Loretto; grandmother of Anthony Loretto, Chris Fragua, Rose T. Fragua, Emily F. Tsosie, Caroline Gachupin, Phillip M. Fragua; Clifford Fragua, Benjamin Fragua, Cindy Fragua, Felicia Fragua & Bonnie Fragua; great-grandmother of Sheryl Fragua, Janeth A. Fragua, Joseph L. Tsosie, Darrick Tsosie, Lorna Tsosie, Robert Tsosie, Joseph E. Gachupin, Jr., Chrislyn Fragua, Loren Wallowing Bull, Amy Fragua, Carmellie Fragua, Aridina Fragua & Jonathan Fragua, Dedric Toribia; great-great grandmother of Anissa Tsosie
PUBLICATIONS: Babcock 1986; Peaster 1997:68-69.

 Emilia Loretto was the matriarch of a large family. The majority of her many descendants became potters. Their family is especially noted for excellence in the creation of Storytellers, Corn Maidens, figures and sculptures. Much of their pottery is done in matte polychrome.

Estella C. Loretto *(Stella Loretto), (collaborates sometimes with Glenda Loretto, her sister)*
(Jemez, active ca. 1978-present: polychrome figures, monumental clay, stone and bronze sculptures, paintings)
BORN: ca. 1960 at Jemez Pueblo
FAMILY: daughter of Joseph & Albenita Loretto; sister of Glenda Loretto; mother of Fawn Loretto
EDUCATION: Institute of American Indian Arts, Santa Fe; Fort Lewis College, Durango, CO; Benito Juarez University, Oaxaca, Mexico; Domotoo School of Traditional Japanese Art, Kameoka, Japan; exchange program participant in Belgium, Nepal, India, Japan, New Zealand, Italy, Australia
TEACHER: Albenita Loretto, her mother
AWARDS: American Field Service Scholarship, Antwerp, Belgium; 1984, 3rd, bowls; 1988, 3rd, non-traditional jars, Indian Market, Santa Fe
EXHIBITIONS: 1981, "American Indian Art in the 1980s," Native American Center for the Living Arts, Niagara Falls, NY; 1985-present, Indian Market, Santa Fe; 1996-present, Eight Northern Indian Pueblos Arts & Crafts Show; Indian Pueblo Cultural Center, Albuquerque; Towa Arts and Crafts Fair, Jemez Red Rocks, NM
FAVORITE DESIGNS: Kachina clay figures
COLLECTIONS: State Capitol, Santa Fe
PUBLICATIONS: New 1981:71; *Four Winds* Summer/Autumn 1981 2(2):7, 10-13; Fawcett & Callander 1982:80; *Southwest Art* Dec. 1990:30; Oct. 1996 26(5):13; *Artwinds* Winter/Spring 1994:13; *Indian Artist* Fall 1996:10; Summer 1996:12; Spring 1997:32; Winter 1997:36; *Navajo Times* July 15, 1999 *Masters of Indian Market* 1996:13; 1998:3,9; Tucker 1998, plate 45, 46; *Native Peoples* Sep/Oct. 2000 13(6):28-31.

 Estella Loretto was an especially talented child who expressed curiosity for cultures around the world at a young age. She was accepted when just 17 in foreign exchange programs and traveled around the world. In the process, she broadened her worldview to embrace a global perspective.

 In 1980. Estella married educator John Eagleday. They lived for a while in Taos before traveling abroad in the Pacific islands of Fiji, Tahiti, New Zealand and Australia. They returned home to Jemez Pueblo in 1982, when Estella's mother, Albenita Loretto, passed away.

 Some time later, Estella and John moved to Spokane, Washington where they made friends with Indian artists of the Pacific Northwest. She began sculpting again, and her work was well received. She was honored as the guest of honor by the Museum of Native American Culture.

 In 1989, she and her daughter, Fawn, then five, returned home again to Jemez Pueblo. Estella explained, "No matter where I travel in the world, these are my people, these are my relatives. There is a lot to learn here, and I have to be open to it."

 Along with Dan Namingha and Duane Makima, Estella Loretto is one of the few Native American artists to own an art gallery in Santa Fe. She named her gallery "Gentle Spirit," located on Gypsy Alley off Canyon Road. John Gravel, reviewer for the *Santa Fe Times*, commented: "Its name is well deserved. The gentle ambiance of her gallery, her art, and spirit, touch you the minute you walk in.

 "Her work has solidified into an affectionate yet focused grace and with each piece revealing a part of her soul. Each piece means something important to her. . .She treats each piece like a part of her family."

 Estella succeeds in making her art meaningful: "What are you going to share with the world that might make a difference?"

 John Villani, reviewer for the Albuquerque Journal, praised her highly: "In many ways, Loretto is a pioneer among female Indian artists. . . She's transcended the limitations of three-dimensional art forms. . .And she's a successful businesswoman in the crowded and competitive Santa Fe gallery scene."

 Estella is passionate about making monumental sculptures that express lasting community value. She acknowledges the influence of Apache sculptor Allan Houser, who taught her, "An artist shouldn't work for making money. What you do is about making art."

 Estella responded, ". . .even though I could have followed Allan's style more closely, I know I had to do something very different so that it could really be my own." She is well on her way to establishing her own respected place in American Indian art history.

Eutemia B. Loretto

(Jemez/San Juan, active ca. 1920s-90s: pottery, wool belts, embroidery)
AWARDS: 1977, Eight Northern Indian Pueblos Arts & Crafts Show
EXHIBITIONS: pre-1982-93, Indian Market, Santa Fe
COLLECTIONS: Museum of New Mexico, Santa Fe
PUBLICATIONS: Parsons 1925:16; *El Palacio* Jan. 1947 54(1):14; Fox 1978:48-49, 91; Sando 1979 9:428, fig. 11; Schaaf 2000:246; Schaaf 2001:293.

F. Loretto

(Jemez, active ca. 1990s-present: Storytellers)
GALLERIES: Palms Trading Company, Albuquerque
PUBLICATIONS: Congdon-Martin 1999:74.

Fannie Loretto *(Little Turquoise, Fannie Wall, Fanny)*

(Jemez/Laguna, Water Clan, active ca. 1977-present: polychrome figures, clowns, modern art clay sculptures, clay masks with feathers, horsehair & corn husk appendages, Madonna and Child figures, Nativities)
BORN: April 22, 1953
FAMILY: daughter of Louis & Carrie R. Loretto; sister of Mary Toya, Alma Maestas, Leonora Lupe L. Lucero, Marie Edna Coriz & Dorothy Trujillo; wife of Steve Wall; mother of Adrian & Kathleen Wall
TEACHER: Carrie R. Loretto, her mother
AWARDS: 1978, 1st, Eight Northern Indian Pueblos Arts & Crafts Show; 1993-98, 1st, New Mexico State Fair, Albuquerque; 1998, 1st; 1999, 1st, Indian Market; Heard Museum Show, Phoenix; 1st, 2nd, La Luz, NM
FAVORITE DESIGNS: Kachina clay figures

Fannie Loretto - Courtesy of John D. Kennedy and Georgiana Kennedy Simpson, Kennedy Indian Arts

GALLERIES: The Indian Craft Shop, U.S. Department of Interior, Washington, D.C.; Francois Gallery, Taos Plaza, NM
PUBLICATIONS: Monthan 1979; Babcock 1986; Congdon-Martin 1999:76; Berger & Schiffer 2000:88, 89, 128.

 Fannie Loretto is a fine ceramic artist who began making pottery at the age of 16. Today, she is a blue ribbon winner at Indian Market and other top Indian art shows. Judges have agreed for almost a quarter of a century that she is an exceptional artist.
 Fannie's fine clay sculptures have emerged in the last decade. Her clay masks feature horsehair, corn husk and ribbon attachments. Their faces are painted in wondrous designs. Her clowns are especially animated and expressive. Her figures of drummers appear in full swing. Fannie's figures seem to come alive.

Fawn Loretto *(collaborates sometimes with Glenda Loretto, her sister)*

(Jemez, active ?-present)
FAMILY: m. granddaughter of Joseph & Albenita Loretto; daughter of Estella Loretto and John Eagleday; niece of Glenda Loretto

Felicia Loretto

(Jemez, active ca. 1990-present: traditional polychrome jars, bowls, Storytellers, friendship pots)
BORN: October 13, 1962
FAMILY: daughter of Terry Loretto; sister of Julie Loretto & Anita Loretto
TEACHER: her mother
AWARDS: Pueblo Grande Show, Phoenix; San Felipe Arts & Crafts Show, San Felipe, NM
EXHIBITIONS: 1995-present, Eight Northern Pueblos Arts & Crafts Show
GALLERIES: Palms Trading Company, Albuquerque
PUBLICATIONS: Congdon-Martin 1999:77; Berger & Schiffer 2000:128.

Felicia Loretto - Courtesy of Georgiana Kennedy Simpson Kennedy Indian Arts,UT

Fran Loretto

(Jemez/Cochiti, active ca. 1980s-present: pottery, jewelry, paintings)
EXHIBITIONS: 1982-present, Indian Market, Santa Fe
PUBLICATIONS: *SWAIA Quarterly,* Fall 1982 17(3):10; *Indian Market Magazine* 1985, 1988, 1989.

Glenda K. Loretto *(collaborates sometimes with Estella Loretto, her sister)*

(Jemez, active ?-present: polychrome figures, effigy pots, modern art clay and bronze sculptures, paintings)
FAMILY: daughter of Joseph & Albenita Loretto; sister of Estella Loretto; aunt of Fawn Loretto
EXHIBITIONS: 1992-present, Indian Market, Santa Fe; 1994-present, Eight Northern Indian Pueblos Arts & Crafts Show
FAVORITE DESIGNS: horned toads
PUBLICATIONS: Hayes & Blom 1998:53.

J. M. Loretto

(Cochiti, active ?-present: polychrome Storytellers, figures)
GALLERIES: Palms Trading Company, Albuquerque
PUBLICATIONS: Congdon-Martin 1999:20.

Jonathan Loretto

(Cochiti, active ca. 1980s-90s: pottery)
EXHIBITIONS: 1989, Indian Market, Santa Fe

Josephine Loretto

(Jemez, active ca. 1940s-present: traditional polychrome jars, bowls)
BORN: ca. 1920s
FAMILY: mother of Mabel Fragua; grandmother of Raylene Fragua

Julie Loretto *(signs J. Loretto), (collaborates sometimes with V. Loretto)*

(Jemez, active ca. 1981-present: Storytellers)
BORN: October 10, 1960
FAMILY: daughter of Terry Loretto; sister of Felicia Loretto; & Anita Loretto
AWARDS: Colorado Indian Market, Denver
PUBLICATIONS: Congdon-Martin 1999:77; Berger & Schiffer 2000:128.

L. Loretto

(Jemez, active ?-present: polychrome, black-on-red jars & bowls)
FAVORITE DESIGNS: clouds, feathers
PUBLICATIONS: Walatowa Pueblo of Jemez, "Pottery of Jemez Pueblo" (1998).

Laverne Loretto-Tosa *(Laverne Loretto Tosa), (signs L. Loretto-Tosa)*

(Jemez, Fire Clan, active ca. 1985-present: stone polished jars, bowls)
BORN: in Albuquerque, NM
FAMILY: p. granddaughter of Priscilla Loretto; daughter of Telesfor Loretto & Priscilla Griego
Loretto; wife of Frederick Tosa; mother of Danielle Tosa & Vernon Tosa
TEACHER: Priscilla Griego Loretto, her mother
EXHIBITIONS: 1994-present, Eight Northern Indian Pueblos Arts & Crafts Show; 1997-present,
Indian Market, Santa Fe; Pueblo Grande Show, Phoenix; Southwest Indian Art Fair, Tucson, AZ
FAVORITE DESIGNS: feathers & geometric
PUBLICATIONS: *Indian Market Magazine* 1998:99.

 Laverne Loretto-Tosa sometimes can be visited while she is displaying her pottery
under the Portal at the Palace of the Governors, on the Plaza in Santa Fe, NM. She
shared that she enjoyed creating pottery, because "it keeps me at home, and I do it on
my own time. I feel this is what I do best. I have two teenagers who are pretty active. I go
to all their games and activities. Both my kids are learning to make pottery, continuing
our long lived tradition."

Leonora Loretto

(see Leonora Loretto Lucero)

Lupe Madalena Loretto

(Jemez, active ca. 1980s-present:
Storytellers)
PUBLICATIONS: Babcock 1986.

*Julie Loretto - Courtesy of
John D. Kennedy and
Georgiana Kennedy Simpson
Kennedy Indian Arts*

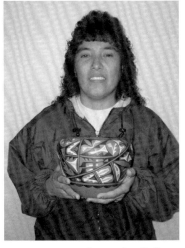

*Laverne Loretto-Tosa -
Courtesy of Jason Esquibel
Rio Grande Wholesale, Inc.*

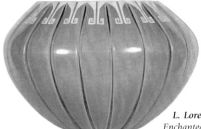

*L. Loretto-Tosa - Courtesy of
Enchanted Village*

Mariam Brenda Loretto

(Jemez, active ca. 1990s-present: traditional polychrome jars, bowls, sculptures)
BORN: July 11, 1967
FAMILY: daughter of Flo & Sal Yepa; sister of Adrianna Loretto, Victor Loretto, Jr.; mother of Robin Loretto, Matthew Panana & Ryan
Panana

Mary H. Loretto *(sometimes signs M. H. Loretto)*

(Jemez, active ca. 1982-present: polished cream & black-on-redware jars & bowls, jewelry, beadwork)
BORN: June 25, 1955
FAMILY: daughter of Cecilia Loretto; sister of Caroline G. Loretto, Geraldine Sandia
TEACHER: Cecilia Loretto, her mother
EDUCATION: Institute of American Indian Arts, Santa Fe
EXHIBITIONS: 1996-present, Eight Northern Indian Pueblos Arts & Crafts Show; IAIA Alumni Show, no date
FAVORITE DESIGNS: Sunface, feathers-in-a-row, waves, rain
GALLERIES: The Indian Craft Shop, U.S. Department of Interior, Washington, D.C.; AmericanIndianProducts.com
PUBLICATIONS: Berger & Schiffer 2000:128.

Nanette Loretto *(signs N. Loretto)*

(Jemez, active ca. 1991-present: polished cream & black-on-redware jars, bowls)
BORN: September 17, 1971
FAMILY: granddaughter of Arthur Loretto & Cecilia A. Loretto; daughter of Caroline Loretto; mother of Jillian, Karina, Maurianna,
Sabrina & Teran Loretto
EXHIBITIONS: 1995-present, Eight Northern Indian Pueblos Arts & Crafts Show; 2001, Jemez Pueblo Red Rocks Arts & Crafts Show
COLLECTIONS: Stacey Jonas-Keeling, Albuquerque
GALLERIES: Paul Speckle Rock Gallery, Santa Clara; Kennedy Indian Arts, Bluff, UT

PUBLICATIONS: Berger & Schiffer 2000:128.

In the summer of 2001, we met Nanette Loretto at the Jemez Pueblo Red Rocks Arts & Crafts Show. She displayed a group of polished cream & black on redware pottery. The quality of her work was exceptional. Her stone polished slip sparkled with perfection. Her designs were finely painted.

Collector Stacey Jonas-Keeling, a nurse from Albuquerque, walked up and exclaimed with enthusiasm, "Nanette's the best. Just look at the quality of her pottery. Yes, she's definitely the best!"

Nanette told us humbly of her early beginnings, "My first pots did not turn out so well. It was really hard. I tried over and over again. Only gradually did my pots improve. It takes a lot of patience to be a potter."

Nanette gazed thoughtfully at her pottery and confided, "I love doing this work, even though it's hard. I'm trying to get my kids into pottery making, so I can help pass the tradition on to the next generation."

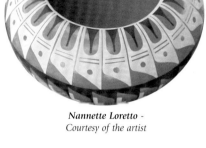

Nannette Loretto -
Courtesy of the artist

Natalie Loretto
(Jemez, active ?-present: matte polychrome Storytellers)
GALLERIES: Palms Trading Company, Albuquerque
PUBLICATIONS: Congdon-Martin 1999:77.

P. Loretto
(Jemez, active ?-present: polychrome on buff jars & bowls, owls)
FAVORITE DESIGNS: clouds, owls, turtles, bears
PUBLICATIONS: Walatowa Pueblo of Jemez, "Pottery of Jemez Pueblo" (1998).

Phil Loretto
(Jemez, active ca. 1960s-present: pottery, jewelry, paintings, poetry)
BORN: ca. 1951
FAMILY: son-in-law of Chee Keams (Navajo jeweler)
EDUCATION: 1968-69, Institute of American Indian Art, Santa Fe; 1976, Fort Lewis College, Durango
GALLERIES: Case Trading Post at the Wheelwright Museum; Packard's, Santa Fe

Priscilla Loretto *(1)*
(Jemez, active ca. 1930s-?: traditional polychrome jars, bowls)
FAMILY: mother of Telesfor Loretto; mother-in-law of Priscilla Griego Loretto; p. grandmother of Laverne Loretto Tosa, Stuart Loretto, Archie Loretto, Michael Loretto & Joseph Loretto; great-grandmother of Danielle Tosa & Vernon Tosa

Priscilla Griego Loretto *(2)*
(Jemez, Fire Clan, active ca. 1950s-?: traditional polychrome jars, bowls)
FAMILY: wife of Telesfor Loretto; mother of Laverne Loretto Tosa, Stuart Loretto, Archie Loretto, Michael Loretto & Joseph Loretto; m. grandmother of Danielle Tosa & Vernon Tosa
EXHIBITIONS: 1995-present, Eight Northern Indian Pueblos Arts & Crafts Show; 1997-present, Indian Market, Santa Fe

Rachel L. Loretto *(signs R. L. Loretto)*
(Jemez, active ca. 1987-present: traditional polychrome jars, bowls)
BORN: March 20, 1954
FAMILY: daughter of Napoleon & Andrea Loretto
TEACHER: Andrea Loretto, her mother & Clara Chosa
DEMONSTRATIONS: 1987, Museum of Indian Arts & Cultures, Santa Fe
PUBLICATIONS: *American Indian Art Magazine* (Autumn 1988):47; Berger & Schiffer 2000:128.

Stella Loretto *(see Estella Loretto)*

Terry Loretto
(Jemez, active ca. 1960s-?: traditional polychrome jars, bowls)
BORN: ca. 1940
FAMILY: mother of Felicia Loretto, Julie Loretto & Anita Loretto

V. Loretto *(collaborates sometimes with J. Loretto)*
(Jemez, active ca. 1981-present: Storytellers)
PUBLICATIONS: Congdon-Martin 1999:77.

B. Louis
(Acoma, active ?-present: polychrome jars, bowls)
COLLECTIONS: Dr. Gregory & Angie Yan Schaaf, Santa Fe

Carmen Louis
(Acoma, active ?-1990+: polychrome jars, bowls)
PUBLICATIONS: Dillingham 1992:206-208.

Carrie Louis
(Acoma, active ?-1990+: polychrome jars, bowls)
PUBLICATIONS: Dillingham 1992:206-208.

Corrine Louis *(collaborates with Gary Louis)*
(Acoma, active ca. 1970-present: early period - black-on-white fineline with some color highlights; later period horsehair jars, vases)
BORN: 1959
FAMILY: granddaughter of Marie Z. Chino; daughter of Carrie Chino-Charlie; sister of JoAnne Chino Garcia, Isabel Charlie & Ann Charlie; wife of Gary Louis
AWARDS: New Mexico State Fair, Albuquerque
GALLERIES: Rio Grande Wholesale, Inc., Palms Trading Co., Albuquerque
PUBLICATIONS: Dillingham 1992:206-208; 1994:82, 89.
> Corrine is the innovator of horsehair pottery. The idea came to her when "one of her own strands of hair fell on the pottery and scorched the pot. It was from this accident that the idea of using such a method to decorate pottery was invented. She and her husband, Gary Louis, developed the technique using horsehair.

Deann Louis
(Acoma, active ?-present: traditional polychrome jars, bowls)
FAMILY: related to Earl & Gerri Louis
PUBLICATIONS: Painter 1998:13.

Earl Louis
(Acoma, active ?-present: traditional polychrome jars, bowls)
FAMILY: related to Deann & Gerri Louis
PUBLICATIONS: Painter 1998:13.

Ervin Louis
(Acoma, active ?-1990+: polychrome jars, bowls)
PUBLICATIONS: Dillingham 1992:206-208.

Gary Louis *(Yellow Corn), (collaborates with Corrine Louis)*
(Acoma, Yellow Corn Clan, active ca. 1967-present: sgraffito & horsehair pottery)
BORN: March 20, 1959
FAMILY: brother of Irwin Louis; husband of Corrine Louis
AWARDS: New Mexico State Fair, Albuquerque
COLLECTIONS: Allan & Carol Hayes
GALLERIES: Rio Grande Wholesale, Inc., Palms Trading Co., Albuquerque
PUBLICATIONS: Dillingham 1992:206-208; Berger & Schiffer 2000:128.

Gerri Louis *(Geraldine), (signs G. Louis, Acoma N.M.)*
(Acoma, active ca. 1982-present: traditional & ceramic polychrome fineline jars & bowls)
BORN: February 12, 1957
FAMILY: daughter of Mike & Delma Vallo; sister of Darrell Patricio; related to Deann & Earl Louis
GALLERIES: Rio Grande Wholesale, Inc., Palms Trading Co., Albuquerque
PUBLICATIONS: Painter 1998:13; Berger & Schiffer 2000:128.

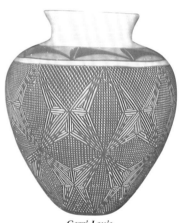

Gerri Louis -
Courtesy of Jason Esquibel
Rio Grande Wholesale, Inc.

Gilbert M. Louis, Jr. *(collaborates with Reycita Louis)*
(Acoma, active ca. 1970s-present: traditional polychrome jars, bowls)
BORN: ca. 1950s
FAMILY: son of Gilbert Louis, Sr.; husband of Reycita Louis
EXHIBITIONS: Indian Market, Santa Fe; ca. 1993-present, Eight Northern Indian Pueblos Arts & Crafts Show
ARCHIVES: Artist File, Heard Museum, Phoenix

Irvin J. Louis *(Vines of the Melons)*
(Acoma, Yellow Corn Clan, active ca. 1969-present: horsehair jars, bowls, wedding vases, bear fetishes, some with inlaid turquoise)
BORN: ca. 1955
FAMILY: brother of Gary Louis
GALLERIES: Rio Grande Wholesale, Inc., Palms Trading Co., Albuquerque
PUBLICATIONS: Painter 1998:13.
> Irvin J. Louis is known for his horsehair pottery, a technique innovated by Corrine Louis. His process is as follows: "He pours a ceramic white slip substance into a mold and then, he pours out the excess slip and allows the slip to dry. The ceramic-ware is then cleaned and polished." He heats up the pottery in a kiln and then randomly tosses horsehair from the mane (thin lines) or tail (thick lines) onto the heated pottery. Carbon from the burning horsehair is pulling into the surface of the pottery, creating abstract marbleized black-on-white patterns.

Jessie G. Louis

(Acoma, active ?-1990+: polychrome & corrugated jars, bowls, canteens, Storytellers)
EXHIBITIONS:1994-present, Eight Northern Indian Pueblos Arts & Crafts Show
COLLECTIONS: John Blom; Dr. Gregory & Angie Yan Schaaf, Santa Fe
FAVORITE DESIGNS: Acoma parrots, split leaves, clouds, rainbows, Thunderbirds,
Rainbirds
PUBLICATIONS: Dillingham 1992:206-208; Hayes & Blom 1996:46-47; 1998:23.

Jessie Louis -
Courtesy of John Blom

J. G. Louis

(Acoma, active, ?-1990s: polychrome ollas)
COLLECTIONS: Dr. Gregory Schaaf, Santa Fe

Lupe Louis

(Acoma, ca. 1950s-?: traditional & ceramic polychrome jars, bowls)
BORN: ca, 1930s
FAMILY: mother of Lucille M. Antonio
STUDENTS: Lucille M. Antonio, her daughter
GALLERIES: Rio Grande Wholesale, Inc., Palms Trading Co., Albuquerque
PUBLICATIONS: Berger & Schiffer 2000:98.

Lupita Louis

(Acoma, active ca. 1870s-1910s+: polychrome jars, bowls)
BORN: ca. 1855; RESIDENCE: Acomita in ca. 1910
PUBLICATIONS: Leopold Bibo, "13th Annual U.S. Census" (1910), New Mexico State Archives, Call T624, Roll 919; in Dillingham
1992:205.

Reycita R. Louis *(Reycita Garcia Louis), (collaborates with Gilbert M. Louis, Jr.)*

(Acoma, active 1970s-present: polychrome jars, bowls, seed pots, dream catchers)
BORN: January 19, 1958; RESIDENCE: Acomita, NM
FAMILY: wife of Gilbert M. Louis, Jr.
EXHIBITIONS: Indian Market, Santa Fe; ca. 1993-present, Eight Northern Indian Pueblos Arts & Crafts Show
PUBLICATIONS: Painter 1998:14.

Alvin Lovato

(Santo Domingo, active, ca. 1980s-present: clay sculptures)
BORN: ca. 1960s
FAMILY: great-great grandson of Benina & Francisco Silva; great-grandson of Santiago Lovato & Monica Silva; grandson of Clara
Lovato Reano; son of Charles Frederick Lovato
FAVORITE DESIGNS: Kachinas, Kiva steps, frets
PUBLICATIONS: Hayes & Blom 1996:146-47.

Anna Marie Lovato *(signs AML)*

(Santo Domingo, active 1978-present: polychrome jars, dough bowls)
BORN: November 8, 1954
FAMILY: mother of Arthur Vigil
GALLERIES: Arlene's Gallery, Tombstone, AZ; Palms Trading Company, Albuquerque
PUBLICATIONS: *Indian Market Magazine* 1988, 1989; Berger & Schiffer 2000:70, 129; *Native Peoples* August 2000:87.

Anthony Lovato

(Santo Domingo, active ca. 1970s-present: pottery, jewelry, silver tufa cast sculpture)
BORN: July 5, 1958
FAMILY: grandson of Santiago Leo Coriz; son of Sedelio Lovato & Mary C. Lovato
EXHIBITIONS: 1992, Heard Museum Show, Phoenix; 1997; "Native American Jewelry & Metalwork: Contemporary Expressions,"
Institute of American Indian Arts Museum, Santa Fe; "The Cutting Edge: Contemporary Southwestern Jewelry and Metalwork,"
Heard Museum, Phoenix; 2001, Red Earth Festival, Oklahoma City
PUBLICATIONS: Pardue 1997:34; Coulter 1997:75.

Charles Frederick Lovato *(C. F. Lovato)*

(Santo Domingo, active 1950s-87: polychrome pottery, paintings, jewelry, textiles, poetry)
LIFESPAN: May 23, 1937 - 1987
FAMILY: great-great grandson of Jose Leandro & Dolorita Baca Leandro; great-grandson of Benina & Francisco Silva; m. grandson of
Santiago Lovato & Monica Silva; son of Joe I. Reano & Clara Lovato Reano; father of Alvin Lovato
EDUCATION: Institute of American Indian Arts
AWARDS:

1968	Bialac Purchase Award, Heard Museum Show, Phoenix	
1969	Avery Award, Heard Museum Show, Phoenix	
1970	Elkus Award, Philbrook Art Museum, Tulsa, OK; Scottsdale National Indian Art Exhibition, Scottsdale, AZ	

1971	Bialac Purchase Award, Heard Museum Show, Phoenix; Kenny Award, Inter-tribal Indian Ceremonial, Gallup; Red Cloud Art Show, SD
1977	Bialac Purchase Award, Heard Museum Show, Phoenix
1979	Elkus Award, Philbrook Art Museum, Tulsa, OK

EXHIBITIONS:

1969	Heard Museum, Phoenix
1971	Heard Museum, Phoenix
1978	Hastings College Art Center, Hastings, NE; Center for Great Plains Studies, University of Nebraska, Lincoln, NE
1985	Indian Market, Santa Fe
1991	Wheelwright Museum, Santa Fe

COLLECTIONS: National Museum of the American Indian, Smithsonian Institution, Washington, D. C.; Heard Museum, Phoenix; Museum of Northern Arizona, Flagstaff; Philbrook Museum of Art, Tulsa; Millicent Rogers Museum, Taos, NM; The Heritage Center, Inc. Collection, Pine Ridge, SD; Center for Great Plains Studies, University of Nebraska, Lincoln, NE

PUBLICATIONS: Dunn 1968; Tanner 1973; Monthan 1975; Broder 1981; Medina 1981; Lovato 1982; *Indian Market Magazine* 1985; Lester 1995:326; Reno 1995:103-04; Schaaf in Matuz, ed. 1997:336-38.

At an early age, Charles Lovato was adopted by his grandmother, Monica Silva. She taught him how to paint and gave him the opportunity to paint some of her pottery. He also learned jewelry skills, carrying forward the Lovato family tradition of fine sandcast silverwork and heishi bead making.

Charles went on to study at the Institute of American Indian Arts. He was influence by his teacher, Jose Rey Toledo (Jemez). Lovato conveyed timeless Santo Domingo pottery designs onto paper and canvas. Charles also explored modern art traditions from around the world. He was especially attracted to abstract expressionism which influence his later work. Charles went on to become Santo Domingo's most famous painter.

Charles served in the U.S. Navy. After receiving an honorable discharge, Charles returned home to New Mexico. Beginning in 1967, Charles won many awards, mostly for his painting. The Heard Museum in Phoenix and the Philbrook Museum in Tulsa took special interest in his work and collected his paintings. The famous painting collector James Bialac provided strong support through his sponsorship of top painting awards with funds to allow purchases for their permanent collection.

Lovato credited R. C. Gorman with encouraging him to show his work more widely. Charles' modern style was growing, along with the work of Joe Herrera, T.C. Cannon, Fritz Scholder and other contemporary artists. Many of Lovato's painting used bold primary colors - blacks, whites and earthtone reds. He began to composing poems to accompany his paintings, such as "He is Pouring Out Stars," and "Upon the Earth Another Night."

His life was short, as he passed away 1987 at the age of fifty. Four years later, in 1991, the Wheelwright Museum of the American Indian in Santa Fe honored him with an exhibition of his art.

Clara Lovato *(see Clara Lovato Reano)*

Corine Lovato

(Santo Domingo, active 1994-present: traditional polychrome & black-on-creamware jars, bowls)
BORN: November 13, 1957
FAMILY: m. granddaughter of Reyes & Ventura Reano; daughter of Tonita R. Lovato & Ike Lovato, Sr.; sister of Dan Lovato, Ray Lovato; mother of Martin Leo Coriz & Merlinda Coriz
TEACHERS: Robert Tenorio & Mary Edna Tenorio
EXHIBITIONS: 1996-2001, Santo Domingo Pueblo Arts & Crafts Show; 1991-present, Eight Northern Indian Pueblos Arts & Crafts Show
FAVORITE DESIGNS: birds, bighorn sheep, turtles, fish

Robert Tenorio gives his student, Corine Lovato, credit for using all traditional materials and for making her pottery in the traditional way. Robert's sister, Mary Edna Tenorio, also has worked with Corine who is making great strides in refining her techniques. We met Corine displaying her pottery and the works of her children at the 2001 Santo Domingo Arts & Crafts Show. Robert Tenorio walked up as we were speaking and began praising Corine for making her pottery in the old, traditional way.

Felix Lovato

(Santo Domingo, active ?-present: pottery)
EXHIBITIONS: 1998-present, Eight Northern Indian Pueblos Arts & Crafts Show

Juanita Lovato

(Santo Domingo, active ca. 1930s-?: traditional polychrome ollas, jars, bowls)
COLLECTIONS: Philbrook Museum of Art, Tulsa, OK, bowl, ca. 1939

Lillian Lovato

(Santo Domingo, active ?-present: pottery, jewelry)
EXHIBITIONS: pre-1985-present, Indian Market, Santa Fe
PUBLICATIONS: *Indian Market Magazine* 1985, 1988, 1989, 1998:99.

Lonnie Lovato

(Santo Domingo, active ca. 1990s-present: polished redware & blackware pottery, figures)
AWARDS: 1993, 2nd, polished blackware or redware (ages 18 & under); 1994, 1st, figures, 1st, polished blackware, Indian Market, Santa Fe

Lupe Lovato *(Lobato)*

(Santo Domingo, active ?: pottery)
ARCHIVES: Laboratory of Anthropology Library, Lab file.

Manuelita Judy Lovato *(ML - jewelry hallmark)*

(Santo Domingo, active 1964-present: ceramic sculpture, stoneware, polychrome jars, effigy jars, bowls, some incised and inlaid with turquoise, mother of pearl, jet, spiny oyster and sugalite; jewelry, sculpture, beadwork)
BORN: ca. 1945
FAMILY: daughter of Reyes Lovato; aunt of Trudy Lovato
EDUCATION: Institute of American Indian Arts, Santa Fe; University of Colorado, Boulder, CO; Northwest College, St. Joseph, MO; College of Santa Fe, NM
TEACHER: Otellie Loloma (Hopi)
AWARDS: 1988, 3rd, non-traditional figures, Indian Market, Santa Fe; Fellowship, Inter-American Indian Institute, Mexico City
EXHIBITIONS: 1965, "Young American Indian Artists, traveling exhibit from Institute of American Indian Arts, Riverside Museum, New York, NY; 1981, "American Indian Art in the 1980s," Native American Center for the Living Arts, Niagara Falls, NY; 1992, Heard Museum Show, Phoenix.
PUBLICATIONS: New 1981:42, 71; Wright 1989, 2000:110; Peaster 1997:146, 158; Schaaf 1999:68.

Beginning in 1970, Manuelita Lovato taught many students at the Institute of American Indian Arts in Santa Fe. Her courses included museology. She also served as Curator at the Institute of American Indian Arts Museum.

Manuelita has traveled extensively, and her work has been exhibited internationally. Her contribution to the 1981 exhibit at the "Turtle Museum" in Niagara Falls, featured a sculpture called "Turtle Mound." Her stoneware depicted almost a dozen sculptured faces of Indians peering out of a mound surmounted by a turtle. The piece was most appropriate for the setting.

Marvin Lovato

(Santo Domingo, active ?-present: pottery, jewelry)
AWARDS: 1998, 1999, Indian Market, Santa Fe
EXHIBITIONS: pre-1985-present, Indian Market, Santa Fe
PUBLICATIONS: *Indian Market Magazine* 1985, 1989.

Pedro Lovato *(signs PL)*

(Santo Domingo, active ?-present: black-on-red plates)
FAVORITE DESIGNS: deer with heartlines, deer print, rain clouds
PUBLICATIONS: Berger & Schiffer 2000:70, 129.

Tonita R. Lovato

(Santo Domingo, active ca. 1930s-?: traditional polychrome jars, bowls)
LIFESPAN: June 2, 1917 - 1981
FAMILY: daughter of Reyes & Ventura Reano; sister of Reyes Quintana; wife of Ike Lovato, Sr.; mother of Corine Lovato, Dan Lovato, Ray Lovato

Marie Lowala

(Cochiti, active ?-present: polychrome jars, bowls)
COLLECTIONS: John Blom
PUBLICATIONS: Hayes & Blom 1998:55.

Alvina Lowden

(Acoma, active ?-1975+: polychrome jars, bowls)
PUBLICATIONS: Minge 1991:195.

Andrea Lowden

(Acoma, active ?-1975+: polychrome jars, bowls)
FAMILY: p. grandmother of Patricia M. Lowden
PUBLICATIONS: Minge 1991:195.

Anita Garcia Lowden

(Acoma, Sun Clan, active ca. 1950s-70s: Anasazi Revival black-on-white & traditional polychrome jars, bowls, vases, plates, turtle effigy canteens)
LIFESPAN: 1930s - 1970s
FAMILY: daughter of Jessie C. Garcia; sister of Marcus Garcia, Chester W. Garcia, Lori Garcia, Tina Garcia & Stella Shutiva; mother of Jerilyn Emanuel & Patricia Lowden; related to Virginia Lowden
COLLECTIONS: Philbrook Museum of Art, Tulsa, OK, olla, ca. 1961; Steve Elmore, Santa Fe
PUBLICATIONS: Harlow 1977.

Steve Elmore and Nedra Matteucci, two top Pueblo pottery dealers and collectors recognize Anita Garcia Lowden as one of the superb potters.

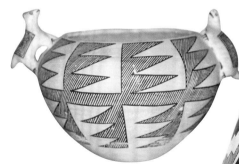

Anita Lowden -
Dr. Sally Archer & Dr. Al Waterman
Yardley, PA

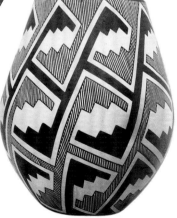

Anita Lowden -
Nedra Matteucci Galleries, Santa Fe

Mary Lowden *(Mary V. Lowden, Mary V. Ray, Mary Ray Lowden)*
(Acoma, active ?-present: polychrome jars, bowls, canteens, figures, Storytellers 1980-, miniatures)
BORN: December 24 or 25, 1941; RESIDENCE: Grants, NM
FAMILY: granddaughter-in-law of Lupe Chavez; sister-in-law of Virginia Lowden
EXHIBITIONS: 1995, Eight Northern Indian Pueblos Arts & Crafts Show
COLLECTIONS: John Blom
PUBLICATIONS: Babcock 1986:137; Hayes & Blom 1998:55.

Patricia M. Lowden
(Acoma, Sun Clan, active ca. 1980s-present: pottery)
BORN: ca. 1960; RESIDENCE: Acoma Pueblo, NM
FAMILY: great-granddaughter of Lupe Chavez; m. granddaughter of Jessie C. Garcia; p. granddaughter of Andrea Lowden; daughter of Anita Garcia Lowden; sister of Jerilyn Emanuel

Virginia Lowden
(Acoma, active 1950s-present: polychrome ollas, jars, bowls)
BORN: June 12, 1936; RESIDENCE: Cubero, NM
FAMILY: granddaughter of Lupe Chavez; sister-in-law of Mary Lowden
EXHIBITIONS: 1985-present, Indian Market, Santa Fe; 1994-present, Eight Northern Indian Pueblos Arts & Crafts Show
PUBLICATIONS: *Indian Market Magazine* 1985-2000; Dillingham 1992:206-208; Painter 1998:14.

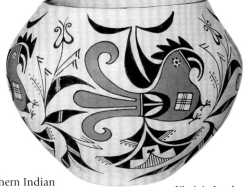

Virginia Lowden -
Wright/McCray Collection, Santa Fe

Arthur Lucario *(signs A. & V. Lucario, Laguna N.M.) (collaborates with Velma Lucario)*
(Acoma/Laguna, active ca. 1987-present: ceramic sgraffito polychrome jars, bowls, vases, Kachinas, jewelry)
BORN: June 23, 1942
FAMILY: son of Paul Lucario, Sr.; brother of Paul Lucario, Jr.; husband of Velma Lucario; father of Ray Lucario (Kachina carver); uncle of Michael P. Lucario
TEACHER: Sally Garcia, his sister
AWARDS: 1995, 1st, New Mexico State Fair, Albuquerque
FAVORITE DESIGNS: Eagle & Long Hair Kachinas, Kokopelli, feathers-in-a-row
GALLERIES: Arlene's Gallery, Tombstone, AZ; Rio Grande Wholesale, Palms Trading Co., Albuquerque
PUBLICATIONS: Berger & Schiffer 2000:129.

Caroline Lucario
(Acoma, active ?-1990+: polychrome jars, bowls)
PUBLICATIONS: Dillingham 1992:206-208.

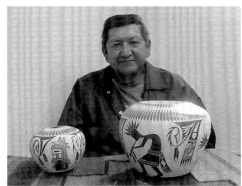

Arthur Lucario - Courtesy of Jason Esquibel
Rio Grande Wholesale, Inc.

Jennie Lucario
(Acoma, active ?-1990+: polychrome jars, bowls)
PUBLICATIONS: Dillingham 1992:206-208.

Juana Lucario
(Acoma, active ?-1990+: polychrome jars, bowls)
COLLECTIONS: Wright Collection, Peabody Museum, Harvard University, Cambridge, MA
PUBLICATIONS: Dillingham 1992:206-208; Drooker & Capone 1998:138.

Michael P. Lucario
(Laguna/Acoma, active ca. 1993-present: traditional & ceramic polychrome carved jars, bowls)
BORN: December 17, 1975
FAMILY: p. grandson of Paul Lucario, Sr.; son of Paul Lucario, Jr.
PUBLICATIONS: Berger & Schiffer 2000:129.

Mrs. Nicholas Lucario
(Acoma, active ca. 1940)
PUBLICATIONS: Minge 1991:195.

Paul Lucario, Jr.
(Acoma/Laguna, active ?-present: ceramic sgraffito polychrome jars, bowls)
BORN: ca. 1940s
FAMILY: son of Paul Lucario, Sr., brother of Arthur Lucario & Sally Garcia; husband of Karen Lucario (Laguna); father of Michelle Pasquale & Michael P. Lucario
STUDENTS: Darrin Pasquale, Michelle Pasquale, his daughter
PUBLICATIONS: Berger & Schiffer 2000:129, 138.

Rebecca Lucario *(signs R. Lucario)*

*Courtesy of John D. Kennedy &
Georgiana Kennedy Simpson
Kennedy Indian Arts*

(Acoma, Yellow Corn Clan, active ca. 1965-present: black-on-white Mimbres Revival, polychrome, black-on-white fineline jars, bowls, effigy pots, seed pots, plates, Storytellers)
BORN: April 18, 1951
FAMILY: m. granddaughter of Toribio & Dolores S. Sanchez; p. granddaughter of Jose Sandoval; daughter of Katherine & Edward Lewis, Sr.; sister of Marilyn Lewis Ray, Judy Lewis, Carolyn Lewis-Concho, Bernard E. Lewis, Diane M. Lewis, Michael Lewis, Edward Lewis, Jr.; wife of Dwight Lucario; mother of David, Duane, Lupiana, Amanda, Iris Lucario
TEACHER: Dolores S. Sanchez, her grandmother
AWARDS:

1983	2nd, 3rd (2), Indian Market
1984	2nd, seed pots, 2nd, vases, Indian Market, Santa Fe
1988	1st, 3rd, Indian Market, Santa Fe
1989	3rd, Indian Market, Santa Fe
1990	1st (?), Indian Market, Santa Fe
1991	Best of Division, 1st, Indian Market
1992	1st (2), Indian Market, Santa Fe
1993	1st, 2nd, Indian Market, Santa Fe
1994	Best of Division, 1st, (2), Indian Market
1996	1st, 3rd, Indian Market, Santa Fe
1998	1st, 2nd, Indian Market, Santa Fe
2000	2nd, plates, 2nd, 3rd, jars, Indian Market, Santa Fe; Best of Show, Best of Division, 1st, 2nd, 3rd, Inter-tribal Indian Ceremonial, Gallup

*Rebecca Lucario -
Dr. Sally Archer & Dr. Al Waterman
Yardley, PA*

EXHIBITIONS: 1985-present, Indian Market, Santa Fe; 1995-present, Eight Northern Indian Pueblos Arts & Crafts Show
COLLECTIONS: John Blom; Jane & Bill Buchsbaum, Dr. Gregory & Angie Yan Schaaf
FAVORITE DESIGNS: Mimbres spiders, lizards, salamanders, fish, Kokopelli, eyedazzlers
GALLERIES: Heard Museum Shop, Phoenix, AZ; Case Trading Post at the Wheelwright Museum, Andrea Fisher Fine Pottery, Santa Fe; Kennedy Indian Arts, Bluff, UT; Rio Grande Wholesale, Palms Trading Company, Albuquerque
PUBLICATIONS: *SWAIA Quarterly* Fall 1982:10-14; *Indian Market Magazine* 1985-2000; *The Messenger,* Wheelwright Museum Spring 1987:3; Winter 1997:14; Trimble 1987:79; *Southwest Art* Sept. 1988:57, 62; Mar. 1989:106; *American Indian Art Magazine* Summer 1990:74; Spring 1992:91; Dillingham 1992:206-208; Hayes & Blom 1996:52-55; 1998:53; Painter 1998:14; Berger & Schiffer 2000:17, 129.

Rebecca Lucario is recognized as one of the top Pueblo Indian potters. The quality of her pottery is exceptional. She is a leading prizewinner, being awarded Best of Division at Indian Market in Santa Fe.

She is best known for two styles: Mimbres Revival pots covered with animal designs and optical eyedazzlers. Her ability to paint complex designs is formidable. Her Mimbres animals are well delineated. Her optical eyedazzlers vibrate with energy. Her work is highly sought after by collectors.

Rebecca shared that she loved making pottery, because "it makes me create and use my imagination." She added, "I want to experiment with new colors and clays. Painting also is relaxing. Painting Mimbres figures allows me to experience new designs and to use different colors."

*Rebecca Lucario -
Andrea Fisher Fine Pottery
Santa Fe*

*Rebecca Lucario -
Andrea Fisher Fine Pottery
Santa Fe*

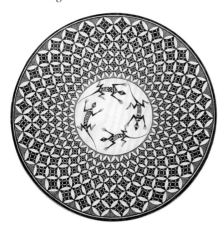

*Rebecca Lucario -
Andrews Pueblo Pottery & Art Gallery*

*Rebecca Lucario -
Bill & Jane Buchsbaum Collection*

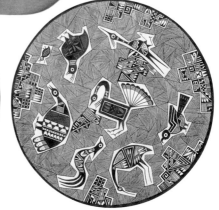

*Rebecca Lucario -
Andrews Pueblo Pottery & Art Gallery*

Velma Lucario *(collaborates with Arthur Lucario), (signs R & V Lucario, Laguna)*

(Acoma/Laguna, active ca. 1987-present: ceramic sgraffito polychrome jars, bowls, vases)
BORN: ca. 1940s
FAMILY: sister-in-law of Sally Garcia; wife of Arthur Lucario; mother of Ray Lucario
(Kachina carver)
AWARDS: 1995, 1st, New Mexico State Fair, Albuquerque
FAVORITE DESIGNS: Eagle & Long Hair Kachinas, Kokopelli, feathers-in-a-row
GALLERIES: Rio Grande Wholesale, Inc., Palms Trading Co., Albuquerque; Arlene's
Gallery, Tombstone, AZ
PUBLICATIONS: Berger & Schiffer 2000:129.

Yvonne Analla Lucas

(Laguna, married into Hopi, active ca. 1990s-present: polychrome jars, bowls)
FAMILY: wife of Steve Lucas
AWARDS: 1998, 2nd; 2000 2nd, 3rd, Indian Market, Santa Fe
EXHIBITIONS: 1997-present, Indian Market, Santa Fe
GALLERIES: Robert Nichols Gallery, Martha Hopkins Streuver, Santa Fe; Adobe East,
Summit, NJ; Native American Collections, Denver, CO; King Galleries of Scottsdale, AZ
PUBLICATIONS: *American Indian Art Magazine* Spr. 1998:17; *Indian Artist* Spr. 1998:63;
Southwest Art Aug. 1998:80; *Indian Market Magazine* 1998:99.

　　　Yvonne is an exceptional and highly talented potter. Her Hopi husband,
Steve Lucas, is one of Dextra Quotsquova's students, and he won Best of Show at
Indian Market. Yvonne observed their techniques, then emerged with her own
pottery in Laguna style. Her pots are gracefully formed, well painted, finely polished.
She has grown into an award winner in the Laguna category at Indian Market.

Antonita Lucero *(Toni)*

(Cochiti, active ?-present: polychrome jars, bowls,
figures, Storytellers)
BORN: September 7, 1942
FAMILY: daughter of Eluterio & Berina Cordero
TEACHER: Stephanie Rhoades
PUBLICATIONS: Berger & Schiffer 2000:129.

Chris Lucero *(see Chris Teller)*

Delray Lucero

(Jemez, Fire Clan, active ca. 1997-present: Bear Storytellers, animal figures - bears with fish)
BORN: August 15, 1984
EXHIBITIONS: 2001, Jemez Pueblo Red Rocks Arts & Crafts Show

Diana Pino Lucero

(Zia, Corn Clan, active ca. 1970s-present: traditional polychrome ollas, jars, bowls, canteens)

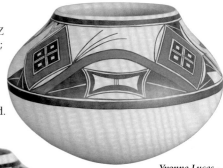

*Yvonne Lucas -Photograph by Tony Molina
Case Trading Post at the
Wheelwright Museum of the American Indian*

*Yvonne Lucas -
Photograph by Bill Bonebrake
Courtesy of Jill Giller
Native American Collections, Denver*

*Yvonne Lucas - Courtesy of
King Galleries of Scottsdale, AZ*

BORN: December 5, 1958
FAMILY: great-great-granddaughter of He-wee'-a & Gaa-
yo-le-nee; m. great-granddaughter of Augustina Aguilar;
m. granddaughter of Manuelita Aguilar Salas & Jesus
Salas (Jemez); daughter of Vicentita S. & John Pino (ca.
1897-?, deceased); sister of John B. Pino, Ronald Pino
TEACHER: Vicentita S. Pino, her mother
AWARDS: 2000, 2nd, Traditional Bowls, Indian
Market, Santa Fe
EXHIBITIONS: 1997-present, Indian Market, Santa Fe;
Heard Museum Show, Phoenix; 1996-present, Eight
Northern Indian Pueblos Arts & Crafts Show;
Walatowa Arts Festival, Jemez Pueblo, NM; New Mexico
State Fair, Albuquerque; Annual Indian/Spanish Market,
Colorado Springs, CO
DEMONSTRATIONS: 1974 Washington, D.C.
ORGANIZATIONS: Indian Arts & Crafts Association
COLLECTIONS: Dr. Gregory & Angie Yan Schaaf, Santa Fe
FAVORITE DESIGNS: deer, bird, rabbit, hummingbird
PUBLICATIONS: *Art Focus* May 1998:5; Sept. 1999:6; *Native Peoples* Sept. 2000:17.

Diana Lucero - Courtesy of the artist

*Delray Lucero -
Photograph by Angie Yan Schaaf*

　　　Diana is one of the few potters at Zia to have her own brochure which states in part: "My mother was my first influence
in my life as a potter. . .My husband and my children have inspired me as well. Their recognition and praise has helped me to
rekindle pride in my work and to make me feel I can be successful as an artist. Their encouragement motivated me to keep
alive this ancient way of pottery making. . ."

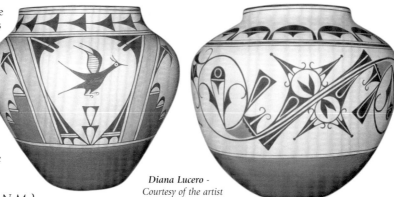

"As we worked and I was "taught"," the mother spirits of the clay rooted themselves in my being, asking for my breath, and seeking life by my hands. My mother tells me the spirits are very possessive, and that our hearts and minds must be free of worldly matters and focused solely on the creation. These days, I can't wait to get home and immerse myself into some aspect of making pottery. I have gotten to the point of looking at nature and everyday objects, and being able to see a design or something to recreate."

Diana Lucero -
Courtesy of the artist

Diane Lucero *(signs D. Lucero, Jemez N.M.)*

(Jemez, Fire Clan, active ca. 1995-present: Storytellers)
BORN: October 1, 1966
FAMILY: daughter of Mary Lucero (1); sister of Joyce Lucero
TEACHER: Joseph Fragua
GALLERIES: The Indian Craft Shop, U.S. Department of Interior, Washington, D.C.
PUBLICATIONS: Berger & Schiffer 2000:129.

Duanna Lucero

(Santo Domingo, active ca. 1990s-present: polychrome jars, bowls)
BORN: May 10, 1982
FAMILY: daughter of Sharon Lucero; mother of Shumaal Lucero

Erwina Lucero

(Jemez, Fire Clan, active ca. 1982-present: polychrome Storytellers, figures)
BORN: September 18, 1968
FAMILY: granddaughter of Mary Lucero (1); daughter of Joyce Lucero

Guadalupe Lucero

(Jemez, active ca. 1950s-?: pottery, paintings)
EDUCATION:1958, Santa Fe Indian School, Santa Fe
COLLECTIONS: Museum of New Mexico, Santa Fe
PUBLICATIONS: Snodgrass 1968; Lester 1997:328.

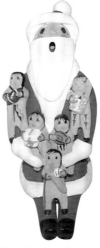

Diane Lucero - Courtesy of
Georgiana Kennedy Simpson
Kennedy Indian Arts, Bluff, UT

Diane Lucero -
Courtesy of John D. Kennedy &
Georgiana Kennedy Simpson
Kennedy Indian Arts

Irvin Lucero *(signs I. Lucero), (collaborates sometimes with Melinda Garcia)*

(Santo Domingo, active ?-present: traditional polychrome ollas, jars, dough bowls)
FAVORITE DESIGNS: plants, banded compositions
GALLERIES: Andrea Fisher Fine Pottery, Santa Fe

Josefita Lucero

(San Felipe, active ?: pottery)
ARCHIVES: Laboratory of Anthropology Library, Santa Fe, lab file.

Joyce Lucero

(Jemez, Fire Clan, active ca. 1982-present: polychrome Storytellers, figures)
BORN: September 18, 1968
FAMILY: daughter of Mary Lucero (1); sister of Diane Lucero; mother of Erwina Lucero
TEACHER: Mary Lucero, her mother
EXHIBITIONS: 1995-present, Eight Northern Indian Pueblos Arts & Crafts Show
FAVORITE DESIGNS: figures with children
GALLERIES: The Indian Craft Shop, U.S. Department of Interior, Washington, D.C.
PUBLICATIONS: Hayes & Blom 1998; Walatowa Pueblo of Jemez, "Pottery of Jemez Pueblo" (1999); Berger & Schiffer 2000:88, 129.

Irvin Lucero & Melinda Garcia -
Andrea Fisher Fine Pottery, Santa Fe

Leonora L. Lucero *(L. Lupe L. Lucero, Leonora Loretto Lucero, Lupe Loretto, L. Lupe Lucero-Loretto), (signs L. Lupe L. Lucero)*

(Jemez/Laguna, Water Clan, married into San Felipe, active ca. 1971-present: polychrome jars, bowls, figures, Storytellers, Koshare Clown Storytellers, Mudheads, lizard effigy pots, paintings)
BORN: December 6, 1943
FAMILY: daughter of Louis & Carrie R. Loretto; sister of Mary Toya, Alma Maestas, Fannie Loretto, Dorothy L. Trujillo (married into San Felipe) and Marie Edna Coriz (married into Santo Domingo); mother of three; aunt of Cecilia Valencia.
TEACHER: Carrie R. Loretto, her mother; Dorothy L. Trujillo, her sister

AWARDS: 1st, New Mexico State Fair, Albuquerque
EXHIBITIONS: 1973, Laguna Arts & Crafts Project participant; 1995-present, Indian Market, Santa Fe
COLLECTIONS: Dr. Gregory & Angie Yan Schaaf, Santa Fe
GALLERIES: The Indian Craft Shop, U.S. Department of Interior, Washington, D.C.; Andrews Pueblo Pottery & Art Gallery, Turquoise Lady, Palms Trading Company, Rio Grande Wholesale, Inc., Albuquerque
PUBLICATIONS: Babcock 1986; Eaton 1990:20; Hayes & Blom 1996:110; 1998; Congdon-Martin 1999:78-79; Berger & Schiffer 2000:89, 129.

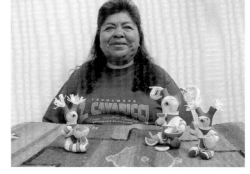

Leonora L. Lucero - Courtesy of Jason Esquibel
Rio Grande Wholesale, Inc.

 Leonora Lucero is one of the Loretto sisters. Her pottery is made from Jemez clays and colors. She participated in the popular movement to create figural pottery in the 1970s and 1980s. She makes Clown Storytellers with cornhusk tassels. Often they are feasting on watermelons.
 Leonora gathers natural clay and fires her figures outdoors in a pit.

Linda Lucero *(see Linda Lucero Fragua)*

Lucia Lucero *(see Lucia Lucero Shije)*

Lucy Lucero
(Acoma, active ?-1975+: polychrome jars, bowls)
PUBLICATIONS: Minge 1991:195.

Lupe Lucero *(see Leonora L. Lucero)*

Lupita Lucero
(Jemez, active ca. 1970s-present: pottery, paintings)
BORN: ca. 1949
AWARDS: Inter-tribal Indian Ceremonial, Gallup; Museum of New Mexico; Scottsdale National Indian Art Exhibition, Scottsdale, AZ
EXHIBITIONS: Philbrook Art Center, Tulsa, OK
PUBLICATIONS: Lester 1997:328.

Magelita Lucero
(Jemez, Fire Clan, active 1920s-?: traditional polychrome jars, bowls)
BORN: ca. 1900s
FAMILY: wife of Narciso Lucero; mother of Margaret Lucero; grandmother of Mary R. Lucero

Margarita Lucero
(Jemez, active ca. 1920s-1970s+: traditional polychrome jars, bowls)
BORN: ca. 1930s
FAMILY: mother of Carol Lucero-Gachupin & Mary Rose Lucero; grandmother of Diane & Joyce Lucero
STUDENTS: Carol Lucero-Gachupin & Mary Rose Lucero, her daughters
 Margarita Lucero taught her daughters how to make pottery in the old, traditional ways. They gathered natural clay. They hand coiled pottery, and fired them outdoors in a pit.

Maria Lucero
(Laguna, active ?-1970s: pottery)
FAMILY: wife of Jose Lucero
EXHIBITIONS: 1972, Indian Market, Santa Fe
PUBLICATIONS: SWAIA Quarterly Fall 1972:6.

Mary I. Lucero *(1), (signs M. I. Lucero)*

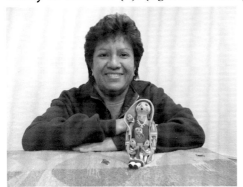

Mary I. Lucero - Courtesy of Jason Esquibel
Rio Grande Wholesale, Inc.

(Jemez, Fire Clan, active ca. 1977-present: Storytellers)
BORN: ca. 1957
FAMILY: sister of Virginia A. Lucero; cousin of Carol Lucero-Gachupin, Mary Rose Lucero
EXHIBITIONS: 1995-present, Eight Northern Indian Pueblos Arts & Crafts Show
FAVORITE DESIGNS: human figures, kiva steps, terraced rain clouds, feathers-in-a-row
GALLERIES: The Indian Craft Shop, U.S. Department of Interior, Washington, D.C.; Rio Grande Wholesale, Alb.; Southwestern Indian Foundation, Gallup
 Mary I. Lucero makes some of the most colorful Storytellers from Jemez. Her grandmothers are wrapped in indigo blue shawls with kiva steps or terraced rain cloud designs along the borders. They wear painted turquoise and squash blossom necklaces. Her babies hold drums and pottery plates with a Mimbres design revived by Julian Martinez, husband of Maria Martinez, called feathers-in-a-row. Mary is joined by her younger sister, Virginia A. Lucero. Both are excellent Storyteller artists.

Mary Rose Lucero *(2), (signs Mary R. Lucero, Jemez)*

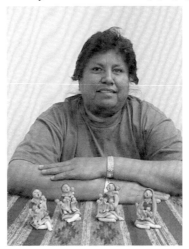

Mary R. Lucero -
Courtesy of Jason Esquibel
Rio Grande Wholesale, Inc.

(Jemez, Fire Clan, active ca. 1960s-present: polychrome Storytellers, Nativities, figures, animals, jars, bowls, turtles, paintings)
BORN: ca. 1940s
FAMILY: granddaughter of Narciso & Magelita Lucero; daughter of Margaret Lucero; sister of Carol Lucero-Gachupin, Betty Ann, Gloria; mother of Diane, William & Joyce Lucero; grandmother of Erwina
TEACHER: Magelita Lucero, her grandmother
STUDENTS: Diane & Joyce Lucero, her daughters
AWARDS: 2nd, Jemez Red Rock Art Show, Jemez, NM; 1999, 4th, New Mexico State Fair, Albuquerque
EXHIBITIONS: 1994-present, Eight Northern Indian Pueblos Arts & Crafts Show; Museum of New Mexico, Santa Fe; Scottsdale National Indian Art Show, Scottsdale, AZ; Washington, D.C.
COLLECTIONS: Dave & Lori Kenney
PUBLICATIONS: Snodgrass 1968; Hayes & Blom 1996; Lester 1997:328; Walatowa Pueblo of Jemez, "Pottery of Jemez Pueblo" (1999).

Mary Rose Lucero commented, "When I sit down to work, not knowing what I would form, it is so amazing what you can do with clay."

Mary R. Lucero -
Courtesy of Jason Esquibel
Rio Grande Wholesale

Mary Lucero *(3)*

(San Felipe, active ?: pottery)
ARCHIVES: Laboratory of Anthropology Library, Santa Fe, lab file.

Nelda Lucero

(Acoma, active ca. 1957-present: traditional & contemporary polychrome jars, bowls)
FAMILY: daughter of Marie C. Torivio; sister of Mary Torivio
TEACHER: Marie C. Torivio, her mother
COLLECTIONS: Allan & Carol Hayes, John Blom
FAVORITE DESIGNS: complex optical patterns, four leaves, clouds
PUBLICATIONS: Dillingham 1992:206-208; Hayes & Blom 1996:52-53; Berger & Schiffer 2000:129.

Mary Rose Lucero -
Dave & Lori Kenney Collection
Santa Fe

Nora Alice Lucero

(Jemez, active ca. 1960s-?: pottery, paintings)

Petra Lucero

(Zia, active ca. 1950s-?: polychrome jars, bowls)
PUBLICATIONS: Barry 1984:105.
One of her spherical bowls is illustrated in Barry 1984. She paints scalloped clouds beneath double orange bands around the rim. Her roadrunner is fleet with sharp tipped tail feathers. The bird's feet hug close to its belly.

Rebecca Lucero

(Jemez, Corn Clan, active ca. 1950s-?: polychrome jars, bowls)
BORN: ca.1940s
FAMILY: wife of Jose Lucero; mother of Linda Lucero Fragua; grandmother of Chrislyn Fragua, Amy Fragua, Loren Wallowing Bull; great-grandmother of Anissa Tsosie (b. 1994)
STUDENTS: Linda Lucero Fragua, her daughter
COLLECTIONS: Philbrook Museum of Art, Tulsa, OK, bowl, ca. 1957

Shumaal Lucero *(collaborates with Genevieve Garcia)*

(Santo Domingo, active ca. 2001-present: black-on-redware pinch pots, animal figures, snakes, dinosaurs)
BORN: January 30, 1999
FAMILY: m. grandson of Sharon Lucero; p. grandson of Genevieve Garcia; son of Duanna Lucero
TEACHERS: Genevieve Garcia, his grandmother; Duanna Lucero, his mother
EXHIBITIONS: 2001, Santo Domingo Indian Arts & Crafts Show
FAVORITE DESIGNS: leaf
Shumaal Lucero — at the age of 2 1/2 — is the youngest potter to appear in the "American Indian Art Series." His paternal grandmother, Genevieve Garcia, commented how one day Shumaal started to make pottery, "He grabbed the clay and did patty cake."
Shumaal sang as he formed his first pinch pot, "Patty mix! Patty mix!"
Shumaal watched his Grandma Genevieve, as she made pottery, and then began to follow her motions. She helped him paint leaves on his pots and supervised the firing of the pottery.
Shumaal then branched off into his own creations. He began forming snakes, dinosaurs and other animal figures.
His mother, Duanna Lucero, also is very proud of her talented young son. Shumaal, his mother and grandmother sometimes make pottery together. Starting at such a young age, Shumaal may enjoy a bright future as an artist.

Virginia A. Lucero *(signs V. Lucero, Jemez)*

(Jemez, Fire Clan, active ?-present: polychrome Storytellers, figures)
BORN: ca. 1964
FAMILY: sister of Mary I. Lucero; cousin of Carol Lucero-Gachupin, Mary Rose Lucero
TEACHERS: Marie Romero & Mary I. Lucero, her sister
FAVORITE DESIGNS: figures with children
GALLERIES: Arlene's Gallery, Tombstone, AZ; Kennedy Indian Arts, UT
 Virginia prepares natural clay in the traditional way. She forms and paints colorful Storytellers with vegetal and mineral pigments. She then fires her pottery figures outdoors in a pit with cedar chips.
 Her figures are lively. They look like they're singing with gusto. Her babies are wide-eyed with smiles on all their faces. Virginia's Storytellers inspire people to smile along with them.

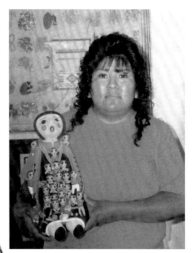

Virginia Lucero -
Courtesy of John D. Kennedy &
Georgiana Kennedy Simpson
Kennedy Indian Arts

William Lucero

(Jemez, ca. 1990s-present: Storytellers)
PUBLICATIONS: Congdon-Martin 1999:80.

Ernestine Lucio

(Zuni, active ca. 1980s-present: polychrome jars, bowls, vases with fluted rims)
BORN: ca. 1970
TEACHER: Jennie Laate
PUBLICATIONS: Rodee & Ostler 1986:85.

Crescencia Lujan

(Santa Ana, active 1910s-?: traditional polychrome ollas, jars, bowls)
EXHIBITIONS: 1925, Indian Market, Santa Fe
COLLECTIONS: School of American Research, Santa Fe, olla, ca. 1925, #387.
PUBLICATIONS: Batkin 1987:203, fn. 103.

Virginia Lucero - Courtesy of
Georgiana Kennedy Simpson
Kennedy Indian Arts, Bluff, UT

Gloria Lujan

(Tigua/Ysleta del Sur, active ca. 1970s-?: polychrome jars, bowls)
PUBLICATIONS: Barry 1984:180-81.

Joe D. Lujan *(signs THL/J. Lujan), (collaborates with Trinnie Herrera Lujan)*

(Sandia/Cochiti, active ca. 1980s-present: Storytellers)
BORN: April 16, 1938; RESIDENCE: Sandia Pueblo
FAMILY: husband of Trinnie Lujan
COLLECTIONS: John Blom
GALLERIES: Kennedy Indian Arts; Palms Trading Company, Albuquerque
PUBLICATIONS: Congdon-Martin 1999:20.

Trinnie Herrera Lujan *(signs T. Lujan or THL/J. Lujan),*
(collaborates sometimes with Joe D. Lujan)

(Cochiti, active ca. 1980s-present: polychrome Storytellers)
BORN: June 3, 1946; RESIDENCE: Sandia Pueblo
FAMILY: wife of Joe D. Lujan
COLLECTIONS: John Blom
GALLERIES: Kennedy Indian Arts, Bluff, UT; Palms Trading Company, Agape Southwest Pueblo Pottery, Albuquerque
PUBLICATIONS: Hayes & Blom 1996:108-09; Congdon-Martin 1999:20.

Joe Lujan -
Courtesy of John D. Kennedy &
Georgiana Kennedy Simpson
Kennedy Indian Arts

Charlene Lukee *(signs C. Lukee)*

(Acoma, active ca. 1988-present: traditional and negative bowls, jars)
BORN: May 23, 1970
FAMILY: daughter of Ramon & Shirley Lukee
PUBLICATIONS: Berger & Schiffer 2000:129.

Trinnie Herrera Lujan -
Courtesy of John Blom

Katerina A. Haskaya Lukee

(Acoma, Roadrunner Clan, active ca. 1990s-present: traditional black-on-white & polychrome jars, bowls)
BORN: ca. 1984
FAMILY: m. granddaughter of Lucy M. Lewis & Toribio Haskaya; daughter of Carmel Lewis Haskaya
EXHIBITIONS: 1991, Indian Market, Santa Fe
PUBLICATIONS: Dillingham 1996:93; Peaster 1997:9.

Lynette Lukee *(signs L.L. Acoma N.M.)*

(Acoma, active ca. 1994-present: ceramic fineline jars & bowls)
BORN: March 1, 1975
FAMILY: daughter of Marvin & Theresa Lukee; sister of Ramona Lukee Chino
GALLERIES: Rio Grande Wholesale, Inc., Palms Trading Co., Albuquerque
PUBLICATIONS: Berger & Schiffer 2000:129.

Mary Lukee

(Acoma/Zuni, active ca. 1950s-1990+: traditional polychrome jars, bowls, wedding vases, figures, Storytellers, jewelry)
BORN: August 17, 1932
FAMILY: granddaughter of Juana Concho; daughter of Juana Pasqual (2); sister of Blanche Antonio
EXHIBITIONS: pre-1985-present, Indian Market, Santa Fe
PUBLICATIONS: *Indian Market Magazine* 1985-2000; Babcock 1986:55, 135, 137; Dillingham 1992:206-208.

Nancy Ann Lukee

(Acoma, active ca. 1970s-present: Anasazi & Tularosa Revival black-on-white, fineline & traditional polychrome jars, bowls, vases)
AWARDS: 1991, 1st, Pasadena Indian Arts & Crafts Show, Pasadena, CA
COLLECTIONS: Luella Schaaf, Oxnard, CA
FAVORITE DESIGNS: human figures, clouds, rain, starburst, leaves, opticals, swirls
PUBLICATIONS: Dillingham 1992:206-208.

Remalda Lukee

(Acoma, active ?-1990+: polychrome jars, bowls)
PUBLICATIONS: Dillingham 1992:206-208.

Shirley Lukee

(Acoma, active ca. 1970s-present: traditional bowls, jars)
BORN: ca. 1950
FAMILY: wife of Ramon Lukee; mother of Charlene Lukee
GALLERIES: Rio Grande Wholesale, Inc., Palms Trading Co., Albuquerque
PUBLICATIONS: Berger & Schiffer 2000:129.

Ted Lukee

(Acoma/Zuni, active ca. 1980s-1990+: pottery, jewelry, gourds)
EXHIBITIONS: pre-1985-present, Indian Market, Santa Fe
PUBLICATIONS: *Indian Market Magazine* 1985-2000;

Terri Lukee *(signs T. Lukee)*

(Acoma, active ca. 1977-present: ceramic fineline jars, bowls)
BORN: September 9, 1937
FAMILY: daughter of Juana & Garcia Chino
TEACHER: Juana Chino, her mother
PUBLICATIONS: Minge 1991:195; Berger & Schiffer 2000:130.

Theresa Lukee *(Teresa)*

(Acoma, active ca. 1960s-present: ceramic polychrome jars, bowls)
BORN: ca. 1940s
FAMILY: wife of Marvin Lukee; mother of Ramona Lukee Chino & Lynette Lukee
STUDENTS: Ramona Chino, her daughter, and Manuel Martinez
GALLERIES: Rio Grande Wholesale, Inc., Palms Trading Co., Albuquerque
PUBLICATIONS: Berger & Schiffer 2000:108.

G. M. *(see Genevieve Magdalena)*

I. R. M *(see Irma Maldonado)*

J. M. S. D. P. *(see Josie Martinez)*

M. M. *(see Manuel Martinez, Acoma)*

M. M.

(Jemez, active ca. 1980s-present: miniatures)
PUBLICATIONS: Schiffer 1991d.

P. M.

(Jemez, active ca. 1980s-present: Storytellers
PUBLICATIONS: Congdon-Martin 1999:80.

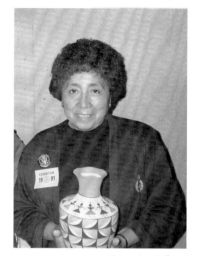

Nancy Ann Lukee -
Photograph by Gregory Schaaf

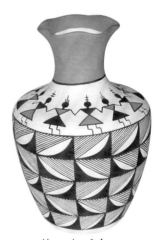

Nancy Ann Lukee -
Luella Schaaf Collection,
Oxnard, CA

Barbara Madalena *(see Barbara Madalena Loretto)*

Shannon Madalena *(Shannon Madelena Ellington)*
(Jemez, active ca. pre-1980s-present: pottery)
AWARDS: 1998, Indian Market, Santa Fe
EXHIBITIONS: pre-1985-present, Indian Market, Santa Fe

Benigna Medina Madelena
(Zia, Corn Clan, married into Jemez Pueblo, active ca. 1900-?: traditional Zia and Jemez style polychrome jars, bowls)
LIFESPAN: ca. 1880-?
FAMILY: wife of Ramon Madelena (Jemez); mother of Persingula M. Gachupin, Elcira Madelena & Josephita Madelena; m. grand-mother of Marie G. Romero, Leonora G. Fragua; m. great-grandmother of Bertha Gachupin, Matthew Fragua, Elmer Fragua, Virgil Fragua, Loren Fragua, Laura Gachupin, Maxine Toya & Virginia Ponca Fragua; great-great-grandmother of Charinda Fragua, Marlinda Fragua, Brandon Fragua, Benina Foley, Gordon Foley & Damian Toya
AWARDS: 1926, Indian Fair [Market], Santa Fe
PUBLICATIONS: U.S. Census 1920, Jemez Pueblo, family 77; Sando 1982:198-99; Batkin 1987:187.

Around 1900, Benigna Medina Madelena introduced Zia pottery techniques into Jemez Pueblo after she married a Jemez Pueblo man, Ramon Madelena. At the time of the 1920 U.S. Census, they were living in Jemez Pueblo with their three daughters - Persingula, Elcina & Josephita. Persingula later married Joe R. Gachupin. Their children and grandchildren became known for their fine traditional pottery, especially matte polychrome on polished redware.

Benigna was an award-winning potter. She won prizes for her Jemez-style pottery at the 1926 Indian Fair, the earlier name of the Santa Fe Indian Market. She was joined at the show by Refugia Toledo and Leonore Baca, two other potters working in the Jemez style.

Bernadette Madelena
(Jemez, active ca. 1990s-present: pottery)
EXHIBITIONS: 1993-present, Indian Market, Santa Fe

Elcira Madelena
(Jemez/Zia, active ca. 1930s-60s+: traditional polychrome jars, bowls)
BORN: ca. 1915
FAMILY: daughter of Ramon & Beninga Madelena; mother of Mary Rose Toya (3)
STUDENT: Mary Rose Toya (3), her daughter
PUBLICATIONS: Berger & Schiffer 2000:154.

Genevieve Madelena *(Magdelena), (signs G. M.)*
(Jemez, active ca. 1940s-present: traditional polychrome jars, bowls)
BORN: April 26, 1931
FAMILY: wife of Frank Madalena; mother of Barbara M. Loretto
EXHIBITIONS: pre-1985-present, Indian Market, Santa Fe
PUBLICATIONS: *Indian Market Magazine* 1988, 1989; Berger & Schiffer 2000:38, 130.

Mary Madelena *(M. Madelena, Magdalena)*
(Jemez, active ca. 1980s-present: matte polychrome Storytellers, black-on-white ollas, jar, bowls, with orange bases)
FAMILY: daughter-in-law of Carmelita Magdalena
EXHIBITIONS: 1985-present, Indian Market, Santa Fe
FAVORITE DESIGNS: optical, frets, mazes, stars
GALLERIES: Kennedy Indian Arts, Bluff, UT; Sunshine Studio at www.sunshinestudio.com
PUBLICATIONS: Congdon-Martin 1999:81.

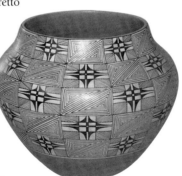

Mary Madelena - Courtesy of Georgiana Kennedy Simpson Kennedy Indian Arts, Bluff, UT

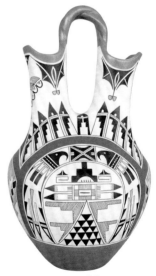

Mary Madelena - Courtesy of Sunshine Studio

Reyes Madelena *(Reyes Madelena-Butler, Madelena Reyes Butler)*
(Jemez, active ca. 1950s-present: traditional sgraffito & traditional polychrome & unpainted storage jars, seed bowls, wedding vases, Storytellers, animal figures, bears, canteens, non-traditional)
BORN: October 3, 1938; RESIDENCE: Moab, UT
FAMILY: mother of Shannon Madalena-Ellington
AWARDS: 1992, 2nd, figures; 1993, 2nd, figures; 1994, 2nd; 1998, Best of Division (2), 1st, 2nd (2); 1999, Indian Market, Santa Fe
EXHIBITIONS: pre-1985-present, Indian Market, Santa Fe
COLLECTIONS: Philbrook Museum of Art, Tulsa, OK, jar, ca. 1966; Wright Collection, Peabody Museum, Harvard University, Cambridge, MA
PUBLICATIONS: *Southwest Art* June 1989:102; *Indian Market Magazine* 1985, 1988, 1989, 1998:99; Drooker & Capone 1998:57, 138.

Alma Loretto Maestas *(Painted Parrot, Alma L. Maestas, Alma Concha Loretto, Alma Loretto Concha),*
(signs ALMA with a Water Clan hallmark)
(Jemez/Laguna, Water Clan, active ca. 1949-present: polychrome Storytellers, Bear Storytellers, Clown Storytellers & figures, Nativities, fetish jars-ca. 1980s)
BORN: October 9, 1941
FAMILY: m. great-granddaughter of Fannie Pino & John Reid; granddaughter of Jose Loretto, Guadalupe Magdelena; daughter of Louis & Carrie R. Loretto; sister of Mary Toya, Fannie Loretto, Leonora Lupe L. Lucero, Marie Edna Coriz & Dorothy Trujillo; wife of Vitalio Maestas; mother of Antoinette Concha, Vernon Loretto, Renee Pumkin Concha, Del Pino Concha, Maruica Concha, Monica Concha, John D., Justin Concha
TEACHER: Carrie R. Loretto, her mother
AWARDS: Indian Market, Santa Fe; Heard Museum Show, Phoenix; New Mexico State Fair, Albuquerque; Inter-tribal Indian Ceremonial, Gallup; 1st, Eight Northern Indian Pueblos Arts & Crafts Show
EXHIBITIONS: 1979, "One Space: Three Visions," Albuquerque Museum, Albuquerque; 1985-present: Indian Market, Santa Fe; 1995-present: Eight Northern Indian Pueblos Arts & Crafts Show
COLLECTIONS: Smithsonian Institution, Washington, D.C.; Plymouth Historical Society, Plymouth, MI; Museum of New Mexico, Museum of International Folk Art, Wheelwright Museum, Santa Fe; Milicent Rogers Museum, Taos, NM
GALLERIES: The Indian Craft Shop, U.S. Department of Interior, Washington, D.C.; Sipapu Gallery, Plymouth, MI; Crosby Collection,, Park City, UT; Adobe Gallery, Albuquerque & Santa Fe; Rio Grande Wholesale, Palms Trading Company, Albuquerque
PUBLICATIONS: Monthan 1979; *National Geographic Magazine* 1982; *American Indian Art Magazine* Spring 1983 8(2):34; *Indian Market Magazine* 1985, 1988, 1989; Babcock 1986; Hayes & Blom 1996; Congdon-Martin 1999:74-75; Berger & Schiffer 2000:108; 130.

Alma Maestas is an award-winning Storyteller artist. She learned from her mother, Carrie Reid Loretto, a respected pottery artist. In 1979, Alma participated in the landmark exhibition, "One Space: Three Visions," at the Albuquerque Museum. Three years later, in 1982, she was featured in *National Geographic Magazine*. In the 1980s, she lived for a while at Taos Pueblo, where she made some fetish jars for a short time.

Alma's style could be characterized as "minimalist," meaning that she has reduced the features of the human form down to minimal shapes. Their eyes are undeliniated. Their ears are covered with caps or blankets. Their noses are like little beaks. Their mouths occasionally open in an oval.

Alma uses a matte orange natural clay. She paints their clothing with a cream clay paint. Her Nativities kneel poised in silent contemplation, while an angel sings. Baby Jesus rests in a Pueblo style cradle.

Alma's fine art pottery figures are admired by a broad public audience. She shares her work gracefully and is widely respected, "God gave me the talent to make pottery, and I really enjoy making people happy."

Alma Concha Maestas -
Courtesy of Jason Esquibel
Rio Grande Wholesale, Inc.

Carmelita Magdalena

(Jemez, Eagle Clan, active ca. 1949-present: black & red-on-cream jars, bowls)
BORN: July 22, 1931
FAMILY: mother of six boys & three girls, including Phyllis M. Tosa; mother-in-law of Mary Madelena; grandmother of Earl, Madalin & Paula Tosa
EXHIBITIONS: pre-1985-present, Indian Market, Santa Fe

Carmelita shared that she enjoyed making pottery because, "I think it's fun and I make a little money."

Carmen Magdalena

(Jemez, active ca. 1960s-80s: polychrome jars, bowls)
COLLECTIONS: Dr. Gregory & Angie Yan Schaaf, Santa Fe
FAVORITE DESIGNS: rosettes, terraced clouds, fineline rain

D. J. Magdalena

(Jemez, active ca. 1980s-present: matte polychrome Storytellers, Drummers)
GALLERIES: Palms Trading Company, Albuquerque
PUBLICATIONS: Congdon-Martin 1999:81.

Rita Magdelena *(see Rita Casiquito)*

C. Mahkee

(Acoma, active ?-1990+: polychrome jars, bowls)
PUBLICATIONS: Dillingham 1992:206-208.

Irma Maldonado *(signs I.R.M.)*

(Acoma, active ca. 1972-present: traditional polychrome jars, bowls)
BORN: August 1, 1932
FAMILY: daughter of Santana Antonio
TEACHER: Santana Antonio, her mother
GALLERIES: Rio Grande Wholesale, Inc., Palms Trading Co., Albuquerque
PUBLICATIONS: Dillingham 1992:206-208; Berger & Schiffer 2000:130.

Dean Malie *(collaborates with Rita Malie), (signs Dean & R Malie, Acoma)*
(Acoma, active ca. 1982-present: traditional polychrome, black-on-orange, black-on-white fineline jars, bowls)
GALLERIES: The Indian Craft Shop, U.S. Department of Interior, Washington, D.C.; Andrews Pueblo Pottery & Art Gallery, Albuquerque
PUBLICATIONS: Berger & Schiffer 2000:18, 130.

Rita Malie *(signs R. Malie or Dean & R Malie, Acoma)*
(Acoma, Yellow Corn & Eagle Clans, active ca. 1982-present: traditional polychrome, black-on-orange, black-on-white fineline jars, bowls)
BORN: September 25, 1946
FAMILY: granddaughter of Pueblo & Maria Garcia; daughter of John & Lupe G. Concho; sister of Ruby Shroulote, Doris Patricio; mother of Tanya, Denise, Darcy Malie, Tyler Malie
TEACHER: Lupe G. Concho, her mother
FAVORITE DESIGNS: deer, birds, fish
GALLERIES: Andrews Pueblo Pottery & Art Gallery, Alb.; Native American Collections, Denver, CO
PUBLICATIONS: Dillingham 1992:206-208; Berger & Schiffer 2000:18, 130.

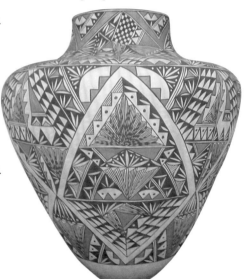

Rita Malie -
Photograph by Bill Bonebrake
Courtesy of Jill Giller
Native American Collections, Denver, CO

Louis Mansfield *(collaborates with Nadine Mansfield), (signs Louis, Nadine Mansfield, Acoma)*
(Acoma, active ca. 1986-present: traditional polychrome jars, bowls)
BORN: February 21, 1968; RESIDENCE: San Fidel, NM
FAMILY: son-in-law of Betty Ramirez-Concho; husband of Nadine Mansfield
TEACHER: Betty Ramirez-Concho, his mother-in-law
AWARDS: 1997, 2nd, New Mexico State Fair, Albuquerque; 1998, 3rd, New Mexico State Fair, Albuquerque
FAVORITE DESIGNS: human figures, lizards, corn plants, starburst, feathers, rain
GALLERIES: The Indian Craft Shop, U.S. Department of Interior, Washington, D.C.
PUBLICATIONS: Berger & Schiffer 2000:130.

Nadine Mansfield *(collaborates with Louis Mansfield),*
(signs Louis, Nadine Mansfield, Acoma)
(Acoma, active ca. 1985-present: traditional polychrome jars, bowls)
BORN: ca. 1968; RESIDENCE: San Fidel, NM
FAMILY: daughter of Betty Ramirez-Concho; wife of Louis Mansfield
TEACHER: Betty Ramirez-Concho, her mother
AWARDS: 1997, 2nd; 1998, 3rd, New Mexico State Fair, Albuquerque
FAVORITE DESIGNS: human figures, lizards, corn plants, starburst, feathers, rain
GALLERIES: The Indian Craft Shop, U.S. Department of Interior, Washington, D.C.
PUBLICATIONS: Berger & Schiffer 2000:130.

Concepcion Mariana
(Acoma, active ?: pottery)
ARCHIVES: Laboratory of Anthropology Library, Santa Fe; lab. file.

Lucilla Mariano
(Laguna, ca. 1930s-?: traditional polychrome jars)
COLLECTIONS: Philbrook Museum of Art, Tulsa, OK, jar, ca. 1938

John Marris
(Laguna, active ca. 1980s-90s: ceramic fineline jars, bowls)
LIFETIME: September 11, 1960 - ca. 1990s
FAMILY: son of Larose Saiz
AWARDS: 1994 New Mexico State Fair, Albuquerque
PUBLICATIONS: Berger & Schiffer 2000:130.

Louis & Nadine Mansfield -
Courtesy of Jason Esquibel
Rio Grande Wholesale, Inc.

Bill Martin *(collaborates with Mary S. Martin)*
(Cochiti, active ca. 1940s-present: polychrome Storytellers, figures, drummers)
BORN: ca. 1920s
FAMILY: husband of Mary S. Martin; father of Gladys Martin & Adrienne Martin

Doloritas Martin
(Acoma, active ca. 1860s-1910s+: polychrome jars, bowls)
BORN: ca. 1850
PUBLICATIONS: Leopold Bibo, "13th Annual U.S. Census" (1910), New Mexico State Archives, Call T624, Roll 919; in Dillingham 1992:205.

Johnny Martin
(Laguna, active ?-present: pottery)
EXHIBITIONS: 1995, Eight Northern Indian Pueblos Arts & Crafts Show

Mary S. Martin *(collaborates with Bill Martin, her husband)*
(Cochiti, active ca. 1940s-present: polychrome Storytellers, figures, drummers)
BORN: June 17, 1927
FAMILY: granddaughter of Maria Seferina Arquero; wife of Bill Martin; mother of Gladys Martin & Adrienne Martin
STUDENTS: Snowflake Flower, her cousin
AWARDS: 1983, 1st, Indian Market, Santa Fe
EXHIBITIONS: pre-1988-present, Indian Market, Santa Fe
GALLERIES: Adobe Gallery, Albuquerque
PUBLICATIONS: Babcock 1986:129; Congdon-Martin 1999:21.
> In 1974, Mary Martin made her first Storyteller. She expressed her faith in traditional firing: "When firing, the weather must be calm; if it is windy, figurines become smoked, which may result in a second firing. Firing depends on Mother Nature. It involves big chance and prayer." (Babcock 1986:129)

Tina Martin *(possibly also Tina Tuttle), (collaborates with Anita Tuttle)*
(Acoma, active ?: pottery, sewing)
RESIDENCE: San Fidel, NM

Crescencia Martinez
(Santa Ana, active ca. 1940s-?: traditional polychrome ollas, jars, bowls)
COLLECTIONS: School of American Research, Santa Fe, olla, ca. 1949, #2370.
PUBLICATIONS: Batkin 1987:203, fn. 103.

Denise Martinez
(Cochiti, active ?: pottery)
PUBLICATIONS: Hotham, 6th ed., 309.

Evelyn Martinez
(Acoma, active ?-1990+: polychrome jars, bowls)
PUBLICATIONS: Dillingham 1992:206-208.

Harold Martinez
(Acoma, active pre-1990)
PUBLICATIONS: Dillingham 1992:206-208.

Josie Martinez *(J. M. S.D.P)*
(Santo Domingo, active ?-present: black-on-black jars, bowls)
PUBLICATIONS: Hayes & Blom 1996:146-47.

Luis Martinez
(Santo Domingo, active ca. 1980s-present: polychrome jars, bowls)
BORN: ca. 1960s
GALLERIES: Isa Fetish, Cumming, GA

*Luis Martinez -
Courtesy of Isa & Dick Diestler
Isa Fetish, Cumming, GA*

Manuel Martinez *(collaborates with Ramona Martinez), (signs M.M. Acoma N.M.)*
(Acoma, active ca. 1988-present: ceramic polychrome jars, bowls)
BORN: December 20, 1963
TEACHER: Theresa Lukee
GALLERIES: Rio Grande Wholesale, Inc., Palms Trading Co., Albuquerque
PUBLICATIONS: Berger & Schiffer 2000:18, 131.

Margaret Martinez
(Acoma, active ?-1990+: polychrome jars, bowls)
PUBLICATIONS: Dillingham 1992:206-208.

Ramona Martinez *(collaborates with Manuel Martinez)*
(Acoma, active ca. 1980s-present: ceramic polychrome jars, bowls)
GALLERIES: Rio Grande Wholesale, Inc., Palms Trading Co., Albuquerque
PUBLICATIONS: Berger & Schiffer 2000:18, 131.

Ronald Martinez *(see Looking Elk)*

Sarah Martinez
(Acoma, active ?-1990+: polychrome Storytellers, jars, bowls)
PUBLICATIONS: Dillingham 1992:206-208; Painter 1998:14.

Stephanie Martinez
(Acoma, active ?-1990+: polychrome jars, bowls)
PUBLICATIONS: Dillingham 1992:206-208.

Teodorita Matai

(Acoma, active ca. 1860s-1910s+: polychrome jars, bowls)
BORN: ca. 1850; RESIDENCE: Acomita in ca. 1910
PUBLICATIONS: Leopold Bibo, "13th Annual U.S. Census" (1910), New Mexico State Archives, Call T624,
Roll 919; in Dillingham 1992:205.

Mavis *(see Mavis B. Herrera)*

*Angelina Medina -
Courtesy of the artist*

Angelina Francis Medina *(Angela, Shru-wa-tsi-tai or Shree-see-yai, Blue Jay)*

(Acoma/Zia/Zuni, Bear Clan, active Christmas Day,1983-present: polychrome jars, effigy bowls, clay sculptures, acrylic painting, jewelry, ornaments, miniatures, silkscreen T-shirt designs)
BORN: December 5, 1942; RESIDENCE: San Ysidro, NM
FAMILY: m. granddaughter of Juana Cimmeron; daughter of Elizabeth Valles & Joe Medina (Zia); wife of Calsue Murray.
STUDENTS: Noreen Simplicio, Anderson Peynetsa, Margie Chavez, Bernadette Chavez, Doreen (Hopi)
AWARDS:

1983	Best Craftsman, 1st, Santa Monica Indian Art Show, Santa Monica, CA
1984	Best Craftsman, 1st (2), Pasadena Indian Art Show, CA; Best Craftsman, 1st (2), Santa Monica Indian Art Show; 1st, Page Indian Art Show, Page, AZ; Most Creative Artist in All Categories, Indian Market, Santa Fe; Special Award, Illinois Art Asso., IL; Special Merit Award for Sculpture, Cedarhurst Arts & Crafts Show
1985	Best Craftsman, 1st (3), Santa Monica Indian Art Show
1986	Most Creative Design in Any Class, Indian Market, Santa Fe; Most Beautiful Pottery, San Francisco Indian Art Show, CA; SWAIA Award for Most Creative Design, Indian Market, Santa Fe
1988	Best of Show, 1st, Pasadena Indian Art Show, CA; 1st, Sculpture, Indian Market, Santa Fe; 1st, 2nd, Colorado Indian Market, Denver; 1st (2), Palm Springs Indian Art Show, CA; Best Craftsman,1st, Santa Monica Indian Art Show
1989	2nd, 3rd, Inter-tribal Indian Ceremonial, Gallup, NM; Best Craftsman, Colorado Indian Market, Denver, CO
1990	Artist of the Year, IACA, Mesa, AZ
1995	Best of Category, IACA, Mesa AZ; Best of Show, 1st, Pasadena Native American Arts Show, CA; 3rd, Indian Market, Santa Fe
1998	1st, 2nd, Indian Art Northwest, Portland
2000	1st (2), 2nd (2), Indian Art Northwest, Portland; Governor's Award, Santa Fe

*Angelina Medina -
Courtesy of the artist*

*Angelina Medina -
Courtesy of Mary Dwyer
Sedona, AZ*

CAREER: elementary teacher, Pinehill Elementary School, Pinehill, NM
EXHIBITIONS: 1983-present, Indian Market, Santa Fe; Eight Northern Indian Pueblos Arts & Crafts Show; Inter-tribal; Heard Show; IACA; Peabody Museum, Harvard, Syracuse University, University of PA at Harrisburg, Miller's Collection; 1994, Madison Library, Madison, NJ
COLLECTIONS: Walton-Anderson, Mary Dwyer
FAVORITE DESIGNS: dancers from the Zia & Acoma traditions
GALLERIES: Case Trading Post at the Wheelwright Museum of the American, Santa Fe; Keshi, Santa Fe
PUBLICATIONS: *Indian Market Magazine* 1985, 1988, 1989; Nahohai & Phelps 1995:89; Painter 1998:14.

Angelina Medina was raised partly by her maternal grandmother, Juana Cimmeron, who was an excellent traditional potter. Juana Cimmeron's family members were originally of the Bear Clan from Zuni. When the Pueblo of Acoma needed them to re-strengthen the Bear Clan at Acoma, the family moved to Acoma where they were given a respected position within Acoma society. Angelina recalled, "I remember watching my grandmother sitting with a board on her lap, rolling out clay for her pottery."

In the 1970s, Angelina participated actively in American Indian affairs. She was at Alcatraz Island in the takeover during the Red Power Movement. She later worked for the President of San Jose State University. At Fort Lewis College, protested state withdrawal of promises to provide free tuition for Indian Students. She was President of Indian Club and organized representatives of All Indian Pueblo Council.

In 1981, Angelina won first prize at her first art competition in California. She continued to demonstrate pottery making across the country. She lectured at Peabody Museum at Harvard University. She also began conducting workshops to relieve stress and to address emotional issues.

Angelina has influenced many people in her life. She has served as an educational role model. Zuni artist Noreen Simplicio spoke with admiration, "This lady friend of mine, Angelina Medina, does beautiful clay sculptures. That's what I've been wanting to do, sculpt with clay, especially human figures." (Nahohai & Phelps 1995:89)

Angelina explained "A person is not limited to one or two things. An artist has unlimited potential to do anything their heart desires."

*Angelina Medina -
Walton-Anderson Collection*

*Angelina Medina- Photograph by Tony Molina
Courtesy of Case Trading Post at the
Wheelwright Museum of the American Indian*

Benina Medina

(Zia, active ca. 1950s-80s: traditional polychrome ollas, jars, dough bowls)
BORN: ca. 1930

Benina Medina made especially beautiful dough bowls. They were masterpieces. She had a nice home on the Zia Plaza.

Cippina Medina

(Cochiti, active ?: polychrome jars, bowls)
COLLECTIONS: Wright Collection, Peabody Museum, Harvard University, Cambridge, MA
PUBLICATIONS: Drooker, et al., 1998:49.

Edna Medina *(see Edna Medina Galiford)*

Elizabeth Medina -
Photograph by Bill Bonebrake
Courtesy of Jill Giller
Native American Collections, Denver

Elizabeth Toya Medina *(Sepia, Liz, Elizabeth Toya), (collaborates sometimes with Marcellus Medina or Sophia Medina)*

Elizabeth Medina -
Courtesy of Jason Esquibel
Rio Grande Wholesale, Inc.

(Jemez/married into Zia, active ca. 1980-present: polychrome jars, bowls)
BORN: November 30, 1956
FAMILY: daughter of Mary S. Toya; sister of Bertina Tosa; wife of Marcellus Medina; daughter-in-law of Sophia & Rafael Medina
TEACHER: Sophia Medina, her mother-in-law
AWARDS: 1984, 1st; 1986, Best Traditional Jar or Bowl over 15";
1988, 2nd, jars; 1991, 3rd, jars, 3rd, bowls; 1992, 1st, jars; 1993, 2nd, traditional jars; 1998, 3rd, H.M., Best of Pottery; 2000, 1st; Indian Market, Santa Fe; 1st, 2nd, 3rd, Eight Northern Indian Pueblos Arts & Crafts Show; New Mexico State Fair, Albuquerque; Colorado Indian Market, Denver
EXHIBITIONS: 1982-present, Indian Market, Santa Fe; 1995-present, Eight Northern Indian Pueblos Arts & Crafts Show
COLLECTIONS: Wright Collection, Peabody Museum, Harvard University, Cambridge, MA; Candace Collier, Houston; Dr. Gregory & Angie Schaaf; Gerald & Laurette Maisel, Tarzana, CA
FAVORITE DESIGNS: roadrunners, robins, berry bushes, flowers, some turtle effigy lids, rain clouds, rainbows, fineline hatching
GALLERIES: Native American Collections, Denver, CO; Adobe Gallery, Rio Grande Wholesale, Palms Trading Co., Andrews Pueblo Pottery & Art Gallery, Agape Gallery, Albuquerque

PUBLICATIONS: *SWAIA Quarterly* Fall 1982:10; Barry 1984:102, 107; Trimble 1987:65-66; Dillingham 1994:106, 114-16; *New Mexico Magazine* August 1994:36; Hayes & Blom 1996:164-65; Peaster 1997:150; Drooker & Capone 1998:139; Tucker 1998: plate 90; Anderson, et al. 1999:46; Berger & Schiffer 2000:131.

Elizabeth Medina is from Jemez, but married into Zia. Her early pots were made in Jemez style. After marrying Marcellus Medina from Zia in 1978, she changed styles. In the traditional way, she received tribal permission to make pottery in the Zia style. She credits her mother-in-law, Sofia Medina, as her source of "inspiration." They collaborated on some pots, working together while developing their family relationship.

Elizabeth is respected for her ability to create pottery ollas with the most beautiful and graceful forms. Her sense of balance and esthetics give her pots a special feeling of harmony. She paints many pots herself, depicting traditional Zia designs. However, her husband, Marcellus Medina, paints some of her pots. His designs mostly portray Zia Pueblo dancers. Their work is recognized as being among the best in contemporary Pueblo pottery.

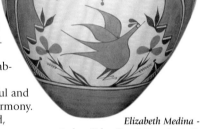

Elizabeth Medina -
Andrea Fisher Fine Pottery, Santa Fe

Geronima Medina *(Jeronima)*

(Zia, active ca. 1910s-?: traditional polychrome ollas, jars, bowls)
BORN: ca. 1882
FAMILY: wife of Jose Medina; mother of Eralia & Rosita Medina
COLLECTIONS: Philbrook Museum of Art, Tulsa, OK, olla, ca. 1939
FAVORITE DESIGNS: birds, butterflies, rainbows
VALUES: On December 4, 1993, a polychrome olla (10" dia.) sold for $4,600 at Sotheby's, lot 104.
PUBLICATIONS: U.S. Census 1920, family 14.

Isabel Medina

(Zia, active ?-1990s: pottery)
EXHIBITIONS: 1992, Indian Market, Santa Fe
VALUES: On May 11, 1998, a polychrome olla, signed Isabel Medina (8.5 x 9.75"), sold for $3,450 at Butterfield & Butterfield, #7383.

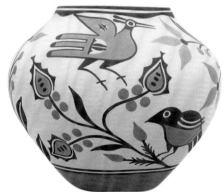

Elizabeth Medina -
Nedra Matteucci Galleries, Santa Fe

Isadora Medina

(Zia, active ca. 1910s-?: traditional polychrome jars, bowls)
BORN: ca. 1894
FAMILY: wife of Atrecio Medina
PUBLICATIONS: U.S. Census 1920, family 15.

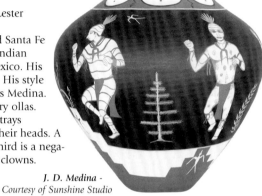

José D. Medina -
Candace Collier Collection, Houston, TX

José D. Medina *(J. D. Medina, José de la Cruz Medina), (collaborated sometimes with Sofia Medina, his sister-in-law)*

(Zia, active ca. 1950s-?: polychrome jars, bowls, paintings)
BORN: ca. 1935
FAMILY: p. grandson of Trinidad Medina; son of San Juanito & Miguelita Medina; brother of Rafael Medina, Anita Candelaria, Lena Medina, Carolina Medina, Ernest Medina Patrick Medina & Priscilla Medina; brother-in-law of Sofia Medina
COLLECTIONS: National Museum of the American Indian, Smithsonian Institution, Washington, D.C., Center for Great Plains Studies, University of Nebraska; Heritage Center Collections, Pine Ridge, South Dakota; Museum of Northern Arizona, Flagstaff; Candace Collier, TX
MATERIALS: acrylic, oil, watercolor, casein, pen and ink
FAVORITE DESIGNS: Pueblo dancers, buffalo dancers, feathers, birds
PUBLICATIONS: Snodgrass 1968:116; Brody 1971; Barry 1984:102, 105, 107; Lester 1995:355; Dillingham 1996:106, 108-09.

 José Medina grew up at Zia Pueblo. From 1949 to 1953, he attended Santa Fe Indian School and continued his education at the Institute of American Indian Arts. He served honorably in the Marine Corps, then returned to New Mexico. His reputation as a painter in various media preceded his painting of pottery. His style is similar to that of his brother, Rafael Medina, and his nephew, Marcellus Medina. They portray Pueblo dancers and bold pictorial scenes in acrylic on pottery ollas.

 Three of J. D.'s ollas, ca. 1979, are illustrated in Barry 1984. One portrays Koshare clowns and Zia Pueblo Indian women dancers with tablitas on their heads. A second is an active frieze of Apache Ga-he or Mountain Spirit dancers. A third is a negative white on black design, like scratchboard, revealing powerful Koshare clowns.

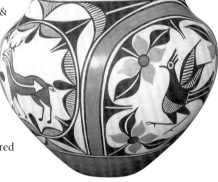

J. D. Medina -
Courtesy of Sunshine Studio

Kimberly H. Medina

(Zia, active ca. 1987-present: polychrome jars, bowls)
BORN: April 24, 1973
FAMILY: great-great-granddaughter of Rosalea Medina Toribio; great-granddaughter of Juanita Toribio Pino; granddaughter of Sofia and Rafael Medina; daughter of Marcellus & Elizabeth Medina; sister of Marcella Medina.
AWARDS: Honorable Mention, Colorado Indian Art Show, Denver
FAVORITE DESIGNS: roadrunners, flowers, rainbows, clouds
PUBLICATIONS: Dillingham 1994:106, 117; Peaster 1997:150; Berger & Schiffer 2000:131.

 Kimberly expresses her feelings of pride in their family heritage. She is proud that her family maintains these traditions, "passed from generation to generation."

Lois Medina *(sometimes collaborates with Sofia Medina, her mother)*

(Zia, Coyote Clan, active ca. 1981-present: traditional polychrome ollas, some with figured lids, jars, bowls, bear figures)
BORN: December 9, 1959
FAMILY: great-granddaughter of Rosalea Medina Toribio; granddaughter of Juanita Toribio Pino; daughter of Sofia and Rafael Medina; sister of Marcellus Medina, Rachel Medina, Samuel Medina, Edna Medina Gailford, Herman Medina & Fred Medina.
TEACHERS: Juanita Toribio Pino, her grandmother; Sofia Medina, her mother
AWARDS: 1996, 1st, Santa Fe Indian Market; 1st, New Mexico State Fair, Albuquerque; 1st Inter-tribal Indian Ceremonial, Gallup
EXHIBITIONS: 1988-present, Indian Market, Santa Fe
COLLECTIONS: Jane & Bill Buchsbaum, Santa Fe; Candace Collier, Houston, TX
FAVORITE DESIGNS: bears, roadrunners, feathers-in-a-row, terraced clouds, rain
VALUES: On May 17, 2000, a polychrome olla, signed Lois Medina, (13 x 17"), sold for $2,160, at Sotheby's, #541.
GALLERIES: Native American Collections; Nedra Matteucci Galleries; Adobe Gallery
PUBLICATIONS: Dillingham 1994:106, 112; Mercer 1995:37, 44; Hayes & Blom 1996:162-63; Peaster 1997:150; Berger & Schiffer 2000:131.

 When Lois Medina began making pottery, her maternal grandmother, Juanita Toribio Pino, sat her down and shared their family traditions related to pottery: "how it was created — the true meaning behind it." Grandmother Pino also gave Lois a bundle of "tools, gourds, brushes, black stone [for painting]." Lois saves these objects respectfully, explaining that they are too precious to use.

Lois & Sophia Medina -
Photograph by Bill Bonebrake
Courtesy of Jill Giller
Native American Collections, Denver

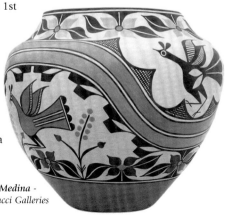

Sofia & Lois Medina -
Nedra Matteucci Galleries

Luciana Medina

(Zia, active ca. 1890s-?: traditional polychrome jars, bowls)
BORN: ca. 1872
FAMILY: wife of Julian Medina
PUBLICATIONS: U.S. Census 1920, family 13.

Marcella Medina

(Zia, active ca. 1990s-present: traditional polychrome ollas, jars, bowls)
BORN: 1974
FAMILY: great-great-granddaughter of Rosalea Medina Toribio; great-granddaughter of Juanita Toribio Pino; granddaughter of Sofia and Rafael Medina; daughter of Marcellus & Elizabeth Medina; sister of Kimberly Medina.
FAVORITE DESIGNS: roadrunners, berry bushes, clouds, rain, kiva step cut-out rims
PUBLICATIONS: Dillingham 1994:106, 117; Peaster 1997:150.

Marcellus Medina *(collaborates with Elizabeth Medina, his wife), (see Zia color illustration)*

Marcellus Medina -
Courtesy of Jason Esquibel
Rio Grande Wholesale, Inc.

(Zia, Coyote Clan, active ca. 1964-present (painting); 1976-present (painting pottery): acrylic & natural pigment polychrome ollas, jars, bowls, pottery painter, watercolors, acrylic paintings)
BORN: January 7, 1954
FAMILY: great-grandson of Rosalea Medina Toribio; grandson of Juanita Toribio Pino; son of Sofia and Rafael Medina; brother of Rachel Medina, Samuel Medina, Edna Medina Galiford, Lois Medina, Herman Medina & Fred Medina; husband of Elizabeth Medina; father of Kimberly, Marcella and Eugene Medina
TEACHER: Rafael Medina, his father
AWARDS: 1984, 1st, jars; 1998, H.M.; Best of Pottery, 1st, 1999 1st, 3rd, Santa Fe Indian Market; Best of Show, 1st, New Mexico State Fair, Albuquerque; 1st Inter-tribal Indian Ceremonial, Gallup; Southwest Indian Painting Convocation
EXHIBITIONS: 1988-present, Indian Market, Santa Fe; 1995-present, Eight Northern Indian Pueblos Arts & Crafts Show
COLLECTIONS: Boston Museum of Fine Art, Boston, MA; Albuquerque International Airport, Albuquerque, NM; Candace Collier, Houston, TX; School of American Research, Santa Fe; Dr. Gregory and Angie Yan Schaaf, Santa Fe
FAVORITE DESIGNS: Pueblo dance figures, Eagle Dancers, Buffalo Dancers
GALLERIES: Adobe Gallery, Rio Grande Wholesale, Palms Trading Company, Albuquerque
PUBLICATIONS: Barry 1984:107; Trimble 1987:66; : *Indian Market Magazine* 1988, 1989, 1996; Dillingham 1994:106, 114-16; Hayes & Blom 1996:164-65; Wyckoff 1996:32; Peaster 1997:150; Tucker 1998: plate 89; Berger & Schiffer 2000:73, 130.

Marcellus Medina is one of the finest Zia painters. He paints both pottery and watercolors. His specialty is using acrylics to paint Pueblo dance figures on polychrome ollas. His figures often overlap the borders, creating the illusion of the figure emerging from the surface.

In 1976, Marcellus began learning how to paint from his father, Rafael Medina, a respected Zia painter. Marcellus was influenced by the style of his father, as well as his uncle, José D. Medina. Together with their uncle, Velino Shije Herrera, they represent the core group of Zia figural painters. They portray both spiritual and social life at Zia Pueblo.

Three polychrome ollas, ca. 1979, formed by Elizabeth and painted by Marcellus were illustrated in Barry 1984. One is painted with Antelope Dancers in profile. A second portrays Zia Pueblo male and female dancers facing head on. A third displays Eagle dancers in dramatic diagonal poses. The foreground contains a frieze of Mimbres animals and Southwest symbols. The creativity of his designs and refined details earn him a reputation as one of Zia's finest pottery painters. His collaboration with his wife, Elizabeth, is in close harmony. Marcellus carries forward the Zia figural painting tradition with style and grace.

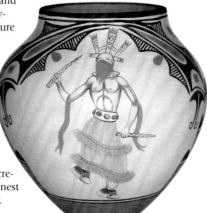

Marcellus & Elizabeth Medina -
Candace Collier Collection, Houston, TX

Maxine Medina

(Zia, active ca. 1994-present: traditional polychrome jars, bowls)
BORN: November 7, 1967
FAMILY: daughter of Henry Shije
TEACHER: Sophia Medina
PUBLICATIONS: Berger & Schiffer 2000:72, 131.

Rachel Medina

(Zia, Coyote Clan, active ca. 1980s-present: polychrome jars, bowls)
BORN: 1961
FAMILY: great-granddaughter of Rosalea Medina Toribio; granddaughter of Juanita Toribio Pino; daughter of Sofia and Rafael Medina; sister of Marcellus Medina, Samuel Medina, Edna Medina Galiford, Lois Medina, Herman Medina & Fred Medina.
EDUCATION: Nursing degree, Eastern University, Portales, NM

TEACHERS: Juanita Toribio Pino, Sofia Medina & Eudora Montoya (Santa Ana)
PUBLICATIONS: Dillingham 1994:106, 113-15; Hayes & Blom 1996; Peaster 1997:150; Berger & Schiffer 2000:52, 131.

Rachel praised her family, "With all the inspiration and guidance and support the family gives to one another, it's good to have them. It makes you feel you can do whatever you want in the art, and you feel successful." (Dillingham 1994:113)

Rachel makes pottery in both Zia and Santa Ana styles. She has lived at both pueblos. Her mother, Sofia Medina, taught her Zia techniques and designs. Eudora Montoya taught her Santa Ana designs.

Rafael Medina *(Raphael, Teeyacheena) (collaborated with his wife, Sophia Medina)*

(Zia, active ca. 1954-present (acrylic painting) and 1970s-present (pottery painting): pottery painter, polychrome jars, bowls, watercolors)
BORN: September 10, 1929
FAMILY: p. grandson of Trinidad Medina; son of San Juanito & Miguelita Medina; brother of José D. Medina; husband of Sophia Medina; father of Marcellus Medina, Rachel Medina, Samuel Medina, Edna Medina Galiford, Lois Medina, Herman Medina & Fred Medina; grandfather of Kimberly Medina, Marcella Medina & Eugene Medina
EDUCATION: Albuquerque Indian School
TEACHERS: Velino Shije Herrera, José Rey Toledo, Geronima Montoya
STUDENTS: Marcellus Medina, his son
AWARDS:

1966	Grand Award, Philbrook Art Center, Tulsa, OK
1967	First, Scottsdale National Indian Art Exhibition, Scottsdale
1969	Heard Museum Guild Show, Phoenix
1970	Inter-tribal Indian Ceremonial, Gallup; Philbrook Art Center, Tulsa, OK
1971	First, Scottsdale National Indian Art Exhibition, Scottsdale
1972	Philbrook Art Center, Tulsa, OK

Rafael Medina -
Candace Collier Collection
Houston, TX

SOLO EXHIBITION: Arizona State Museum, Tucson, AZ
EXHIBITIONS: 1979, "One Space: Three Visions," Albuquerque Museum, Albuquerque
COLLECTIONS: National Museum of the American Indian, Smithsonian Institution, Washington, D.C.; Arizona State Museum, University of Arizona, Tucson, AZ; Museum of Northern Arizona, Flagstaff; Philbrook Art Center, Tulsa, OK; School of American Research, Santa Fe, olla, formed by Sofia Medina, ca. 1979, SAR 1979-10; Katherine H. Rust Children's Collection; Candace Collier, Houston, TX
MATERIALS: acrylic paint on clay
FAVORITE DESIGNS: Pueblo dancers, Water Serpents, kiva steps, corn plants, clouds
VALUES: On May 30, 1996, a polychrome jar, signed Rafael & Sofia Medina (8.5 x 9.5"), sold for $1,725, at Butterfield & Butterfield, #3119.

On February 4, 2000, a polychrome jar signed Rafael & Sofia Medina (11.5 x 11"), sold for $2,310 at R. G. Munn, #951.
PUBLICATIONS: Snodgrass 1968; Tanner 1968, 1973; Brody 1971:170-72; Highwater 1976; *Southwest Art* Winter 1977-78; Silverman 1978; Mahey, et. al. 1980; Schmid and Houlihan 1980; Dittert & Plog 1980:50; Broder 1981; Hoffman, et al. 1984; Barry 1984:102; Trimble 1987:66; Williams, ed. 1990; Dillingham 1994:106, 110-11; Peaster 1997:150.

As a child, Rafael Medina was fascinated by nature. His careful study of animals and birds, as well as the human figure, gives his art great strength in artistic form. His first art commission came when he was a student at Albuquerque Indian School. Patron Mary Mitchell commissioned him to make 50 diner place cards. She continued to encourage and aid his artistic development. He is recognized as a fine easel artist, as well as a painter of pottery.

Rafael Medina is respected as one of Zia's finest painters, along with his brother, José D. Medina and Velino Shije Herrera (Ma Pe Wi). Rafael and José grew up watching their Grandmother Trinidad Medina paint pots. They also were neighbors of Ma Pe Wi, who sang while painting at his easel. Rafael drew from the powerful images of Zia ceremonial dancers and painted them onto pottery often formed by his wife, Sophia Medina.

Rafael's easel style of painting became influenced in the 1960s by the international "Modern Art Movement." J. J. Brody (1971:172) pointed out the Cubist, post-Cubist and Surrealistic styles incorporated into his work. His paintings on pottery seem more influenced by the Studio style of the Dorothy Dunn era at the Santa Fe Indian School. His subjects are mostly traditional dancing figures floating in space or outlined as in other Zia pottery. Rafael's work evokes strong reactions, as he challenges the boundaries of the art form. His use of acrylic paint after the pot has been fired places some of his work in a non-traditional category.

A 1977 polychrome olla illustrated in Barry 1984 depicts Zia Antelope dancers poised between terraced rain clouds with vertical hatching.

Rosalie Medina *(Rosalia, Roselea, Rosary, Rosalie Medina Toribio)*

(Zia, Coyote Clan, active ca. 1880s-?: traditional polychrome ollas, jars, bowls)
BORN: ca. 1870
FAMILY: mother of Juanita Toribio Pino, Maria Bridgett; grandmother of Sofia Medina, Candelaria Gachupin
FAVORITE DESIGNS: flowers, leaves
PUBLICATIONS: *El Palacio* Oct. 16, 1922:94; Hering 1985:153; Batkin 1987:120; Dillingham 1996:106.
PHOTOGRAPHS: by Matilda Coxe Stevenson (1888), in National Anthropological Archives, Smithsonian Institution, "Sisters, Cleverest Artists in Ceramics in Zia," negative #2178.

Jonathan Batkin, Director of the Wheelwright Museum in Santa Fe, described Rosalie Medina as the matriarch of a "long line of great potters." The first woman anthropologist, Matilda Coxe Stevenson photographed Rosalie and her sister in 1888. Rosalie stands on the right dressed in a traditional black manta with a wool belt. The pot atop her head is about 12 inches in diameter, a classic form swelling in the middle with a graceful curve up to the rim. The shoulder and neck are both decorated with four divisions of flowers with big leaves.

Rosario Medina

(Zia, active ca. 1870s-?: traditional polychrome jars, bowls)
BORN: ca. 1851
FAMILY: mother of Amado Medina; grandmother of Romero, Candelaria, Refugia Medina
PUBLICATIONS: U.S. Census 1920, family 16.

Rufina Medina *(see Ruby Panana)*

Sofia P. Medina *(Sophia, Sofia Pino, S. P. Medina), (collaborated with Rafael Medina, José de la Cruz Medina, Lois Medina & Elizabeth Medina)*

(Zia, Coyote Clan, active ca. 1963-present: polychrome jars, dough bowls, chili bowls)
BORN: February 9, 1932
FAMILY: m. granddaughter of Rosalea Medina Toribio; daughter of Andres & Juanita Toribio Pino; wife of Rafael Medina; mother of Marcellus Medina, Rachel Medina, Samuel Medina, Edna Medina Galiford, Lois Medina, Herman Medina & Fred Medina
TEACHER: Trinidad Medina, her husband's grandmother
COLLECTIONS: Wright Collection, Peabody Museum, Harvard University, Cambridge, MA; Heard Museum, Phoenix; Katherine H. Rust Children's Collection; Don & Lynda Shoemaker; Ron & Doris Smithee, OK

Sofia & daughter Lois Medina -
Courtesy of Isa & Dick Diestler, Isa Fetish, Cumming, GA

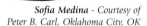

Sofia Medina - Courtesy of
Peter B. Carl, Oklahoma City, OK

EXHIBITIONS: 1979, "One Space: Three Visions," Albuquerque Museum, Albuquerque; 1988-present, Indian Market, Santa Fe
FAVORITE DESIGNS: roadrunners, rainbows, clouds, kiva steps
COLLECTIONS: Wright Collection, Peabody Museum, Harvard University, Cambridge, MA; School of American Research, Santa Fe, olla, painted by Rafael Medina, ca. 1979, SAR 1979-10; Don & Lynda Shoemaker, Santa Fe
GALLERIES: Nedra Matteucci Galleries, Robert Nichols Gallery, Rainbow Man, Santa Fe; Adobe Gallery, Andrews Pueblo Pottery & Art Gallery, Agape Gallery, Albuquerque
PUBLICATIONS: *Arizona Highways* May 1974:42; Tanner 1976:122-23; Dittert & Plog 1980:50; *American Indian Art Magazine* Autumn 1981:75; Spring 1990:25; Spring 1995:37; Barry 1984:102, 105; Trimble 1987:66; *Indian Market Magazine* 1988, 1989; Dillingham 1994:106, 109-11; Mercer 1995:36-37, 44; Hayes & Blom 1996; Peaster 1997:150; Drooker & Capone 1998:69, 139; Berger & Schiffer 2000:130.

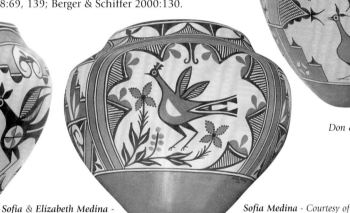

Sophia Medina - Courtesy of
Don & Lynda Shoemaker, Santa Fe

Sofia & Elizabeth Medina -
Nedra Matteucci Galleries

Sofia Medina - Courtesy of
Ron & Doris Smithee, Harrah, OK

Sofia Medina was taught by one of the best Zia potters, Trinidad Medina, the grandmother of Sofia's husband, Rafael Medina. In 1954, Sofia encouraged Rafael to paint. He became a celebrated easel artist.

Beginning in the 1970s, she collaborated sometimes with her husband, Rafael Medina, who painted Pueblo dance figures on her pots. Some of her pots also were painted by her brother-in-law, José D. Medina. Sofia is an accomplished painter in her own right. Her pots are masterfully created. She makes some of the most beautifully shaped and painted ollas.

Sofia also has collaborated with Lois Medina, her daughter, and Elizabeth Medina, her daughter-in-law. Sofia's son, Marcellus, is the husband of Elizabeth, and they collaborate in pottery making.

Sofia is known for creating some of the largest Zia ollas in the second half of the 20th Century. She continues the tradition of making large pots. Sofia's smaller pieces also are finely made and beautifully painted. She is respected as a modern master carrying forward her ancient traditions.

Sofia explained how pottery making helps one's spirit: "Spiritually, the pottery can ease your mind. I do sing a lot when I am working. . .worse than a radio!" (Dillingham 1994:110)

Tomasina Medina

(Zia, active ca. 1920s-?: traditional polychrome jars, bowls)
BORN: ca. 1899
FAMILY: daughter-in-law of Isadora Medina; wife of Lorenzo Medina; sister-in-law of Bartole Medina; mother of Juan Jesus J. Medina, Juan B. Medina
PUBLICATIONS: U.S. Census 1920, family 28.

Trinidad Medina

(Zia, active ca. 1920s-?; polychrome jars & bowls)
LIFESPAN: ca. 1890s - 1965
FAMILY: sister of Antonio Gachupin; wife of José D. Medina; mother of San Juanito Medina; grandmother of Rafael Medina, José de la Cruz (painter), Anita Candelaria, Lena Medina, Carolina Medina, Ernest Medina, Patrick Medina, Priscilla Medina
AWARDS: 1928, 1st, New Mexico State Fair, Albuquerque; 1939, 1st, Indian Market, Santa Fe
DEMONSTRATIONS: 1933, Century of Progress Exposition, Chicago; 193, Golden Gate International Exposition, San Francisco
EXHIBITIONS: 1936-50s, Indian Market, Santa Fe

Trinidad Medina - Courtesy of Andrea Fisher Fine Pottery, Santa Fe

COLLECTIONS: Museum of Indian Arts and Culture, Santa Fe; Museum of New Mexico, Santa Fe; Frank Sorauf, Minneapolis, MN; Philbrook Museum of Art, Tulsa, OK, jar, olla, ca. 1920, bowl, ca. 1940, bowl, ca. 1941, cooking pot, olla, ca. 1947; Eugene Thaw Collection, Santa Fe.
GALLERIES: Andrea Fisher Fine Pottery, Santa Fe
VALUES: On Nov. 29, 2000, a polychrome olla, attributed Trinidad Medina, (9.5 x 10.5" dia.), sold for $20,300, at Sotheby's, #88.
 On Nov. 1999, a storage jar, attributed Trinidad Medina, (18 1/2 x 21 1/2"), sold for $34,500, at Butterfields & Butterfields.
 On August 16, 1998, a polychrome jar, signed "Trinidad Medina August 1st, 1928" (10 x 13"), with 1st Ribbon from 1928 New Mexico State Fair, sold for $3,850, at Allard Auctions, #111.
 On May 30, 1996, a large polychrome jar (25 1/2 x 26"), est. $18,000-22,000, at Sotheby's, #38.
 On November 29, 1988, a polychrome olla, signed Trinidad Medina, (11.25" dia.), sold for $2,475, at Sotheby's, #238.
PUBLICATIONS: *El Palacio* Sept. 1943:226; Snodgrass 1968:116; *SWAIA Quarterly* Fall 1972:7-10; *American Indian Art Magazine* Winter 1986:17; Autumn 1988:45; Summer 1990:26; Winter 1995:21; Spring 1999:20; Summer 2000:31; Batkin 1987:122, 203 fn.96, 97; Dillingham 1994:106-07, 110; Cohen 1995; Mercer 1995:36-37; Hayes & Blom 1996:162-63; Bernstein in Matuz, ed., 1998:377-78.
 Trinidad Medina is considered one of the best Zia potters in the first half of the 20th century. She was especially known for her large polychrome storage jars with unique designs. From 1930 to 1946, Trinidad was sponsored by trader Wick Miller to demonstrate pottery making across the country. This public exposure made her famous.
 Sofia Medina recalled, "She always told me instead of sitting around after the children went to school to work on pottery. Pottery making was important. Financially she could depend on that. She said she'd teach me — but first she said, 'tell me and promise whatever I teach you, pass it on to my grandchildren so in the future they will profit from it and in the future my work would continue.'" (Dillingham 1994:110)

Crucita Melchor *(collaborated sometimes with Santana Melchor)*

(Santo Domingo, active ca. 1950s-present: polychrome ollas, jars, bowls)

Crucita Melchor - Photograph by Angie Yan Schaaf

BORN: ca. 1932
FAMILY: m. granddaughter of Maria Garcia (1); daughter of Santana Melchor; sister of Ray Melchor & Dolorita Melchor; mother of Joe Melchor; p. grandmother of Marcella & Mandy Melchor
AWARDS: 1976, 2nd, jars; 1979, 3rd; 1999, Focus Artist, Indian Market, Santa Fe
EXHIBITIONS: pre-1976-present, Indian Market, Santa Fe; 1977, Smithsonian Institution, Washington, D.C.
COLLECTIONS: Wright Collection, Peabody Museum, Harvard University, Cambridge, MA; School of American Research, Santa Fe; Dr. Gregory Schaaf, Santa Fe

Crucita Melchor - Janie & Paul K. Conner Collection

PUBLICATIONS: Tanner 1976:125; *SWAIA Quarterly* Fall/Winter 1976 11(3/4):13; Harlow 1977; *Indian Market Magazine* 1985, 1988, 1989, 1999:58; ; Coe 1986:131-35; Trimble 1987:102; Dillingham 1994:130-31; Hayes & Blom 1996; Drooker et al. 1998:139; Anderson 1999:54.
 Crucita Melchor learned pottery making from her mother, Santana Melchor, a respected master potter. Crucita followed in her mother's footsteps, producing fine traditional pottery. With respect for their old ways, Crucita and her mother were noted for creating a "spirit line" opening in their double line bands. She explained, "All my pots have double lines - my mother called them the spirit lines. It leaves a little opening that the spirit can get out."
 In 1999, Crucita Melchor was honored as a focus artist in the *Indian Market Magazine*. She spoke of her wishes for the future: "I want for the whole family to learn, while I'm still here. Because I don't want to lose it."
 Crucita concluded by giving thanks to Mother Earth: "I'm happy that the Earth gives me sand and dirt to make a living. I'm always happy about that."

Darlene Melchor

(Santo Domingo, active ca. 1970s-present: polychrome jars, bowls)
BORN: ca. 1950s
FAMILY: daughter of Dolorita Melchor; sister of Michael, JoAnn, Marlene, & Irene (René);
mother of Neil Travis
PUBLICATIONS: Dillingham 1994:130.

Dolorita Melchor *(collaborates sometimes with Crucita Melchor)*

(Santo Domingo, active ca. 1954-present: polychrome jars, bowls, jewelry, heishi)
BORN: ca. 1937
FAMILY: daughter of Santana Melchor; sister of Ray and Crucita Melchor; mother of Michael,
JoAnn, Marlene, Darlene & Irene Melchor; grandmother of Lambert, James, Jr., Camie,
Christina, Steven Melchor
EDUCATION: Santa Fe Indian School
TEACHER: Santana Melchor, her mother
AWARDS: 1975, 1st, jars, Indian Market, Santa Fe
EXHIBITIONS: 1954, Arts & Crafts Show, Santa Fe Indian School, Santa Fe; ?-present, Indian
Market, Santa Fe; Santo Domingo Arts & Crafts Show
COLLECTIONS: School of American Research, Santa Fe; Dr. Gregory Schaaf, Santa Fe
PUBLICATIONS: Santa Fe Indian School, *Teguayo* 1954, 1956; *SWAIA Quarterly* Fall 1975
10(3):4; Tanner 1976:121; Barry 1984:114; *Indian Market Magazine* 1985, 1988; Dillingham
1994:130-31, 134; Anderson 1999; Schaaf 2001:281.

Irene Melchor *(René Melchor)*

(Santo Domingo, active ca. 1970s-present: polychrome jars, bowls)
BORN: ca. 1950s
FAMILY: daughter of Dolorita Melchor; sister of Michael, JoAnn, Marlene, Darlene
PUBLICATIONS: Dillingham 1994:130.

James Melchor, Jr.

(Santo Domingo, active 1990s -present: polychrome, jars, bowls)
FAMILY: son of James Melchor, Sr.

JoAnn Melchor

(Santo Domingo, active ca. 1970s-present: polychrome
jars, bowls)
BORN: ca. 1950s
FAMILY: daughter of Dolorita Melchor; sister of
Michael, Marlene, Darlene & Irene (René)
PUBLICATIONS: Dillingham 1994:130.

Magdalena Melchor

(Cochiti, active ?: pottery)
ARCHIVES: Laboratory of Anthropology Library, Santa
Fe, lab file.

Mandy Melchor

(Santo Domingo, active ca. 1990s-present: polychrome
jars, bowls, miniatures)
BORN: ca. 1970s
FAMILY: great-granddaughter of Santana Melchor;
granddaughter of Crucita Melchor; daughter of Joe
Melchor; sister of Marcella & Austin
PUBLICATIONS: Dillingham 1994:134.

Marcella Melchor

(Santo Domingo, active ca. 1990s-present: polychrome jars, bowls)
BORN: ca. 1970s
FAMILY: great-granddaughter of Santana Melchor; granddaughter of Crucita Melchor; daughter
of Joe Melchor; sister of Mandy & Austin
PUBLICATIONS: Dillingham 1994:130.

Marlene Melchor

(Santo Domingo, active ca. 1978-present: polychrome jars, bowls)
BORN: ca. 1950s
FAMILY: daughter of Dolorita Melchor; sister of Michael, JoAnn, Darlene & Irene (René); mother of Steven
EXHIBITIONS: 1978, Indian Market, Santa Fe
PUBLICATIONS: Barry 1984:114; Dillingham 1994:130.

(Left to right): Aaron Melchor, Alexandria
Dolorita Melchor, Steven Melchor &
Darlene Melchor - Photo by Angie Schaaf

James Melchor, Jr. -
Photograph by Angie Yan Schaaf

JoAnn Melchor -
Photograph by Angie Yan Schaaf

Marlene Melchor -
Photograph by Angie Yan Schaaf

Santana Melchor (*Santana Garcia*)

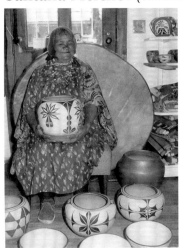

Santana Melchor - Courtesy of the Melchor family

(Santo Domingo, active ca. 1920s-78: polychrome large storage jars, ollas, jars, bowls, owls, jewelry)
LIFESPAN: ca. 1889 - 1978
FAMILY: daughter of Maria Garcia(1); wife of Melchor; mother of Crucita Melchor, Ray Melchor and Dolorita Melchor; m. grandmother of Michael, Joann, Marlene, Darlene & Irene (René) Melchor
TEACHER: Maria Garcia, her mother
STUDENTS: her children and grandchildren
AWARDS: 1975, 1st, jars; 1977, 3rd, bowls, Indian Market, Santa Fe
EXHIBITIONS: Indian Market, Santa Fe; 1977, Smithsonian Institution, Washington, D.C.; 1979, "One Space: Three Visions," Albuquerque Museum, Albuquerque
COLLECTIONS: Wright Collection, Peabody Museum, Harvard University, Cambridge, MA; Heard Museum, Phoenix; Philbrook Museum of Art, Tulsa, OK, bowl, ca. 1930, owl, ca. 1946; Rick Dillingham Collection, olla, ca. 1971; Christopher Webster, Dr. Gregory & Angie Yan Schaaf, Santa Fe; Eason Eige, Albuquerque
GALLERIES: Nedra Matteucci Galleries, Andrea Fisher Fine Pottery, Santa Fe; Richard M.

Santana Melchor - Courtesy of Christopher Webster, Santa Fe

Howard, Santa Fe; Sunshine Studio at www.sunshinestudio.com
PUBLICATIONS: *SWAIA Quarterly* 1972 Fall/Winter 1972 7(6):4; *Indian Trader* June 15, 1974:8; Tanner 1976:121; Harlow 1977; *American Indian Art Magazine* Autumn 1981 6(4):75; Barry 1984:114; Coe 1986:200; Batkin 1987:99; Dillingham 1994:130-31; Hayes & Blom 1996, 1998; Peaster 1997; Drooker 1998:139; *New Mexico Magazine* Jan. 1999 77(1):38.

Through the mid-20th century to the 1970s, Santana Melchor was one of the most important and prolific Santa Domingo potters. She helped keep the earlier traditional techniques and styles alive. Her large ollas are masterpieces of Pueblo Indian pottery. Even her smaller pieces are often exceptional in the quality of construction, form and design.

In February, 1974, Santana was part of a delegation of Pueblo Indian women who flew to Washington, D.C.. She explored the Smithsonian Institution and met Pat Nixon, then the first lady and wife of President Richard M. Nixon.

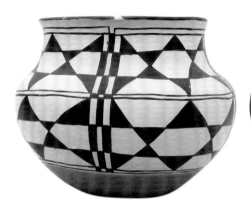

Santana Melchor - Courtesy of Nedra Matteucci Galleries, Santa Fe

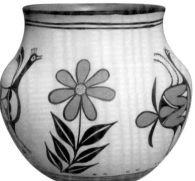

Santana Melchor - Courtesy of Richard M. Howard, Santa Fe

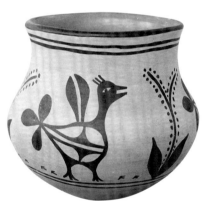

Santana Melchor - Courtesy of Eason Eige, Albuquerque

Patsy Mike (*signs P. Mike, Acoma N.M.*)

(Acoma, active ca. 1970-present: traditional polychrome jars, bowls)
BORN: February 17, 1951
GALLERIES: Rio Grande Wholesale, Inc., Palms Trading Co., Albuquerque
PUBLICATIONS: Berger & Schiffer 2000:132.

Andrea Miller

(Acoma, active ca. 1870s-1910s+: polychrome jars, bowls)
BORN: ca. 1860; RESIDENCE: McCartys in ca. 1910
PUBLICATIONS: Leopold Bibo, "13th Annual U.S. Census" (1910), New Mexico State Archives, Call T624, Roll 919; in Dillingham 1992:205.

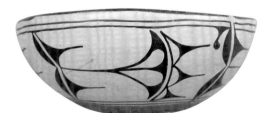

Santana Melchor - Courtesy of Sunshine Studio

Annie Miller

(Acoma, active ca. 1880s-1910s+: polychrome jars, bowls)
BORN: ca. 1865; RESIDENCE: Acomita in ca. 1910
PUBLICATIONS: Leopold Bibo, "13th Annual U.S. Census" (1910), New Mexico State Archives, Call T624, Roll 919; in Dillingham 1992:205.

Barbara Miller
(Acoma, active ?-1990+: polychrome jars, bowls)
PUBLICATIONS: Dillingham 1992:206-208.

Karen Miller *(see Karen Pacheco)*

Lupe Miller
(Acoma, active ca. 1850s-1910s+: polychrome jars, bowls)
BORN: ca. 1840; RESIDENCE: McCartys in ca. 1910
PUBLICATIONS: Leopold Bibo, "13th Annual U.S. Census" (1910), New Mexico State Archives, Call T624, Roll 919; in Dillingham 1992:205.

Marie Miller
(Acoma, active ca. 1975-1990)
FAMILY: mother of Melinda Miller; m. grandmother of Sharon Miller & Karen Pacheco
PUBLICATIONS: Minge 1991:195; Dillingham 1992:206-208.

Melinda Miller *(works with Karen Miller)*
(Acoma, active ca. 1975-present: traditional & ceramic polychrome jars, bowls)
RESIDENCE: Acoma Pueblo, NM
FAMILY: mother of Karen Pacheco, Sharon Miller
PUBLICATIONS: Minge 1991:195; Dillingham 1992:206-208; Painter 1998:14.

Sharon Miller
(Acoma, active ?-1990+: polychrome jars, bowls, seed pots)
FAMILY: m. granddaughter of Marie Miller; daughter of Melinda Miller; sister of Karen Pacheco
PUBLICATIONS: Dillingham 1992:206-208.

Patsy Mike
(Acoma, active ca. 1960s-present: traditional & ceramic jars, bowls)
BORN:1940s
FAMILY: mother of Marcia Estevan & Paula Estevan
STUDENTS: Marcia Estevan & Paula Estevan, her daughters
GALLERIES: Rio Grande Wholesale, Inc., Palms Trading Co., Albuquerque
PUBLICATIONS: Berger & Schiffer 2000:113.

Claudia Mitchell
(Acoma, Roadrunner Clan, active ca. 1980s-present: pottery)
BORN: ca. 1950s
FAMILY: m. granddaughter of Lucy M. Lewis & Toribio Haskaya Luis; daughter of Emma Lewis Mitchell

Donna Mitchell
(Acoma, active ?-present: pottery)
ARCHIVES: Artist File, Heard Museum Library, Phoenix

Emma Lewis Mitchell *(Emma Lewis)*

Emma Mitchell - Courtesy of John D. Kennedy and Georgiana Kennedy Simpson Kennedy Indian Arts

(Acoma, Roadrunner Clan, active ca. 1952-present: Mimbres & Anasazi Revival black-on-white & polychrome ollas, jars, bowls, seed pots, plates, owls)
BORN: October 4, 1931, Acoma Pueblo, NM
FAMILY: daughter of Lucy M. Lewis & Toribio Haskaya Luis; mother of Kathleen Garcia, Adam Garcia, Chris Garcia, Merle Garcia, Claudia Mitchell, Ivan Mitchell, Andrew Mitchell; grandmother of Todd James, Chad David, Jason & Manuel Garcia
AWARDS: 1974, 1st; 1975, 1st; 1977, 2nd; 1978, 2nd (2); 1979, 3rd; 1989, 2nd, Indian Market, Santa Fe
EXHIBITIONS:

1960-2001	Indian Market, Santa Fe
1979	"One Space: Three Visions," Albuquerque Museum, Alb.
1987	Native American Rights Fund Event, Boulder, CO
1993	Taipei International Exhibition of Traditional Arts & Crafts, Taipei Fir Arts Museum, Taiwan
1997	"The Legacy of Generations," National Museum of Women in the Arts, Washington, D.C.
1999-2000	Very Special Arts, Albuquerque, NM

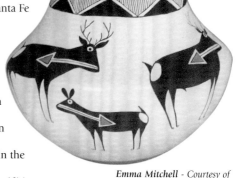

Emma Mitchell - Courtesy of Dave & Lori Kenney, Santa Fe

DEMONSTRATIONS/WORKSHOPS:

1979-88 One week ceramic workshop, Idyllwild Arts, Idyllwild, CA
1990 Indiana University Institute for Advanced Study, Bloomington
1991 One week ceramic workshop, Minnesota State University, Mankato, MN
1997-2001 One week ceramic workshop, University of Santa Cruz, CA
1998-2001 One week ceramic workshop, Taos Art Institute, Taos, NM
1999 U.S.-Canadian Arts Exchange, Toronto, Hamilton, Dundas, Ontairio, Canada
1999 One week ceramic workshop, Cushing Academy, Boston, MA
2000 One week ceramic workshop, Kalamazoo Institute of Art, Kalamazoo, MI

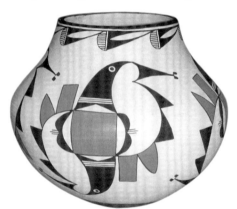

Emma Lewis Mitchell -
Andrews Pueblo Pottery and Art Gallery

COLLECTIONS: Wright Collection, Peabody Museum, Harvard University, Cambridge, MA; Heard Museum, Phoenix; Albuquerque Museum, Albuquerque; Maxwell Museum of Anthropology, Albuquerque; Brooklyn Museum of Arts, Brooklyn, NY; San Diego Museum of Man, San Diego, CA; Southwest Museum, Los Angeles, CA; Volunteer Park Museum, Seattle, WA; Dave & Lori Kenney, Santa Fe
FAVORITE DESIGNS: Mimbres animals, turtles, birds, parrots, mountain sheep, rabbits, deer with heartlines, split leaves, berry bushes
GALLERIES: Indian Craft Shop, U.S. Department of Interior, Washington, D.C.; Andrea Fisher Fine Pottery, Santa Fe; Kennedy Indian Arts, Bluff, UT; Andrews Pueblo Pottery and Art Gallery, Albuquerque; Sunshine Studio at www.sunshinestudio.com
PUBLICATIONS: Peterson 1984: 24+; Dillingham 1992:206-208; 1994:92; Reano 1995:112; Hayes & Blom 1996:48-49; Hill & Hill, eds. 1997:208-09; Peterson 1997; Drooker & Capone 1998:138; Painter 1998:13.

Emma Lewis Mitchell is the daughter of the famous Acoma matriarch, Lucy M. Lewis. In explaining the spirituality of pottery, Emma shared, "There's a prayer that goes into digging the clay; there's a prayer that goes into refining it. There's a prayer for making the pots, and maybe two prayers for bringing them to the dealer." (Hill & Hill, eds. 1997:209)

Emma and her sisters, mostly Dolores Lewis Garcia, have traveled for over 20 years giving demonstrations and workshops on pottery making across the country and around the world. They have done much in promoting cross-cultural exchanges.

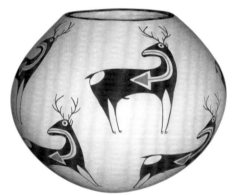

Emma Lewis - Courtesy of
Andrea Fisher Fine Pottery, Santa Fe

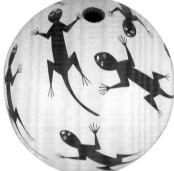

Emma Lewis Mitchell -
Courtesy of Sunshine Studio

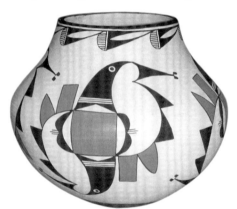

Emma Lewis - Courtesy of
Andrea Fisher Fine Pottery, Santa Fe

Candelaria Montana

(San Felipe, active ?: traditional polychrome jars, bowls, seed pots)
COLLECTIONS: Heard Museum, Phoenix
ARCHIVES: Laboratory of Anthropology Library, Santa Fe, lab file.

Valencia Montero

(San Felipe, active ca. 1970s-?: black-on-white jars, bowls)
PUBLICATIONS: Hayes & Blom 1996:110.

Dora Montoya *(see Eudora Montoya)*

Dorothy Montoya

(Sandia, active ca. 1970s-present: traditional polychrome ollas)
FAVORITE DESIGNS: diagonal stars, Rainbird (Zia influence)
PUBLICATIONS: Hayes & Blom 1996:108-09.

Eleuria Montoya

(Santa Ana, active ?: pottery)
ARCHIVES: Artist's File, Heard Museum, Phoenix

Elvira Montoya

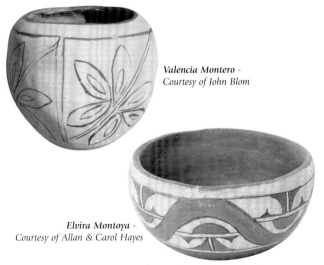

Valencia Montero -
Courtesy of John Blom

Elvira Montoya -
Courtesy of Allan & Carol Hayes

(Santa Ana, active ca. 1940s-present: polychrome jars, bowls, corner fireplace scenes, miniature ollas, embroidery, sewing)
BORN: ca. 1920s
COLLECTIONS: Wright Collection, Peabody Museum, Harvard University, Cambridge, MA
PUBLICATIONS: Hayes & Blom 1996:128-29; Drooker 1998:63, 139; Tucker 1998, plates 102, 103.

Eudora L. Montoya *(Dora, signed E. or D. Montoya)*

(Santa Ana, active 1920s-70s?: polychrome jars, bowls, canteens)
LIFESPAN: ca. 1905 or 1906 - ?
TEACHER: her mother
STUDENTS: Rachel Medina (Zia)
AWARDS: 1983, 3rd, Indian Market, Santa Fe
EXHIBITIONS: pre-1982-1992, Indian Market, Santa Fe
COLLECTIONS: Smithsonian Institution, Department of Anthropology, Washington, D.C.,
item #409805; Wright Collection, Peabody Museum, Harvard University, Cambridge, MA;
Philbrook Museum of Art, Tulsa, OK, jar, ca. 1950
GALLERIES: Andrews Pueblo Pottery and Art Gallery, Albuquerque
PUBLICATIONS: *El Palacio* May 1949 56(5):140; Tanner 1976:123; Strong in Ortiz, ed.
1979:403; *SWAIA Quarterly* Fall 1982:11; Barry 1984: 108-09; Trimble 1987:64; Bayer
1994:227; Dillingham 1996:113; Hayes & Blom 1996:128-29; Drooker 1998:63, 132; Clark 1998:32.

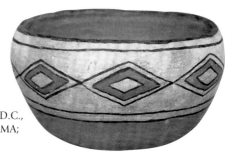

Eudora Montoya - Andrews Pueblo Pottery and Art Gallery, Albuquerque, NM

When Eudora Montoya was born, only about 225 people lived in Santa Ana Pueblo. She learned pottery making from her mother in the 1920s. She recalled her early days: "I learned when I was just a little girl, helping my momma make bean pots. I learned everything from her and, I guess, she learned from her mother."

Eudora was sent to Indian boarding school in her childhood. She returned home during summer vacations, "I would come home in the summers and help Momma make pottery; she would be putting on the designs and we'd sit and she would stir the paint in that black pot, making Santa Ana pottery. . . That's how come I learned."

In 1946, she returned to her pottery full time. Eudora explained, "I like the mud, to work it, and I missed doing it. In those days there were still a few ladies making the old-style pots." However as the years rolled by, she became perhaps the only active potter from Santa Ana.

In 1972, Eudora created a class to teach Santa Ana pottery making. She was encouraged by Nancy Winslow, a non-Indian woman from Albuquerque. There were 17 students who participated the first year in the revival project. Their efforts helped to preserve Santa Ana style pottery.

In 1988, *Indian Market Magazine* honored her in a feature artist's profile: "Eudora Montoya is a small, self-effacing woman, but as a bearer of Pueblo Indian culture her contribution has been larger than life. Through her efforts and the knowledge she safeguarded, the centuries-old tradition of Santa Ana-style pottery, once in danger of extinction, remains vitally alive."

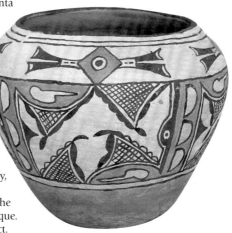

Eudora Montoya - Andrews Pueblo Pottery and Art Gallery, Albuquerque

Frances Yepa Montoya

(Jemez, active ca. 1970s-present, Storytellers)
BORN: ca. 1956
PUBLICATIONS: Babcock 1986.

James Montoya

(San Felipe/Isleta, active ca. 1990s-present: pottery)
EXHIBITIONS: 1995-present, Eight Northern Indian Pueblos Arts & Crafts Show

John Montoya *(signs J. Montoya, Sandia Pueblo)*

(Sandia, active ca. 1987-present: Anasazi & Mimbres Revival, traditional polychrome jars, dough bowls, animal figures - owls, turtles)
BORN: February 1, 1960
RESIDENCE: Albuquerque
FAMILY: son of Bernanda Montoya-Vigil
TEACHER: his grandfather
COLLECTIONS: Candace Collier, Houston, TX; Dr. Gregory & Angie Yan Schaaf, Santa Fe
FAVORITE DESIGNS: Sandia Peak, thunderclouds, lightning, deer, Water Serpent, lizards
GALLERIES: Nedra Matteucci Galleries, Santa Fe; Bien Mur; Agape Gallery, Palms Trading Co., Albuquerque; Case Trading Post at the Wheelwright Museum of the American Indian, Santa Fe
PUBLICATIONS: Hayes & Blom 1996:108-09; Berger & Schiffer 2000:132.

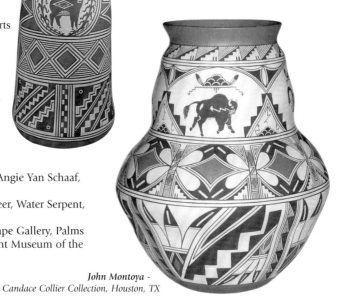

John Montoya - Candace Collier Collection, Houston, TX

John Montoya - Photograph by Tony Molina Case Trading Post at the Wheelwright Museum of the American Indian Santa Fe

Julian Montoya
(Isleta, active ?: pottery)
EXHIBITIONS: 1995-present, Eight Northern Indian Pueblos Arts & Crafts Show

Mariana Montoya
(Isleta, active ca. 1993-present: Storyteller necklaces)
BORN: ca. 1920
FAMILY: mother of Daisy Chapa
PUBLICATIONS: Berger & Schiffer 2000:104.

Mary L. Montoya *(signs M. L. Montoya, Santa Ana, Jemez)*
(Jemez/Santa Ana, active ca. 1967-present: traditional polychrome jars, bowls)
BORN: August 26, 1939
PUBLICATIONS: Hayes & Blom 1996:128-29; Berger & Schiffer 2000:132.

Renee Montoya *(R. Montoya)*
(Santa Ana, active 1990s-present: polychrome & whiteware jars, bowls)
GALLERIES: Agape, Albuquerque
PUBLICATIONS: Hayes & Blom 1996:128-29.

Renee Montoya -
Courtesy of Allan & Carol Hayes

Robert Montoya
(Sandia, active ?-present: polychrome jars, bowls, paintings, architecture)
FAMILY: father of Catherine Paisano
COLLECTIONS: Indart, Inc.
FAVORITE DESIGNS: birds, corn plants, clouds, lightning, feathers-in-a-row

Trinidad Montoya
(Cochiti, active ca. 1900s-40s: traditional polychrome jars, bowls)
BORN: 1877
FAMILY: wife of Alcario Montoya; mother of Estefanita Montoya, Candelaria
Montoya
COLLECTIONS: Philbrook Museum of Art, Tulsa, OK, bowl, ca. 1939
ARCHIVES: U.S. Census, Cochiti, 1920, family 36; Laboratory of Anthropology
Library, Santa Fe, lab file.

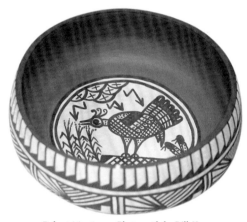

Robert Montoya - Photograph by Bill Knox
Courtesy of Indart Incorporated

Victoria Montoya
(Cochiti, active ca. 1910s-?:traditional polychrome jars, bowls)
BORN: ca. 1890
FAMILY: mother of Aurelia Suina; mother-in-law of Tony Suina, Sr.; grandmother of Tony Suina, Jr.; great-grandmother of Carilin
Grace Suina, Marie Charlotte Suina, Maria Suina, Patty Suina

Beninga Moquino *(Benina)*
(Zia, active ca. 1910s-?: traditional polychrome ollas, jars, bowls)
BORN: ca. 1893
FAMILY: wife of Augustin Moquino; mother of Jose G., Clarita & Ignacio Moquino
PUBLICATIONS: U.S. Census 1920, family 19.

Juana R. Moquino
(Zia, active ?: pottery)
ARCHIVES: Laboratory of Anthropology Library, Santa Fe; lab. file.

Morning Star *(see Kevin Lewis)*

Rachel Morningstar
(Cochiti, active, ?-present: polychrome figures, duck ornaments)
PUBLICATIONS: *Indian Artist* Winter 1997 3(1):66, 68, 73.

Dee Morris
(Acoma, active ?-1970s: pottery)
PUBLICATIONS: *Arizona Highways* January 1974 50 (1):31, 45; May 1974 50 (5):45.

Darlene Munoz
(Isleta/Paiute: active ca. 1980s-present: pottery)
AWARDS: 1987, Thunderbird Foundation Award/Scholarship, Red Cloud Indian Art Show, Pine Ridge, SD

Irene Nahohai

(Zuni, born into Eagle Clan, active ca. 1970s-present: traditional polychrome cornmeal bowls)
FAMILY: m. granddaughter of La Wa Ta; daughter of Josephine Nahohai; sister of Randy
Nahohai, Priscilla Tsethlikai and Milford Nahohai
DEMONSTRATIONS: 1986, Folklife Festival, Smithsonian Institution, Washington, D.C.
FAVORITE DESIGNS: terraced clouds, tadpoles, dragonflies
PUBLICATIONS: Rodee & Ostler 1986:66.

Irma Nahohai

(Zuni, active ?-present: polychrome owls)
PUBLICATIONS: Bassman 1996:24.

Josephine Nahohai -
Bill & Jane Buchsbaum Collection, Santa Fe

Jaycee Nahohai

(Zuni, active ca. 1990s-present: polychrome jars, bowls)
FAMILY: great-grandson of La Wa Ta; p. grandson of Josephine Nahohai; son of Randy & Rowena Nahohai

Josephine Nahohai *(collaborated sometimes with her husband (Frog Clan), who painted some of her water jars, and sometimes with her son, Milford Nahohai)*

(Zuni, born into Eagle Clan, active ca. 1930s-?: traditional polychrome ollas, jars, cornmeal bowls, kiva bowls, frog pots, owls, jewelry)
BORN: July 20, 1912
FAMILY: daughter of La Wa Ta; niece of Myra Eriacho & Lonkeena; mother of Randy
Nahohai, Milford Nahohai, Irene Nahohai & Priscilla Tsethlikai; mother-in-law of Rowena
Him Nahohai; grandmother of Josh, Alec & Jaycee Nahohai
TEACHERS: Daisy Hooee, Myra Eriacho, her aunt, and La Wa Ta, her mother
AWARDS: 1985, Fellowship from the School of American Research, Santa Fe; 1989, 3rd,
jars; 1992, Best of Division, Traditional Pottery, 1st, Zuni jars, Indian Market, Santa Fe
EXHIBITIONS: 4th of July Powwow, Flagstaff, AZ; ca. pre-1988-present, Indian Market
DEMONSTRATIONS: 1986, Folklife Festival, Smithsonian Institution, Washington,
D.C.; 1987, Museum of Indian Arts & Cultures, Santa Fe; Idyllwild Arts, Idyllwild, CA
COLLECTIONS: Heard Museum, Phoenix, AZ; Dr. Fred Belk, NM; Candace Collier,
Houston, TX; Jane & Bill Buchsbaum, Angie Yan Schaaf, Santa Fe
FAVORITE DESIGNS: owls, frogs and tadpoles for rain, kiva steps, terraced rain clouds, zigzag
flowing water, dragonflies to summon the clouds, deer (before 1986)

Dr. Fred Belk Collection, NM

PUBLICATIONS: *El Palacio* Jan. 1947:14; Babcock 1986; Coe 1986:208; Rodee & Ostler 1986:2364;
Trimble 1987:84-85, 107; *Indian Market Magazine* 1988, 1989, 1996:63; 1999:47; *Southwest Profile* Oct. 1990:11; *New Mexico
Magazine* June 1992:47; *Santa Fean* Aug. 1992:25; School of American Research, *Annual Report* 1994:15; Nahohai & Phelps 1995:22-
31; Mercer 1995:42; Ostler, Rodee & Nahohai 1996:14, 29, 30, 124; Bassman 1996; *Indian Trader* Oct. 1996:19; Painter 1998:184-
90; Anderson et al. 1999:42; Marshall 2000:82.

 When Josephine Nahohai was a little girl, she used to go with her mother to collect clay at Dowa Yalanne, Corn Mountain.
She and a group of Zuni women went together. They delivered beautiful, thoughtful prayers and cornmeal to Mother Earth, as
they carefully gathered the clay as a blessing.

 Josephine didn't make pottery as a girl. She instead became a jeweler. However, when the price of silver and turquoise
soared in the 1970s, Josephine turned to pottery making. She recognized that all she had to do to make pottery was to collect
the clay and natural paints. They were free from Mother Earth. Josephine asked for advice from Daisy Hooee, a Hopi woman
potter who married into Zuni. Josephine also talked with her aunt. She soon got her whole family involved. In the beginning
her husband painted her pots, but soon she learned to do it herself.

 She gathers clay at the mesa, but gets some white slip from her friend at Laguna Pueblo. She uses wild mustard or bee-
weed with a small amount of powdered hematite for her black paint.

 Josephine made pots to help support her family's income, as well as ceremonial pots for the Mudhead group used in the
Going-of-the-Kachinas Ceremony. She made unique owl figures. Their eyes bulge out
with lines radiating outward like the rays of the sun.

 For many years, Josephine was one of the Olla Maidens, a Zuni social dance
group who dance with pottery water jars on their heads. They performed
throughout the Southwest and beyond.

 In 1985, Josephine won the Katrin H. Lamon Artist's Fellowship from
the School of American Research to teach Zuni women to make traditional
pottery. The Nahohai and Bica families were among those who kept pottery
making alive in the mid-20th century. Both families made owls, as does
Josephine, who says the owl "is the protector of the night, always on the
lookout for your family and making sure that your family is safe."

 Josephine and her son, Milford, studied historic Zuni pottery at the
Smithsonian Institution in Washington, D.C. Her family and circle have
contributed greatly to the development of Zuni pottery. Josephine advises
young people to create pottery with "blessings in mind."

 For a more in-depth profile of Josephine and other Zuni potters, we strongly
recommend an excellent book by Milford Nahohai and Elisa Phelps, *Dialogues with
Zuni Potters* (Zuni A:shivi Publishing: Zuni, NM, 1995).

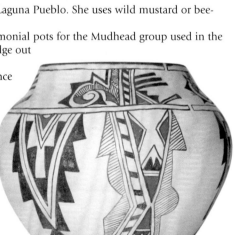

Candace Collier Collection, Houston, TX

Milford Nahohai *(sometimes collaborated with Josephine Nahohai)*

(Zuni, born into Eagle Clan, active ca. 1983-present: traditional polychrome, some corrugated, unslipped redware effigy jars, corn-meal bowls, owls, turtle figures, paintings, writing)
FAMILY: m. grandson of La Wa Ta; son of Josephine Nahohai; brother of Randy
Nahohai, Irene Nahohai and Priscilla Tsethlikai

*Milford Nahohai - Courtesy of
Georgiana Kennedy Simpson
Kennedy Indian Arts, Bluff, UT*

EDUCATION: Fort Lewis College, Durango, CO
TEACHER: Josephine Nahohai, his mother
STUDENTS: Dion, his nephew
AWARDS: 1992, Best of Division, Traditional Pottery, 1st, Zuni jars, 1993, Indian Market
EXHIBITIONS: ca. 1988-present, Indian Market, Santa Fe
DEMONSTRATIONS: 1986, Folklife Festival, Smithsonian Institution, Washington,
D.C.; Idyllwild Arts, Idyllwild, CA; College of Santa Fe
COLLECTIONS: Heard Museum, Phoenix, AZ
FAVORITE DESIGNS: Rainbirds, rain clouds, terraced clouds, water serpents (Kolowisi), frogs,
tadpoles, turtles, friendship, zigzag water flowing
GALLERIES: Pueblo of Zuni Arts & Crafts, Zuni, NM; Keshi, Santa Fe; Kennedy Indian Arts, Bluff, UT
PUBLICATIONS: Rodee & Ostler 1986:40-48, 57; Trimble 1987:84-85, 107; *Indian Market Magazine*
1988, 1989; 1999:47; Nahohai & Phelps 1995:10, 11, 44-51; Bassman 1996:19; *Indian Artist* Fall 1996:27-28; *Indian Traders* Oct.
1996:19; Jan. 1997:24; *Native Peoples* Spring 1997:78; Painter 1998:184-90; Anderson et al. 1999:20, 48; Marshall 2000:82.

 Milford Nahohai comes from a respected pottery-making family. He sometimes paints pottery made by his mother, Josephine Nahohai. They both have studied historic Zuni pottery at the Smithsonian Institution in Washington, D.C.. Milford has contributed to the revival of historic designs, forms and paints. He studied the use of old mineral pigments.

 Milford served as manager of the Pueblo of Zuni Arts and Crafts. He has traveled widely promoting Zuni artists.

 Milford Nahohai and his co-author, Elisa Phelps, deserve much praise for their authorship of an excellent book, *Dialogues with Zuni Potters* (Zuni A:shiwi Publishing, Zuni, NM, 1995). Milford and Elisa interviewed many contemporary potters at Zuni and made an unique contribution to scholarship. We strongly recommend this book to our readers.

Randy Nahohai *(collaborated sometimes with Josephine Nahohai)*

(Zuni, born into Eagle Clan, active ca. 1983-present: polychrome and fineline whiteware & orangeware, some slipcast glazeware, jars, large ollas, cornmeal bowls, clay flutes shaped as frogs, Corn Maiden sculptures, some experimental pieces with high-fired glazes, bronze Corn Maidens, pastels, pen & ink drawings)
FAMILY: m. grandson of La Wa Ta; son of Josephine Nahohai; brother of Milford Nahohai, Irene Nahohai & Priscilla Tsethlikai;
husband of Rowena Him Nahohai; father of Josh, Alec & Jaycee Nahohai
EDUCATION: Institute of American Indian Arts, Santa Fe
TEACHER: Josephine Nahohai
AWARDS: 1990, 2nd, Zuni Show, Museum of Northern Arizona, Flagstaff, AZ; Best of Division, Inter-tribal Indian Ceremonial
EXHIBITIONS: Indian Market, Santa Fe; Sedona Arts Center, Sedona, AZ
DEMONSTRATIONS: 1986, Folklife Festival, Smithsonian Institution, Washington, D.C.
COLLECTIONS: Heard Museum, Phoenix, AZ; Roxanne & Greg Hofmann
FAVORITE DESIGNS: Matsayka Long-haired Kachina, Kokopelli, Sun face, Rainbird, Deer-in-His-House, deer with heartlines, water serpent, feathers, rain, mountains, lightning, dragonflies, frogs
VALUES: On May 17, 2000, a polychrome olla, signed R. Nahohai, (12.5 x 12"), sold for $2,700, at Sotheby's, #540.
GALLERIES: The Indian Craft Shop, U.S. Department of Interior, Washington, D.C.; Turquoise Village, Pueblo of Zuni Arts & Crafts, Zuni, NM; Keshi, Santa Fe; Indian Art Unlimited, IL; Andrea Fisher Fine Pottery, Santa Fe; Case Trading Post at the Wheelwright Museum of the American Indian, Santa Fe
INTERNET: www.sunshinestudio.com
PUBLICATIONS: Rodee & Ostler 1986:23, 50-53, 57, 60-61; Trimble 1987:84; *Indian Market Magazine* 1988, 1989:69; 1996:63; Nahohai & Phelps 1995:cover, 32-43; Mercer 1995:41, 44; Lester 1995:381; Bassman 1996:vi, 16, 22, 26, 28; Hayes & Blom 1996; 1998; *Indian Trader* Oct. 1996:19; Painter 1998:184-90; Marshall 2000:82.

 By the early 1990s, Randy Nahohai and his wife, Rowena Him were among the best known Zuni potters. Randy jokingly described the decrease in mid-20th century pottery production at Zuni to be the result of "too much tupperware."

 Randy credits his experiences looking at old Zuni pottery, especially the ancient Matsa'kya ware made by his ancestors. He saw a collection in New York at the Heye Center, National Museum of the American Indian. He also was influenced by Hawikuh pottery, another ancient ancestral style. He makes sketches of Zuni pottery designs in a sketchbook.

 Randy gathers clay at Pia Mesa, south of Zuni. He collects and prepares clay with traditional respect. He and his wife, Rowena, also use some micaceous clay. The quality of their work is exceptional. Randy sometimes makes large ollas, up to 17" in diameter.

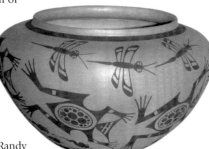

*Randy Nahohai -
Andrea Fisher Fine Pottery, Santa Fe*

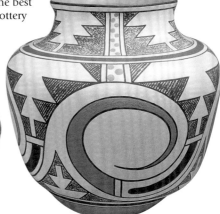

*Randy Nahohai -
Photograph by Tony Molina, Case Trading Post
Wheelwright Museum of the American Indian*

Rowena Him Nahohai *(Rowena Him)*

(Zuni, active ca. 1970s-present: polychrome jars, bowls, owls, duck canteens, figures of bears with heartlines, beadwork, jewelry)
FAMILY: daughter-in-law of Josephine Nahohai; wife of Randy Nahohai; mother of Josh, Alec & Jaycee Nahohai
EDUCATION: Institute of American Indian Arts, Santa Fe
EXHIBITIONS: 1988-present, Indian Market, Santa Fe
DEMONSTRATIONS: 1986, Folklife Festival, Smithsonian Institution, Washington, D.C.
COLLECTIONS: Heard Museum, Phoenix
FAVORITE DESIGNS: Rainbirds, scrolls, feathers, Matsayka clouds
GALLERIES: Pueblo of Zuni Arts & Crafts, Zuni, NM; The Indian Craft Shop, U.S. Department of Interior, Washington, D.C.
PUBLICATIONS: Rodee & Ostler 1986:23, 38, 52-56, 64; Coe 1986:207; Trimble 1987:85; *Indian Market Magazine* 1988, 1989; Nahohai & Phelps 1995: cover, 32-43; Bassman 1996:28; Hayes & Blom 1996; *Indian Trader* Oct. 1996:18; Painter 1998:184-90; Congdon Martin 1999.

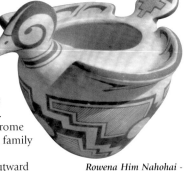

Rowena Him Nahohai -
Courtesy of John Blom

Rowena Him Nahohai is a masterful potter. She creates fine traditional Zuni polychrome pottery. She is to be honored in her own right. She married into the prominent Nahohai family of fine potters.

She is especially noted for her fine owls. Their eyes bulge out with lines radiating outward like the rays of the sun. She makes a hole into the soft clay as she is forming an owl. If she gets a dent, she simply blows in the hole to restore the rounded form.

Anahwake Nahtanaba

(Cochiti/Laguna/Caddo/Chickasaw/Choctaw, active ca. 1960s-present: Storytellers, beadwork, paintings, sculptures)
BORN: ca. 1941
PUBLICATIONS: *Indian Trader* Dec. 2000 31(12):19.

Jocelyn Quam Namingha

Jocelyn Namingha - Courtesy of
Robert Nichols Gallery, Santa Fe

(Zuni, active ca. 1996-present: polychrome jars, bowls, plates)
BORN: October 9, 1965
FAMILY: wife of Les Namingha
TEACHER: Dextra Quotskuyva, Les Namingha
AWARDS: 1997, H.M., 1999, H.M., Heard Museum Show, Phoenix; 1997, 3rd; 1998, Challenge Award for Traditional Pottery, 1999, 1st; 2001, 3rd, Indian Market, Santa Fe
EXHIBITIONS: 1997-present, Indian Market, Santa Fe
GALLERIES: Robert Nichols Gallery, Santa Fe
PUBLICATIONS: *American Indian Art Magazine* Spring 1998:17; Summer 1999:64; *Southwest Art* Aug. 1999:50.

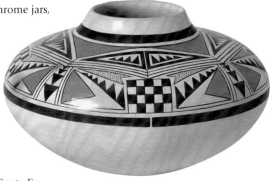

Jocelyn Namingha- - Courtesy of
Robert Nichols Gallery, Santa Fe

Les Namingha- - Courtesy of
Robert Nichols Gallery, Santa Fe

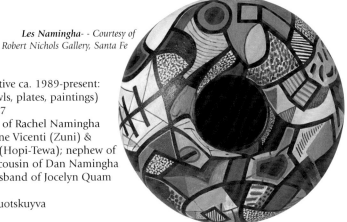

Les Namingha

Les Namingha - Courtesy of
Robert Nichols Gallery, Santa Fe

(Zuni/Hopi-Tewa, active ca. 1989-present: polychrome jars, bowls, plates, paintings)
BORN: April 26, 1967
FAMILY: p. grandson of Rachel Namingha Nampeyo; son of Irene Vicenti (Zuni) & Emerson Namingha (Hopi-Tewa); nephew of Dextra Quotskuyva; cousin of Dan Namingha & Hisi Nampeyo; husband of Jocelyn Quam Namingha
TEACHER: Dextra Quotskuyva
AWARDS:
1993 2nd, Traditional Bowls, Indian Market, Santa Fe
1997 Best of Pottery, Challenge Award, Indian Market, Santa Fe
1998 Judge's Choice Award, Heard Museum Show, Phoenix; 1st, Zuni Jars, Indian Market
1999 2nd, Indian Market, Santa Fe; Best in Class, Pottery, Inter-tribal Indian Ceremonial, Gallup
2001 Best of Division, Indian Market, Santa Fe
GALLERIES: Blue Rain Gallery, Taos; Robert Nichols Gallery, Santa Fe; Faust Gallery, Phoenix; King Galleries of Scottsdale, AZ; Adobe East, Scottsdale, AZ; Native New Mexico, Inc., Santa Fe; Southwest Trading Co., Chicago, IL

PUBLICATIONS: *American Indian Art Magazine* Spring 1993:83; Summer 1993:83; Spring 1998:17, 29, 87; Autumn 1998:94; Spring 1999:63, 73 Summer 1999:28; Dillingham 1996:14, 56; *Indian Artist* Summer 1996:61; Winter 1998:19 Spring 1998:62,63; Fall 1998:86; Winter 1999:76; Peaster 1997:55; Brown 1998:53; Jacka 1998:99-104, 129; Schaaf 1998:84-85, 94, 189; *Native Peoples* Spring 1998:36-37; *Santa Fean* Aug. 1998:52, 57, 102; *Indian Trader* Apr. 1999:9-10; *Cowboys & Indians* Nov. 1999:95; Sept. 2000:93, 95; Berger & Schiffer 2000:133.

Daisy Nampeyo *(see Daisy Hooee)*

Louis Nampeyo

(Cochiti/Hopi-Tewa, active ?: pottery)
ARCHIVES: Heard Museum Library, Phoenix

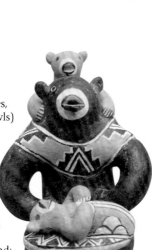

Les Namingha-
Gerald & Laurette Maisel Collection, CA

Edna Naranjo

(Cochiti, active ?-present: pottery)
EXHIBITIONS: 1994, Indian Market, Santa Fe
COLLECTIONS: Allan & Carol Hayes

Lorin Naranjo

(Cochiti, active ?: figures)
COLLECTIONS: Heard Museum, Phoenix

Louis Naranjo *(collaborated sometimes with Virginia Naranjo)*

(San Ildefonso, married into Cochiti, Oak Clan, active ca. 1977-97: polychrome Storytellers, Nativities, figures - deer, bears, antelope, wall plaques, jars, bowls)
LIFESPAN: August 17, 1932 - March 6, 1997
FAMILY: son of Frances Naranjo Suina; brother of Sarah Suina; husband of Virginia Naranjo (m. 1961); father of Mary Edna Trujillo & Pauline Naranjo
TEACHERS: Frances Suina, his mother, and Virginia Naranjo, his wife
AWARDS: 1983, 3rd; 1986, John R. Bott Memorial Award, Best Cochiti Storyteller; 1988, 1st, 3rd (2); 1989, 2nd; 1990, 1st, 3rd; 1991, 2nd (2); 1992, 2nd; 1993, 3rd; 1994, 2nd; 1996, 2nd, 3rd, Indian Market, Santa Fe
EXHIBITIONS: pre-1976-present, Indian Market,
COLLECTIONS: Allan & Carol Hayes, John Blom
FAVORITE DESIGNS: figures - bears, Santa Claus, priests, tourists, cowboys, fox, animal dancers, Nativities

Virginia Naranjo & Louis Naranjo -
Courtesy of Virginia Naranjo

Louis & Virginia Naranjo -
Courtesy of Allan & Carol Hayes

VALUES: On August 12, 2000, a polychrome Storyteller, signed Louis Naranjo (8 x 10″), sold for $1,540, at Allard Auctions, #886.
GALLERIES: Adobe Gallery, Albuquerque
PUBLICATIONS: Tanner 1976:121; *SWAIA Quarterly* Fall 1976:15; *American Indian Art Magazine* Spring 1983 8(2):39; *Indian Market Magazine* 1985, 1988, 1989; Babcock 1986:130; *New Mexico Magazine* 1988:46-53; Mercer 1995:123, 44; Peaster 1997:29; Hayes & Blom 1998:33, 35, 41, 43, 60; Congdon-Martin 1999:22-23; Batkin 1999.

Louis Naranjo began his career as a potter late in life, after his wife, Virginia, had a stroke. She and his mother taught him how to make pottery. He is famous as the innovator of the Bear Storytellers. He got the idea while deer hunting. He walked around a large rock and froze in his tracks. Before him sat a mother bear playing with her twin cubs. Louis backed out slowly around the rock and took off running. Later he thought about the playful scene of the mother bear with her cubs and decided to make the first Bear Storyteller. He also was the first to make Antelope Storytellers.

Pauline Naranjo

(Cochiti, Pumpkin Clan, active ca. 1981-present: polychrome jars, bowls, Storytellers, figures-bears, foxes, wall plaques)
BORN: June 21, 1969
FAMILY: daughter of Louis & Virginia Naranjo; sister of Mary Edna Trujillo; mother of Dale, Michelle & Jeremy

Samantha Naranjo

(Cochiti, active ?-present: pottery)
COLLECTIONS: Allan & Carol Hayes

Virginia Naranjo *(collaborated sometimes with Louis Naranjo), (see portrait with Louis Naranjo)*

(Cochiti, Pumpkin Clan, active ca. 1962-present: polychrome jars, bowls, Storytellers, Nativities, wall plaques, animal figures: deer, antelope)
BORN: October 19, 1932
FAMILY: p.granddaughter of Juanita Romero; daughter of Salvador & Evaline Arquero; niece of Juanita Arquero; daughter-in-law of Frances Naranjo Suina; wife of Louis Naranjo; mother of Mary Edna Trujillo & Pauline Naranjo

TEACHER: Frances Suina, her mother-in-law
AWARDS: 1979, 2nd; 1983, 3rd; 1993, 3rd; 1995, 1st, Figures, Indian Market, Santa Fe
EXHIBITIONS: pre-1985-present, Indian Market, Santa Fe
COLLECTIONS: Allan & Carol Hayes, John Blom
PUBLICATIONS: Tanner 1976:121; Monthan 1979:81; *Indian Market Magazine* 1985, 1988, 1989; Babcock 1986:130; Trimble 1987:59-61; *New Mexico Magazine* 1988:46-53; Mercer 1995:123, 44; Peaster 1997:29; Hayes & Blom 1998:33, 35, 41, 60; Congdon-Martin 1999:22-23.

In 1961, Virginia married Louis Naranjo. She learned pottery making while helping her mother-in-law, Frances Naranjo Suina. Virginia became an award-winning artist. After she suffered a stroke, Virginia taught her husband, Louis, how to make pottery. She now does much of the sanding aided sometimes by Pauline Naranjo, their daughter.

Virginia began making Nativities around 1971. She included wild animals such as deer, antelope, bears and foxes. In 1974, she and her husband began making Storytellers.

Yvonne Nashboo *(collaborates sometimes with Brian Tsethlikai), (sign B.T./Y.N., Zuni)*

(Zuni, Eagle Clan, active ca. 1995-present: polychrome polished redware effigy pots, seed bowls, vases, miniatures)
BORN: ca. 1975
FAMILY: daughter of Eva & William Nashboo; sister of Tammy Belson
TEACHERS: Phil Hughte, Tammy Belson, her sister
FAVORITE DESIGNS: lizards, salamanders
GALLERIES: Rio Grande Wholesale, inc., Albuquerque

Chris Nastacio *(C. Nastacio)*

(Zuni, active ?-present, polychrome jars, bowls, ladles, fish figures)
FAVORITE DESIGNS: tadpoles, fish
PUBLICATIONS: Hayes & Blom 1996; 1998:19, 55.

Chris Nastacio - Courtesy of John Blom

Yvonne Nashboo & Brian Tsethlikai -
Courtesy of Jason Esquibel
Rio Grande Wholesale, Inc.

Gunnison Natachu

(Zuni, active ca. 1970s-80s+: polychrome jars, cornmeal bowls with handles)
COLLECTIONS: Smithsonian Institution, Museum of Natural History, Washington, D.C.
FAVORITE DESIGNS: tadpoles, flying ants

Charmae Shields Natseway *(Charmae Theresa Darnell Shields),*

Charmae Natseway - Courtesy of
John D. Kennedy and
Georgiana Kennedy Simpson
Kennedy Indian Arts

(collaborates sometimes with Thomas Natseway, her husband)
(Acoma, Yellow Corn Clan, active ca. 1977-present: polychrome jars, bowls, Nativities, figures, contemporary forms)
BORN: August 1, 1958
FAMILY: m. granddaughter of Toribio & Dolores S. Sanchez; daughter of Don & Ethel Shields; sister of Jack Shields, Mae; wife of Thomas Natseway, Laguna potter
TEACHERS: Ethel Shields and Dolores Sanchez
AWARDS: 1984, 3rd; 1988, 1st; 1989, 3rd; 1990, 1st; 1991, 1st, 3rd; 1992, 1st, 2nd; 1994, 3rd, Indian Market, Santa Fe; Heard Museum Show, Phoenix; New Mexico State Fair, Albuquerque; Inter-tribal Indian Ceremonial, Gallup
COLLECTIONS: John Blom
GALLERIES: The Indian Craft Shop, U.S. Department of Interior, Washington, D.C.; Native American Collections, Denver, CO; Andrews Pueblo Pottery & Art Gallery, Rio Grande Wholesale, Inc., Palms Trading Co., Albuquerque; Blue Thunder Fine Indian Art at www.bluethunderarts.com
PUBLICATIONS: Monthan 1979:48; Barry 1984:96; Dillingham 1992:206-208; Hayes & Blom 1996:52-53; Peaster 1997:22-23; Painter 1998:14; Berger & Schiffer 2000:135.

Charmae Natseway -
Blue Thunder Fine Indian Art at
www.bluethunderarts.com

Charmae Natseway was born into a respected pottery-making family. She received excellent training from Dolores S. Sanchez, her grandmother, and Ethel Shields, her mother.

Early in the 1980s, she was interviewed by reporter Thomas Natseway from Laguna Pueblo. They fell in love and soon married. They initially lived with her parents at Acoma Pueblo.

Charmae is noted for the superb quality of her pottery. She also creates unique forms: pyramids, cylinders & boxes. She and her husband are top award winners. He sometimes paints her pottery.

Charmae Natseway -
Photograph by Bill Bonebrake
Courtesy of Jill Giller
Native American Collections, Denver, CO

Lorinda Natseway

(Acoma, active ?-present: pottery)
GALLERIES: The Indian Craft Shop, U.S. Department of Interior, Washington, D.C.

Thomas G. Natseway

Thomas Natseway -
Courtesy of Jason Esquibel
Rio Grande Wholesale, Inc.

(Laguna, married into Acoma, Bear Clan, active ca. 1980-present: black-on-white (Mimbres & Kayenta Revival), black & white-on-red (Four Mile) & polychrome jars, bowls, miniatures)
BORN: April 19, 1953
FAMILY: son of Peter & Betty Natseway; brother of Peter, Jr., Robert, Ron, Steven, Francis, Kathleen, Daniel, Patty, Johnny & Jerry Natseway; son-in-law of Don & Ethel Shields (Acoma); husband of Charmae Natseway (Acoma)
TEACHERS: Ethel Shields and Charmae Natseway
AWARDS:

1988	2nd (2), miniatures jars, figures, Indian Market, Santa Fe
1989	Miniature Pottery Award, 1st, 2nd (2), Indian Market Santa Fe
1991	Miniature Pottery Award, 1st (2), 2nd (2), Indian Market, Santa Fe
1992	2nd (2), 3rd, miniatures, Indian Market, Santa Fe
1993	Miniature Pottery Award, 1st, 2nd, 3rd, miniatures, Indian Market, Santa Fe
1995	Best of Class, miniatures, Indian Market, Santa Fe
1996	2nd (3), Indian Market, Santa Fe
1998	1st, 2nd, Indian Market, Santa Fe
1999	Indian Market, Santa Fe
2000	1st, miniature melon bowl, 1st, miniature traditional vase, 2nd, Nativities, 1st, 3rd, miniature vases, bowls, Indian Market, Santa Fe

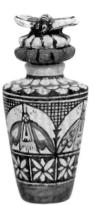

Thomas Natseway -
King Galleries of Scottsdale

EXHIBITIONS: 1982-present, Indian Market, Santa Fe
DEMONSTRATIONS: Maxwell Museum of Anthropology, University of New Mexico, Albuquerque; San Diego Museum of Man, San Diego, CA
COLLECTIONS: Candace Collier, Houston, TX; Jane & Bill Buchsbaum, Santa Fe
FAVORITE DESIGNS: flowers, butterflies, swirls, Kayenta designs, Mimbres animals, lizards, bugs
GALLERIES: Andrews Pueblo Pottery & Art Gallery, Adobe Gallery, Albuquerque & Santa Fe; Rio Grande Wholesale, Albuquerque; King Galleries of Scottsdale, AZ; Native American Collections, Denver, CO; Serendipity Trading Co., Estes Park, CO; Blue Thunder Fine Indian Art at www.bluethunderarts.com
PUBLICATIONS: *SWAIA Quarterly* Fall 1982:10; *Indian Market Magazine* 1985, 1988, 1989:35, 1996:63; Schiffer 1991d:46; *American Indian Art Magazine* Spring 1992:32; Hayes & Blom 1996:176; 1998:56-57; Peaster 1997:22-23; *Santa Fean* Aug. 1999:106.

Thomas Natseway and his wife, Charmae, make some of the finest miniature pottery. He began his career in the 1970s in the field of journalism. After interviewing Charmae at Acoma Pueblo, they fell in love and were married. They lived initially with her mother, noted Acoma potter Ethel Shields, daughter of the respected Dolores S. Sanchez. Ethel and Charmae taught Thomas how to make pottery. He chose to make miniatures so as not to compete directly with his wife and in-laws. Thomas proclaimed, "I enjoy my art!"

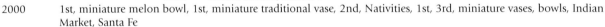

Thomas Natseway -
Blue Thunder Fine Indian Art at
www.bluethunderarts.com

Louise Negal *(Negale)*

(Zia, Coyote Clan, active ca. 1980s-present: polychrome jars, bowls)
FAMILY: sister of Florenda Shije
PUBLICATIONS: Hayes & Blom 1996:164-65; Peaster 1997:151.

P. Nez

(Cochiti, active ca. 1988-present: polychrome Storytellers)
BORN: November 2, 1958
GALLERIES: Palms Trading Company, Albuquerque
PUBLICATIONS: Congdon-Martin 1999:24; Berger & Schiffer 2000:90.

Cecilia Nieto

(Santo Domingo, active ca. 1920s-present: traditional polychrome and black-on-cream ollas, jars, chili bowls, pitchers)
BORN: ca. 1910
FAMILY: mother of John Nieto, Victoria Nieto, Jimmy Nieto, Ruby Nieto, Frances N. Tenorio, Josephine Nieto, Gabbie Nieto, Clara Lovato & Perfilia Nieto; grandmother of Christina Nieto, Jacque Nieto
COLLECTIONS: Dr. Gregory & Angie Yan Schaaf, Santa Fe

Christina Nieto
(Santo Domingo, active ca. 1980s-present: polychrome jars, bowls)
BORN: ca. 1960
FAMILY: p. granddaughter of Cecilia Nieto; daughter of Jimmy & Geraldine Nieto

Josie R. Nieto
(Santo Domingo, active ? - present: polychrome, jars, bowls, plates)
FAMILY: wife of John Nieto
COLLECTIONS: Dr. Gregory & Angie Yan Schaaf, Santa Fe

Reyes Nietolato
(Santo Domingo, active ca. 1910s-?: traditional polychrome ollas, jars, bowls)
COLLECTIONS: Philbrook Museum of Art, Tulsa, OK, jar, ca. 1920.

Gina R. Olivas
(Santo Domingo/Taos/Hispanic: active ca. 1990-present: pottery)
BORN. March 13, 1960
PUBLICATIONS: Berger & Schiffer 2000:137.

Andrea Ortiz
(Santo Domingo, active ca. 1920s-?: polychrome jars, bowls)
LIFESPAN: ca. 1900 - 1993
FAMILY: mother of Andres Tenorio, Cecilia Tenorio Ward; mother-in-law of Juanita Tenorio (painter, jeweler), grandmother of Robert Tenorio, Paulita Pacheco, Mary Edna Tenorio & Hilda Coriz; great-grandmother of Andrew Pacheco & Ione Coriz
PUBLICATIONS: Dillingham 1994:130-31; Peaster 1997; Hayes & Blom 1996.

Armanda Ortiz
(Cochiti, active ca. 1990s-present: polychrome jars, bowls, figures)
BORN: ca. 1988
FAMILY: m. granddaughter of Seferina & Guadalupe Ortiz; daughter of Leon & Jackie Ortiz
PUBLICATIONS: Dillingham 1994:120; Hayes & Blom 1998:41.

C. Ortiz
(Acoma, active ?-present: polychrome jars, bowls)
COLLECTIONS: John Blom

Carla Ortiz *(collaborates with Chuck Ortiz)*
(Acoma, active ?-1990+: polychrome jars, bowls)
RESIDENCE: San Fidel, NM
ARCHIVES: Artist File, Heard Museum Library, Phoenix
PUBLICATIONS: Dillingham 1992:206-208.

Chuck Ortiz *(collaborates with Carla Ortiz)*
(Acoma, active ?-1990+: polychrome jars, bowls)
ARCHIVES: Artist File, Heard Museum Library, Phoenix
PUBLICATIONS: Dillingham 1992:206-208.

Dominick Ortiz
(Cochiti, active ca. 1999-present: pottery)
BORN: CA. 1994
EXHIBITIONS: 1999-present, Indian Market, Santa Fe
PUBLICATIONS: *Journal North Indian Market* 1999:42.

Donna Ortiz *(signs D. O. Jemez N.M.)*
(Jemez, active ca. 1962-present: traditional polychrome jars, bowls)
BORN: September 2, 1953
FAMILY: daughter of Juan R. & Mrs. Tafoya
TEACHER: her mother
PUBLICATIONS: Berger & Schiffer 2000:137.

Evelyn R. Ortiz *(Evelyn R. Chino)*
(Acoma, active 1950s-present: polychrome jars, bowls)
BORN: October 21, 1938; RESIDENCE: San Fidel, NM
FAMILY: mother of Judy Ortiz
EXHIBITIONS: 1985-present: Indian Market, Santa Fe; 1988, "Legends Renewed: American Indian Art Today," The Society of Arts & Crafts, Boston, MA; 1992-present, Eight Northern Indian Pueblos Arts & Crafts Show
PUBLICATIONS: Dillingham 1992:206-208; Painter 1998:14.

Guadalupe Ortiz *(see Cochiti color illustration)*
(Cochiti, active ca. 1998-present: polychrome jars, bowls, figures, drums, rattles, wood carvings)
BORN: December 10, 1929
FAMILY: husband of Seferina Ortiz; father of Joyce Lewis, Mary Janice Ortiz, Inez Ortiz, Virgil Ortiz, Leon Ortiz & Angie Ortiz
AWARDS: 1998, Indian Market, Santa Fe; New Mexico State Fair, Albuquerque
EXHIBITIONS: 1998-present, Indian Market, Santa Fe; 1999, "Ortiz Family," Robert Nichols Gallery, Santa Fe; 1999, "Clay People," Wheelwright Museum, Santa Fe
COLLECTIONS: Allan & Carol Hayes; Dr. Gregory & Angie Yan Schaaf, Santa Fe
FAVORITE DESIGNS: human figures, frogs, water serpents, bears, buffalo & dogs
GALLERIES: Andrews Pueblo Pottery and Art Gallery, Albuquerque
PUBLICATIONS: *SWAIA Quarterly* Fall 1982:12; Tanner 1976:121; *Indian Market Magazine* 1985, 1988, 1989; Dillingham 1994:120; Peaster 1997:27.

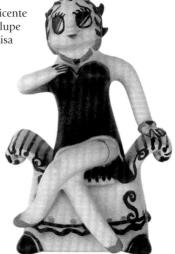

Guadalupe Ortiz - Andrews Pueblo Pottery and Art Gallery, Albuquerque, NM

Ida Ortiz
(Acoma, Roadrunner Clan, active ca. 1940s-present: traditional polychrome jars, bowls)
BORN: ca. 1930s
FAMILY: daughter of Eva Histia; mother of Lavine Torivio
PUBLICATIONS: Dillingham 1992:206-208.

Inez Ortiz *(see Juanita Ortiz)*

Janice Ortiz *(see Mary Janice Ortiz)*

Joe Ortiz
(San Felipe, active ?-present: pottery, woodcarving)

Joyce Ortiz *(see Joyce Ortiz Lewis)*

Juanalita G. Ortiz
(Acoma, active ca. 1975-1990: traditional polychrome jars, bowls))
PUBLICATIONS: Minge 1991:195; Dillingham 1992:206-208.

Juanita Inez Ortiz *(Mapuwana, Wild Rose), (sometimes signs I. Ortiz), (see Cochiti color illustration)*
(Cochiti, active ca. 1984-present: polychrome jars, bowls, figures, Storytellers)
BORN: August 11, 1960
FAMILY: great-great-granddaughter of Santiago & Magdelena Quintana; great-granddaughter of Vicente & Reyes T. Romero; granddaughter of Nestor & Laurencita Herrera; daughter of Seferina & Guadalupe Ortiz; sister of Joyce Lewis, Mary Janice Ortiz, Virgil Ortiz, Leon Ortiz & Angie Ortiz; mother of Lisa Holt, Krystal Henderson & Katherine Ortiz; grandmother of Dominique
TEACHERS: Laurencita Herrera, her grandmother, and Seferina Ortiz, her mother
AWARDS: 1998, Honorable Mention; 1999, Best of Division, 1st, 2nd; 2000, Best of Division, Non-Traditional Pottery, 1st, 2nd, Figures, Indian Market, Santa Fe
EXHIBITIONS: 1997-present, Indian Market, Santa Fe; 1999, "Ortiz Family," Robert Nichols Gallery, Santa Fe; 1999, "Clay People," Wheelwright Museum, Santa Fe
FAVORITE DESIGNS: Storytellers, Nativities, bears, owls, turtles, clay drums
COLLECTIONS: Allan & Carol Hayes, John Blom
GALLERIES: Andrews Pueblo Pottery & Art Gallery, Adobe Gallery, Albuquerque & Santa Fe; Palms Trading Company, Albuquerque; Robert Nichols Gallery, Santa Fe; King Galleries of Scottsdale,
ARCHIVES: Heard Museum Library, artist file.
PUBLICATIONS: Babcock 1986:130; Dillingham 1994:120; Peaster 1997; Hayes & Blom 1998:41; *Native Peoples* Spring 1998 11(1):35; Congdon-Martin 1999:24-25; Batkin 1999; *American Indian Art Magazine* Summer 1999 24(3):20.

 Juanita Inez Ortiz spoke with respect for her family tradition, "It was brought down from generation to generation. Making pottery is my hobby. It is very calming, without stress."

Juanita Inez Ortiz - King Galleries of Scottsdale

Katherine Ortiz
(Cochiti, active ca. 1990s-present: traditional pottery, figures)
BORN: ca. 1980s
FAMILY: great-great-great-granddaughter of Santiago & Magdelena Quintana; great-great-granddaughter of Vicente & Reyes T. Romero; great-granddaughter of Nestor & Laurencita Herrera; granddaughter of Seferina & Guadalupe Ortiz; daughter of Juanita Inez Ortiz; sister of Lisa Holt, Krystal Ortiz
TEACHER: Juanita Inez Ortiz, her mother

Krystal Ortiz *(see Krystal Henderson)*

Judy Ortiz

(Acoma, active ?-present: polychrome Storytellers, jars, bowls)
COLLECTIONS: John Blom
EXHIBITIONS: 1995, Eight Northern Indian Pueblos Arts & Crafts Show
PUBLICATIONS: Hayes & Blom 1998:35.

Linda Ortiz

(Acoma, active ?-present: pottery)
GALLERIES: The Indian Craft Shop, U.S. Department of Interior, Washington, D.C.

Mamie Ortiz

(Acoma, active ca. 1970s-80s: traditional polychrome jars, bowls)
EXHIBITIONS: 1974-85, Indian Market, Santa Fe
PUBLICATIONS: *SWAIA Quarterly* Fall 1974:13; Dillingham 1992:206-208.

Marie Ortiz

(Acoma, active ?: traditional polychrome jars, bowls)
FAMILY: grandmother of Viola M. Ortiz
COLLECTIONS: Heard Museum, Phoenix

Mary Janice Ortiz *(Janice Ortiz, M. J. Ortiz)*

(Cochiti, active ca. 1970s-present: polychrome jars, bowls, figures, Nativities, Storytellers)
BORN: ca. 1956
FAMILY: granddaughter of Mr. & Mrs. Nestor Herrera; daughter of Seferina & Guadalupe Ortiz; sister of Inez Ortiz, Virgil Ortiz, Leon Ortiz, Juanita Ortiz, Lucy Ortiz & Angie Ortiz; mother of Kimberly & Jackie Walker
AWARDS: 2000, 1st (2), 2nd, Figures, Indian Market, Santa Fe; 2001, Best of Division, Indian Market, Santa Fe
EXHIBITIONS: ?-present, Indian Market, Santa Fe; 1999, "Ortiz Family," Robert Nichols Gallery, Santa Fe; 1999, "Clay People," Wheelwright Museum, Santa Fe
COLLECTIONS: Wright Collection, Peabody Museum, Harvard University, Cambridge, MA; Jane & Bill Buchsbaum; Don & Lynda Shoemaker, Santa Fe
PUBLICATIONS: Babcock 1986:130; Dillingham 1994:120; Peaster 1997:27; Drooker, et al. 1998:49,138; *Native Peoples* Spring 1998 11(1):35; Batkin 1999; *American Indian Art Magazine* Summer 1999 24(3):20.

Janice Ortiz - Courtesy of
Don & Lynda Shoemaker
Santa Fe

M. J. Ortiz - Courtesy of
Don & Lynda Shoemaker, Santa Fe

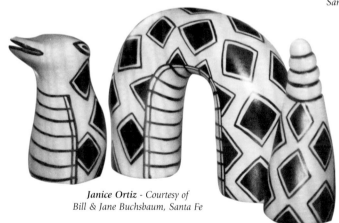

Janice Ortiz - Courtesy of
Bill & Jane Buchsbaum, Santa Fe

Norma Jean Ortiz *(see Norma Jean Juanico)*

Peferius Ortiz

(Cochiti, active ?-present: polychrome Storytellers, figures, frogs)
PUBLICATIONS: Congdon-Martin 1999:26.

Santana Ortiz

(Acoma, active ?: pottery)
PUBLICATIONS: Mather 1990.

Seferina Ortiz

(Cochiti, Oak Clan, active ca. 1950s-present: polychrome jars, bowls, effigy pots, lizard canteens, figures, Storytellers, Nativities, Deer Dancers, drummers, harpist, flute player, tourists, turtles, owls, miniatures)
BORN: October 1, 1931
FAMILY: m. granddaughter of Vicente & Reyes T. Romero; p. granddaughter of Seferina Suina; daughter of Nestor & Laurencita Herrera; sister of Mary Francis Herrera & 7 others; wife of Guadalupe Ortiz; mother of Joyce Lewis, Mary Janice Ortiz, Inez Ortiz, Virgil Ortiz, Leon Ortiz & Angie Ortiz
TEACHER: Laurencita Herrera, her mother
AWARDS: 1968, 2nd; 1970, 2nd; 1971, 2nd; 1977, 2nd; 1982,1st, New Mexico State Fair, Albuquerque; 1976, 2nd; 1978, 1st; 1979, 3rd; 1982, 1st & 2nd; 1983, 1st & 2nd; 1984, 2nd & 3rd; 1985, 1st & 2nd; 1988, 1st & 2nd; 1990, 1st & 3rd; 1991, 1st & 3rd; Figure Sets; 1992, John R. Bott Memorial Award, Best Achievement in a Traditional Cochiti Pueblo Storyteller Figure, 1st, 2nd; 2000, 1st, Storytellers, 2nd, Figures, Indian Market, Santa Fe; 1983, National Endowment for the Arts, National Heritage Fellowship, Washington, D.C;
EXHIBITIONS: 1950-present, Indian Market, Santa Fe; 1979, "One Space: Three Visions," Albuquerque Museum, Albuquerque; 1988, "Earth, Hands, Life: Southwestern Ceramic Figures, Heard Museum, Phoenix; 1999, "Ortiz Family," Robert Nichols Gallery, Santa Fe; "Clay People," Wheelwright Museum, Santa Fe
COLLECTIONS: Wright Collection, Peabody Museum, Harvard University, Cambridge, MA; Albuquerque Museum, Storyteller, ca. 1978; Allan & Carol Hayes; John Blom; Dr. Gregory & Angie Yan Schaaf, Santa Fe; Ron & Doris Smithee, Harrah, OK; Bill & Jane Buchsbaum, Santa Fe
FAVORITE DESIGNS: Storytellers, figures, Nativities, drummers, bears
GALLERIES: Hoel's Indian Shop, Oak Creek Canyon, AZ; Andrea Fisher Fine Pottery, Santa Fe
PUBLICATIONS: *Arizona Highways* May 1974 50(5):41; *SWAIA Quarterly* Fall 1974:2; Fall 1976:13; Fall 1982:10; Tanner 1976:121; *American Indian Art Magazine* Spring 1983 8(2):30-31; Summer 1999 24(3):20; Barry 1984:115-18; *Indian Market Magazine* 1985, 1988, 1989, 1996:53, 63, 1999:61; Babcock 1986:130; Coe 1986:202-03; Trimble 1987; Dillingham 1996; Hayes & Blom 1996, 1998; Peaster 1997:24, 27-28; Drooker, et al., 1998:49, 138; Hayes & Blom 1998:33, 55, 57; Congdon-Martin 1999:26.

At the 2000 Santa Fe Indian Market, we met Seferina Ortiz, her husband, Guadalupe, and her children - Joyce, Mary Janice, Inez, Virgil, Leon & Angie. The whole family was especially kind toward us. They greeted us with old time Pueblo hospitality.

Seferina Ortiz is one of the important matriarchs of Cochiti Storytellers and figural pottery. She also makes exceptional polychrome ollas in the old way. She passed her traditional techniques and firing methods onto her children who have become top, award-winning potters.

Seferina is the most highly represented Pueblo potter in the Wright Collection of the Peabody Museum at Harvard University. The Wright Collection contains 32 pieces of her pottery. The pieces were purchased by William R. Wright and then donated to the Peabody Museum.

Seferina commented, "I like working with clay, because I can make anything that comes to my mind."

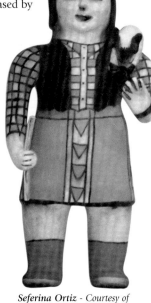

Seferina Ortiz -
Photograph by Bill Knox
Courtesy of Indart Incorporated

Seferina Ortiz -
Hoel's Indian Shop
Oak Creek Canyon, AZ

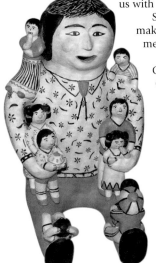

Seferina Ortiz - Courtesy of
Andrea Fisher Fine Pottery, Santa Fe

Seferina Ortiz - Courtesy of
Ron & Doris Smithee, Harrah, OK

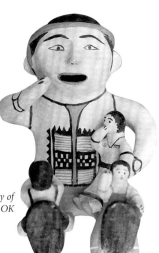

Seferina Ortiz - Courtesy of
Bill & Jane Buchsbaum, Santa Fe

Viola M. Ortiz

(Acoma, active ?-1990+: polychrome jars, bowls)
BORN; September 23, 1956; RESIDENCE: Acomita, NM
FAMILY: great-granddaughter of Mary Histia; granddaughter of Marie Ortiz
PUBLICATIONS: Dillingham 1992:206-208.

Virgil T. Ortiz

(Cochiti, Oak Clan, active 1975-present: polychrome jars, bowls, figures, paintings, fashions, photography, videos)

BORN: May 8, 1969

FAMILY: son of Seferina & Guadalupe Ortiz; brother of Joyce Lewis, Mary Janice Ortiz, Inez Ortiz, Leon Ortiz & Angie Ortiz

AWARDS: 1983, 1st; 1984, 2nd (2), Student (18 years or younger); 1989, 1st; 1990, 1st; 1991, 1st, 3rd; 1992, 1st; 1993, 1st, Indian Market, Santa Fe

EXHIBITIONS:

1983-2001	Indian Market, Santa Fe
1988	Heard Museum, Phoenix
1990	1st, Storytellers, 1st, Figures, Indian Market
1991	3rd, Figures, Indian Market, Santa Fe
1993	1st, Storytellers, Indian Market, Santa Fe
1994	1st, Storytellers, Indian Market, Santa Fe
1995	Best of Class, Traditional Pottery, Indian Market
1996	1st (2), Storytellers, FiguresIndian Market, Santa Fe
1999	Wheelwright Museum, Robert Nichols Gallery, Santa Fe
2000	Spencer Museum of Art, University of Kansas; "Blue Rain Gallery 2000", San Francisco
2001	Un Art Populaire, Cartier Foundation for Contemporary Art, Paris, France; American Craft Museum, NY

COLLECTIONS: Wright Collection, Peabody Museum, Harvard University, Cambridge, MA; Smithsonian Institution, Washington, D.C.; American Craft Museum, NY; Denver Art Museum, Denver; Cartier Museum, Paris, France; Hallmark Cards, Kansas City, MO; Spencer Art Museum, Kansas City, MO; Wheelwright Museum, Santa Fe; Museum of Indian Arts & Cultures, Santa Fe; Poeh Museum, Pojoque; Allan & Carol Hayes; John Blom; Richard M. Howard, Bill & Jane Buchsbaum, Dr. Gregory & Angie Schaaf

Bill & Jane Buchsbaum Collection

VALUES: In August 2001, a standing figure (15" h.) sold for $4,000 at the Wheelwright Museum Auction, Santa Fe, #62.

GALLERIES: Andrea Fisher Fine Pottery, Robert Nichols Gallery, Santa Fe; Adobe Gallery, Albuquerque and Santa Fe; Andrews Pueblo Pottery & Art Gallery, Robert Gallegos, Albuquerque

PUBLICATIONS: *Indian Market Magazine* 1985, 1988, 1989; Babcock 1986:130; *The Messenger*, Wheelwright Museum Spring 1991:4; *American Indian Art Magazine* Winter 1994 20(1):27; Spring 1995 20(2):17, 37; Spring 1998 23(2):29; Summer 1998 23(3):83; Summer 1999 24(3):20; Autumn 1999 24(4):38; Mercer 1995:4, 12, 13, 44; *Indian Artist* Spring 1995:21; Dillingham 1996:124-25; Hayes & Blom 1996; 1998:32-3; Peaster 1997:27; Drooker, et al., 1998:49; *Native Peoples* Spring 1998 11(1):35; *Santa Fean* Aug. 1998 26(7):55, 76, 102-03; *Southwest Art* Aug. 1998 28(3):178; Summer 1999 12(4):18, 28; Feb./Mar. 2000 13(2):84; Batkin 1999:13-14, 32-40; *ative Artists* Summer 1999 1(1):30-33; *Indian Market Magazine* 1999:61; *Cowboys & Indians* Dec. 1999 7(6):78; Sept. 2000 8(4):94; *Navajo Times* Aug. 10, 2000 39(32):6; *News from Indian Country* Nov. 2000 14(20):17b; Nyssen 2001.

In the world of Pueblo Indian Pottery, Virgil Ortiz gives new meaning to the word "HOT." Not only is he one of the most popular clay sculptors, some of his figures are scantily clad in back leather complete with nipple rings. However, the artist displays a diversity of different characters from Pueblo culture and tradition.

Virgil began his artistic career as a child, "I made my first piece, a Storyteller, when I was 6. It was a seated mother carrying a basket. She had breasts, but I painted a suit and tie on her, which is funny, since now I do hermaphrodites and cross-dressers."

Virgil explains that his figures are drawn from 19th century and early 20th century figures from Cochiti. Some figures were inspired by bizarre circus performers from Mexico — including the Two-headed Man, the Muscle Man, and Tattooed Ladies - who toured New Mexico over a hundred years ago. Other figures portray Opera Singers and characters seen in Pueblo puppet shows.

Virgil commented on his subject matter, "People who look, act, or think differently are labeled and often cast out from their communities. Today, people embrace these figurines. Perhaps they recognize themselves as the outcasts of their own modern societies."

Virgil loves to get his friends together, dress up and act out the characters: "I sometimes wear makeup or dress a certain way, but that's more a matter of theatrics than sexuality. We can't be defined by those external labels. I would rather be photographed to look like a freak than to pose under a piñon tree gazing off into the distance while holding one of my pieces."

Bill & Jane Buchsbaum Collection

Virgil's work has attracted a whole new body of contemporary collectors who want something wild and wonderful. Museum curators, top art dealers and magazine editors are but a few who have joined the parade leading to the home of Virgil Ortiz. By 1996, he was recognized as one of the "Masters of Indian Market." Virgil also was one of the stars of the Wheelwright Museum's popular exhibit, "The Clay People," along with Nora Naranjo-Morse and Roxanne Swentzell.

Bill and Jane Buchsbaum - patrons of the new pottery wing at the Museum of Indian Arts & Cultures - collect not only Vigil's figures, but also his exceptional traditional

Bill & Jane Buchsbaum Collection

pottery. Bill recalled, "I remembered when Virgil first showed us one of his fantastic ollas. We just had to add it to our collection. Virgil said that his mother, Seferina, was encouraging him to continue to make traditional pottery in the old way."

Jane added, "We have added to our collection Virgil's figures and traditional pots. We think they are wonderful!"

A bright future lies before Virgil Ortiz. As an artist, his work is technically excellent and visually interesting. As a personality, he has the flair of Salvador Dali, yet is shy and soft spoken in public. His intelligence radiates in conversation. His respect for his parents and family is commendable.

Virgil is determined to help pass on the tradition of Cochiti figural pottery: "I think my role now is to help be a part of the continuation, part of the timeline. I was to make that link and spread it to the younger generation. My plan is not to have it die out, that's all."

Virgil's talent is growing in many directions. He has added a line of designer fashions to his offerings. He also is designing fine photographs of models in extravagant poses and producing videos. His work is attracting a worldwide audience beyond Indian art circles. Virgil Ortiz is becoming an internationally recognized artist and designer who preserves the highest standards of excellence.

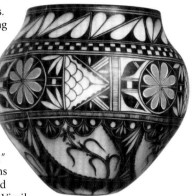

Bill & Jane Buchsbaum Collection

Leanna Othole

(Zuni, active ca. 1990s-present: polychrome jars, bowls)

Angie Reano Owen

(Santo Domingo, active ca. 1960s-present: traditional polychrome jars, bowls, jewelry)
BORN: ca. 1940s
FAMILY: m. great-great-granddaughter of Dolorita Baca Leandro & Jose Leandro; m. great-granddaughter of Benina Silva & Francisco Silva; m. granddaughter Monica Silva & Santiago Lovato; p. granddaughter of Isidro Reano; daughter of Clara Lovato Reano & Joe I. Reano; sister of Vicky Reano Tortalita, Rose Reano, Celestino Reano, Joe L. Reano, Percy Reano, Avelino Reano, Frank Reano & Charles Lovato; wife of Larry Tortalita; mother of Vicky Celestino, Rose Reano, Joe L. Reano, Percy Reano, Avelino & Frank Reano

Anacita J. Paca

(Santo Domingo, active ca. 1960s-?: contemporary black-on-white with orange-based glazeware jars, bowls)
FAVORITE DESIGNS: clouds
PUBLICATIONS: Eaton 1990:21.

Andrew Pacheco *(William Andrew Pacheco)*

(Santo Domingo, active ca. 1985-present: polychrome jars, bowls, canteens, animal figures, jewelry with Gladys Pacheco)
BORN: October 16, 1975
FAMILY: son of Gilbert & Paulita Pacheco; nephew of Robert Tenorio
EDUCATION: New Mexico State University, Las Cruces; University of New Mexico, Albuquerque; Cornell University, NY
AWARDS: 1986, 1st, pottery (ages 12 & under); 1988, 1st (2), pottery (ages 12 & under); 1989, 2nd, figures, 3rd, pottery (ages 18 & under); 1991, Young Potter's Award; 1992, 3rd; 1993, 2nd (ages 18 & under); 1996, 2nd, Indian Market, Santa Fe
EXHIBITIONS: 1986-present, Indian Market, Santa Fe; 1995-present, Eight Northern Indian Pueblos Arts & Crafts Show
COLLECTIONS: Heard Museum, Phoenix; School of American Research, Santa Fe; Rockwell Museum, Corning, NY; Natural History Museum, Los Angeles, CA

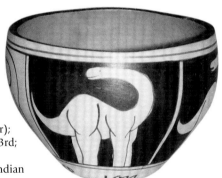

Andrew Pacheco- Courtesy of *Andrea Fisher Fine Pottery, Santa Fe*

PUBLICATIONS: *The Messenger,* Wheelwright Museum Autumn 1990:7; Spring 1991:4; Dillingham 1994:136, 140-41; Hayes & Blom 1996, 1998; Peaster 1997; *Santa Fean* Aug. 1997 25(7):101; Tucker 1998: plate 105; *Native Peoples* Feb.-April 1998 11(1):34; Anderson 1999:15.

Andrew is famous for his dinosaur designs on traditional Santo Domingo jars and bowls. His parents and Uncle Robert Tenorio encouraged him.

Dora Pacheco

(Santo Domingo, active ?: pottery)
FAMILY: daughter of Marie Pacheco; sister of Ramos Pacheco, Eddie Pacheco & Remeijo Pacheco

Gilbert Pacheco *(collaborates with Paulita Pacheco), (sign Paulita Pacheco & a Corn hallmark)*

(Santo Domingo, active ca. 1975-present: polychrome jars, chili & dough bowls, canteens, pitchers)
BORN: June 9, 1940
FAMILY: son of Lorencita Pacheco; brother of Vivian Sanchez, Trinidad Pacheco, Laurencita Calabaza; husband of Paulita Tenorio Pacheco; father of Andrew Pacheco
AWARDS: 1993, 1st, traditional bowls, Indian Market, Santa Fe; Eight Northern Indian Pueblos Arts & Crafts Show
EXHIBITIONS: ?-present, Santo Domingo Pueblo Arts & Crafts Show; 1989-present, Indian Market, Santa Fe; 1995-present, Eight Northern Indian Arts & Crafts Show; Smithsonian Institution, Washington, D.C.
COLLECTIONS: Gerald & Laurette Maisel, Tarzana, CA
PUBLICATIONS: Dillingham 1994:136-39; Tucker 1998: plate 105.

Karen Pacheco *(Karen Miller), (works with Melinda Miller)*

(Acoma, active ?-1990+: traditional & ceramic polychrome jars, bowls)
RESIDENCE: Acoma Pueblo, NM
FAMILY: m. granddaughter of Marie Miller; daughter of Melinda Miller; sister of Sharon
PUBLICATIONS: Dillingham 1992:206-208; Painter 1998:14.

Laurencita Pacheco

(Santo Domingo, active ca. 1940s-?: traditional polychrome jars, bowls)
BORN: ca. 1920
FAMILY: mother of Gilbert Pacheco, Vivian Sanchez, Trinidad Pacheco & Laurencita Calabaza;
grandmother of Santana Calabaza

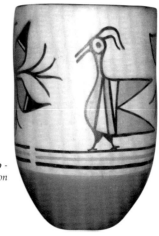

Paulita Pacheco -
Janie & Paul K. Conner Collection

Marie C. Pacheco

(Santo Domingo, active ?: pottery)
FAMILY: mother of Dora Pacheco, Ramos Pacheco, Eddie Pacheco & Remeijo Pacheco
ARCHIVES: Laboratory of Anthropology Library, Santa Fe, Lab. File
PUBLICATIONS: Harlow 1977.

Paulita Pacheco *(collaborates with Gilbert Pacheco), (sign Paulita Pacheco & a Corn hallmark)*

(Santo Domingo, active ca. 1971-present: traditional polychrome jars, dough bowls, canteens, pitchers, plates)
BORN: December 10, 1943
FAMILY: m. granddaughter of Clemente & Nescita Calabaza; p. granddaughter of Andrea Ortiz;
daughter of Juanita C. Tenorio; sister of Robert Tenorio, Mary Edna Tenorio and Hilda Coriz; wife
of Gilbert Pacheco; mother of Rose A. Pacheco, Mark Pacheco, William Andrew Pacheco
TEACHERS: Andrea Ortiz, her grandmother, & Juanita C. Tenorio, her mother; Robert Tenorio,
her brother
AWARDS: 1988, 3rd, plates; 1989, 1st, 2nd; 1992, 2nd, jars; 1993, 1st, bowls; 1994, 2nd,
jars, Indian Market, Santa Fe; Eight Northern Indian Pueblos Arts & Crafts Show
EXHIBITIONS: 1990-present, Santo Domingo Pueblo Arts & Crafts Show; 1989-present,
Indian Market, Santa Fe; 1994-present, Eight Northern Indian Arts & Crafts Show;
Smithsonian Institution, Washington, D.C.
COLLECTIONS: Smithsonian Institution, Washington, D.C.; Philbrook
Museum of Art, Tulsa, OK, dough bowl, ca. 1996; Gerald & Laurette
Maisel, Tarzana, CA; Janie & Paul K. Conner, Santa Fe
GALLERIES: Native American Collections, Denver, CO; Kennedy
Indian Arts, UT; Andrea Fisher Fine Pottery, Santa Fe
PUBLICATIONS: *The Messenger*, Wheelwright Museum
Autumn 1990:7; Spring 1991:4; Dillingham 1994:136; Hayes
& Blom 1996; Peaster 1997; Tucker 1998: plates 104, 105;
Berger & Schiffer 2000:70, 137.

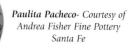

Paulita Pacheco- Courtesy of
Andrea Fisher Fine Pottery
Santa Fe

 Paulita & Gilbert described their pottery making: "We
are reproducing traditional Santo Domingo pottery. It is a
long process, but we enjoy creating pottery that people can use."

Roger A. Pacheco

(Santo Domingo/Hopi, active ca. 1997-present: pottery)
BORN: Feb. 4, 1970
PUBLICATIONS: Berger & Schiffer 2000:137.

Rose Pacheco

(Santo Domingo, active ca. 1976-present: polychrome dolls, animal figures, rabbits, ornaments, miniatures)
BORN: December 2, 1968
FAMILY: daughter of Gilbert & Paulita Pacheco
EXHIBITIONS: 1989-94, Indian Market, Santa Fe
FAVORITE DESIGNS: flowers, butterflies
 Rose Pacheco shared, "My favorite part of pottery making is designing. I also like meeting lots of people."

Teresa Leanna Pacheco

(Santo Domingo, active ca. 1990s-present)
BORN: ca. 1989
EXHIBITIONS: 1997-present, Eight Northern Indian Pueblos Arts & Crafts Show

Trinidad Pacheco

(Santo Domingo, active ca. 1970s-present: polychrome jars, bowls, canteens)
BORN: ca. 1940s
FAMILY: sister of Vivian Sanchez, Gilbert Pacheco, Laurencita Calabaza
PUBLICATIONS: Dillingham 1994:136.

William Andrew Pacheco *(see Andrew Pacheco)*

Reyes Pacheco
(Zia, active ?: pottery)
ARCHIVES: Laboratory of Anthropology Library, Santa Fe, lab. file.

Andrew Padilla, Jr. *(Butch)*

Andrew Padilla, Jr. -
Photograph by Bill Bonebrake
Courtesy of Jill Giller
Native American Collections, Denver

(Laguna/Santa Clara: active ca. 1966-present: whiteware melon bowls, jars, wedding vases, figures - turtles, blackware (1966-82))
BORN: 1956
FAMILY: p. grandson of Reycita Padilla (Santa Clara); son of Gladys Paquin (Laguna) & Andy Padilla (Santa Clara); brother of Danny Padilla
TEACHERS: Reycita Padilla, his grandmother, and Gladys Paquin, his mother
AWARDS: 1989, 2nd, melon bowls, Indian Market, Santa Fe; 1999, 4th, New Mexico State Fair, Albuquerque
GALLERIES: Adobe Gallery, Rio Grande Wholesale, Albuquerque; Hoel's Indian Shop, Oak Creek Canyon, AZ; Native American Collections, Denver, CO
PUBLICATIONS: *SWAIA Quarterly* Fall 1982:11; *Indian Market Magazine* 1985, 1988, 1989, 1994:149; 1995:46; 1996:63; 1997:44; 1998:67; 1999:65; *The Messenger* (Wheelwright Museum) Summer 1994:inside cover; Hayes & Blom 1996:88; 1998:25; Peaster 1997:74, 76, 79; *Art Focus* May/June 1998:5; Congdon-Martin 1999:127; Schaaf 2000:81.

In 1966, Andrew Padilla began learning at the age of ten pottery making from his paternal grandmother, Reycita Padilla. For 16 years, Andrew made Santa Clara style blackware. In 1982, he switched to the white clay from Laguna, home of his mother, Gladys Paquin. She helped him refine his techniques.

Andrew now is well known for his white melon bowls. The form is found in ancient times in the Colima culture. Helen Shupla is best noted for her refinement of melon bowls. Andrew expanded the volume of the ribs, extending forms both vertically and horizontally. He often adds terraced rain cloud lids to his jars. The overall effect is elegant.

Andrew Padilla, Jr. -
Hoel's Indian Shop
Oak Creek Canyon, AZ

Andrew Padilla, Jr. -
Courtesy of Jason Esquibel
Rio Grande Wholesale, Inc.

Danny Padilla *(Dan, signed The Laguna Kid)*
(Laguna/Santa Clara: active ca. 1960s-?: whiteware melon bowls, jars, wedding vases)
LIFESPAN: 1950s-?
FAMILY: p. grandson of Reycita Padilla (Santa Clara); son of Gladys Paquin (Laguna) & Andy Padilla (Santa Clara); brother of Andrew Padilla, Jr.
TEACHERS: Reycita Padilla, his grandmother, and Gladys Paquin, his mother
EXHIBITIONS: 1985-88, Indian Market, Santa Fe

Donaciano Padilla
(Santo Domingo, active ?: pottery)
ARCHIVES: Laboratory of Anthropology Library, Santa Fe; Lab. File.

Elizabeth Sanchez Paisano *(Liz M. Paisano), (collaborates with Lee Paisano)*
(Acoma, active ca. 1950s-90+: polychrome jars, bowls)
BORN: May 3, 1935; RESIDENCE: Acoma Pueblo, NM
ARCHIVES: Artist File, Heard Museum Library, Phoenix
PUBLICATIONS: Dillingham 1992:206-208.

Lee Paisano *(collaborates with Elizabeth Sanchez Paisano)*
(Acoma, active ?-1990+: polychrome jars, bowls, jewelry)
RESIDENCE: Acoma Pueblo, NM
PUBLICATIONS: Dillingham 1992:206-208.

Michelle Paisano *(Michelle Paisano-Schwebach)*
(Acoma/Laguna, active ca. 1980s-present: polychrome jars, bowls, Storytellers, Nativities, sets)
RESIDENCE: Westminster, CO
FAMILY: m. granddaughter of Frances Torivio; daughter of Ruth Paisano
AWARDS: 1991, 3rd, sets; 1992, 3rd; 1993, 3rd; 1994, 3rd, Indian Market, Santa Fe
EXHIBITIONS: 1988-present, Indian Market, Santa Fe
PUBLICATIONS: Dillingham 1992:206-208; Peaster 1997:13.

Ruth B. Paisano *(R. Paisano)*

(Acoma, active ca. 1980s-present, polychrome jars, bowls)
FAMILY: daughter of Frances Pino Torivio; sister of Wanda Aragon & Maria Lilly Salvador; mother of Michelle Paisano
EXHIBITIONS: ca. 1985-present, Indian Market, Santa Fe
PUBLICATIONS: Peaster 1997:11-13.

Florence Pajarito *(F. Pajarito)*

(Santo Domingo, active ? - present: polychrome, jars, bowls, beadwork, jewelry)
FAMILY: daughter of Joe & Mary Pajarito
EXHIBITIONS: 1996-present, Eight Northern Indian Pueblos Arts & Crafts Show; 1998-present, Indian Market, Santa Fe
COLLECTIONS: Dr. Gregory & Angie Yan Schaaf, Santa Fe

Mary Pajarito

(Santo Domingo, active ? - present: polychrome, jars, bowls)
FAMILY: wife of Joe Pajarito; mother of Florence Pajarito

Brenda Paloma

(Zuni, active ?-present: pottery)
GALLERIES: The Indian Craft Shop, U.S. Department of Interior, Washington, D.C.
PUBLICATIONS: Mercer 1995:41-44.

Gabriel Paloma

Gabriel Paloma - Photograph by Michael E. Snodgrass, Denver, CO

(Zuni, Dogwood & Child of Tobacco Clans, active ca. 1979-present: polychrome jars, corn-meal bowls, cups, mixed media, acrylic paintings, water colors, Kachinas)
BORN: September 21, 1966
FAMILY: son of Herman & Janice Paloma; brother of Brenda Paloma & 5 others; husband of Phyllis Chavez; father of Brandon, Brian & Kollin
EDUCATION: University of New Mexico, Albuquerque/Gallup, NM
TEACHERS: Jennie Laate (pottery), Herrin Othole (art), Mary Beahm (art)
STUDENTS: 9th to 12th grade students at Zuni High School, Creative Arts Program of Zuni
AWARDS: Curator's Award, 1st, 2nd, Zuni Show, Museum of Northern Arizona, Flagstaff, AZ; Inter-tribal Indian Ceremonial, Gallup, NM
EXHIBITIONS: 1997, "Singing the Clay," Cincinnati Museum of Art, Cincinnati, OH; Zuni Show, Museum of Northern Arizona, Flagstaff
COLLECTIONS: Houston Museum of Natural Sciences, Houston, TX
FAVORITE DESIGNS: water serpents, tadpoles, terraced clouds, rain, swirls, dragonflies.
PUBLICATIONS: Nahohai & Phelps 1995:72-77; Mercer 1995:39-42; Hayes & Blom 1998:168.

Gabriel is famous for his fantastic cornmeal bowls. He forms the handles into water serpents or dragonflies. He sometimes adds real Macaw parrot feathers and fur.

Gabriel learned from Jennie Laate while at Zuni High School. He attended classes at the University of New Mexico and continued at the satellite campus in Gallup. He then worked as the assistant to Eileen Yatsattie with Creative Arts of Zuni.

After Noreen Simplicio retired, Gabriel took over as teacher for the pottery-making classes at Zuni High School. He reportedly has taught over a hundred students. He takes them to collect clay at Pia Mesa. They make their own dark brown paint made from wild spinach and hematite or iron stone.

Gabriel shared, "I truly believe that I can be like other Pueblo potters who have demonstrated and entered prestigious arts & crafts show. I do what I do best in making "Zuni Style" pottery — hand-coiled, polychrome jars and cornmeal bowls. As a teacher, I hope that I will set a good example for my students to continue what they have learned from me."

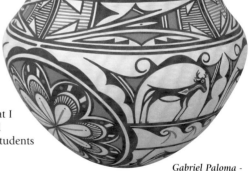

Gabriel Paloma - Dr. Gregory & Angie Yan Schaaf Collection

Annie Panana *(collaborates sometimes with Luisa Panana)*

(Jemez, active ?: tan-on-polished redware jars, bowls)
FAVORITE DESIGNS: horizontal zigzag shoulder panels, horizontal bands of terraced clouds main panels
PUBLICATIONS: Harlow 1977; Peaster 1997:61.

Louisa Panana *(Luisa Panana), (collaborates sometimes with Annie Panana)*

(Jemez/Cochiti, active ca. 1920s-80s: traditional matte polychrome and tan-on-polished redware jars, bowls)
BORN: ca. 1900
FAMILY: grandmother of Veronica Sando
FAVORITE DESIGNS: horizontal zigzag shoulder panels, horizontal bands of terraced clouds main panels
PUBLICATIONS: Harlow 1977; Peaster 1997:61.

Reyes Jo Panana *(signs R. Panana, Jemez)*

(Jemez, active ca. 1985-present: Koshare clown Storytellers and flute player figures)
BORN: February 26, 1961
FAMILY: daughter of Stella Panana; niece of Pauline & Ralph Sarracino; cousin of Matthew Panana
AWARDS: 1996, 1st, Indian Market, Santa Fe; 1997, 2nd, 1998, 1st, Indian Market, Santa Fe; New Mexico State Fair, Albuquerque; Inter-tribal Indian Ceremonial, Gallup; 1st, Eight Northern Indian Pueblos Arts & Crafts Show
EXHIBITIONS: 1994-present, Indian Market, Santa Fe; 1994-present, Eight Northern Indian Pueblos Arts & Crafts Show
COLLECTIONS: Drs. Judith & Richard Lasky, New York City; Walton-Anderson

Reyes Panana - Courtesy of Jason Esquibel Rio Grande Wholesale, Inc.

GALLERIES: Arizona Art Gallery, Scottsdale, AZ; Indian Traders West, Santa Fe; Rio Grande Wholesale, Palms, Albuquerque; Kennedy Indian Arts, UT
PUBLICATIONS: Congdon-Martin 1999:82; Berger & Schiffer 2000:89, 137.

Reyes Panana makes very attractive Koshare clown figures. Many are depicted eating watermelons. Reyes gathers and mixes natural clay. She uses both mineral and vegetal paints. She fires her figures outdoors with cedar chips. She has developed into a top prizewinner.

Reyes Panana & M. Fragua - Drs. Judith & Richard Laskey Collection Photograph by Adam Hume

Ruby Panana *(Rufina Medina)*

(Zia, Coyote Clan, active ca. 1983-present: polychrome jars, bowls, wedding vases, vases, canteens - some with turquoise insets)
BORN: April 8, 1954
FAMILY: granddaughter of Joe & Ascenciona Galvan Pino; daughter of Seferina Bell; sister of Eleanor Griego & Reyes Pino; wife of Larry W. Panana; mother of Sharayne L. Panana
TEACHER: Seferina Bell, her mother
AWARDS: 1985, 1st, New Mexico State Fair; 1998, 2nd, 3rd, 2000, 2nd, Indian Market, Santa Fe; Judge's Special Award, Heard Museum Guild Market, Phoenix; 2001, Best Native Traditional Pottery, Colorado Springs Fine Arts, CO; 2nd & 3rd, Eight Northern Indian Pueblos Arts & Crafts Show
EXHIBITIONS: 1994-present, Indian Market, Santa Fe; 1994-present, Eight Northern Indian Pueblos Arts & Crafts Show
COLLECTIONS: Wright Collection, Peabody Museum, Harvard University, Cambridge, MA; Dr. Paul K. & Janie Conner; Wright/McCray; Dr. Gregory & Angie Yan Schaaf, Santa Fe
FAVORITE DESIGNS: roadrunners, hummingbirds, flowers, rainbows, clouds, kiva steps
GALLERIES: The Indian Craft Shop, U.S. Department of Interior, Washington, D.C.; Museum of Northern Arizona Shop, Flagstaff, AZ; Native American Collections, Denver, CO; Claywood Gallery, San Antonio, TX; Andrea Fisher Fine Pottery, Santa Fe; Shangri-La, Jemez Springs, NM; Agape Gallery, Albuquerque

Ruby Panana with collector Janie Conner - Photograph by Paul K. Conner

Ruby Panana - Courtesy of Georgiana Kennedy Simpson Kennedy Indian Arts, Bluff, UT

PUBLICATIONS: Drooker & Capone1998:139; *Destinations Travel Magazine* (August 2000).

Ruby Panana is a top award-winning Zia potter who lives at Jemez Pueblo. She learned well from her mother, the respected Seferina Bell. Ruby is known for creating some of the largest classic polychrome ollas, in the tradition of Trinidad Medina and Sophia Medina.

Ruby makes excellent, polychrome canteens. She insets turquoise in some of them. Most of her canteens are painted with lively roadrunners. They are pottery gems. We first met Ruby years ago when she was exhibiting some of her large ollas at the Eight Northern Indian Pueblos Arts & Crafts Show. She was happy, as she was being very well received. We saw her at the 2000 Indian Market on the last day when she was nearly sold out. She greeted us warmly. Ruby works hard as a potter, and she has earned her great success. She commented, "It gives me a way to express my feelings. It is hard work, but it gives me a sense of peace and relaxes me."

Ruby Panana - Wright/McCray Collection

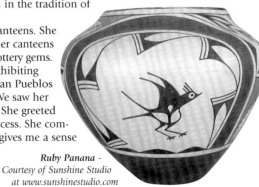

Ruby Panana - Courtesy of Sunshine Studio at www.sunshinestudio.com

Sharayne Panana

(Zia, active ca. 1990s-present: traditional polychrome jars, bowls)
FAMILY: great-granddaughter of Joe & Ascenciona Galvan Pino; m. granddaughter of Seferina Bell; daughter of Larry W. & Ruby Panana
AWARDS: 1998, Indian Market, Santa Fe

Raphaelita Panchero *(Pacheco)*

(Santo Domingo, active ca. 1890s-?: traditional polychrome ollas, jars, bowls)
COLLECTIONS: Philbrook Museum of Art, Tulsa, OK, jar, ca. 1900.

Carrie Pancho *(Poncho?)*

(Acoma, active ?: storage jars)
ARCHIVES: Artist File, Heard Museum Library, Phoenix

Livia Roxie Panteah *(Roxie Panteah)*

(Zuni, active ?: polychrome jars, dough bowls, cornmeal bowls with handles, pitchers, six-sided plates, wedding vases, miniature bread ovens with tiny hand-carved tools and little loaves of bread)
FAMILY: daughter of Florentine Panteah, a jeweler
TEACHER: Jennie Laate
FAVORITE DESIGNS: Sunface, clouds, rain, starburst, Arrow to the Sun, frogs, dragonflies, Rainbirds, deer with heartlines
COLLECTIONS: Houston Museum of Natural History, Houston, TX
PUBLICATIONS: Nahohai & Phelps 1995:cover, 92-100.

Milford Nahohai, manager of Pueblo of Zuni Arts & Crafts, admires Livia Roxie Panteah's "precision in her designing." She identifies her early work as thick, but in time her pots became thinner. Her designs became increasingly more complex. In the mid-1990s, she did some bowls with cut outs of frog outlines.

Gladys Paquin -
Nedra Matteucci Galleries

Clara Paquin

(Santa Ana, active ca. 1950s-?: polychrome jars, bowls, embroidery, sewing)
GALLERIES: Ta-Ma-Ya Arts and Crafts Co-op, Santa Ana
PUBLICATIONS: Barry 1984:108; Trimble 1987:64; Eddington & Makov 1995; Tucker 1998: plate 103; Schaaf 2001:299.

Gladys Paquin *(signs Sratyu'we, G. Paquin, Laguna, N.M.)*

Gladys Paquin - Photograph by Bill Bonebrake
Courtesy of Jill Giller
Native American Collections, Denver

(Laguna/Zuni, active ca. June 1980-present: traditional polychrome jars, bowls, beadwork)
BORN: ca. 1940s
FAMILY: wife of Andy Padilla, Sr. (Santa Clara); mother of Andrew Padilla, Jr. & Danny Padilla
STUDENTS: Danny & Andrew Padilla, Jr., her sons; Max Early, Myron Sarracino
AWARDS:

1984	1st, Santa Monica Indian Art Show, CA
1986	Best of Division, 1st, Indian Market, Santa Fe
1987	2nd, Indian Market, Santa Fe
	2nd, Santa Monica Indian Art Show, CA
1988	3rd, Okmulgee Indian Market, OK
1991	2nd, Twin Cities Indian Market, MN
1993	Indian Art Fund Award for Best of Traditional Crafts; 1st, Indian Market, Santa Fe
1995	2nd, 3rd, Eiteljorg Indian Market, Indiana
1998	3rd, Indian Market, Santa Fe

COLLECTIONS: Indian Pueblo Cultural Center, Albuquerque; Museum of Indian Arts & Cultures, Santa Fe; School of American Research, Santa Fe; Cincinnati Art Museum, OH; Natural History Museum, Los Angeles, CA; Dr. Gregory & Angie Yan Schaaf, Santa Fe; Indart, Inc.
FAVORITE DESIGNS: leaves, flowers, pinwheels, eternity
GALLERIES: Tribal Arts Zion, Springdale, UT; Andrews Pueblo Pottery & Art Gallery, Rio Grande Wholesale, Albuquerque; Native American Collections, Denver, CO; Charles King, Scottsdale, AZ; Nedra Matteucci, Andrea Fisher Fine Pottery, Santa Fe
PUBLICATIONS: *Indian Market Magazine* 1985, 1988, 1989, 1995, 1996, 1997; Coe 1986:206, 237; Trimble 1987:105; Peckham 1990; Dillingham 1992:62-65, 88, 112, 174, 176, 199; Mercer 1995:19, 44; Hayes & Blom 1996:88; Peaster 1997:7, 74, 76, 78, 79, 158; *Art Focus* May 1998:5.

Gladys Paquin was born in Rehoboth, New Mexico to a Zuni father and a Laguna mother. She explained, "I was raised at Santa Ana Pueblo from the age of 10. I returned to my mother's reservation to stay in 1979."

When she developed the desire to make pottery, she returned to her step-mother at Santa Ana to ask her how to mix the clay. "Through trial and error and much patience, I began making my pottery in June 1980."

Gladys continues to use natural materials: "My clay is gray which I dig out from the hills here on the Laguna reservation. My paints are all natural clays. The black paint is from the Rocky Mountain Bee plant mixed with a mineral rock."

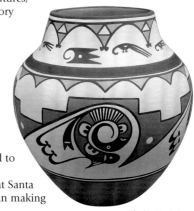

Gladys Paquin -
Photograph by Bill Knox
Courtesy of Indart Inc.

Gladys Paquin -
Photograph by Tony Molina
Case Trading Post at the
Wheelwright Museum, Santa Fe

Gladys makes traditional pots fired outdoors with cow chips and cedar wood. She taught her firing techniques to other potters, including her sons, Danny & Andrew Padilla, Jr., as well as Max Early and Myron Sarracino. Rick Dillingham illustrated her traditional firing. She explained, "The hardest part was learning how to fire, to control the fire, to know the fire." (Dillingham 1992:62-63)

In comparing Laguna and Acoma designs, Gladys pointed out that Laguna designs are more often divided into threes and Acoma usually in fours. Laguna designs are described as less busy and more spacious. She often includes a "spirit break," adding a small rectangle to one line. She explains that it represents "eternity. In the sky there's a hole and there's something coming down, something eternal, never-ending."

Gladys shared her creative process: "I make the shape the same so the pattern comes out right. When I can relax and enjoy making [the pots], I can wait for a design to come to mind. I sometimes do little bits of designs and wait for separate inspirations."

Gladys concluded that pottery making for her is a spiritual act: "Pottery is a lot like your relationship with God. God molds you and puts you in the fire."

Gladys also is to be commended for making her own illustrated brochure.

Gladys Paquin -
Courtesy of Sunshine Studio
at www.sunshinestudio.com

Bertie Pasqual *(B. Pasqual)*
(Santa Ana, active ca. 1950s-?: polychrome jars, bowls, miniature ollas, embroidery, sewing)
COLLECTIONS: Wright Collection, Peabody Museum, Harvard University, Cambridge, MA
PUBLICATIONS: Drooker 1998:63, 139; Tucker 1998: plate 103.

Blanche Pasqual *(collaborates with Mary Pasqual)*
(Acoma, active ?: pottery)
RESIDENCE: San Fidel, NM
ARCHIVES: Artist File, Heard Museum Library, Phoenix

Juana Pasqual *(1)*
(Acoma, active ca. 1880s-1910s+: polychrome jars, bowls)
BORN: ca. 1865; RESIDENCE: Acomita in ca. 1910
PUBLICATIONS: Leopold Bibo, "13th Annual U.S. Census" (1910), New Mexico State Archives, Call T624, Roll 919; in Dillingham 1992:205.

Juana Concho Pasqual *(2), (collaborated sometimes with Blanche Antonio)*
(Acoma, active ca. 1920s-1990+: traditional polychrome jars, bowls, Storytellers)
BORN: January 17, 1900; RESIDENCE: San Fidel, NM
FAMILY: daughter of Juana Concho; mother of Blanche Antonio, Mary Lukee; grandmother of Bonnie Leno & Kimberly Pasqual
EXHIBITIONS: ?-1989, Indian Market, Santa Fe
PUBLICATIONS: *SWAIA Quarterly* Fall 1971:8; Fall 1976:12; Babcock 1986:137; *Indian Market Magazine* 1988, 1989; Dillingham 1992:206-208; Reno 1995:214.

Kimberly Pasqual
(Acoma, active ca. 1970s-present: Storytellers)
BORN: ca. 1950s
FAMILY: m. granddaughter of Juana Pasqual (2); related to Blanche Antonio, Mary Lukee & Bonnie Leno
PUBLICATIONS: Babcock 1986:137.

Laura Pasqual
(Acoma, active ?-1990+: polychrome jars, bowls)
PUBLICATIONS: Dillingham 1992:206-208.

Mary Pasqual *(collaborates with Blanche Pasqual)*
(Acoma, active ?: pottery)
RESIDENCE: San Fidel, NM
ARCHIVES: Artist File, Heard Museum Library, Phoenix

Roseanne Pasqual
(Acoma, active ?-1990+: polychrome jars, bowls)
PUBLICATIONS: Dillingham 1992:206-208.

Romolda Pasqual
(Acoma, active ca. 1950s-?: traditional polychrome jars, bowls)
BORN: ca. 1930s
FAMILY: daughter-in-law of Juana Pasqual (2)
PUBLICATIONS: Babcock 1986:137.

Aurelia Pasquale
(Acoma, active ?-1990+: polychrome jars, bowls)
PUBLICATIONS: Dillingham 1992:206-208.

Becky Pasquale *(see Rebecca Pasquale)*

Camille Sanchez Pasquale
(Acoma, active ?-1990+: polychrome jars, bowls)
PUBLICATIONS: Dillingham 1992:206-208.

Darin Pasquale *(collaborates with Michelle Pasquale, Laguna) (signs D. M. Pasquale)*
(Acoma, active ca. 1991-present: sgraffito ceramic jars, bowls, wedding vases, contemporary forms)
BORN: February 14, 1965
FAMILY: son of Harold & Becky Pasquale; husband of Michelle Pasquale
TEACHER: Paul Lucario, Jr.
AWARDS: 1990, 1993, 1996, 1st, New Mexico State Fair, Albuquerque; 1st, New Mexico Doll and Ceramic Expo
FAVORITE DESIGNS: bears with heart lines, hummingbirds, feathers in a row, flowers
GALLERIES: Rio Grande Wholesale, Inc., Palms Trading Co., Albuquerque
PUBLICATIONS: Hayes & Blom 1997; Berger & Schiffer 2000:135.

Katerina Pasquale
(Acoma, active ?-1990+: polychrome jars, bowls)
PUBLICATIONS: Dillingham 1992:206-208.

Michelle Pasquale *(collaborates with Darin Pasquale), (signs D. M. Pasquale, Laguna Pueblo)*
(Laguna, active ca. 1991-present: sgraffito ceramic jars, bowls, wedding vases, canteens, contemporary forms, some carved redware with white backgrounds and black painted figures in relief)
BORN: May 16, 1969
FAMILY: p. granddaughter of Paul Lucario, Sr.; daughter of Paul Lucario, Jr. and Karen Lucario; sister of Michael P. Lucario; wife of Darin Pasquale (Acoma)
TEACHER: Paul Lucario, Jr., her father
AWARDS: 1990, 1993, 1996, 1st, New Mexico State Fair, Albuquerque 1st, New Mexico Doll and Ceramic Expo
FAVORITE DESIGNS: bears with heart lines, hummingbirds, feathers-in-a-row, flowers
GALLERIES: Rio Grande Trading Co., Palms, Albuquerque
PUBLICATIONS: Hayes & Blom 1998:23; Berger & Schiffer 2000:138.

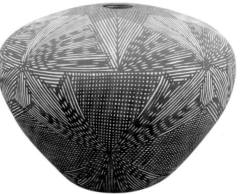

Rebecca Pasquale -
Courtesy of Jason Esquibel
Rio Grande Wholesale, Inc.

Ramalda Pasquale
(Acoma, active ?-1990+: polychrome jars, bowls)
PUBLICATIONS: Dillingham 1992:206-208.

Rebecca Pasquale *(Becky Pasquale), (signs B. Pasquale)*
(Acoma, active ca. 1960s-present: traditional black-on-white, fineline & polychrome jars, bowls, seed pots, clay baskets, miniatures)
BORN: ca. 1940
FAMILY: wife of Harold Pasquale; mother of Yolanda P. Trujillo, Marcella Augustine; mother-in-law of James Augustine
FAVORITE DESIGNS: feathers-in-a-row, flowers, chickens
PUBLICATIONS: Schiffer 1991d:50.

Adrian Patricio -
Courtesy of Jason Esquibel
Rio Grande Wholesale, Inc.

Rita Pasquale
(Acoma, active ?-1990+: polychrome jars, bowls)
PUBLICATIONS: Dillingham 1992:206-208.

Adrian Ann Patricio
(Acoma, active ca. 1987-present: sgraffito & polychrome jars & bowls)
BORN: July 28, 1961
FAMILY: daughter of Rafalita Antonio
PUBLICATIONS: Berger & Schiffer 2000:138.

Darrell Patricio - Courtesy of
Drs. Judith & Richard Lasky
Photograph by Adam Hume

Darrell Patricio
(Acoma, active ca. 1983-present: fineline jars & bowls)
BORN: January 7, 1964
FAMILY: son of Mike & Delma Vallo; brother of Gerri Louis
AWARDS: 1st, 3rd, New Mexico State Fair, Albuquerque
COLLECTIONS: Drs. Judith & Richard Lasky, New York City
PUBLICATIONS: Dillingham 1992:206-208; Berger & Schiffer 2000:135.

Doris Patricio *(collaborates with Patrick Patricio), (signs D. Patricio)*

(Acoma, active ca. 1975-present: traditional polychrome ollas jars, bowls, wedding vases)
BORN: ca. 1950; RESIDENCE: Acoma Pueblo, NM
FAMILY: wife of Patrick Patricio; mother of Stephanie M. Patricio Nez
COLLECTIONS: Dr. Gregory & Angie Yan Schaaf, Santa Fe
FAVORITE DESIGNS: parrots, feathers, leaves, rain, clouds
PUBLICATIONS: Barry 1984:95; Minge 1991:195; Dillingham 1992:206-208.
 Doris Patricio is known for her classic polychrome ollas with parrot designs. They are high shouldered, gracefully formed and well painted. Her style is influenced by late 19th and early 20th century Acoma ollas.

Dorothy Patricio

(Acoma, active ?-present: polychrome jars, bowls, clay baskets)
FAVORITE DESIGNS: birds, flowers
COLLECTIONS: John Blom
PUBLICATIONS: Hayes & Blom 1998:29.

Doug Patricio

(Acoma, active ?-1990+: polychrome jars, bowls)
PUBLICATIONS: Dillingham 1992:206-208.

Frances Patricio *(see Frances Patricio Concho)*

Francis Patricio

(Acoma, active ?-1990+: polychrome jars, bowls)
PUBLICATIONS: Dillingham 1992:206-208.

Georgia Patricio *(signed G. Patricio?)*

(Acoma, active ?-present: polychrome fineline jars, bowls)
FAMILY: related to Leo & Lionel Patricio
GALLERIES: River Trading Post, East Dundee, IL
PUBLICATIONS; Painter 1998:14.

Helen Patricio *(collaborated sometimes with Jose Patricio)*

(Acoma, active ca. 1930s-75: traditional polychrome jars, bowls)
BORN: ca. 1920s
FAMILY: wife of Jose Patricio; mother of Frances Patricio Concho;
m. grandmother of Marietta P. Juanico & Norbert L. Patricio
STUDENTS: Frances Patricio Concho, her daughter
PUBLICATIONS: Minge 1991:195; Berger & Schiffer 2000:110.

Israel Patricio

(Acoma, active ?-1990+: polychrome jars, bowls)
PUBLICATIONS: Dillingham 1992:206-208.

Jose Patricio *(collaborated with Helen Patricio)*

(Acoma, active ca. 1940s-70s: traditional polychrome jars, bowls)
BORN: ca. 1920s
FAMILY: husband of Helen Patricio; father of Frances Patricio Concho; grandfather of Marietta P. Juanico
STUDENTS: Frances Patricio Concho, his daughter
GALLERIES: Rio Grande Wholesale, Inc., Palms Trading Co., Albuquerque
PUBLICATIONS: Berger & Schiffer 2000:110.

Joyce Patricio

(Acoma, active ?-1990+: polychrome jars, bowls)
PUBLICATIONS: Dillingham 1992:206-208.

Leo Patricio *(signs Patricio, Acoma N.M.)*

(Acoma, active ca. 1975-present: traditional & ceramic jars, bowls)
BORN: August 27, 1957
FAMILY: son of Elsie Routzen; related to Georgia & Leo Patricio
TEACHER: Elsie Routzen, his mother
GALLERIES: Rio Grande Wholesale, Inc., Palms Trading Co., Albuquerque
PUBLICATIONS: Dillingham 1992:206-208; Painter 1998:14; Berger & Schiffer 2000:135.

G. Patricio -
Courtesy of Joe Zeller
River Trading Post, East Dundee, IL

Lillie Patricio *(signs Lillie Patricio, Pueblo of Acoma, year the pottery was made)*

Lillie Patricio - Courtesy of Jason Esquibel
Rio Grande Wholesale, Inc.

(Acoma, active ca. 1985-present: fineline black-on-white & polychrome jars, bowls, vases, contemporary forms, animal & nature paintings)
BORN: April 8, 1970
FAMILY: daughter of Mike Patricio, Sr.; sister of Michael Patricio, Jr., Sandra Patricio
TEACHER: Mike Patricio, Sr.
COLLECTIONS: Johanna Leibfarth, SC
GALLERIES: Rio Grande Wholesale, Inc., Palms Trading Co., Albuquerque
PUBLICATIONS: Berger & Schiffer 2000:138.

Lillie Patricio -
Courtesy of Jason Esquibel
Rio Grande Wholesale, Inc.

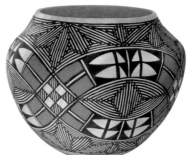

Lillie Patricio -
Johanna Leibfarth Collection, SC

Lionel Patricio

(Acoma, active ?-present: polychrome jars, bowls)
FAMILY: related to Georgia & Leo Patricio
PUBLICATIONS: Painter 1998:14.

Michael Patricio, Sr. *(Mike Patricio)*

(Acoma, active ca. 1960s-present: black-on-white & polychrome jars, bowls)
BORN: ca. 1940s
FAMILY: father of Michael Patricio, Jr., Lillie Patricio & Sandra Patricio
STUDENTS: Michael Patricio, Jr., Lillie Patricio & Sandra Patricio, his children

Michael Patricio, Jr. *(collaborates with Jennifer Estevan)*

(Acoma, active ca. 1983-present: traditional black-on-white jars, bowls)
BORN: January 17, 1968
FAMILY: son of Mike Patricio, Sr.; brother of Lillie Patricio, Sandrea Patricio
COLLECTIONS: Allan & Carol Hayes, John Blom
FAVORITE DESIGNS: lightning
GALLERIES: Rio Grande Wholesale, Inc., Palms Trading Co., Albuquerque
PUBLICATIONS: Dillingham 1992:206-208; Hayes & Blom 1996:iv; Berger & Schiffer 2000:138.

Myron P. Patricio

(Acoma, active ?-1990+: polychrome jars, bowls)
PUBLICATIONS: Dillingham 1992:206-208.

Norbert L. Patricio *(signs N. L. Patricio)*

(Acoma, active ca. 1979-present: traditional fineline jars, bowls)
BORN: September 23, 1970
FAMILY: son of Isidore & Frances Concho
COLLECTIONS: Johanna Leibfarth, South Carolina
GALLERIES: Rio Grande Wholesale, Inc., Albuquerque
PUBLICATIONS: Berger & Schiffer 2000:138.

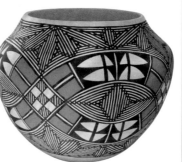

Norbert L. Patricio -
Johanna Leibfarth Collection, SC

Robert Patricio - Courtesy of Jason Esquibel
Rio Grande Wholesale, Inc.

Patrick Patricio *(collaborates with Doris Patricio)*

(Acoma, active ca. 1975-present: traditional fineline & polychrome jars, bowls)
BORN: ca. 1945; RESIDENCE: Acoma Pueblo, NM
FAMILY: husband of Doris Patricio; father of Stephanie M. Patricio Nez
PUBLICATIONS: Dillingham 1992:206-208.

Robert Patricio

(Acoma, active ?-present: traditional polychrome jars, bowls)
GALLERIES: Rio Grande Wholesale, Inc., Albuquerque

Robert Patricio -
Courtesy of Jason Esquibel
Rio Grande Wholesale, Inc.

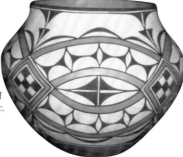

R. Patricio

(Acoma, active ?-present: pottery)
GALLERIES: The Indian Craft Shop, U.S. Department of Interior, Washington, D.C.

Sandrea Patricio *(signs S. B. Patricio, Acoma N.M.)*
(Acoma, active ca. 1987-present: traditional fineline jars, bowls)
BORN: October 8, 1967
FAMILY: daughter of Michael Patricio, Sr.; sister of Michael Patricio, Jr., Lillie Patricio
TEACHER: Michael Patricio, Sr., her father
GALLERIES: Rio Grande Wholesale, Inc., Palms Trading Co., Albuquerque
PUBLICATIONS: Berger & Schiffer 2000:138.

Stephanie M. Patricio *(Stephanie M. Patricio Nez), (signs S. Patricio Nez)*
(Acoma, Corn/Small Bear Clans, active ca. 1982-present: Tularosa Revival, traditional polychrome jars, bowls)
BORN: September 3, 1970
FAMILY: m. granddaughter of Lupe & John Conch; p. granddaughter of Helen & Jose Patricio; daughter of Doris & Patrick Patricio; wife of Curtis Nez; mother of Alison Nez
TEACHERS: Doris Patricio, her mother, and her grandmother
AWARDS: 1st, Mesa Verde Art Show, Mesa Verde, CO
FAVORITE DESIGNS: lizards, swirls, fineline
GALLERIES: Rio Grande Wholesale, Inc., Palms Trading Co., Albuquerque
PUBLICATIONS: Berger & Schiffer 2000:138.
 Stephanie Patricio shared, "I enjoy making and painting pottery to carry on my traditional way of life."

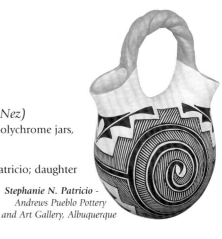

Stephanie N. Patricio - Andrews Pueblo Pottery and Art Gallery, Albuquerque

Marie C. Pavheco *(see Marie C. Pacheco)*

Albina Payatiamo
(Acoma, active ca. 1890s-1910s+: polychrome jars, bowls)
BORN: ca. 1880; RESIDENCE: Acomita in ca. 1910
PUBLICATIONS: Leopold Bibo, "13th Annual U.S. Census" (1910), New Mexico State Archives, Call T624, Roll 919; in Dillingham 1992:205.

Alice Paytiamo
(Acoma, active ?-1990+: polychrome jars, bowls)
PUBLICATIONS: Dillingham 1992:206-208.

Lupe Paytiamo
(Acoma, active ?-1975+: polychrome jars, bowls)
PUBLICATIONS: Minge 1991:195.

Maria Paytiamo
(Acoma, active ca. 1890s-1910s+: polychrome jars, bowls)
BORN: ca. 1871; RESIDENCE: Acomita in ca. 1910
PUBLICATIONS: Leopold Bibo, "13th Annual U.S. Census" (1910), New Mexico State Archives, Call T624, Roll 919; in Dillingham 1992:205.

C. Pecos
(Jemez, active ?-present: polychrome Storytellers, figures)
FAVORITE DESIGNS: figures with children; figures of corn grinders set within miniature Pueblo room
PUBLICATIONS: Walatowa Pueblo of Jemez, "Jemez Pottery" (1998).

Carol T. Pecos *(signs Pecos, Jemez N.M.)*
(Jemez, Sun Clan, active ca. 1950s-present: redware jars, bowls, seed pots, wedding vases, Storytellers, Corn Maidens, figures, sets)
FAMILY: daughter of Frank & Louisa Fragua Toledo (2); sister of Felapita Toledo Yepa, Jose R. Toledo, Michael Toledo, Joe Rafael Toledo, Bernice Louise Gachupin; wife of Jose Pecos; mother of Irwin Pecos & Rose Pecos-Sun Rhodes
STUDENTS: Irwin Pecos & Rose Pecos-Sun Rhodes, her children
AWARDS: 1988, 3rd, Storytellers; 1990, 1st (2), figures, sets; 1991, 1st, Storytellers; 1992, 3rd, sets; 1993, 1st, figures; 1996, 2nd, non-traditional jars, Indian Market, Santa Fe
EXHIBITIONS: pre-1985-present, Indian Market, Santa Fe
COLLECTIONS: Museum of Northern Arizona, Flagstaff; Dr. Gregory & Angie Yan Schaaf
FAVORITE DESIGNS: Rainbirds, clouds, rain
GALLERIES: Adobe Gallery, Palms Trading Company, Albuquerque; Crosby Collection, Park City, UT
PUBLICATIONS: *Indian Market Magazine* 1985, 1988, 1999; Babcock 1986; Eaton 1990:13; Hayes & Blom 1996:82-83; Congdon-Martin 1999:83.

Carol Pecos - Dr. Gregory & Angie Yan Schaaf Collection

Caroline Pecos *(Caroline Quintana)*
(Cochiti, Fox Clan, active 1910-1980s: traditional polychrome jars, bowls, figures, beadwork)
LIFESPAN: 1890-1995
FAMILY: wife of Mr. Quintana (1st), Santiago Pecos (2nd); mother of Helen Cordero & Trinidad Herrera

Gina Pecos *(Jeana Pecos)*

(Sandia, active ca. 1980s-present)
PUBLICATIONS: Hayes & Blom 1996:108-09.

Irwin Louis Pecos *(signs I. Pecos, Jemez N.M.)*

(Jemez, active ca. 1981-present: polychrome figures, canteens)
BORN: December 16, 1953
FAMILY: son of Jose & Carol Pecos; brother of Rose Pecos-Sun
Rhodes, Jackie, Pecos Stephanie Pecos
TEACHER: Carol Pecos, his mother
AWARDS: 1990, 3rd, Indian Market, Santa Fe
EXHIBITIONS: 1993-present, Indian Market, Santa Fe
PUBLICATIONS: Babcock 1986; Berger & Schiffer 2000:139.

J. Pecos

(Jemez, active ?-present: polychrome Storytellers, figures, jars & bowls)
FAVORITE DESIGNS: figures with children; drummers, turtles, bears
PUBLICATIONS: Walatowa Pueblo of Jemez, "Jemez Pottery" (1998).

Jackie Pecos

(Jemez, active ca. 1980s-present: Storytellers)
FAMILY: m. granddaughter of Louisa F. Pecos; daughter of Carol Pecos; sister of Rose
Pecos-Sun Rhodes, Stephanie Pecos
PUBLICATIONS: Babcock 1986:69, 144-45.

Jeanette Pecos

(Jemez, active ca. 1970s-present: Storytellers)
AWARDS: 1998, 2nd, Indian Market, Santa Fe
EXHIBITIONS: 1997-present, Indian Market, Santa Fe
PUBLICATIONS: Babcock 1986:69, 144-45.

Juanita Pecos

(Zia, active ca. 1890s-1939+: traditional polychrome ollas, jars, bowls)
COLLECTIONS: Philbrook Museum of Art, Tulsa, OK, olla, ca. 1904, bowl, ca. 1939

Lucinda Pecos

(Jemez, ca. 1940s-?: traditional polychrome ollas, jars, bowls)
COLLECTIONS: Philbrook Museum of Art, Tulsa, OK, bowl, ca. 1949

Monica Pecos

(Cochiti, active ?-present: polychrome Storytellers, jars, bowls, frogs)
COLLECTIONS: Dr. Gregory & Angie Yan Schaaf, Santa Fe
PUBLICATIONS: Congdon-Martin 1999:26.

Nancy Pecos

(Jemez/Cochiti, ca. 1950s-?: traditional polychrome jars, bowls)
COLLECTIONS: Museum of New Mexico, Laboratory of Anthropology, Santa Fe, polychrome bowl, ca. 1961.
EXHIBITIONS: 1979, "One Space: Three Visions," Albuquerque Museum, Albuquerque
FAVORITE DESIGNS: lightning, triangles with dots, Xs, dots in a row
PUBLICATIONS: Harlow 1977.
ARCHIVES: Laboratory of Anthropology Library, Santa Fe, lab. file

Rose Pecos-Sun Rhodes

(Jemez, active ca. 1972-present: polychrome Storytellers, Nativities, sets, figures, jars & bowls)
BORN: May 23, 1956
FAMILY: daughter of Jose & Carol Pecos; sister of Irwin Pecos; related to Heather Sun Rhodes
TEACHER: Carol Pecos, her mother
AWARDS: 1988, 3rd, Nativities; 1989, 1st, Nativities; 1990, 1st, Storytellers; 1991, 2nd, 3rd, Storytellers; 1992, 1st, figures; 1993,
1st, sets, 2nd, Storytellers; 1998, 2nd, figures; 1999, Indian Market, Santa Fe
EXHIBITIONS: pre-1985-present, Indian Market, Santa Fe
GALLERIES: Adobe Gallery, Albuquerque & Santa Fe; Crosby Collection, Park City, UT; Arlene's Gallery, Tombstone, AZ
PUBLICATIONS: Indian Market Magazine 1985, 1988, 1989; Babcock 1986; *The Messenger*, Wheelwright Museum, Santa Fe
Autumn 1990:7; Congdon-Martin 1999:84; Berger & Schiffer 2000:139.

Stephanie Pecos

(Jemez, active ca. 1980s-present: Storytellers)
FAMILY: m. granddaughter of Louisa F. Pecos; daughter of Carol Pecos; sister of Rose Pecos-Sun Rhodes, Jackie Pecos
PUBLICATIONS: Babcock 1986:69, 144-45.

*Gina Pecos - Courtesy of
Allan & Carol Hayes*

*Irwin Pecos -
Courtesy of John D. Kennedy and
Georgiana Kennedy Simpson
Kennedy Indian Arts*

Angelita Pedraza
(Tigua/Ysleta del Sur, active ca. 1990s-?: polychrome jars, bowls)
PUBLICATIONS: *New Mexico Magazine* Dec. 1997:55-57, 60.

Agnes Pedro
(Acoma, active ?-1990+: polychrome jars, bowls)
PUBLICATIONS: Dillingham 1992:206-208.

Josephine Pedro
(Acoma, active ca. 1942-present: traditional & ceramic polychrome jars, bowls)
BORN: July 25, 1930
PUBLICATIONS: Berger & Schiffer 2000:139.

Sherrel Pedro *(signs S. Pedro, Laguna)*
(Laguna, active ca. 1992-present: polychrome figures, jars, bowls)
BORN: April 1, 1952
FAMILY: daughter of Ruth Kajond
COLLECTIONS: Angie Yan Schaaf, Santa Fe
PUBLICATIONS: Berger & Schiffer 2000:139.

Crescenciana Peña *(Maria Crescencia Peña)*
(Santa Ana, active ca. 1890s-1940s: traditional polychrome jars, bowls)
BORN: ca. 1877
FAMILY: wife of Manuel Peña; mother of Maria Lupe, Leo Peña, Regno Peña, Lalo Peña, Juan Peña, Lolita Peña
COLLECTIONS: Philbrook Museum of Art, Tulsa, OK, bowl, jar, ca. 1939
PUBLICATIONS: U.S. Census, 1920, Santa Ana, family 16; *El Palacio* May 1949 56(5):140; Bayer 1994:227.
　　　　Crescenciana and her daughter, Lolita, along with Eudora Montoya used to sell their pottery at Coronado Monument.

Lolita Peña
(Santa Ana, active ca. 1930s-?: polychrome jars, bowls)
FAMILY: daughter of Crescenciana Peña & Manuel Peña
PUBLICATIONS: *El Palacio* May 1949 56(5):140; Bayer 1994:227.

Trini Peña *(signs T. Peña), (collaborates with Del Mar Tenorio)*
(Santo Domingo, active ?-present: large polychrome storage jars, bowls)

Travis Penketewa
(Zuni, active ca. 1992-present, traditional polychrome jars, bowls, duck effigies)
BORN: April 7, 1972
PUBLICATIONS: Hayes & Blom 1998:47; Berger & Schiffer 2000:139.

Penlio
(Acoma, active ?: pottery)
COLLECTIONS: Heard Museum, Phoenix

Kevin Peshlakai
(Cochiti, ca. 1980s-present: Storytellers)
BORN: ca. 1964
FAMILY: grandson of Helen Cordero
PUBLICATIONS: Babcock 1986:28, 128-31.

Ella Peters
(Acoma, active ?-1990+: polychrome jars, bowls)
PUBLICATIONS: Dillingham 1992:206-208.

Agnes Peynetsa *(collaborates sometimes with Berdel Soseeah)*
(Zuni, active ca. 1984-present, polychrome on whiteware jars, cornmeal bowls, effigy frog & lizard pots, frog figures, seed pots, canteens, miniatures, jewelry)
BORN: November 11, 1962

Agnes Peynetsa -
Courtesy of Isa & Dick Diestler
Isa Fetish, Cumming, GA

FAMILY: daughter of Charles & Wilma Peynetsa; wife of Berdel Soseeah; sister of Priscilla Peynetsa and Anderson Peynetsa
TEACHER: Jennie Laate, Anderson Peynetsa, her brother and Priscilla Peynetsa, her sister
AWARDS: Indian Market, Santa Fe; "Zuni Show," Museum of Northern Arizona, Flagstaff
EXHIBITIONS: 1993-present, Indian Market, Santa Fe; Heard Museum Show, Phoenix; 1996-present, Eight Northern Indian Pueblos Arts & Crafts Show
FAVORITE DESIGNS: Water Serpent (Kolowisi), frog, lizards, salamanders, tadpoles, terraced clouds
COLLECTIONS: Dave & Lori Kenney, Santa Fe
GALLERIES: The Indian Craft Shop, U.S. Department of Interior, Washington, D.C.; Pueblo of Zuni Arts & Crafts, Zuni, NM; Palms Trading Co., Albuquerque; Keshi, Santa Fe; Arlene's Gallery, Tombstone, AZ

PUBLICATIONS: Schiffer 1991d:47; Nahohai & Phelps 1995:58-63; Bassman 1996; Hayes & Blom 1996; 1998:51, 53; *Indian Market Magazine* 1996:64; 1998:100; Peaster 1997; *Indian Artist* Winter 1997:72; Painter 1998:184-90; Berger & Schiffer 2000:75, 139.

Agnes Peynetsa was introduced to pottery making in Jennie Laate's classes at Zuni High School. Agnes later was encouraged by Anderson Peynetsa, her brother, and Priscilla Peynetsa, her sister. Agnes married Berdel Soseeah, and they began making pottery together. Berdel forms the pots, while Agnes forms the lips and effigy figures, usually lizards or frogs. He sands the pots, and she paints them using a traditional yucca brush.

Agnes prefers white clay. They respectfully gather clay ironstone for their black paint at Nutria. They often go with Marie Soseeah, her mother-in law.

Agnes Peynetsa -
Dave & Lori Kenney Collection
Santa Fe

Anderson Peynetsa *(collaborates with Avelia Peynetsa, signs AA Peynetsa), (signs A. Peynetsa alone)*

(Zuni, active ca. 1980s-present: traditional black-on-redware, polychrome seed pots, jars, ollas, bowls, canteens, duck effigy pots, frogs, ducks)
FAMILY. son of Charles & Wilma Peynetsa; brother of Agnes Peynetsa and Priscilla Peynetsa; husband of Avelia Peynetsa; father of Ashley Peynetsa
TEACHER: Jennie Laate
EXHIBITIONS: 1985-present, Indian Market, Santa Fe; 1988, Zuni Show, Museum of Northern Arizona, Flagstaff; Heard Museum Show, Phoenix; 1999-present. Eight Northern Indian Pueblos
DEMONSTRATIONS: Folklife Festival, Smithsonian Institution
FAVORITE DESIGNS: Rainbirds, frogs, lizards, deer with heartlines, Deer-in-His-House, rosettes, Water Serpents, salamanders
COLLECTIONS: Drs. Judith & Richard Lasky, New York City; Indart, Inc.
GALLERIES: The Indian Craft Shop, U.S. Department of Interior, Washington, D.C.; Turquoise Village, Running Bear Zuni Trading Post, Pueblo of Zuni Arts & Crafts, Zuni, NM; Keshi, Santa Fe; Francois Gallery, Taos, NM; Native American Collections, Denver, CO; King Galleries, Scottsdale, AZ; Sunshine Studio at www.sunshinestudio.com
PUBLICATIONS: Coe 1986:208; Babcock 1986; Rodee & Ostler 1986:59, 62; Trimble 1987:85; *Indian Market Magazine* 1988, 1989, 1996:64; Eaton 1990:29-31; Nahohai & Phelps 1995:back cover, 52-57; Mercer 1995:42, 44; Bassman 1996:23, 25, 26; *Indian Trader* Oct. 1996:19; Hayes & Blom 1996; 1998:51, 53; Peaster 1997; Berger & Schiffer 2000:76.

Anderson Peynetsa -
Photograph by Bill Bonebrake
Courtesy of Jill Giller
Native American Collection

Anderson Peynetsa -
King Galleries of Scottsdale, AZ

Anderson Peynetsa was one of the "star students" who learned pottery making from Jennie Laate. His first class was in eighth grade. He progressed through the beginning, intermediate and advanced courses.

In 1986, Ralph T. Coe, a renowned scholar of Native American Art, described Anderson as "richly talented" and a successful graduate of the pottery program at the Zuni High School.

In 1988, he and his wife, Avelia, collaborated on pottery they entered at the Zuni Show, Museum of Northern Arizona in Flagstaff. The museum purchased one of their black-on-red duck effigy pots. Two years later, the museum added one of their black-on-red ollas with a frieze of eight deer with heartlines around the neck. During this period, the Peynetas also began applying water serpents, as three-dimensional relief figures onto the outside of some of their pots.

Today, Anderson is among the best contemporary Zuni pottery painters. He is noted for his "precise, flowing lines." He also is an excellent sculptor, applying relief figures as noted onto some of his pottery. His lizard figures seem to walk out of the surface of his pots, reminiscent of European master M. C. Escher. Anderson displays a bold and flowing style. His pottery is often quite innovative.

Anderson Peynetsa -
Blue Thunder Fine Indian Art at
www.bluethunderarts.com

A. A. Peynetsa-
Courtesy of John Blom

Avelia Peynetsa *(collaborates with Anderson Peynetsa, signs AA Peynetsa)*

(Zuni, active ca. 1980s: black-on-redware; polychrome jars, bowls, seed pots, effigy pots, frogs, ducks)
FAMILY: great-granddaughter of Catalina Zunie; wife of Anderson Peynetsa; mother of Ashley Peynetsa
TEACHER: Jennie Laate
EXHIBITIONS: Heard Museum Show, Phoenix; Eight Northern Indian Pueblos; 1998-present, Indian Market, Santa Fe
FAVORITE DESIGNS: frogs, lizards, ducks
GALLERIES: The Indian Craft Shop, U.S. Department of Interior, Washington, D.C.; Running Bear Zuni Trading Post, Turquoise Village, Pueblo of Zuni Arts & Crafts, Zuni, NM
PUBLICATIONS: Nahohai & Phelps 1995:back cover, 58-63; Bassman 1996:23, 25, 26; Hayes & Blom 1996; 1998:51, 53; Peaster 1997:156.

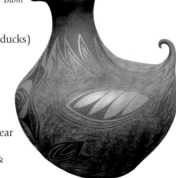

Priscilla Peynetsa *(signs P. Peynetsa, Zuni N.M.), (collaborates sometimes with Daryl Westika)*

(Zuni, active ca. 1980-present, black-on-orangeware, polychrome jars, bowls, effigy pots, clay pipes, frogs, pottery necklaces)
BORN: May 27, 1961
FAMILY: daughter of Charles & Wilma Peynetsa; sister of Agnes Peynetsa and Anderson Peynetsa; wife of Daryl Westika
TEACHER: Jennie Laate
STUDENTS: Agnes Peynetsa, her sister
AWARDS: Heard Museum, Phoenix; Museum of Northern Arizona, Flagstaff
EXHIBITIONS: 1988-present, Indian Market, Santa Fe; 1988, Zuni Show, Museum of Northern Arizona, Flagstaff; Heard Museum Show, Phoenix;1994-present, Eight Northern Indian Pueblos
COLLECTIONS: Museum of Northern Arizona, Flagstaff
FAVORITE DESIGNS: lizards, water serpents, deer-with-heartlines, clouds
GALLERIES: The Indian Craft Shop, U.S. Department of Interior, Washington, D.C.; Turquoise Village, Pueblo of Zuni Arts & Crafts, Zuni, NM; Keshi, Santa Fe
PUBLICATIONS: Rodee & Ostler 1986:58, 72-74; *Indian Market Magazine* 1988, 1989; Eaton 1990:2, 3, 29-31; Nahohai & Phelps 1995: 56, 59, 61; Bassman 1996:22, 23; Hayes & Blom 1996:170-71, 180; 1998:27, 51, 61; Peaster 1997:156; Peterson 1997; Berger & Schiffer 2000:76, 139.

Priscilla Peynetsa - Dr. Gregory & Angie Yan Schaaf Collection

Priscilla Peynetsa is a courageous artist. After a life threatening accident, she successfully returned to making pottery. Her work and determination are commendable, an inspiration for everyone.

Priscilla is an exceptional pottery painter. Her style is bold and creative. She also is perhaps the only potter at Zuni who makes popular pottery necklaces.

Scott Peynetsa

(Zuni, active ?: polychrome jars, bowls)
GALLERIES: Kennedy Indian Arts, Bluff, UT

Scott Peynetsa - Courtesy of Georgiana Kennedy Simpson Kennedy Indian Arts, Bluff, UT

Wilma Peynetsa

(Zuni, active ca. 1970s-?: pottery painter, contemporary greenware jars, bowls)
FAMILY: wife of Charles Peynetsa; mother of Anderson, Agnes and Priscilla Peynetsa
PUBLICATIONS: Eaton 1990:61.

Juana Phillips

(Acoma, Eagle & Parrot Clans, active ca. 1950s-present: traditional polychrome jars, bowls)
BORN: ca. 1930
FAMILY: wife of Thomas Phillips; mother of Santana Phillips; grandmother of Anthony & Josephine Phillips

Santana Phillips

(Acoma, Eagle & Parrot Clans, active ca. 1970s-present: Mimbres Revival black-on-white & traditional fineline jars, bowls)
BORN: January 11, 1950
FAMILY: daughter of Thomas & Juana Phillips; sister of nine; mother of Anthony & Josephine Phillips
TEACHER: Juana Phillips, her mother
FAVORITE DESIGNS: starburst
GALLERIES: Rio Grande Wholesale, Inc., Palms Trading Co., Albuquerque
PUBLICATIONS: Dillingham 1992:206-208; Berger & Schiffer 2000:139.

Santana Phillips shared her love for her mother, Juana Phillips: "I cherish my mother's pottery work. I continue to enjoy working with pottery."

Ascenciona Galvan Pino *(Ascencion)*

(Zia, Coyote Clan, ca. 1930s-?: traditional polychrome ollas, jars, bowls)
BORN: ca. 1910s
FAMILY: wife of Joe Pino; mother of Katherine Pino, Seferina Bell, Laura Pino, Tomasita Pino & Filamino Pino; grandmother of Ruby Panana, Reyes Pino & Eleanor Pino-Griego
STUDENTS: Katherine Pino, Seferina Bell, Laura Pino, Tomasita Pino, her daughters
COLLECTIONS: Philbrook Museum of Art, Tulsa, OK, bowl, ca. 1939
PUBLICATIONS: U.S. Census 1920, family 3A.

Santana Phillips - Courtesy of Jason Esquibel Rio Grande Wholesale, Inc.

Bernadette Pino *(signs B. W. Pino, Zia)*

(Jemez, married into Zia, active ca. 1982-present: polychrome jars, bowls)
BORN: January 27, 1960
FAMILY: daughter of Rudy Wiquiu (Jemez)
TEACHER: mother-in-law (Zia)
PUBLICATIONS: Berger 2000:139.

C. Pino

(Cochiti, active ?-present: polychrome bear figures)
PUBLICATIONS: Congdon-Martin 1999:26.

Carlotta Pino

(Zia, active ca. 1910s-?: traditional polychrome ollas, jars, bowls)
BORN: ca. 1890s
FAMILY: wife of Peter Pino; mother of Ambrosia Pino; p. grandmother of Veronica Pino Baca

Concepcion Pino

(Zia, active ?: pottery)
ARCHIVES: Laboratory of Anthropology Library, Santa Fe; lab. file.

Crescencia Pino

(Santa Ana, active ca. 1960s-70s: pottery)
EXHIBITIONS: 1972, Indian Market, Santa Fe
PUBLICATIONS: *SWAIA Quarterly* Fall 1972:7.

Dolores Pino

(Zia, Water Clan, active ca. 1958-present: traditional bowls, also loom woven maiden shawls, embroidered capes, shirts, kilts, braided rain sash belts, beadwork)
BORN: July 28, 1942
FAMILY: daughter of Antonio Lucero & Lucia Lucero Shije; wife of Moses Pino (retired Governor of Zia Pueblo); sister of Gilbert Lucero, Pauline Panana, Jeanann Pino & Patrick Lucero; mother of Benedict Lucero, Sharon Pino & Gabriel Pino
EDUCATION: Zia Day School; Albuquerque Indian School
TEACHER: Lucia Lucero Shije, her mother
COLLECTIONS: Dr. Gregory & Angie Yan Schaaf, Santa Fe

Dolores Pino is an exceptional, multi-talented artist. She makes some traditional bowls, but is better known as a top Pueblo textile weaver and a fine beadworker. She also assumes community responsibilities. She and her family worked especially hard for Zia Pueblo when her husband, Moses, Pino, served as Governor.

We met Dolores, her husband, Moses, and her sister-in-law, Veronica Pino Baca during the Zia dances on Easter Sunday, 2001. They welcomed us to share dinner with them at their family home on the Plaza. The meal was especially delicious, featuring dishes of red and green chili, tamales, salads and desserts.

Dolores and her husband made special trips to their homes to bring back samples of their artwork to show us. I gasped when I saw her hand woven maiden shawl, the best I've ever seen from any Pueblo in New Mexico. This textile, a style popular at Hopi in Arizona, was woven on a vertical loom with a white cotton center and red and black wool bands. She also showed us one of her finely braided white cotton rain belt sashes. Inside the little balls were braided cornhusk rings woven in the old, traditional way. We were impressed. Dolores gave the credit to her mother, Lucia Lucero Shije, who taught her various artforms.

Before we departed, Dolores gave me and my wife, Angie Yan Schaaf, gifts of beadwork. We were overwhelmed by the kind reception we received. We appreciate their gifts of friendship.

Dolorita Pino -
Photograph by Travis Mellon. Courtesy of
Andrews Pueblo Pottery & Art Gallery

Dolorita Galvan Pino

(Zia, Tobacco Clan, active ca. 1941-present: traditional polychrome jars, bowls, weavings)
BORN: October 6, 1928, Zia Pueblo
FAMILY: m. granddaughter of Reyes Arsala Herrera & Juan Pedro Herrera, p. granddaughter of Nicolas Galvan; daughter of Ascencion & Herrera Galvan; sister of Pablita Galvan Lucero & Harveana Helen Medina; wife of Juan D. Pino; mother of Teresita Mellon, Stanley Pino, Harry Pino and Antonita Pino; grandmother of Travis Mellon
EDUCATION: Albuquerque Indian School
FAVORITE DESIGNS: roadrunners, red birds, rainbows, clouds, rain, steps
PUBLICATIONS: Peaster 1997:151.

Dolorita Galvan Pino has been making pottery for over 60 years. She learned from her mother and grandmother. She has passed her knowledge on to her children and grandchildren. Dolorita explain she enjoys making pottery, because "it keeps me self-employed at home, and gives me a break from housework. These things are important, since Social Security hasn't made me rich yet."

Dominguita H. Pino

(Zia, active ca. 1930s-70s: traditional polychrome ollas, jars, bowls)
FAVORITE DESIGNS: roadrunners, rainbows, clouds, waves
GALLERIES: Nedra Matteucci Galleries, Santa Fe
PUBLICATIONS: Tanner 1976:122; *Southwest Art* Nov. 1988:42.

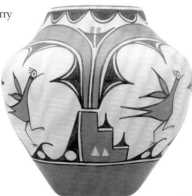

Dominguita Pino - Courtesy of
Nedra Matteucci Galleries, Santa Fe

Edna Pino

(Acoma, active ?-1990+: polychrome jars, bowls)
PUBLICATIONS: Dillingham 1992:206-208.

Eleanor Pino-Griego

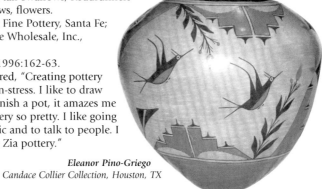

Eleanor Pino-Griego -
Courtesy of Jason Esquibel
Rio Grande Wholesale, Inc.

Eleanor Pino-Griego - Courtesy of the artist

(Zia, Coyote/Sage Brush Clans, active ca. 1970s-present:
traditional polychrome jars, bowls, vases)
BORN: April 7, 1953
FAMILY: granddaughter of Joe Pino & Ascencion
Galvan Pino; daughter of Laura Pino; sister of Reyes
Pino, Ruby Panana, Anthony Pino & Rachel Jaranillo;
wife of Felix Griego; mother of Gabriel, Daniel,
Carolyn, Candice Griego
TEACHERS: Ascencion Galvan Pino, her grandmother;
and Laura Pino, her mother
AWARDS: 2000, 2nd, Vases, Indian Market, Santa Fe; Eight
Northern Indian Pueblos Arts & Crafts Show; Wichita Indian
Art Show, KA; Mesa Verde Indian Art Show, CO; San Felipe Pueblo
Indian Art Show, NM
EXHIBITIONS: 1997-present, Indian Market, Santa Fe; 1996-present, Eight Northern Indian
Pueblos Arts & Crafts Show
COLLECTIONS: Wichita Indian Arts Museum, KA; Candace Collier, Houston, TX; Dr. Fred
Belk, NM; Robert Fisher, Dr. Gregory & Angie Yan Schaaf, Santa Fe
FAVORITE DESIGNS: Split-tail Swallows, Roadrunners
with striped wings, rainbows, flowers.
GALLERIES: Andrea Fisher Fine Pottery, Santa Fe;
Wright's Indian Collections, Rio Grande Wholesale, Inc.,
Albuquerque; Zuni Indian Traders
PUBLICATIONS: Hayes & Blom 1996:162-63.

Eleanor Pino-Griego shared, "Creating pottery
helps me to sit down and un-stress. I like to draw
birds and flowers. When I finish a pot, it amazes me
that I created a piece of pottery so pretty. I like going
to art shows to meet the public and to talk to people. I
enjoy introducing the public to Zia pottery."

Eleanor Pino-Griego
Dr. Fred Belk Collection, NM

Eleanor Pino-Griego
Candace Collier Collection, Houston, TX

Erlinda Pino

(Zia, Coyote Clan, active ca. 1990s-present: traditional
polychrome ollas, jars, bowls)
EXHIBITIONS: 1994-present, Indian Market, Santa Fe
COLLECTIONS: Wright/McCray, Santa Fe; Dave & Lori
Kenny, Santa Fe
FAVORITES DESIGNS: roadrunners, rainbows, flowers,
clouds, rain
GALLERIES: Palms Trading Co., Albuquerque
PUBLICATIONS: Berger & Schiffer 2000:74.

Frances Torivio Pino (*see Frances Torivio*)

Juana Pino

(Zia, active ca. 1910s-?: traditional polychrome jars, bowls)
BORN: ca. 1896
FAMILY: wife of Andres Pino; mother of James & Agustin Pino
PUBLICATIONS: U.S. Census 1920, family 12.

Juanita B. Pino

(Acoma, ca. 1930s-?: traditional polychrome ollas, jars, bowls)
COLLECTIONS: Philbrook Museum of Art, Tulsa, OK, jar, ca. 1939

Juanita Toribio Pino

(Zia, Coyote Clan, active ca. 1930-80s: traditional polychrome jars, bowls)
LIFESPAN: ca. 1900 -1987
FAMILY: daughter of Rosalea Medina Toribio, sister of Maria Bridgett; mother of Sofia Medina;
aunt of Candelaria Gachupin
EXHIBITIONS: 1972, Indian Market, Santa Fe;1979, "One Space: Three Visions," Albuquerque

Erlinda Pino -
Wright/McCray Collection
Santa Fe

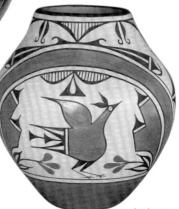

Erlinda Pino -
Dave & Lori Kenney Collection
Santa Fe

Museum, Albuquerque
COLLECTIONS: Museum of New Mexico, Laboratory of Anthropology, Santa Fe, olla, ca. 1950.
FAVORITE DESIGNS: roadrunners, rainbows, clouds, rain
VALUES: On May 26, 1999, a polychrome olla (11″ h.), signed Juanita Pino in pencil, sold for $1,840, at Sotheby's, #46.
PUBLICATIONS: *SWAIA Quarterly* Fall 1972:7; Tanner 1976:121; Barry 1984:102, 104; Dillingham 1994:106, 109, 112.

Juanita's granddaughter, Lois Medina, said, "When I started working, my grandma [Juanita Pino] sat me down and told me the story behind pottery, how it was created - the true meaning behind it. She gave me everything - some old purse with old tools, gourds, brushes, black stone..."

One of Juanita's polychrome ollas, ca. 1960, is composed of a scallop design painted around the rim and a repetitive rainbow shaped cloud around the neck. The main body of the pot is a design of diagonal cloud bands and criss-crossed clouds with diagonal hatching. (Barry 1984:104-05)

June Pino
(Acoma, active ?-present: traditional polychrome ollas, jars bowls)
FAVORITE DESIGNS: deer with heartline
GALLERIES: Rio Grande Wholesale, Inc., Albuquerque

Katherine Pino *(Kathy)*
(Zia, Coyote Clan, active ca. 1950s-present: traditional polychrome ollas, jars, bowls)
BORN: ca. 1935
FAMILY: daughter of Ascencion Galvan Pino & Joe Pino; sister of Seferina Bell, Laura Pino, Tomasita Pino & Filamino Pino
TEACHER: Ascencion Galvan Pino, her mother
STUDENTS: Veronica Pino Baca
COLLECTIONS: John Blom
PUBLICATIONS: Mercer 1995:36, 37, 44; Hayes & Blom 1996:164-65; 1998.

Veronica Pino Baca recalled when Katherine Pino used to encourage her, "Come on! We're going to make some potteries."

Veronica said Katherine learned from her mother, Ascencion Galvan Pino, whose pottery is in the collection of the Philbrook Museum in Tulsa, OK.

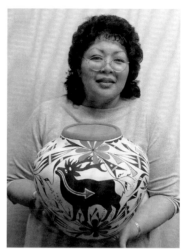

June Pino - Courtesy of Jason Esquibel
Rio Grande Wholesale, Inc.

Laura Pino
(Zia, Coyote Clan, ca. 1950s-?: traditional polychrome ollas, jars, bowls)
BORN: ca. 1930s
FAMILY: daughter of Joe Pino & Ascencion Galvan Pino; sister of Katherine Pino, Seferina Bell, Tomasita Pino & Filamino Pino; mother of Reyes Pino & Eleanor Pino-Griego
TEACHER: Ascencion Galvan Pino, her mother

Lucrecia Pino
(Zia, active ca. 1860s-?: traditional polychrome jars, bowls)
BORN: ca. 1847
FAMILY: wife of Pedro Pino; mother of Onan B. Pino & Perfecto Pino
PUBLICATIONS: U.S. Census 1920, family 17.

Martina Pino
(Zia, active ca. 1900s-?: traditional polychrome jars, bowls)
BORN: ca. 1882
FAMILY: wife of Tomas Pino; mother of Goviana Pino & Reyes Pino
PUBLICATIONS: U.S. Census 1920, family 2.

Kathy Pino -
Courtesy of John Blom

Moses Pino
(Zia, Coyote/Arrow Clans, active ca. 1950s-present: traditional polychrome jars, bowls, also beaded bow guards, men's beaded shoulder bags with tin cone dangles, textiles, loom weaving, paintings, bows & arrows)
BORN: July 20, 1939
FAMILY: m. grandson of Santiago Shije & Joseffa Galvan; p. grandson of Peter Pino & Carlotta Pino; son of Refugia Galvan Shije & Santiago Shije; brother of Juan D. Pino, Ramon Pino, Florence Pino & Veronica Pino Baca; husband of Dolores Pino; father of Benedict Lucero, Sharon Pino, Gabriel Pino; uncle of Randy Moquino
CAREER: retired Governor of Zia Pueblo; Bureau of Indian Affairs, 1974-2000
FAVORITE DESIGNS: Sun, arrowheads, feathers, lightning, rain, roses

Moses Pino showed us one of his traditional polychrome miniature bowls with cloud designs. He also showed us a recently formed jar which he had painted the first coat of red slip. He was humble about his pottery.

However, Moses is best known for his exceptional beadwork. He makes beautiful beaded men's shoulder bags worn in Pueblo ceremonies. His beaded bow guards are precision made with small beads and complex designs. He is a highly intelligent and experienced person, being a retired Governor of Zia Pueblo. He and his family treated us with kindness.

Pablita Pino *(1)*
(Acoma, active ca. 1930s-?: traditional polychrome jars, bowls)
COLLECTIONS: Philbrook Museum of Art, Tulsa, OK, jar, ca. 1939

Pablita Pino *(2)*

(Zia, active ?: pottery)
FAMILY: sister of Dolorita Pino
PUBLICATIONS: Peaster 1997:151.

Perfilia Pino

(Zia, active ca. 1910s-?: traditional polychrome jars, bowls)
BORN: ca. 1897
FAMILY: wife of Juan Benito Pino; mother of Lucinda Pino, Ramon Pino
PUBLICATIONS: U.S. Census 1920, family 5.

Refugia Shije Pino

(Zia, Tobacco/Coyote/Arrow Clans, active ca. 1920s-?: traditional polychrome ollas, jars, bowls, cross-stitch embroidery)
FAMILY: daughter of Joseffa Galvan Shije & Santiago Shije; wife of Santiago Shije; mother of Veronica Pino Baca

Refugia Pino

(Zia, active ca. 1920s-?: traditional pottery)
BORN: ca. 1902
FAMILY: wife of Ambroisio Pino; mother of Juan Domingo Pino
PUBLICATIONS: U.S. Census 1920, family 4.

Regina Pino

(Laguna, active ca. 1973-1999: traditional polychrome jars, bowls)
FAMILY: mother of Alfred Pino (painter)
EDUCATION: 1973, Laguna Arts & Crafts Project participant

Reyes Pino

(Zia, Coyote Clan, ca. 1970s-present: traditional polychrome ollas, jars, bowls, pitchers)
BORN: ca. 1950s
FAMILY: granddaughter of Joe Pino & Ascencion Galvan Pino; daughter of Laura Pino; sister of Eleanor Pino-Griego, Ruby Panana
TEACHER: Ascencion Galvan Pino, her grandmother; and Laura Pino, her mother
EXHIBITIONS: 1979, "One Space: Three Visions," Albuquerque Museum, Albuquerque
COLLECTIONS: Museum of New Mexico, Laboratory of Anthropology, Santa Fe, olla, ca. 1961.
FAVORITE DESIGNS: birds, flying creatures, clouds, kiva steps
PUBLICATIONS: Mercer 1995:37; Hayes & Blom 1996:162-65.

Santana Pino

(Acoma, ca. 1920s-?: traditional polychrome jars, bowls)
BORN: ca. 1900
FAMILY: mother of Rose Poncho; m. grandmother of Clara Santiago & Florina Vallo; great-grandmother of Nathaniel J. Vallo, Frederica Vallo & Melissa Vallo

Serafina Pino

(Zia, active ?-present: traditional polychrome jars, bowls, miniature bread ovens)
COLLECTIONS: Allan & Carol Hayes
PUBLICATIONS: Hayes & Blom 1998:6.

Serafina Pino - Courtesy of Allan & Carol Hayes

Tomasita Pino

(Zia, Coyote Clan, ca. 1950s-?: traditional polychrome ollas, jars, bowls)
BORN: ca. 1930s
FAMILY: daughter of Joe Pino & Ascencion Galvan Pino; sister of Katherine Pino, Seferina Bell, Laura Pino & Filamino Pino; mother of Reyes Pino & Eleanor Pino-Griego
TEACHER: Ascencion Galvan Pino, her mother

Vicentita S. Pino *(signs V.S. P. or V. P. with a bird hallmark in 1970s)*

(Zia, Corn Clan, active ca. 1930-present: traditional polychrome ollas, storage jars, dough bowls, vases, miniature pottery houses, fireplaces)
BORN: May 24, 1917
FAMILY: great-granddaughter of He-wee'-a & Gaa-yo-le-nee; m. granddaughter of Augustina Aguilar; daughter of Manuelita Aguilar Salas & Jesus Salas (Jemez); wife of John Pino (ca. 1897-?, deceased); mother of John B. Pino, Ronald Pino & Diana Lucero
TEACHER: Augustina Aguilar, her grandmother
STUDENT: Diana Lucero, her daughter
AWARDS:

1934	1st, H.M., Inter-tribal Indian Ceremonial, Gallup	
1938	1st, Indian Market, Santa Fe	
1956	1st, Indian Market, Santa Fe	
1970	1st, jars over 15" high, Indian Market, Santa Fe	

1974 White House, Washington, D.C.; 1st, jars, Indian Market, Santa Fe
2000 Jemez Pueblo Red Rocks Arts & Crafts Show, Jemez, NM; 3rd, Traditional
 Vases, Indian Market, Santa Fe

EXHIBITIONS: 1938-present, Indian Market, Santa Fe; 1995-present, Eight Northern Indian Pueblos Arts & Crafts Show New Mexico State Fair, Albuquerque; Inter-tribal Indian Ceremonial, Gallup

COLLECTIONS: Smithsonian Institution, Washington, D.C.; Heard Museum, Phoenix; Museum of Indian Arts & Cultures, School of American Research, Santa Fe; Indian Pueblo Cultural Center, Albuquerque; Philbrook Museum of Art, Tulsa, OK, bowl, ca. 1939, jar, ca. 1949, dough bowl, ca. 1958; Dr. Gregory & Angie Yan Schaaf, Santa Fe

ORGANIZATIONS: Indian Arts & Crafts Association

FAVORITE DESIGNS; roadrunners, deer, 2 & 3 tail feather birds, rabbits, hummingbirds, robins, swallows.

VALUES: On February 4, 2001, a polychrome jar (11 x 13"), estimated $1,200-1,800, at Munn's, item #1113.

PUBLICATIONS: U.S. Census 1920, family 25; *El Palacio* Jan. 1947:13; *SWAIA Quarterly* Fall 1971; Fall 1974:3; *Arizona Highways* May 1974:41; Tanner 1976:122; Eddington & Makov 1995; Painter 1998:218; *Native Artists* Summer 1999:28.

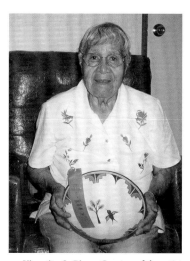

Vicentita S. Pino - Courtesy of the artist

 In the spring of 2001, we met Vicentita Pino and her daughter, Diana Lucero, exhibiting their pottery at the Indian Arts & Crafts Association Show in Albuquerque. They were very kind and gracious, sharing much information and reviewing the manuscript for Zia Pueblo potters.

 Vicentita recalled growing up in the 1920s with her grandmother, Augustina Aguilar, who taught her how to make miniature pottery houses: "My grandmother and I use to take her water jars and my pottery houses to the Santo Domingo Pueblo Feast Day. I got $4 for my houses, when I was only 10-12 years old."

 Vicentita is one of the few Zia potters to have her own brochure which states in part: "Vicentita S. Pino began her pottery making around the age of 15, when she made 100 serving bowls. The family's food supply was dwindling and her grandmother was sick. It was up to Vicentita to make, paint and fire these pieces. The pottery was to be sold or traded for food and other needed items. This was the beginning of her "career."

 "Vicentita was chosen to represent the Pueblo of Zia as one of the 19 pueblo potters to travel to Washington, D.C. . . During this visit in 1974, then First Lady Pat Nixon was hostess to this group of potters and was presented with pottery from each of the potters. These pieces were donated to the Smithsonian Institution at the end of Mr. Nixon's presidency.

 "Although in her 80's now, she still forms and designs her own creations and continues to be recognized for her craftsmanship. Her family is very proud of her past successes and continues to feel pride in her work today."

 Her daughter, Diana Lucero recalled how her mother always encouraged her without being "pushy."

 "She would tell me stories of her grandmother's endeavors at pottery making. . . My mother had always been the one to actually prepare the materials for our pottery making. I remember digging the clay and watching my father crushing the rocks (basalt), getting it ready for my mother to grind into a fine powder.

 "As a child, I remember watching my mother setting up her clay and making her pottery in the middle of the room. I'd watch her create a piece and give it her spirit. I would sit besides her hoping I could transfer my spirit into the clay, as I had watched her do. . ."

Marvin Pinto

(Zuni, active ?-present: polychrome jars, bowls, fetishes)
PUBLICATIONS: Painter 1998:184-90.

*Vicentita S. Pino -
Courtesy of the artist*

Tulis Platero

(Acoma, active ca. 1880s-1910s+: polychrome jars, bowls)
BORN: ca. 1870; RESIDENCE: McCartys in ca. 1910
PUBLICATIONS: Leopold Bibo, "13th Annual U.S. Census" (1910), New Mexico State Archives, Call T624, Roll 919; in Dillingham 1992:205.

Monica Poma

(Acoma, active ?-present: traditional polychrome jars, bowls, wedding vases)
PUBLICATIONS: Berger & Schiffer 2000:140.

Adella Poncho

(Acoma, active ?-1990+: polychrome jars, bowls)
GALLERIES: Kennedy Indian Arts, Bluff, UT
PUBLICATIONS: Dillingham 1992:206-208.

Aggie Poncho *(see Aggie Henderson-Poncho)*

Carrie Poncho

(Acoma, active ?: pottery)
ARCHIVES: Lab File, Laboratory of Anthropology, Santa Fe

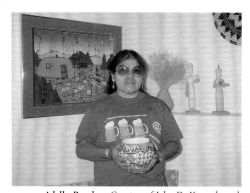

*Adella Poncho - Courtesy of John D. Kennedy and
Georgiana Kennedy Simpson, Kennedy Indian Arts*

Gertrude R. Poncho *(collaborates with Richard L. Martinez)*
(Acoma, active ?-1990+: polychrome jars, bowls)
Family: Sister of Shdiya'araits'a; wife of Richard L. Martinez, Laguna
PUBLICATIONS: Dillingham 1992:206-208; Hayes & Blom 1997.

Josephine Poncho
(Laguna, active ca. 1973-?: traditional polychrome jars, bowls)
EDUCATION: 1973, Laguna Arts & Crafts Project participant

Mrs. Juan Poncho
(Cochiti, active ?: pottery)
ARCHIVES: Laboratory of Anthropology Library, Santa Fe, lab file.

Juana Maria (?) Poncho
(Acoma, active ca. 1870s-1910s+: polychrome jars, bowls)
BORN: ca. 1860; RESIDENCE: Acomita in ca. 1910
PUBLICATIONS: Leopold Bibo, "13th Annual U.S. Census" (1910), New Mexico State Archives, Call T624, Roll 919; in Dillingham 1992:205.

Mabel Poncho
(Laguna, active ?-present: traditional polychrome jars, bowls)
BORN: ca.1920s
FAMILY: wife of Edward Poncho, Sr. & Mabel Poncho; mother of Sue Tapia; m. grandmother of Patrick Valencia & Matt Valencia
EDUCATION: 1973, Laguna Arts & Crafts Project participant
STUDENTS: Sue Tapia, her daughter
PUBLICATIONS: Schaaf 2000:252.

> Mabel was raised in Mesita Village on the Laguna Reservation in New Mexico. Her mother sold pottery along old U.S. Route 66 during the early to mid-1950s. Mabel worked in the Laguna style pottery, but she rarely sold commercially. Most of her work was used for ceremonial purposes.

Maria Poncho
(Acoma, active ca. 1880s-1936+: traditional polychrome large ollas, jars)
BORN: ca. 1872; RESIDENCE: Acomita in ca. 1910
COLLECTIONS: Taylor Museum, Colorado Springs, CO, olla, ca. 1936, #4381
FAVORITE DESIGNS: birds, parrots, rosettes, clouds
VALUES: On May 26, 1999, a large polychrome olla (15 x 18"), attributed to Maria Poncho [Pancho], sold for $7,475, at Sotheby's, #52.
PUBLICATIONS: Leopold Bibo, "13th Annual U.S. Census" (1910), New Mexico State Archives, Call T624, Roll 919; in Dillingham 1992:205; Batkin 1987:31.

Rose Poncho *(signs R. Poncho, Acoma N.M.)*
(Acoma, active ca. 1937-present: traditional & ceramic polychrome jars, bowls)
BORN: November 21, 1921
FAMILY: daughter of Santana Pino; mother of Clara Santiago & Florina Vallo; grandmother of Nathaniel, Frederica & Melissa
PUBLICATIONS: Berger & Schiffer 2000:140.

Rosita Pujacante
(Acoma, active ca. 1870s-1910s+: polychrome jars, bowls)
BORN: ca. 1860; RESIDENCE: Acomita in ca. 1910
PUBLICATIONS: Leopold Bibo, "13th Annual U.S. Census" (1910), New Mexico State Archives, Call T624, Roll 919; in Dillingham 1992:205.

Marie Qualo
(Zuni, active ?: polychrome ollas, jars, bowls)
FAVORITE DESIGNS: Deer-in-His-House

Paula Quam
(Zuni, active ca. 1980s-present: polychrome jars, bowls, vases with fluted rims)
BORN: ca. 1970
TEACHER: Jennie Laate
PUBLICATIONS: Rodee & Ostler 1986:84.

Faye Quandelacy
(Zuni, active ca. 1970s-present: polychrome jars, bowls, jewelry, sculptor, carvings)
BORN: ca. 1958
FAMILY: daughter of Ellen Quandelacy
EDUCATION: Institute of American Indian Arts, Santa Fe
GALLERIES: Indian Craft Shop, Washington, D.C.; Keshi, Wadle Galleries, Ltd., Santa Fe; Red Rock Trading Co., Alexandria VA
PUBLICATIONS: Reano 1995:138.

Agrapina Ortiz Quintana *(Egrepina)*

(Cochiti, Turquoise Clan, Turquoise Kiva, active ca. 1900s-50s+?: large polychrome storage jars)
BORN: May 23, 1887
FAMILY: daughter-in-law of Sanjuana Quintana; wife of Marcial Quintana; mother of Paublino, Celistino, Catalina, Crucita, Maria Beronica Quintana
COLLECTIONS: National Park Service, Santa Fe
PUBLICATIONS: U.S. Census 1920, family 50; *El Palacio* Sept. 1943 1(9):226; Lange 1959:162, 514; Toulouse 1977:56.

 Agrapina Ortiz Quintana was famous for her large storage jars. She reportedly once made one so big, that she could not get it out of her house. With much coaxing, her husband, Marcial, finally was persuaded to remove the door and one side of adobe bricks. After much effort, the giant pot was moved outside where it was successfully fired traditionally.

 Agrapina was active in the ceremonial life of Cochiti. Lange listed her as a member of the Kwe'rana Society.

 In the 1930s, Agrapina created pottery for display in public buildings. This was her contribution to the Public Works of Art Project and the Works Progress Administration (WPA). Her pottery went on exhibit at the National Park Service Regional Headquarters in Santa Fe.

Angel Quintana *(signs A.Q.)*

(Cochiti, active ?-present: polychrome jars, bowls, figures, miniatures, ornaments)
BORN: August 12, 1936
FAMILY: granddaughter of Estefanita & Juan Herrera; daughter of Paul & Felipa Trujillo; sister of five others
PUBLICATIONS: Berger & Schiffer 2000:141.

Catalina Quintana

(Cochiti, Turquoise Clan, Turquoise Kiva, active ca. 1930s-?: traditional polychrome storage jars, bowls)
BORN: ca. 1914
FAMILY: p. granddaughter of Sanjuana Quintana; daughter of Agrapina Ortiz Quintana & Marcial Quintana; sister of Paublino, Celistino, Crucita, Maria Beronica Quintana
PUBLICATIONS: U.S. Census 1920, family 50.

Cresencia Quintana *(Crescencia)*

(Cochiti, active ca. 1920s-?: traditional polychrome jars, bowls)
BORN: ca. 1900
FAMILY: grandmother of Maria Priscilla; great-grandmother of Mary Eunice Ware
PUBLICATIONS: Babcock 1986:135.

Crucita Quintana

(Cochiti, Turquoise Clan, Turquoise Kiva, active ca. 1930s-?: traditional polychrome storage jars, bowls)
BORN: ca. 1916
FAMILY: p. granddaughter of Sanjuana Quintana; daughter of Agrapina Ortiz Quintana & Marcial Quintana; sister of Paublino, Celistino, Catalina, Maria Beronica Quintana
PUBLICATIONS: U.S. Census 1920, family 50.

Irene Quintana *(signs Irene, Cochiti)*

(Cochiti, active ?-present: polychrome Storytellers, jars, bowls, leatherwork)
BORN: January 30, 1929
PUBLICATIONS: Berger & Schiffer 2000:141.

Margaret Quintana *(1)*

(Cochiti, active ca. 1940s-present: polychrome jars, bowls, Storytellers)
BORN: ca. 1920
FAMILY: wife of Geronimo [Jerry] Quintana; mother of Mary E. Quintana & Pablo B. Quintana
PUBLICATIONS: Berger & Schiffer 2000:141.

Margaret Quintana *(2)*

(Cochiti, active 1970s-present: pottery)
FAMILY: wife of Pablo B. Quintana; mother of Pamela E. Quintana & Olivia Quintana
GALLERIES: The Indian Craft Shop, U.S. Department of Interior, Washington, D.C.
PUBLICATIONS: Berger & Schiffer 2000:141.

Margaret Behan Quintana *(3)*

(Cheyenne, married into Cochiti, active ca. 1982-present: Storytellers, Nativities, some in micaceous clay)
BORN: July 4, 1948
FAMILY: daughter of Harry & Daisy Behan
AWARDS: 1990, 1st (2), 3rd; 1998, Indian Market, Santa Fe; New Mexico State Fair, Albuquerque; Inter-tribal Indian Ceremonial, Gallup, NM
EXHIBITIONS: 1990-present, Indian Market, Santa Fe
PUBLICATIONS: Hayes & Blom 1996, 1998; Congdon-Martin 1999:120; Berger & Schiffer 2000:141.

Maria Beronica Quintana

(Cochiti, Turquoise Clan, Turquoise Kiva, active ca. 1940s-?: traditional polychrome storage jars, bowls)
BORN: ca. 1920
FAMILY: p. granddaughter of Sanjuana Quintana; daughter of Agrapina Ortiz Quintana & Marcial Quintana;
sister of Paublino, Celistino, Catalina, Crucita Quintana
PUBLICATIONS: U.S. Census 1920, family 50.

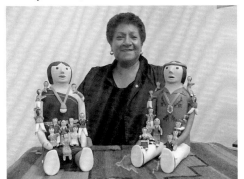

*Mary Quintana -
Courtesy of Jason Esquibel
Rio Grande Wholesale, Inc.*

Mary E. Quintana-Baca *(Parrot, Liz Baca Quintana)*

(Cochiti, active ca. 1980-present: polychrome jars, bowls,
Storytellers, Nativities)
BORN: December 21, 1944 or 1946
FAMILY: daughter of Geronimo [Jerry] & Margaret Quintana
(1); sister of Pablo Quintana
AWARDS: Eight Northern Indian Pueblos Arts & Crafts
Show; New Mexico State Fair, Albuquerque
GALLERIES: The Indian Craft Shop, U.S. Department of
Interior, Washington, D.C.; Rio Grande Wholesale, Inc.
PUBLICATIONS: Congdon-Martin 1999:26-27; Berger &
Schiffer 2000:90, 141.

Mary E. Quintana makes large, colorful Storytellers, She uses turquoise
paint to simulate turquoise jewelry. Each of her babies have their own jewelry
and clothing designs. Her Nativities feature animals, miniature bowls, drums
and fruit. She gathers clay around Cochiti and forms her dolls by hand. She
paints with brilliant shades of acrylic paint.

*Mary Quintana - Courtesy of Jason Esquibel
Rio Grande Wholesale, Inc.*

Olivia Quintana

(Cochiti, active ca. 1990-present: polychrome jars, bowls, Storytellers)
BORN: 1970s
FAMILY: p. granddaughter of Geronimo (Jerry) & Margaret Quintana; daughter of Margaret & Pablo Quintana
GALLERIES: The Indian Craft Shop, U.S. Department of Interior, Washington, D.C.

Pablo B. Quintana *(Ke-Sto-We, One Who Carries Arrows)*

(Cochiti, active ca. 1957-present: polychrome micaceous Storytellers, Angels, Nativities, clay
& bronze sculptures, acrylic paintings, pencil drawings)
BORN: July 17, 1947
FAMILY: nephew of Helen Cordero; son of Geronimo [Jerry] & Margaret Quintana (1);
brother of Mary Quintana; husband of Margaret Quintana (2); father of Pamela E. Quintana
& Olivia Quintana
TEACHER: Margaret Quintana, his mother; Helen Cordero, his aunt
EDUCATION: New York City Prep School
AWARDS: 1991, John R. Bott Memorial Award for Best Storyteller; First, Cochiti Storytellers,
1st, Indian Market, Santa Fe; John Bott Memorial Award, First Place in Category
EXHIBITIONS: pre-1991-93, Indian Market, Santa Fe
GALLERIES: The Indian Craft Shop, U.S. Department of Interior, Washington, D.C.; Rio
Grande Wholesale, Palms Trading Company, Albuquerque
PUBLICATIONS: Congdon-Martin 1999:28; Berger & Schiffer 2000:90, 141.

Pablo B. Quintana was inspired to make Storytellers. By age 10, he had his hands in the
clay, encouraged by his mother, Margaret Quintana (1), and inspired by his famous aunt,
Helen Cordero.

As a teenager, Pablo accepted the opportunity to attend a New York City prep school. In
the 1960s, the New York art world was abuzz with famous artists from Jasper Johns to Andy
Warhol. Pablo followed a tradition of Pueblo Indian artists who visited and exhibited in
New York City, including the San Ildefonso painters Awa Tsireh, Tse-ye-mu, Julian Martinez.

Pablo returned from New York City to Cochiti Pueblo where the highest buildings were
maybe two or three stories tall. He described the experience of switching back and forth between America's largest city and one
of New Mexico's smallest Pueblos as a "culture shock."

During the 1970s, when his Aunt Helen Cordero was gaining international fame for her Storytellers, Pablo regained his
focus as a potter. He began gathering clay at both Cochiti and Picuris, adding micaceous clay to make his Storytellers sparkle.
He began preparing the clay, forming his figures and firing them outdoors in a pit.

Pablo explained how much effort goes into pottery making: "People say that it's free to make my art, but it is not as easy
as they say. It's difficult work. I am honored to have been gifted with such a talent."

*Pablo Quintana -
Courtesy of Jason Esquibel
Rio Grande Wholesale, Inc.*

Pamela E. Quintana

(Cochiti, active ca. 1989-present: polychrome jars, bowls, Storytellers)
BORN: June 17, 1974
FAMILY: p. granddaughter of Geronimo (Jerry) & Margaret Quintana; daughter of Margaret & Pablo Quintana
GALLERIES: The Indian Craft Shop, U.S. Department of Interior, Washington, D.C.
PUBLICATIONS: Berger & Schiffer 2000:90, 141.

Reyes Quintana

(Santo Domingo, active ca. 1930s-?: traditional polychrome jars, bowls)
BORN: ca. 1910
FAMILY: daughter of Reyes & Ventura Reano; sister of Tonita R. Lovato

Tonita Quintana *(perhaps the same as Antonita Quintana Calabaza)*

(Santo Domingo, active ca. 1910s-?: traditional polychrome ollas, jars, bowls)
AWARDS: 1924, 2nd, Indian Market, Santa Fe; 1926, 2nd, Indian Market, Santa Fe
PUBLICATIONS: Toulouse 1977:53.
 In 1924 and 1926, Tonita Quintana and Felipa Aguilar were award winners from Santo Domingo at Indian Market, in Santa Fe.

B. R. *(see Bear Routzen)*

B. B. Ramirez

(Acoma, active ?-present: polychrome jars, bowls)
COLLECTIONS: Dr. Gregory & Angie Yan Schaaf, Santa Fe

Betty Ramirez-Concho

(Acoma, active ca. 1980s-present: polychrome jars, bowls)
BORN: ca. 1940s
FAMILY: mother of Nadine Mansfield; mother-in-law of Louis Mansfield
STUDENTS: Nadine & Louis Mansfield
PUBLICATIONS: Dillingham 1992:206-208.

Nadine Ramirez

(Acoma, active ?-1990+: polychrome jars, bowls)
PUBLICATIONS: Dillingham 1992:206-208.

Delores Raton

(Santa Ana, active ?: pottery)
ARCHIVES: Laboratory of Anthropology Library, Santa Fe, lab file.

Gloria Hansen Ray

(Acoma, active ca. 1960s-?: pottery)
BORN: ca. 1950
FAMILY: granddaughter of Lucy M. Lewis; daughter of Ann Lewis; mother of Regina Ray

Joselita Ray

(Acoma, active ca. 1975-90)
PUBLICATIONS: Minge 1991:195; Dillingham 1992:206-208.

Lydia Ray

(Acoma, active ?-1990+: polychrome jars, bowls, owls, fetishes)
PUBLICATIONS: Dillingham 1992:206-208.

Marilyn Ray - Courtesy of King Galleries of Scottsdale, AZ

Marilyn J. Ray *(Marilyn Henderson, Marilyn Ray-Henderson, Marilyn Lewis Ray)*

Marilyn Ray - Courtesy of Jason Esquibel Rio Grande Wholesale, Inc.

(Acoma, Yellow Corn Clan, active ca. 1966-present: traditional & non-traditional polychrome jars, bowls, Storytellers (1978-), Nativities, human figures, children, dogs, animal figures, birds, butterflies, polychrome jars, bowls)
BORN: August 14, 1954
FAMILY: granddaughter of Toribio & Dolores S. Sanchez; daughter of Katherine & Edward Lewis; sister of Carolyn Lewis Concho, Diane M. Lewis, Judy M. Lewis, Sharon Lewis, Rebecca Lucario, Bernard E. Lewis
TEACHERS: Dolores S. Sanchez and Katherine Lewis
AWARDS: 1980, 1st, New Mexico State Fair, Albuquerque; 1982, 1st, 2nd, 3rd; 1983, 2nd, 3rd; 1989, 3rd; 1991, Best of Division; 1993, 3rd, non-traditional bowls; 1994, 1st, Storytellers, 3rd, Nativities, 1st, 3rd, figures; 2000, 2nd (2), Indian Market, Santa Fe; 1998, 1st (2), 2nd, 2000, 1st, Eight Northern Indian Pueblos Arts & Crafts Show
EXHIBITIONS: 1982-present, Indian Market, Santa Fe; 1995-present, Eight Northern Indian Pueblos Arts & Crafts Show; Heard Museum Show, Phoenix
COLLECTIONS: John Blom
FAVORITE DESIGNS: mother & child, grandmothers and babies, fisherman catching a fish, Mimbres lizards
GALLERIES: Tribal Arts Zion, Springdale, UT; King Galleries of Scottsdale, AZ; Andrea Fisher Fine Pottery, Santa Fe; Adobe Gallery, Andrews Pueblo Pottery & Art Gallery, Rio Grande Wholesale, Inc., Palms Trading Co., Albuquerque

PUBLICATIONS: *SWAIA Quarterly* Fall 1982:11; *American Indian Art Magazine* Spring 1983:37; Summer 1986:13; Autumn 1988:16; Summer 1990:74; *Indian Market Magazine* 1985-2000; Babcock 1986:52-56. 90. 108, 136; *The Messenger,* Wheelwright Museum Spring 1987:3; Spring 1996:12; Winter 1997:14; *Southwest Art* Nov. 1990:135; Mar. 1997:62; Dillingham 1992:206-208; Bahti 1996:26; Hayes & Blom 1996:52-53; Painter 1998:15; Congdon-Martin 1999:50-51; Berger & Schiffer 2000:20, 90, 140.

Marilyn Henderson Ray comes from a family of successful pottery makers. She learned from her grandmother, Dolores S. Sanchez, beginning at the age of 12. Her grandmother gave her a special stone to polish her pottery. They collected natural clay together.

Marilyn is well known for her Storytellers. Her "new style" features more animated figures, such as a grandfather drinking from a miniature canteen. She is noted for her detailed painting. She uses native clay and natural paints.

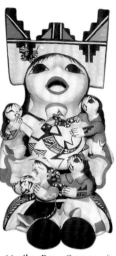

Marilyn Ray - Courtesy of Andrea Fisher Fine Pottery Santa Fe

Regina Ray
(Acoma, active ca. 1980s-present: pottery)
EXHIBITIONS: 1991, Indian Market, Santa Fe

Rose Ray
(Acoma, active ?-1990+: polychrome jars, bowls)
PUBLICATIONS: Dillingham 1992:206-208.

Sandra Ray
(Acoma, active ?-1990+: polychrome jars, bowls)
PUBLICATIONS: Dillingham 1992:206-208.

B. Reano *(B. R.)*
(Acoma, active ?-present: polychrome, black-on-white jars, bowls, miniatures)
COLLECTIONS: Dr. Gregory & Angie Schaaf, Santa Fe
FAVORITE DESIGNS: Mimbres animals
PUBLICATIONS: Hayes & Blom 1998.

Clara Lovato Reano *(Clara Lovato)*
(Santo Domingo, active ca. 1940s-present: traditional polychrome jars, bowls, sewing, jewelry, paintings)
BORN: ca. 1920s
FAMILY: m. great-granddaughter of Dolorita Baca Leandro & Jose Leandro; m. granddaughter of Benina Silva & Francisco Silva; daughter Monica Silva & Santiago Lovato; sister of Alvelino Lovato, Santana Rosetta, Mary Rosetta, Martin Lovato & Mrs. Pete Aguilar; wife of Joe I. Reano; mother of Vicky Reano Tortalita, Rose Reano, Celestino Reano, Angie Reano Owen, Joe L. Reano, Percy Reano, Avelino Reano, Frank Reano & Charles Lovato
EXHIBITIONS: pre-1976-present, Indian Market, Santa Fe
PUBLICATIONS: *SWAIA Quarterly* Fall/Winter 1976 11(3/4):12; Fall 1982 17(3):9-10; Wright 1989, 2000:265; *Four Winds* Spring 1990 1(2):67; *Indian Market Magazine* 1988; *Indian Artist* Summer 1996 2(3):26; Dubin 1999; Cirillo 44.

Dean Reano *(signs D. Reano, Acoma N.M.)*
(Acoma/Santo Domingo/Sioux, active ca. 1981-present: miniature black-on-white & polychrome plates, bowls, jars)
BORN: December 22, 1956
COLLECTIONS: Allan & Carol Hayes, John Blom
FAVORITE DESIGNS: Mimbres animals
GALLERIES: The Indian Craft Shop, U.S. Department of Interior, Washington, D.C.; Rio Grande Wholesale, Inc., Palms Trading Co., Andrews Pueblo Pottery & Art Gallery, Albuquerque
PUBLICATIONS: Schiffer 1991d:51; Berger & Schiffer 2000:141.

Divine Routzen Reano *(signs D. Reano, Acoma N.M.)*

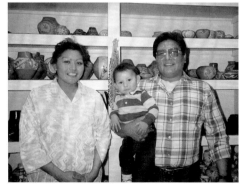

Divine R. Reano & family - Courtesy of John D. Kennedy and Georgiana Kennedy Simpson, Kennedy Indian Arts

(Acoma, active ca. 1983-present: Mimbres Revival black-on-white & traditional polychrome jars, bowls, plates, miniatures)
BORN: February 13, 1959
FAMILY: daughter of James & Mae Routzen
COLLECTIONS: John Blom; Dr. Gregory & Angie Yan Schaaf, Santa Fe; Dave & Lori Kenney, Santa Fe
FAVORITE DESIGNS: bears, deer, quail
GALLERIES: Adobe Gallery, Rio Grande Wholesale, Inc., Albuquerque
PUBLICATIONS: Schiffer 1991d:51; Dillingham 1992:206-208; Berger & Schiffer 2000:141.

Divine R. Reano - Dave & Lori Kenney Collection Santa Fe

Donna Reano
(Acoma, active ?-present: polychrome and black-on-white jars, bowls, miniatures)
COLLECTIONS: Dr. Gregory & Angie Schaaf, Santa Fe
FAVORITE DESIGNS: Mimbres animals, fineline
PUBLICATIONS: Hayes & Blom 1998:11.

Encarnacion Reano
(Santo Domingo, active ?: pottery)
ARCHIVES: Laboratory of Anthropology Library, Santa Fe; Lab. File.

Mrs. Gabriel Reano
(Santo Domingo, active ?: pottery)
ARCHIVES: Laboratory of Anthropology Library, Santa Fe; Lab. File.

Maria Reano
(Isleta, active ?: pottery)
ARCHIVES. Laboratory of Anthropology Library, Santa Fe; lab. file.

Richard A. Reano *(signs R. R. Laguna N.M.)*
(Laguna, active ca. 1995-present: ceramic jars & bowls)
BORN: February 26, 1969
FAMILY: son of Mary Reano
PUBLICATIONS: Berger & Schiffer 2000:141.

Ventura Reano
(Santo Domingo, active ca. 1910s-?: traditional polychrome jars, bowls)
BORN: ca. 1890s
FAMILY: wife of Reyes Reano; mother of Tonita R. Lovato, Reyes Quintana

Carrie Reid
(Laguna, active ca. 1910s-?: polychrome jars, bowls)
FAMILY: wife of Louis Loretto (Jemez); mother of Dorothy Trujillo (Cochiti style)
PUBLICATIONS: Monthan 1979:37.

Luann Reid
(Acoma, active ?-1990+: polychrome jars, bowls)
PUBLICATIONS: Dillingham 1992:206-208.

Magdeline Reid *(Maggie Reid)*
(Acoma, active ?-1990+: polychrome jars, bowls)
PUBLICATIONS: Dillingham 1992:206-208.

Tortolita Reyes *(see Reyes Tortolito)*

Rachel M. Rhoades
(Cochiti, active ca. 1980s-?: pottery)
EXHIBITIONS: ?-1988, Indian Market
PUBLICATIONS: 1988, *Indian Market Magazine.*

Stephanie Rhoades *(see Snowflake Flower)*

Beatrice Loretto Riley *(Beatrice Loretto), (signs B. Loretto)*
(Jemez, active ca. 1962-present: polychrome Storytellers, Nativities, friendship pots, ornaments)
BORN: ca. 1951
FAMILY: sister of Angie Loretto-Riley & Lucy Loretto
GALLERIES: The Indian Craft Shop, U.S. Department of Interior, Washington, D.C.; Rio Grande Wholesale, Palms Trading Company
PUBLICATIONS: Congdon-Martin 1999.
 Beatrice Riley has been making fine pottery figures for almost four decades. Her Storytellers are singing or in meditation. Some have graceful shawls and wear turquoise necklaces. Their arms are filled with babies; some crawling on their grandmother's back.

Bertha Riley
(Laguna, active ca. 1973-?: traditional polychrome jars, bowls)
FAMILY: granddaughter of Mary Gaithea; niece of Evelyn Cheromiah; wife of Stuart Riley, Sr.; mother of Stuart Riley, Jr.
EDUCATION: 1973, Laguna Arts & Crafts Project participant

Mrs. Miguel Riley
(Laguna, ca. 1920s-?: traditional polychrome ollas, jars, bowls, wedding vases)
COLLECTIONS: Philbrook Museum of Art, Tulsa, OK, wedding vase, ca. 1935.

Renita R. Riley
(Laguna/Isleta, active ca. 1990s-present: pottery)
EXHIBITIONS: 1995-present, Eight Northern Indian Pueblos Arts & Crafts Show

Stuart Riley, Jr.
(Laguna, active ?-present: traditional polychrome jars, bowls)
FAMILY: great-grandson of Mary Gaithea; son of Bertha & Stuart Riley, Sr.

Tessa Riley
(Jemez, active ?-present: pottery)
EXHIBITIONS: 1998-present, Eight Northern Indian Pueblos Arts & Crafts Show

Juanita Rinee
(Acoma, active ?-1975+: polychrome jars, bowls)
PUBLICATIONS: Minge 1991:195.

Lucy F. Robela *(Lucilia, Lucila, Lucia F. Robela, Rodela)*
(Tigua/Ysleta del Sur, active ca. 1970s-?: polychrome & black-on-white jars, bowls, wedding vases)
COLLECTIONS: Wright Collection, Peabody Museum, Harvard University, Cambridge, MA
FAVORITE DESIGNS: leaves, clouds
PUBLICATIONS: Barry 1984:180-81; Hayes & Blom 1996:172-73; Drooker 1998:139.

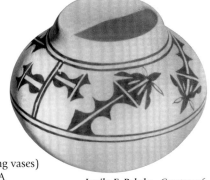

Lucila F. Robela - Courtesy of Allan & Carol Hayes

D. Margaret Rodriquez-Chavez
(Laguna, active ca. 1990s-?: pottery)
EXHIBITIONS: 1997-present, Indian Market, Santa Fe

Dennis Andrew Rodriquez *(D. A. Rodriquez, Andrew Rodriquez)*
(Laguna, active ca. 1980s-?: brown umber mottled clay animal figures - bears, some with turquoise insets)
AWARDS: 1992, 1st, figures, 3rd, misc.; 1998, 2000, 1st, 3rd, sets, Indian Market, Santa Fe
EXHIBITIONS: 1992-present, Indian Market, Santa Fe
PUBLICATIONS: Hayes & Blom 1996; 1998:41; *Southwest Art* Aug. 1998:95.

Pam Rodriguez
(Acoma, active ?-1990+: polychrome jars, bowls, seed pots)
PUBLICATIONS: Dillingham 1992:206-208.

Lucy Rogers *(Lucia)*
(Jemez, Fire Clan, active ca. 1930's-?: traditional polychrome jars, bowls)
BORN: May 19, 1919
FAMILY: daughter of Christina Sabaquie & Abran Sabaquie; sister of Petra Chavez Romero, Lupita, Dulcinea, Juanita Fragua, Epifanio, Juan Chavez
ARCHIVES: United States Census, Jemez Pueblo, ca. 1920, family 26.

Aaron Romero *(collaborates with Cynthia Romero)*
(Acoma, active ?-1990+: polychrome jars, bowls)
PUBLICATIONS: Dillingham 1992:206-208.

Albert Romero *(collaborates with Patricia Romero)*
(Acoma, active ?-1990+: polychrome jars, bowls)
PUBLICATIONS: Dillingham 1992:206-208.

Ann Romero
(Acoma, active ca. 1960s-present: polychrome jars, bowls, sgraffito)
BORN: ca. 1940s
FAMILY: mother of Deidra Antonio & Gregory Romero
PUBLICATIONS: Berger & Schiffer 2000:98, 142.

Annette Romero
(Cochiti, active ca. 1962-present: polychrome Storytellers, figures)
BORN: February 4, 1944
FAMILY: daughter of Margaret & Pablo Quintana
PUBLICATIONS: Berger & Schiffer 2000:90, 142.

Cecilia Romero
(Jemez, active ca. 1950s-?: traditional polychrome jars, bowls)
BORN: ca. 1940
FAMILY: wife of Barnabe Romero; mother of Diane Sando & Roberta Sando
TEACHER: Diane Sando & Roberta Sando, her daughters

Cynthia Romero *(collaborates with Aaron Romero)*

(Acoma, active ?-1990+: polychrome jars, bowls)
PUBLICATIONS: Dillingham 1992:206-208.

Diego Holly Romero

(Cochiti, active ca. 1986-present: traditional & contemporary polychrome and black-on-white jars, bowls, sculpture)
BORN: June 1, 1964
FAMILY: p. grandson of Teresita Romero; son of Salvador Romero & Nell Romero; brother of Mateo Romero
EDUCATION: Institute of American Indian Arts, Santa Fe, AFA, 1986; Otis/Parsons Art Institute, BFA, 1990; University of California, Los Angeles, MFA, 1993
TEACHERS: Otellie Loloma
AWARDS: 1993, 3rd, Bowls, Indian Market, Santa Fe; 1995-96, Best of Division, Best of Class, 1st, Contemporary Pottery, Indian Market; 1998-99, Indian Market, Santa Fe; 2000, Best of Division, 1st, Non-traditional pottery, Heard Museum Show, Phoenix; 2001, Best of Division, Non-traditional Pottery, Indian Market, Santa Fe

EXHIBITIONS:

1986	"Graduation Show," Institute of American Indian Arts Museum, Santa Fe
1990	"Clay Ninety, Eighty-Nine, Eighty-Eight," Otis/Parsons Art Institute North Gallery, Los Angeles, CA
1992	"Creativity is Our Tradition," Institute of American Indian Arts Museum, Santa Fe
1992--2001	Indian Market, Santa Fe
1993	"MFA Exhibition," Wright Art Gallery, University of California, Los Angeles, CA; "Into the Forefront: American Indian Art in the 20th Century,"Denver Art Museum, Denver, CO; "N.C.E.C.A. '93," National Council on Education for the Ceramic Arts, San Diego, CA
1994	"American Highway Series," Robert Nichols Gallery, Santa Fe; Crow Canyon Archaeological Invitational, Chicago, IL; "Mimbres in the 20th Century," Museum of Indian Arts & Culture, Santa Fe
1995	"Chongo Brothers: Third Generation Cochiti Artists," Museum of Indian Arts & Cultures, Santa Fe
1996	Peabody Essex Museum, Salem, MA; The Society for Contemporary Craft, Pittsburgh, PA; Robert Nichols Gallery, Santa Fe; "Southwest '96, Museum of New Mexico, Museum of Fine Arts, Santa Fe; Weisman Museum, Minneapolis, MN; Gallery 10, Scottsdale, AZ; The New Museum of Contemporary Art," New York, NY
1997-98	Gallery 10, Carefree, AZ; Robert Nichols Gallery, Santa Fe; Kentucky Art & Craft Gallery, Louisville, KY
1999	IAIA, Santa Fe; One Person Show, Robert Nichols Gallery, Santa Fe
2000	Museum of Fine Arts, Museum of New Mexico, Santa Fe; Heard Museum Show, Phoenix; Robert Nichols Gallery, Santa Fe; Faust Gallery, Scottsdale

COLLECTIONS: Heard Museum, Phoenix; Kansas City Art Museum, Kansas City, MO; Mint Museum of Art, Charlotte, NC; Denver Art Museum, Denver, CO; Institute of American Indian Arts Museum, Santa Fe; Museum of New Mexico, Museum of Indian Arts and Culture, Santa Fe; Peabody Essex Museum, Salem, MA; Poeh Museum, Pueblo of Pojoaque, NM; Weisman Museum, Minneapolis, MN; Rockwell Museum, New York, NY; British Museum, London; Hallmark Cards, Inc., Kansas City, Mo
GALLERIES: Robert Nichols Gallery, Santa Fe; Native New Mexico, Inc., Santa Fe
INTERNET: www.britesites.com/native_artist_interviews
PUBLICATIONS: Hill 1992; *American Indian Art Magazine* Winter 1995 21(1):108; Autumn 1996 4(4):63; Spring 1998 23(2):29; Summer 1998 23(3):83; Autumn 1998 23(4):94; Winter 1998 21(1):29; Gifts of the Spirit 1996; *Indian Artist* Summer 1996 2(3):70, 72; Spring 1997: 3(1):32; Winter 1998 4(1):63; Spring 1998 4(2):63; Fall 1998 4(4):86; Winter 1999: 5(1):64, 76; *Indian Market Magazine* 1996:64; 1998:30; *Native Peoples* Spring 1998 11(1):34-35; 1999:42, 46; Matuz, ed. 1997:492-94; Tucker 1998: plate 81; *Santa Fean* Aug. 1998 26(7):76; June 2000 28(5):69; *Expedition* 1999 41(3):48; *New Mexico Magazine* Aug. 2000 78(8):62-63: Abbott; Nyssen 2001.

Diego Romero's most popular style looks like a cross between Mimbres and Classic Greek pottery. However, his use of gold leaf and comic strip style characters places him squarely in the realm of modern art.

In the innovative "Chongo Brothers" series, Romero unleashes harsh but meaningful commentaries on contemporary Indian life. He uses powerful symbols and addresses sensitive issues. In his own words, Romero explains that his work is focused on "industrialization of Indian land, cars, automobiles, broken hearts, bars, Indian gaming."

Diego and his brother, painter Mateo Romero, were born in Berkeley, CA and returned to New Mexico in the 1980s. They burst onto the art scene with new styles, and re-connected with their ancient roots.

In the mid-1980s, Diego studied under Otellie Loloma, the respected Hopi potter, painter and sculptor, at the Institute of American Indian Arts in Santa Fe. Otellie encouraged her students to explore a wide array of techniques and materials drawn from a more global ceramic tradition. Otellie and her famous first husband, Charles Loloma, studied ceramics at Alfred University in New York.

While earning advanced art degrees in the 1990s at Otis/Parsons Art Institute, and at the University of California, Los Angeles, Diego studied the history of art and studio techniques. He and his brother appear to have been influenced by the styles of Andy Warhol and Roy Lichtenstein, two major contemporary artists. The Romero brothers incorporated these modern art styles into some of their works.

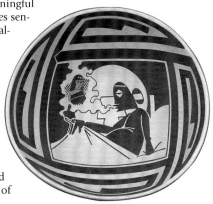

Diego Romero - Courtesy of Phil Cohen
Native New Mexico, Inc., Santa Fe

Gertrude Romero *(Gertrude Concho)*

(Acoma, active ca. 1962-present: Acoma polychrome jars, bowls)
BORN: March 30, 1942
FAMILY: daughter of Mr. & Mrs. Phillip Concho; mother of Michael Romero
TEACHER: her grandmother
STUDENTS: Michael Romero, her son
GALLERIES: Rio Grande Wholesale, Inc., Palms Trading Co., Albuquerque
PUBLICATIONS: Berger & Schiffer 2000:142.

Gregory Romero *(collaborates with Mary Romero)*

(Acoma, active ca. 1979-present: ceramic sgraffito black-on-red & polychrome jars, bowls)
BORN: June 29, 1961
FAMILY: son of Ann Romero
TEACHER: Ann Romero, his mother
GALLERIES: Rio Grande Wholesale, Inc., Palms Trading Co., Albuquerque
PUBLICATIONS: Dillingham 1992:206-208; Berger & Schiffer 2000:20, 142.

Helen Romero *(works with Pat Romero)*

(Acoma, active ?-present: pottery)
RESIDENCE: Acoma Pueblo
ARCHIVES: Artist File, Heard Museum, Phoenix

Juanita Romero *(1)*

(Cochiti, Cottonwood Clan, active 1880s-1961: traditional polychrome jars, bowls)
LIFESPAN: 1865 - March 25, 1961
FAMILY: wife of Juan Arquero (1st), Santiago Romero (2nd); mother of Salvador Arquero; p.grandmother of Virginia Naranjo

Juanita Romero *(2)*

(Acoma, active ?-1990+: polychrome jars, bowls)
PUBLICATIONS: Dillingham 1992:206-208.

Katherine Romero

(Laguna, active ca. 1973-?: traditional polychrome jars, bowls)
EDUCATION: 1973, Laguna Arts & Crafts Project participant

Lupe Romero *(signed Walatowa)*

(Jemez, active ca. 1920s-?: Storytellers, pottery)
BORN: ca. 1900
FAMILY: mother of Persingula Tosa; m. grandmother of Pauline Romero
EXHIBITIONS: pre-1973-?, Indian Market, Santa Fe
PUBLICATIONS: *SWAIA Quarterly* Fall 1973 8(3):3; Babcock 1986.

Marcus Romero

(Jemez, active ?-present: pottery)
AWARDS: 2000, 3rd, Animal Figures (ages 17 & under), Indian Market, Santa Fe

Margaret Romero *(see Margaret Romero Sarracino)*

Maria Priscilla Romero *(1), (Marie)*

(Cochiti, active ca. 1979-present: polychrome Storytellers)
BORN: 1936
FAMILY: daughter of Maggie Chalan; mother of Mary Eunice Ware
TEACHERS: Maggie Chalan, her mother, and Teresita Romero, her mother-in-law
STUDENTS: Rose M. Brown, Mary Eunice Ware, her daughter
GALLERIES: Adobe Gallery, Albuquerque & Santa Fe
PUBLICATIONS: Babcock 1986:130; Congdon-Martin 1999:29; Berger & Schiffer 2000:102.

Marie Romero *(2)*

(Cochiti, active ca. 1990-present: polychrome jars, bowls, Storytellers)
EXHIBITIONS: 1982, Indian Market, Santa Fe
GALLERIES: Adobe Gallery, Albuquerque & Santa Fe
PUBLICATIONS: *SWAIA Quarterly* Fall 1982 17(3):10; Congdon-Martin 1999:5, 29.

Marie R. Romero *(3)*

(Jemez, active ca. 1920s-?: traditional matte polychrome & polished redware & tanware jars, bowls, wedding vases)
GALLERIES: Andrea Fisher Fine Pottery, Santa Fe; River Trading Post, East Dundee, IL

Marie R. Romero (3) -
Courtesy of Joe Zeller
River Trading Post, East Dundee, IL

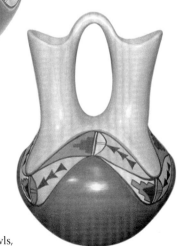

Marie R. Romero (3) - Courtesy of
Andrea Fisher Fine Pottery

Marie G. Romero (4), (Marie Gachupin), (signs Marie G. Romero, Jemez, Walatowa)

Marie Romero - Courtesy of Jason Esquibel Rio Grande Wholesale, Inc.

(Jemez, Corn Clan, active ca. 1935-present: traditional matte polychrome & polished red-ware jars, bowls, wedding vases, canteens, Storytellers, miniature kivas & Old Lady in the Shoe Scenes, Nativities, hunter figures)
BORN: July 27, 1927
FAMILY: daughter of Joe R. & Persingula M. Gachupin; sister of Leonora G. Fragua; mother of Laura Gachupin; grandmother of Camilla Toya & Damian Toya
AWARDS: 1976, 1st, Storyteller; 1977, 1st, figures; 1978, 2nd, figure-hunter; 1979, 3rd (2); 1981, 2nd; 3rd (2); 1983, 3rd; 1984, 1st, Nativities, 2nd, figures; 1986, 2nd, wedding vases; 1988, 2nd, jars; 1989, Nativities; 1990, 3rd, vases; 1993, 2nd, sets; 1996, 2nd, 3rd; 1999, 3rd; 2000, 3rd, Nativities, Indian Market, Santa Fe; Heard Museum Show, Phoenix; Inter-tribal Indian Ceremonial, Gallup; Eight Northern Indian Pueblos Arts & Crafts Show; New Mexico State Fair, Albuquerque
EXHIBITIONS: pre-1976-present, Indian Market, Santa Fe
GALLERIES: Adobe Gallery, Rio Grande Wholesale, Inc., Palms Trading Co., Alb.; Kennedy Indian Arts, Bluff, UT
PUBLICATIONS: *SWAIA Quarterly* Fall/Winter 1976

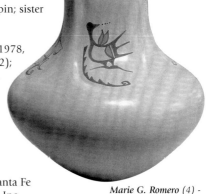

Marie G. Romero (4) - Courtesy of Joe Zeller River Trading Post, East Dundee, IL

11(3/4):12, 15; *American Indian Art Magazine* Spring 1983 8(2):36; Autumn 1987 12(4):23; Barry 1984:122-23; *Southwest Art* December 1986 16(8):22; Trimble 1987:69; *The Messenger*, Wheelwright Museum Summer 1990:cover, 2,4; Schiffer 1991d:49; Hayes & Blom 1996; Peaster 1997 61, 65-68, 157; Tucker 1998, plate 72; *Indian Market Magazine* 1998:100; Congdon-Martin 1999:84-85; Berger & Schiffer 2000:142.

Marie G. Romero has been making pottery for over half a century. She is known for making beautiful traditional pottery. She passed her knowledge on to her daughters, Laura Gachupin and Maxine Toya. They developed in making excellent Storytellers.

Marie has a great sense of humor. She creates whimsical Pueblo scenes like the "Old Woman and the Shoe." However, in Marie's versions, the shoe has been replaced with a Pueblo moccasin, filled with Pueblo children and babies.

Marie creates canteens with Pueblo figures appliqued onto the sides. This poses an interesting new direction, parallel to the Zuni tradition of adding effigy appliques, such as frog pots. Marie creates multi-figured compositions of Pueblo life. "Storytelling Time" portrays three children and a dog in rapt attention, listening to a Pueblo woman telling stories. "Pueblo Hunter" shows a Pueblo man chasing a rabbit in a desertscape. "Corn Grinding Time" portrays five Pueblo women grinding corn, while one sings to the rhythm of a drum. The overall effect takes one into the Pueblo world in a good way.

Marie G. Romero (4) - Courtesy of Georgiana Kennedy Simpson Kennedy Indian Arts, Bluff, UT

Marilyn Romero

(Acoma, active ?: traditional polychrome and fineline ollas, jars, bowls)
COLLECTIONS: Eason Eige, Albuquerque

Marilyn Romero - Courtesy of Eason Eige, Albuquerque, NM

Mary Romero (collaborates with Greg Romero)

(Acoma, active ?-1990+: polychrome jars, bowls)
PUBLICATIONS: Dillingham 1992:206-208.

Mary Eunice Romero (M. E. Romero)

(Cochiti, active ca. 1980s-present: Storytellers, animal figures, Story Turtles, watercolors, beadwork, dolls, needlework, ribbon shirts, dresses)
BORN: October 4, 1958, Norfolk, VA
AWARDS: 1993, 3rd, Storytellers, 1999, Indian Market, Santa Fe
EXHIBITIONS: 1992-present, Indian Market, Santa Fe

Michael Romero (Shy-Yai-Zta), (collaborates with Robin Romero), (signs M. R. Romero, Acoma N.M.), (see portrait with Robin Romero)

(Acoma, active ca. 1988-present: ceramic sgraffito jars, bowls)
BORN: October 5, 1964
FAMILY: m. grandson of Philip & Mrs. Concho; son of Gertrude Romero; husband of Robin Romero
TEACHER: Gertrude Romero, his mother
AWARDS: 1997, 1st, New Mexico State Fair, Albuquerque
FAVORITE DESIGNS: Kachinas, realistic animal figures in black & white
GALLERIES: Rio Grande Wholesale, Inc., Palms Trading Co., Albuquerque
PUBLICATIONS: Berger & Schiffer 2000:142.

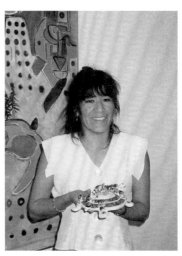

Mary Eunice Romero - John D. Kennedy and Georgiana Kennedy Simpson Kennedy Indian Arts

Pat Romero *(works with Helen Romero)*

(Acoma, active ?-1990+: polychrome jars, bowls)
PUBLICATIONS: Dillingham 1992:206-208.

Patricia Romero *(collaborates with Albert Romero)*

(Acoma, active ?-1990+: polychrome jars, bowls)
PUBLICATIONS: Dillingham 1992:206-208.

Pauline Romero *(Anita)*

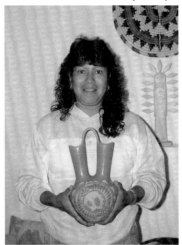

Pauline Romero - Courtesy of John D. Kennedy and Georgiana Kennedy Simpson Kennedy Indian Arts

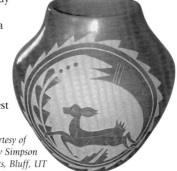

Pauline Romero - Courtesy of Joe Zeller River Trading Post, East Dundee, IL

(Jemez, active ca. 1981-present: polished redware & tanware swirl melon jars, wedding vases, vases, some sgraffito)
BORN: September 25, 1962
FAMILY: m. granddaughter of Lupe Romero; daughter of Persingula R. Tosa; related to Marie Romero, Christine Tosa & Maxine Toya
TEACHERS: Persingula R. Tosa, her mother; Lupe Romero, her grandmother
AWARDS: 1993-97, 1st, 2nd, Indian Market, Santa Fe; New Mexico State Fair, Albuquerque; Inter-tribal Indian Ceremonial, Gallup
FAVORITE DESIGNS: melons, kiva steps, feathers-in-a-row, swirls
GALLERIES: Rio Grande Wholesale, Albuquerque; Kennedy Indian Arts, Bluff, UT
PUBLICATIONS: Hayes & Blom 1996; 1998:25; Walatowa Pueblo of Jemez, "Pottery of Jemez Pueblo" (1999); Berger & Schiffer 2000:38, 142.

 At the age of 19, Pauline learned pottery making from her mother, Persingula R. Tosa. She learned to gather clay in the hills of Jemez Pueblo. She stone polishes her pottery, sometimes carving sgraffito designs. She is best known for her two-tone red and tan ware swirl pottery.

Pauline Romero - Courtesy of Georgiana Kennedy Simpson Kennedy Indian Arts, Bluff, UT

Percy Romero

(Cochiti, active ?: pottery)
ARCHIVES: Laboratory of Anthropology Library, Santa Fe

Petra Chavez Romero

(Laguna/Jemez, Fire Clan, active ca. 1920s-99: traditional polychrome & poster paint jars, bowls, canoes, tipis, bird ashtrays, salt & pepper shakers)
BORN: ca. 1904 - 1999
FAMILY: daughter of Christina Sabaquie & Abran Sabaquie; sister of Lucy Rogers, Lupita, Dulcinea, Dorothy Sabaquie, Juanita Fragua, Epifanio, Juan Chavez; wife of Santiago Romero; mother of Loretta Cajero, Margaret Romero Sarracino; m. grandmother of Esther Cajero, Raphael Sarracino, Florence Yepa, Genevieve Chinana, Robert Sarracino, Sharon Sarracino; great-grandmother of Joetta Cajero Loretta, Aaron Cajero, Sr., Michelle Sandia, Renee Sandia, Dory Sandia, Adrian Sandia & Ben Sandia
ARCHIVES: United States Census, Jemez Pueblo, ca. 1920, family 26.

 Granddaughter Flo Yepa recalled that Petra Chavez Romero used to sell her pottery at Soda Dam. She made colorful miniature tipis, canoes and other artforms popular with the general public.

Priscilla Romero

(Cochiti, active ca. 1980s-present: pottery)
EXHIBITIONS: 1988-present, Indian Market, Santa Fe
PUBLICATIONS: *Indian Market Magazine* 1988, 1989.

Reyes T. Romero *(R. Romero)*

(Cochiti, active ca. 1910s-?: traditional polychrome jars, bowls)
BORN: ca. 1890
FAMILY: wife of Vicente Romero; mother of Pelaria, Lorencita, Catalina, Porfilia & Lucy R. Suina
COLLECTIONS: Allan & Carol Hayes, John Blom; Don & Lynda Shoemaker
PUBLICATIONS: U.S. Census, Cochiti, 1920, family 22; Babcock 1986:130-33; Batkin 1987:111; Hayes & Blom 1996.

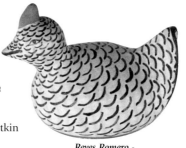

Reyes Romero - Don & Lynda Shoemaker Collection Santa Fe

Rita Romero

(Laguna, active ca. 1973-?: traditional polychrome jars, bowls)
EDUCATION: 1973, Laguna Arts & Crafts Project participant

Robyn Romero *(collaborates with Michael Romero), (signs R. M. or M & R Romero Acoma Sky City)*

(Acoma, active ca. 1988-present: ceramic sgraffito black-on-white jars, bowls, contemporary forms)
BORN: March 21, 1968
FAMILY: m. granddaughter of Helen R. Vallo; daughter of Angelina & Wilbert Aragon, Sr.; sister of Deborah A. Aragon & Wilbert Aragon, Jr.; wife of Michael Romero
AWARDS: 1997, 1st, New Mexico State Fair, Albuquerque
FAVORITE DESIGNS: Kachinas & realistic animal figures, elk, deer, wolves, hummingbirds, feathers-in-a-row
GALLERIES: Rio Grande Wholesale, Inc., Palms Trading Co., Albuquerque
PUBLICATIONS: Berger & Schiffer 2000:143.

Teresa Romero *(possibly Teresita Chavez Romero)*

(Cochiti, active ca. 1910s-?: traditional polychrome ollas, jars, bowls)
LIFESPAN: ca. 1900-?
FAMILY: wife of Diego Romero [the elder]; mother of Tonita Romero, Salvador Romero & Pasqual Romero
PUBLICATIONS: U.S. Census 1920, family 39.

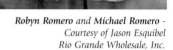

Robyn Romero and Michael Romero -
Courtesy of Jason Esquibel
Rio Grande Wholesale, Inc.

Teresita Chavez Romero *(Terecita)*

(Cochiti, Shipewe Clan, Turquoise Kiva, active ca. 1910s-1960s+: traditional large polychrome storage jars, effigy jars, ollas, bowls, Storytellers, miniatures)
LIFESPAN: May 14, 1894 - ?
FAMILY: mother-in-law of Maria Priscilla Romero; mother of Santiago Romero; p. grandmother of Diego Romero & Mateo Romero
STUDENTS: Maria Priscilla Romero, her daughter-in-law
EXHIBITIONS: 1979, "One Space: Three Visions," Albuquerque Museum, Albuquerque
COLLECTIONS: Museum of New Mexico, Laboratory of Anthropology, Santa Fe, Storyteller, ca. 1960; John Blom
FAVORITE DESIGNS: raised frogs, birds, clouds
PUBLICATIONS: Lange 1959:162; *Arizona Highways* May 1974 50(5):22; Toulouse 1977:32-33; *American Indian Art Magazine* Spring 1983 8(2):37, 42; Babcock 1986:130.

 Teresita Chavez Romero was known for her large storage jars. She was active in the ceremonial life of the Pueblo. Lange recorded her as a member of the Kwe'rana Society.

 Teresita made sitting figures, posed in a position similar to Helen Cordero's Storytellers. Her forms may have been an important inspiration and model for later figures. Her "Bread Woman" (ca. 1960) is illustrated in Toulouse (p. 32-33).

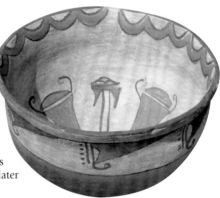

*Attributed to **Teresita Romero** -*
Courtesy of John Blom

Juanarita Rontzi *(Juanalita Routzin?)*

(Acoma, active ca. 1880s-1910s+: polychrome jars, bowls)
BORN: ca. 1865; RESIDENCE: Acomita in ca. 1910
PUBLICATIONS: Leopold Bibo, "13th Annual U.S. Census" (1910), New Mexico State Archives, Call T624, Roll 919; in Dillingham 1992:205.

Johnnie Rosetta *(Juan Rosetta)*

(Santo Domingo, active ca. 1970s-present: pottery, jewelry, 14 K gold heishi bead maker)
BORN: ca. 1949
FAMILY: m. grandson of Monica Silva; son of Mary Rosetta & Ray Rosetta; brother of Joe Rosetta; husband of Marlene Rosetta
EXHIBITIONS: 1988-present, Indian Market, Santa Fe
COLLECTIONS: Keams Canyon Arts & Crafts Collection, AZ
PUBLICATIONS: Wright 1989:116; Dubin 1999; Cirillio; Schiffer 1990:131.

Kendrick Rosetta

(Santo Domingo, active ca. 1990s-present: pottery)
AWARDS: 2000, 1st, 2nd, (ages 12 & under), Indian Market, Santa Fe

Mary Rosetta

(Santo Domingo, active ca. 1940s-present: traditional polychrome jars, bowls, sewing, jewelry)
BORN: ca. 1930
FAMILY: m. great-granddaughter of Dolorita Baca Leandro & Jose Leandro; m. granddaughter of Benina Silva & Francisco Silva; daughter of Monica Silva & Santiago Lovato; sister of Alvelino Lovato, Clara L. Reano, Santana Rosetta, Martin Lovato & Mrs. Pete Aguilar; wife of Ray Rosetta; mother of Joe Rosetta & Johnnie Rosetta
PUBLICATIONS: Ellis 1976:11; *American Indian Art Magazine* Autumn 1996 21(4):39.

Ray Rosetta
(Santo Domingo, active ca. 1950s-present: pottery, jewelry)
BORN: ca. 1929
FAMILY: husband of Mary Rosetta; father of Joe Rosetta & Johnnie Rosetta
EXHIBITIONS: 1988-present, Indian Market, Santa Fe
PUBLICATIONS: *Indian Market Magazine* 1988, 1989; Wright 1989:116; *American Indian Art Magazine* Autumn 1996 21(4):39;
Baxter: 196; Cirillo; Dubbin 1999.

Santana Rosetta
(Santo Domingo, active ca. 1940s-present: traditional polychrome jars, bowls, sewing)
BORN: ca. 1920s
FAMILY: m. great-granddaughter of Dolorita Baca Leandro & Jose Leandro; m. granddaughter of Benina Silva & Francisco Silva;
daughter Monica Silva & Santiago Lovato; sister of Alvelino Lovato, Clara L. Reano, Mary Rosetta, Martin Lovato & Mrs. Pete
Aguilar; wife of Diego Rosetta (jeweler); mother of Joseph Rosetta, mother-in-law of Jessie Rosetta (potter)
COLLECTIONS: Sally Seagrave Collection, polychrome jar, leaf design
> Santana Rosetta was the daughter of the famous potter, Monica Silva. She made beautiful bowls, red polished inside with
> polychrome designs painted on the outside.
> Diego Rosetta, her husband, used a hand grinder to make jewelry out in front of their home.

Trudy Mae Rosetta
(Santo Domingo, active ca. 1990s-present: figures)
AWARDS: 1993, 2nd, 3rd, figures; 1994, figures (ages 18 & under), Indian Market, Santa Fe
ARCHIVES: Heard Museum Library, Phoenix, artist file.

Rosita
(Santo Domingo, active ca. 1890s-1910s+: traditional polychrome jars, bowls)
COLLECTIONS: American Museum of Natural History, Washington, D.C., #29.0/177.
PUBLICATIONS: Batkin 1987:99.
> Rosita, Joseffa, Felipita Aguilar Garcia, Asuncion Aguilar Cate, Mrs. Ramos Aguilar and Margarite Tenorio were six promi-
> nent Santo Domingo potters around the turn of the 20th Century.

Bear Routzen *(signs B. R.)*
(Acoma, active ?-present: polychrome jars, bowls)
GALLERIES: The Indian Craft Shop, U.S. Department of Interior, Washington, D.C.
PUBLICATIONS: Dillingham 1992:206-208.

Devine or Divine Routzen *(see Divine Routzen Reano)*

E. P. Routzen
(Acoma, active ?: pottery)
COLLECTIONS: Heard Museum, Phoenix

Elsie Routzen
(Acoma, active ca. 1950s-present: traditional polychrome jars, bowls)
BORN: ca. 1930s
FAMILY: mother of Leo Patricio
STUDENTS: Leo Patricio, her son
COLLECTIONS: John Blom
GALLERIES: Rio Grande Wholesale, Inc., Palms Trading Co., Albuquerque
PUBLICATIONS: Dillingham 1992:206-208; Berger & Schiffer 2000:138.

Katherine Routzen
(Acoma, active ?-1990+: polychrome jars, bowls)
PUBLICATIONS: Dillingham 1992:206-208.

Mae Routzen
(Acoma, active ca. 1960s-?: traditional polychrome jars, bowls)
BORN: ca. 1940
FAMILY: wife of James Routzen; mother of Divine Reano
PUBLICATIONS: Dillingham 1992:206-208.

Marcie Routzen
(Acoma, active ?-1990+: polychrome jars, bowls)
PUBLICATIONS: Dillingham 1992:206-208.

Adrian Roy *(see Adrienne Roy Keene)*

Rebecca Russell *(signs SRI-TZEE-YAA)*
(Santa Ana, active ca. 1987-present: ceramic jars, bowls)
BORN: December 1, 1957
FAMILY: granddaughter of Rose Armijo
AWARDS: 1993, New Mexico State Fair, Albuquerque
PUBLICATIONS: Berger & Schiffer 2000:143.

Patrick Rustin *(collaborates with Shawna Garcia-Rustin)*
(Apache, married into Acoma, active ca. 1991-present: traditional polychrome jars, bowls)
BORN: ca. 1970
FAMILY: husband of Shawna Garcia-Rustin; father of Wade, Natalie & Patrick, Jr.
AWARDS: 1997, 3rd, New Mexico State Fair, Albuquerque; 1998, Best of Show, New Mexico State Fair, Albuquerque; 2000, Best of Show, Best Pottery, 1st, New Mexico State Fair, Albuquerque
DEMONSTRATIONS: 1997, Utility Shack (Indian art gallery), Albuquerque
GALLERIES: Bien Mur, Sandia Pueblo; Adobe Gallery, Palms Trading Co. Trading Co., Skip Maesel's, Albuquerque
FAVORITE DESIGNS: birds, kiva steps, Sun Clan, rain, clouds, mountains
GALLERIES: Rio Grande Wholesale, Inc., Palms Trading Co., Albuquerque
PUBLICATIONS: Berger & Schiffer 2000:118.
> Patrick Rustin (San Carlos Apache) forms and fires the pottery, noted for fine, thin walled whiteware as light as bone china. Shawna paints the designs. Together, Patrick and Shawna are a successful husband and wife pottery-making team. Their pottery has been judged Best of Show for two years at the New Mexico State Fair.

C. L. S. *(see Caroline L. Seonia)*

D. S. *(see Diane Sando)*

M. L. S *(see Manuel L. Shroulote)*

M. S./G. *(See Melody Simpson)*

O. S.
(Jemez, active ?-present: pottery miniatures)
PUBLICATIONS: Schiffer 1991d.

R. L. S. *(see Regina Leno-Shutiva)*

S. S.
(Jemez, active ?-present: pottery miniatures)
PUBLICATIONS: Schiffer 1991d.

S. T. S. *(see Santana T. Seonia)*

Christina Sabaquie *(Sabaquiu)*
(Jemez, Fire Clan, active ca. 1900's-?: traditional polychrome jars, bowls)
BORN: ca. 1886
FAMILY: wife of Abran Sabaquie; mother of Petra Chavez Romero, Lupita, Dulcinea, Juanita Fragua, Epifanio, Adelara (Dorothy Sabaquie), Lucia (Lucy Rogers), Juan Chavez; granddaughter of Margaret Romero Sarracino, Juana Marie Pecos, Alfred Romero, Mike Romero, Celestino Romero, Jerry Romero, Patrick Romero, Bernadette Burk; great-grandmother, Florence Sarracino Yepa, Sharon Sarracino, Genevieve Chinana, Raphael Sarracino, Robert Sarracino
ARCHIVES: United States Census, Jemez Pueblo, ca. 1920, family 26.
> Christina Sabaquie was the matriarch of the Jemez Fire Clan. Artistic talent ran in her family. Among her descendants are many fine potters, painters and sculptors.

Dorothy Sabaquie *(Adelara Sabaquie)*
(Jemez, Fire Clan, active ca. 1920's-?: traditional polychrome jars, bowls)
BORN: ca. 1907
FAMILY: daughter of Christina Sabaquie & Abran Sabaquie; sister of Petra Chavez Romero, Lupita, Dulcinea, Juanita Fragua, Epifanio, Lucia (Lucy Rogers), Juan Chavez
ARCHIVES: United States Census, Jemez Pueblo, ca. 1920, family 26.

Kathleen Sabaquie *(signs K. Sabaquie)*
(Jemez, active ca. 1992-present: polychrome jars, bowls, vases)
BORN: October 1, 1966
FAMILY: daughter of Rosita Sabaquie; sister of Jacqueline S. Shendo
TEACHER: Rosita Sabaquie, her mother
FAVORITE DESIGNS: clouds
PUBLICATIONS: Walatowa Pueblo of Jemez, "Pottery of Jemez Pueblo" (1999); Berger & Schiffer 2000:143.

Rosita Sabaquie
(Jemez, active ca. 1960-?: pottery)
BORN: ca. 1940s
FAMILY: mother of Kathleen Sabaquie & Jacqueline S. Shendo
STUDENTS: Kathleen Sabaquie & Jacqueline S. Shendo, her daughters

Julie Saiz
(Zia, active ca. 1990s-present: polychrome jars, bowls, refrigerator magnets)
PUBLICATIONS: Hayes & Blom 1998:60-1.

Francisco V. Salas *(Frances)*
(Zia, active ca. 1990s-present: polychrome jars, bowls)
BORN: September 1, 1962
FAMILY: daughter of Juanico & Teresita Galvan
TEACHER: Lois Medina
PUBLICATIONS: Berger & Schiffer 2000:143.

Juanita M. Salas
(Zia, active ca. 1870s-?: traditional polychrome jars, bowls)
BORN: ca. 1855
FAMILY: wife of San Antonio Salas; mother of Virginia Salas & Jesus Salas
PUBLICATIONS: U.S. Census 1920, family 24.

Manuelita Aguilar Salas
(Zia, Corn Clan, active ca. 1890s-1918: traditional polychrome ollas, jars, bowls)
BORN: ca. 1890s
FAMILY: m. granddaughter of He-wee'-a & Gaa-yo-le-nee; daughter of Augustina Aguilar; niece of Elisio Aguilar; wife of Jesus Salas (Jemez, Corn Clan); mother of Vicentita S. Pino; m. grandmother of John B. Pino, Ronald Pino & Diana Lucero

Virginiana Salas *(Virginia)*
(Jemez/Zia, Corn Clan, active ca. 1890s-1984: traditional polychrome large ollas, jars, bowls)
LIFESPAN: ca. 1890 - 1984
FAMILY: daughter of Juanita M. Salas & San Antonio Salas; sister of Jesus Salas; sister-in-law of Manuelita Aguilar Salas; aunt of Vicentita S. Pino
COLLECTIONS: Philbrook Museum of Art, Tulsa, OK, olla, ca. 1939, #PO-161
PUBLICATIONS: U.S. Census 1920, family 24; Batkin 1987:121, 203, fn. 95.

Lautit Saluhsitsa
(Zuni, active ca. 1890s-?: traditional polychrome jars, bowls
COLLECTIONS: Smithsonian Institution, Museum of Natural History, Washington, D.C.

Carleen Salvador *(Carlene)*
(Acoma, active ca. 1970s-?: polychrome jars, bowls, miniatures)
FAMILY: granddaughter of Frances Pino Torivio; daughter of Maria Lilly & Wayne Salvador, Sr.; sister of Roberta, Darlene & Ryan Paul
AWARDS: 1976, 3rd, Indian Market, Santa Fe
PUBLICATIONS: SWAIA Quarterly Fall 1976:15; Peaster 1997:13.

Darlene Salvador
(Acoma, active ca. 1980s-present: polychrome jars, bowls)
FAMILY: granddaughter of Frances Pino Torivio; daughter of Maria Lilly & Wayne Salvador, Sr.; sister of Roberta, Carleen & Ryan Paul
AWARDS: 1986, 3rd, pottery (ages 12 & under), Indian Market, Santa Fe
PUBLICATIONS: Dillingham 1992:206-208; Peaster 1997:13.

Gary Salvador
(Acoma, active ?-1990+: polychrome jars, bowls)
PUBLICATIONS: Dillingham 1992:206-208.

George A. Salvador *(signs G. A. Salvador Acoma, N.M.)*
(Acoma, active ca. 1984-present: traditional polychrome jars, bowls)
BORN: February 7, 1952
FAMILY: son of Mr. & Mrs. Grace Salvador
AWARDS: 1980, "Most Traditional Pottery," Museum of Yuma, AZ
PUBLICATIONS: Berger & Schiffer 2000:144.

Gloria Salvador
(Acoma, active ?-1990+: polychrome jars, bowls)
ARCHIVES: Artist File, Heard Museum, Phoenix
PUBLICATIONS: Dillingham 1992:206-208.

Lilly M. Salvador *(Lillian, Maria Lilly Salvador, Lilly Torivio Salvador)*
(Acoma, active ca. 1975-present: Nativities, figures, Anasazi Revival black-on-white, polychrome jars, bowls, jewelry, weaving, embroidery, acrylic paintings)
BORN: April 6, 1944; RESIDENCE: Acoma Pueblo, NM
FAMILY: daughter of Frances Pino Torivio; niece of Lolita Concho; sister of Wanda Aragon & Ruth Paisano; wife of Wayne Salvador, Sr.; mother of Carleen, Roberta, Darlene & Ryan Paul
EDUCATION: New Mexico State University, NM
TEACHER: Frances Torivio, her mother
AWARDS:

1976	3rd, Scottsdale National Indian Arts Exhibition, Scottsdale, AZ
1983	3rd, Indian Market, Santa Fe
1984	3rd, Indian Market, Santa Fe
1989	1st, Indian Market, Santa Fe
1990	2nd, 3rd, Indian Market, Santa Fe
1991	1st, Indian Market, Santa Fe; Heard Museum, Phoenix
1992	1st, 2nd, Indian Market, Santa Fe; 1st, Colorado Indian Market, Denver
1993	2nd, Indian Market, Santa Fe
1994	1st, 2nd, 3rd, Indian Market, Santa Fe
1998	1st, 2nd, 3rd, Indian Market, Santa Fe; Pasadena Craftsmen Show, Pasadena, CA
2000	1st (2), 2nd, Acoma Jars, Indian Market, Santa Fe

EXHIBITIONS: 1979, "One Space: Three Visions," Albuquerque Museum, Albuquerque; 1989-present: Indian Market, Santa Fe; 1996-present, Eight Northern Indian Pueblos Arts & Crafts Show
COLLECTIONS: Museum of Fine Arts, Boston; Heard Museum, Phoenix; Albuquerque Museum, Albuquerque, olla, ca. 1978
PUBLICATIONS: Monthan 1979:81; Barry 1984:89; Trimble 1987:76; Minge 1991:195; *U.S. News and World Report* July 1991; Dillingham 1992:206-208; Reano 1995:145; Lester 1995:484; Peaster 1997:11-13; Painter 1998:15.

 Lillian Salvador is a masterful potter and a fine artist of many art forms. In 1977, she made her first Nativity set. Her mother, Frances Torivio, praised her daughter for having surpassed her in ability: "I just love her pottery. . .[they] are much thinner than mine." (Trimble1987:76.)

Roberta Salvador
(Acoma, active ca. 1970s-present: polychrome jars, bowls)
FAMILY: granddaughter of Frances Pino Torivio; daughter of Maria Lilly & Wayne Salvador, Sr.; sister of Darlene, Carleen & Ryan Paul
PUBLICATIONS: Peaster 1997:13.

Rufina Salvador
(Acoma, active ca. 1870s-1910s+: polychrome jars, bowls)
BORN: ca. 1855; RESIDENCE: McCartys in ca. 1910
PUBLICATIONS: Leopold Bibo, "13th Annual U.S. Census" (1910), New Mexico State Archives, Call T624, Roll 919; in Dillingham 1992:205.

Ryan Paul Salvador
(Acoma, active 1980s-present: figures)
FAMILY: grandson of Frances Pino Torivio; son of Maria Lilly & Wayne Salvador, Sr.; brother of Roberta, Darlene & Carleen Salvador
AWARDS: 1992, 3rd, figures; 1993, 1st, figures (ages 18 & under), Indian Market, Santa Fe
EXHIBITIONS: 1997-present, Indian Market, Santa Fe; 1996-present, Eight Northern Indian Pueblos Arts & Crafts Show
PUBLICATIONS: Peaster 1997:13.

Theresa Salvador *(signs T. Salvador)* *(see Theresa Garcia)*

Veronica Salvador *(signed V. Salvador)*
(Acoma, active ca. 1975-1990)
COLLECTIONS: Peter B. Carl, Oklahoma City, OK
PUBLICATIONS: Minge 1991:195; Dillingham 1992:206-208.

V. Salvador -
Peter B. Carl Collection
Oklahoma City, OK

Juan(a) Maria San
(Acoma, active ca. 1860s-1910s+: polychrome jars, bowls)
BORN: ca. 1845; RESIDENCE: McCartys in ca. 1910
PUBLICATIONS: Leopold Bibo, "13th Annual U.S. Census" (1910), New Mexico State Archives, Call T624, Roll 919; in Dillingham 1992:205.

Marcelina Sanantinio
(Acoma, active ca. 1860s-1910s+: polychrome jars, bowls)
BORN: ca. 1845; RESIDENCE: Acomita in ca. 1910
PUBLICATIONS: Leopold Bibo, "13th Annual U.S. Census" (1910), New Mexico State Archives, Call T624, Roll 919; in Dillingham 1992:205.

Manuelita Sanches *(Sanchez)*

(Acoma, active ca. 1880s-1910s+: polychrome jars, bowls)
BORN: ca. 1865; RESIDENCE: Acomita in ca. 1910
PUBLICATIONS: Leopold Bibo, "13th Annual U.S. Census" (1910), New Mexico State Archives, Call T624, Roll 919; in Dillingham 1992:205.

Anelit Sanchez

(Zuni, active ?: polychrome ollas, jars, bowls)
FAVORITE DESIGNS: Deer-in-His-House, rosettes

Aubrey Sanchez

(Santa Ana, active ?: polychrome jars, bowls)
COLLECTIONS: Indart, Inc.

Dale Sanchez

(Acoma, active ?-1990+: polychrome jars, bowls)
PUBLICATIONS: Dillingham 1992:206-208.

Aubrey Sanchez -
Photograph by Bill Knox
Courtesy of Indart Incorporated

Deborah A. Jojola Sanchez *(see Deborah Jojola)*

Delores Sandovol Sanchez *(1)*, *(Dolores S. Sanchez)*

(Acoma, Yellow Corn Clan, active ca. 1890s-1980s+: traditional polychrome ollas, jars, bowls)
LIFESPAN: ca. 1888 - 1991
FAMILY: daughter of Josephita Sandoval & Joe A. Sandovol; wife of Toribio Sanchez; mother of Marie S. Juanico, Judy Lewis (1), Ethel Shields & Katherine Lewis; m. grandmother of Delores Aragon, Dolores Sanchez, Carolyn Concho, Diane Lewis, Sharon Lewis, Rebecca Lucario, Charmae Natseway, Jack Shields
STUDENTS: Marie S. Juanico, Judy Lewis (1), Ethel Shields, Katherine Lewis, Rebecca Lucario, & Marilyn Henderson
DEMONSTRATIONS: Heard Museum, Phoenix
COLLECTIONS: Heard Museum, Phoenix
GALLERIES: Robert Nichols Gallery, Santa Fe
PUBLICATIONS: Barry 1984:89; Minge 1991:195; Brown 1993:18-19; Peaster 1997:21.

 Delores Sanchez learned pottery making in the late 19th century from her mother, Josephita Sandovol. They grew up in a traditional Acoma way of life. They observed many changes from the arrival of the railroad to the space age era.

 Delores lived to be 102 years old. She made pottery for over 80 years. She was a frequent demonstrator of pottery making at the Heard Museum in Phoenix. In her autumn years, she still loved "the feel of clay in her hands."

Dolores Histia Sanchez *(2)*

(Acoma, active ca. 1920s-75+:traditional polychrome jars, bowls)
FAMILY: daughter of San Juan Histia & Mary Histia; mother of Cindy Sanchez Lewis; m. grandmother of Alvin Lewis, Jr.
TEACHER: Mary Histia, her mother

Dorothy Sanchez *(paints pots made by men in her family)*

(Acoma, active ?-1990+: polychrome jars, bowls)
FAMILY: wife of James Sanchez; daughter-in-law of Suyme Sanchez, an Acoma War Chief; mother of Jennifer Sanchez; mother-in-law of Salina Sanchez
ARCHIVES: Artist File, Heard Museum Library, Phoenix
PUBLICATIONS: Dillingham 1992:206-208.

Earline Sanchez

(Acoma, active ?-1990+: polychrome jars, bowls)
PUBLICATIONS: Dillingham 1992:206-208.

Gerti Sanchez *(Mapoo)*

(Isleta, active ca. 1970s-present:pottery)
BORN; June 5, 1959

Josephine Sanchez *(Jo Sanchez)*

(Acoma, Eagle Clan, active ca. 1950-90: traditional polychrome jars, bowls, seed pots, mugs)
BORN: ca. 1930
FAMILY: daughter of Lita L. & Clifford L. Garcia; sister of Virginia Victorino, Edna G. Chino & Maxine Sanchez
PUBLICATIONS: Dillingham 1992:206-208.

Katherine Sanchez *(see Katherine Sanchez Lewis)*

M. Sanchez

(Acoma, ? - present: black-on-white Storyteller turtles, figures)
GALLERIES: Adobe Gallery, Albuquerque & Santa Fe
PUBLICATIONS: Congdon-Martin 1999:53.

Mary Sanchez

(Acoma, active ?-1990+: polychrome jars, bowls)
FAVORITE DESIGNS: Kokopelli, clouds
PUBLICATIONS: Dillingham 1992:206-208; Peaster 1997:157.

Maxine Sanchez

(Acoma, Eagle Clan, active ca. 1950-75+: traditional polychrome jars, bowls)
BORN: ca. 1930
FAMILY: daughter of Lita L. & Clifford L. Garcia; sister of Virginia Victorino, Edna G. Chino & Josephine Sanchez
PUBLICATIONS: Minge 1991:195.

Melissa Sanchez

(Acoma, active ?-present: pottery)
GALLERIES: The Indian Craft Shop, U.S. Department of Interior, Washington, D.C.

Monica Sanchez

(Acoma, active ?-1990+: polychrome jars, bowls)
PUBLICATIONS: Dillingham 1992:206-208.

Santana Sanchez

(Acoma, Red Corn Clan, active ca. 1910s-?: traditional polychrome, black-on-red ollas, jars, bowls)
BORN: ca. 1890
FAMILY: sister of Marie Z. Chino; wife of Siome Sanchez; mother of James Sanchez, Elliot Sanchez & Gladys Sanchez Garcia; m. grandmother of Lena Garcia Aragon, Geraldine Garcia, Marie Garcia Vallo, Alan "Thunder Cloud" Garcia & Beatrice Garcia; m. great-great grandmother of Shawna Garcia-Rustin; Elliott Garcia, Jr., Lynette Garcia, Janet Garcia & Terrance Garcia
PUBLICATIONS: Dillingham 1992:167-69; *Indian Market Magazine* 1993:9.
PHOTOGRAPH: M. James Slack, staff photographer, Historic American Building Survey (WPA), 1934, in collection of John Beeder.
 In 1934, Santana Sanchez was recorded as making "excellent pottery." She also was the Registrar for visitors to Acoma Pueblo and the "custodian of the Church keys."

Selina Sanchez

(Acoma, active ?-1990+: polychrome jars, bowls)
BORN: August 4, 1962
FAMILY: daughter-in-law of Dorothy Sanchez; sister-in-law of Jennifer Sanchez
PUBLICATIONS: Dillingham 1992:206-208.

Steven R. Sanchez

(Santa Ana, active ca. 1990s-present: pottery)
EXHIBITIONS: 1993-present, Indian Market, Santa Fe

Vanessa Lewis Sanchez *(Vanessa Lewis)*

(Cochiti, active ca. 1990s-present: polychrome jars, bowls, Storytellers)
BORN: 1986
FAMILY; m. granddaughter of Ivan Lewis & Rita Banada; daughter of Patricia Lewis; sister of Kevin Lewis
PUBLICATIONS: Dillingham 1994:92; Peaster 1997:30.

Vivian Sanchez

(Santo Domingo, active ca. 1970s-present: polychrome jars, bowls, canteens, textiles, sewing, jewelry)
BORN: ca. 1940s
FAMILY: sister of Trinidad Pacheco, Gilbert Pacheco, Laurencita Calabaza
EXHIBITIONS: 1973-present, Indian Market, Santa Fe
PUBLICATIONS: *SWAIA Quarterly* Fall 1973 8(3):4; *Indian Market Magazine* 1985, 1988, 1989; Dillingham 1994:136.

Mary Sandee

(Acoma, active ?-1990+: polychrome jars, bowls)
PUBLICATIONS: Dillingham 1992:206-208.

A. Sandia

(Jemez, active ?: pottery)
PUBLICATIONS: Artist File, Laboratory of Anthropology Library, Santa Fe

Alyssa Sandia

(Jemez, active ca. 1990s-present: pottery)
EXHIBITIONS: 1995, Eight Northern Indian Pueblos Arts & Crafts Show

Arthur Sandia

(Jemez, active ?-present: polychrome jars & bowls)
BORN: ca. 1940
FAMILY: husband of Rose Sandia; father of Cyndee S. Brophy

Debbie Sandia *(signs D. Sandia)*

(Jemez, active ca. 1990-present: stone polished tan & redware jars, bowls)
BORN: December 3, 1969
FAMILY: granddaughter of Cecilia & Arthur Loretto; daughter of Wilbert & Geraldine Sandia;
sister of Natalie Sandia, Rachel Sandia
TEACHERS: Wilbert & Geraldine Sandia, her parents
PUBLICATIONS: Berger & Schiffer 2000:144.

Dory Sandia *(signs D. Sandia, Jemez N.M.)*

(Jemez, Fire Clan, active ca. 1992-present: traditional polished jars & bowls)
BORN: May 21, 1968
FAMILY: great-grandson of Petra & Santiago Romero (Laguna); grandson of Margaret & Frank
Sarracino (Jemez); son of Sharon Sarracino Sandia & Johnny Sandia; brother of Renee
Sandia, Adrian Sandia & Ben Sandia
TEACHER: Sharon Sandia, his mother
FAVORITE DESIGNS: Kachina Sun face, corn
PUBLICATIONS: Berger & Schiffer 2000:144.

Dory Sandia - Courtesy of Jason Esquibel
Rio Grande Wholesale, Inc.

Dory Sandia shared that he liked creating pottery, because "it brings joy to collectors and other people." He explains what each pot represents and said he likes them "to go with a lot of happiness."

Geraldine F. Sandia *(G. Sandia, Jemez, N.M.), (collaborates with Wilbert Sandia)*

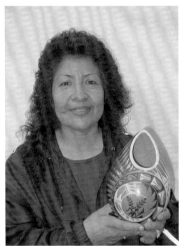

(Jemez/Acoma, active ca. 1972-present: traditional & non-traditional
matte polychrome, matte brown-on-tanware & stone polished
black & cream on redware jars, bowls, vases, wedding vases)
BORN: January 2, 1950; RESIDENCE: Jemez Pueblo
FAMILY: daughter of Cecilia & Arthur Loretto; wife of Wilbert
Sandia; mother of Debbie, Natalie & Rachel
AWARDS: 1983, 1st, 3rd; 1984, 3rd, jars; 1988, 1st, misc.,
2nd, jars; 1990, 2nd, jars, 2nd, wedding vases; 1991, 1st,
jars; 1992, 1st, jars, 3rd, non-traditional forms; 1994, 2nd,
jars; 1993, 2nd, jars; 1998, 1st, 2nd; 2000, 3rd, Indian
Market, Santa Fe; 1980, 1st, 2nd, 3rd, Heard Museum Show,
Phoenix; Inter-tribal Indian Ceremonial, Gallup
EXHIBITIONS: pre-1980-present, Indian Market, Santa Fe;
1995, Eight Northern Indian Pueblos Arts & Crafts Show
COLLECTIONS: Heard Museum, Phoenix
FAVORITE DESIGNS: feathers-in-a-row, corn, Rainbirds, clouds
GALLERIES: Native American Collections, Inc., Denver, CO;
Adobe Gallery; Rio Grande Wholesale, Inc.
PUBLICATIONS: *SWAIA Quarterly* Fall 1982 17(3):10-11;
Indian Market Magazine 1985, 1988, 1989; Hayes & Blom
1996; 1998:25; Berger & Schiffer 2000:144.

Geraldine Sandia -
Rio Grande Wholesale, Inc.

Geraldine Sandia -
Photograph by Bill Bonebrake
Courtesy of Jill Giller
Native American Collections, Denver

For over two decades, Geraldine F. Sandia has been a prize-winning potter. She gathers clay in the hills above Jemez Pueblo, hand coils, stone polishes and fires her pots outdoors. She is an excellent painter. Her pots are beautiful.

Kenny Sandia

(Jemez, active ?-present: traditional polychrome jars, bowls, figures)
FAMILY: nephew of Funina S. Armijo; cousin of Connie R. Armijo, Laureen Armijo
STUDENT: Connie R. Armijo, his cousin

Marsha Sandia *(signs M. Sandia)*

(Jemez, active ca. 1992-present: polychrome jars, bowls)
BORN: September 25, 1968
FAMILY: daughter of Mary Ann Sandia
PUBLICATIONS: Berger & Schiffer 2000:144.

Mary Ann Sandia *(signs M. Sandia, Jemez)*

(Jemez, active ca. ca. 1990-present: polychrome and black-on-matte redware jars, bowls, vases)
BORN: April 28, 1955
FAMILY: mother of Marsha Sandia
FAVORITE DESIGNS: optical, repeating four petal flower patterns with rain hatched backgrounds
PUBLICATIONS: Hayes & Blom 1996:82-83; Berger & Schiffer 2000:144.

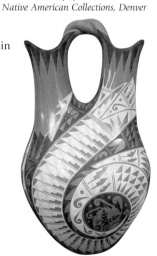

Geraldine Sandia -
Courtesy of Jason Esquibel
Rio Grande Wholesale, Inc.

Natalie Sandia *(signs N. Sandia Jemez)*

(Jemez, active ca. 1992-present: polychrome, black-on-red jars, bowls, vases)
BORN: April 2, 1966
FAMILY: granddaughter of Cecilia & Arthur Loretto; daughter of Wilbert & Geraldine Sandia; sister of Rachel Sandia, Debbie Sandia
EXHIBITIONS: 1994-present, Indian Market, Santa Fe; 1995-present, Eight Northern Indian Pueblos Arts & Crafts Show
FAVORITE DESIGNS: feathers, clouds
PUBLICATIONS: Walatowa Pueblo of Jemez, "Pottery of Jemez Pueblo" (1999); Berger & Schiffer 2000:144.

R. Sandia

(Jemez, active ca. 1980s-present: polychrome jars, bowls, seed pots)
FAVORITE DESIGNS: swirling compositions of corn plants, Rainbirds, feathers-in-a-row
PUBLICATIONS: Hayes & Blom 1996:82-83.

Natalie Sandia -
Courtesy of Isa & Dick Diestler
Isa Fetish, Cumming , GA

Rachel Sandia

(Jemez, active ?-present: polychrome, black-on-red jars, bowls, vases)
FAMILY: granddaughter of Cecilia & Arthur Loretto; daughter of Wilbert & Geraldine Sandia; sister of Natalie Sandia, Debbie Sandia
EXHIBITIONS: 1993-present, Indian Market, Santa Fe
FAVORITE DESIGNS: feathers, clouds, daisies
PUBLICATIONS: Walatowa Pueblo of Jemez, "Pottery of Jemez Pueblo" (1999).

Rose Sandia

(Jemez, active ?-present: polychrome jars & bowls)
BORN: ca. 1940
FAMILY: wife of Arthur Sandia; mother of Cyndee S. Brophy
PUBLICATIONS: Berger & Schiffer 2000:100.

Sharon Sandia *(see Sharon Sarracino)*

Wilbert Sandia *(collaborates with Geraldine Sandia)*

(Jemez, active ca. 1960s-present: pottery)
BORN: ca. 1940s
FAMILY: husband of Geraldine Sandia; father of Debbie Sandia, Natalie Sandia & Rachel Sandia
AWARDS: 1983, 1st, 3rd; 1984, 3rd, jars; 1992, 1st, jars, 3rd, non-traditional forms, Indian Market
EXHIBITIONS: pre-1980-present, Indian Market, Santa Fe
PUBLICATIONS: *Indian Market Magazine* 1985, 1988, 1989; Berger & Schiffer 2000:144.

Rachel Sandia -
Courtesy of Isa & Dick Diestler
Isa Fetish, Cumming , GA

Albenita Sando

(Jemez, Sun Clan, active ca. 1930s-present: traditional polychrome pottery)
BORN: ca. 1920
FAMILY: mother of Julia Chinana; m. grandmother of Marian L. Chinana
EXHIBITIONS: 1995-present, Eight Northern Indian Pueblos Arts & Crafts Show

Caroline Sando *(Peacock Feathers, C. Sando)*

(Jemez, active ca. 1971-present: polychrome Storytellers, figures, friendship pots)
BORN: December 14, 1963
FAMILY: m. great-granddaughter of Juan & Susanita Celo; m. granddaughter of Hubert & Andrea Tsosie; daughter of Irene Herrera; sister of Leonard Tsosie & Rebecca Tsosie
TEACHER: Andrea Tsosie, her grandmother
AWARDS: 1993, 2nd, sets; 1994, 3rd, Storytellers; 1st, 2nd, 3rd; 1998, 3rd, H.M., Indian Market, Santa Fe; Pueblo Grande, Phoenix, AZ

Caroline Sando -
Courtesy of Jason Esquibel
Rio Grande Wholesale, Inc.

EXHIBITIONS: 1992-present, Indian Market, Santa Fe; Inter-tribal Indian Ceremonial, Gallup, NM; Pueblo Grande, Phoenix
FAVORITE DESIGNS: figures with children
GALLERIES: Walatowa Pueblo Visitors Center, Jemez Pueblo; Rio Grande Wholesale, Inc., Albuquerque
PUBLICATIONS: Walatowa Pueblo of Jemez, "Pottery of Jemez Pueblo" (1999); Berger & Schiffer 2000:39, 91, 144.

Caroline Sando makes large Storytellers, some are 20 inches tall. She covers them with babies. She may hold the record for the most babies on a single Storyteller. Her grandmothers sing with gusto and wear turquoise necklaces, some with real turquoise. Their faces have angular forms and puffy cheeks painted with red circles. Many of her figures hold miniature bowls with feathers-in-a-row designs.

Caroline Sando - Ron & Doris Smithee Collection, OK

D. Sando

(Jemez, active ?-present: Storytellers)
PUBLICATIONS: Congdon-Martin 1999.

Diane Sando *(signs D.S. Jemez N.M.)*

(Jemez, active ca. 1976-present: polychrome Storytellers)
BORN: May 13, 1959
FAMILY: daughter of Barnabe & Cecilia Romero; sister of Roberta Sando
PUBLICATIONS: Berger & Schiffer 2000:145.

Josephine Sando

(Jemez, active ca. 1950s-?: traditional polychrome jars, bowls)
BORN: ca. 1930s
FAMILY: wife of Leandro Silk; mother of Amalia Silk
STUDENTS: Amalia Silk, her daughter

Kenny Sando -
Photograph by Bill Bonebrake
Courtesy of Jill Giller
Native American Collections, Denver

Kenneth James Sando *(Kenny, Christmas Deer), (signs K. J. Sando, Jemez N.M.)*

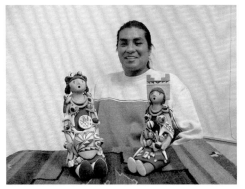

Kenny Sando - Courtesy of Jason Esquibel
Rio Grande Wholesale, Inc.

(Jemez, active ca. 1985-present: polychrome, black and white on polished redware ollas, jars, bowls, matte polychrome Storytellers, Corn Maidens, Clowns, bears & turtles)
BORN: December 22, 1963
FAMILY: son of Lawrence & Juanita Gonzales Sando; brother of Wilma Gachupin
TEACHERS: his grandmother, friends Donald Chinana & Gabriel Cajero
STUDENTS: Wilma M. Gachupin
AWARDS: 1st, 2nd, New Mexico State Fair, Albuquerque; Inter-tribal Indian Ceremonial, Gallup
COLLECTIONS: Ed Samuels, Jemez Springs, NM
FAVORITE DESIGNS: human figures, Kokopelli, bears, frogs, feathers-in-a-row, clouds
GALLERIES: The Indian Craft Shop, U.S. Department of Interior, Washington, D.C.; Native American Collections, Inc., Denver, CO; Rio Grande Wholesale, Inc., Albuquerque
PUBLICATIONS: Congdon-Martin 1999:88; Berger & Schiffer 2000:39, 91, 145.

Kenneth James Sando is a talented pottery artist. His work is especially well refined. He gathers clay from the hills overlooking Jemez Pueblo. He hand-forms each piece. He is highly skilled at both ceramic sculpture and hand coiled pottery. His painting style is distinctive and his work is high quality, as reflected by his awards.

Collector Ed Samuels commented, "Kenneth is a gracious person. He is handsome with long brown hair. The quality of his pottery is high, using wild spinach for black and clay paint for red and white slip. The detail of his painting is fine. He mixes pumice with his clay. He is likable. He's a nice guy."

Mabel Sando

(Jemez, active ca. 1940s-?: traditional polychrome jars, bowls)
BORN: ca. 1920s
FAMILY: wife of Frank Sando; mother of Frances S. Toya

Roberta Sando *(signs R. Sando)*

(Jemez, active ca. 1976-present: traditional polychrome jars, bowls)
BORN: July 30, 1952
FAMILY: daughter of Barnabe & Cecilia Romero; sister of Diane Sando
PUBLICATIONS: Berger & Schiffer 2000:145.

T. Sando

(Jemez, active ?-present: Storytellers)
PUBLICATIONS: Congdon-Martin 1999:89.

Veronica Sando

(Jemez, active ca. 1987-present: traditional polychrome jars, bowls, wedding vases)
BORN: August 12, 1942
FAMILY: granddaughter of Louisa Panana
TEACHER: Louisa Panana, her grandmother
EXHIBITIONS: 1994-present, Eight Northern Indian Pueblos Arts & Crafts Show
PUBLICATIONS: Berger & Schiffer 2000:145.

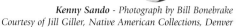

Kenny Sando - Photograph by Bill Bonebrake
Courtesy of Jill Giller, Native American Collections, Denver

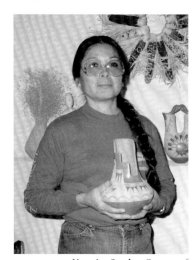

Veronica Sando - Courtesy of
John D. Kennedy and
Georgiana Kennedy Simpson
Kennedy Indian Arts

Pete Sandorot
(Isleta, active ?: pottery)
ARCHIVES: Laboratory of Anthropology Library, Santa Fe; lab. file.

Cecelia Sandoval
(Acoma, active ?-1990+: polychrome jars, bowls)
PUBLICATIONS: Dillingham 1992:206-208.

Mrs. C. M Sandovol
(Acoma, active ?: traditional brown-on-cream ollas, jars, bowls)

Mrs. Jose A. Sandoval
(Acoma, active ca. 1940)
PUBLICATIONS: Minge 1991:195.

Marie R. Sandoval
(San Felipe, active ca. 1948-present: traditional polychrome jars, bowls)
BORN: January 4, 1937
FAMILY: daughter of Bridgett Esquibel
PUBLICATIONS: Berger & Schiffer 2000:50, 144.

Pietra Sandoval
(San Felipe, active ca. 1930s-?: traditional ollas, jars, food bowls, cooking pots)
COLLECTIONS: Philbrook Museum of Art, Tulsa, OK, bowl, food bowl, cooking pot, ca. 1939
PUBLICATIONS: Batkin 1987:117.

Dolores Sandy *(Sanchez?)*
(Acoma, active ca. 1950s-?: traditional polychrome jars, bowls)
COLLECTIONS: Philbrook Museum of Art, Tulsa, OK, jar, ca. 1961

Rosita San Isidero
(Zia, active ca. 1890s-?: traditional polychrome jars, bowls)
BORN: ca. 1877
FAMILY: wife of Jose San Isidero
PUBLICATIONS: U.S. Census 1920, family 22.

Jennie Sanshu
(Laguna, active ca. 1973-?: traditional polychrome jars, bowls)
EDUCATION: 1973, Laguna Arts & Crafts Project participant

Clara Santiago *(signs Kuutimaits'a, meaning "Mountain")*
(Acoma, active ca. 1982-present: traditional & ceramic polychrome jars, bowls, molded pillow forms)
BORN: November 13, 1951
FAMILY: daughter of Rose Poncho; sister of Florina Vallo
AWARDS: art shows in Denver, Kansas City & Houston
FAVORITE DESIGNS: lizards
GALLERIES: Rio Grande Wholesale, Inc., Palms Trading Co., Albuquerque
PUBLICATIONS: Berger & Schiffer 2000:145.

Lola Santiago
(Acoma, active ca. 1900-?: traditional polychrome jars, bowls)
LIFESPAN: ca. 1900-?
FAMILY: sister of Helice Vallo; wife of Martin Ortiz; mother of Lucy Martin Lewis, Joseph Ortiz & Albert Ortiz
PUBLICATIONS: Peterson 1984:35, 71.

 Lola Santiago is the mother of Lucy M. Lewis, perhaps the most famous Acoma potter in history. Ironically, little is known of Lola. She and her sister, Helice Vallo, were pottery makers who participated in the ceremonial life of the Pueblo.

Maria Santiago
(Acoma, Roadrunner, active ca. 1880s-?: traditional polychrome ollas, jars, bowls)
LIFESPAN: ca. 1860s - ?
FAMILY: wife of Kahhaikia; mother of Marie Santiago; m. grandmother of Santana Cimmeron Cerno; great-grandmother of Joseph Cerno, Sr. & others

Mildred Saracino *(see Mildred Sarracino)*

Caroline Sarracino *(see Caroline Garcia-Sarracino)*

Edwin L. Sarracino *(collaborates sometimes with Minerva Sarracino) (signs E. & MI. Sarracino, Acoma N.M.)*
(Acoma, active ca. 1987-present: traditional polychrome jars, bowls)
BORN: March 8, 1951
FAMILY: son of Marie A. Vallo; husband of Minerva Sarracino
COLLECTIONS: John Blom
FAVORITE DESIGNS: kiva steps, clouds, leaves, feathers, corrugated necks
GALLERIES: Kennedy Indian Art; Towaylane Trading Co., Tucson, AZ; Palms Trading Co., Albuquerque
PUBLICATIONS: Dillingham 1992:206-208; Hayes & Blom 1996:52-53; Berger & Schiffer 2000:145.

Minerva Sarracino & Edwin Sarracino -
Courtesy of John D. Kennedy and
Georgiana Kennedy Simpson, Kennedy Indian Arts

Faith Sarracino *(collaborated with Zelda Sarracino)*
(Acoma, active ?-1990+: polychrome jars, bowls)
PUBLICATIONS: Dillingham 1992:206-208.

Frances Sarracino
(Acoma, active ?-1975+: polychrome jars, bowls)
PUBLICATIONS: Minge 1991:195.

Francis Sarracino
(Acoma, active ?-1990+: polychrome jars, bowls)
PUBLICATIONS: Dillingham 1992:206-208.

Janice Sarracino *(collaborates with Ben Toya)*
(Jemez, active ?: polychrome jars, bowls)
BORN: ca. 1970
FAMILY: daughter of Rafael & Pauline Sarracino (2); wife of Ben Toya.
Rafael's sister is Flo Yepa
 Janice is an excellent pottery painter. She paints pots formed by her husband, Ben Toya.

Jolene Sarracino *(Mickey)*
(Acoma, active ?-1990+: polychrome jars, bowls)
RESIDENCE: San Fidel, NM
PUBLICATIONS: Dillingham 1992:206-208.

Leona Sarracino
(Acoma, active ?-1990+: polychrome jars, bowls)
PUBLICATIONS: Dillingham 1992:206-208.

Lupy Sarracino
(Acoma, active ca. 1860s-1910s+: polychrome jars, bowls)
BORN: ca. 1855
RESIDENCE: Acomita in ca. 1910
PUBLICATIONS: Leopold Bibo, "13th Annual U.S. Census" (1910), New Mexico State Archives, Call T624, Roll 919; in Dillingham 1992:205.

Margaret Romero Sarracino
(Jemez/Laguna, Fire Clan, active ca. 1940s-?: traditional polychrome ollas, jars, bowls)
BORN: July 29, 1925
FAMILY: m. granddaughter of Abran & Christina Sabaquie; daughter of Petra & Santiago Romero, Laguna; sister of Juana Marie Pecos, Mike Romero, Alfred Romero, Celestino Romero, Jerry Romero, Patrick Romero, Bernadette Burk; wife of Francisco Frank Sarracino (Laguna, Roadrunner Clan); mother of Raphael Sarracino, Florence Yepa, Genevieve Chinana, Robert Sarracino & Sharon Sarracino

Marie Sarracino *(Saracino)*
(Acoma, ca. 1920s-83)
LIFESPAN: ca. 1903 - 1983
PHOTOGRAPH: M. James Slack, staff photographer, Historic American Building Survey (WPA), 1934, in collection of John Beeder.
 Marie Sarracino was the interpreter in 1934 for the Historic American Building Survey, part of the WPA. From 1979
 to 1983, Marie was a tour guide at Acoma Pueblo.

Mildred Sarracino *(Saracino)*
(Acoma, active ?-1990+: polychrome jars, bowls)
PUBLICATIONS: Dillingham 1992:206-208.

Minerva Sarracino *(collaborates sometimes with Edwin L. Sarracino) (signs E. & MI. Sarracino, Acoma N.M.)*

(Acoma, active ca. 1987-present: traditional polychrome and corrugated jars, bowls, pitchers)
BORN: ca. 1950s
FAMILY: wife of Edwin L. Sarracino
COLLECTIONS: John Blom
GALLERIES: Kennedy Indian Art; Towaylane Trading Co., Tucson, AZ; Palms Trading Co., Albuquerque
PUBLICATIONS: Dillingham 1992:206-208; Hayes & Blom 1996:52-53; Berger & Schiffer 2000:145.

Myron Sarracino *(Kaa Ooa Dinn Naa), (signs M. Sarracino)*

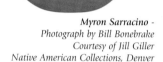

(Laguna, active ca. 1984-present: fineline black-on-white Anasazi & Tularosa Revival; black-on-red Mimbres Revival; traditional black-on-red & polychrome ollas, jars, bowls)
BORN: January 8, 1967
FAMILY: grandson of Thelma & Sandy Sarracino; son of Joan and Mike Sarracino; nephew of Bertha Riley; cousin of Stewart Riley, Jr.
TEACHER: Gladys Paquin
AWARDS: 1988, Honorable Mention, New Mexico State Fair, Albuquerque; 1993, 1st, Inter-tribal Indian Ceremonial, Gallup; 1994, Best of Show, Best in Traditional Pottery, Eight Northern Indian Pueblos Arts & Crafts Show
COLLECTIONS: Dr. Gregory & Angie Yan Schaaf, Santa Fe; Indart, Inc.

Myron Sarracino - Courtesy of Jason Esquibel Rio Grande Wholesale, Inc.

Myron Sarracino - Photograph by Bill Bonebrake Courtesy of Jill Giller Native American Collections, Denver

FAVORITE DESIGNS: Bighorn sheep, clouds, rain, swirls, feathers-in-a-row, checkerboard, lightning, frets
GALLERIES: Rio Grande Wholesale, Palms Trading Company, Albuquerque; Native American Collections, Denver, CO
PUBLICATIONS: *Cowboys & Indians* Sept. 1999:166; Berger & Schiffer 2000:44, 145.

Myron Sarracino is one of the top award-winning Pueblo Indian potters. He was trained by one of the best, Gladys Paquin. They produce some of Laguna's finest pottery. Both are known for thin walled, light as a feather pottery, with exceptional painting.

Myron branched away from Gladys in style, transcending from 19th century Laguna polychrome types back to ancient Mimbres and Tularosa pottery traditions. He dedicates himself to the study of ancient designs which inspire him to create unique variations. The result is pottery that displays an ancient look, with contemporary refinements. Myron is especially known for his swirl designs, inspired by the migration trails.

Indian art judges have showered Myron with prize ribbons, including Best of Show and Best in Traditional Pottery. He was barely 21 when he started winning awards. Myron credits his grandparents, Thelma and Sandy Sarracino, and his friends, Verna Soloman & Gladys Paquin, as sources of his inspiration.

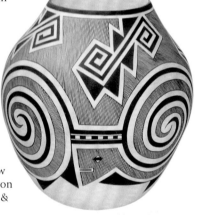

Myron Sarracino - Photograph by Bill Knox Courtesy of Indart Incorporated

Nori R. Sarracino

(Acoma, active ca. 1930s-?: traditional polychrome jars)
COLLECTIONS: Philbrook Museum of Art, Tulsa, OK, jar, bowl, ca. 1939

Pauline Sarracino *(1)*

(Jemez, active ca. 1960s-present: traditional polychrome jars, bowls; also paints Kachinas)
BORN: ca. 1950
FAMILY: wife of Ralph Sarracino (Hopi/Laguna/Jemez), Kachina carver; mother of Geraldine Toya

Pauline Sarracino *(2)*

(Jemez, active 1970s-?)
BORN: ca. 1950
FAMILY: wife of Rafael Sarracino; sister-in-law of Flo Yepa; mother of Janice Sarracino; mother-in-law of Ben Toya

Robert Sarracino

(Jemez/Laguna, Fire Clan, active ca. 1980s-present: polychrome jars, bowls, sculptures)
BORN: July 27, 1963
FAMILY: m. great-grandson of Abran & Christina Sabaquie; m. grandson of Petra & Santiago Romero; p. grandson of Josephine & Antonio Sarracino (Old Laguna); son of Margaret Romero Sarracino & Francisco (Frank) Sarracino (Roadrunner Clan); brother of Raphael Sarracino, Genevieve Chinana, Flo Sarracino Yepa & Sharon Sarracino

Sharon Sarracino *(Sharon Sandia), (signs S. Sarracino, Jemez)*

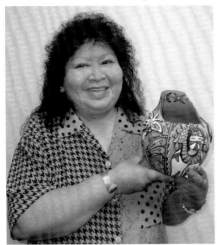

Sharon Sarracino - Rio Grande Wholesale, Inc.

(Laguna/Jemez, Fire/Roadrunner Clans, active ca. 1973-present: traditional & contemporary polychrome vases, wedding vases, jars, bowls, some with appliques of figures, sculptures)
BORN: ca. March 23, 1953
FAMILY: m. great-granddaughter of Abran & Christina Sabaquie; m. granddaughter of Petra & Santiago Romero (Laguna); daughter of Margaret Sarracino & Frank Sarracino; sister of Raphael Sarracino, Florence Yepa, Genevieve Chinana, Robert Sarracino; mother of Renee Sandia, Dory Sandia, Adrian Sandia & Ben Sandia
STUDENTS: her children and Joseph Fragua, Janice and Ben Toya, Florence Yepa & Genevieve Chinana
AWARDS: Best of Show, Santa Monica Indian Art Show, CA; New Mexico State Fair, Alb.
PUBLICATIONS: Berger & Schiffer 2000:145.

Sharon Sarracino described making pottery: "It makes me happy. It makes me feel good, painting my designs and creating my different styles. It's what the Creator gave to me, this gift to create traditional pottery. This is why I create my own ideals. My designs feature Corn Maidens, rainbow colors and a speckled background. I am the first in Jemez to have this exact style."

What makes Sharon's pottery so unique is her use of three-dimensional appliques and her broad color palette. She is best known for her Corn Maidens and Butterfly Maidens with elaborate tableta headdresses. Her backgrounds are filled with swirling designs with optical qualities.

Zelda Sarracino *(collaborated with Faith Sarracino)*

(Acoma, active ?-1990+: polychrome jars, bowls)
PUBLICATIONS: Dillingham 1992:206-208.

Juanita Sarsina

(Acoma, active ?-1990+: polychrome jars, bowls)
PUBLICATIONS: Dillingham 1992:206-208.

Dolores Scaiseloh

(Acoma, active ca. 1860s-1910s+: polychrome jars, bowls)
BORN: ca. 1845; RESIDENCE: Acomita in ca. 1910
PUBLICATIONS: Leopold Bibo, "13th Annual U.S. Census" (1910), New Mexico State Archives, Call T624, Roll 919; in Dillingham 1992:205.

Ruby Schrulote *(see Ruby Shroulote)*

Lupita Schutio

(Acoma, active ca. 1880s-1910s+: polychrome jars, bowls)
BORN: ca. 1865; RESIDENCE: Acomita in ca. 1910
PUBLICATIONS: Leopold Bibo, "13th Annual U.S. Census" (1910), New Mexico State Archives, Call T624, Roll 919; in Dillingham 1992:205.

Michelle Paisano Schwebach *(see Michelle Paisano)*

Sandra Scissons

(Acoma, active ?-1990+: polychrome jars, bowls)
PUBLICATIONS: Dillingham 1992:206-208.

Rose May Scott

(Laguna, active ca. 1973-?: traditional polychrome jars, bowls)
EDUCATION: 1973, Laguna Arts & Crafts Project participant

Juanarita Sea-atie

(Acoma, active ca. 1860s-1910s+: polychrome jars, bowls)
BORN: ca. 1850; RESIDENCE: Acomita in ca. 1910
PUBLICATIONS: Leopold Bibo, "13th Annual U.S. Census" (1910), New Mexico State Archives, Call T624, Roll 919; in Dillingham 1992:205.

Maria Seitemai

(Acoma, active ca. 1860s-1910s+: polychrome jars, bowls)
BORN: ca. 1845; RESIDENCE: McCartys in ca. 1910
PUBLICATIONS: Leopold Bibo, "13th Annual U.S. Census" (1910), New Mexico State Archives, Call T624, Roll 919; in Dillingham 1992:205.

Sharon Sarracino -
Courtesy of Jason Esquibel
Rio Grande Wholesale, Inc.

Daisy Sena
(Acoma, active ?-1990+: polychrome jars, bowls)
PUBLICATIONS: Dillingham 1992:206-208.

Margaret Sena
(Acoma, active ?-1990+: polychrome jars, bowls)
PUBLICATIONS: Dillingham 1992:206-208.

Caroline L. Seonia *(CLS, Jemez N.M.)*
(Jemez, active ca. 1960-present: matte polychrome Storytellers, figures, jars, bowls, miniature kivas)
BORN: March 30, 1928
FAMILY: daughter of Jose & Persingula Loretto
PUBLICATIONS: Babcock 1986; Hayes & Blom 1998:35; Congdon-Martin 1999:90-91; Berger & Schiffer 2000:146.

Juanita Seonia
(Jemez, Coyote Clan, active 1981-present: polychrome Storytellers, Nativities; figures, miniatures)
BORN: August 1, 1971
FAMILY: m.granddaughter of Lucas & Juanita Toledo; daughter of Santana Seonia; sister of Kennetta & Marian Seonia; mother of Leanndra, Ashley & Dyanna
AWARDS: 1984, 3rd, Storyteller, Eight Northern Pueblo Indian Arts & Crafts Show; 1993, 1st, Nativities, New Mexico State Fair, Alb.
EXHIBITIONS: 1983-1991, Pueblo Grande Show, Phoenix; 1984, Indian Market, Santa Fe; 1998-99, Eight Northern Pueblo Indian Arts & Crafts Show; 1990-present, Jemez Pueblo Red Rocks Arts & Crafts Show
FAVORITE DESIGNS: Corn Maidens, kiva cutout, moccasins
GALLERIES: Bien Mur, Sandia Pueblo, NM
PUBLICATIONS: Walatowa Pueblo of Jemez, "Pottery of Jemez Pueblo" (1999).

Kenneth Seonia, Jr.
(Jemez, active ?-present: polychrome jars, bowls, ornaments)
BORN: ca. 1950
FAMILY: son of Kenneth Seonia, Sr.; father of Marian K. Seonia
FAVORITE DESIGNS: feathers, rain clouds, corn plants, Pueblo human figures
PUBLICATIONS: Walatowa Pueblo of Jemez, "Pottery of Jemez Pueblo" (1999).

Kennetta Seonia
(Jemez, Coyote Clan, active 1990s-present: Storytellers, figures, drums)
FAMILY: m.granddaughter of Lucas & Juanita Toledo; daughter of Santana Seonia; sister of Juanita & Marian Seonia

Marian K. Seonia *(signs Seonia, Jemez, NM)*
(Jemez, active ca. 1995-present: traditional polychrome jars, bowls)
BORN: January 4, 1973
FAMILY: granddaughter of Kenneth Seonia, Sr.; daughter of Kenneth Seonia, Jr.
PUBLICATIONS: Berger & Schiffer 2000:146.

Santana T. Seonia *(Santana M. Seonia), (signs Santana Seonia, S. Seonia or S.T.S.)*
(Jemez, Coyote Clan, active ca. 1960s-present: polychrome Storytellers, Nativities, figures, wedding vases, ornaments, miniature hot air balloons)
BORN: July 21, 1947
FAMILY: daughter of Lucas & Juanita Toledo; mother of Juanita Seonia & Marian Seonia
TEACHER: Juanita Toledo, her mother
AWARDS: New Mexico State Fair, Albuquerque; San Felipe Arts & Crafts Show, San Felipe Pueblo, NM
COLLECTIONS: Dr. Gregory Schaaf, Santa Fe
FAVORITE DESIGNS: figures with children in moccasins, friendship bowls, kivas, pueblo houses, canoes, ovens, drums, tipis, angels, bells
GALLERIES: Wind River Trading Company, Santa Fe
PUBLICATIONS: Babcock 1986; Hayes & Blom 1998:35; Walatowa Pueblo of Jemez, "Pottery of Jemez Pueblo" (1999); Congdon-Martin 1999:85; Berger & Schiffer 2000:146.

Juanarita Serna
(Acoma, active ca. 1870s-1910s+: polychrome jars, bowls)
BORN: ca. 1860; RESIDENCE: Acomita in ca. 1910
PUBLICATIONS: Leopold Bibo, "13th Annual U.S. Census" (1910), New Mexico State Archives, Call T624, Roll 919; in Dillingham 1992:205.

Seferina Sevenna
(Cochiti, active ?: pottery)
PUBLICATIONS: Harlow 1977.

Christopher Seymour

(Acoma, active ?-1990+: polychrome jars, bowls)
PUBLICATIONS: Dillingham 1992:206-208.

Lois Seymour

(Acoma, active ?-1990+: polychrome jars, bowls)
PUBLICATIONS: Dillingham 1992:206-208.

Margaret Seymour

(Acoma, active ?-present: polychrome jars, bowls)
EXHIBITIONS: ?-1974, Indian Market, Santa Fe; 1999-present, Eight Northern Indian Pueblos Arts & Crafts Show
PUBLICATIONS: *SWAIA Quarterly* Fall 1976:14; Dillingham 1992:206-208.

Mary Ann Seymour *(Mary Ann Garcia)*

(Acoma, Sun Clan, active 1960s-present: traditional polychrome jars, bowls, miniatures)
BORN: December 23, 1955; RESIDENCE: Acomita, NM
FAMILY: sister of Elliott Garcia, Sr., Wilfred Garcia; sister-in-law of Beatrice Garcia
AWARDS: 1998, Indian Market, Santa Fe
EXHIBITIONS: 1992, Heard Museum Show, Phoenix; 1994-present: Indian Market, Santa Fe; 1995-present, Eight Northern Indian Pueblos Arts & Crafts Show
PUBLICATIONS: Dillingham 1992:206-208.
 Mary Ann Seymour expressed herself strongly, "As a Native American woman artist, I take pride in the originality of the shapes and designs of my pottery. My potteries have been collected nationally and worldwide by private collectors."

Vivian Seymour

(Acoma, Red Corn Clan, active ca. 1980s-present: traditional polychrome jars, bowls)
BORN: August 26, 1960; RESIDENCE: Acoma, NM
FAMILY: daughter of Mr. & Mrs. A. Garcia; sister of Theresa Garcia
STUDENTS: Theresa Garcia, her sister
GALLERIES: The Indian Craft Shop, U.S. Department of Interior, Washington, D.C.
PUBLICATIONS: Dillingham 1992:206-208; Berger & Schiffer 2000:119.

Marcelina Shawrutie

(Acoma, active ca. 1880s-1910s+: polychrome jars, bowls)
BORN: ca. 1865; RESIDENCE: Acomita in ca. 1910
PUBLICATIONS: Leopold Bibo, "13th Annual U.S. Census" (1910), New Mexico State Archives, Call T624, Roll 919; in Dillingham 1992:205.

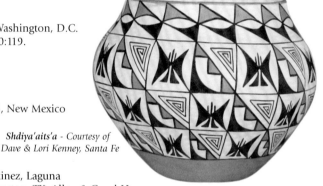

Shdiya'aits'a - Courtesy of Dave & Lori Kenney, Santa Fe

Shdiya'aits'a *(Shdiya'araits'a)*

(Acoma, active ?-present: traditional polychrome jars, bowls)
FAMILY: sister of Gertrude Poncho; sister-in-law of Richard L. Martinez, Laguna
COLLECTIONS: Dave & Lori Kenny, Santa Fe; Candace Collier, Houston, TX; Allan & Carol Hayes
FAVORITE DESIGNS: diagonal bands of alternating motifs - kiva steps, rain, triangular frets, butterflies, parrots
PUBLICATIONS: Dillingham 1992:206-08; Hayes & Blom 1998:31.

Andrieta Shendo *(Andrieta Shendoh)*

(Jemez, Coyote Clan, active ca. 1900-?: traditional cooking pots & polychrome jars, bowls, wedding vases)
BORN: ca. 1884
FAMILY: wife of Juanito Shendoh; mother of Reyes Shendo Toya (2) & Jeronima Shendoh; m. grandmother of Clara Gachupin, Marie Vigil, Paul Toya, Ralph Toya, Mike Toya, Allen Toya, Johnny Toya; great-grandmother of Lorraine Chinana, Ida Yepa, Pauline Vigil, Lawrence Albert Vigil, Dennis Vigil, Erma Waquie & Georgia Vigil-Toya
PUBLICATIONS: U.S. Census 1920, family 46.

Anna Marie Shendo

(Jemez, active ca. 1940s-?: matte polychrome & polished redware ollas, jars, lidded bowls, wedding vases, seed jars)
BORN: ca. 1920s
FAMILY: mother of Mary Louis Eteeyan; mother-in-law of William Eteeyan; m. grandmother of Kimberly Eteeyan

Imagene Shendo *(Imogene)*

(Jemez, active ?-present)
FAMILY: related to Carol Vigil, Mildred Shendo, Linda & Wilma L. Baca

Jacqueline S. Shendo *(signs J. S. Shendo, Jemez N.M.)*

(Jemez, active ca. 1986-present: polychrome Storytellers, jars, bowls)
BORN: July 12, 1961
FAMILY: daughter of Rosita Sabaquie; sister of Kathleen Sabaquie
TEACHER: Rosita Sabaquie, her mother
PUBLICATIONS: Berger & Schiffer 2000:146.

Jeronima Shendo *(1)*

(Jemez, Coyote Clan, active ca. 1920s-?: traditional cooking pots & polychrome jars, bowls, wedding vases)
BORN: ca. 1911
FAMILY: daughter of Juanito & Andrieta Shendoh; sister of Reyes Shendo Toya (2)
PUBLICATIONS: U.S. Census 1920, family 46.

Jeronima Shendo *(2)* *(Geronima Shendo)*

(Jemez/Santa Clara, Corn Clan, active ?-present: pottery)
FAMILY: daughter of Rita Casiquito; sister of Juanita Fragua; niece of Marie Lupe Romero
PUBLICATIONS: Peaster 1997:62; Tucker 1998: plate 69; Schaaf 2000:91.

Jimmy Shendo

(Jemez, active ?: Storytellers)
PUBLICATIONS: Congdon-Martin 1999:91.

Juanita Shendo *(signs J. Shendo)*

(Jemez, active ca. 1985-present: polychrome jars, bowls)
BORN: June 15, 1957
TEACHER: her mother
GALLERIES: Palms Trading Company, Albuquerque
PUBLICATIONS: Congdon-Martin 1999:91; Berger & Schiffer 2000:146.

Marie Reyes Shendo

(Jemez, active ca. 1940s-present: contemporary sgraffito polished redware jars, bowls, vases, wedding vases, seed pots)
BORN: ca. 1920s
FAMILY: mother of Linda Baca; grandmother of Wilma L. Baca
STUDENT: Wilma L. Baca, her granddaughter

Mildred Shendo

(Jemez, active ?-present)
FAMILY: related to Imagene Shendo, Carol Vigil, Linda & Wilma L. Baca

Roberta Shendo

(Jemez, active ca. 1980-present: matte polychrome stone polished redware wedding vases)
BORN: August 4, 1959
TEACHER: her mother
FAVORITE DESIGNS: clouds, corn plants, kiva steps
GALLERIES: The Indian Craft Shop, U.S. Department of Interior, Washington, D.C.; Tribal Arts Zion, Springdale, UT; Kennedy Indian Arts, UT
PUBLICATIONS: Hayes & Blom 1996:84; Walatowa Pueblo of Jemez, "Pottery of Jemez Pueblo" (1999); Berger & Schiffer 2000:40, 146..
 Roberta Shendo is an exceptional pottery painter. Her compositions are complex, often swirling. Her eye for detail is delineated with gracefully painted lines. Her stone polish on the areas outside the principal design is smooth and glossy. The overall effect of her pottery is quite pleasing.

Roberta Shendo - Courtesy of John D. Kennedy and Georgiana Kennedy Simpson Kennedy Indian Arts

Charmae Shields *(see Charmae Natseway)*

Curtis Shields

(Acoma, Eagle Clan, active ?-present: pottery)
FAMILY: grandson of John Carillo; son of Chris & Michelle Shields; brother of Isaac & Natasha Shields
AWARDS: 2000, 3rd, Figures, Indian Market, Santa Fe

Donna Rey Shields

(Acoma, active ?: pottery)
ARCHIVES: Artist File, Heard Museum Library, Phoenix

Ethel Shields

(Acoma, Yellow Corn Clan, active ca. 1938-present: traditional polychrome & Mimbres Revival jars, bowls, effigy pots, effigy canteens, Storytellers (1978-present), Nativities, figures, Christmas ornaments, miniatures)
BORN: September 17, 1926
FAMILY: m. granddaughter of Josephita Sandoval & Joe A. Sandovol; daughter of Toribio & Dolores S. Sanchez; sister of Katherine Lewis; aunt of Judy Lewis (1); wife of Don Shields (jeweler); mother of 8 children including Charmae Natseway (potter), Chris Shields and Jack (powwow dancer); mother-in-law of Judy Shields & Verda Mae Shields
EDUCATION: Albuquerque Indian School
TEACHER: Dolores S. Sanchez, her mother

AWARDS: 1984. 3rd; 1988, 3rd; 1989, 3rd; 1994, 1st; 1996, 3rd, Indian Market, Santa Fe
EXHIBITIONS: pre-1985-present: Indian Market, Santa Fe
COLLECTIONS: Heard Museum, Phoenix; Wheelwright Museum, Santa Fe; Lyndsey Wagner (movie actress); John Blom
FAVORITE DESIGNS: human figures, turtles, corn, snakes, birds, animals, feathers-in-a-row, rain
GALLERIES: Adobe Gallery, Albuquerque, Kennedy Indian Arts, Inc.
PUBLICATIONS: Monthan 1979:46-48; Barry 1984:89; Babcock 1986:52-55, 90, 107, 109, 138; Eaton 1990:22; Dillingham 1992:206-208; Peaster 1997:21-23; Hayes & Blom 1998:31; Congdon-Martin 1999:53.

Ethel Shields - Courtesy of John D. Kennedy and Georgiana Kennedy Simpson Kennedy Indian Arts

On May 1, 2001, we met Ethel and her sister, Katherine Lewis. They were showing their pottery at the San Felipe Pueblo Feast Day. Ethel displayed traditional pottery jars and bowls, as well as a graceful figure of a Pueblo grandmother and a Nativity set. She proudly showed us her photo album filled with pictures taken over the years of her career.

Ethel is famous for her Nativity sets, but she began making traditional pottery three decades earlier in the 1940s. She recalled working with her mother making and marketing pottery during World War II: "We would load all the pottery into a wagon and drive to the main road [Route 66] between Grants and Albuquerque; that was before it was paved. We would sit there at a roadside stand and sell the pottery to people driving by." (Monthan 1979:46)

For twelve years, Ethel, her husband, Don Shields (jeweler), and their children lived in Tucson. Ethel worked for the Indian Center there. They later returned to Acoma Pueblo.

Ethel has made hundreds of Nativity sets. She began making them in 1975. Two years later, she began making larger figures. She also makes Christmas tree ornaments and miniatures.

Ethel was influenced in later life by Anasazi pottery styles. She and a relative traveled to Mesa Verde, where she saw displays of ancient pottery. She was especially impressed by effigy jars & canteens. After returning to Acoma, she began making Anasazi style animal forms such as birds and turtles. She then innovated Storyteller pitchers with faces, legs and arms full of babies. She also made Tularosa Revival ware, featuring effigy turtle and corn cob canteens in black-on-white fineline style.

Isaac Shields

(Acoma, Eagle Clan, active ?-present: pottery)
FAMILY: grandson of John Carillo; son of Chris & Michelle Shields; brother of Curtis & Natasha Shields
AWARDS: 1999, Indian Market, Santa Fe

Jack Shields

(Acoma, Yellow Corn Clan, active ca. 1980s-present: Storytellers)
BORN: ca. 1961
FAMILY: grandson of Dolores Sanchez; son of Don & Ethel Shields
PUBLICATIONS: Babcock 1986:55, 138.

Judy Shields

(Acoma, active 1983-present: polychrome Storytellers, figures, jars, bowls, owls, turtles, lizards, miniatures)
BORN: April 4, 1962
FAMILY: daughter-in-law of Ethel & Don Shields
AWARDS: 1991, 1st, 2nd; 1993, 3rd (2), figures & traditional forms; 1994, 3rd; 2000, 2nd, figures, 3rd, traditional forms, Indian Market, Santa Fe
EXHIBITIONS: 1992-present: Indian Market, Santa Fe
COLLECTIONS: Heard Museum, Phoenix; Allan & Carol Hayes, John Blom
FAVORITE DESIGNS: Storytellers, owls, turtles, lizards
GALLERIES: Rio Grande Wholesale, Inc., Palms Trading Co., Albuquerque
PUBLICATIONS: Schiffer 1991d:52; Dillingham 1992:206-208; Peaster 1997:22-23; Hayes & Blom 1998:57.

Judy Shields - Courtesy of John D. Kennedy and Georgiana Kennedy Simpson Kennedy Indian Arts

Michelle Shields

(Acoma, Eagle Clan, active ca. 1991-present: traditional polychrome jars, bowls, wedding vases with turquoise insets, vases with lids)
BORN: September 23, 1972
FAMILY: daughter of John Carillo; wife of Chris Shields; mother of Isaac, Curtis & Natasha
TEACHERS: Ethel Shields, her mother & Charmae Natseway
FAVORITE DESIGNS: butterflies & parrots
GALLERIES: Bien Mur, Rio Grande Wholesale, Inc., Palms Trading Co., Albuquerque
PUBLICATIONS: Berger & Schiffer 2000:21, 147.

Michelle Shields described pottery making as "self-fulfilling." She added that pottery is "something I can leave in this world."

Natasha Shields

(Acoma, Eagle Clan, active ca. 1990s-present: pottery)
FAMILY: granddaughter of John Carillo; daughter of Chris & Michelle Shields; sister of Curtis & Isaac Shields

Shawn Shields

(Acoma, active 1990s-present: pottery, miniatures, necklaces, jewelry)
AWARDS: 1998, 2000, 2nd, Figures, 3rd, Miniatures, Indian Market, Santa Fe
ARCHIVES: Artist's File, Heard Museum, Phoenix

Verda Mae Shields

(Acoma, active ca. 1990s-present: polychrome jars, bowls)
FAMILY: daughter-in-law of Don & Ethel Shields
PUBLICATIONS: Peaster 1997:23.

Adrienne Shije

(Jemez/Pecos, married into Zia, active ca. 1980-present: Storytellers, traditional polychrome jars, bowls)
BORN: March 23, 1956
FAMILY: granddaughter of Marie Toledo; goddaughter of Dorothy Trujillo; daughter-in-law of Eusebia Shije; mother of Marie Shije, Erin Shije
TEACHERS: Alma Maestas, Marie G. Romero, Eusebia Shije.
GALLERIES: Adobe Gallery, Albuquerque
PUBLICATIONS: Babcock 1986:57, 59, 60, 140; *Indian Market Magazine* 1988; Congdon-Martin 1999:92.

> Adrienne Shije shared, "My little daughter, Erin, loves babies on my Storytellers. She's always trying to take them off. I think she's jealous. Sometimes I spend more time with them than with her. I tell her, 'They're your little brothers. You can't be mean to them.'"

Benina Shije

(Zia, active ?: polychrome jars, bowls)

> According to Juanita Fragua (Jemez), Benina Shije was important in helping to revive pottery making at Jemez Pueblo.

Carmelita Shije

(Zia, active ca. 1930s-?: traditional polychrome jars, bowls)
BORN: ca. 1900
FAMILY: wife of Gregorio Shije; mother of Marcellina Shije (b. 1918)
PUBLICATIONS: U.S. Census 1920, family 10.

Cornelia J. Shije *(signs C. J. Shije)*

(Zia/Acoma, Eagle Clan, active 1970s-present: pottery)
BORN: ca. 1960s
FAMILY: daughter of Vicente & Juanita C. Shije; sister of Yvonne Shije Grayson; wife of Greg P. Shutiva; mother of Kymberly, Gregg, Thomas, Lauren Shutiva
EXHIBITIONS: 1997-present, Eight Northern Indian Pueblos Arts & Crafts Show
COLLECTIONS: Rita Coolidge; Bill Mooney

C. J. Shije -
Photograph by Michael E. Snodgrass, Denver

Dominga Shije

(Zia, active ca. 1880s-?: traditional polychrome jars, bowls)
BORN: ca. 1870
FAMILY: mother of Juan Diego Shije
PUBLICATIONS: U.S. Census 1920, family 6.

Eusebia Shije

(Zia, active ca. 1950s-present: traditional polychrome jars, bowls)
BORN: ca. 1930
FAMILY: sister of Teresita Galvin; mother-in-law of Adrienne Shije
AWARDS: 1976, 1st, 3rd, bowls; 1978, 1st, 2nd, jars; 1979, Richard M. Howard Award for Best Traditional Zia Pottery; 1980, Richard M. Howard Award for Best Traditional Zia Pottery; 1981, Indian Arts Fund Award for Overall Excellence; 1984, 1st, jars, 2nd, bowls; 1988, 3rd, jars; 1989, 3rd, jars, Indian Market, Santa Fe
EXHIBITIONS: 1976-present, Indian Market, Santa Fe; 1995-present, Eight Northern Indian Pueblos Arts & Crafts Show
PUBLICATIONS: *Arizona Highways* May 1974:42; Tanner 1976:122; *SWAIA Quarterly* Fall 1976:12, 14; Fall 1982: 10-11; Barry 1984:102, 105-06; *Indian Market Magazine* 1985, 1988, 1989; Babcock 1986:140; Trimble 1987:65-7; Hayes & Blom 1996:164-65; Peaster 1997:151.

Eusebia Shije -
Courtesy of John Blom

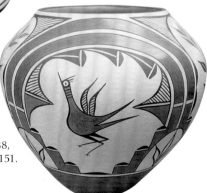

Florence Shije

(Zia, active ca. 1900s-70s: traditional polychrome jars, bowls)
BORN: ca. 1888
FAMILY: daughter-in-law of Sabado Shije; wife of Sebastian Shije; mother of Emiliano Shije
PUBLICATIONS: U.S. Census 1920, family 23; *SWAIA Quarterly* Fall 1972:7.

Eusebia Shije - Photograph by Tony Molina
Case Trading Post at the Wheelwright Museum
of the American Indian, Santa Fe

Florenda Shije
(Zia, active ca. 1980s-present: polychrome jars, bowls)
FAMILY: sister of Louise Negal; niece of Seferina Bell
PUBLICATIONS: Peaster 1997:151.

Joseffa Galvan Shije
(Zia, Tobacco/Coyote/Arrow Clans, active ca. 1910s-?: traditional polychrome ollas, jars, bowls)
BORN: ca. 1890s
FAMILY: wife of Santiago Shije; mother of Refugia Shije Pino; m. grandmother of Veronica Pino Baca

Juanita C. Shije
(Zia/Acoma, active ca. 1960s-present: polychrome jars, bowls)
BORN: ca. 1940
FAMILY: mother of Yvonne Shije Grayson and Cornelia J. Shije
EXHIBITIONS: 1997-present, Eight Northern Indian Pueblos Arts & Crafts Show
COLLECTIONS: Indart, Inc.; Wright/McCray Collection, Santa Fe

Juanita C. Shije -
Photograph by Michael E. Snodgrass, Denver

Lociana Shije
(Zia, active ca. 1930s-?: traditional polychrome jars, bowls)
BORN: ca. 1869-?
FAMILY: wife of Juan Rey Shije; mother-in-law of Jim Medina; grandmother of Jose Antonio Shije & Rosenda Shije
AWARDS: 1941, Indian Market, Santa Fe
EXHIBITIONS: 1979, "One Space: Three Visions," Albuquerque Museum, Alb.
COLLECTIONS: Museum of New Mexico, Albuquerque, olla, ca. 1941.
FAVORITE DESIGNS: roadrunners, rainbows, clouds, rain
PUBLICATIONS: U.S. Census 1920, family 12; *El Palacio* Oct. 1941:226; *SWAIA Quarterly* Fall 1972:7, 9; Toulouse 1977:color illustration after page 32.

Lucia Lucero Shije
(Zia, Water Clan, active ca. 1930s-?: traditional polychrome ollas, jars, bowls, loom weaving, mantas, embroidered capes, maiden shawls, braided rain sash belts, kilts)
BORN: ca. 1920
FAMILY: wife of Antonio Lucero; mother of Gilbert Lucero, Dolores Pino, Pauline Panana, Jeanann Pino; m. grandmother of Benedict Lucero, Sharon Pino, Gabriel Pino
STUDENTS: her children, including Dolores Pino

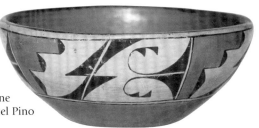

Juanita Shije -
Wright/McCray Collection, Santa Fe

Mary M. Shije
(Zia, active ?-1990s: pottery)
EXHIBITIONS: 1986-?, Eight Northern Indian Pueblos Arts & Crafts Show
COLLECTIONS: Michael Hering Collection, Santa Fe
FAVORITE DESIGNS: Roadrunner, rainbow
PUBLICATIONS: Hering 1987:45.

Reyes Shije
(Zia, active ca. 1880s-?: traditional polychrome jars, bowls)
BORN: ca. 1865
FAMILY: wife of Juan Pedro Shije; mother of Vivian & Velino Shije Herrera
PUBLICATIONS: U.S. Census 1920, family 26.

Rita Shije
(Zia, active ca. 1890s-?: traditional polychrome jars, bowls)
BORN: ca. 1878
FAMILY: wife of Isidro Shije; mother of Luciana & Ivan Jose Shije
PUBLICATIONS: U.S. Census 1920, family 8.

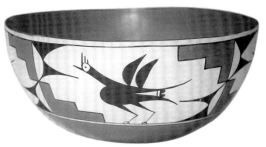

Juanita Shije -
Photograph by Bill Knox
Courtesy of Indart Incorporated

Theodora Shije
(Zia, active ?: pottery)
ARCHIVES: Laboratory of Anthropology Library, Santa Fe; lab. file.

Yvonne Shije *(see Yvonne Shije Grayson)*

Virginiana Solas *(see Virginia Salas)*

Ilene Shroulote *(collaborates with Warren Shroulote)*
(Acoma, active ?-1990+: polychrome jars, bowls)
PUBLICATIONS: Dillingham 1992:206-208.

Manuel L. Shroulote *(signs MLS)*
(Acoma, active ca. 1990-present: traditional polychrome jars, bowls)
BORN: October 14, 1962
FAMILY: son of John & Ruby Shroulote
PUBLICATIONS: Berger & Schiffer 2000:147.

Ruby Shroulote *(Schroulote, Shrulote), (signs Mrs. Ruby Shroulote)*
(Acoma, active ?-present: traditional polychrome & fineline ollas, jars, bowls)
FAMILY: wife of John Shroulote
COLLECTIONS: Dr. Fred Belk, New Mexico, Allan & Carol Hayes
FAVORITE DESIGNS: parrots, rainbows, clouds

Warren Shroulote *(collaborates with Ilene Shroulote)*
(Acoma, active ?-1990+: polychrome jars, bowls)
PUBLICATIONS: Dillingham 1992:206-208.

Ernest Shutiva *(collaborated with Stella Shutiva)*
(Acoma, active ca. 1960s-?: traditional polychrome jars, bowls)
BORN: ca. 1930s
FAMILY: husband of Stella Shutiva; father of Jacqueline Shutiva Histia
PUBLICATIONS: Dedera 1985:41.

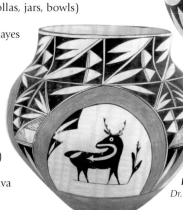

*Ruby Shroulote -Courtesy of
Allan & Carol Hayes*

*Ruby Shroulote -
Dr. Fred Belk Collection, NM*

Jackie Histia Shutiva *(see Jackie Shutiva Histia)*

Regina Leno Shutiva *(see Regina Leno-Shutiva)*

Sandra Shutiva *(Sandra Shutiva Garcia), (collaborates sometimes with Wilfred Garcia)*
(Acoma, active ca. 1980s-present: polychrome jars, bowls, figures)
FAMILY: granddaughter of Jessie C. Garcia;daughter of Ernest & Stella Shutiva; sister of Jacqueline Shutiva Histia; wife of Wilfred Garcia
AWARDS: 1988, 1st, 2nd, 3rd; 1989, 1st, Indian Market, Santa Fe
EXHIBITIONS: 1988-present, Indian Market, Santa Fe; 1995-present, Eight Northern Indian Pueblos Arts & Crafts Show
COLLECTIONS: John Blom
PUBLICATIONS: Jacka 1988:122; *Indian Market Magazine* 1988-2000; Dillingham 1992:206-208; Reano 1995:59; Hayes & Blom 1996:52-53.

 Sandra Shutiva comes from a family with strong roots in Acoma pottery making. Her great-grandmother, Jessie C. Garcia, was one of the great potters. Her mother, Stella Shutiva, is famous especially for her unique corrugated white owls.

 Sandra and her husband, Wilfred Garcia, are distinguished for making large, elegant white jars with ear of corn appliques or carvings of cliff dwelling scenes. Their pottery is well formed and artistic in composition and design.

Stella Shutiva *(collaborated with Ernest Shutiva), (signed S. H. Shutiva)*
(Acoma, active ca. 1950s-present: traditional polychrome & corrugated whiteware jars, bowls, double vases, wedding vases, canteens, plates, human figures, white corrugated owls, animal figures)
LIFESPAN: July 12, 1939 - ca. 1997; RESIDENCE: San Fidel, NM
FAMILY: daughter of Jessie Garcia; wife of Ernest Shutiva; mother of Jacqueline Shutiva Histia, Sandra Shutiva
STUDENTS: Wilfred Garcia
AWARDS: 1974, 1st; 1976, 2nd; 1978, 3rd (2); 1981, 1st, Indian Market, Santa Fe; 1970s-80s, Inter-tribal Indian Ceremonial, Gallup,
EXHIBITIONS: pre-1973-1997, Indian Market, Santa Fe; 1979, "One Space: Three Visions," Albuquerque Museum, Albuquerque; 1981, "American Indian Art in the 1980s," Native American Center for the Living Arts, Niagara Falls, NY; 1987, Inter-tribal Indian Ceremonial, Gallup; 1997, "Recent Acquisitions from the Herman and Claire Bloom Collection," Heard Museum, Phoenix
DEMONSTRATIONS: 1973, Smithsonian Institution
COLLECTIONS: Heard Museum, Phoenix; Albuquerque Museum, Albuquerque, NM, corrugated double vase, ca. 1978; John Blom; Dr. Gregory & Angie Yan Schaaf, Santa Fe
FAVORITE DESIGNS: human figures, Rainbirds, owls, rain, clouds
PUBLICATIONS: *SWAIA Quarterly* Fall 1973:3; Fall 1974:3, 13; *American Indian Art Magazine* Summer 1976:12; Tanner 1976:123; Barry 1984:89; Dedera 1985:41-42; Babcock 1986:55; Trimble 1987:78-79; New 1991:46, 75; Minge 1991:195; Dillingham 1992:206-208; Reano 1995:149; Peaster 1997:20; Painter 1998:15; Hayes & Blom 1996:52-53;1998:25, 49.

*Stella Shutiva - Courtesy of
John D. Kennedy and
Georgiana Kennedy Simpson
Kennedy Indian Arts*

*Stella Shutiva - Courtesy of
Candace Collier, Houston, TX*

Stella Shutiva was profiled in Don Dedera's 1985 book, *Artistry in Clay*. He praised her "high quality pottery." The author also recounted her 1973 demonstration at the Smithsonian Institution where she studied their collection of Acoma pottery with "the goal of combining a feeling of the past with contemporary design."

Stella credited her mother, Jessie Garcia, with reviving corrugated pottery. Stella commented, "I just adored her corrugated pots. I wondered if I could ever do it. If I just watch my mom, it's hard to learn my own way. So I had to do it myself. It took almost four years.

After Stella passed away, her husband, Ernest, gave her tools to their daughter, Jackie. Among them was an "octagon-shaped carpenter's pencil used to corrugate the coils." (Peaster 1997:20)

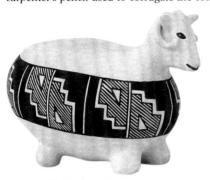

Stella Shutiva - Courtesy of
Gloria Couch, Corrales, NM

S. H. Shutiva - Courtesy of
Peter B. Carl, Oklahoma City, OK

Stella Shutiva - Courtesy of
Dave & Lori Kenney, Santa Fe

Lupota Siemaniowie

(Acoma, active ca. 1870s-1910s+: polychrome jars, bowls)
BORN: ca. 1861; RESIDENCE: Acomita in ca. 1910
PUBLICATIONS: Leopold Bibo, "13th Annual U.S. Census" (1910), New Mexico State Archives, Call T624, Roll 919; in Dillingham 1992:205.

Lucilla Sievos

(Cochiti, ca. 1930s-?: traditional polychrome ollas, jars, bowls)
COLLECTIONS: Philbrook Museum of Art, Tulsa, OK, olla, ca. 1946

Amalia Silk

(Jemez, active ca. 1983-present: traditional polychrome polished & sgraffito jars, bowls)
BORN: November 19, 1958
FAMILY: daughter of Leandro & Josephine Sando
TEACHER: Josephine Sando, her mother
PUBLICATIONS: Berger & Schiffer 2000:147.

Monica Silva - Courtesy of
Nedra Matteucci Galleries, Santa Fe

Monica Silva

(Santa Clara, married into Santo Domingo, active ca. 1910s-1940s+: polished blackware, polychrome red and black-on-cream, black-on-red, polychrome redware vases, jars, bowls, dough bowls, oval bowls with hen shaped lids)
BORN: ca. 1900
FAMILY: m. granddaughter of Dolorita Baca & Jose Leandro; daughter of Benina & Francisco Silva; wife of Santiago Lovato; mother of Alvelino Lovato, Mrs. Pete Aguilar, Clara Lovato Reano, Santana Rosetta & Martin Lovato; grandmother of Vickie Reano Tortalita, Charles Lovato (painter), Angie Reano Owen, Paul Rosetta, Cissie Rosetta, Henry Rosetta, Joe Frances Rosetta, Carl Rosetta, Lupe Rosetta, Reyes Rosetta, Rose Reano, Celestino Reano, Joe L. Reano, Percy Reano, Avelino Reano, Frank Reano, Joe Rosetta, Johnnie Rosetta, Marvin Lovato, Calvin Lovato, Dora L & Vergie L.
EXHIBITIONS: 1996, "Pottery from the Fred Harvey Company Collection, Phoenix
COLLECTIONS: Heard Museum, Phoenix; Denver Art Museum, Denver; School of American Research, Santa Fe, ca. #SAR 1982-7-19a&b; Richard M. Howard, Santa Fe; Philbrook Museum of Art, Tulsa, OK, olla, wedding vase, ca. 1941, jar, ca. 1950.
VALUES: On November 29, 2000, black-on-cream dough bowl, attributed to Monica Silva, (9.5 x 18"), sold for $3,000, at Sotheby's, #97.

On June 5, 1998, black-on-cream dough bowl, attributed to Monica Silva, (10 x 18"), sold for $2,420 at R. G. Munn, #868.
PUBLICATIONS: *El Palacio* Oct. 16, 1922 8(8):94, 96; *SWAIA Quarterly* Fall/Winter 1972 7(63):7; Tanner 1973:195; Toulouse 1977:53; Blair 1986:70, 168, 184; Batkin 1987:99-100, 202; Howard & Pardue 1996:21; *Indian Artist* Summer 1996 2(3):26; Schaaf 2000:92.

Monica Silva was born and raised at Santa Clara Pueblo. She came from a respected family of potters. In the 1910s, she married Santiago Lovato of Santo Domingo and moved to his pueblo. She helped popularize black-on-blackware and red-on-redware pottery there. In return, she also learned and mastered Santo Domingo pottery styles and techniques. She made important contributions to the history of Pueblo pottery.

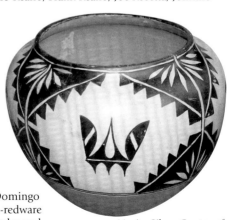

Monica Silva - Courtesy of
Richard M. Howard, Santa Fe

Noreen Simplicio

*Noreen Simplicio with collector **Isa Diestler** - Courtesy of Isa Fetish, Cumming, GA*

(Zuni, Badger/Child of an Eagle Clans, active ca. 1977-present: polychrome fine-line whiteware & orangeware ollas, jars, cornmeal bowls, effigy pots, seed bowls, lizard bowls, figures, miniatures)
FAMILY: granddaughter of Winifred Bowekaly; daughter of Mike & Carmelita Simplicio; sister of Leroy, Lydia, Sharen & Coleen Simplicio; wife of George Epaloose; mother of Kenneth Epaloose
TEACHERS: Jennie Laate & Angelina Medina
STUDENTS: 1990-91, over a hundred Zuni High School students
AWARDS: 1988, Featured New Artist, 3rd, miniatures; 1989, 1st (4), 2nd, 3rd; 1996, 1st, Bowls, 1st, Figures; 1998, 2nd; 3rd, 1999, 2000, 1st, 2nd, 3rd, Indian Market, Santa Fe; 1992, 3rd, Inter-tribal Indian Ceremonial, Gallup, NM
EXHIBITIONS: 1988-present, Indian Market, Santa Fe; 1999-present, Eight Northern Indian Pueblos Arts & Crafts Show; Heard Museum Show, Phoenix, AZ; Inter-tribal Indian Ceremonial, Gallup, NM; Pueblo Grande Show, Phoenix, AZ

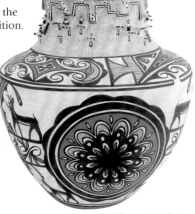

Noreen Simplicio - Sunshine Studio

COLLECTIONS: Heard Museum, Phoenix, AZ; A:shiwi A:wan Museum & Heritage Center, Zuni; Sunshine Studio, Dr. Gregory & Angie Yan Schaaf, Santa Fe; Dan Ostermiller, Roxanne and Greg Hofman; Indart, Inc.
FAVORITE DESIGNS: Deer-in-His-House, lizards, salamanders, tadpoles, birds, terraced clouds, feathers, rain; carved village scenes
GALLERIES: Pueblo of Zuni Arts & Crafts, Zuni, NM; Arlene's Gallery, Tombstone, AZ; Tribal Arts Zion, Springdale, UT; Agape, Albuquerque; Blue Rain Gallery, Taos, NM; Heard Museum Shop, Phoenix, AZ; Turquoise Village; Native American Collections, Denver, CO; Isa Fetish, Cumming, GA
INTERNET: www.sunshinestudio.com
PUBLICATIONS: *Indian Market Magazine* 1988, 1989, 1996, 1998:100; Nahohai & Phelps 1995: cover, 84-91; Bassman 1996:22, 27; Hayes & Blom 1996; 1998:52-57; *Indian Trader* October 1996:19; Painter 1998:184-90.

Noreen Simplicio looked back to her childhood, "My future as a potter began when I was a young child playing in the mud. . .making mud pies and mud pots."

Noreen became a student of Jennie Laate at Zuni High School. Jennie taught her how to gather and to process clay, as well as how to form pottery: "My talents emerged as I had my first lesson in pottery-making in 1977 at Zuni High School. Classes were instructed by the late Jennie Laate, an Acoma woman. I learned as much as I could from Jennie, because I knew I could be a successful potter."

Noreen later received much encouragement and assistance from Angelina Medina, the award winning Zuni/Acoma potter and sculptor. "Angela inspired me to further develop my skills and to venture into the increasingly competitive world of Pueblo pottery."

"In 1988, I entered my first competitive art show. There, I experienced the thrill of receiving an Award of Excellence for my work. In August, I was a featured New Artist at the 67th Annual Indian Market in Santa Fe. In May of 1989, I entered six pieces in competition. Four were awarded 1st Place, one 2nd and one 3rd Place ribbons."

In 1990-91, Noreen Simplicio reportedly taught over a hundred students to make pottery at Zuni High School. She carried forward when Jennie Laate retired. Noreen gives her teachers much credit: "Angelina Medina and Jennie Laate have been great inspirations in my life. Being a full-time potter has been a rewarding experience."

Noreen offered her personal thoughts, "I cherish the gift that Mother Earth gave me. I am able to share my talent and gifts through my work. I have met many wonderful people. I am very proud. I feel good about my pottery. I enjoy having my hands in clay!!!"

*Noreen Simplicio -
Photograph by Bill Bonebrake
Courtesy of Jill Giller
Native American Collections, Denver*

Melody M. Simpson *(signs MS/G Acoma, N.M.)*
(Acoma, active 1989-present: ceramic sgraffito & polychrome jars, bowls, seed pots, turtles, sculptures)
BORN: March 26, 1960
AWARDS: 1998, Indian Market, Santa Fe
EXHIBITIONS: 1992-present: Indian Market, Santa Fe; 1994-present, Eight Northern Indian Pueblos Arts & Crafts Show
FAVORITE DESIGNS: figures holding hands in a row, feathers-in-a-row, kiva steps
PUBLICATIONS: Painter 1998:15; Tucker 1998: plate 87; Berger & Schiffer 2000:147.

Dorothy Siow
(Acoma, active ?-1975+: polychrome jars, bowls)
PUBLICATIONS: Minge 1991:195.

Mary Small *(Kal-La-Tee, New Indian Basket)*

(Jemez, Sun Clan, married into San Felipe, active ca. 1950-present: matte polychrome greyware jars, bowls, wedding vases, some exceptionally large pottery with turquoise insets, Storytellers, Bear Storytellers, ornaments, miniatures)
BORN: July 12, 1940
FAMILY: daughter of Seriaco & Perfectita Toya; wife of Frank Tenorio (San Felipe); mother of Louie Toya, Lettie Small & Scott Small
TEACHER: Perfectita Toya, her mother
AWARDS: 1981-, 1st, Indian Market, Santa Fe; 1999, 1st, Powhatan Renape Nation Indian Arts Festival; Heard Museum Show, Phoenix; New Mexico State Fair, Albuquerque; Inter-tribal Indian Ceremonial, Gallup; Indian Arts & Crafts Association Show, Albuquerque; Fine Arts Enterprises Show, Mesa Verde, CO
EXHIBITIONS: 1973-present, Eight Northern Indian Pueblos Arts & Crafts Show; 1974-present, Indian Arts & Crafts Association Show, Albuquerque; pre-1985-present, Indian Market, Santa Fe
COLLECTIONS: Dr. Gregory & Angie Yan Schaaf
FAVORITE DESIGNS: corn plants, clouds, feathers-in-a-row
GALLERIES: The Indian Craft Shop, U.S. Department of Interior, Washington, D.C.; Arlene's Gallery, Tombstone, AZ; Adobe Gallery, Albuquerque & Santa Fe; Rio Grande Wholesale, Inc., Albuquerque; River Trading Post, East Dundee, IL
PUBLICATIONS: *Indian Market Magazine* 1985, 1988, 1989, 1996, 1998; *Southwest Profile* Nov./Dec. 1985 8(7):20-22; *American Indian Art Magazine* Spring 1992 13(1):29; Winter 1996 22(1):82; Hayes & Blom 1996:82-83; Bahti 1996:13, 17; *Indian Trader* July 1996 27(7):27; June 1999 30(6):20; December 1999 30(12):18; *Santa Fe Visitor's Guide* 1998; Congdon-Martin 1999:93; Berger & Schiffer 2000:40, 147.

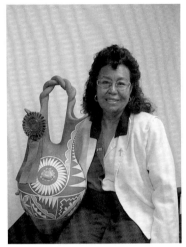

Mary Small -
Courtesy of Jason Esquibel
Rio Grande Wholesale, Inc.

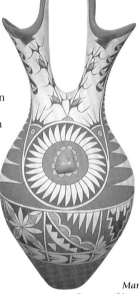

Mary Small -
Courtesy of Joe Zeller
River Trading Post, IL

Mary Small creates traditional and contemporary pottery with a unique gray slip and polychrome designs. She makes some exceptionally large pots. Her wedding vases are formed with twist handles and often turquoise insets in the center of a swirling composition of painted corn plants, lightning & prayer feathers.

Mary also pleasantly greets the public. She is a consistent prizewinner at major Indian art shows. She is like a jewel in the Indian art world. She enjoys a warm following of collectors.

Al Anthony of Adobe Gallery in Albuquerque credits Mary Small with helping to revive fine quality pottery making at Jemez. She worked hard over the decades to encourage excellence and a sense of pride. She has succeeded in helping to bring out the best among her friends and family.

Mary views pottery making to be a spiritual act. She prays during each step in the process. She explains, "When my pottery is finished, they are blessed. They have power." With respect for Mother Earth, Mary accepts her blessing graciously.

Scott Small

(Jemez/San Felipe, Sun Clan, active ?-present: pottery)
FAMILY: grandson of Seriaco & Perfectita Toya; son of Mary Small (Jemez); sister of Louie Toya & Lettie Small
GALLERIES: The Indian Craft Shop, U.S. Department of Interior, Washington, D.C.; Rio Grande Wholesale, Inc., Albuquerque
PUBLICATIONS: Hayes & Blom 1998:40-41.

Mary Small -
Courtesy of Jason Esquibel
Rio Grande Wholesale, Inc.

Scott Small -
Courtesy of Jason Esquibel
Rio Grande Wholesale, Inc.

Simon Small

(San Felipe, active ca. 1980s-present: pottery, jewelry)
EXHIBITIONS: 1992-present, Indian Market, Santa Fe:
PUBLICATIONS: *Southwest Profile*, Nov. 1985:20.

Sheila Chavez Smith *(signs S. C. Jemez, N.M.)*

(Jemez, active ca. 1992-present: traditional polychrome jars, bowls)
BORN: June 24, 1971
FAMILY: daughter of Celina Chavez
TEACHER: Celina Chavez, her mother
PUBLICATIONS: Berger & Schiffer 2000:147.

Tim Smith *(see Coyote)*

Snowflake Flower *(Snowflake, Estephanita Cordero, Stephanie C. Rhoades; hallmark - snowflake & flower)*

(Cochiti, Fox Clan, active ca. 1979-present: polychrome Storytellers, Nativities, jars, bowls, owls, figures)

BORN: December 26, 1931
FAMILY: m. granddaughter of Estephanita Herrera; daughter of Eluterio & Berina Cordero; sister of Ada Suina, Polly Cordero, Mary Cordero, Joe Cordero & Francis Cordero; wife of Cipriano Loretto (Jemez); mother of Phillip Loretto, Mary Francis Loretto, Patricia Ann Loretto, Mary Mildred Loretto & Jonathan Loretto
EDUCATION: 1985, BS in Education, University of New Mexico, Albuquerque
TEACHER: Berina Cordero, her mother, and Mary Martin, her cousin
AWARDS: 1983, 3rd; 1984, 2nd; 1989, 1st, Storytellers, 1st, Figures; 1993, John R. Botts Award for Best Storyteller, 2nd, Indian Market, Santa Fe; John Botts Memorial, Best Cochiti Storyteller; 1995, 1st; Nativities; Indian Markete 1998, 2nd, Southwest Indian Art Show
EXHIBITIONS: 1983-98, Indian Market, Santa Fe; New Mexico State Fair, Albuquerque; 1992-present, Santo Domingo Arts & Crafts Show; 1999-present, Albuquerque Indian Market
COLLECTIONS: Allan & Carol Hayes; John Blom; Dave & Lori Kenney
FAVORITE DESIGNS: prayer feathers, coyotes, prairie dogs, bears, turtles
GALLERIES: The Indian Craft Shop, U.S. Department of Interior, Washington, D.C.; Andrews Pueblo Pottery & Art Gallery, Rio Grande Wholesale, Albuquerque
PUBLICATIONS: *Indian Market Magazine* 1985, 1988, 1989; *Southwest Profile* Oct. 1989 12(9):30-31; *American Indian Art Magazine* Winter 1993 19(1):29; Bahti 1996:35; Hayes & Blom 1996; 1998:43, 49; Congdon-Martin 1999:29-30; *Cowboys & Indians* Dec. 1999 7(6):78; Berger & Schiffer 2000:142.

Snowflake Flower -
Photograph by Angie Yan Schaaf

In the Summer of 2001, we met Snowflake Flower at the Albuquerque Indian Market. Her figural group of prairie dogs and several of her Storytellers were acquired by avid collectors, as soon as the show opened. She was especially helpful proofreading the Cochiti manuscript. She kindly shared her memories and knowledge, reciting successive generations for family tree charts.

Snowflake Flower told about her namesake, Grandmother Estephanita, matriarch of the Fox Clan. Snowflake Flower shared how her mother taught her to make pottery. As a little girl, she asked her mother why her miniature figures were larger at first and seemed to shrink smaller after the firing. Later, her cousin, Mary Martin, also helped in her pottery development.

Snowflake Flower pointed to the prayer feathers on top of each of her figures: "I began putting these feathers on my figures in 1983, when my daughter, Patricia Ann Loretto, went into a coma. I continued to put these feathers on my figures, so the prayers for her recovery would be spread through more and more people. Finally, on December 21, 1999, our prayers were answered when my daughter woke up after being asleep for 16 years! They called and said she just woke up. They put her on the phone and my daughter said to me, 'Hi Mom. I love you Mom. Merry Christmas Mom.' She woke up hungry for strawberries!

Snowflake Flower -
Dave & Lori Kenney Collection

Snowflake Flower continued, "Now I pray for my health, so I can continue to live with her. I am thankful for all who bought my pottery over the years, carrying the prayers for my daughter to their homes."

Snowflake Flower -
Courtesy of the artist

Verna Solomon

(Laguna/Zuni, active ca. 1980s-present: traditional & contemporary pottery, stoneware, raku, mixed media masks)
EXHIBITIONS: 1994-present, Indian Market, Santa Fe; 1995-present, Eight Northern Indian Pueblos Arts & Crafts Show
PUBLICATIONS: *Indian Market Magazine* 1988, 1994, 1995, 1997, 1998; *Southwest Art* Nov. 1990:25; Dillingham 1992:203-04; Tucker 1998: plate 112.

Verna balances between traditional and contemporary styles of pottery: "I like change, but I also like tradition. I have both in me, and I try to show it in my art. All the ideas I've ever had in my pottery have kept the Native American elements I keep in me. With the raku, I've used turquoise stones or modeled kiva steps, representations of nature and some part of my Southwestern upbringing."

"It is good to keep tradition, so it won't die out, but we also want the children to express themselves. If we are going to compete with non-Indians in contemporary art, we have to go with the flow." (Dillingham 1992:203)

Berdel Soseeah *(collaborates with Agnes Peynetsa)*

(Zuni, active ?-present: polychrome jars, bowls, frogs, miniatures)
FAMILY: son of Marie Soseeah; brother of Loubert Soseeah; husband of Agnes Peynetsa
EXHIBITIONS: 1998-present, Indian Market, Santa Fe
PUBLICATIONS: Nahohai & Phelps 1995:back cover, 58-63; Painter 1998:184-90.

Berdel and his wife, Agnes, are a husband-wife pottery-making team. They collect their clay often in the company of his mother, Marie Soseeah. Berdel forms the pottery at night, then Agnes forms the frog and lizard figures to be added to their effigy pots. Berdel sands them smooth, and Agnes paints them. The final work is fired in a kiln. They are known for their beautiful and graceful forms.

Loubert Soseeah *(signs L. Soseeah)*

(Zuni, active ca. 1980s-present: white slipped and unslipped polychrome jars, dough bowls, cornmeal bowls with twist handles, canteens, stone carvings)
BORN: ca. 1967
FAMILY: son of Marie Soseeah; brother of Berdel Soseeah
FAVORITE DESIGNS: frogs, tadpoles, terraced clouds, rain, swirls, rosettes
PUBLICATIONS: Rodee & Ostler 1986:63, 74, 78-81; Nahohai & Phelps 1995:61.
 Loubert Soseeah is especially noted for making beautifully painted and well-formed dough bowls and canteens. His jars often have long graceful necks. He makes larger forms than most Zuni potters. He is respected as a fine potter with a bright future. However, much of his time now is devoted to carving fetishes. He is a multi-talented artist.

Marie Soseeah

(Zuni, active ca. 1960s-?: traditional polychrome jars, bowls)
BORN: ca. 1940s
FAMILY: mother of Berdel & Loubert Soseeah; mother-in-law of Agnes Peynetsa
PUBLICATIONS: Nahohai & Phelps 1995:59.
 Marie Soseeah often gathers clay in a traditional way with her sons, Berdel and Loubert, along with Berdel's wife, Agnes Peynetsa. They collect ironstone at Nutria.

Sratyuiue

(Laguna, active ca. 1980s-90s: polychrome jars, bowls)
FAVORITE DESIGNS: birds, split leaf

Sri-Tzee-Yaa *(see Rebecca Russell)*

Dolores Stein

(Acoma, active ca. 1900s-60s?: traditional polychrome jars, bowls)
BORN: ca. 1890s
FAMILY: mother of Frances Abeita; grandmother of Louise Amos & Jennie Laate; great-grandmother of Maggie Laate
PUBLICATIONS: Babcock 1986:155; Berger & Schiffer 2000:98.

Irene Stevens

(Acoma, active ?-1990+: polychrome jars, bowls)
PUBLICATIONS: Dillingham 1992:206-208.

Manuel Stevens *(signs STEVENS)*

(Acoma, Bear Clan, active ca. 1984-present: traditional polychrome bowls, some large ollas up to 24 x 20")
BORN: June 16, 1957
FAMILY: m. grandson of Lolita Garcia; son of James & Rosita Stevens
TEACHER: Rosita Stevens, his mother
PUBLICATIONS: Berger & Schiffer 2000:148.

Rose Stevens *(Rosita Stevens)*

(Acoma, Bear Clan, active ca. 1960s-?: traditional polychrome jars, bowls)
BORN: ca. 1940
FAMILY: daughter of Lolita Garcia; wife of James Stevens; mother of Sharon Stevens, Manuel Stevens & Virginia Garcia
STUDENTS: Manuel Stevens, her son

Sharon Stevens *(Butterfly, Turquoise), (signs S. or S. L. Stevens & Bear Paw hallmark, Acoma, NM)*

(Acoma, Bear Clan, active ca. 1973-present: large Mimbres & Anasazi Revival & traditional fineline black-on-white, black-on-red, polychrome storage jars with handles, ollas, jars, bowls)
BORN: September 24, 1960
FAMILY: granddaughter of Lolita Garcia; daughter of James & Rose (Rosita) Stevens; sister of Virginia Garcia & Manuel Stevens
TEACHERS: Lolita Garcia, her grandmother, and Rose Stevens, her mother
FAVORITE DESIGNS: lizards, turtle back [concentric rectangles], frets, rain
GALLERIES: Rio Grande Wholesale, Inc., Palms Trading Co., Albuquerque
PUBLICATIONS: Dillingham 1992:206-208; Berger & Schiffer 2000:148.
 Sharon Stevens explained her favorite designs: "Lizards are believed to bring good luck, and turtles bring you long life." She paints her designs with a yucca brush using traditional paints. She says that she likes to make larger pottery, because she can be "more creative with designs."

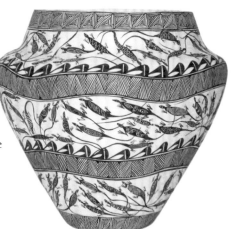

Sharon Stevens -
Candace Collier Collection, Houston, TX

Sharon Stevens - Courtesy of Jason Esquibel
Rio Grande Wholesale, Inc.

Virginia Stevens

(Acoma, active ?-1970s-present: polychrome jars, bowls)
GALLERIES: GALLERIES: Rio Grande Wholesale, Inc., Albuquerque
PUBLICATIONS: Dillingham 1992:206-208.

*Virginia Stevens -
Courtesy of Jason Esquibel
Rio Grande Wholesale, Inc.*

Dale Suazo

(Acoma, active ?-1990+: polychrome jars, bowls)
PUBLICATIONS: Dillingham 1992:206-208.

Ada Suina *(Ada Cordero) (collaborates sometimes with Tony Suina)*

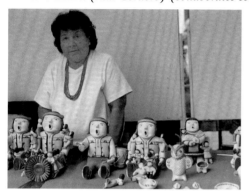

Ada Suina - Courtesy of the artist

(Cochiti, Fox Clan, active 1973-present:
polychrome jars, bowls, Storytellers,
drummers, figures)
BORN: May 20, 1930
FAMILY: m. granddaughter of Juan &
Estefanita Herrera; daughter of Berina &
Eluterio Cordero; sister of Snowflake Flower;
daughter-in-law of Aurelia Suina; wife of Tony Suina
(drummaker); mother of Caroline Grace Suina, Marie Charlotte Suina, Maria
Suina, Patty Suina, Regina Suina & 6 others.
AWARDS: 1976, 2nd; 1979 1st (2); 1980, 1st (3); 1981, 2nd (2); 1983, 1st (2);
1984, John R. Bott Award, Best Cochiti Storyteller, 1st 2nd; 1989, John R. Bott
Award, Best Cochiti Storyteller; 1991, 1st, 2nd; 1992, 2nd; 1993, 1st, Figures;
1994, John R. Bott Award, Best Cochiti
Storyteller; 1995, 1st, Figures; 1996, 1st,
2nd, 3rd; 1998, 3rd; 1999, 1st, Indian
Market, Santa Fe; Inter-tribal Indian Ceremonial, Gallup, NM; New Mexico State Fair,
Albuquerque
EXHIBITIONS: pre-1976-present, Indian Market, Santa Fe; 1979, "One Space: Three Visions,"
Albuquerque Museum, Albuquerque
DEMONSTRATIONS: 1987, Museum of Indian Arts & Cultures, Santa Fe
COLLECTIONS: Museum of Albuquerque, Albuquerque, Nativity, ca. 1978
GALLERIES: Hoel's Indian Shop, Oak Creek Canyon, AZ; Adobe Gallery, Albuquerque
& Santa Fe; Andrews Pueblo Pottery & Art Gallery, Albuquerque
PUBLICATIONS: Tanner 1976:121; *SWAIA Quarterly* Fall 1976:13; Fall 1982:10;
Monthan 1979:31-33; Barry 1984:115, 118; Babcock 1986:130; Trimble 1987; *Indian
Market Magazine* 1988, 1989; *American Indian Art Magazine* Aug. 1988 13(4):47;
Southwest Art May 1989:68, 70; Congdon-Martin 1999:30; Berger & Schiffer 2000:148.

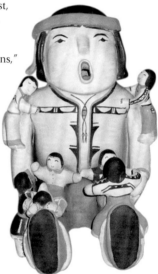

*Ada Suina - Courtesy of
Hoel's Indian Shop
Oak Creek Canyon, AZ*

Ada Suina was inspired to make pottery by her grandmother, Estefanita
Herrera, who was an accomplished potter. Ada watched her make large dough
bowls and pitchers with lizard spouts. Ada's cousin, Virginia Naranjo, taught her
the fine points of pottery making.

Ada is best known for her Nativities which she began making in 1977. She also
is admired for her traditionally fired Storytellers and figures. She explained, "Firing
is the main part of the pottery process and always the hardest part."

Ada is an innovative artist, who explores different directions in her artwork: "As
you go along, you always try to teach yourself something new."

Anita Suina *(1)*

(Cochiti, active ca. 1930s-?: traditional polychrome jars, bowls)
BORN: ca. 1900-1910
FAMILY: sister of Marianita Venado; mother of Ernest Suina; mother-in-law of Louise Q. Suina; p. grandmother of Vangie Suina; p.
great-grandmother of Randi Simone Suina, Jalen Suina, Melanie Suina

Anita Suina *(2)*

(Cochiti, active ca. 1960s-?: pottery)
BORN: ca. 1940s
PUBLICATIONS: *Southwest Art* June 1983 13(1):83-84.

Anthony W. Suina *(Collaborates sometimes with Mary Vangie Suina)*

(Cochiti, active ca. 1980s-?: Storytellers)
ARCHIVES: Artist's file, Heard Museum Library, Phoenix

Antonita Cordero Suina *(see Toni Suina)*

Aurelia Suina

(Left to right): **Juanita Arquero, Aurelia Suina &
Virginia Naranjo** *- Courtesy of Virginia Naranjo*

(Cochiti, active ca. 1930s-70s: traditional polychrome jars, bowls, Storytellers,
Nativities, owl figures, beadwork)
BORN: October 30, 1911
FAMILY: daughter of Victoria Montoya; niece of Reycita Romero; wife of Pasqual
Suina (drummaker); mother of Tony Suina; grandmother of Caroline Grace
Suina, Marie Charlotte Suina, Maria Suina, Patty Suina & Regina Suina
EXHIBITIONS: 1979, "One Space: Three Visions," Albuquerque Museum,
Albuquerque
COLLECTIONS: Wright Collection, Peabody Museum, Harvard University,
Cambridge, MA; Museum of New Mexico, Laboratory of Anthropology, Santa Fe,
ca. 1975
PUBLICATIONS: Tanner 1976:121; Toulouse 1977:32-33; Monthan 1979:83;
American Indian Art Magazine Spring 1983 8(2):30, 36; *Indian Market Magazine*
1985, 1988, 1989; Babcock 1986:131; Drooker, et al., 1998:49, 138.
 Aurelia made pottery in the old traditional way. Her work is highly sought
after for her use of traditional techniques and materials. Her pots have a fine
patina from her careful polishing. In 1968, she made her first Storyteller.

B. Suina

(Cochiti, active ca. 1990-present: polychrome Storytellers, Mudheads)
GALLERIES: Palms Trading Company, Albuquerque; Crosby Collection, Park City, UT
PUBLICATIONS: Congdon-Martin 1999:32.

Brian Suina *(Joseph Brian Suina)*

(Cochiti, active ca. 1990s-present: polychrome ollas, jars, bowls, bird figures)
BORN; June 25, 1966
EDUCATION: Institute of American Indian Arts, Santa Fe
FAVORITE DESIGNS: Water Serpents, clouds, water, rain
COLLECTIONS: Heard Museum, Phoenix; Dr. Gregory & Angie Yan Schaaf, Santa Fe; John Blom
GALLERIES: Millicent Rogers Museum Shop, Taos, NM

Buffy Cordero Suina *(see Buffy Cordero)*

Carol Suina

(Cochiti, active ca. 1990-present: polychrome Storytellers)
PUBLICATIONS: Congdon-Martin 1999:34.

Caroline Grace Suina

(Cochiti, active ca. 1970s-present: Storytellers)
BORN: November 7, 1955
FAMILY: p. great-granddaughter of Victoria Montoya; m. granddaughter of Eluterio & Berina Cordero; p.
granddaughter of Aurelia Suina & Tony Suina, Sr.; daughter of Ada Suina & Tony Suina, Jr.; sister of Marie
Charlotte Suina, Maria Suina & Patty Suina
EXHIBITIONS: 1983, Indian Market, Santa Fe
PUBLICATIONS: Babcock 1986:131.

D. Suina *(Water Fox)*

(Cochiti, active ca. 1990-present: polychrome Storytellers, Mudheads)
PUBLICATIONS: Congdon-Martin 1999:34.

Dena M. Suina *(Denia Suina)*

(San Felipe, married into Cochiti, active ca. 1991-present: traditional & non-traditional poly-
chrome Storytellers)
BORN: September 12, 1961
FAMILY: daughter of Joe & Juana Trancosa; daughter-in-law of Ada Suina
TEACHER: Ada Suina, her mother-in-law
AWARDS: 1998, 2nd; 1999, 1st, Indian Market, Santa Fe; 1999, New Mexico State Fair,
Albuquerque; 2nd, Inter-tribal Indian Ceremonial, Gallup
EXHIBITIONS: 1988-present, Indian Market, Santa Fe
COLLECTIONS: John Blom
GALLERIES: Tribal Arts Zion, Springdale, UT; Arlene's Gallery, Tombstone, AZ; Andrews
Pueblo Pottery & Art Gallery, Rio Grande Wholesale, Palms Trading Company, Albuquerque
PUBLICATIONS: Hayes & Blom 1996; Congdon-Martin 1999:35; Berger & Schiffer 2000:148.
 Dena M. Suina is from San Felipe and married into Cochiti. She learned to create
Storytellers by watching her mother-in-law, Ada Suina. Dena is noted for making the
tiniest babies on her Storytellers. Each are sculpted and painted with precision. Her work
is very clean and well balanced. She makes male drummers, as well as grandmothers.
She hand coils and forms her figures, then paints them with intricate designs.

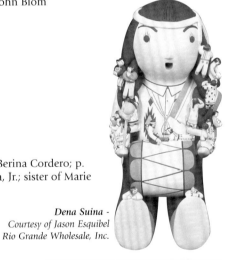

*Dena Suina -
Courtesy of Jason Esquibel
Rio Grande Wholesale, Inc.*

*Dena Suina - Courtesy of Jason Esquibel
Rio Grande Wholesale, Inc.*

Denise Suina
(Cochiti, active ?-present: polychrome jars, bowls)
PUBLICATIONS: Hayes & Blom 1998:35.

Elizabeth Suina *(see Buffy Cordero)*

Esther K. Suina *(signs E. K. Suina with Blooming Flower hallmark), (collaborates with Joseph Suina)*
(Cochiti/Apache/Hopi, active ca. 1977-present: polychrome jars, bowls, Storytellers)
BORN: April 1, 1943
AWARDS: Indian Market, Santa Fe; Inter-tribal Indian Ceremonial, Gallup, NM; New Mexico State Fair, Albuquerque
GALLERIES: Palms Trading Company, Albuquerque
PUBLICATIONS: Congdon-Martin 1999:35; Berger & Schiffer 2000:149.

Evangeline F. Suina
(Cochiti, active ca. 1970s-present: pottery, beadwork)
BORN: ca. 1940s
FAMILY: m. granddaughter of Vicente & Reyes T. Romero; daughter of Lucy R. Suina
EXHIBITIONS: 1988-present, Indian Market, Santa Fe
PUBLICATIONS: *Indian Market Magazine* 1988, 1989.

Frances Naranjo Suina
(Cochiti/San Ildefonso, active1930-80s: traditional polychrome jars, bowls, Storytellers, figures, Nativities, angels, pigs, miniatures)
BORN: September 2, 1902 at San Ildefonso Pueblo
FAMILY: daughter of Juan Roybal (San Ildefonso); first husband was Mr. Naranjo, second husband was Mr. Suina; mother of Louis Naranjo, Sarah Suina, 4 other children; mother-in-law of Virginia A. Naranjo; p. grandmother of Mary Edna Trujillo & Pauline Naranjo
EDUCATION: St. Catherine's Orphanage, St. Catherine's Indian School, Santa Fe; Cochiti Indian School
AWARDS: 1973, 1st; Storytellers; 1974, 1st, Indian Market, Santa Fe
EXHIBITIONS: "Nacimientos: Manger Scenes from the Sallie Wagner Collection," Museum of Northern Arizona, Flagstaff, AZ
COLLECTIONS: Sallie Wagner
PUBLICATIONS: *Arizona Highways* May 1974; Tanner 1976:121; Monthan 1979:34-36; Peaster 1997:29.

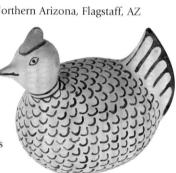

Frances Suina - Courtesy of Eason Eige Albuquerque

Frances Naranjo was born in 1902. She became an orphan when she was less than one-year-old. Her father was Juan Roybal, a painter from San Ildefonso. Frances was the youngest of five daughters.

Frances made pottery through the depression of the 1930s. She learned the old traditional techniques. She continued to use yucca brushes and natural clay throughout her career as a potter.

Twenty-five years ago, Frances was considered "one of the skilled bowl and pot makers of Cochiti Pueblo." (*Arizona Highways* May 1974)

Frances Suina - Courtesy of Don & Lynda Shoemaker Santa Fe

Grace Suina
(Cochiti, active ca. 1990-present: polychrome Storytellers)
GALLERIES: Crosby Collection, Park City, UT
PUBLICATIONS: Congdon-Martin 1999:36.

Ignacita Suina *(see Ignacia Suina Arquero)*

Joseph D. Suina *(collaborates with Esther Suina), (signs Joseph Suina or Blooming Flower, EK Suina)*
(Cochiti, active ca. 1982-present: polychrome Storytellers, owls)
BORN: ca. 1943
AWARDS: Indian Market, Santa Fe; Inter-tribal Indian Ceremonial, Gallup; New Mexico State Fair, Albuquerque
COLLECTIONS: John Blom
PUBLICATIONS: Hayes & Blom 1996:64; 1998:49; Congdon-Martin 1999:36; Berger & Schiffer 2000:149.

Joseph Suina - Courtesy of John Blom

Judith A. Suina *(Judy) (signs J. Suina)*
(Cochiti, active ca. 1982-present: polychrome jars, bowls, Storytellers)
BORN: April 14, 1960
FAMILY: daughter of Dorothy & Onofre Trujillo; sister of Cecilia Valencia Trujillo, Frances Pino, Onofre Trujillo, Jr.
EXHIBITIONS: 1994-present, Indian Market, Santa Fe
COLLECTIONS: Dr. Gregory & Angie Yan Schaaf, Santa Fe
PUBLICATIONS: Babcock 1986:132; Hayes & Blom 1996:62; Bahti 1996:28; Congdon-Martin 1999:36; Berger & Schiffer 2000:149.

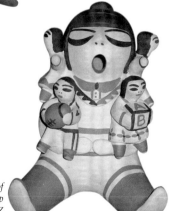

Judy Suina - Courtesy of Hoel's Indian Shop Oak Creek Canyon, AZ

Katherine Suina

(Cochiti, active ?-present: polychrome jars, bowls, figures, Storytellers)
BORN: ca. 1930
FAMILY: wife of Efracio Suina; mother of Carolyn S. Trujillo
PUBLICATIONS: Berger & Schiffer 2000: 155.

Laurencita Suina

(Cochiti, active ca. 1950s-?: traditional polychrome jars, bowls, turtle pots)
COLLECTIONS: Philbrook Museum of Art, Tulsa, OK, turtle pot, ca. 1957

Louise Q. Suina *(1)*

(Cochiti, active ca. 1970s-present: polychrome Storytellers)
BORN: ca. 1939
FAMILY: daughter-in-law of Anita Suina; cousin of Helen Cordero & Seferina Ortiz; wife of Ernest Suina; mother of Vangie Suina; mother-in-law of Judith Suina; m. grandmother of Randi Simone Suina, Jalen Suina, Melanie Suina
GALLERIES: Adobe Gallery, Albuquerque & Santa Fe
PUBLICATIONS: Southwest Art June 1983 13(1):84; Babcock 1986:132; Congdon-Martin 1999:37.

Louise E. Suina *(2)*

(Cochiti, active ?-present: polychrome Storytellers, Corn Maiden figures)
EXHIBITIONS: pre-1985-1989, Indian Market, Santa Fe
COLLECTIONS: John Blom; Walton-Anderson
GALLERIES: Andrews Pueblo Pottery & Art Gallery, Albuquerque
PUBLICATIONS: *Indian Market Magazine* 1985, 1988, 1989; Hayes & Blom 1998:35;
Congdon-Martin 1999:37.

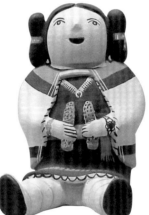

Lucy R. Suina

(Cochiti, active ca. 1940s-?: Storytellers - ca. 1974)
BORN: March 9, 1921
FAMILY: daughter of Vicente & Reyes T. Romero; sister of Pelaria, Catalina, Porfilia & Laurencita Herrera; mother of Evangeline Suina; cousin of Helen Cordero
STUDENTS: Tony Dallas (Hopi/Pima)
EXHIBITIONS: 1988-97, Indian Market, Santa Fe
PUBLICATIONS: Babcock 1986:132; *Indian Market Magazine* 1988, 1989.

Louise E. Suina (2) -
Walton-Anderson Collection

Marie Charlotte Suina

(Cochiti, Fox Clan, active ca. 1970s-present: polychrome jars, bowls, Storytellers - ca. 1980, Nativities, figures)
BORN: July 19, 1954
FAMILY: m. great-granddaughter of Juan & Estefanita Arquero Herrera; m. granddaughter of Eluterio & Berina Cordero; daughter of Ada Suina & Tony Suina, Jr.; sister of Caroline Grace Suina, Maria Suina & Patty Suina
AWARDS: 1988, 2nd, Storytellers, Indian Market, Santa Fe
EXHIBITIONS: 1983-present, Indian Market, Santa Fe
PUBLICATIONS: Babcock 1986:132; Hayes & Blom 1996:62-63; 1998:35; Schiffer 1997:54; Congdon-Martin 1999:37-38.

Mary Suina *(Mary Vangie Suina, Mary Evangeline Suina, Evangela Suina, Mary E. Suina), (signs Mary or Vangie Suina, AWS), (collaborates sometimes with Anthony W. Suina)*

(Cochiti, active ca. 1981-present: polychrome jars, bowls, Storytellers, Nativities, scenes, paintings)
BORN: April 25, 1959
FAMILY: p. granddaughter of Anita Suina (1); daughter of Ernest & Louise Q. Suina; mother of Randi Simone Suina, Jalen Suina, Melanie Suina
TEACHER: Louise Q. Suina, her mother
AWARDS: 1983, 3rd; 1984, 3rd (2); 1991, 2nd, Indian Market, Santa Fe; Best of Show, Heard Museum, Phoenix, AZ
EXHIBITIONS: 1982-present, Indian Market, Santa FE
PUBLICATIONS: *Southwest Art* June 1983 13(1):82-84, 87; October 1996 26(5):34; Babcock 1986:132; *American Indian Art Magazine* Autumn 1987 12(4):24; Summer 1988 13(3):12; Berger & Schiffer 2000:149.

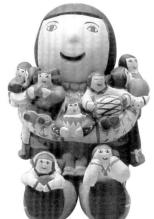

N. Suina

(Cochiti, Water Fox Clan, active ?-present: Storytellers)
PUBLICATIONS: Congdon-Martin 1999:38.

Norma A. Suina *(signs N.S. Cochiti N.M.)*

(Cochiti/Hopi, active ca. 1977-present: polychrome jars, bowls, Storytellers, Mudheads)
BORN: March 30, 1944
FAMILY: daughter of Ellis Fredericks
TEACHER: Dorothy Trujillo
PUBLICATIONS: Berger & Schiffer 2000:91, 149.

Vangie Suina -
Walton-Anderson Collection

Ramus Suina

(Cochiti, active ?-present: Storytellers, pottery)
EXHIBITIONS: Eight Northern Indian Pueblos Arts & Crafts Show
PUBLICATIONS: *American Indian Art Magazine* Autumn 1987 12(4):16.

Santana Suina

(Cochiti, active ca. 1890s-?: pottery)
BORN: ca. 1880
FAMILY: daughter of Maria Seferina Arquero

Sarah Suina

(Cochiti/San Ildefonso, active ca. 1940s-?: pottery)
BORN: ca. 1920s
FAMILY: m. granddaughter of Juan Roybal (San Ildefonso); daughter of Frances Naranjo Suina (San Ildefonso) & Mr. Suina (Cochiti); half sister of Louis Naranjo

Seferina Suina *(see Maria Seferina Arquero)*

T. T. Suina

(Cochiti, Water Fox Clan, active ?-present: Storytellers)
PUBLICATIONS: Congdon-Martin 1999:38.

Toni Suina *(Antonita Cordero Suina, Tony Cordero)*

(Cochiti, Fox Clan, active ca. 1980s-?: Storytellers)
BORN: ca. 1948
FAMILY: great-granddaughter of Magdelena & Santiago Quintana; daughter of Fred & Helen Cordero; sister of George Cordero; aunt of Tim Cordero; wife of Del Trancosa
GALLERIES: Adobe Gallery, Albuquerque
PUBLICATIONS: Babcock 1996:28, 128-31; Peaster 1997:25; Congdon-Martin 1999:32.

Toni Suina learned pottery making from Helen Cordero, her famous mother. She makes Storytellers. Little information has been recorded about her.

Vangie F. Suina *(see Mary Suina)*

Suitsa

(Zuni, active ?: pottery)
ARCHIVES: Laboratory of Anthropology Library, Santa Fe; lab. file.

Sunrise drawing - hallmark *(see Elliott Garcia)*

Heather Sun Rhodes

(Jemez, active ca. 1990-present: miniature pots)
AWARDS: 1989, 2nd, 3rd, figures (ages 12 & under); 1991, 2nd, 3rd, figures (ages 12 & under); 1993, 2nd (ages 12 & under), Indian Market, Santa Fe

A. T. *(see Andrea Tafoya)*

J. V. T.

(Jemez, active ?-present: polychrome redware jars, bowls, vases)
FAVORITE DESIGNS: sacred clowns

L. T. *(see Lavine Torivio)*

P. B. T.

(Jemez, active ?-present: Corn Maidens)

V. J. T. *(see Verda J. Toledo)*

Andrea Tafoya *(signs A.T.)*

(Jemez, active ?-present: matter polychrome & fineline ollas, jars, bowls)
FAVORITE DESIGNS: kiva steps, clouds, feathers
PUBLICATIONS: Berger & Schiffer 2000:40.

Angelita Q. Tafoya

(Santo Domingo, active ?-present: cream-on-red & black-on-black pottery, jewelry)
EXHIBITIONS: 1995-present, Eight Northern Indian Pueblos Arts & Crafts Show

Brenda Tafoya *(Brenda Lou Tafoya), (hallmark - Kiva Step design with signature)*

(Jemez, active ca. 1982-present: redware sgraffito, traditional stone polished & polychrome jars, bowls)
BORN: May 3, 1963
FAMILY: daughter of David & Vangie Tafoya; sister of Helen Henderson & Tyron Tafoya
AWARDS: New Mexico State Fair, Albuquerque
EXHIBITIONS: 1997-2001, Indian Market; Eight Northern Indian Pueblos Arts & Crafts Show; Jemez Red Rocks Arts & Crafts Show, Jemez Pueblo, NM; University of Tucson Show, Tucson
FAVORITE DESIGNS: water serpents, hummingbirds, butterflies, owls, melon cut, rain clouds, finelines, daisies
PUBLICATIONS: *Indian Trader* Nov. 1999 30(11):10; Berger & Schiffer 2000:149.

Brenda is one of the few artists who created her own biographical profile and printed it as a flyer. She stated in part: "I have learned from my mother to do pottery. When I first started doing pottery, they would be crooked and my mother would tell me, 'It's okay, just keep making them. Once you sand them down, they will get their shape.' I will always remember that and that is exactly what I tell my daughter. . .I hope that she will carry on her grandmother's and my designs.

"I used to watch my mother form, polish and design her pots. She kept encouraging me to do my own designs, which I did. I will always be grateful to my mother for teaching and encouraging me to do pottery and that one day I will become as famous as she is today."

John D. Kennedy and Georgiana Kennedy Simpson Kennedy Indian Arts

Brenda Tafoya - Courtesy of Jason Esquibel Rio Grande Wholesale, Inc.

Mrs. Juan R. Tafoya

(Jemez, active ca. 1950s-?: traditional polychrome jars, bowls)
BORN: ca. 1930s
FAMILY: wife of Juan R. Tafoya; mother of Donna Ortiz

Pauline Tafoya

(Jemez, active ?-present: polychrome jars, bowls)
FAVORITE DESIGNS: rain clouds, finelines, daisies
PUBLICATIONS: Walatowa Pueblo of Jemez, "Pottery of Jemez Pueblo" (1999).

Terry Tafoya

(Jemez, active ?-present: sgraffito polished redware jars, bowls, seed pots)
FAVORITE DESIGNS: Water Serpent, clouds, lightning, feathers-in-a-row
PUBLICATIONS: Hayes & Blom 1996:84-85.

Tyron Tafoya

(Jemez, active ?-present: polychrome & sgraffito jars & bowls)
FAMILY: son of David & Vangie Tafoya; brother of Brenda Tafoya, Helen Tafoya Henderson

Vangie Tafoya - Courtesy of Joe Zeller River Trading Post, East Dundee, IL

Vangie Tafoya *(sometimes signs V. Tafoya)*

(Jemez/San Ildefonso, active ca. 1982-present: polished redware, black-on-white sgraffito jars, seed pots, melon bowls, wedding vases, canteens, pitchers, miniatures)
BORN: August 4, 1944
FAMILY: granddaughter of Maria Sanchez Colaque; wife of David Tafoya; mother of Brenda Tafoya, Helen Tafoya Henderson & Tyron Tafoya; grandmother of at least one; related to Maria Martinez
STUDENTS: Brenda Tafoya, her daughter, Carmelita Gachupin
AWARDS: Best of Show, New Mexico State Fair, Albuquerque; 1993, 3rd, sgraffito; 1996, 3rd, 1999, 2nd, Indian Market, Santa Fe; Inter-tribal Indian Ceremonial, Gallup; Heard Museum, Phoenix; 1st, 2nd, Eight Northern Pueblos Arts & Crafts Show; 3rd, Mescalero Apache Art Show
EXHIBITIONS: 1992-present, Indian Market, Santa Fe; 1994-present, Eight Northern Indian Pueblos Arts & Crafts Show

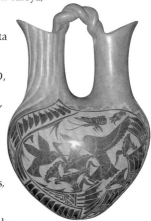

Vangie Tafoya - Courtesy of Jason Esquibel Rio Grande Wholesale, Inc.

FAVORITE DESIGNS: Water Serpents, clouds, hummingbirds, eagles, feathers-in-a-row, floating feathers, kiva steps, fineline rain
GALLERIES: River Trading Post, IL; Kennedy Indian Arts, Bluff, UT
PUBLICATIONS: Barry 1984:119, 130; Schiffer 1991d:49; Hayes & Blom 1996:82-83; *Native Peoples* Feb., Mar., Apr. 1997 10(2):28; Walatowa Pueblo of Jemez, "Jemez Pottery" (1998); *Indian Market Magazine* 1998:100; Berger & Schiffer 2000:40, 147.

Vangie Tafoya - Courtesy of Jason Esquibel Rio Grande Wholesale, Inc.

Tai-u-tetse

(Zuni, active ?: pottery)
ARCHIVES: Laboratory of Anthropology Library, Santa Fe; lab. file.

Sue Tapia *(collaborates with Tom Tapia) (signs "Sue" or "Tom & Sue")*

(Laguna/married into San Juan, active ca. 1987-present: carved blackware, duotones (red & black), sgraffito jars, bowls, embroidery)
BORN: May 11, 1946
FAMILY: daughter of Edward Poncho, Sr. & Mabel Poncho; wife of Tom Tapia (San Juan); mother of
Patrick Valencia & Matt Valencia
TEACHER Mabel Poncho, her mother
AWARDS:

1994	First, Eight Northern Indian Pueblos Arts & Crafts Show
	Third, Inter-tribal Indian Ceremonial, Gallup
1995	First, Second, Eight Northern Indian Pueblos Arts & Crafts Show
	First, Second, Inter-tribal Indian Ceremonial, Gallup
1999	First, Second, Eight Northern Indian Pueblos Arts & Crafts Show
no date	New Mexico State Fair, Albuquerque

COLLECTIONS: Jill Giller, Native American Collections, Denver, CO; Tom & Millie McEntire,
Las Vegas, NV
GALLERIES: Andrea Fisher Fine Pottery, Santa Fe
PUBLICATIONS: Hayes & Blom 1996:126; Schaaf 2000:252; Berger & Schiffer 2000:145.

Tom & Sue Tapia -
Andrea Fisher Fine Pottery
Santa Fe

Alisa Taptto

(Acoma, active ca. 1991-present: traditional polychrome seed pots)
BORN: November 30, 1970
FAMILY: daughter of David & Monica Taptto
TEACHER: Monica Taptto, her mother
AWARDS: Best of Show, 1st, Southern Plains Indian Art Show, Anadarko, OK
PUBLICATIONS: Berger & Schiffer 2000:148.

Monica Taptto

(Acoma, active ca. 1970s-present: traditional polychrome seed pots)
BORN: ca. 1950
FAMILY: wife of David Taptto; mother of Alisa Taptto
STUDENTS: Alisa Taptto, her daughter

Tempe Tenans

(Santo Domingo, active ca. 1940s-?: traditional polychrome ollas, jars, bowls)
COLLECTIONS: Philbrook Museum of Art, Tulsa, OK, jar, ca. 1950

Chris Teller *(Christine, Chris Lucero, Pe-ou, Misty), (signs C. Teller, Isleta, N.M.)*

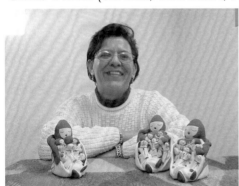

Chris Teller - Courtesy of Jason Esquibel
Rio Grande Wholesale, Inc.

(Isleta, active ca. 1973-present: Storytellers, Nativities, sculptures, figures, poly-
chrome jars, bowls)
BORN: January 10, 1956
FAMILY: m. great-great-granddaughter of Marcellina Jojola; m. great-granddaugh-
ter of Emilia Lente Carpio; m. granddaughter of Rudy & Felicita Jojola; daughter
of Stella Teller & Louis Teller; sister of Mona, Robin & Lynette Teller
AWARDS: 1989, 1st, New Mexico State Fair, Albuquerque;
1995, 1st, Indian Market, Santa Fe; 1996, 2nd, New Mexico
State Fair, Albuquerque; 1998, 3rd, Indian Market, Santa
Fe
EXHIBITIONS: 1985-present, Indian Market, Santa Fe;
1995-96, Eight Northern Indian Pueblos Arts & Crafts
Show
GALLERIES: The Indian Craft Shop, U.S.
Department of Interior, Washington, D.C.; Tribal
Arts Zion, Springdale, UT; Arlene's Gallery,
Tombstone, AZ

PUBLICATIONS: *Indian Market Magazine* 1985, 1988; Babcock 1986:79, 154; Hayes & Blom 1996,
1998:35; Peaster 1997:59; Congdon-Martin 1999; Berger & Schiffer 2000:151.

Chris Teller is a top prize-winning Storyteller artist. She won first prize for Storytellers at
Indian Market in Santa Fe. Her Storytellers are among the few with crossed legs. Her figures have
sleeping eyes. The grandmothers and babies often are singing. Some wear their hair in Hopi
butterfly whorls. Her animal figures hug the ground. Her work is distinctive and attractive.

Christine Teller -
Walton-Anderson Collection

Leslie Teller *(see Leslie Valardez)*

Lynette Teller

(Isleta, active ca. 1984-present: Storytellers, figures, polychrome jars, bowls)
BORN: August 21, 1963
FAMILY: m. great-great granddaughter of Marcellina Jojola; m. great-granddaughter of Emilia Lente Carpio; m. granddaughter of Rudy & Felicita Jojola; daughter of Stella & Louis Teller; sister of Chris Lucero, Mona, & Robin Teller
AWARDS: 1996, 2nd, Indian Market, Santa Fe; New Mexico State Fair, Albuquerque; Inter-tribal Indian Ceremonial, Gallup
EXHIBITIONS: 1985-present, Indian Market, Santa Fe; 1995-present, Eight Northern Indian Pueblos Arts & Crafts Show
GALLERIES: The Indian Craft Shop, U.S. Department of Interior, Washington, D.C.
PUBLICATIONS: *Indian Market Magazine* 1985, 1988, 1989, 1996:53, 54; Babcock 1986:79, 154; Hayes & Blom 1996; Peaster 1997:59; Congdon-Martin 1999; Berger & Schiffer 2000:151.

Mona Teller *(Pa-Shawn-Thupa-Wa, Ramona Teller Blythe)*

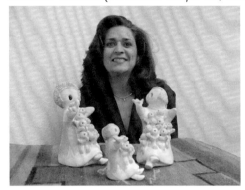

(Isleta, active ca. 1972-present: Storytellers, Corn Maiden, Nativities, figures, turtles, polychrome jars, bowls)
BORN: October 15, 1960
FAMILY: m. great-great granddaughter of Marcellina Jojola; m. great-granddaughter of Emilia Lente Carpio; m. granddaughter of Rudy & Felicita Jojola; daughter of Stella & Louis Teller; sister of Chris Lucero, Robin & Lynette Teller; mother of Christopher Teller & Nicol Teller Blythe
TEACHERS: Stella Teller, her mother and her sisters
AWARDS: Indian Market, Santa Fe; New Mexico State Fair, Albuquerque; Inter-tribal Indian Ceremonial, Gallup
GALLERIES: The Indian Craft Shop, U.S. Department of Interior, Washington, D.C.; Bien Mur; Rio Grande Wholesale, Palms Trading Company, Albuquerque
PUBLICATIONS: *Indian Market Magazine* 1988, 1989; Babcock 1986:79, 154; Hayes & Blom 1996; Peaster 1997:59; Congdon-Martin 1999; Berger & Schiffer 2000:92, 151.

Mona Teller - Courtesy of Jason Esquibel Rio Grande Wholesale, Inc.

Mona Teller - Walton-Anderson Collection

Mona Teller is a fine clay sculptor. She forms graceful figures for Storytellers, Nativities and other figures. She calls her figures of children at play the "Moz Kids." Her animal figures have unique and fun personalities.

Mona has a strong sense of design. One of her Storytellers comes to life as a bird lands on Grandmother's finger. Each figure strikes a distinctive pose. Mona Teller's clay sculptures are most attractive.

Nanette Teller

(Isleta, active ?-present: pottery, figures, snakes)
PUBLICATIONS: Hayes & Blom 1998:53.

Nicole B. Teller *(Nicol)*

(Isleta, active ca. 1990s-present: traditional figures, polychrome jars, bowls)
BORN: April 6, 1978
FAMILY: m. great-great-great-granddaughter of Marcellina Jojola; m. great-great-granddaughter of Emilia Lente Carpio; m. great-granddaughter of Rudy & Felicita Jojola; m. granddaughter of Stella & Louis Teller; daughter of Ramona Blythe (Mona) Teller
PUBLICATIONS: Berger & Schiffer 2000:151.

Robin Teller *(Marie Valardez, Maria Robin Teller Velardez)*

(Isleta, active ca. 1988-present: Mother Nature Storytellers, Nativities, human & animal figures, polychrome jars, bowls)

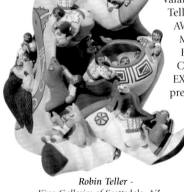

BORN: March 7, 1954
FAMILY: m. great-great-granddaughter of Marcellina Jojola; m. great-granddaughter of Emilia Lente Carpio; m. granddaughter of Rudy & Felicita Jojola; daughter of Stella & Louis Teller; wife of Ray Valardez; sister of Chris, Mona, & Lynette Teller; mother of Leslie Teller Valardez
AWARDS: 1991, 1st, Storytellers; 1992, 3rd, figures, Indian Market, Santa Fe; 1998, Best of Division, figurative pottery, Heard Museum, Phoenix; Eight Northern Pueblo Indian Arts & Crafts Show, New Mexico
EXHIBITIONS: 1988-present, Indian Market, Santa Fe; 1994-present, Eight Northern Indian Pueblos Arts & Crafts Show, New Mexico
COLLECTIONS: Walton-Anderson
GALLERIES: Bien Mur, Albuquerque; Adobe East, Delray Beach, FL
PUBLICATIONS: *American Indian Art Magazine* Spring 1992:32, 91; Winter 1993:28; Summer 1999:20; Hayes & Blom 1996, 1998:151; Peaster 1997:59; Congdon-Martin 1999; Berger & Schiffer 2000:151.

Robin Teller - King Galleries of Scottsdale, AZ

Robin Teller - Walton-Anderson Collection

Stella Teller

(Isleta, active ca. 1962-present: Storytellers, Nativities; figures, sets, polychrome jars, bowls, wedding vases, canteens, wind chimes, some with effigy appliques, early experimental greenware)
FAMILY: daughter of Rudy & Felicita Jojola; wife of Louis Teller; mother of Chris, Mona, Robin & Lynette Teller
AWARDS: 1978, 3rd, Nativity; 1979, 2nd, Storyteller; 1980, 2nd; 1981, 3rd; 1984, 1st, sets, 3rd, non-traditional jars; 1998, 2nd, Indian Market, Santa Fe
EXHIBITIONS: 1979, "One Space: Three Visions," Albuquerque Museum, Albuquerque; 1982-present, Indian Market, Santa Fe; 1995-present, Eight Northern Indian Pueblos Arts & Crafts Show
COLLECTIONS: Wright Collection, Peabody Museum, Harvard University, Cambridge, MA; Folk Museum, Berlin, Germany; Frank Kinsel, San Anselmo, CA; Peter B. Carl, OK, Walton-Anderson
FAVORITE DESIGNS: turtles, rain, clouds, kiva steps, Pueblo dancers
VALUES: On May 26, 1999, a large polychrome seed jar (14″ dia.), signed Stella Teller, Isleta, N.M., 79, sold for $1,495, at Sotheby's, #301.
GALLERIES: Tribal Arts Zion, Springdale, UT
PUBLICATIONS: *American Indian Art Magazine* Spring 1977:6; Summer 1983:33; Spring 1984:72; Summer 1988:9; Spring 1992:95; Summer 1992:99; Autumn 1992:87; Winter 1993:29, 76; Winter 1996:82; *SWAIA Quarterly* Fall 1982:11; Barry 1984:178-79; *Southwest Profile* July 1985:42; *Indian Market Magazine* 1985, 1988, 1989. 1996:53, 65; Trimble 1987:24-24, 74, 82-83, 106-07; *Indian Artist* Spring 1995:20; Bahti 1996:15; Hayes & Blom 1996, 1998; Peaster 1997:59-60; Drooker & Capone 1998:56, 138; Berger & Schiffer 2000:92, 151.

Stella Teller -
Peter B. Carl Collection
Oklahoma City, OK

Stella Teller -
Walton-Anderson
Collection

Del Mar Tenorio *(collaborates with Trini Peña)*

(Santo Domingo, active ?-present: large polychrome storage jars, bowls)
COLLECTIONS: Sunshine Studio
FAVORITE DESIGNS: horses, leaves

Gary Tenorio, Sr. *(signs G. Tenorio, Santo Domingo)*

(Santo Domingo, active ca. 1980-present: polychrome jars, bowls, Storytellers)
BORN: September 29, 1957
FAMILY: son of Victor & Ramona Tenorio
AWARDS: Indian Market, Santa Fe
PUBLICATIONS: Berger & Schiffer 2000:151.

Juanita Calabaza Tenorio

(Santo Domingo, active ca. 1940s-?: traditional polychrome ollas, jars, bowls, jewelry)
BORN: ca. 1920s
FAMILY: daughter of Clemente & Nescita Calabaza; wife of Andres Tenorio; mother of Robert Tenorio, Paulita Pacheco, Mary Edna Tenorio and Hilda Coriz
ARCHIVES: Heard Museum Library, Phoenix, artist file.

Karen Tenorio

(Santo Domingo, active ?-present: polychrome Storytellers)
PUBLICATIONS: Bahti 1996:32-33.

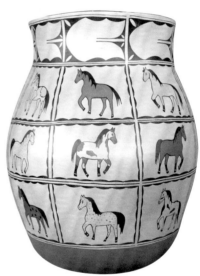

Del Mar Tenorio & T. Peña -
Courtesy of Sunshine Studio

Kendrick Owen Tenorio

(Santo Domingo, active 1990s-present: traditional polychrome jars, bowls)
FAMILY: son of Howard & Francine Tenorio
AWARDS: 2001, Judge's Award, Indian Market, Santa Fe

Lupe L. Tenorio

(Santo Domingo, active ca. 1940s-80s: traditional polychrome, jars, bowls)
BORN: ca. 1920
FAMILY: mother of Emiliano Tenorio; grandmother of Vicky T. Calabaza; great-aunt of Robert Tenorio
STUDENT: Vicky T. Calabaza, her granddaughter; Robert Tenorio, her great-nephew
EXHIBITIONS: Santo Domingo Pueblo Arts & Crafts Show
 Lupe L. Tenorio was a master potter. She "shared some of her special techniques" with her granddaughter, Vicky T. Calabaza, and Robert Tenorio, a top award-winner.

Margarite Tenorio

(Santo Domingo, active ca. 1890s-1910s+: traditional polychrome jars, bowls)
COLLECTIONS: American Museum of Natural History, Washington, D.C., #29.0/172.
PUBLICATIONS: Batkin 1987:99.

Marlene Tenorio-Vallo *(signs M. Tenorio with Kokopelli hallmark)*

(Santa Ana, active ca. 1992-present: large black-on-white & black-on-red sgraffito, contemporary polychrome ollas, jars, bowls, vases)
BORN: February 27, 1963
FAMILY: daughter of Ruth and Bernardino Tenorio; wife of Nathaniel Vallo (Acoma); related to Lena Garcia
TEACHER: Nathaniel Vallo, her husband
AWARDS: 1993, 2nd, 3rd, New Mexico State Fair, Albuquerque
COLLECTIONS: Candace Collier, Houston, TX
FAVORITE DESIGNS: Sunface, Kokopelli, Pueblo traditional men and women, buffalo, bears, rabbits, birds, owls, quail, lizards, butterflies, flowers, plants, feathers-in-a-row, clouds
GALLERIES: Rio Grande Wholesale, Palms Trading Company, Albuquerque
PUBLICATIONS: Mary Laura, Calendars; Berger & Schiffer 2000:152.

Marlene Tenorio - Courtesy of Candace Collier, Houston, TX

 Marlene Tenorio-Vallo is an excellent designer. Her intricate sgraffito carved pottery takes one into a natural Pueblo world of plants, animals, birds, insects, all basking in the illumination of the Sunface. Her work is most attractive.
 Marlene confided: "The beauty of nature fills my heart and mind, then my thoughts become reality on my pottery."

Mary Edna Tenorio *(collaborates sometimes with Robert Tenorio)*

(Santo Domingo, active ca. 1970s-present: traditional polychrome jars, bowls, canteens, Storytellers, fireplaces)
BORN: ca. 1955
FAMILY: m. granddaughter of Clemente & Nescita Calabaza; p. granddaughter of Andrea Ortiz; daughter of Juanita Tenorio; sister of Paulita Pacheco, Robert Tenorio and Hilda Coriz
STUDENTS: Corine Lovato
PUBLICATIONS: Dillingham 1994:136, 141.

Matilda Tenorio

(Santo Domingo, active pre-1985-present: pottery, jewelry)
EXHIBITIONS: 1985-present, Indian Market, Santa Fe
PUBLICATIONS: *Indian Market Magazine* 1985, 1988, 1989.

*Mary Edna Tenorio painted by **Robert Tenorio** - Andrea Fisher Fine Pottery, Santa Fe*

Odelia Tenorio

(Santo Domingo, active ?-present: pottery, jewelry)
EXHIBITIONS: 1995-present, Eight Northern Indian Pueblos Arts & Crafts Show

Robert Tenorio *(signs Robert Tenorio with hallmark - Small Dipper constellation)*

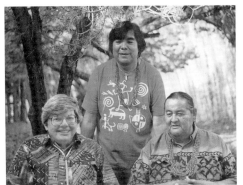

(Left to right): **Richard M. Howard, Robert Tenorio & Gilbert Pacheco** - *Courtesy of Richard M. Howard*

(Santo Domingo, active ca. 1960s-present: traditional polychrome & black-on-red large storage jars, ollas, jars, chili bowls, dough bowls, canteens, plates, miniatures)
BORN: December 29, 1950
FAMILY: m. grandson of Clemente & Nescita Calabaza; p. grandson of Andrea Ortiz; son of Andres Tenorio & Juanita Calabaza Tenorio; brother of Paulita Pacheco, Mary Edna Tenorio and Hilda Coriz; uncle of Ione Coriz
EDUCATION: Institute of American Indian Arts & Cultures, Santa Fe
TEACHERS: Andrea Ortiz, his grandmother; Lupe Tenorio, his great-aunt; Otellie Loloma (Hopi), IAIA teacher
STUDENTS: Corine Lovato & many more
AWARDS:

1967	Indian Market, Santa Fe
1968	Heard Museum Show, Phoenix
1971	Tenth Scottsdale National Indian Arts Exhibition, Scottsdale, AZ
1974	1st, jars, Indian Market
1976	1st, pottery necklace, Indian Market, Santa Fe
1977	Special Award - Traditional, pre-1930 design, large jar, 3rd, Indian Market
1979	Judges Award, 1st, 2nd (2), Indian Market, Santa Fe
1980	Judges Award, 1st (2), Indian Market, Santa Fe
1981	1st, Indian Market, Santa Fe
1983	1st, 2nd (2), Indian Market, Santa Fe
1984	Best Traditional Large Pottery Jar, Pot Carrier Award, 1st, bowls, 2nd, jars, Indian Market, Santa Fe
1988	Indian Art Fund Award for Overall Excellence, 1st, 2nd, Indian Market
1991	Large Pottery Award, Best Traditional Bowl 15 inches or more, 1st, jars, 1st, bowls, 2nd canteens, Indian Market, Santa Fe
1992	1st, Jars, 1st Bowls, 1st, Canteens, Indian Market, Santa Fe
1993	1st, Traditional Jars, 1st, Canteens, Indian Market, Santa Fe
1994	2nd, Traditional Bowls, Indian Market, Santa Fe
1996	2nd, Traditional Jars, Indian Market, Santa Fe

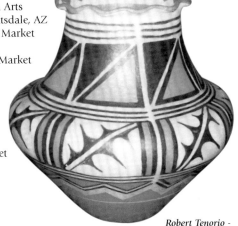

Robert Tenorio - Janie & Paul K. Conner Collection

1998 1st, 2nd, Indian Market, Santa Fe
2000 1st (2), Indian Market, Santa Fe; Governor's Award, Santa Fe; 1st, Eight
 Northern Indian Pueblos Arts & Crafts Show; New Mexico State Fair, Alb.

EXHIBITIONS: pre-1974-present, Indian Market, Santa Fe; pre-1995-present, Eight Northern Indian Pueblos Arts & Crafts Show

COLLECTIONS: Wright Collection, Peabody Museum, Harvard University, Cambridge, MA; Nagoya Museum, Japan; Royal Family, Great Britain; School of American Research, Santa Fe; Drs. Judith & Richard Lasky, New York City; Gerald & Laurette Maisel, Tarzana, CA; Richard M. Howard, Jane & Bill Buchsbaum, Don & Lynda Shoemaker, Dr. Gregory & Angie Yan Schaaf, K. & Janie Conner, Santa Fe

FAVORITE DESIGNS: human figures, deer, antelope, big horn sheep, birds, flowers, clouds

VALUES: On May 26, 1999, a large polychrome olla (16" h.), signed Robert Tenorio, sold for $4,312, at Sotheby's, #68.

On December 4, 1997, a large polychrome olla (17 1/2" h.), signed Robert Tenorio, sold for $4,312, at Sotheby's, #298.

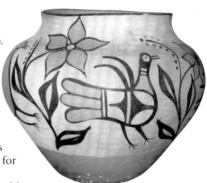

Robert Tenorio -
Janie & Paul K. Conner Collection

PUBLICATIONS: *SWAIA Quarterly* Fall 1973:3; Fall 1974:3; Fall/Winter 1876:12; Fall 1977:15, 17; Fall 1982:10, 14, 25; Tanner 1976:131; Barry 1984:114-15; *Indian Market Magazine* 1985, 1988, 1989; *American Indian Art Magazine* Spring 1986:20; Spring 1987:83; Summer 1992:22; *The Messenger,* Wheelwright Museum Winter 1986:5; Autumn 1990:5-6; Spring 1991:4; Spring 1994: inside cover; Fall/Winter 1994:5; Spring 1995:9; Spring 1995:12; Coe 1986:200; Trimble 1987:13, 15, 22-23, 28-29, 62-63; *Southwest Art* March 1989:103, 106; Dillingham 1994:136; Nichols August/September 1994:20-21; Mercer 1995:30, 44; Hayes & Blom 1996, 1998; Peaster 1997; Drooker 1998:139; Tucker 1998: plate 105; Schaaf 1998:68; *Indian Market Magazine* 1998:100; Anderson 1999:15; *New Mexico Magazine* Aug. 1999:66; *Santa Fean* August 1999:98-99; Berger & Schiffer 2000:69, 71, 152.

Robert Tenorio is respected for his years of careful experimentation with styles, clays, slips, designs and forms. He has made a long study of Pueblo Indian pottery from ancient times to the present. He continues to experiment, as he searches the countryside for special clays and natural paints.

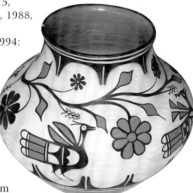

Robert Tenorio - Courtesy of
Don & Lynda Shoemaker, Santa Fe

When Robert was a student at IAIA, Hopi artist and teacher Otellie Loloma saw him working clay, and said, "You need to enroll in the ceramics class." She arranged for him to enroll in her class. She taught him different techniques, including wheel-thrown stoneware. She encouraged her students to explore new techniques and materials.

Robert is a gracious host, inviting many, many people to his home to eat dinner during feast days. He uses old Santo Domingo feast bowls, some perhaps a century old. His home beautifully displays his cherished collection of old pots and much more.

Robert presents himself well. He is one of the few Pueblo Indian potters who has a color brochure. He also travels widely making presentations on his artwork directly to collectors and galleries. His professional, yet personal, approach to being an artist has made him very successful.

Robert is a great teacher. He loves to share his knowledge with others. He expresses himself well with strong verbal skills. One looks forward to visiting Robert, because each time is a memorable learning experience. He has a strong following of friends and patrons.

Robert shared his joy for pottery making: "I feel good to be reproducing the old style Santo Domingo pottery that can actually be used, as well as producing collectors' items and museum quality pieces."

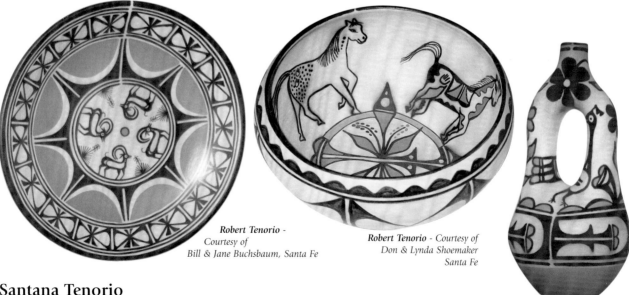

Robert Tenorio -
Courtesy of
Bill & Jane Buchsbaum, Santa Fe

Robert Tenorio - Courtesy of
Don & Lynda Shoemaker
Santa Fe

Robert Tenorio - Courtesy of
Bill & Jane Buchsbaum, Santa Fe

Santana Tenorio

(Santo Domingo, active ?: pottery)
ARCHIVES: Laboratory of Anthropology Library, Santa Fe, lab file.

Thomas Tenorio *(U-Nah-Thee-Wah)*

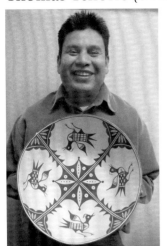

*Thomas Tenorio -
Courtesy of Jason Esquibel
Rio Grande Wholesale, Inc.*

(Santo Domingo, active ca. 1972-present: traditional polychrome & black-on-red, large storage jars, bowls, miniatures)
BORN: June 15, 1963
FAMILY: grandson of Pete Aguilar; son of Trinidad Aguilar & Anacita Tenorio
AWARDS: 1996, 1st; 1997, 2nd; 1998, 1st, 2nd; 1999, 2nd, New Mexico State Fair, Albuquerque; Inter-tribal Indian Ceremonial, Gallup; shows in Texas, Ohio, Colorado, Pennsylvania & New York
FAVORITE DESIGNS: flowers, tulips, vines, clouds
GALLERIES: King Galleries, Scottsdale, AZ; Rio Grande Wholesale, Palms, Andrew's Pueblo Pottery, Albuquerque, NM
PUBLICATIONS: Hayes & Blom 1998:60; Berger & Schiffer 2000:71, 152.

Thomas Tenorio makes large black-on-red storage jars. One 14 x 13″ is illustrated in color in the book, *Pueblo and Navajo Contemporary Pottery*, by Guy Berger & Nancy Schiffer. The quality of his pottery is exceptional. He uses traditional clay and paints. He continues the highest standards of excellence in Santo Domingo pottery.

Thomas explained how he learned pottery making by "conducting one-on-one interviews with potters, research, reading text books, and by trial and error." He developed his knowledge into a curriculum, and began teaching classes in pottery making.

Thomas has developed two main styles of pottery. The first is the traditional Santo Domingo style of the 1880s-1920s. The second is a contemporary style of black-on-redware with distinctive carved outlines so the painted design panels stand out in relief. His jars extend upward in form. His vases feature tall thin necks with clay stoppers. His unique new style is gaining in popularity, as collectors across the country discover his work.

Thomas fires his smaller pots outdoors in a pit. The effects of smoke distinguish them. For his larger pots, Thomas built a special kiln somewhat like a bread oven. He fires them with cedar. His big pots come out clean, without fire clouds. He explained that fewer pots crack in the oven.

Thomas is a potter with a bright future. We watch with interest as his experience grows.

*Thomas Tenorio -
Janie & Paul K. Conner
Collection*

*Thomas Tenorio -
King Galleries
of Scottsdale*

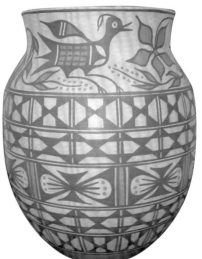

*Thomas Tenorio -
Courtesy of Jason Esquibel
Rio Grande Wholesale, Inc.*

Vicki Tenorio *(see Vicki Calabaza)*

Maricito Terro

(Laguna, active ca. 1950s-?: traditional polychrome jars, bowls)
COLLECTIONS: Philbrook Museum of Art, Tulsa, OK, jar, ca. 1957.

Nancy Thompson

(Acoma, active ?: pottery)
ARCHIVES: Artist's File, Heard Museum, Phoenix

Thundercloud *(Alan Garcia, Allen), (works with Mary Thundercloud)*

(Acoma, active ca. 1980s - present: polychrome jars, bowls)
BORN: 1960s
FAMILY: m. grandson of Santana & Siome Sanchez; son of Lorenzo & Gladys Garcia; brother of Lena Garcia Aragon, Geraldine Garcia, Marie Garcia Vallo, & Beatrice Garcia
COLLECTIONS: Dr. Gregory & Angie Yan Schaaf, Santa Fe

Mary Thundercloud *(works with Alan Garcia Thundercloud)*

(Acoma, active c. ?: polychrome jars, bowls)

Nick Tinnaka *(Zuni Nick)*

(Zuni, active 1890-1920s: pottery)
PUBLICATIONS: Culin 1904:20; Batkin 1986:165, 204, n.126.

Santana Titla *(S. Titla)*

(Acoma, active ?-present: polychrome jars, bowls, figures)
COLLECTIONS: John Blom
FAVORITE DESIGNS: mouse
PUBLICATIONS: Hayes & Blom 1998:57.

Amelita Toledo *(collaborated with Jose Rey Toledo, her husband)*

(Jemez, active ca. 1930s-?: traditional polychrome pottery)
FAMILY: wife of Jose Rey Toledo

Andrea Toledo

(Jemez, active ca. 1920s-?: traditional polychrome ollas, jars, bowls)
BORN: ca. 1909
FAMILY: daughter of Refugia Moquino Toledo & José Ortiz Toledo; sister of Angelita, Jose Ignacio Toledo & Jose Rey Toledo
TEACHER: Refugia Moquino, her mother
PUBLICATIONS: U.S. Census 1920: family 79.
 Andrea Toledo was an older sister of the famous Jemez artist, Jose Rey Toledo.

Angelita Toledo

(Jemez, active ca. 1920s-?: traditional polychrome ollas, jars, bowls)
BORN: ca. 1907
FAMILY: daughter of Refugia Moquino Toledo (Zia) & José Ortiz Toledo (Jemez); sister of Andrea, Jose Ignacio Toledo & Jose Rey Toledo
TEACHER: Refugia Moquino, her mother
PUBLICATIONS: U.S. Census 1920: family 79.
 Angelita Toledo was an older sister of the famous Jemez artist, Jose Rey Toledo.

Brophy Toledo

(Jemez, active ?-present: jars, bowls, miniatures)
PUBLICATIONS: Schiffer 1991d.

C. T. Toledo *(collaborates with L. T. Toledo)*

(Jemez, active ?-present: pottery)
GALLERIES: The Indian Craft Shop, U.S. Department of Interior, Washington, D.C.

Clemente F. Toledo

(Jemez, active ca. 1981-present: traditional polychrome & carved jars, bowls, vases)
BORN: October 4, 1958
FAMILY: son of Joe & Esther Toledo
AWARDS: Indian Market, Santa Fe
FAVORITE DESIGNS: feathers, kiva steps, yucca
GALLERIES: Adobe Gallery, Albuquerque, Santa Fe
 Clemente F. Toledo's pottery is unique in that he carves his designs out so they stand in relief. He then paints them in matte polychrome. This style is reminiscent of Hopi potter Thomas Polacca, the son of Fannie Nampeyo. Clemente's work is distinguished by his forms and designs.

Cyndee Sandia Brophy Toledo *(see Cyndee S. Brophy)*

Cypriana Toledo

(Jemez, active ?-present: pottery)
EXHIBITIONS: 1994, Eight Northern Indian Pueblos Arts & Crafts Show

D. Toledo

(Jemez, active ?-present: Storytellers)
GALLERIES: Palms Trading Company, Albuquerque
PUBLICATIONS: Congdon-Martin 1999:93.

Frances Toledo

(Jemez, Sun Clan, active ca. 1947-present: Storytellers, friendship pots, wedding vases, turtles, canoes, jars, bowls, embroidery)
BORN: February 27, 1937
FAMILY: daughter of Pasqual & Terresita B. Fragua; wife of Michael Toledo Sr.; mother of Bertha Danielson, Lorain Thomas, Elizabeth Fahey, Michael Toledo, Jr., Harold Toledo & Earl Toledo
FAVORITE DESIGNS: Sunface, turtles

Frances Toledo - Photograph by Angie Yan Schaaf

Jose Ignacio Toledo

(Jemez, active ca. 1930s-?: pottery painter)
BORN: ca. 1917
FAMILY: son of Refugia Moquino Toledo (Zia) & José Ortiz Toledo (Jemez); brother of Angelita, Andrea & Jose Rey Toledo
TEACHERS: Refugia Moquino, his mother
PUBLICATIONS: U.S. Census 1920: family 79.
 Jose Ignacio Toledo was the younger brother of the famous Jemez artist, Jose Rey Toledo. Their mother taught them how to paint pottery.

Jose Ortiz Toledo

(Jemez, active ca. 1900s-?: pottery painter)
LIFESPAN: ca. 1880 - ?
FAMILY: husband of Refugia Moquino Toledo (Zia); father of Angelita, Andrea, Jose Ignacio Toledo & Jose Rey Toledo
TEACHER: Refugia Moquino, his wife
PUBLICATIONS: U.S. Census 1920: family 79.

 Jose Ortiz Toledo was the father of the famous Jemez artist, Jose Rey Toledo.

José Rey Toledo *(Tia-na, meaning "Northeast Place," used by his father's clan; Shobah Woonhon, meaning "Morning Star;" Aluh Hochi, meaning "Lightning;" Mus Truwi, meaning "a little mountain creature with great power"), (collaborated in his youth with Refugia Moquino Toledo, and later with Amelita Toledo, his wife)*

(Jemez/Pecos/Zia, active ca. 1930s-1994: pottery painter, watercolors, murals, linocuts, silk screens, book illustrations, jewelry)
LIFESPAN: June 28, 1915 - April 1, 1994
FAMILY: son of Refugia Moquino Toledo (Zia) & José Ortiz Toledo (Jemez/Pecos); brother of Angelita, Andrea & Jose Ignacio Toledo; husband of Amelita Toledo
TEACHERS: Refugia Moquino, his mother; Velino Shije Herrera (Ma Pe Wi), his uncle
EDUCATION: Albuquerque Indian School (1935); Bachelor of Arts degree, University of New Mexico (1951); Master of Arts degree, University of New Mexico (1955); Doctorate degree, University of California, Berkeley (1972)
AWARDS: 1947, Grand Prize, 1st, Philbrook Art Center Show, Tulsa, OK; Heard Museum Show, Phoenix; Inter-tribal Indian Ceremonial, Gallup; New Mexico State Fair, Albuquerque
EXHIBITIONS:

1937	American Indian Exposition and Congress, Tulsa, OK
1939-40	Golden Gate International Exposition and San Francisco World's Fair, San Francisco
1947-65	"American Indian Paintings from the Permanent Collection," Philbrook Art Center, Tulsa (traveling)
1955-61	European Tour, sponsored by the University of Oklahoma
1978	"100 Years of Native American Painting," Oklahoma Museum of Art, Oklahoma City, OK
1979-80	"Native American Paintings," Joslyn Art Museum, Omaha, NE (traveling)
1980	"Native American Art at the Philbrook," Philbrook Museum, Tulsa, OK (traveling)
1981	"Native American Painting," Amarillo Art Center, TX
1984-85	"Indianacher Kunstler" (traveling, Germany), organized by the Philbrook Museum, Tulsa, OK
1985	"The Hunt and the Harvest: Pueblo Paintings from the Museum of the American Indian"
1988	"When the Rainbow Touches Down," Heard Museum, Phoenix
1996	"Drawn from Memory: James T. Bialac Collection of Native American Art," Heard Museum, Phoenix

PUBLICATIONS: U.S. Census 1920: family 79; *New Mexico Magazine* December 1936 14(12):23; 1957 35(2):37, 54-55; "American Indian Painting," 2nd Annual Philbrook Art Center Show Catalog 1947:13; *El Palacio* 1948 55(6):191; 1950 57(8):243-44; Jacobson and d'Ucel 1950; *Arizona Highways* Feb. 1950; Dunn 1968; Snodgrass 1968; Milton, ed. 1969; Brody 1971; Tanner 1958, 1968, 1973; Highwater 1976; Silberman 1978; Mahey, et al. 1980; Broder 1981; King 1981; Fawcett & Callander 1982:82; *Southwest Art* June 1983 13(1):79; Hoffman, et al. 1984; Golder 1985:21-29; Samuels 1985; Seymour 1988:153-55, 177-79, 188, 198, 329, 361; Scarberry-Garcia 1994; Wyckoff 1996:30-31, 41, 189, 258-60; *American Indian Art Magazine* Winter 1994:37; Spring 1997:17; Lester 1997:562-63; *Native Peoples* Spring 1997 10(2):61; *Gilcrease Journal* Winter 1997-98 5(2):38-39; Anderson et al. 1999:78.

 José Rey Toledo is best known as a watercolor painter. However, he grew up watching the pottery making of his mother, Refugia Moquino (Zia). He painted some of her pots, as documented by Bruce Bernstein, Assistant Director for Cultural Resources, National Museum of the American Indian. From childhood, José expressed a gift for "rendering visual images of the natural world." (Bernstein in Matuz 1997:574-76)

 Toledo revealed, "I was a very curious child. My earliest inspiration came from seeing the kiva wall paintings — those beautiful murals — when I was a youngster." He recalled peaking through a hole in his mother's shawl to see the Katsinas coming into the kiva. He carefully observed the mural paintings on the walls of the kiva and their relationship to the appearance of the Katsina spirits. This experience was profound and "led to the closer observance of my mother's pottery making and drawing symbolic pictures." Toledo also was more interested in the paintings of his famous uncle, Velino Shije Herrera (Ma Pe Wi) from Zia Pueblo. Toledo developed a very beautiful and refined style of painting, noted especially for his scenes of Kachinas, as well as Pueblo ceremonial and traditional village life.

 After the death of his father in 1928, Toledo attended Albuquerque Indian School. In the mid-1930s, he lived in Santa Fe with his uncle Ma Pe Wi. Toledo worked at the Wheelwright Museum (formerly the Museum of Navajo Ceremonial Art). He married Amelita Toya, a Jemez/Pecos woman, in 1938, and they raised a family of eight children.

 At the end of the Great Depression, he painted some of greatest works in the WPA program. During World War II, he helped the war effort by moving to Phoenix and working as a draftsman for an airplane factory.

 In 1947, Toledo won his first of many awards, the Grand Prize at the Annual Indian painting competition sponsored by the Philbrook Museum of Art in Tulsa, OK. He returned to Santa Fe and worked for over a decade as an art instructor at the Santa Fe Indian School (1949-56). During this time he completed his B.A. degree from the University of New Mexico. He went on to earn an M.A. & Ph.D., a laudable accomplishment.

 In 1969, Toledo explained, ". . .this talent is a gift from the Great Spirit. It is a medium I can use for communicating to the world the story of the American Indian's gratitude to his Creator, for the gift of life and its abundance which may be rightfully attained through honest effort and sacrifice." (interview by Adelina Defender, South Dakota Review Summer 1969)

 In 1981, Toledo confided, "I am getting on in years. . .I still love to work with the ability that the Great Spirit endowed me with. . .As long as art expression continues to be seeking the truth in life and is genuinely sincere in its statement for the public it should be. . .nurtured." When he reached retirement age, Toledo surprised everyone by launching a successful acting career in Hollywood. He appeared in almost a dozen motion pictures, including: *The Legend of the Lone Ranger, Nightwing, Bobby Joe and the Outlaws,* and *The Man and the City.* José Rey Toledo was a man of many talents.

Juanita Toledo *(Juanita Toya)*

(Pecos/Jemez, Coyote Clan, active ca. 1940s-present: redware with dark brown glaze paint outlining cream design elements)
BORN: ca. 1920s
FAMILY: wife of Lucas Toledo; mother of Santana Seonia; grandmother of Juanita & Marian Seonia
EXHIBITIONS: pre-1985-89, Indian Market, Santa Fe
PUBLICATIONS: *El Palacio* Jan. 1947 54(1):14; Fox 1977:52; *New Mexico Magazine* July 1979:21-23; Eaton 1990:14; Peterson 1997:19.

L. T. Toledo *(collaborates with C. T. Toledo)*

(Jemez, active ?-present: pottery)
GALLERIES: The Indian Craft Shop, U.S. Department of Interior, Washington, D.C.

Lorraine Toledo *(signs Toledo, Jemez)*

(Jemez, active ca. 1990-present: polychrome jars, bowls)
BORN: August 31, 1959
FAMILY: granddaughter of Juan & Reyes Toya; daughter of Frank & Margaret Toya; sister of Rosalie Toya
TEACHER: Margaret Toya, her mother
PUBLICATIONS: Berger & Schiffer 2000:152.

Louisa Toledo *(1)*

(Jemez, active ca. 1890s-?: traditional polychrome ollas, jars, bowls)
COLLECTIONS: Philbrook Museum of Art, Tulsa, OK, olla, ca. 1900; Dr. Paul K. & Janie Conner

Louisa Fragua Toledo *(2) (signed L. Toledo)*

(Jemez, Sun Clan, active ca. 1920s-1995: large storage jars, bowls, Storytellers)
LIFESPAN: 1900 - 1995
FAMILY: wife of Frank Toledo; mother of Felapita Toledo Yepa, Jose R. Toledo, Michael Toledo, Joe Rafael Toledo, Carol Pecos, Bernice Louise Gachupin, J. R. Toledo
COLLECTIONS: Philbrook Museum of Art, Tulsa, OK, bowl, ca. 1939
GALLERIES: Crosby Collection, Park City, UT
PUBLICATIONS: Babcock 1986; Congdon-Martin 1999:94

Louisa Toledo (1) -
Janie & Paul K. Conner Collection

Louise Mae Toledo

(Laguna, active ca. 1973-?: traditional polychrome jars, bowls)
EDUCATION: 1973, Laguna Arts & Crafts Project participant

Mrs. Lucas Toledo

(Jemez, active ca. 1930-?: traditional polychrome jars, bowls)
BORN: ca. 1910s
FAMILY: mother of Mary Margaret Toledo

Lucy C. Toledo *(signs L. C. Toledo)*

(Jemez/Tesuque, Corn Clan, active ca. 1926-present: traditional polychrome jars, bowls, wedding vases, Rain Gods)
BORN: June 12, 1916
FAMILY: daughter of Juan R Chavez (Jemez) & Filapeta Coriz Chavez (Tesuque); sister of Mary Jane Buck, Jimmy Chavez, Marie Chavez, Charlie Chavez, Joseph Chavez, Reyes Collaque; wife of Juan I. Toledo; mother of Elsie Yepa, Mary Virginia Tafoya, Joseph Brophy Toledo
EXHIBITIONS: ca. 1970-present, Indian Market, Santa Fe
COLLECTIONS: Museum of Indian Arts & Cultures, Santa Fe
ARCHIVES: Lab File, Laboratory of Anthropology Library, Santa Fe
 Lucy C. Toledo confided, "I use to make pots all the time. That's how I bought groceries for my kids."

Lucy C. Toledo -
Photograph by Angie Yan Schaaf

Lynn Toledo

(Jemez, active ?-present: pottery)
EXHIBITIONS: 2000, Indian Market, Santa Fe

Mary Margaret Toledo

(Jemez, active ca. 1957-present: traditional polychrome jars, bowls, wedding vases)
BORN: March 16, 1936
FAMILY: daughter of Mr. & Mrs. Lucas Toledo
TEACHER: her mother
PUBLICATIONS: Berger & Schiffer 2000:152.

Refugia Moquino Toledo *(Refugia Moquino)*,
(collaborated sometimes with José Rey Toledo)

(Zia, married into Jemez, active ca. 1920s-?: both Zia and Jemez style polychrome jars, bowls)
BORN: ca. 1884
FAMILY: wife of José Ortiz Toledo; mother of José Rey Toledo; mother-in-law of Amelia Toya Toledo
AWARDS: 1926, Indian Fair [Market], Santa Fe
PUBLICATIONS: U.S. Census 1920: family 79; Sando 1982:198-99; Batkin 1987:187.

> Refugia was an award-winning potter from Zia who married into Jemez. She won prizes for her Jemez style pottery at the 1926 Indian Fair, the earlier name of the Santa Fe Indian Market. About this time, her little helper was her son, José Rey Toledo, who was destined to become one of the greatest painters in the history of Southwest Indian painting. She started him off, encouraging young José to paint her pottery.

Verda Toledo -
Photograph by Bill Bonebrake
Courtesy of Jill Giller
Native American Collections, Denver

Verda J. Toledo *(signs V.J.T. Jemez, N.M.)*

(Jemez, active ca. 1995-present: traditional Anasazi Revival, black and orange-on-tan jars, bowls)
BORN: June 30, 1941
TEACHER: Tom Tenorio
FAVORITE DESIGNS: deer, parrots, rain, kiva steps
PUBLICATIONS: Berger & Schiffer 2000:40, 152.

Toni *(possibly Toni Antonio)*

Angela Toribio

(Sandia, active 1990s-present: pottery)
BORN: ca. 1960s

Edna Toribio

(Acoma, active ?-1990+: polychrome jars, bowls)
PUBLICATIONS: Dillingham 1992:206-208.

Edwin Francis Toribio

(Acoma, active ?-1990+: polychrome jars, bowls)
PUBLICATIONS: Dillingham 1992:206-208.

Verda Toledo - Photograph by Jill Giller
Native American Collections, Denver

Harviana Toribio

(Zia, active ca. 1910s-48: polychrome ollas, jars, bowls, tiles, miniature adobe houses)
LIFESPAN: ca. 1890s - 1948
FAMILY: daughter of Tomas Salas Pino; wife of Francisco Toribia; mother of Elsie Pino; mother-in-law of Ramon Pino
STUDENTS: Elsie Pino, her daughter
COLLECTIONS: Taylor Museum, Colorado Springs, CO, 3 tiles, ca. 1935-40, cat. # 340-342, olla, ca. 1938, #6042; School of American Research, Santa Fe, #2369.
FAVORITE DESIGNS: birds, clouds, adobe houses and undulating band on the neck
PUBLICATIONS: *SWAIA Quarterly* Fall 1972:7; Batkin 1987:90, 130, 153, 203, n. 95.
PHOTOGRAPHS: Mitchell A. Wilder, portrait, ca. 1938, Taylor Museum, Colorado Springs, CO, neg. #798.

Isabel Toribio *(Torrebio)*

(Zia, active ca. 1910s-?: traditional polychrome storage jars, bowls)
BORN: ca. 1893
FAMILY: wife of Alajandro Toribio
COLLECTIONS: Smithsonian Institution, Washington, D.C., storage jar, signed Isabel Torrebio, #418993.
PUBLICATIONS: U.S. Census 1920, family 27; Hering 1985:109-110; Batkin 1987:122, n. 99; Hayes & Blom 1996:162-63; Anderson et al. 1999:46-47.

> In 1922, a large polychrome storage jar by Isabel Toribio was collected by the Smithsonian Institution. It was collected new. On the bottom is signed, "Isabel Torrebio," perhaps the oldest documented signature on a Zia pot.

Juanita Toribio

PUBLICATIONS: *El Palacio* Oct. 16, 1922:94.

Lucinda Toribio *(Torribio)*

(Zia, ca. 1920s-?: traditional polychrome ollas, jars, bowls)
BORN: ca. 1899
FAMILY: wife of Jose Rey Toribio; mother of Louise, Angelena & Francisco Toribio
COLLECTIONS: Philbrook Museum of Art, Tulsa, OK, olla, ca. 1939
PUBLICATIONS: U.S. Census 1920, family 20; Dittert & Plog 1980:50.

Lupe Toribio
(Acoma, active ca. 1860s-1910s+: polychrome jars, bowls)
BORN: ca. 1845; RESIDENCE: Acomita in ca. 1910
PUBLICATIONS: Leopold Bibo, "13th Annual U.S. Census" (1910), New Mexico State Archives, Call T624, Roll 919; in Dillingham 1992:205.

Maria Toribio
(Acoma, active ca. 1890s-1910s+: polychrome jars, bowls)
BORN: ca. 1875; RESIDENCE: Acomita in ca. 1910
PUBLICATIONS: Leopold Bibo, "13th Annual U.S. Census" (1910), New Mexico State Archives, Call T624, Roll 919; in Dillingham 1992:205.

Maria Bridgett Toribio *(see Maria Bridgett)*

Rosalea Medina Toribio *(see Rosalea Medina)*

Rosario Toribio
(Zia, active ?: pottery)
ARCHIVES: Laboratory of Anthropology Library, Santa Fe; lab. file.

Teofilo Toribio *(see Teofila Torivio)*

George Torino
(Acoma, active ?: pottery animal figures, birds)

Brenda Torivio
(Acoma, active ?-1990+: polychrome jars, bowls)
PUBLICATIONS: Dillingham 1992:206-208.

Brian Torivio
(Acoma, active ca. 1990s-present: pottery, seed jars)
BORN: April 7, 1973
ARCHIVES: Artist File, Heard Museum Library, Phoenix

Dorothy Torivio *(sometimes signs D. Torivio)*

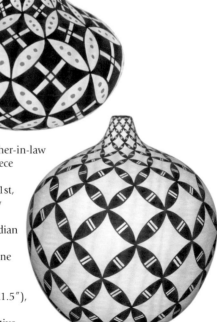

*Dorothy Torivio -
King Galleries of Scottsdale, AZ*

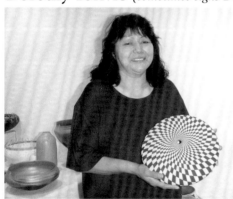

*Dorothy Torivio - Courtesy of
Andrea Fisher Fine Pottery, Santa Fe*

(Acoma, active pre-1974-present: traditional black-on-white & polychrome jars, bowls, seed pots, figures, deer, owls)
BORN: August 19, 1946
FAMILY: daughter of Mary Valley; wife of Peter Concho; daughter-in-law of Lolita Concho; sister of Juanita Keen; aunt of Sandra M. Victorino; mother of four children
TEACHERS: Mary Valley, her mother, and Lolita Concho, her mother-in-law
STUDENTS: Sandra Victorino, her niece
AWARDS: 1984, Best of Division, Traditional Pottery, 1st, jars, 2nd, seed pots; 1993, 3rd, figures; 1994, 1st, 2nd; 1998, 1st, Indian Market, Santa Fe; 1st, Best of Show, Inter-tribal Indian Ceremonial, Gallup; New Mexico State Fair, Alb.; Heard Museum Show, Phoenix
EXHIBITIONS: 1985-present, Indian Market, Santa Fe; 1995-present, Eight Northern Indian Pueblos Arts & Crafts Show
COLLECTIONS: Heard Museum, Phoenix; John Blom; Gerald & Laurette Maisel, CA; Jane & Bill Buchsbaum, Dr. Gregory & Angie Schaaf
FAVORITE DESIGNS: eyedazzlers, Mimbres animals (ca. 1982-83), night star
VALUES: On May 17, 2000, a black-on-white seed jar, signed Dorothy Torivio, (10.5 x 11.5"), sold for $9,000, at Sotheby's, #544.
GALLERIES: The Indian Craft Shop, U.S. Department of Interior, Washington, D.C.; Native American Collections, Denver, CO; King Galleries of Scottsdale, AZ; Tribal Arts Zion, Springdale, UT; Arlene's Gallery, Tombstone, AZ; Adobe Gallery, Rio Grande Wholesale, Inc., Palms Trading Co.,

*Dorothy Torivio - Courtesy of
Andrea Fisher Fine Pottery*

Albuquerque; Sunshine Studio, Andrea Fisher Fine Pottery, Native New Mexico, Inc., Nedra Matteucci Galleries, Robert Nichols Gallery, Santa Fe

ARCHIVES: Artist File, Heard Museum Library, Phoenix

PUBLICATIONS: *American Indian Art Magazine* Winter 1984:23; Autumn 1985:18; Winter 1985:14; Spring 1986:20; Autumn 1985:20; Autumn 1987:24; Winter 1987:27; Spring 1988:66; Spring 1988:66; Autumn 1990:35; Spring 1992:32; Autumn 1992:81; Spring 1997:25; Winter 1997:96; *Art Talk* March 1985:13; Jacka May 1986:12-13; Benson 1986-1987:40; *Ceramics Monthly* October 1985:81; April 1987:77-79; Trimble 1987:79; Jacka 1988:55, 125; Schiffer 1991d:53; Dillingham 1992:206-208; Cohen 1993; Reano 1995:170; Hayes & Blom 1996:52-53; Peterson 1997:20205; *Indian Trader* Mar. 1997:66; *Indian Artist* Spring 1997:33; Winter 1998:64; Painter 1998:15.

Dorothy Torivio is respected as one of the finest Southwest Indian potters. She is a top award winner. She is noted for her traditional pottery with eyedazzler designs based on the repetition of singular design elements in both positive and negative patterns.

The late Lee Cohen of Gallery 10 in Santa Fe & Scottsdale promoted Dorothy as one of the stars of his presentation. Beginning in 1984, Lee featured her in his colorful ads in *American Indian Art Magazine*. In 1993, Lee commissioned award-winning feature writer, Roberta Burnett, to profile Dorothy in his book, *Art of Clay*. Burnett recognized her as one of the "most abstract designers in Native American ceramics." (Cohen 1993:121) Lee's son, Phil Cohen, continues to promote Dorothy's pottery.

Dorothy explained her love for sharing her pottery with others: "I love the travel and expressing myself about my pottery, it creates inspiration for the younger artists out there."

In 1997-98, art historian Susan Peterson included Dorothy and her pottery in a major exhibition at The National Museum of Women in the Arts in Washington D.C. The exhibit then traveled to the Heard Museum in Phoenix., AZ. Dorothy is profiled in a beautiful accompanying book, *Pottery by American Indian Women: The Legacy of Generations*. Here Dorothy gives credit to her mother, Mary Valley, as well as Lucy M. Lewis, Marie Z. Chino. Dorothy recognized God as her divine source of inspiration for her designs.

Dorothy Torivio -
Photograph by Bill Bonebrake
Courtesy of Jill Giller
Native American Collections, Denver

Frances Pino Torivio *(Frances T. Pino), (often signs Frances Torivio)*

(Acoma, active ca. 1920s-present: Mimbres & Anasazi Revival black-on-white & traditional polychrome ollas, jars, bowls, Storytellers, Nativities, human & animal figures, owls, canteens, plates)

BORN: April 1, 1905

FAMILY: daughter of Teofila Torivio; sister of Lolita Concho; mother of Maria Lilly Salvador, Wanda Aragon & Ruth Paisano

STUDENTS: Edna G. Chino & her daughters

AWARDS: 1976, 3rd; 1978, 3rd; 1980, 3rd; 1983, 3rd; 1992, 3rd; 1994, 3rd, Indian Market

EXHIBITIONS: 1979, "One Space: Three Visions," Albuquerque Museum, Albuquerque; pre-1982-present: Indian Market, Santa Fe; pre-1996-present, Eight Northern Indian Pueblos Arts & Crafts Show; no date, Soviet National Museum, Russia

COLLECTIONS: Wright Collection, Peabody Museum, Harvard University, Cambridge, MA; Angie Yan Schaaf, Santa Fe; Michael Snodgrass, Denver, CO

FAVORITE DESIGNS: Mimbres style animals, bugs and figures; four directions and seasons, flowers, rainbows, parrots, chickens, flowers

GALLERIES: Adobe Gallery, Albuquerque & Santa Fe; Nedra Matteucci Galleries, Santa Fe

PUBLICATIONS: Dillingham 1977:84; Monthan 1979:81; Barry 1984:89; Babcock 1986:138; Coe 1986:206-07; Trimble 1987:76; Dillingham 1992:206-208; Peaster 1997:11-13; Drooker & Capone 1998:138; Painter 1998:15; Congdon-Martin 1999:53.

Frances Torivio - Courtesy of
Michael E. Snodgrass, Denver

Frances Torivio is one of the important matriarchs of Acoma Pueblo pottery. She kindly taught traditional pottery-making classes not only for her own family, but also for many, many more. Her pottery is prized around the world.

Frances described how she and her sister, Lolita Concho, "learned the hard way," without someone to teach them. Frances gained fame as an outstanding potter. She made thin-walled, hand-coiled pottery in the old traditional way. She painted her pottery with mineral earth pigments, then fired them out-of-doors in a bonfire.

In 1976, Frances led an effort to revive traditional Acoma pottery making. She taught pottery classes at the Pueblo. Her students benefited greatly from her kind support in sharing traditional techniques and materials.

In the mid-1980s, Frances grew concerned about how long she would have the strength to continue making the big pots. She expressed gratitude that her children were going to continue the family tradition of pottery making.

We visited with Frances at the 2001 Indian Market in Santa Fe. At the age of 96, she still proudly displayed her latest pottery creations. Her display of small bowls and plates was remarkable! One of her family members translated to her in their Keres language that we planned to illustrate one of her polychrome plates with a large Mimbres bug design on the cover of this book. Frances lit up and smiled, nodding gracefully.

Frances Torivio - Courtesy of
Nedra Matteucci Galleries

Jackie Torivio *(K. Jackie Torivio, Rainbow), (collaborates with Michael Torivio)*
(Acoma/Laguna/Hopi, active 1970s-present: traditional & non-traditional polychrome jars, bowls, seedpots)
BORN: November 29, 1957; RESIDENCE: Acoma Pueblo, NM
AWARDS: 1990, 1st, 3rd; 1991, 1st, 2nd, 3rd; 1992, 1st; 1993, 3rd; 1994, 1st (2); 1998, 2nd; 1999, Indian Market, Santa Fe
EXHIBITIONS: 1992-present: Indian Market, Santa Fe
PUBLICATIONS: *Indian Artist* Spring 1995:28; Painter 1998:15.

James Torivio *(Jim Torivio, Jr.), (signs J. Torivio, Acoma N.M.), (collaborates with Priscilla Torivio)*
(Acoma, active 1972-present: traditional polychrome jars, bowls)
BORN: February 12, 1956
FAMILY: son of Rosinda & Jimmy Torivio
EXHIBITIONS: ?-present: Indian Market, Santa Fe
COLLECTIONS: John Blom
PUBLICATIONS: Dillingham 1992:206-208; Berger & Schiffer 2000:153.

Juanalita Torivio
(Acoma, ca. 1930s-?: traditional ollas, jars, bowls)
COLLECTIONS: Philbrook Museum of Art, Tulsa, OK, olla, ca. 1939

Katherine Torivio
(Acoma, active ?-1990+: polychrome jars, bowls)
RESIDENCE: Acoma Pueblo, NM
PUBLICATIONS: Dillingham 1992:206-208.

Lambert Torivio
(Acoma, active ?-1990+: polychrome jars, bowls)
PUBLICATIONS: Dillingham 1992:206-208.

Lavine Torivio *(signs LT, Acoma N.M.)*
(Acoma, Roadrunner Clan, active ca. 1987-present: vases, wedding vases)
BORN: January 2, 1955
FAMILY: m. granddaughter of Eva Histia; daughter of Ida Ortiz
TEACHER: Eva Histia, her grandmother
PUBLICATIONS: Berger & Schiffer 2000: 153.

Lena Torivio
(Acoma, active ?-1975+: polychrome jars, bowls)
PUBLICATIONS: Minge 1991:195.

Marie C. Torivio
(Acoma, active ca. 1940s-1990: traditional polychrome jars, bowls)
BORN: ca. 1930s
FAMILY: mother of Nelda Lucero, Loretta Garcia & Mary Torivio; grandmother of Leslie M. Garcia
STUDENTS: Loretta Garcia, Leslie M. Garcia, Mary Torivio & Mildred Antonio, her niece
COLLECTIONS: Candace Collier, Houston, TX
PUBLICATIONS: Minge 1991:195; Dillingham 1992:206-208; Berger & Schiffer 2000:118, 129, 153.

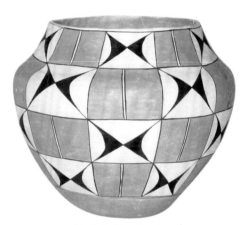

*Marie Torivio - Courtesy of
Candace Collier, Houston, TX*

Mary Torivio *(signs M. Torivio)*
(Acoma, active ca. 1985-present: traditional polychrome jars, bowls)
BORN: January 6, 1945
FAMILY: daughter of Marie C. Torivio
TEACHER: Marie C. Torivio, her mother
PUBLICATIONS: Minge 1991:195; Dillingham 1992:206-208; Berger & Schiffer 2000:153.

Michael M. Torivio *(Mike), (collaborates with Jackie Torivio)*
(Acoma, active 1970s-present: non-traditional unpainted & polychrome jars, bowls, seed pots, vases, wedding vases, owls, figures, miniatures)
BORN: February 13, 1958; RESIDENCE: Acoma Pueblo, NM
AWARDS: 1990, 1st; 1991, 1st (2); 1992, 1st (2); 1993, 1st; 1994, 1st, 2nd; 3rd, 1996, 3rd; 1998, 3rd, Indian Market, Santa Fe
EXHIBITIONS: 1992-present: Indian Market, Santa Fe
PUBLICATIONS: Dillingham 1992:206-208; *Indian Artist* Spring 1995:28.

Priscilla Torivio *(collaborates with Jim Torivio), (signs Priscilla Jim)*
(Acoma, active ?-present: polychrome jars, bowls, seed, canteen, paintings)
BORN: December 12, 1955; RESIDENCE: Acoma Pueblo, NM
EXHIBITIONS: 1996-present, Indian Market, Santa Fe
PUBLICATIONS: *Indian Market Magazine* 1996-2000; Dillingham 1992:206-208.

R. H. Torivio
(Acoma, active ?-present: Storyteller owls)
PUBLICATIONS: Congdon-Martin 1999:53.

Rose Torivio
(Acoma, Roadrunner Clan, active ca. 1950s-?: traditional polychrome jars, bowls, wedding vases, Storytellers)
BORN: May 14, 1935
FAMILY: m. granddaughter of Helice Vallo; daughter of Eva B. Histia; sister of Hilda Antonio & Ida Ortiz; niece of Lucy Lewis, Elizabeth Wocanda
AWARDS: 1976, 2nd, Indian Market, Santa Fe
EXHIBITIONS: 1976, Indian Market, Santa Fe
PUBLICATIONS: *SWAIA Quarterly* Fall 1976:13.

Rosecinda Torivio
(Acoma, active ?-1975+: polychrome jars, bowls)
PUBLICATIONS: Minge 1991:195.

Teofila Torivio *(Teofilo Toribio)*
(Acoma, active ca. 1900-?: traditional polychrome jars, bowls)
BORN: ca. 1870s
FAMILY: mother of Frances Pino Torivio, Juanita Keen, Katherine Analla, Lolita Concho, Concepcion Garcia

Isabel Torrebio *(see Isabel Toribio)*

Lucinda Torribio *(see Lucinda Toribio)*

Crucita Tortalita
(Santo Domingo, active ?-1980s: pottery)
EXHIBITIONS: 1985, Indian Market, Santa Fe

Edwina Tosa Tortalita
(Jemez, active ?-present: Storytellers, Clowns, polychrome jars, bowls)
FAMILY: granddaughter of Persingula Tosa; daughter of Dolora Tosa
GALLERIES: Rio Grande Wholesale, Albuquerque, NM; Kennedy Indian Arts
PUBLICATIONS: Congden-Martin 1999:94.

Joe V. Tortalita
(Santo Domingo, active ca. 1960s-present: pottery, jewelry)
EXHIBITIONS: pre-1985-96, Indian Market, Santa Fe
PUBLICATIONS: *Arizona Highways* Aug. 1973:5; *Indian Market Magazine* 1985, 1988, 1989.

Reyes Tortolito *(Tortolita Reyes)*
(Santo Domingo, active ca. 1890s-?: traditional polychrome ollas, large storage jars, bowls)
COLLECTIONS: Philbrook Museum of Art, Tulsa, OK, storage jar, ca. 1939.

Bertina Tosa *(Ice Line)*, (signs B. Tosa, Jemez)
(Jemez, active ca. 1973-present: polychrome polished redware jars, bowls, vases, Storytellers.)
BORN: ca. 1960
FAMILY: daughter of Mary S. Toya; sister of Elizabeth Medina; sister-in-law of Marcellus Medina (Zia)
FAVORITE DESIGNS: terraced clouds, kiva steps, feathers, leaves, fineline rain
GALLERIES: Rio Grande Wholesale, Albuquerque
 Bertina Tosa is an excellent traditional potter. Her main style is matte polychrome on stone polished redware. She gathers local clay, hand coils, paints and fires her pottery outdoors with cedar chips. Her pieces are quite beautiful, often filled with well-balanced, triple bands of designs.

Christina Chinana Tosa *(Christine)*, (signs C. Tosa)
(Jemez, Oak Clan, active ca. 1970-present: traditional black-on-red-ware, black-on-white jars, bowls, wedding vases)
BORN: February 19, 1950 or 1959
FAMILY: daughter of Anacita Chinana & Casimiro Toya; sister of Donald R. Chinana, Marie Chinana, Marie Waquie, Persingula Chinana Gonzales, Georgia Chinana; wife of Manuel Tosa
TEACHER: Anacita Chinana, her mother
PUBLICATIONS: Berger & Schiffer 2000:153.

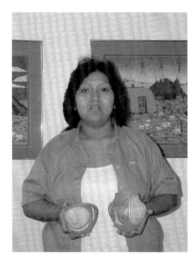

Edwina Tosa Tortalita - Courtesy of John D. Kennedy and Georgiana Kennedy Simpson Kennedy Indian Arts

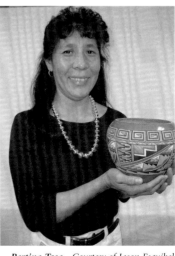

Bertina Tosa - Courtesy of Jason Esquibel Rio Grande Wholesale, Inc.

Christina Tosa - Courtesy of Candace Collier, Houston, TX

Christine R. Tosa

(Jemez, active ca. 1962-present: traditional black-on-redware, plain redware, and black-on-whiteware wedding vases, jars, melon, bowls)
BORN: ca. 1950
FAMILY: daughter-in-law of Persingula Tosa; mother of Maxine & Jennifer Andrew
TEACHER: Persingula Tosa, her mother-in-law
FAVORITE DESIGNS: melons, birds, Rainbirds, clouds, vines, leaves, corn plants
GALLERIES: Rio Grande Wholesale, Albuquerque

Danielle Tosa

(Jemez, Fire Clan, active ca. 1990s-present: stone polished jars, bowls)
FAMILY: p. great-granddaughter of Priscilla Loretto; granddaughter of Telesfor Loretto & Priscilla Griego Loretto; daughter of Laverne Loretto-Tosa & Frederick Tosa; sister of Vernon Tosa
TEACHER: Laverne Loretto Tosa, her mother
AWARDS: 1998, 2nd, miniature pottery, Indian Market, Santa Fe

Laverne Loretto Tosa (see Laverne Loretto-Tosa)

Madeline Tosa (Madelene, Madalene)

(Jemez, polychrome jars, bowls, wedding vases)
GALLERIES: Kennedy Indian Arts, Bluff, UT

Marie Tosa

(Jemez, active ca. 1960s-present: Storytellers, pottery)
BORN: ca. 1940
FAMILY: mother of Timothy M. Tosa
STUDENTS: Timothy M. Tosa
EXHIBITIONS: 1994, Indian Market, Santa Fe

P. Tosa

(Jemez, active ?-present: matte polychrome Corn Maidens)
INTERNET: www.sunshinestudio.com

Persingula R. Tosa

(Jemez, active ca. 1940s-present: polished redware, polychrome poster painted jars, bowls, vases, figures, Pueblo scenes, owls)
BORN: ca. 1924
FAMILY: daughter of Lupe Romero, mother of Pauline Romero; mother-in-law of Christine R. Tosa
STUDENTS: Pauline Romero, Christine R. Tosa
EXHIBITIONS: ?-1995, Indian Market, Santa Fe
COLLECTIONS: Wright Collection, Peabody Museum, Harvard University, Cambridge, MA; Candace Collier, Houston, TX
PUBLICATIONS: *Arizona Highways* May 1974 50(5):22; Babcock 1986; Drooker & Capone 1998:57, 138; Congdon-Martin 1999:94.

 Persingula R. Tosa's pottery scene of a woman grinding corn inside a Pueblo room is preserved at the Peabody Museum, Harvard University.

Phyllis M. Tosa

(Jemez, active ca. 1970s-present: pottery, weaving, knitting, crochet, embroidery, sewing)
BORN: April 10
FAMILY: daughter of Carmelita Magdelena; wife of Paul Tosa; mother of Earl, Madeline & Paula Tosa
EXHIBITIONS: 1985-present, Indian Market, Santa Fe; 1996-present, San Felipe Pueblo Arts & Crafts Show, San Felipe, NM; Pueblo Grande Show, Phoenix; Northwest Art Show, Portland, OR; 2001, Jemez Red Rock Indian Arts & Crafts Show
COLLECTION: School of American Research, Santa Fe
FAVORITE DESIGNS: butterflies, feathers
PUBLICATIONS: *Indian Market Magazine* 1985, 1988, 1989; School of American Research Annual Report 1999:21; Schaaf 2001:307.

 Phyllis M. Tosa explained, "I get to make something different every time. It makes me feel proud."

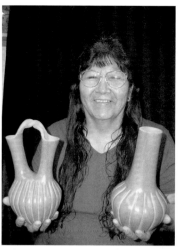

Christine Tosa - Courtesy of Jason Esquibel Rio Grande Wholesale, Inc.

Madeline Tosa - Courtesy of John D. Kennedy and Georgiana Kennedy Simpson Kennedy Indian Arts

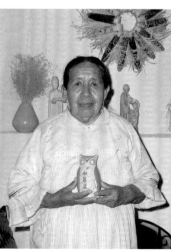

Persingula Tosa - Courtesy of John D. Kennedy and Georgiana Kennedy Simpson Kennedy Indian Arts

Phyllis M. Tosa - Courtesy of the artist. Photograph by Angie Yan Schaaf

Segora Y. Tosa
(Jemez, active ?: pottery)
ARCHIVES: Lab File, Laboratory of Anthropology Library, Santa Fe

Shadrack Tosa
(Jemez, active ?-present: polychrome bear figures)
FAVORITE DESIGNS: bears
PUBLICATIONS: Walatowa Pueblo of Jemez, "Pottery of Jemez Pueblo" (1999).

Timothy M. Tosa *(signs T. Tosa Jemez N.M.)*
(Jemez, active ca. 1982-present: polychrome Storytellers)
BORN: June 19, 1965
FAMILY: son of Marie Tosa
TEACHER: Marie Tosa, his mother
PUBLICATIONS: Berger & Schiffer 2000:153.

Vernon Tosa
(Jemez, Fire Clan, active ca. 1990s-present: stone polished jars, bowls)
FAMILY: p. great-grandson of Priscilla Loretto; grandson of Telesfor Loretto & Priscilla Griego Loretto; son of Laverne Loretto-Tosa & Frederick Tosa; brother of Danielle Tosa
TEACHER: Laverne Loretto Tosa, his mother

Toya *(see Margaret Toya, Rosalie Toya or Rosanna Toya)*

Anita F. Toya *(sometimes signs A. Toya)*
(Jemez, active ca. 1970s-present: polychrome Storytellers, Clown Storytellers, Corn Maidens, jars, bowls)
FAMILY: daughter of Mary E. Toya & Casimiro Toya; sister of Melinda Toya Fragua, Mary Ellen Toya (2), Judy Toya (2), Yolanda Toya, Casimiro Toya, Jr., Etta Toya Gachupin
EXHIBITIONS: 1988-present, Indian Market, Santa Fe
GALLERIES: Palms Trading Company, Albuquerque
PUBLICATIONS: *Indian Market Magazine* 1988; Hayes & Blom 1998:35; Congdon-Martin 1999:.

B. Toya *(1)*
(Jemez, active ?-present: polychrome jars, bowls, wedding vases)
FAVORITE DESIGNS: clouds, daisies, fineline
PUBLICATIONS: Walatowa Pueblo of Jemez, "Jemez Pottery" (1998).

B. Toya *(2)*
(Jemez, active ?-present: Storytellers)
GALLERIES: Palms Trading Company
PUBLICATIONS: Congdon-Martin 1999:95.

Ben Toya *(1) (Benjamin Toya), (signs J.B. Toya), (collaborates with Janice Sarracino)*
(Jemez, active ca. 1987-present: polychrome jars, bowls)
BORN: February 29, 1964
FAMILY: son-in-law of Rafael & Pauline Sarracino (2); husband of Janice Sarracino.
TEACHER: Sharon Sarracino, his wife's aunt
AWARDS: New Mexico State Fair, Albuquerque; Boulder, Colorado Art Show
PUBLICATIONS: Berger & Schiffer 2000:153.
 Ben Toya and Janice Sarracino are a husband and wife pottery-making team He forms the pots well, and she is an excellent pottery painter. They still do traditional firings outdoors.

Benjamin Toya *(2) (collaborates with Geraldine Toya)*
(Jemez, Acorn Clan, active ca. 1985-present: fineline, polychrome jars, vases, wedding vases, bowls)
FAMILY: husband of Geraldine Toya
AWARDS: 1998, Best of Show, Best of Pottery, 1st, New Mexico State Fair, Albuquerque; 1999, 1st, New Mexico State Fair, Albuquerque
GALLERIES: Rio Grande Wholesale, Albuquerque
 Benjamin and Geraldine Toya are a husband and wife pottery-making team. They are noted for their large fineline black-on-white with polychrome highlights on tall vases. Their wedding vases are especially beautiful. They have been rewarded for their efforts, winning Best of Show and Best of Pottery at the 1998 New Mexico State Fair.

Bertilla G. Toya
(Jemez, active ?-present)
RESIDENCE: Jemez Pueblo

Benjamin & Geraldine Toya -
Courtesy of Jason Esquibel
Rio Grande Wholesale, Inc.

Camilla Toya (see Mariam Toya)

Damian M. Toya (Corn Clan hallmark), (collaborates sometimes with Mariam Toya)

(Jemez, Zia Corn Clan, active ca. 1977-present: Storytellers, traditional polished redware & tanware melon swirl pots, jars, bowls)
BORN: November 6, 1971
FAMILY: great-granddaughter of Joe R. & Persingula M. Gachupin; granddaughter of Marie G. Romero; daughter of Maxine R. Toya & Clarence Toya; niece of Laura Gachupin; sister of Camilla Toya
TEACHERS: Marie G. Romero, her grandmother; Maxine Toya, her mother & Laura Gachupin, her aunt
STUDENTS: Mariam Camilla Toya
AWARDS: 1984, 1st, pottery; 1989, 1st, figures (ages 18 & under); 1990, Excellence in Young Potters Award, 1st; 1992, 2nd, melon bowls, 2nd, Misc; 1993, 2nd, miniature melon bowl; 2000, 2nd, Indian Market, Santa Fe; Eight Northern Indian Pueblos Arts & Crafts Show
EXHIBITIONS: 1982-present, Indian Market, Santa Fe; Heard Museum Show
DEMONSTRATIONS: Idyllwild Arts, Idyllwild, CA
GALLERIES: Andrews Pueblo Pottery & Art Gallery, Agape, Wright's Gallery, Rio Grande Wholesale, Palms Trading Company, Albuquerque
PUBLICATIONS: Peaster 1987:65, 67' Congdon-Martin 1999:96; Berger & Schiffer 2000:41, 153.

Damian Toya - Courtesy of Jason Esquibel Rio Grande Wholesale, Inc.

Damian Toya is admired for her beautiful melon swirl pots and vases. She makes both polished redware and tanware. Her lines are uniform. Her sanding is precise. In honor of her high quality of artistry, she was awarded first prize at Indian Market. She also makes Storytellers.

In 2001, Damian stated, "Pottery making has been in my family for years. I am the fifth generation. I love the way the clay feels when I work with it. Clay has it's own Spirit, so I actually connect with it."

Damian shared one family saying: "Be good to the clay, and the clay will be good to you." The artist added, ". . .so I always talk to my pieces."

When asked which was her favorite, Damian replied, "All the pots that I create are my favorite, because each one is a part of me."

Damian Toya - Courtesy of Jason Esquibel Rio Grande Wholesale, Inc.

Dannette Toya (signs D. Toya Jemez)

(Jemez, active ca. 1991-present: traditional polychrome Storytellers, Nativities, figures, jars, bowls)
BORN: October 22, 1974
FAMILY: daughter of Clemente & Lorraine Toledo
TEACHERS: her grandmother & aunt
GALLERIES: Palms Trading Company, Albuquerque
PUBLICATIONS: Congdon-Martin 1999:96; Berger & Schiffer 2000:153.

Dolores Toya

(Jemez, active ?-present: polychrome jars, bowls)
GALLERIES: Andrews Pueblo Pottery and Art Gallery, Albuquerque

Eloise Toya (Eloise Toya Ortiz)

(Jemez, active ca. 1980s-present polychrome jars, bowls, turtle, figures, sets)
FAMILY: daughter of Mary Rose Toya; sister of Norma Toya
AWARDS: 1990, 1st, figure sets, 3rd, jars, Indian Market, Santa Fe
EXHIBITIONS: pre-1985-present, Indian Market, Santa Fe
PUBLICATIONS: *Indian Market Magazine* 1985, 1988, 1989.

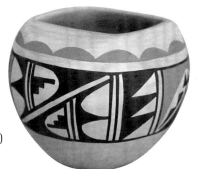

Dolores Toya - Courtesy of Andrews Pueblo Pottery and Art Gallery Albuquerque, NM

Etta Toya (see Etta Toya Gachupin)

Frances S. Toya (signs F. Toya, Jemez)

(Jemez, active ca. 1965-present: traditional polychrome jars, bowls)
BORN: September 14, 1946
FAMILY: daughter of Mabel & Frank Sando
TEACHER: Mabel Sando, her mother
PUBLICATIONS: Berger & Schiffer 2000:153.

Gary N. Toya

(Jemez, active ?-present: traditional & contemporary polychrome jars, bowls)
PUBLICATIONS: Painter 1998:16.

Georgia V. Toya (see Georgia Vigil-Toya)

Geraldine Toya *(Laguna Flower)*, *(collaborates with Benjamin Toya (2))*
(Jemez, Coyote Clan, active ca. 1987-present: fineline black-on-white, polychrome jars, vases, wedding vases, bowls)
BORN: October 26, 1966
FAMILY: wife of Benjamin Toya (2)
AWARDS: 1998, Best of Show, Best of Pottery, 1st, New Mexico State Fair, Albuquerque; 1999, 1st, New Mexico State Fair, Alb.
GALLERIES: Rio Grande Wholesale, Inc., Albuquerque

Geronima Toya
(Jemez, active ?: pottery)
ARCHIVES: Lab File, Laboratory of Anthropology, Santa Fe

Inez V. Toya
(Jemez, active ?-present: traditional & contemporary polychrome jars, bowls)
PUBLICATIONS: Painter 1998:16.

J. B. Toya *(see Janice Sarracino and Ben Toya (1))*

J. F. Toya *(see John Fitzgerald Toya)*

Jacqueline R. Toya *(signs J. Toya)*
(Jemez, active ca. 1987-present: traditional polychrome jars, bowls)
BORN: January 22, 1975
FAMILY: daughter of Mr. & Mrs. Joseph Toya, Sr.
TEACHER: Mrs. Joseph Toya, Sr.
PUBLICATIONS: Berger & Schiffer 2000:153.

Janice Sarracino Toya *(collaborates sometimes with Ben Toya)*
(Jemez, active ca. 1980s-present: traditional polychrome jars, bowls)
BORN: ca. 1960s
FAMILY: p. granddaughter of Margaret Romero Sarracino & Frank Sarracino; daughter of Pauline & Rafael Sarracino; wife of Ben Toya
TEACHER: Sharon Sarracino, her aunt

John Fitzgerald Toya *(signs J. F. Toya)*
(Jemez, active ?-present: matte polychrome & redware jars, some sgraffito bowls, vases, human effigy bowls, Corn Maiden figures)
EXHIBITIONS: 1994-present, Eight Northern Indian Pueblos Arts & Crafts Show
FAVORITE DESIGNS: clouds, hummingbirds, feathers
PUBLICATIONS: Hayes & Blom 1996:18; Walatowa Pueblo of Jemez, "Jemez Pottery" 1998; Congdon-Martin 1999:97.
 John F. Toya creates unique human effigy bowls. They feature an attached head, corn kernel bodies with a kiva step shaped mouth, inset in a larger pottery bowl. He has created a new form, a variant of a corn maiden figure.

Judy Toya *(Judith)*, *(signs J. Toya)*
(Jemez, active ca. 1972-present: matte polychrome Storytellers, Nativities)
BORN: September 19, 1953
FAMILY: daughter of Casimiro & Mary E. Toya; sister of Melinda Toya Fragua, Mary Ellen Toya (2), Yolanda Toya, Casimiro Toya, Jr., Etta Toya Gachupin & Anita Toya
TEACHER: Mary E. Toya
AWARDS: 2000, 1st, Nativities, Indian Market, Santa Fe
EXHIBITIONS: pre-1985-present, Indian Market, Santa Fe
COLLECTIONS: Dr. Gregory & Angie Yan Schaaf, Santa Fe
PUBLICATIONS: *Indian Market Magazine* 1985; Babcock 1986; Congdon-Martin 1999:97; Berger & Schiffer 2000:31, 93, 154.

K. F. Toya
(Jemez, active ?-present: Storytellers)
PUBLICATIONS: Condon-Martin 1999:97/

L. Toya
(Jemez, active ?-present: polychrome on matte tanware & black-on-white jars, bowls, vases)
FAVORITE DESIGNS: clouds, hummingbirds, feathers, fineline, eagles, Mudheads, Rainbow Man, butterflies, village scenes
PUBLICATIONS: Walatowa Pueblo of Jemez, "Jemez Pottery" (1998).

Lawrence Toya *(collaborates with Ruby N. Toya)*, *(signs L. Toya and R. N. Toya)*
(Jemez, active ca. 1982-present: polychrome jars, bowls, figures of bears, birds, miniatures,)
BORN: June 28, 1961
FAMILY: son of Martha Toya; husband of Ruby Nastacio Toya (Zuni, Bear Clan); father of Glendon & Delvin Toya
TEACHER: Martha Toya, his mother
FAVORITE DESIGN: feather-in-a-row, bears, birds
EXHIBITIONS: 1997, Eight Northern Indian Pueblos; 2001, Jemez Pueblo Red Rocks Arts & Crafts Show
PUBLICATIONS: Berger & Schiffer 2000:154.

Loretto Toya
(Jemez, active ?-present: matte polychrome Nativities, animal figures)
PUBLICATIONS: Congdon-Martin 1999:98.

Lyda M. Toya
(Jemez, active ca. 1975-present: polychrome Storytellers, jars, bowls)
BORN: April 6, 1954
TEACHERS: mother and sister
PUBLICATIONS: Congdon-Martin 1999:98; Berger & Schiffer 2000:154.

MacKenzie Toya
(Jemez, active ?-present: figures)
AWARDS: 1994, 2nd, Figures, Indian Market, Santa Fe

Margaret Toya *(signs Toya, Jemez)*
(Jemez, active ca. 1957-present: traditional polychrome jars, bowls)
BORN: September 17, 1935
FAMILY: daughter of Juan & Reyes Toya; wife of Frank Toya; mother of Lorraine Toledo & Rosalie Toya
TEACHER: her mother-in-law
STUDENT: Lorraine Toledo, her daughter
EXHIBITIONS: 1994, Eight Northern Indian Pueblos Arts & Crafts Show
PUBLICATIONS: Berger & Schiffer 2000:154.

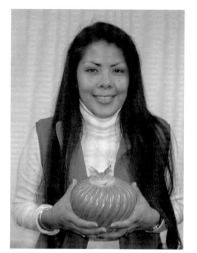

Mariam Camilla Toya -
Courtesy of Jason Esquibel
Rio Grande Wholesale, Inc.

Mariam Toya *(Rainbow Basket, Mia Toya, Camilla Toya), (collaborates sometimes with Damian Toya)*
(Jemez, Zia Corn Clan, active ca. 1988-present: polished redware and tanware swirl pots, melon pots, some with lids featuring butterfly appliques, canteens)
BORN: ca. 1974
FAMILY: granddaughter of Marie Romero; daughter of Maxine Toya; sister of Damian Toya; niece of Laura Gachupin; cousin of Gordon Foley
TEACHERS: Marie Romero, her grandmother and Maxine Toya, her mother
AWARDS: 1992, 2nd; 1993, Best Young Potter Award, 1st, 3rd; 1996, 2nd; 1998, 2nd, 3rd; 1999 2nd; 2000, 1st, 2nd, Indian Market, Santa Fe
EXHIBITIONS: 1993-present, Indian Market, Santa Fe
PUBLICATIONS: Peaster 1987:67.

Marie Ellen Toya
(Jemez, active ca. 1980s-present: Storytellers)
EXHIBITIONS: 1992-96, Indian Market, Santa Fe
PUBLICATIONS: Congdon-Martin 1999:99.

Marie Roberta Toya
(Jemez, active ca. 1980-present: polychrome & stone polished Storytellers, Nativities, jars, bowls, seed pots)
BORN: July 6, 1956
FAMILY: daughter of Casmiro & Mary E. Toya
TEACHER: Mary E. Toya, her mother
EXHIBITIONS: pre-1985-present, Indian Market, Santa Fe
PUBLICATIONS: Babcock 1986; Congdon-Martin 1999:99; Berger & Schiffer 2000:41, 93, 154.

Martha Toya
(Jemez, active ca. 1960s-present: traditional polychrome jars, bowls)
BORN: ca. 1940s
FAMILY: mother of Marie M. Chinana (2) & Lawrence Toya
STUDENTS: Marie M. Chinana, her daughter; Lawrence Toya, her son, Ruby Nastacio Toya
PUBLICATIONS: Harlow 1977.

Mary E. Toya *(1)*
(Jemez, active ca. 1950s-present: matte polychrome, red & black-on-tan Storytellers, jars, bowls, plates, wedding vases)
BORN: ca. 1934
FAMILY: wife of Casimiro Toya, Sr.; mother of Melinda Toya Fragua, Mary Ellen Toya (2), Judy Toya (2), Marie Roberta Toya, Yolanda Toya, Casimiro Toya, Jr., Etta Toya Gachupin & Anita Toya
STUDENTS: Melinda Toya Fragua, Judy Toya, Yolanda Toya & Mary Ellen Toya (2), her daughters
FAVORITE DESIGNS: kiva steps, terraced clouds, cloud tracers
PUBLICATIONS: Babcock 1986; Hayes & Blom 1996:82; Peaster 1997:61; Berger & Schiffer 2000:78.

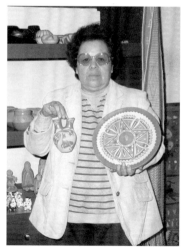

Mary E. Toya (1) - Courtesy of
John D. Kennedy and
Georgiana Kennedy Simpson
Kennedy Indian Arts

Mary E. Toya was famous for creating some of the largest Storytellers. Some of her dolls were covered with over a hundred babies. She passed her pottery-making tradition on to her daughters, so her positive influence will be felt forever.

Mary Ellen Toya *(2), (sometimes signs M. Ellen Toya)*

(Jemez, active ca. 1982-present: traditional coiled jars & bowls, polychrome Storytellers, Nativities)
BORN: March 28, 1955
FAMILY: daughter of Mary E. & Casimiro Toya, Sr.; sister of Melinda Toya Fragua, Judy Toya (2),
Yolanda Toya, Casimiro Toya, Jr., Etta Toya Gachupin & Anita Toya
TEACHER: Mary E. Toya, her mother
AWARDS: 1981, 3rd; 1990, 2nd, Storytellers, 3rd, Nativities; 1996, 3rd; 1998, Indian Market, Santa
Fe; New Mexico State Fair, Albuquerque
EXHIBITIONS: 1985-present, Indian Market, Santa Fe
GALLERIES: Andrea Fisher Fine Pottery, Santa Fe
PUBLICATIONS: Babcock 1986; Hayes & Blom 1996:82; Congdon-Martin 1999:98-99; Berger &
Schiffer 2000:78, 154.

Mary Ellen Toya has been described as a "champion" in her efforts to promote traditional
hand coiled pottery. She also creates beautiful Storytellers.

*Mary Ellen Toya (2) -
Andrea Fisher Fine Pottery
Santa Fe*

Mary Loretto Toya *(3), (Mary Loretto, Mary Toya)*

(Jemez, Water Clan, active ca. 1970s-?: polychrome figures)
BORN: ca. 1950s?
FAMILY: daughter of Louis & Carrie R. Loretto; sister of Fannie Loretto, Alma Maestas, Leonora Lupe L. Lucero,
Marie Edna Coriz & Dorothy Trujillo
PUBLICATIONS: Monthan 1979:84.

Mary Loretto Toya makes polychrome kneeling figures with rounded bodies. Their wearing blankets are painted with intri-
cate patterns. Her work has been acknowledged for excellence.

Mary Rose Toya *(4), (M. R. Toya or Mary R. Toya)*

(Jemez, active ca. 1960-present traditional & ceramic polychrome turtle, figures, jars, bowls, plates)
BORN: April 25, 1936
FAMILY: daughter of Elcira Madelena (Jemez/Zia); mother of Eloise & Norma Toya
TEACHERS: Elcira Madelena, her mother, and Zia grandmother
AWARDS: 1992, 2nd plates, Indian Market, Santa Fe
EXHIBITIONS: pre-1985-present, Indian Market
FAVORITE DESIGNS: Kachinas, turtles, feathers-in-a-row, kiva steps, clouds, rain
PUBLICATIONS: *Indian Market Magazine* 1985, 1988, 1989; Walatowa Pueblo of Jemez, "Pottery of Jemez Pueblo" (1999); Berger &
Schiffer 2000:41, 154.

Mary S. Toya *(5)*

(Jemez, active ca. 1960s-?: traditional polychrome polished redware jars, bowls)
BORN: ca. 1940
FAMILY: mother of Bertina Tosa & Elizabeth; mother-in-law of Phyllis Toya & Marcellus Medina
STUDENTS: Bertina Tosa, her daughter; Phyllis Toya, her daughter-in-law

Maxine R. Gachupin Toya *(New Snow), (signs Maxine Toya with Corn Clan hallmark)*

(Jemez, Zia Corn Clan, active ca. 1971-present: matte polychrome & polished
redware Storytellers, Corn Maidens, clay sculptures, figures, miniature kivas,
owls, textiles, prints, paintings, author)
BORN: April 25, 1948
FAMILY: m. great-granddaughter of Benigna Medina Madalena; m. granddaugh-
ter of Joe R. & Persingula M. Gachupin; daughter of Marie G. Romero; sister of
Laura Gachupin; mother of Damian Toya, Mariam Camilla Toya
EDUCATION: Jemez Village Day School; Institute of American Indian Arts, Santa
Fe; Eastern New Mexico University, Portales; University of New Mexico,
Albuquerque
TEACHERS: Persingula M. Gachupin, Marie G. Romero, Scott Momaday &
Natachee Scott
STUDENTS: Damian Toya, Mariam Camilla Toya, other children of Jemez
AWARDS: 1974, Best of Division; 1978, Best of Division, 1st, figures; 1979, Best
of Division (2), 1st (3), 2nd, figures; 1980, 2nd (3); 1981, 1st; 1983, 3rd; 1984,
1st, 3rd, figures; 1988, 2nd, misc., 3rd, Storytellers; 1989, 1st, Storytellers, 1st,
3rd, figures; 1991, 1st, 2nd, figures; 1992, Best of Division, Non-traditional
Pottery, 1st, 2nd, figures; 1993, 1st, Storytellers, 2nd, figures; 1994, 2nd, Storytellers; 1996, 3rd; 1998, 1st, 2nd, 3rd; 2000, 1st (2),
3rd, Indian Market, Santa Fe; 1974-present, 1st, 2nd, 3rd, New Mexico State Fair, Albuquerque; 1974-present, 1st, 2nd, 3rd, Eight
Northern Indian Pueblos; 1979, "Exceptional Figurine," Governor's Award, Santa Fe; Philbrook Indian Art Exhibition, Tulsa, OK;
Inter-tribal Indian Ceremonial, Gallup; 1999, 1st, 3rd, Indian Market, Santa Fe
EXHIBITIONS: 1974-present, Indian Market, Santa Fe; 1979, "One Space: Three Visions," Albuquerque Museum,
Albuquerque;1981, "American Indian Art in the 1980s," Native American Center for the Living Arts, Niagara Falls, NY
COLLECTIONS: Albuquerque Museum, Albuquerque, clown figure, ca. 1979.
FAVORITE DESIGNS: clowns eating watermelons, owls, corn plants, clouds
GALLERIES: Adobe Gallery, Albuquerque & Santa Fe; Andrews Pueblo Pottery & Art Gallery, Rio Grande Wholesale, Albuquerque

*Maxine Toya - Courtesy of Jason Esquibel
Rio Grande Wholesale, Inc.*

PUBLICATIONS: *American Indian Art Magazine* Spring 1983 8(2):36; *Indian Market Magazine* 1985, 1988, 1989; Autumn 1987 12(4):23; Winter 1993 19(1):76; Barry 1984:121, 123; Trimble 1987:68-70; Wright 1989:134; New 1991:76; Hayes & Blom 1996:82; Peaster 1997:61, 65-67, 157; Congdon-Martin 1999:101.

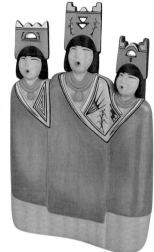

Maxine Gachupin Toya comes from a prolific pottery-making family. Her grandmother, Persingula Gachupin, is highly respected. Her mother, Marie G. Romero, and sister, Laura Gachupin, are known for their beautiful pottery. They became important makers of Storytellers and pottery figures. Her mother and baby owls have big red eyes with rows of carefully painted feathers.

Maxine began her formal education at Jemez Village Day School. She was fortunate to study under Natachee Scott and N. Scott Momaday, the noted Pulitzer prize-winning author. The young Jemez student excelled and continued through a successful college career. She then became an elementary school teacher. Maxine is a prominent educator. She has touched the lives of many Jemez children, introducing several to pottery making.

Maxine advanced as a top award-winning artist. She exhibited widely and was well received. She is talented in many forms of art. She is particularly adept at modeling native clay figures and painting them with colorful slips. She makes Sacred Clowns eating watermelons, pounding on drums and shaking their rattles. Her work draws from the past while pointing toward the future: She explained, "I want to achieve the balance between traditional and contemporary."

Maxine is committed to teaching pottery making. She takes her fifth grade class to gather clay: "How are the children going to learn if we don't share the talents that we have? We're not taking it with us to wherever we are going." (Trimble 1987:68-70.)

Maxine concluded that she loved pottery making because, "It's a gift I was born with. I have deep reverence for and honor my mentors: Benigna Medina Madalena, Persingula Gachupin, Marie G. Romero, Laura Gachupin, and my children."

Maxine Toya - Courtesy of
Andrews Pueblo Pottery & Art Gallery
Albuquerque, NM

Melissa Toya
(Jemez, active ca. 1980s-present: pottery)
FAMILY: daughter of Mary E. Toya & Casimiro Toya; sister of Mary Ellen Toya (2), Judy Toya , Yolanda Toya, Casimiro Toya, Jr., Melinda Toya Fragua; Etta Toya Gachupin & Anita Toya
AWARDS: 1992, 1st, miniatures (ages 12 & under), Indian Market, Santa Fe

Mia Toya *(see Camilla Toya)*

Myra Toya
(Jemez, active ca. 1990s-present: sgraffito jars, bowls, pots)
AWARDS: 1992, 1st, sgraffito, Indian Market, Santa Fe

Norma Toya
(Jemez, active ca. pre-1985-present polychrome turtle, figures)
FAMILY: daughter of Mary Rose Toya; sister of Eloise Toya
AWARDS: 1993, 3rd, Storytellers; 1994, 2nd, figures, Indian Market, Santa Fe
EXHIBITIONS: pre-1985-present, Indian Market, Santa Fe
PUBLICATIONS: *Indian Market Magazine* 1985, 1988, 1989.

Perfectita Toya *(Perfecta)*
(Jemez, Sun Clan, ca. 1920s-80s: pottery, woven belts, yucca sifter baskets)
BORN: ca. 1900s
FAMILY: wife of Seriaco Toya; mother of Mary Small; m. grandmother of Scott Small
PUBLICATIONS: *El Palacio* Jan. 1947 54(1):14; *Southwest Profile* Nov./Dec. 1985 8(7):20.

Phyllis Toya *(signs P. Toya)*
(Jemez, active ca. 1985-present: polychrome Storytellers, jars, bowls)
BORN: September 21, 1961
FAMILY: daughter of Ruby C. Waquie; daughter-in-law of Mary S. Toya
TEACHER: Mary S. Toya, her mother-in-law
PUBLICATIONS: Hayes & Blom 1998:35; Berger & Schiffer 2000:154.

R. F. Toya
(Jemez, active ?-present: matte polychrome Nativities, figures)
GALLERIES: Palms Trading Company, Albuquerque
PUBLICATIONS: Congdon-Martin 1999:102.

Reyes Toya *(1)*
(Jemez, active ca. 1930s-60s+: traditional polychrome jars, bowls)
BORN: ca. 1915
FAMILY: wife of Juan Toya; mother of Margaret Toya; grandmother of Lorraine Toledo & Rosalie Toya

Reyes Shendo Toya *(2) (Reyes Shendoh)*

(Jemez, Coyote Clan, active ca. 1919-present: traditional cooking pots & polychrome jars, bowls, wedding vases)
BORN: ca. April 16, 1907
FAMILY: daughter of Juanito & Andrieta Shendoh; sister of Jeronima Shendoah; wife of Jose Maria Toya; mother of Clara Gachupin, Marie Vigil; grandmother of Lorraine Chinana, Ida Yepa, Georgia Vigil-Toya, Angela Chinina & Emon yepa
STUDENT: her daughters, granddaughters
FAVORITE DESIGNS: clouds, feathers
PUBLICATIONS: U.S. Census 1920, family 46.

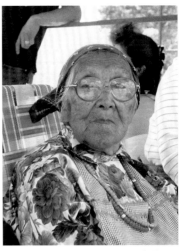

Reyes S. Toya -
Photograph by Angie Yan Schaaf

Rosalie Toya *(Rosa Lee Toya), (signs Toya, Jemez)*

(Jemez, active ca. September 23, 1962: matte polychrome Storytellers, jars, bowls, wedding vases)
BORN: September 23, 1962
FAMILY: granddaughter of Juan & Reyes Toya; daughter of Frank & Margaret Toya; mother of Roseanna Toya
STUDENT: Roseanna Toya, her daughter
GALLERIES: Palms Trading Company, Albuquerque
PUBLICATIONS: Hayes & Blom 1996; Congdon-Martin 1999:102; Berger & Schiffer 2000:154.

Roseanna Toya

(Jemez, active ca. 1995-present: traditional polychrome jars, bowls)
BORN: March 8, 1981
FAMILY: great-granddaughter of Juan & Reyes Toya; granddaughter of Frank & Margaret Toya; daughter of Rosalie Toya
PUBLICATIONS: Berger & Schiffer 2000:154.

Ruby Nastacio Toya *(collaborates with Lawrence Toya), (signs L. Toya and R. N. Toya)*

(Zuni, Bear Clan, married into Jemez, active ca. 1982-present: polychrome jars, bowls, figures of bears, birds, miniatures, fetishes, jewelry)
BORN: September 7, 1957
FAMILY: m. granddaughter of Conrad & Lola Lesarlley; daughter of Celestine & Delphine Nastacio; sister of Beatrice Weebothee, Randy Nastacio, Delia Cachini, Lorreta Nastacio, Juana Lutse, Cyrus Lutse, Victoria Lutse, Hermanita Lutse; wife of Lawrence Toya; mother of Glendon & Delvin Toya
TEACHER: Jennie Laate, her high school teacher, and Martha Toya, her mother-in-law
EXHIBITIONS: 1997, Eight Northern Indian Pueblos Arts & Crafts Show; 1990s-present, Jemez Pueblo Red Rocks Arts & Crafts Show
COLLECTIONS: Charlotte Schaaf, Santa Fe
FAVORITE DESIGNS: bears, lizards, eagles, owls, swans, clouds, feather-in-a-row
PUBLICATIONS: Berger & Schiffer 2000:154.

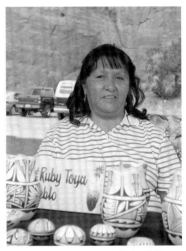

Ruby N. Toya -
Photograph by Angie Yan Schaaf

 In the Summer of 2001, we met Ruby Nastacio Toya at the Jemez Pueblo Red Rocks Arts & Crafts Show. She said that she wished to honor her teacher, "I give a lot of credit to my mother-in-law, Martha Toya (Jemez), for teaching me her techniques. I was gifted to make these potteries. When I touch the Earth clay, I feel good."
 Ruby sometimes can be found selling her pottery under the Portal on the Plaza in downtown Santa Fe. She is friendly and speaks with enthusiasm in sharing her knowledge of pottery-making traditions.

Yolanda Toya

(Jemez, active ca. 1977-present: matte polychrome Storytellers)
BORN: April 21, 1967
FAMILY: daughter of Mary E. Toya & Casimiro Toya; sister of Melinda Toya Fragua, Melissa Toya, Mary Ellen Toya (2), Judy Toya, Casimiro Toya, Jr., Etta Toya Gachupin & Anita Toya
TEACHER: Mary E. Toya
EXHIBITIONS: pre 1988-present, Indian Market, Santa Fe
GALLERIES: Andrews Pueblo Pottery & Art Gallery, Albuquerque
PUBLICATIONS: Babcock 1986; Congdon-Martin 1999:102; Berger & Schiffer 2000:94, 154.

Del Trancosa

(Cochiti/San Felipe, active ca. 1980-present: polychrome Storytellers, figures, turtles)
BORN: August 2, 1951
FAMILY: son-in-law of Helen Cordero
FAVORITE DESIGNS: Sunfaces, lambs, turtles, lightning, clouds
GALLERIES: Adobe Gallery, Albuquerque
PUBLICATIONS: *American Indian Art Magazine* Spring 1983 8(2):36; Babcock 1986:133; Congdon-Martin 1999:40.

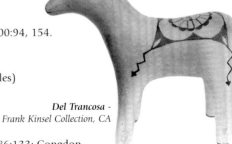

Del Trancosa -
Frank Kinsel Collection, CA

Kevin Trancosa

(San Felipe, active ca. 1990s, traditional micaceous jars, bowls)
LIFESPAN: April 6, 1968 - ?
TEACHER: Hubert Candelario
EXHIBITIONS: 1997-present, Indian Market, Santa Fe
COLLECTIONS: Indart, Inc.
GALLERIES: Native American Collections, Denver, CO; King Galleries of Scottsdale, AZ
PUBLICATIONS: *The Messenger,* Wheelwright Museum Summer 1996:5,8; Fall-Winter 1996:10; *American Indian Art Magazine* Winter 1997:96-97; *Native Peoples* Feb.-Apr. 1998:34, 37; *Indian Artist Magazine* Winter 1998:63; Berger & Schiffer 2000:155.

*(Left to right): **Hubert Candelario** & **Kevin Trancosa** - Courtesy of Jill Giller, Native American Collections, Denver*

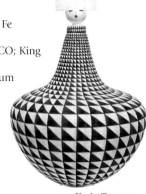

Kevin Trancosa - King Galleries of Scottsdale, AZ

Kevin Trancosa - Photograph by Bill Knox Courtesy of Indart Incorporated

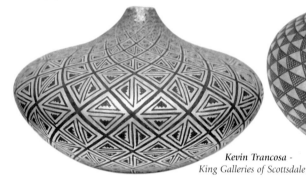

Kevin Trancosa - King Galleries of Scottsdale

Kevin Trancosa - Photograph by Bill Bonebrake Courtesy of Jill Giller Native American Collections, Denver

Adrian Trujillo

(Acoma, active ?-present: polychrome ollas, jars, bowls)
FAVORITE DESIGNS: deer with heartlines
PUBLICATIONS: Dillingham 1992:206-208.

April Trujillo

(Cochiti, active ca. 1990s-present: pottery, figures)
AWARDS: 1992, 1994, 1996, Student Artist, Heard Museum, Phoenix
ARCHIVES: Heard Museum Library, artist file.

Carolyn S. Trujillo *(signs C. S. Trujillo, Cochiti N. M.)*

(Cochiti, active ca. 1960s-90s: polychrome jars, bowls, figures, Storytellers)
BORN: September 16, 1949
FAMILY: daughter of Efracio & Katherine Suina
TEACHER: Katherine Suina
PUBLICATIONS: Berger & Schiffer 2000: 155.

Catherine Trujillo *(see Kathy Trujillo)*

Cecilia V. Trujillo *(signs C. V. Trujillo, Cochiti N.M.)*

(Cochiti, active ca. 1977-present: polychrome jars, bowls, Storytellers, Nativities)
BORN: October 12, 1954
FAMILY: m. granddaughter of Carrie & Louis Loretto; daughter of Onofre & Dorothy Trujillo; sister of Judith A. Suina
TEACHER: Dorothy Trujillo
PUBLICATIONS: Berger & Schiffer 2000:94, 155.

David Trujillo

(Cochiti, active ?-present: polychrome Storytellers)
GALLERIES: Palms Trading Company, Albuquerque
PUBLICATIONS: Congdon-Martin 1999:42.

Deanna Trujillo

(Sandia, active ?-present: pottery)
FAMILY: cousin of Charles Trujillo (jeweler)

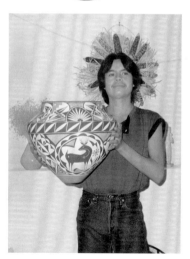

Adrian Trujillo - Courtesy of John D. Kennedy and Georgiana Kennedy Simpson Kennedy Indian Arts

Dorothy Trujillo *(Dorothy Loretto) (signs D. Trujillo, Cochiti, N.M.)*

(Laguna/Jemez, married into Cochiti, Water Clan, active ca. 1950-90s: polychrome jars, bowls, Storytellers, Nativities, figures, sculptures, jewelry, storytelling)

LIFESPAN: ca. April 26, 1932 - ca. 1990s

FAMILY: p. granddaughter of Guadalupe Madalena Loretto (Jemez); daughter of Carrie Reid (Laguna) & Louis Loretto (Jemez); sister of Mary E. Toya, Marie Edna Coriz, Alma Concho Loretto, Fannie Wall Loretto, Leonora Lupe Lucero; wife of Onofre Trujillo. Sr. (jeweler); mother of Judith A. Suina, Cecilia V. Trujillo, Frances Pino, Onofre Trujillo, Jr. & 2 other children

EDUCATION: San Diego Mission School

TEACHERS: Guadalupe, Carrie Reid & Damacia Cordero, her husband's aunt

STUDENTS: Judith A. Suina, Norma A. Suina, Cecilia V. Trujillo

AWARDS: Indian Market, Santa Fe; New Mexico State Fair, Albuquerque; Santo Domingo Arts & Crafts Show, Santo Domingo

EXHIBITIONS: pre-1985, Indian Market, Santa Fe

COLLECTIONS: Smithsonian Institution, Museum of Natural History, Washington, D.C.; John Blom; Heard Museum, Phoenix

PUBLICATIONS: Monthan 1979:37-39; Barry 1984:115-16; *Indian Market Magazine* 1985, 1988, 1989; Babcock 1986:133; Eaton 1990:20; *The Messenger,* Wheelwright Museum Summer 1995:5; Hayes & Blom 1996; 1998:33; Batkin 1999; Congdon-Martin 1999:40-42; Berger & Schiffer 2000:78, 94,149, 155.

Dorothy Trujillo makes Cochiti-style pottery, although she was born to a Laguna mother and a Jemez father. She attended the San Diego Mission School and learned pottery making during summer vacations from her mother and grandmother. At the age of 10, she was making figures, such as mothers with child, figures in canoes and portraits of chiefs.

When Dorothy married Onofre Trujillo, she moved to Cochiti Pueblo and earned permission to use Cochiti clay. Her husband's aunt, Damacia Cordero, taught her to do Cochiti-style pottery

Dorothy began making Storytellers before 1970. Two years later, she began making Nativities. St. Bonaventure Church in Cochiti commissioned one especially large set. Dorothy shares her pottery-making knowledge with others. She has taught at least three people, including two of her own daughters. Her Storytellers may have only one or over 40 babies. One of her Storytellers is on exhibit at the Smithsonian Institution, Museum of Natural History, Washington, D.C.

Elizabeth N. Trujillo

(Cochiti, active ca. 1970s-present: polychrome large storage jars, ollas, jars, bowls, ollas, lamp bases, mugs shaped like drums, figures, deer, beadwork)

BORN: December 12, 1949

FAMILY: wife of Ray H. Trujillo

AWARDS: 1983, 3rd; 1984, 3rd, Jars; 1989, 1st, Jars; 1990, Best of Class, Best of Division, 1st, 1994, 1st, jars, Indian Market, Santa Fe

EXHIBITIONS: pre-1985, Indian Market, Santa Fe; 1997, Eight Northern Indian Pueblos Arts & Crafts Show

COLLECTIONS: Wright Collection, Peabody Museum, Harvard University, Cambridge, MA; John Blom; Dr. Gregory & Angie Yan Schaaf, Santa Fe

PUBLICATIONS: *Southwest Art* June 1983 13(1):55-64; Nov. 1990:25; *Indian Market Magazine* 1985, 1988, 1989; Drooker, et al., 1998:50, 138; Hayes & Blom 1998:43.

In 1990, Elizabeth Trujillo's large Cochiti storage jars was judged the best pot at Indian Market, Santa Fe. The pot was tall with two neck bands, a shoulder band and a fast moving cloud design in black-on-cream.

Evon Trujillo

(Cochiti/San Ildefonso, active ca. 1980s-present: Storytellers)

BORN: 1959

FAMILY: m. granddaughter of Jose A. Aguilar & Rosalie Aguilar (San Ildefonso); p. granddaughter of Helen Cordero; daughter of Kathy Trujillo (Catherine Aguilar) & Gabe Yellowbird Trujillo

Felipa Trujillo *(Felipa Herrera)*

(Cochiti, active ca. 1950s-present: polychrome Storytellers, Nativities)

BORN: April 27, 1908

FAMILY: daughter of Juan & Estefanita Arquero Herrera; sister of Toñita, Belena, Candelaria & Santiago Herrera; wife of Paul Trujillo; aunt of Helen Cordero (by marriage) and Ada Suina; mother of Angel Quintana & five others

EDUCATION: St. Catherine's Indian School, Santa Fe

AWARDS: Indian Market, Santa Fe; New Mexico State Fair, Albuquerque

COLLECTIONS: Wright Collection, Peabody Museum, Harvard University, Cambridge, MA

GALLERIES: Adobe Gallery, Albuquerque; Andrews Pueblo Pottery & Art Gallery, Albuquerque

FAVORITE DESIGNS: Storytellers, Nativities, angels, mother & child, frogs with open mouths

PUBLICATIONS: U.S. Census 1920, family 42; *New Mexico Magazine* (December 1976); Monthan 1979:40-42; Babcock 1986:134; Hayes & Blom 1998; Drooker, et al., 1998:47, 50, 138; Congdon-Martin 1999:43.

Felipa Trujillo - Courtesy of Andrews Pueblo Pottery & Art Gallery

Felipa Trujillo grew up helping her mother, Estefanita Herrera, make pottery. They made bowls and jars with lizard spouts. After her mother passed away around 1960, Felipa began signing her own pots. She expanded into making figures.

About 1969, Felipa received her first commission to make a Nativity. She started out painting their dress in Spanish-style, and then switched to making them in Indian-style. By the 1980s, she was making about a dozen sets per year.

Felipita Trujillo *(may be the same as Felipa Trujillo)*

(Cochiti, active ?: canteens with lizard figures)

COLLECTIONS: Wright Collection, Peabody Museum, Harvard University, Cambridge, MA

PUBLICATIONS: Drooker, et al., 1998:50.

Gabe Yellowbird Trujillo *(J.G. Yellowbird Trujillo)*
(Cochiti, active ca. 1974-present: pottery, drums, drum earrings)
BORN: June 16, 1930
FAMILY: adopted son of Trini Herrera; husband of Kathy Trujillo; father of Ivan, Evon, Roberta & Jeanette Trujillo
EXHIBITIONS: pre-1988-present, Indian Market, Santa Fe; 1994-1997, Eight Northern Indian Pueblos Arts & Crafts Show
PUBLICATIONS: *Indian Market Magazine* 1988; *Southwest Art* Feb. 1993 22(9):106; *Native Peoples* Winter 1996-97 9(3):36-40.

Geri Trujillo *(Geraldine Trujillo)*
(Cochiti/San Juan, active ?-present: polychrome Storytellers, turtles)
EXHIBITIONS: pre-1985-1997, Indian Market, Santa Fe
GALLERIES: Andrews Pueblo Pottery & Art Gallery, Albuquerque
PUBLICATIONS: *Indian Market Magazine* 1985, 1988, 1989; Congdon-Martin 1999:43; Schaaf 2000:253.

Ivan Trujillo *(Can-su-da)*
(Cochiti/San Ildefonso: active ca. 1990s-present: pottery, drums)
BORN: ca. 1950s
FAMILY: grandson of Trini Herrera; son of Gabe Yellowbird Trujillo & Kathy Trujillo; brother of Evon, Roberta & Jeanette Trujillo
AWARDS: Artist in residence at the Museum of Indian Arts & Cultures
EXHIBITIONS: 1995-present, Indian Market, Santa Fe; 1995-present, Eight Northern Indian Pueblos Arts & Crafts Show
PUBLICATIONS: *Native Peoples* Winter 1996-97 9(3):36-40; Schaaf 2000:225.

Joanne Trujillo
(Cochiti, active ?-present: pottery, Storytellers)
COLLECTIONS: Dr. Gregory & Angie Yan Schaaf, Santa Fe
PUBLICATIONS: *Cowboys & Indians* Winter 1999 7(6):52.

Juanita Trujillo
(Cochiti, active ca. 1940s-?: pottery)
COLLECTIONS: Allan & Carol Hayes

Kathy Trujillo *(Katy, Catherine Aguilar Trujillo)*
(San Ildefonso, married into Cochiti, active ca. 1950s-?: Storytellers)
BORN: August 28, 1931
FAMILY: daughter of Jose A. & Rosalie Aguilar (San Ildefonso); daughter-in-law of Trini Herrera; wife of Gabe Yellowbird Trujillo; mother of Evon Trujillo, Ivan Trujillo, Roberta Trujillo, Jeanette Trujillo
PUBLICATIONS: Babcock 1986:134; *American Indian Art Magazine* Spring 1983 8(2):36-37.

Leonard Trujillo *(collaborates with Mary T. Trujillo (3))*
(Cochiti, active ca. 1980s-present: polychrome Storytellers, jars, bowls, bows & arrows)
BORN: ca. 1930s
Family: adopted son of Fred & Helen Cordero; husband of Mary Trujillo
AWARDS: 1992, Best of Division, Traditional Pottery, 1st, 3rd (3); 1993, 2nd, Indian Market, Santa Fe
EXHIBITIONS: 1992-present, Indian Market, Santa Fe; 1998-present, Eight Northern Indian Pueblos Arts & Crafts Show
GALLERIES: Andrews Pueblo Pottery & Art Gallery, Albuquerque; Foutz Trading Company, Shiprock, AZ
PUBLICATIONS: *Southwest Art* Feb. 1993 22(9):106; Hayes & Blom 1998:35; Congdon-Martin 1999:44-45.

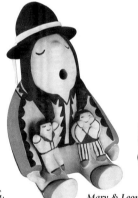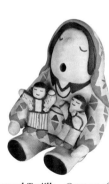

Mary & Leonard Trujillo - Courtesy of Don & Lynda Shoemaker, Santa Fe

Maria Trujillo
(Laguna, Turkey Clan, active ca. 1920s-?: traditional polychrome jars, bowls)
BORN: ca. 1905
FAMILY: mother of Sarah Garcia (married into Acoma); grandmother of Debbie G. Brown and Goldie Hayah; great-grandmother of Juliet Hayah

Mary E. Trujillo *(1)*
(Isleta/San Juan, active ?-present: micaceous bean pots, figures, jars, bowls, clothing)
EXHIBITIONS: 1995-present, Eight Northern Indian Pueblos Arts & Crafts Show
COLLECTIONS: School of American Research, Santa Fe, SAR1995-4-5
PUBLICATIONS: *Pueblo Horizons* Summer 1993 17:1; Anderson 1999:113, 170; Schaaf 2000:254.

Mary Edna Trujillo *(2)*, *(formerly Mary Edna Naranjo)*
(Cochiti, Pumpkin Clan, active 1975-present: polychrome jars, bowls, figures)
BORN: March 27, 1965
FAMILY: daughter of Louis & Virginia Naranjo; sister of Pauline Naranjo

Mary T. Trujillo *(3), (sometimes collaborates with Leonard Trujillo)*
(Cochiti/San Juan, active ca. 1983-present: polychrome jars, bowls, Storytellers, figures, micaceous lidded bean pots, bows & arrows)
BORN: May 26, 1937
FAMILY: daughter of Jose & Leonidas Cata Tapia; daughter-in-law of Helen Cordero; wife of Leonard Trujillo
TEACHER: Helen Cordero, her mother-in-law
EXHIBITIONS: 1982-present, Indian Market, Santa Fe; 1998-present, Eight Northern Indian Pueblos Arts & Crafts Show
AWARDS: 1984 2nd (4); 1988, 3rd, Figures, Indian Market, Santa Fe; 1990-91. Lamon Scholar, School of American Research, Santa Fe; 1991, 1st, 2nd; 1992, 1st, 3rd (3), Indian Market, Santa Fe; Inter-tribal Indian Ceremonial, Gallup; Eight Northern Pueblo Indian Arts & Crafts Show
COLLECTIONS: Heard Museum, Phoenix; School of American Research, Santa Fe
FAVORITE DESIGNS: Storytellers, bears, angels, drummers
PUBLICATIONS: *SWAIA Quarterly* Fall 1982:10-14; *American Indian Art Magazine* Spring 1983 8(2):36; *Indian Market Magazine* 1985, 1988, 1989; Babcock 1986:134; Trimble 1987:54, 56, 58, 61, 104; *Southwest Art* Feb. 1993 22(9):106; School of American Research, *Annual Report* 1994:15; Hayes & Blom 1998:35; Congdon-Martin 1999:43-45; Anderson 1999:170; Berger & Schiffer 2000:95, 155; Schaaf 2000:254.

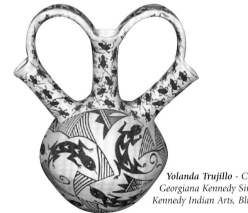

Mary & Leonard Trujillo - Walton-Anderson Collection

Merlinda Trujillo
(Acoma, active ?-1990+: polychrome jars, bowls)
PUBLICATIONS: Dillingham 1992:206-208.

Onofre Trujillo, Jr.
(Cochiti/Jemez, active ca. 1980s-present: Storytellers)
BORN: ca. 1969
FAMILY: great-grandson of Lupe Madalena Loretto (Jemez) m. grandson of Carrie Reid Loretto & Louis Loretto (Jemez: jeweler); son of Dorothy Trujillo (Jemez) & Onofre Trujillo, Sr. (Cochiti); brother of Frances Pino, Cecilia Valencia Trujillo & Judith Suina
PUBLICATIONS: Babcock 1986:135.

Patrick S. Trujillo *(signs Tsi-na-tyi, Rain Clouds hallmark)*
(Cochiti, active ca. 1993-present: polychrome jars, bowls, figures, Storytellers)
BORN: March 5, 1954
FAMILY: grandson of Damacia Cordero; son of Marie Laweka
TEACHER: Dominica Cordero
PUBLICATIONS: Berger & Schiffer 2000:155.

Paul Trujillo
(Cochiti, active ca. 1950s-present: polychrome Storytellers, Nativities)
BORN: ca. 1910
FAMILY: husband of Felipa Trujillo; uncle of Helen Cordero; father of six
AWARDS: Indian Market, Santa Fe; New Mexico State Fair, Albuquerque
PUBLICATIONS: *New Mexico Magazine* (December 1976); Monthan 1979:40-42.

Ray H. Trujillo
(Cochiti, active ca. pre-1985-present: pottery, beadwork)
EXHIBITIONS: pre-1985-present, Indian Market, Santa Fe; 1997-present, Eight Northern Indian Pueblos Arts & Crafts Show
PUBLICATIONS: *Indian Market Magazine* 1985, 1989.

Roberta H. Trujillo
(Acoma, active ca. 1987-present: ceramic polychrome jars, bowls)
BORN: May 23, 1951
FAMILY: daughter of Ventura Howeya
TEACHER: grandmother & Ventura Howeya, her mother
PUBLICATIONS: Berger & Schiffer 2000:155.

Rufina Trujillo
(Cochiti, active ?-present: polychrome Storytellers)
GALLERIES: Adobe Gallery, Albuquerque
PUBLICATIONS: Congdon-Martin 1999:46.

Yolanda P. Trujillo
(Acoma, active ca. 1985-present: traditional polychrome jars, bowls)
BORN: February 7, 1963
FAMILY: daughter of Harold & Rebecca Pasquale
TEACHERS: her grandmother & Rebecca Pasquale, her mother
COLLECTIONS: John Blom
GALLERIES: The Indian Craft Shop, U.S. Department of Interior, Washington, D.C.; Kennedy Indian Arts, Bluff, UT
PUBLICATIONS: Dillingham 1992:206-208; Berger & Schiffer 2000:155.

Yolanda Trujillo - Courtesy of Georgiana Kennedy Simpson Kennedy Indian Arts, Bluff, UT

Tsayutitsa *(Mrs. Milam's mother)*

(Zuni, active ca. 1910s-50s: traditional polychrome-on-white, black-on-tan, large ollas, drum pots, jars, bowls)
FAMILY: mother of Mrs. Milam
COLLECTIONS: Laboratory of Anthropology, Museum of New Mexico, Santa Fe; School of American Research, Santa Fe; Museum of Northern Arizona, Flagstaff, AZ, 2 ollas, ca. 1920s; Taylor Museum, Colorado Springs, CO, drum pot, ca. 1928, #4364, polychrome storage jar, ca. 1925-35, #4371; Denver Art Museum, black-on-tan jar, ca. 1932, #1932.374; Zuni Tribal Council, Zuni, NM, large storage jar, ca. 1939.
FAVORITE DESIGNS: rosettes, Rainbirds, other birds, swirls, kiva steps, deer with heartlines
PUBLICATIONS: Underhill 1944:85; Hardin 1983:4; Batkin 1987:158-59, 165; Eaton 1990:26-27; Marie Soseeah American Indian Art Magazine Marie Soseeah Summer 1991:49; Mercer 1995:38; Hayes & Blom 1996:168; Anderson, et al. 1999:56-57.

> Tsayutitsa and Catalina Zunie were among the dozen top Zuni potters from the 1920s through 1950. She is known for large, superbly formed jars with swollen shoulders and complex designs. She also made huge drum pots, some painted with a single large deer with a heartline, considered among the most famous types of Zuni ceramics. The neck was made so a deerskin drum hide could be tied to the top of the pot.

Brian Tsethlikai *(collaborates sometimes with Yvonne Nashboo), (signs B.T./Y.N., Zuni)*

(Zuni, Parrot Clan, active ca. 1995-present: polychrome polished redware effigy pots, seed bowls, vases, miniatures)
BORN: ca. 1978
FAVORITE DESIGNS: lizards, salamanders
GALLERIES: Rio Grande Wholesale, Albuquerque

G. Tsethlikai

(Acoma, active ?-present: polychrome jars, bowls)

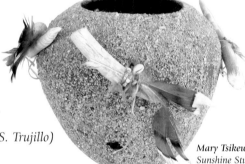

*G. Tsethlikai - Courtesy of
Peter B. Carl, Oklahoma City, OK*

Priscilla Tsethlikai *(Priscilla Nahohai),*
(collaborated sometimes with Josephine Nahohai)

(Zuni, born into Eagle Clan, active ca. 1970s-present: traditional polychrome cornmeal bowls)
FAMILY: m. granddaughter of La Wa Ta; daughter of Josephine Nahohai; sister of Randy Nahohai, Irene Nahohai and Milford Nahohai
DEMONSTRATIONS: 1986, Folklife Festival, Smithsonian Institution, Washington, D.C.
FAVORITE DESIGNS: terraced clouds, tadpoles, dragonflies
PUBLICATIONS: Rodee & Ostler 1986:52.

Mary Tsikewa

(Zuni, active ?-present: fetish pots)
GALLERIES: Sunshine Studio at www.sunshinestudio.com

Concepcion Tsinatay

(Acoma, active ?: traditional polychrome jars, bowls)
ARCHIVES: Lab file, Laboratory of Anthropology Library, Santa Fe.

Tsi-na-tyi, Rain Clouds hallmark *(see Patrick S. Trujillo)*

*Mary Tsikewa - Courtesy of
Sunshine Studio*

Sadie Tsipa *(signed Sadie T.)*

(Zuni, active ca. 1940s-?: traditional polychrome jars, bowls, owls, effigy jars, frog pots)
COLLECTIONS: Wright Collection, Peabody Museum, Harvard University, Cambridge, MA; Dr. Gregory & Angie Yan Schaaf, Santa Fe
FAVORITE DESIGNS: deer with heartlines, frogs
PUBLICATIONS: Hayes & Blom 1996; Drooker & Capone 1998:71, 140; Congdon-Martin 1999.

Andrea Tsosie *(signs A. Tsosie - Jemez)*

(Jemez, active ca. 1977-1990s: traditional polychrome jars, bowls)
BORN: June 4, 1922
FAMILY: daughter of Mr. & Mrs. Juan Celo; wife of Hubert Tsosie; mother of Rebecca Tsosie, Leonard Tsosie, Irene Herrera; m. grandmother of Caroline Sando
PUBLICATIONS: Berger & Schiffer 2000:156.

Darrick L. Tsosie *(signs D. Tsosie)*

(Jemez, active ca. 1990s-present: polychrome on matte tanware Storytellers, corn figures)
BORN: ca. 1977
FAMILY: m. great-grandson of Emilia Loretto; m. grandson of Felix & Grace L. Fragua; son of Leonard & Emily F. Tsosie; brother of Joseph L. Tsosie, Lorna Tsosie & Robert Tsosie
AWARDS: 1989, 1st, figures (ages 12 & under); 1992, 1st, 3rd, figures; 1993, 1st, figures (ages 18 & under); 1994, 2nd, 3rd, figures, Indian Market, Santa Fe
EXHIBITIONS: 1994-present, Indian Market, Santa Fe
FAVORITE DESIGNS: figures with children, bears
PUBLICATIONS: Peaster 1997:69, 71; Berger & Schiffer 2000:95, 156.

Emily Fragua Tsosie *(Emily Fragua), (signs E. Tsosie, E.F. Tsosie, E. Fragua Tsosie or Fragua Tsosie)*

Emily Fragua Tsosie -
Courtesy of Jason Esquibel
Rio Grande Wholesale, Inc.

(Jemez, active ca. 1963-present: matte polychrome on tanware Storytellers, Clowns, Cat Storytellers, Corn Maidens, drummers & other figures, Nativities, owls)
BORN: June 4, 1951
FAMILY: m. granddaughter of Emilia Loretto; daughter of Felix & Grace L. Fragua; sister of Chris Fragua, Clifford Kim Fragua (2), Felicia Fragua Curley, Bonnie Fragua, Carol Fragua Gachupin (1), Rose T. Fragua, Phillip M. Fragua, Benjamin Fragua & Cindy Fragua; wife of Leonard Tsosie; mother of Joseph L. Tsosie, Darrick Tsosie, Lorna Tsosie & Robert Tsosie
TEACHERS: Grace L. Fragua, her mother, and Emilia Loretto, her grandmother
STUDENTS: Cheryl Fragua; Leonard Tsosie, her husband
AWARDS: 1st, Eight Northern Indian Pueblos Arts & Crafts Show; 1981, 3rd; 1993, 2nd, Storytellers, 3rd, Nativities; 1994, 3rd, figures, Indian Market, Santa Fe Inter-tribal Indian Ceremonial, Gallup
EXHIBITIONS: pre-1981-present, Indian Market, Santa Fe; pre-1997, Eight Northern Indian Pueblos Arts & Crafts Show
COLLECTIONS: Sunshine Studio; Walton-Anderson
FAVORITE DESIGNS: figures with children
GALLERIES: Adobe Gallery; Turquoise Lady, Rio Grande Wholesale, Albuquerque; Kennedy Indian Arts, Bluff, UT

Emily Fragua Tsosie -
Walton-Anderson Collection

PUBLICATIONS: *SWAIA Quarterly* Fall 1982 17(3):11; Barry 1984:121; *Indian Market Magazine* 1985, 1988, 1989; Babcock 1986; *American Indian Art Magazine* Spring 1990 15(2):89; Winter 1996 22(1):82; Peaster 1997:69; Congdon-Martin 1999:65, 104-05; Berger & Schiffer 2000:95, 154.

Emily Fragua Tsosie -
Courtesy of Sunshine Studio

Emily Fragua Tsosie is a fine art clay sculptor. Her figures are exceptionally well formed, with animated expressions. She adds corn husk tassels to make them even more lifelike. Her figures have individual personalities, expressing happiness and joy.

Emily's figures are very popular. Her Cat Storytellers have attracted particular attention. Her clowns and other figures almost always are singing. They bring delight to all ages. Emily's figures reach out and touch people's hearts.

Around 1985, Emily was encouraged to make the first Cat Storyteller by Santa Fe collector Challis Thiessen who shared her personal account: "We looked for two years, without success, for Cat Storytellers to sell in our Southwest art booth at a local cat show. We met Emily Tsosie at Indian Market in Santa Fe. She was selling delightful Storytellers of frogs, bears and other animals, but not cats. I suggested that she try making a mother cat with kittens. Emily welcomed the idea and soon produced the first of many. People at the cat show loved them! Now, 15 years later, her cats are among her best sellers."

Emily Fragua Tsosie -
Courtesy of Sunshine Studio

Joseph L. Tsosie

(Jemez, active ca. 1990s-present: pottery)
BORN: ca. 1970s
FAMILY: m. great-grandson of Emilia Loretto; m. grandson of Felix & Grace L. Fragua; son of Leonard & Emily F. Tsosie; brother of Darrick Tsosie, Lorna Tsosie & Robert Tsosie
EXHIBITIONS: 1992-present, Indian Market, Santa Fe

Leonard Tsosie *(Corn Hill), (signs Leonard Tsosie with Corn Hill hallmark or L. Tsosie-Corn Hill, Jemez)*

Leonard Tsosie - Courtesy of Jason Esquibel
Rio Grande Wholesale, Inc.

(Jemez, active ca. 1991-present: matte polychrome Storytellers, Drummers, Clowns, horses with children, jars, bowls)
BORN: June 10, 1941
FAMILY: m. grandson of Juan & Susanita Celo; son of Hubert & Andrea Tsosie; brother of Rebecca Tsosie & Irene Herrera; uncle of Caroline Sando; husband of Emily Fragua-Tsosie; father of Joseph L., Darrick, Lorna & Robert Tsosie
TEACHER: Emily Fragua-Tsosie, his wife
AWARDS: 1996, 3rd; 1997, 2nd, Eight Northern Indian Pueblos Arts & Crafts Show; 1996, 2nd; 1997, 2nd, Indian Market, Santa Fe
EXHIBITIONS: 1994-present, Indian Market, Santa Fe; 1997, Eight Northern Indian Pueblos Arts & Crafts Show
GALLERIES: Rio Grande Wholesale, Palms Trading Company, Albuquerque; Sunshine Studio at www.sunshinestudio.com
PUBLICATIONS: *American Indian Art Magazine* Winter 1996 22(1):82; Peaster 1997:69; Congdon-Martin 1999:106; Berger & Schiffer 2000:80, 144, 156.

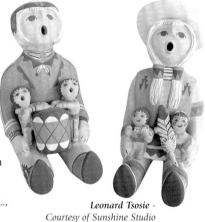

Leonard Tsosie -
Courtesy of Sunshine Studio

Lorna Tsosie

(Jemez, active 1990s-present; matte polychrome Storytellers)
BORN: ca. 1970s
FAMILY: m. great-granddaughter of Emilia Loretto; m. granddaughter of Felix & Grace L. Fragua; daughter of Leonard & Emily F. Tsosie; sister of Darrick Tsosie, Joseph L. Tsosie & Robert Tsosie
PUBLICATIONS: Peaster 1997:69; Schaaf 2000:128.

Lucy Tsosie

(Jemez, active ?-present: matter polychrome Storytellers, figures)
PUBLICATIONS: Congdon-Martin 1999:106.

Marie Tsosie

(Jemez: active ?-present: polychrome & polished redware jars, bowls)
GALLERIES: Kennedy Indian Arts, Bluff, UT

Mary S. Tsosie

(Jemez, active ca. 1970s-present: polychrome jars, melon bowls, wedding vases, ollas with cutouts and miniature kiva scenes inside)
AWARDS: 1984, 2nd, bowls, 2nd, jars; 1992, 2nd, wedding vases, 3rd, melon bowls, Indian Market, Santa Fe
EXHIBITIONS: pre-1985-present, Indian Market, Santa Fe
COLLECTIONS: Wright Collection, Peabody Museum, Harvard University, Cambridge, MA
PUBLICATIONS: Indian Market Magazine 1985, 1988, 1989; Drooker & Capone 1998:57, 138.

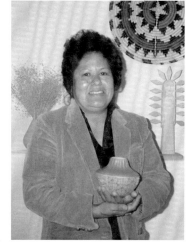

Marie Tsosie - Courtesy of John D. Kennedy and Georgiana Kennedy Simpson Kennedy Indian Arts

Rebecca Tsosie

(Jemez, active ca. 1960s-present: polychrome Storytellers, jars, bowls)
BORN: ca. 1940s
FAMILY: m. granddaughter of Juan & Susanita Celo; daughter of Hubert & Andrea Tsosie; sister of Leonard Tsosie & Irene Herrera; aunt of Caroline Sando

Robert Tsosie

(Jemez, active ca. 1990s-present: matte polychrome Storytellers)
BORN: ca. 1970s
FAMILY: m. great-grandson of Emilia Loretto; m. grandson of Felix & Grace L. Fragua; son of Leonard & Emily F. Tsosie; brother of Darrick Tsosie, Lorna Tsosie & Joseph L. Tsosie
PUBLICATIONS: Peaster 1997:69.

Theresa Tsosie

(Jemez: active ?-present: polychrome & polished redware jars, bowls)
GALLERIES: Kennedy Indian Arts, Bluff, UT

Anita Tuttle *(collaborates with Tina Martin)*

(Acoma, active ?-1990+: polychrome jars, bowls, sewing)
RESIDENCE: San Fidel, NM
ARCHIVES: Artist File, Heard Museum Library, Phoenix
PUBLICATIONS: Dillingham 1992:206-208.

Tina Tuttle

(Acoma, active ?-1990+: polychrome jars, bowls)
PUBLICATIONS: Dillingham 1992:206-208.

V. *(see Dale Vicente)*

E. M. V. *(see Evelyn Vigil)*

G. V. *(see Greg P. Victorino)*

L. V. *(see Laura Vallo)*

Joe L. Valdo

(Acoma, active ca. 1980s-present: pottery)
PUBLICATIONS: *Indian Market Magazine* 1988-89;

M. Valdo

(Cochiti, active ?-present: polychrome Storytellers, figures, drummers)
GALLERIES: Palms Trading Company, Albuquerque
PUBLICATIONS: Congdon-Martin 1999:46.

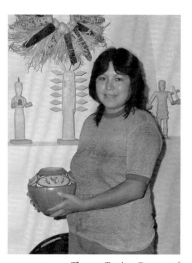

Theresa Tsosie - Courtesy of John D. Kennedy and Georgiana Kennedy Simpson Kennedy Indian Arts

Marjorie S. Valdo

(Acoma/Hopi, active ca. 1980s-present: pottery)
RESIDENCE: Grants, NM
EXHIBITIONS: 1988-89, Indian Market, Santa Fe
PUBLICATIONS: *Indian Market Magazine* 1988-89; Schaaf 1999:163.

Cecilia Valencia *(sometimes signs C. Valencia)*

(Jemez, Water Clan; married into San Felipe, active ca. 1970s-?: polychrome jars, bowls, figures, Storytellers, Nativities)
BORN: ca. 1954
FAMILY: m. granddaughter of Louis & Carrie R. Loretto; daughter of Dorothy Loretto Trujillo, niece of Leonora Loretto Lucero and Marie Edna Coriz; sister of Frances Pino, Judith Suina, Onofre Trujillo II
EXHIBITIONS: 1994-present, Indian Market, Santa Fe
GALLERIES: Palms Trading Company, Albuquerque
PUBLICATIONS: Babcock 1986:57. 132-35, 139; Eaton 1990:20; Congdon-Martin 1999:47.
　　　　Cecilia Valencia's pottery is made from Jemez clays and natural paints. She participated in the popular movement to create figural pottery and Storytellers in the 1970s and 1980s.

Patricia Valencia

(Jemez, active ca. 1967-present: traditional polychrome jars, bowls, wedding vases)
BORN: February 21, 1956
FAMILY: daughter of Mary Celo
EXHIBITIONS: 1997, Eight Northern Indian Pueblos Arts & Crafts Show
PUBLICATIONS: Berger & Schiffer 2000:157.

Patricia Ann Valencia

(Santo Domingo, active ca. 1990s-present: pottery, jewelry)
EXHIBITIONS: 1999, Eight Northern Indian Pueblos Arts & Crafts Show

Concepsion Valle

(Acoma, active ca. 1900-1910s+: polychrome jars, bowls)
BORN: ca. 1885
PUBLICATIONS: Leopold Bibo, "13th Annual U.S. Census" (1910), New Mexico State Archives, Call T624, Roll 919; in Dillingham 1992:205.

Dorothy Valley

(Acoma, active ?-1990+: polychrome jars, bowls)
PUBLICATIONS: Dillingham 1992:206-208.

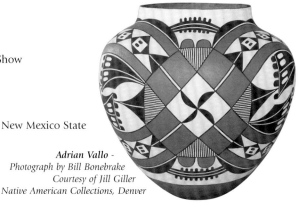

*Adrian Vallo -
Photograph by Bill Bonebrake
Courtesy of Jill Giller
Native American Collections, Denver*

Mary Valley *(1)*

(Acoma, active ca. 1940s-80s+: traditional polychrome jars, bowls)
BORN: ca. 1920s
FAMILY: mother of Dorothy Torivio

Mary Ann Valley *(2) (signs MA Valley, Acoma N.M.)*

(Acoma, active ca. 1982-present: traditional fineline jars, bowls, miniatures)
BORN: September 1, 1961
FAMILY: daughter of Mr. & Mrs. Pasqual Concho
TEACHER: her grandmother
PUBLICATIONS: Berger & Schiffer 2000:157.

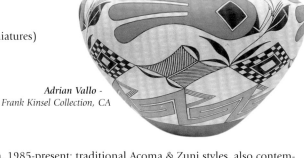

*Adrian Vallo -
Frank Kinsel Collection, CA*

Vallo *(see Simon Vallo)*

Adrian Vallo *(Adriana), (signs A. Vallo, Acoma N.M.)*

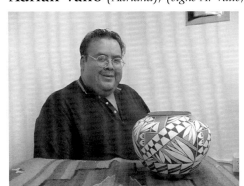

*Adrian Vallo - Courtesy of Jason Esquibel
Rio Grande Wholesale, Inc.*

(Acoma, active ca. 1985-present: traditional Acoma & Zuni styles, also contemporary polychrome ollas, jars, bowls, miniatures)
BORN: February 6, 1964
FAMILY: grandson of Santana Cerno; daughter of Dennis & Loretta Vallo; nephew of Joseph Cerno, Sr. & Rachel Concho
TEACHER: Santana Cerno
AWARDS: 1992, 2nd, New Mexico State Fair, Albuquerque; 1994, 3rd, Casa Grande, AZ Show
COLLECTIONS: Frank Kinsel, olla with parrot design, San Anselmo, Ca; Dave & Lori Kenny, Santa Fe; John Blom
FAVORITE DESIGNS: deer with heart lines, parrots, clouds, feathers, checkerboard
GALLERIES: Native American Collections, Inc., Denver; Rio Grande Wholesale, Palms Trading Co., Albuquerque
PUBLICATIONS: Schiffer 1991d:157; Hayes & Blom 1996; Berger & Schiffer 2000:157.

Mrs. Andres D. Vallo

(Acoma, active ca. 1940)
PUBLICATIONS: Minge 1991:195.

C. R. Vallo

(Acoma, active ca. 1950s-60s?: owls)
COLLECTIONS: Dr. Gregory Schaaf, Santa Fe

Darlene L. Vallo

(Navajo, in the style of Acoma, active ca. 1990-present: Storytellers)
BORN: January 16, 1962
FAMILY: daughter of Ben & Bessie Lee
TEACHER: her brother
GALLERIES: Palms Trading Co., Albuquerque
PUBLICATIONS: Dillingham 1992:206-208; Congdon-Martin 1999:54; Berger & Schiffer 2000:157.

Delilah Vallo

(Acoma, active ?-1990+: polychrome jars, bowls)
PUBLICATIONS: Dillingham 1992:206-208.

Delma Vallo

(Acoma, active ca. 1950s-?: polychrome & fineline black-on-white jars, bowls)
BORN: April 14, 1935
FAMILY: wife of Mike Vallo; mother of Gerri Louis & Darrell Patricio
AWARDS: Best of Show, 1st
FAVORITE DESIGNS: stars, snowflakes
PUBLICATIONS: Painter 1998:16; Berger & Schiffer 2000:22, 128, 157.

Delma Vallo - Courtesy of
Andrews Pueblo Pottery & Art Gallery

Elizabeth Vallo

(Acoma, active ca. 1975-1990)
PUBLICATIONS: Minge 1991:195; Dillingham 1992:206-208.

Ergil F. Vallo, Sr. *(Dalawepi - "Colors of the Rainbow")*

(Acoma/Hopi, active ca. 1981-present: polychrome & sgraffito jars, bowls, canteens, blackware with bright polychrome paint in the lines and carved areas)
BORN: December 1, 1959
FAMILY: son of Harold & Laura Vallo; brother of Anthony Concho
STUDENTS: Anthony Concho, his brother
AWARDS: 1994, 2nd, Inter-tribal Indian Ceremonial, Gallup; 1st, 2nd, 3rd, New Mexico State Fair, Albuquerque; Laguna Pueblo Show, Laguna, NM
COLLECTIONS: Allan & Carol Hayes
FAVORITE DESIGNS: Kachinas, Mudheads, Mimbres animals, Kiva steps, terraced clouds
GALLERIES: The Indian Craft Shop, U.S. Department of Interior, Washington, D.C.; Blue Thunder Fine Indian Art
PUBLICATIONS: Schiffer 1991d; Dillingham 1992:206-208; Hayes & Blom 1996:172-73; 1998:23; Schaaf 1999:163; Berger & Schiffer 2000:109, 157.

Eulilia Vallo

(Acoma, active ca. 1890s-?: black-on-white Tularosa revival style jars, bowls, canteens)
BORN: ca. 1870s at Acomita
FAMILY: mother of Jose Luis Vallo; mother-in-law of Lupita Vallo; grandmother of Juana Leno; great-grandmother of Rose, Phyllis, Marie, Isabel and Regina Leno
TEACHER: Juana Leno, her granddaughter; Rose, Phyllis, Marie, Isabel and Regina Leno, her great-granddaughters
PUBLICATIONS: Monthan 1979:43.

Eva Vallo

(Acoma, active ?-1990+: polychrome jars, bowls)
PUBLICATIONS: Dillingham 1992:206-208.

Florina Vallo *(Florine)*

(Acoma, active ca. 1960s-present: polychrome jars, bowls)
BORN: ca. 1940s
FAMILY: granddaughter of Santana Pino; daughter of Rose Poncho; wife of Earl Vallo; mother of Frederica Vallo Antonio, Melissa Antonio & Nathaniel J. Vallo
ARCHIVES: Artist File, Heard Museum, Phoenix

Florinda Vallo

(Acoma, active ?-1990+: polychrome jars, bowls)
PUBLICATIONS: Dillingham 1992:206-208.

Freida H. Vallo

(Acoma, active ?-present: polychrome jars, bowls)
PUBLICATIONS: Painter 1998:16.

Genevieve Vallo

(Acoma, active ?-1990+: polychrome jars, bowls)
PUBLICATIONS: Dillingham 1992:206-208.

Gladys Vallo

(Acoma, active ?: pottery)
ARCHIVES: Lab file, Laboratory of Anthropology Library, Santa Fe.

Helen Vallo

(Acoma, active ca. 1975-1990)
PUBLICATIONS: Minge 1991:195; Dillingham 1992:206-208.

Helice Vallo

(Acoma, Roadrunner Clan, active ca. 1900s-?: traditional polychrome large ollas, large storage vessels, large water jars, utilitarian containers)
LIFESPAN: ca. 1890s-?
FAMILY: sister of Lola Santiago; sister-in-law of Martin Ortiz; aunt of Lucy Martin Lewis & Elizabeth Wocanda; mother of Eva Histia; grandmother of Hilda Antonio, Rose Torivio & Ida Ortiz; great-grandmother of Mary J. Garcia & Lavine Torivio
STUDENTS: Lucy M. Lewis
PUBLICATIONS: Peterson 1984:36, 71, 82, 124, 206.

Lucy Lewis's son, Andrew Lewis, recalled his great-aunt Helice: "I was about five or six when. . .Aunt Helice Vallo would ask me to take her up to Acoma, and we'd go in the wagon. She used to make those real big pots; they were all good."

Lucy acknowledged Aunt Helice as a strong influence on her pottery making. (Peterson 1984:82) Lucy learned by watching Aunt Helice make pots.

Andrew also recalled Aunt Helice's favorite snack: "She'd grind down some red chili on a stone and make a fresh tortilla and spread butter on it and put that ground chili on top like jam."

Jay Vallo *(Nah-Sde-Te, Jeannette A. Vallo)*

(Acoma, Eagle Clan, active ca. 1981-present: traditional fineline jars, bowls)
BORN: January 1, 1959
FAMILY: granddaughter of Lita L. & Clifford L. Garcia; daughter of Elmer L. & Edna G. Chino; sister of Corrine J. Chino, Brian A. Chino, Judy Shields & Germaine Reed
AWARDS: 1995, 2nd, no dates, 1st, 3rd, New Mexico State Fair, Albuquerque
GALLERIES: Rio Grande Wholesale, Inc., Palms Trading Co., Albuquerque
PUBLICATIONS: Dillingham 1992:206-208; Berger & Schiffer 2000:157.

Jennie or Jenny Vallo

(Acoma, active ca. 1975-1990: polychrome jars, bowls)
PUBLICATIONS: Minge 1991:195; Dillingham 1992:206-208.

Jeanette Vallo

(Acoma, active ?-present: polychrome jars, bowls, wedding vases)
GALLERIES: Rio Grande Wholesale, Albuquerque

Jo Vallo *(collaborates with Lee Vallo)*

(Acoma, active ?-1990+: polychrome jars, bowls)
PUBLICATIONS: Dillingham 1992:206-208.

Juana Vallo

(Acoma, active ?-1990+: polychrome jars, bowls)
PUBLICATIONS: Dillingham 1992:206-208.

Juanita Vallo

(Acoma, active ?-1975+: polychrome jars, bowls)
PUBLICATIONS: Minge 1991:195.

Kim M. Vallo

(Acoma, Red Corn & Small Oak Clans, active ca. 1980s-present: black-on-white fineline jars, bowls, wedding vases, large ollas, miniatures)
BORN: ca. 1968
FAMILY: daughter of Simon & Marie Vallo (2); sister of Leland & Thomas Vallo
FAVORITE DESIGNS: starburst, feathers-in-a-row
GALLERIES: Rio Grande Wholesale, Inc., Palms Trading Co., Albuquerque
PUBLICATIONS: Painter 1998:16.

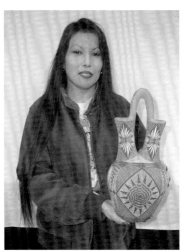

Jeanette Vallo - Courtesy of Jason Esquibel
Rio Grande Wholesale, Inc.

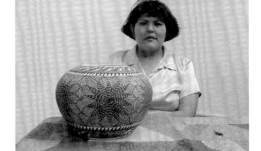

Kim Vallo *- Courtesy of Jason Esquibel*
Rio Grande Wholesale, Inc.

Laura Vallo *(Laura Chino) (signs LV, Acoma N.M.)*
(Acoma, active ca. 1987-present: traditional polychrome jars, bowls)
BORN: December 29, 1942
FAMILY: daughter of Mr. & Mrs. Tony Vallo; niece of Eva Histia
TEACHER: Eva Histia, her aunt
PUBLICATIONS: Berger & Schiffer 2000:158.

Lee Vallo *(collaborates with Jo Vallo)*
(Acoma, active ?-1990+: polychrome jars, bowls)
PUBLICATIONS: Dillingham 1992:206-208.

Leland Robert Vallo *(Pinion Mesa), (signs L. Vallo, Acoma N.M.)*
(Acoma, Red Corn Clan, active ca. 1992-present: traditional & ceramic black-on-white fineline & polychrome jars, bowls)
BORN: October 18, 1969
FAMILY: son of Simon & Marie Vallo (2); brother of Kim & Thomas Vallo
AWARDS: 1995, 1st, 1996, 1st, 1997, 2nd, 1998, 3rd, New Mexico State Fair, Albuquerque
FAVORITE DESIGNS: Tularosa Revival, swirls
GALLERIES: Rio Grande Wholesale, Inc., Palms Trading Co., Albuquerque
PUBLICATION: Berger & Schiffer 2000:23, 158.

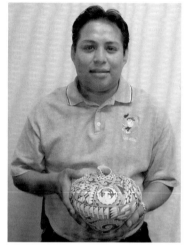

Lillie Vallo *(Lilly)*
(Acoma, active ca. 1975-1990)
PUBLICATIONS: Minge 1991:195; Dillingham 1992:206-208.

Lolla Vallo *(Lola)*
(Acoma, active ca. 1930s-?: traditional polychrome jars, bowls, canteens)
COLLECTIONS: Philbrook Museum of Art, Tulsa, OK, jar, canteen, ca. 1939

Lucita Vallo
(Acoma, active ca. 1930s-90: traditional polychrome jars, bowls)
BORN: ca. 1910s
FAMILY: mother of Cecilia Hepting; grandmother of Victoria Hepting
PUBLICATIONS: Dillingham 1992:206-208; Berger & Schiffer 2000:121.

Leland Vallo - Courtesy of Jason Esquibel
Rio Grande Wholesale, Inc.

Lupita Vallo
(Acoma, active ca. 1920-?: traditional black-on-white Tularosa revival style jars, bowls, canteens)
BORN: ca. 1900
FAMILY: daughter-in-law of Eulilia Vallo; wife of Jose Luis Vallo; of Juana Leno
COLLECTIONS: Philbrook Museum of Art, Tulsa, OK, jar, ca. 1939
PUBLICATIONS: Monthan 1979:43.

Mabel Vallo
(Acoma, active ?-1990+: polychrome jars, bowls)
PUBLICATIONS: Dillingham 1992:206-208.

Margie Vallo
(Acoma, active ?-1990+: polychrome jars, bowls)
PUBLICATIONS: Dillingham 1992:206-208.

Marie A. Vallo *(1)*
(Acoma, active ca. 1940s-75+: traditional polychrome jars, bowls)
BORN: ca. 1930
FAMILY: mother of Edwin L. Sarracino
STUDENTS: Edwin L. Sarracino, her son
PUBLICATIONS: Minge 1991:195.

Marie Vallo *(2) (signs M. Vallo, Acoma N.M.)*
(Acoma, Red Corn Clan, active ca. 1960-90s: traditional & ceramic polychrome jars, bowls)
LIFESPAN: April 21, 1949 - ?
FAMILY: daughter of Lorenzo & Gladys Garcia; wife of Simon Vallo; mother of Leland R. Vallo, Kim Vallo, Thomas Vallo
AWARDS: New Mexico State Fair, Albuquerque
PUBLICATIONS: Dillingham 1992:206-208; Berger & Schiffer 2000:158.

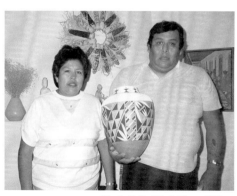

Marjie Vallo
(Acoma, active ?-1975+: polychrome jars, bowls)
PUBLICATIONS: Minge 1991:195.

Marie Vallo (2) & Simon Vallo -
Courtesy of John D. Kennedy and
Georgiana Kennedy Simpson, Kennedy Indian Arts

Nathaniel J. Vallo *(signs N. Vallo Acoma, N.M.)*

(Acoma, active ca. 1985-present: black-on-white sgraffito & fineline jars, bowls)
BORN: November 25, 1965
FAMILY: grandson of Rose Poncho; son of Florina & Earl Vallo; brother of Frederica & Melissa Antonio
AWARDS: 1994, 2nd, 3rd, New Mexico State Fair, Albuquerque
FAVORITE DESIGNS: Kokopelli, Kachinas, Mimbres animals, eyedazzlers
GALLERIES: Rio Grande Wholesale, Inc., Palms Trading Co., Albuquerque
PUBLICATIONS: Berger & Schiffer 2000:158.

 Nathaniel J. Vallo carves onto pottery some of the most detailed and complex pictorial scenes from nature and the Kachina world. He explained, "A vision of ancestry comes to mind in every piece of pottery that I etch."

Pearl Vallo *(signs P. Vallo)*

(Acoma, active ca. 1967-present: traditional polychrome jars, bowls)
BORN: Mary 15, 1940
TEACHER: her mother
PUBLICATIONS: Dillingham 1992:206-208.

Raphael Vallo

(Acoma, active ?-present: Storytellers)
PUBLICATIONS: Congdon-Martin 1999: 54.

Roselide Vallo

(Acoma, active ?-1975+: polychrome jars, bowls)
PUBLICATIONS: Minge 1991:195.

Santana Vallo

(Acoma, active ca. 1975-1990)
PUBLICATIONS: Minge 1991:195; Dillingham 1992:206-208.

Simon Vallo *(collaborates sometimes with Marie Vallo), (signs Vallo), (see portrait with Marie Vallo (2))*

(Acoma, active ca. 1983-present: traditional polychrome jars, bowls)
BORN: April 15, 1948
FAMILY: husband of Marie Vallo (2); son of Henry L. Vallo; father of Leland R. Vallo, Kim Vallo, Thomas Vallo
TEACHER: his mother
PUBLICATIONS: Dillingham 1992:206-208; Berger & Schiffer 2000:158.

Susie Vallo

(Acoma, active ?-1990+: polychrome jars, bowls)
PUBLICATIONS: Dillingham 1992:206-208.

Velma Vallo

(Acoma, active ?-1990+: polychrome jars, bowls)
PUBLICATIONS: Dillingham 1992:206-208.

M. Van Pelt

(Cochiti, active ca. 1980s-present: polychrome Storytellers)
GALLERIES: Palms Trading Company, Albuquerque
PUBLICATIONS: Congdon-Martin 1999:43.

Simon Vallo - Courtesy of Georgiana Kennedy Simpson Kennedy Indian Arts, Bluff, UT

Faith Vargas *(signs F. Vargas, Acoma N.M.)*

(Acoma, active ca. 1992-present: ceramic polychrome jars, bowls)
BORN: November 6, 1964
FAMILY: daughter of Elliott Sanchez
TEACHER: her grandmother
PUBLICATIONS: Berger & Schiffer 2000:158.

Leslie Teller Velardez *(Leslie Teller)*

(Isleta, active ca. 1990-present: Storytellers, Nativities, figures)
BORN: June 14, 1973
FAMILY: m. great-granddaughter of Rudy & Felicita Jojola; m. granddaughter of Stella & Louis Teller; daughter of Ray & Marie (Robin) Teller
AWARDS: 1996, 2nd, Figures, Indian Market, Santa Fe
EXHIBITIONS: 1993-present, Indian Market, Santa Fe; 1995-present, Eight Northern Indian Pueblos Arts & Crafts Show
GALLERIES: Arlene's Gallery, Tombstone, AZ
PUBLICATIONS: Hayes & Blom 1996; Peaster 1997:59; Berger & Schiffer 2000:151.

Marie Valardez *(see Lynette Teller)*

Marianita Venado
(Cochiti, active ca. 1930s-?: traditional polychrome, black-on-cream jars, bowls)
BORN: ca. 1900-10
FAMILY: sister of Anita Suina (1); aunt of Ernest Suina
COLLECTIONS: Allan & Carol Hayes
FAVORITE DESIGNS: flowers, leaves, whirlwind
PUBLICATIONS: Hayes & Blom 1996:60.

Dale Vicente *(signs V. Acoma, NM)*
(Acoma, active ca. 1984-present: traditional & ceramic polychrome jars, bowls)
BORN: September 26, 1954
FAMILY: son of Mr. & Mrs. Willie Vicente
PUBLICATIONS: Berger & Schiffer 2000:158.

Gordon Vicente *(collaborates sometimes with Star R. Vicente)*
(Acoma, active ?-1990+: polychrome jars, bowls)
PUBLICATIONS: Dillingham 1992:206-208.

Kimberly Vicente
(Zia/Acoma, active ?-present: pottery)
EXHIBITIONS: 1999-present, Eight Northern Indian Pueblos Arts & Crafts Show

Regina Vicente
(Acoma, active ca. 1975-1990)
PUBLICATIONS: Minge 1991:195; Dillingham 1992:206-208.

Santana Vicente
(Acoma, active ?-1990+: polychrome jars, bowls)
PUBLICATIONS: Dillingham 1992:206-208.

Celecita Yawkia Vicenti
(Zuni, Deer Clan, active ca. 1960s-70s: traditional polychrome jars, bowls)
BORN: ca. 1920s
FAMILY: wife of Cecil Vicenti; mother of 11, including Lydia Vicenti Lalio

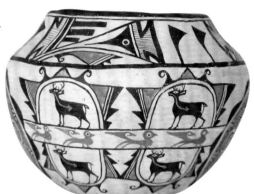

Celecita Y. Vicenti -
Courtesy of Lydia Vicenti Lalio

Nelson Vicenti *(N. Vicenti)*
(Zuni, active ca. 1990s-present: traditional polychrome jars, bowls, owls)
AWARDS: 1996, 1st, Zuni Jars, Indian Market, Santa Fe
EXHIBITIONS: 1995-present, Indian Market, Santa Fe; 1995-present, Eight Northern Indian Pueblos Arts & Crafts Show
PUBLICATIONS: Hayes & Blom 1996; Painter 1998:184-90.

Bernadette Victorino *(Bernie), (collaborates with Margaret Ascencio)*
(Acoma, active ?-1990+: polychrome jars, bowls)
PUBLICATIONS: Dillingham 1992:206-208.

Beverly Victorino *(Beverly Garcia), (signs B. Victorino or B. Garcia)*
(Acoma, active ca. 1962-present: polychrome jars, bowls)
BORN: January 14, 1955
FAMILY: m. granddaughter of Lupe & John Concho; daughter of Florence & Fred Waconda; sister of Loretta Joe; mother of Dylene Victorino
GALLERIES: The Indian Craft Shop, U.S. Department of Interior, Washington, D.C.
PUBLICATIONS: Dillingham 1992:206-208; Berger & Schiffer 2000:159.

Nelson Vicenti -
Courtesy of John Blom

Charlene Victorino
(Cochiti, active ca. 1994-present, pottery)
BORN: April 11, 1980

Clara M. Victorino
(Acoma, active ca. 1950s-?: traditional polychrome jars, bowls)
COLLECTIONS: Hollister Collection, University of Massachusetts

Consepsion Victorino
(Acoma, active ca. 1870s-1910s+: polychrome jars, bowls)
BORN: ca. 1855
PUBLICATIONS: Leopold Bibo, "13th Annual U.S. Census" (1910), New Mexico State Archives, Call T624, Roll 919; in Dillingham 1992:205.

Darin Victorino

(Acoma, Parrot Clan, active ca. 1985-present: traditional & contemporary polychrome jars, bowls)
FAMILY: husband of Kim Victorino; father of 3 sons & 1 daughter
TEACHER: Juanita Keene, his wife's grandmother
AWARDS: 2001, Master's Show, Red Earth, Oklahoma City, OK; Indian Market, Santa Fe; Heard Museum, Phoenix; New Mexico State Fair, Albuquerque; Inter-tribal Indian Ceremonial, Gallup; Eight Northern Indian Pueblos Arts & Crafts Show; New Mexico Ceramic & Doll Show

> Darin Victorino shared how he got started as a potter: "When I was ready to make pottery, I asked by wife's grandmother, Juanita Keene, what she used to make her pottery. She showed me different tools she made from gourds, red cedar and bone tools for incision and corrugating pottery."

> Darin also spoke on the joys of pottery making: "I enjoy making pottery, as it is challenging and relaxing. What I enjoy most is painting pottery, because I can express my own ideas and techniques, as well as the meaning behind the art. Painting also allows me to put traditional and contemporary designs and styles together, and to create new visions and story of our ways of life."

> Regarding the future, Darin expressed: "In the years to come, I intend to continue to pass on the art of painting and traditional pottery making and all I have learned not only to my children, but also to other young Indian people in my own community."

Deloritas Victorino

(Acoma, active ca. 1890s-1910s+: polychrome jars, bowls)
BORN: ca. 1880
PUBLICATIONS: Leopold Bibo, "13th Annual U.S. Census" (1910), New Mexico State Archives, Call T624, Roll 919; in Dillingham 1992:205.

Dylene Victorino *(signs D. Victorino)*

(Acoma, Yellow Corn Clan, active ca. 1993-present: ceramic fineline & polychrome jars, bowls)
BORN: February 3, 1979
FAMILY: m. great-granddaughter of Lupe & John Concho; m. granddaughter of Florence & Fred Waconda; daughter of Beverly & Monroe Victorino; sister of Charlene, Kathy, Nerissa, Roxanne & Mervin Victorino; wife of Brian Ortiz; mother of Daylene & Brian Ortiz
TEACHERS: Beverly & Monroe Victorino, her parents
COLLECTIONS: Johanna Leibfarth, South Carolina
FAVORITE DESIGNS: fineline & flower pot designs
GALLERIES: Rio Grande Wholesale, Inc., Albuquerque
PUBLICATIONS: Berger & Schiffer 2000:159.

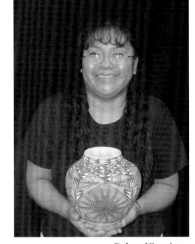

Dylene Victorino -
Courtesy of Jason Esquibel
Rio Grande Wholesale, Inc.

> Dylene Victorino comes from a long line of potters. She explained, "It is my tradition to follow the work of my culture. I like to paint, because it is something to do and a lot of fun. I plan to teach my children, nieces and nephews to follow our footsteps to make pottery."

D. Victorino -
Johanna Leibfarth Collection, SC

Greg P. Victorino *(signs G. V. or Greg Victorino, Acoma)*

(Acoma, Eagle Clan, active ca. 1972-present: black-on-white fineline & polychrome jars, bowls, wedding vases, paintings)
BORN: February 27, 1960
FAMILY: m. grandson of Lita L. & Clifford L. Garcia; son of Paul & Virginia Victorino; brother-in-law of Sandra Victorino
FAVORITE DESIGNS: eyedazzlers
GALLERIES: Arlene's Gallery, Tombstone, AZ; Rio Grande Wholesale, Inc., Palms Trading Co., Albuquerque
PUBLICATIONS: Berger & Schiffer 2000:159.

> Greg Victorino is an outstanding pottery painter. His work has been described as "uniquely wonderful." He is especially noted for his "imaginative designs which awe and amaze" his collectors.

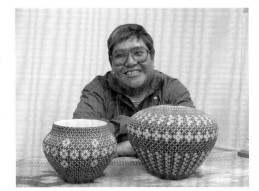

Greg Victorino - Courtesy of Jason Esquibel
Rio Grande Wholesale, Inc.

LaDonna Victorino

(Acoma, active ?-1990+: polychrome water jars, bowls)
PUBLICATIONS: Dillingham 1992:206-208.

Luisa Victorino

(Acoma, active ca. 1880s-1910s+: polychrome jars, bowls)
BORN: ca. 1870
PUBLICATIONS: Leopold Bibo, "13th Annual U.S. Census" (1910), New Mexico State Archives, Call T624, Roll 919; in Dillingham 1992:205.

Mary Victorino *(M. W. Cheromiah Victorino), (sometimes signs , M. W. Cheromiah, Old Laguna)*

(Laguna, Roadrunner Clan, active ca. 1970s-present: traditional black-on-white with orange base, polychrome ollas, jars, bowls)
BORN: ca. 1950s
FAMILY: m. granddaughter of Mariano Cheromiah; daughter of Evelyn Cheromiah; sister of Lee Ann Cheromiah & Wendy Cheromiah Kowemy
AWARDS: 1996, 1st, Indian Market, Santa Fe
EXHIBITIONS: 1992-present, Indian Market, Santa Fe
COLLECTIONS: Dave & Lori Kenney, Dr. Gregory & Angie Schaaf; Enchanted Village
FAVORITE DESIGNS: Kokopelli, clouds

Monroe F. Victorino *(signs Victorino Acoma N.M.)*

(Acoma, active ca. 1977-present: traditional & ceramic fineline & polychrome jars, bowls)
BORN: May 18, 1940
FAMILY: husband of Beverly Victorino; father of Dylene, Charlene, Kathy, Nerissa, Roxanne & Mervin Victorino; grandfather of Daylene & Brian Ortiz
PUBLICATIONS: Berger & Schiffer 2000:159.

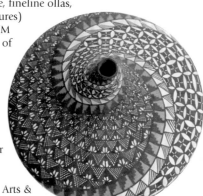
Mary Victorino -
Courtesy of Enchanted Village

Sandra M. Victorino

(Acoma, Acorn/Eagle Clans, active 1983-present: traditional polychrome & black-on-white, fineline ollas, jars, bowls, vases, wedding vases, seed pots, miniatures)

BORN: February 10, 1958; RESIDENCE: McCartys, NM
FAMILY: granddaughter of Lita. L. Garcia; daughter of Pearl Leno; niece of Dorothy Torivio; sister of Corrine J. Chino & Brian A. Chino; wife of Cletus Victorino, Sr.; mother of Rochelle, Cletus, Jr., Joey, Preston
TEACHERS: Lita L. Garcia, her grandmother & Dorothy Torivio, her aunt
AWARDS:

Sandra Victorino -
Courtesy of Johanna Leibfarth, SC

1986	3rd, seed jar, Colorado Art Show, Boulder	
1987	1st, 2nd, 3rd, Inter-tribal Indian Ceremonial, Gallup	
1990	2nd, 3rd, Eight Northern Indian Pueblos Arts & Crafts Show	
1991	1st, large seed jar, Arizona Art Show, Scottsdale, AZ; 1st, 2nd, Indian Market, Santa Fe; 1st, Eight Northern Indian Pueblos Arts & Crafts Show	
1992	2nd, Indian Market, Santa Fe	
1993	Inter-tribal Indian Ceremonial, Gallup; 1st, 2nd, Texas Art Show, Dallas TX; 1st, H.M., Indian Market, Santa Fe	

Sandra Victorino -
Courtesy of Johanna Leibfarth

1994 1st, New Mexico State Fair, Albuquerque; 1st, Texas Art Show, Dallas TX; Best of Category, 1st, Inter-tribal Indian Ceremonial, Gallup
1995 3rd, Indian Market, Santa Fe; Best of Class (seed vase), Best of Division, 1st, Texas Art Show, Dallas TX
1996 Challenge Award, 3rd, H.M., Indian Market, Santa Fe; Heard Museum, Phoenix
1997 1st, Eight Northern Indian Pueblos Arts & Crafts Show; 2nd, H.M., Indian Market, Santa Fe
1998 2nd, Indian Market, Santa Fe
1999 2nd, Indian Market, Santa Fe; 2nd, 3rd, H.M., Inter-tribal Indian Ceremonial, Gallup
COLLECTIONS: Heard Museum, Phoenix; Johanna Leibfarth, South Carolina; John Blom; Dr. Gregory & Angie Yan Schaaf, Santa Fe
FAVORITE DESIGNS: eyedazzlers, snowflakes, pinwheels, swirls, checkerboards, Kokopelli, step to step, tear drops, fineline
GALLERIES: Native American Collections, Inc., Denver, CO; Tribal Arts Zion, Springdale, UT; Andrea Fisher's Fine Art, Santa Fe; Arlene's Gallery, Tombstone, AZ; Rio Grande Wholesale, Inc., Palms Trading Co., Albuquerque; Leona King Gallery, Scottsdale, AZ; Kleywood Southwest, American West Galleries
PUBLICATIONS: *Indian Trader* October 1987:27; Dillingham 1992:206-208; Hayes & Blom 1996:54-55; *American Indian Art Magazine* Spring 1997:25; Painter 1998:16; Tucker 1998: plate 97.

 Sandra Victorino is widely respected for her large, intricately painted ollas. Her designs often repeat hundreds of swirling bands of symbols, creating an optical effect called "eyedazzlers." Sandra wrote her own biographical profile: "Hi! I am Sandra Victorino. I have been doing my traditional pottery for about 10 years and enjoy it. I am from the Pueblo of Acoma, also

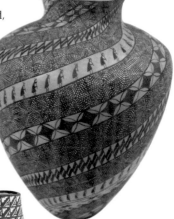
Sandra Victorino -
Blue Thunder Fine Indian Art
at www.bluethunderarts.com

Sandra Victorino -
Photograph by Bill Bonebrake
Courtesy of Jill Giller
Native American Collection

known as Sky City, New Mexico. I have lived there all my life, and I am proud to be from Acoma.

"The way I learned was watching my grandmother (Lita L. Garcia) making her pottery. So I thought I would try. Pottery making was handed down from generation to generation.

"At first I tried to paint with a yucca brush, but it was hard. It takes a lot of practice and patience. It is hard to get the clay, because it is all Mother Earth material. When I work with my pottery clay, it is something special to me. I can create new shapes of pottery, and I imagine what designs I will use on it."

Sandra concluded, "It brings great pride to me and my family to see my artwork in galleries and people's homes.

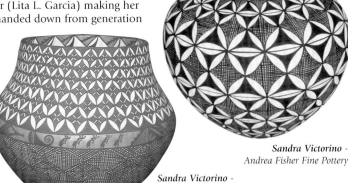

Sandra Victorino -
Andrea Fisher Fine Pottery

Sandra Victorino -
Courtesy of Jason Esquibel
Rio Grande Wholesale, Inc.

Virginia Victorino

(Acoma, Eagle Clan, active ca. 1942-present: polychrome jars, bowls)
BORN: November 26, 1933
FAMILY: daughter of Lita L. & Clifford L. Garcia; sister of Josephine Sanchez; Maxine Sanchez & Edna G. Chino; wife of Paul Victorino; mother of Greg P. Victorino
TEACHER: Lita Garcia, her mother
PUBLICATIONS: Minge 1991:195; Dillingham 1992:206-208.

Alberta V. Vigil *(collaborated sometimes with Marie T. Vigil)*

(Jemez, Coyote Clan, active ca. 1980s-present: polychrome redware & grayware jars, bowls, figures, embroidery)
BORN: February 2, 1964
FAMILY: m. great-granddaughter of Juanito & Andrieta Shendo; m. granddaughter of Jose Maria. Toya & Reyes Shendo Toya (2); daughter of Albert E. Vigil & Marie T. Vigil; sister of Lorraine Chinana, Ida Yepa, Georgia Vigil-Toya; mother of Evan Brice Vigil, Lyle Burton Vigil & Kalen Tony Vigil
TEACHER: Marie T. Vigil, her mother

Alberta V. Vigil shared, "I enjoy painting pottery. I also painted some pots made by my mother, Marie T. Vigil."

Arthur Vigil

(Santo Domingo/Tesuque, active ca. 1980s-present: pottery)
BORN: ca. 1970s
FAMILY: grandson of Manuel & Vicenta Vigil; son of Anna Marie Lovato
EXHIBITIONS: 1988, Indian Market, Santa Fe
PUBLICATIONS: *Indian Market Magazine* 1988; *Eight Northern Indian Pueblos Visitors Guide* 1996:35; Congdon-Martin 1999; Schaaf 2000:270.

Alberta Vigil -
Photograph by Angie Yan Schaaf

Alberta Vigil & Georgia Vigil-Toya -
Courtesy of the artists

Beverly Vigil

(Jemez, active ?-present: polished redware sgraffito jars, bowls, seed pots, miniatures)
FAVORITE DESIGNS: Water Serpents, opticals
PUBLICATIONS: Schiffer 1991d:49.

Carol D. Vigil

(Jemez, active ca. 1985-present: polished redware sgraffito jars, bowls, vases, some large, sewing)
BORN: March 18, 1960
FAMILY: daughter of Cerelia Baca; cousin of Wilma L. Baca
TEACHER: her grandmother
AWARDS: 1990, 1st, sgraffito with stones, 1st, other sgraffito; 1992, 3rd, sgraffito; 1998, 3rd; 1999, Indian Market, Santa Fe; New Mexico State Fair, Albuquerque; Inter-tribal Indian Ceremonial, Gallup; Eight Northern Indian Pueblos Arts & Crafts Show
EXHIBITIONS: 1989-present, Indian Market, Santa Fe; 1998, Eight Northern Indian Pueblos Arts & Crafts Show
PUBLICATIONS: *American Indian Art Magazine* Spring 1990 15(2):26; *Southwest Art* Nov. 1990:25; Hayes & Blom 1996:viii-ix; *Cowboys & Indians* Sep. 1999:95; Sep. 2000:94; Berger & Schiffer 2000:41, 159.

Carol Vigil is an exceptional contemporary potter. Her work is often large and impressive. The shapes of her pots are unique, including some with elongated necks and diagonal rims. Her designs are complex. Some optical patterns become smaller around the shoulders. Her stone polish is smooth and glossy. The overall effect is most pleasing.

Carol Vigil - Courtesy of John D. Kennedy
and Georgiana Kennedy Simpson
Kennedy Indian Arts

Dennis Vigil

(Jemez, active ca. 1980s-present: pottery)
FAMILY: m. great-grandson of Andrieta & Juanito Shendo; grandson of Jose M. Toya & Reyes S. Toya (2); son of Albert & Marie T. Vigil; brother of Lorraine Chinana, Ida Yepa, Georgia Vigil-Toya, Alberta Vigil, Pauline Vigil, Lawrence Albert Vigil, & Erma Waquie
EXHIBITIONS: 1999-present, Indian Market, Santa Fe

Evelyn Vigil *(sometimes signed E.M.V.)*

Evelyn Vigil - Allan & Carol Hayes

(Pecos/Jemez, active ca. 1940s-present: Pecos Glazeware, tanware & redware with dark brown glaze paint outlining cream and orange design elements, yucca sifter baskets)
LIFESPAN: ca. 1920s - 1995
FAMILY: mother of Andrea Vigil Fragua, & 6 other children; 15 grandchildren
STUDENTS: Andrea Vigil Fragua, her daughter
AWARDS: 1977, 3rd, bowls; 1979, 1st, 2nd, glazed jars, Indian Market, Santa Fe
EXHIBITIONS: pre-1977-83, Indian Market, Santa Fe; 1979, "One Space: Three Visions," Albuquerque Museum, Albuquerque
DEMONSTRATIONS: 1987, Museum of Indian Arts & Cultures, Santa Fe
PUBLICATIONS: *SWAIA Quarterly* Fall 1977 12(3):15; *New Mexico Magazine* July 1979:21-23; Barry 1984:134; Mauldin 1984:28; Trimble 1987:70-71; *American Indian Art Magazine* Autumn 1988 13(4):47; Eaton 1990:14; Hayes & Blom 1996:82; Peterson 1997.19.

Evelyn Vigil is a direct descendant of the 38 people from Pecos Pueblo who moved in 1828 to Jemez Pueblo. She deserves much credit for her productive efforts in the 1970s and 1980s promoting a revival of Pecos glazeware. She was joined by her daughter Andrea Vigil Fragua, as well as Juanita Toya Toledo and Persingula M. Casiquito.

Evelyn collected clay, temper and natural paint pigments around Pecos. She found the old grindstones near their source of sandstone temper. She mixed the galena (lead ore, red iron) with guaco (wild spinach) to create her dark brown paint. The red iron from Cerrillos was determined to be superior to the local Pecos source. Through persistent experimentation, she discovered that only fir bark burned hot enough to melt her galena paint into a glaze.

When her first glazeware pots survived the firing, she recalled, "I couldn't get my breath. There they were, just like the old Pecos pots. I cried. And when I got my breath, I yelled to everyone, 'Come look! My pots came out!' Everyone ran, and I kept crying and laughing."

The type of glazeware they revived was made originally from about 1250 to 1700. These early glazeware pots are highly valued by collectors. The revival of Pecos glazeware represents a major contribution in the art history of Pueblo pottery. Evelyn reflected, "I like the old things. I like to bring back our history."

Georgia L. Vigil-Toya *(Georgia L. Vigil, Georgia V. Toya), (signs G. Vigil)*

(Jemez, Coyote Clan, active ca. 1984-present: Mimbres Revival, matte polychrome, sgraffito blackware & redware jars, bowls, kiva bowls, vases, wedding vases)
BORN: ca. 1966
FAMILY: m. great-granddaughter of Juanito & Andrieta Shendo; granddaughter of Jose M. Toya & Reyes S. Toya; daughter of Marie Vigil; sister of Lorraine Chinana, Ida Yepa; niece of Clara Gachupin
TEACHER: Reyes S. Toya, her grandmother
AWARDS: 2nd, New Mexico State Fair, Albuquerque; Merit Award, Inter-tribal Indian Ceremonial, Gallup
EXHIBITIONS: 1995-present, Eight Northern Indian Pueblos Arts & Crafts Show; 1997-present, Indian Market
FAVORITE DESIGNS: deer, mountain lions, birds, turtles, fish, Water Serpents, terraced clouds, human figures, Sun face, eagles, corn plants, feathers-in-a-row
GALLERIES: Rio Grande Wholesale, Albuquerque
PUBLICATIONS: *American Indian Art Magazine* Spring 1988 13(2):70; Eaton 1990:13; Walatowa Pueblo of Jemez, "Jemez Pottery" (1998).

Georgia Vigil-Toya - Courtesy of Rio Grande Wholesale, Inc.

Georgia Vigil-Toya - Courtesy of Candace Collier, Houston, TX

Marie Toya Vigil *(Marie T. Vigil)*

(Jemez, Coyote Clan, active ca. 1950s-present: matte polychrome redware & grayware jars, bowls, figures, miniatures, embroidery)
BORN: August 23, 1929
FAMILY: m. granddaughter of Andrieta & Juanito Shendo; daughter of Jose M. Toya & Reyes S. Toya (2); wife of Albert Vigil; mother of Lorraine Chinana, Ida Yepa, Georgia Vigil-Toya, Alberta Vigil, Pauline Vigil, Lawrence Albert Vigil, Dennis Vigil & Erma Waquie
TEACHER: Reyes Toya, her mother
STUDENTS: her daughters
EXHIBITIONS: 2001, Jemez Pueblo Red Rocks Arts & Crafts Show
FAVORITE DESIGNS: feathers

In May 2001, we met Marie T. Vigil at the Jemez Pueblo Red Rocks Arts & Crafts Show. She expressed how their "cultural techniques are expected to be followed and preserved." She pointed to her daughters and said, "The tradition is handed down with natural resources in mind."

Marie said that she likes to make miniatures. She bundles them up, rides the bus to Santa Fe, and sells them under the portal on the Plaza.

Marie T. Vigil - Photograph by Angie Yan Schaaf

Monica Vigil

(Santo Domingo, active ?: pottery)
COLLECTIONS: Heard Museum, Phoenix
ARCHIVES: Heard Museum Library, Phoenix, artist file.

A. W. *(see Angela Waquie)*

J. A. W *(see Joseph A. Waquie)*

Debra A. Waconda *(Deborah)*

(Acoma/Laguna, Yellow Corn Clan, active ca. 1986-present: fineline & polychrome jars, bowls)
BORN: January 17, 1971
FAMILY: granddaughter of John & Lupin Concho; daughter of Florence & David Waconda, Sr.; sister of Fred & David Waconda, Jr.; wife of Myron Estevan; mother of Isaac, Shaquille, Samantha, LeeAnn, Latera
GALLERIES: Rio Grande Wholesale, Inc., Albuquerque
PUBLICATIONS: Dillingham 1992:206-208.
 Debra Waconda commented that pottery making takes her "back in the early days. I enjoy doing pottery, because it is in my family."

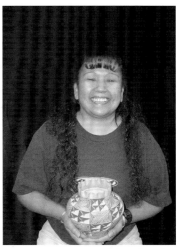

Debra Waconda -
Courtesy of Jason Esquibel
Rio Grande Wholesale, Inc.

Edna Waconda

(Acoma, active ?: polychrome jars)
COLLECTIONS: Heard Museum, Phoenix
ARCHIVES: Artist File, Heard Museum Library, Phoenix

Elizabeth Waconda *(signs E. Waconda)*

(Acoma, Roadrunner Clan, active ca. 1940s-90+: polychrome jars, bowls)
BORN: ca. 1920s
FAMILY: daughter of Helice Vallo; sister of Eva Histia; aunt of Hilda Antonio, Rose Toribio & Ida Ortiz
COLLECTIONS: Wright Collection, Peabody Museum, Harvard University, Cambridge, MA
PUBLICATIONS: Dillingham 1992:206-208; Reno 1995:9; Drooker & Capone 1998:138.

Florence Concho Waconda *(collaborated with Fred Waconda)*

(Acoma, Yellow Corn Clan, active ca. 1950s-90s: traditional polychrome jars, bowls)
BORN: ca. 1930s
FAMILY: daughter of Lupe & John Concho; sister of Rita Malie; wife of Fred Waconda; mother of Loretta Joe & Beverly Victorino; m. grandmother of Dylene, Charlene, Kathy, Nerissa, Roxanne & Mervin Victorino
PUBLICATIONS: Dillingham 1992:206-208.

Fred Waconda *(collaborated with Florence Concho Waconda)*

(Acoma, active ca. 1950s-90s: traditional polychrome jars, bowls)
BORN: ca. 1930s
FAMILY: husband of Florence Concho Waconda; father of Loretta Joe & Beverly Victorino; m. grandfather of Dylene, Charlene, Kathy, Nerissa, Roxanne & Mervin Victorino
PUBLICATIONS: Dillingham 1992:206-208.

Maureen Waconda

(Jemez/Laguna, active 1970s-present: polychrome jars, bowls, wedding vases)
TEACHERS: Bertha Gachupin, Leonora Fragua
GALLERIES: Kennedy Indian Arts, Bluff, UT

Diana Wade

(Jemez, active ?: pottery)
FAMILY: related to Charles Chinana

Diane Wade *(D. Wade, Wounded Horse)*

(Isleta, active ?-present: sgraffito blackware jars, bowls; polished siennaware canteens, figures - bears)
FAVORITE DESIGNS: buffalo, bears, feathers-in-a-row
PUBLICATIONS: Hayes & Blom 1996.

Consepsion Waitie

(Acoma, active ca. 1880s-1910s+: polychrome jars, bowls)
BORN: ca. 1865; RESIDENCE: Acomita in ca. 1910
PUBLICATIONS: Leopold Bibo, "13th Annual U.S. Census" (1910), New Mexico State Archives, Call T624, Roll 919; in Dillingham 1992:205.

Maureen Waconda - Courtesy of
John D. Kennedy and
Georgiana Kennedy Simpson
Kennedy Indian Arts

Kimberly Walker
(Cochiti, active ca. 1990s-present: polychrome jars, bowls)
BORN: ca. 1978
FAMILY: daughter of Mary Janice Ortiz; sister of Jackie Walker
PUBLICATIONS: Dillingham 1994:120.

Kathleen Wall

Kathleen Wall - Photograph by Angie Yan Schaaf

(Jemez, active ca. 1991-present: clown, Pueblo women dance figures & clay masks)
BORN: September 29, 1972
FAMILY: granddaughter of Louis & Carrie R. Loretto; daughter of Fannie Loretto & Steve Wall; sister of Adrian Wall & Marcus Wall
EDUCATION: 1991-94, Institute of American Indian Arts, Santa Fe
TEACHERS: Fannie Loretto & Steve Wall, her parents, & Laura Fragua
AWARDS: 1998, 2nd; 2000, 1st, Storytellers, 2nd, Sets; 2001, 1st, Indian Market, Santa Fe; 2000, 1st, New Mexico State Fair, Albuquerque; 2001, Best of Division, Jemez Pueblo Red Rocks Arts & Crafts Show; Eight Northern Indian Pueblos Arts & Crafts Show; Dallas Arts & Crafts Show, Dallas, TX
EXHIBITIONS: 1999-present, Indian Market, Santa Fe; 1999-present, Eight Northern Indian Pueblos Arts & Crafts Show; Jemez Red Rocks Arts & Crafts Show; Dallas Arts & Crafts Show, Dallas, TX; New Mexico State Fair, Albuquerque
GALLERIES: Native American Collections, Inc., Denver, CO; Kennedy Indian Arts, Bluff, UT
PUBLICATIONS: *Cowboys & Indians* Nov. 1999:95; Berger & Schiffer 2000:96, 160.

In the Summer of 2001, we met Kathleen Wall at the Jemez Pueblo Red Rocks Arts & Crafts Show. She had just won Best of Division for her large clay figures. Her family was proud of her.

Kathleen comes from a respected family of innovators in contemporary Jemez Pueblo pottery. Her mother, Fannie Loretto, was one of the first to make clay masks, an art form that Kathleen continued. However, Kathleen moved forward in creating some of the finest large pottery figures. Her large clay sculptures of clowns and Pueblo Indian women dancers are especially remarkable and highly collectable.

Marcus Wall
(Jemez, active ca. 1990s-present: polychrome jars, bowls, sculptures)
RESIDENCE: Jemez Pueblo, NM
AWARDS: 1993, 3rd (ages 18 & under), Indian Market, Santa Fe

Wallowing Bull *(see Felicia Fragua Curley)*

Juana Waneih
(Acoma, active ca. 1870s-1910s+: polychrome jars, bowls)
BORN: ca. 1860; RESIDENCE: Acomita in ca. 1910
PUBLICATIONS: Leopold Bibo, "13th Annual U.S. Census" (1910), New Mexico State Archives, Call T624, Roll 919; in Dillingham 1992:205.

Josephine Wania *(Josephina)*
(Acoma, active ca. 1930s-?: traditional polychrome jars, bowls)
COLLECTIONS: Philbrook Museum of Art, Tulsa, OK, jar, ca. 1939, jar, ca. 1940

Pablita Waniehe *(1)*
(Acoma, active ca. 1860s-1910s+: polychrome jars, bowls)
BORN: ca. 1845; RESIDENCE: Acomita in ca. 1910
FAMILY: mother of Pablita Waniehe (2)
PUBLICATIONS: Leopold Bibo, "13th Annual U.S. Census" (1910), New Mexico State Archives, Call T624, Roll 919; in Dillingham 1992:205.

Pablita Waniehe *(2)*
(Acoma, active ca. 1890s-1910s+: polychrome jars, bowls)
BORN: ca. 1882; RESIDENCE: Acomita in ca. 1910
PUBLICATIONS: Leopold Bibo, "13th Annual U.S. Census" (1910), New Mexico State Archives, Call T624, Roll 919; in Dillingham 1992:205.

Billie Wanya
(Acoma, active ?-1990+: polychrome jars, bowls)
PUBLICATIONS: Dillingham 1992:206-208.

Elma Wanya

(Acoma, active ?-1975+: polychrome jars, bowls)
PUBLICATIONS: Minge 1991:195.

Angela Waquie *(signs A. W. Jemez)*

(Jemez, active ca. 1987-present: polychrome on matte tanware jars, bowls, wedding vases)
BORN: November 1, 1946
TEACHER: her grandmother
PUBLICATIONS: Berger & Schiffer 2000:42160.

Christine Waquie

(Jemez, active ca. 1970s-present: Storytellers)
FAMILY: daughter of Felipita Waqui; sister of Joseph A. Waquie

Corina N. Waquie *(signs C. Waquie)*

(Jemez, active ?-present: matte polychrome Storytellers, sifter baskets)
PUBLICATIONS: Coe 1986:204-05; Congdon-Martin 1999:107.

Felipita Waquie

(Jemez, active ca. 1950s-?: polychrome on matte tanware jars, bowls)
BORN: ca. 1930s
FAMILY: mother of Joseph A. Waquie & Christine Waquie
STUDENTS: her children
EXHIBITIONS: pre-1985-1994, Indian Market, Santa Fe
PUBLICATIONS: *SWAIA Magazine* 1985, 1988, 1989.

Joseph A. Waquie *(signs JAW, Jemez, NM)*

(Jemez, active ca. 1985-present: polychrome on matte tanware fireplace corners, jars, bowls, wedding vases)
BORN: May 6, 1956
FAMILY: son of Felipita Waquie; brother of Christine Waquie
TEACHER: Felipita Waquie, his mother
FAVORITE DESIGNS: clouds, feathers
PUBLICATIONS: Walatowa Pueblo of Jemez, "Pottery of Jemez Pueblo" (1999); Berger & Schiffer 2000:42, 160.

Judy Toya Waquie

(Jemez, active ?-present: polychrome Storytellers, figures)
EXHIBITIONS: pre-1985-1989, Indian Market, Santa Fe
FAVORITE DESIGNS: figures with children
PUBLICATIONS: *SWAIA Magazine* 1989; Walatowa Pueblo of Jemez, "Pottery of Jemez Pueblo" (1999).

Marie L. Waquie

(Jemez, active ca. 1960s-present: polychrome jars & bowls)
BORN: ca. 1940s
FAMILY: daughter of Anacita Chinana & Casimiro; sister of Marie Chinana, Persingula Chinana Gonzales, Georgia F. Chinana, Marie Chinana (3) & Christina Chinana Tosa
EXHIBITIONS: pre-1989-1994, Indian Market, Santa Fe
PUBLICATIONS: *SWAIA Magazine* 1989.

Shelly Waquie

(Jemez, active ?-present: polychrome jars, bowls, wedding vases)
FAVORITE DESIGNS: clouds, feathers
PUBLICATIONS: Walatowa Pueblo of Jemez, "Pottery of Jemez Pueblo" (1999).

Katherine Waquiri

(Jemez, active ?-present: matte polychrome Storytellers)
PUBLICATIONS: Congdon-Martin 1999:107.

Pauline Waquiri

(Jemez, active ?-present: matte polychrome Storytellers)
PUBLICATIONS: Congdon-Martin 1999:107.

D. Ward

(Isleta, active ?: pottery)
PUBLICATIONS: Hayes & Blom 1996

Mary Eunice Ware

(Cochiti, active ca. 1980-present: Storytellers)
BORN: ca. 1958
FAMILY: great-granddaughter of Cresencia Quintana; granddaughter of Teresita Romero; daughter of Maria Priscilla Romero
PUBLICATIONS: Babcock 1986:135.

Marcus Waseta

(Zuni, active ?: pottery)
PUBLICATIONS: *The Messenger,* Wheelwright Museum Summer 1990:2; Autumn 1990:1.

Consepsion Watzai

(Acoma, active ca. 1860s-1910s+: polychrome jars, bowls)
BORN: ca. 1845; RESIDENCE: Acomita in ca. 1910
PUBLICATIONS: Leopold Bibo, "13th Annual U.S. Census" (1910), New Mexico State Archives, Call T624, Roll 919; in Dillingham 1992:205.

Teddy Weakie

(Zuni, active ca. 1930s-1960s: fetish jars, jewelry, fetish carver)
FAMILY: father of Edna Leki, Dinah Gasper; grandfather of Lena Boone, Anderson Weakie
He is said to have been the first one in his family to make fetish jars.

Agnes Weeker

(Laguna, active ca. 1973-?: traditional polychrome jars, bowls)
EDUCATION: 1973, Laguna Arts & Crafts Project participant

West Mountain *(signs West Mountain, Laguna, N.M.)*

(Laguna/Cochiti, Lizard Clan, active ca. 1990s-present: contemporary sgraffito polished blackware some with turquoise insets, ollas, jars, bowls)
BORN: ca. 1975
FAVORITE DESIGNS: Kachinas, feathers-in-a-row, terraced clouds, crosses
GALLERIES: Rio Grande Wholesale, Albuquerque

Amy Westika

(Zuni, active ca. 1910s-?: traditional polychrome jars, bowls)
BORN: ca. 1890
FAMILY: mother of Eloise Westika
TEACHER: her mother

Angie Westika *(collaborates with Todd Westika)*

(Zuni, active ?-present: pottery)

Daryl Westika *(Darrel, Darrell Westika), (signs D. Westika), (collaborates sometimes with Priscilla Peynetsa)*

(Zuni, active ca. 1980s-present: traditional black-on-orangeware, polychrome jars, bowls, duck effigy jars, miniatures, fetish carvings)
BORN: ca. 1950s
FAMILY: husband of Priscilla Peynetsa
FAVORITE DESIGNS: Deer-in-His-House, bears, ducks, butterflies, clouds, scallops
COLLECTIONS: John Blom
GALLERIES: Pueblo of Zuni Arts & Crafts, Zuni, NM
PUBLICATIONS: Eaton 1990:3; Rodee & Ostler 1990:77; Schiffer 1991d:47; Hayes & Blom 1996:170-71; 1998:49-53; Baseman 1996:25, 70.

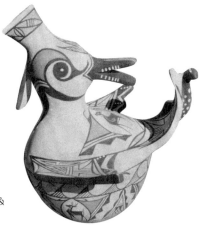

Daryl Westika -
Courtesy of John Blom

Eloise Westika *(signs E.W. Zuni N.M.)*

(Zuni, active ca. 1927-present: traditional polychrome jars, bowls, beadwork)
BORN: January 1, 1913
FAMILY: daughter of Amy Westika
TEACHER: her grandmother
PHOTOGRAPHS: School of American Research, Santa Fe
PUBLICATIONS: Rodee & Ostler 1986:40; Berger & Schiffer 2000:160.
Eloise Westika was a participant in the Zuni dance group, the Olla Maidens, who performed throughout the Southwest. They were especially popular at the Inter-tribal Indian Ceremonial parade in Gallup.

Todd Westika *(collaborates with Angie Westika)*

(Zuni, active ?-present: pottery)
PUBLICATIONS: Painter 1998:184-90.

We'wha *(We-Wha, We-We, Wa-Wah)*

(Zuni, Badger Clan, active ca. 1870s-?: traditional polychrome ollas, jars, cornmeal bowls with handles, also textiles, embroidered mantas, belts)
LIFESPAN: ca. 1849 - 1896
FAMILY: foster son/daughter of José Palle, a Zuni rain priest; father of one or more children
DEMONSTRATIONS: Smithsonian Institution, Washington, D.C.
COLLECTIONS: Smithsonian Institution, Washington, D.C.; President Grover Cleveland Collection
PUBLICATIONS: Stevenson 1904:20, 310, 374, 380; Parsons 1916:523; James 1920; Bunker 1956:99-100; Fox 1978:31; Basso 1979:19; Batkin 1987:20-21; Roscoe 1991:39, 50-52, 121; Schaaf 2001:310.

We'wha was a famous Zuni berdache or man-woman. She was photographed dressed as a woman in an embroidered manta. She was pictured weaving float warp wool belts. She also made pottery, and grew to be considered the best potter at Zuni. She was considered the first Zuni to offer their pottery for sale to non-Indian collectors. We'wha's parents died when she was an infant. Her mother was from the Badger Clan, and her father was from the Dogwood Clan. She and her small brother were adopted by their father's sister. She also had two daughters and a son, who became her foster sisters and brother.

In 1879, We'wha was commissioned by the first American woman anthropologist, Matilda Cox Stevenson, to make pottery for the National Museum, forerunner of the Smithsonian Institution in Washington, D.C.. When gathering clay at Corn Mountain, We'wha cautioned Ms. Stevenson not to speak, explaining: "Should we talk, my pottery would crack in the baking, and unless I pray constantly the clay will not appear to me." After gathering over 150 pounds of clay, We'wha piled it in a blanket, tied the ends around her forehead and carried the load down the steep mesa. Ms. Stevenson reportedly did not know for many years that We'wha was anatomically a man.

Ms. Stevenson later took We'wha to demonstrate weaving at the National Museum of the Smithsonian Institution in Washington, D.C. We'wha lived for six months with Ms. Stevenson in the nation's capitol. We'wha contributed during this time to studies of Zuni culture, language, arts and crafts, including studies of Zuni clans by linguist Albert S. Gatschet, whose notes are in the National Anthropological Archives.

On June 12, 1886, the *Evening Star* newspaper reported: ". . .Zuni maiden, Wa-wah, a priestess, and a person of importance among her own people. . .Wa-Wah came there to weave a blanket on the loom and explain the use of the implements. . ."

On June 23 1886, We'wha met President and Mrs. Grover Cleveland. We'wha gave them one of her small Zuni pots as a present. This reportedly was the first time in history that an American president ever shook hands with an American Indian berdache. In 1890s, author George Wharton James was a guest in We'wha's home. He called her "one of the most noted and prominent" Zuni people. He added, "she was of masculine build and had far more of the man in her character than the woman. Yet she excelled all other of the Zuni women in the exercise of her skill in blanket and pottery making."

In late 1896, We'wha died at Zuni. She was mourned by all, and her loss was considered a "calamity."

After We'wha's death in 1904, We'wha was described by Matilda Coxe Stevenson as "the strongest character and the most intelligent of the Zuni tribe." She also called her the "most active and most progressive." In 1916, anthropologist Elsie Clews Parsons described her as "a notable character" and "the celebrated lhamana," a Zuni term referring to a berdache.

Former Zuni Indian agent Robert Bunker praised We-Wha as a "man of enormous strength who lived a woman's daily life in woman's dress, but remained a power in his Pueblo's gravest councils." She served as an interpreter for the Zuni tribe. She also was initiated into the South Kiva. She participated in masked dances.

Whar-te *(The Industrious Woman)*

(Jemez, active ca. 1820s-1849+: traditional large Trios Polychrome storage jars)
FAMILY: wife of the Governor of Jemez
PUBLICATIONS: Batkin 1987:122.
ILLUSTRATIONS: portrait painting by Richard H. Kern, ca. 1849, chromolithograph.

Alice Poncho White

(Acoma, Sun Clan, active ca. 1930s-?: traditional polychrome ollas, jars, bowls)
BORN: ca. 1910
FAMILY: wife of Frank Zieu White (Little Bear Clan); mother of Rachel White James

Rachael White

(Acoma, active ca. 1960s-present: traditional polychrome jars, bowls)
BORN: ca. 1940
FAMILY: wife of James White; mother of Darla Davis; m. grandmother of Melville & Alicia Kelsey
STUDENTS: Darla Davis, her daughter
PUBLICATIONS: Berger & Schiffer 2000:111.

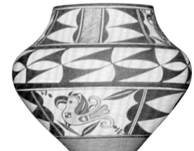

Shayetsa White Dove -
Courtesy of Wanda Campbell
Indian Art Unlimited, IL

Shayetsa White Dove *(Sister to the Hopi Kachinas)*

(Acoma, active 1984-present: traditional & contemporary polychrome & black-on-white jars, bowls, large ollas, clay sculptures)
BORN: July 7, 1956
FAMILY: granddaughter of Connie O. Cerno; daughter of Margaret & James Garcia
TEACHER: Connie O. Cerno, her grandmother
AWARDS: 1999, 1st, 2nd, New Mexico State Fair, Albuquerque
EXHIBITIONS: 1985-present: Indian Market, Santa Fe
FAVORITE DESIGNS: parrot, flowers
GALLERIES: Native American Collections, Inc., Denver, CO; Rio Grande

Shayetsa White Dove - Courtesy of
Jason Esquibel. Rio Grande Wholesale, Inc.

Wholesale, Inc., Palms Trading Co., Albuquerque

VALUES: On June 5, 1998, a polychrome olla signed Shayetsa White Dove (9 x 10"), sold for $1,540 at R. G. Munn, #825.

PUBLICATIONS: Dillingham 1992:206-208; *National Geographic Magazine*; Painter 1998:16; Berger & Schiffer 2000:160; *Travel Magazine*.

Shayetsa White Dove makes beautiful traditional and contemporary polychrome ollas, jars and bowls. Her painting style, while rooted in tradition, has a contemporary flair reflecting her personal artistic tastes. Her parrots display flowing tail feathers and long beaks. Her split leaves are elongated with fineline tips. Her compositions are well balanced and harmonious. She has been honored as a top prizewinner at the New Mexico State Fair.

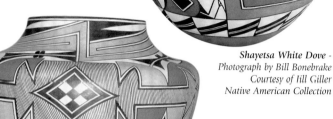

Shayetsa White Dove -
Photograph by Bill Bonebrake
Courtesy of Jill Giller
Native American Collection

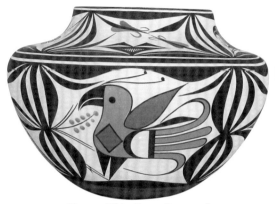

Shayetsa White Dove - *Courtesy of*
Andrews Pueblo Pottery & Art Gallery, Albuquerque

Shayetsa White Dove -
Andrea Fisher Fine Pottery
Santa Fe

Martha Wilkinson

(Acoma, active ?-1990+: polychrome jars, bowls)
PUBLICATIONS: Dillingham 1992:206-208.

Louise Willie *(Louise Amos, Louis Abeita)*

(Acoma, active ca. 1960-present: traditional polychrome jars, bowls)
BORN: November 3, 1946
FAMILY: m. granddaughter of Delores Stern; daughter of Frances & Lorenzo Abeita
PUBLICATIONS: Berger & Schiffer 2000:161.

Annetta Wilson

(Cochiti/San Ildefonso, active ca. 1970s-?: polychrome Storytellers, drums covered in figures)
COLLECTIONS: Wright Collection, Peabody Museum, Harvard University, Cambridge, MA
PUBLICATIONS: Drooker, et al., 1998:50, 138.

Nora Wilson

(Acoma, active ?-1975+: polychrome jars, bowls)
PUBLICATIONS: Minge 1991:195; Dillingham 1992:206-208.

Juana Maria Yaca

(Acoma, active ca. 1860s-1910s+: polychrome jars, bowls)
BORN: ca. 1845; RESIDENCE: McCartys in ca. 1910
PUBLICATIONS: Leopold Bibo, "13th Annual U.S. Census" (1910), New Mexico State Archives, Call T624, Roll 919; in Dillingham 1992:205.

Pabla Yaca

(Acoma, active ca. 1890s-1910s+: polychrome jars, bowls)
BORN: ca. 1875; RESIDENCE: McCartys in ca. 1910
PUBLICATIONS: Leopold Bibo, "13th Annual U.S. Census" (1910), New Mexico State Archives, Call T624, Roll 919; in Dillingham 1992:205.

Keyteayai Yamoon

(Acoma, active ca. 1860s-1910s+: polychrome jars, bowls)
BORN: ca. 1845; RESIDENCE: Acomita in ca. 1910
PUBLICATIONS: Leopold Bibo, "13th Annual U.S. Census" (1910), New Mexico State Archives, Call T624, Roll 919; in Dillingham 1992:205.

Eileen Yatsattie

(Zuni, active ca. 1980s-present: polychrome jars, cornmeal bowls, frog pots, miniatures)
FAMILY: great-granddaughter of Catalina Zuni
TEACHER: Josephine Nahohai
EXHIBITIONS: 1998, Indian Market, Santa Fe
DEMONSTRATIONS: 1994, University of Illinois, Urbana
FAVORITE DESIGNS: frogs, tadpoles, terraced clouds, rain
GALLERIES: The Indian Craft Shop, U.S. Department of Interior, Washington, D.C.; Pueblo of Zuni Arts & Crafts, Zuni, NM
PUBLICATIONS: *Southwest Profile* Oct. 1990:11; *Native Peoples* Summer 1993:44; Fall 1997:68; Nahohai & Phelps 1995:64-71; Bassman 1996:23, 29; *Indian Trader* Oct. 1996:19; "Indian Summer," *Santa Fe Reporter* 1998:22; *Plateau Journal* Winter 1999/2000:24.

 Around 1985, Eileen Yatsattie began using traditional clays and paints with encouragement from Josephine Nahohai. Before that, Eileen used commercial clays and paints. Josephine taught Eileen the process of collecting an preparing natural Zuni clay.

 Eileen makes not only pots for collectors, but also many for religious use, including for Shalako, the Zuni winter ceremony. She makes fine cornmeal bowls with and without handles. She also makes frog effigy pots; some with just their heads in sculptured relief. They look like frogs floating in a pond sticking their heads out of the water. Her grandfather taught her Zuni prayers associated with pottery making.

 Beginning in 1990, Eileen served as Director for the Zuni arts & crafts co-op. She shares her knowledge of pottery making with others. She uses yucca fruit, instead of wild spinach, for her dark brown paint. She does both kiln and traditional firing with sheep manure. Eileen also is the founder and director of the Creative Arts Program of Zuni.

 Eileen continues her study of historic pottery in museums, because she explains that their old pots give her "inspiration to try new things. My main focal point is to continue the traditional designs." (Nahohai & Phelps 1995:71)

Connie Yatsayte

(Zuni, active ca. 1980s-?: pottery)
FAMILY: m. granddaughter of Nellie Bica; daughter of Quanita Kalestewa & Jack Kalestewa; sister of Erma Jean Homer, Roweena Lemention

Timmy E. Yazzie *(Time Yazzie)*

(San Felipe/Navajo, active ca. 1991-present: pottery, jewelry)
BORN: October 16, 1954
FAMILY: son of Andy & Minnie Yazzie
TEACHERS: Chalmers Day, Jimmy Harrison
PUBLICATIONS: Berger & Schiffer 2000:162.

Yellow Corn *(see Gary Louis)*

Yepa *(see Florinda Chinana)*

Alvina Yepa

(Jemez, Sun Clan, active ca. 1982-present: stone polished redware jars, melon bowls, large sgraffito ollas.)

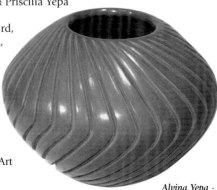

BORN: August 4, 1954
FAMILY: m. granddaughter of Frank & Louisa Fragua Toledo; p. granddaughter of Cristino & Juanita Fragua Yepa; daughter of Nick & Felipita Yepa; sister of Jose, Albert, Cristino, Lawrence, Wallace & Priscilla Yepa
TEACHER: Felipita Yepa, her mother
AWARDS: 1989, 1st, 2nd, sgraffito; 3rd, melon bowls; 1994, Best of Division, 1st, red sgraffito, 3rd, melon bowls, 1996, 2nd, sgraffito; 1998, 3rd; 2000, 1st, red sgraffito, Indian Market, Santa Fe; Heard Museum Show, Phoenix; Inter-tribal Indian Ceremonial, Gallup
EXHIBITIONS: pre-1985-present, Indian Market, Santa Fe; 1994-present, Eight Northern Indian Pueblos Art & Crafts Show

Alvina Yepa - Courtesy of John D. Kennedy and Georgiana Kennedy Simpson, Kennedy Indian Arts

Alvina Yepa - Photograph by Bill Knox Courtesy of Indart Incorporated

FAVORITE DESIGNS: melons, flowers, stars
PUBLICATIONS: *Indian Market Magazine* 1989; *American Indian Art Magazine* Winter 1996 22(1):82; Winter 1998 24(1):86; Berger & Schiffer 2000:162.

Bessie Yepa *(Bess Yepa), (sometimes signs B. Yepa)*

(Jemez, active ?-present: stone polished & matte polychrome, matte red-on-tanware jars, bowls, effigy pots, Storytellers Corn Maidens, figures, mother & child, animals, ornaments)
FAVORITE DESIGNS: feathers, rain clouds, corn plants, Pueblo human figures, animals
PUBLICATIONS: Barry 1984:130; Walatowa Pueblo of Jemez, "Pottery of Jemez Pueblo" (1999); Congdon-Martin 1999:107.

Emma Yepa

(Jemez, Coyote Clan, active ca. 1980-present: stone polished redware & tanware, some sgraffito, melon swirl pots)
BORN: May 13, 1968
FAMILY: granddaughter of Jose & Reyes Toya; daughter of Jose & Ida Yepa; wife of Albert Arizmendi, Sr.; mother of Dianna Yepa, Diann Yepa, Breanna Arizmendi, Albert Arizmendi, Jr.
AWARDS: 2000, 1st; 2001, 2nd, Jemez Red Rocks Arts & Crafts Show
EXHIBITIONS: 1997-present, Indian Market, Santa Fe; 1997-present, Eight Northern Indian Pueblos Art & Crafts Show; 1998-present, Southwest Museum Show, Los Angeles, CA
GALLERIES: Andrews Pueblo Pottery and Art Gallery, Albuquerque
PUBLICATIONS: *Indian Market Magazine* 1998:100.

Emmet Trevor Yepa

(Jemez, active ca. 2000-present: traditional polychrome jars, bowls)
BORN: March 5, 1994
FAMILY: grandson of Flo & Sal Yepa; son of Adrianna Loretto
TEACHERS: Flo & Sal Yepa, Adrianna Loretto

Felipita Toledo Yepa *(Felita)*

(Jemez, Sun Clan, active ca. 1940s-?: stone polished redware jars, bowls)
BORN: ca. 1921
FAMILY: daughter of Frank & Louisa Fragua Toledo (2); sister of Jose R. Toledo, Michael Toledo, Joe Rafael Toledo, Bernice Louise Gachupin; wife of Nick Yepa; mother of Alvina, Salvador, Jose, Albert, Cristino, Wallace, Priscilla & Lawrence Yepa
STUDENT: Alvina Yepa, her daughter

Felita Yepa

(Jemez, active ca. 1940s-?: stone polished redware & blackware jars, bowls)
BORN: ca. 1920s
FAMILY: mother of Lawrence Yepa
STUDENT: Lawrence Yepa, her son

Flo Yepa *(Florence Yepa), (sometimes collaborates with Sal Yepa)*

(Jemez/Laguna, Fire Clan, active ca. 1970s-present: many styles, including traditional revival of pre-19th century Jemez styles of black-on-tanware, as well as polychrome jars, bowls)
BORN: April 5, 1949
FAMILY: m. great-granddaughter of Abran & Christina Sabaquie; m. granddaughter of Petra & Santiago Romero; p. granddaughter of Josephine & Antonio Sarracino (Old Laguna); daughter of Margaret Romero Sarracino & Francisco (Frank) Sarracino (Roadrunner Clan); sister of Raphael Sarracino, Genevieve Chinana, Robert Sarracino & Sharon Sarracino; wife of Sal Yepa; step-mother of Miriam Brenda Loretto, Victor Loretto, Jr., Adrianna Loretto
FAVORITE DESIGNS: deer, clouds, rain, corn, lightning
GALLERIES: Santa Fe Décor, Inc., Santa Fe & Houston
PUBLICATIONS: Hayes & Blom 1996:82, 88; Colorado PBS Special 1999.

Flo Yepa deserves a lot of credit for her years of dedicated work experimenting with different natural clays, slips and paints. She and her husband, Sal Yepa, have an attractive shop next to the main road outside the village. Flo's sister, Sharon Sarracino, also is an accomplished potter, and the two share their knowledge.

We stopped and visited with Flo Yepa one day. She was excited about her recent experiments. With enthusiasm, she showed us the samples of different clays she had collected far and wide. She then was working on reviving a black-on-greyware style found in early historic Jemez sites. We respect Flo & Sal Yepa and encourage their continued experiments in pottery making.

Florinda Yepa

(Jemez, active ca. 1970s-present: Storytellers)
BORN: ca. 1954
PUBLICATIONS: Babcock 1986.

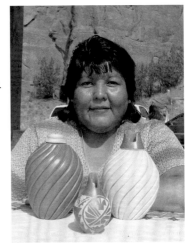

Emma Yepa -
Photograph by Angie Schaaf

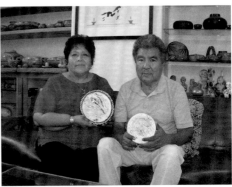

Emma Yepa -
Courtesy of
Andrews Pueblo Pottery
and Art Gallery

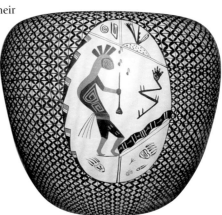

Flo & Sal Yepa - Photograph by Angie Schaaf

Flo & Sal Yepa -
Courtesy of the artists

Flo Yepa - Courtesy of the artist

Ida R. Yepa

(Jemez, Coyote Clan, active ca. 1960s-present: sgraffito redware & matte tanware jars, bowls, heart shaped vases)
BORN: ca. 1940s
FAMILY: m. great-granddaughter of Juanito & Andrieta Shendo; m. granddaughter of Reyes S. Toya (2); daughter of Albert & Marie Vigil; sister of Lorraine Chinana & Georgia Vigil-Toya; wife of Jose Yepa; mother of Emma Yepa; grandmother of Dianna Yepa, Diann Yepa, Breanna Arizmendi, Albert Arizmendi, Jr.
EXHIBITIONS: 1994-present, Eight Northern Indian Pueblos Art & Crafts Show
FAVORITE DESIGNS: terraced clouds, hummingbirds, feathers-in-a-row, leaves
PUBLICATIONS: Berger & Schiffer 2000:42, 162.

Ida Yepa makes attractive contemporary forms, such as heart-shaped vases. Her stone polished redware is traditionally made, then carved in sgraffito with beautiful designs. She draws from traditional Jemez designs, as well as from nature.

Juanita Fragua Yepa *(1)*

(Jemez, Eagle Clan, active ca. 1910s-?: traditional polychrome jars, bowls)
BORN: ca. 1890s
FAMILY: wife of Cristino Yepa, Sr.; mother of Nick Yepa; p. grandmother of Jose, Albert, Cristino, Lawrence, Wallace Alvina, Salvador & Priscilla Yepa

Juanita Yepa *(2) (signs J. Yepa, Jemez)*

(Jemez, active ca. 1957-present: traditional polychrome jars, bowls, jewelry)
BORN: June 7, 1937
FAMILY: daughter of Mr. & Mrs. John Fragua
TEACHER: Mrs. John Fragua, her mother
PUBLICATIONS: Harlow 1977; Berger & Schiffer 2000:163.

Lawrence Yepa *(signs L. Yepa, Jemez Pue.)*

(Jemez, Sun Clan, active ca. 1980-present: stone polished redware & blackware, sgraffito jars, bowls)
BORN: October 15, 1948
FAMILY: m. grandson of Frank & Louisa Fragua Toledo; p. grandson of Cristino & Juanita Fragua Yepa; son of Nick & Felapita Toledo Yepa; brother of Jose, Albert, Cristino, Wallace Alvina, Salvador & Priscilla Yepa
TEACHER: Filapita Toledo Yepa, his mother
AWARDS: 1994, 3rd, sgraffito, Indian Market, Santa Fe
FAVORITE DESIGNS: kiva steps, terraced clouds
PUBLICATIONS: Berger & Schiffer 2000:163.

Lupe L. Yepa

(Jemez, active ca. 1940s-present: traditional polychrome jars, bowls, miniatures)
BORN: ca. 1920s
FAMILY: mother of Florinda Yepa Chinana & Virginia Chinana
STUDENTS: Florinda Yepa Chinana & Virginia Chinana, her daughters

Lupita Yepa

(Jemez, active ?-present: polychrome & sgraffito redware & matte tanware jars, bowls, ornaments, miniatures)
EXHIBITIONS: 1994-present, Eight Northern Indian Pueblos Art & Crafts Show
FAVORITE DESIGNS: feathers, rain clouds, corn plants, rattles
PUBLICATIONS: Walatowa Pueblo of Jemez, "Pottery of Jemez Pueblo" (1999).

Marcella Yepa

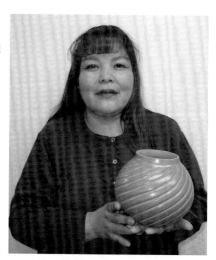

(Jemez, Sun Clan, active ca. 1983-present: stone polished redware & tanware melon swirl pots, jars, wedding vases)
BORN: March 16, 1964
FAMILY: p. granddaughter of Felipita & Nick Yepa; daughter of Salvador Yepa & Dorene Carpenter; niece of Alvina Yepa; cousin of Emma Yepa & Lawrence Yepa; mother of Donoran Yepa, Shaunna Yepa & Benjamin Yepa
TEACHERS: Felipita Yepa, Alvina Yepa
EXHIBITIONS: Santo Domingo Arts & Crafts Show
DEMONSTRATIONS: Utility Shack Indian Arts, Albuquerque
GALLERIES: Andrew Pueblo Pottery, Nizhoni, Rio Grande Wholesale, Albuquerque; Kennedy Indian Arts, Bluff, UT
PUBLICATIONS: Hayes & Blom 1996:84; *New Mexico Magazine* 1996.

Marcella Yepa proclaimed, "Pottery is the way of my life. I was raised to create beautiful works of art."

Marcella makes beautiful melon swirl pots. She stone polishes her redware and tanware pottery. She gathers natural clay, hand coils and sculpts her forms and fires her pottery outdoors with cedar chips.

Marcella concluded, "I plan to work on pottery as long as I can."

Marcella Yepa - Courtesy of Jason Esquibel Rio Grande Wholesale, Inc.

Maxine T. Yepa *(Maxine Andrews), (early work signed Maxine Andrews; contemporary work signed Maxine Yepa Walatowa/Jemez)*
(Jemez, Oak Clan, active ca. 1985-present: matte polychrome & stone polished black-on-redware, melon swirl pots, jars, bowls, wedding vases, thin necked vases)
BORN: ca. 1970
FAMILY: m. granddaughter of Anasita Chinana, daughter of Christine Tosa; sister of Jennifer Andrew; niece of Pauline Romero; cousin of Donald Chinana
FAVORITE DESIGNS: Sunface, large birds standing in profile, feathers-in-a-row, sunflowers, clouds, rainbows
GALLERIES: Rio Grande Wholesale, Albuquerque

Maxine Yepa - Courtesy of Jason Esquibel
Rio Grande Wholesale, Inc.

Paul M. Yepa *(collaborates with Juanita Shendo)*
(Jemez, active ca. 1987-present: polychrome jars, bowls)
BORN: November 27, 1956

Sal Yepa *(Salvador), (collaborates with Flo Yepa), (see portrait with Flo Yepa)*
(Jemez, Sun Clan, active ?-present: many styles, including traditional revival of pre-19th century Jemez styles of black-on-tanware, as well as polychrome jars, bowls)
BORN: January 22, 1940
FAMILY: m. grandson of Frank & Louisa Fragua Toledo; p. grandson of Cristino & Juanita Fragua Yepa; son of Nick & Felapita Toledo Yepa; brother of Jose, Albert, Cristino, Wallace Alvina, Lawrence & Priscilla Yepa; husband of Flo Yepa; father of Mariam, Victor & Adrianna Loretto; grandfather of Robin Loretto, Matthew Panana, Ryan Panana, Emmet Trevor Yepa
GALLERIES: Santa Fe Décor, Inc.
PUBLICATIONS: Hayes & Blom 1996:82-83.

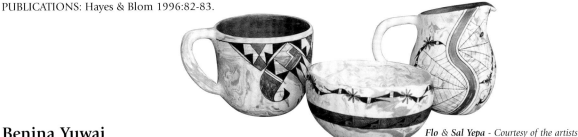

Flo & Sal Yepa - Courtesy of the artists

Benina Yuwai
(Laguna, active ca. 1920s-?: traditional polychrome jars, bowls)
STUDENTS: Maria Chiwiwi (Isleta)
PUBLICATIONS: Parsons 1928:604; Batkin 1991:191, 205, n. 137.
 When Benina Yuwai taught Maria Chiwiwi how to make pottery, she told her to ask the "Clay Mother for clay."

Tonia Zavala
(Tigua/Ysleta del Sur, active ca. 1970s-?: polychrome, black & red on orangeware jars, bowls, vases)
FAVORITE DESIGNS: kiva steps, lightning, clouds, diamonds in a row
PUBLICATIONS: Hayes & Blom 1996:172.

Tiffin M. Zellers
(Zuni, active ca. 1990s-present: pottery)
BORN: ca. 1973
EXHIBITIONS: 1998, Indian Market, Santa Fe
PUBLICATIONS: *Santa Fe Reporter* 1998:22.

Grace Ziutie
(Acoma, active ca. 1890s-1910s+: polychrome jars, bowls)
BORN: ca. 1875; RESIDENCE: Acomita in ca. 1910
PUBLICATIONS: Leopold Bibo, "13th Annual U.S. Census" (1910), New Mexico State Archives, Call T624, Roll 919; in Dillingham 1992:205.

Consepsion Zuni
(Acoma, active ca. 1870s-1910s+: polychrome jars, bowls)
BORN: ca. 1860; RESIDENCE: Acomita in ca. 1910
PUBLICATIONS: Leopold Bibo, "13th Annual U.S. Census" (1910), New Mexico State Archives, Call T624, Roll 919; in Dillingham 1992:205.

F. Zuni
(Isleta, active ?: pottery)
COLLECTIONS: Wright Collection, Peabody Museum, Harvard University, Cambridge, MA.
PUBLICATIONS: Drooker & Capone 1998:56, 138.

Kim Zuni

(Zuni, active ?-present: pottery)
PUBLICATIONS: *Pueblo Horizons* Fall 1996:6.

Lena Zuni

(Zuni, active ?: pottery)
PUBLICATIONS: Mercer 1995:40.

M. Zuni

(Isleta, active ?: Storytellers, miniatures)
GALLERIES: Adobe Gallery, Albuquerque
ARCHIVES: Heard Museum Library, Phoenix, artist file.
PUBLICATIONS: Congdon-Martin 1999:127.

Maria Zuni

(Acoma, active ca. 1870s-1910s+: polychrome jars, bowls)
BORN: ca. 1860; RESIDENCE: Acomita in ca. 1910
PUBLICATIONS: Leopold Bibo, "13th Annual U.S. Census" (1910), New Mexico State Archives, Call T624, Roll 919; in Dillingham 1992:205.

Mary Zuni *(signs M. Zuni)*

(Laguna, active ca. 1996-present, polychrome jars, bowls)
BORN: June 2, 1956
FAMILY: daughter of Diego & Mary Abeita
PUBLICATIONS: Berger & Schiffer 2000:163.

Povi Zuni

(Isleta/San Juan, active ca. 1940s-?: Storytellers, jewelry)
BORN: ca. 1920
FAMILY: mother of Mary Lou Kokaly

Catalina Zunie *(Zuni)*

(Zuni, active ca. 1910s-50s: polychrome jars, cornmeal bowls, frog pots, effigy pots)
FAMILY: mother of Flora; great-grandmother of Avelia Peynetsa & Eileen Yatsattie
FAVORITE DESIGNS: frogs, tadpoles
GALLERIES: Runing Bear Zuni Trading Post, Zuni, NM
PUBLICATIONS: Hardin 1983:36-37; Batkin 1987:165; Nahohai & Phelps 1995:55; Hayes & Blom 1996:168, 170; Anderson et al. 1999:42.

Catalina Zunie and Tsayutitsa were among the few fine Zuni potters from the 1920s through 1930s who we know by name. Catalina reportedly taught a few people pottery making during her career in a program sponsored by the Bureau of Indian Affairs. At least two of her great-granddaughters are potters - Eileen Yatsattie and Avelia Peynetsa.

Bibliography

Abbott, Larry
 A Time of Visions: Interviews with Native American Artists. Kent, CT.

Aberle, Sophie D.
 1948 The Pueblo Indians of New Mexico: Their Land, Economy, and Civil Organization. *Memoirs of the American Anthropological Association* 70.

Anderson, Duane
 1999 All That Glitters: The Emergence of Native American Micaceous Art Pottery in Northern New Mexico. Santa Fe: School of American Research Press.

Anderson, Duane, et. al.
 1999 Legacy: Southwest Indian Art at the School of American Research. Santa Fe: School of American Research Press.

Anonymous
 1920 Fine Exhibit of Pottery. *El Palacio* 8(7-8): 217
 1922 The Southwest Indian Fair. *El Palacio* 13(8):93-7.
 1923 The Southwest Indian Fair. *El Palacio* 15(6):100-04.
 1924 The Indian Fair. *El Palacio* 17(6-7):165-69.
 1926 The Indian Fair. *El Palacio* 21(6):154-57.
 1962 IAF [Indian Arts Fund] Chronology. Bruce Ellis Collection, Museum of New Mexico History Library.

Anthony, Al
 1982 Cochiti Pueblo Storytellers. Albuquerque: Adobe Gallery.

Applegate, Frank G.
 1929 Indian Stories from the Pueblos. Philadelphia: J.B. Lippincott.

Archuleta, Margaret and Renard Strickland
 1991 Shared Visions: Native American Painting and Sculpture. Phoenix: The Heard Museum.

Arnold, David
 1983 Pueblo Pottery: 2,000 Years of Artistry. *National Geographic Magazine* (November) 162(5): cover, 599.

Austin, Mary
 1934 Indian Pottery of the Rio Grande. Pasadena, CA: Esto Publishing Co.

Babcock, Barbara A.
 1978 Helen Cordero, The Storyteller Lady. *New Mexico Magazine.*
 1983 Clay Changes: Helen Cordero and the Pueblo Storyteller. *American Indian Art Magazine* 8(2):30-39.

Babcock, Barbara A., Guy Monthan, and Dories Monthan
 1986 The Pueblo Storyteller: Development of a Figurative Ceramic Tradition. Tucson: University of Arizona Press.

Bahti, Mark
 1988 Pueblo Stories and Storytellers. Tucson: Treasure Chest Publications.

Bahti, Tom
 1966 Southwestern Indian Arts and Crafts. Flagstaff, AZ: KC Publications.
 1968 Southwestern Indian Tribes. Las Vegas, KC Publications.
 1970 Southwestern Indian Ceremonials. Flagstaff, AZ: KC Publications.
 1988 Pueblo Stories and Storytellers. Tucson, AZ: Treasure Chest Publications.

Bandelier. Adolph F.A.
 1890-92 Final Report of Investigations Among the Indians of the Southwestern United States, Carried on Mainly in the Years from 1880 to 1885. 2 vols. *Papers of the Archaeological Institute of American, American Series* 3 and 4. Cambridge, MA
 1966-1984 *The Southwestern Journals of Adolph F. Bandelier.* Charles H. Lange and Carroll L. Riley, with Elizabeth M. Land, eds. 4 vols. Albuquerque: University of New Mexico Press; Santa Fe: The School of American Research and Museum of New Mexico Press.
 1969 *A History of the Southwest: A Study of the Civilization and Conversion of the Indians in Southwestern United States and Northwestern Mexico from the Earliest Times to 1700.* Vol. 1: A Catalogue of the Bandelier Collection in the Vatican Library, Rome and St. Louis: Jesuit Historical Institute.

Bandelier, Adolph F.A. and Edgar L. Hewett
 1937 Indians of the Rio Grande Valley. Albuquerque: University of New Mexico Press.

Barry, John W.
 1984 American Indian Pottery. Florence AL: Books Americana.

Barsook, et al.
 1974 Seven Families in Pueblo Pottery. Albuquerque: Maxwell Museum.

Batkin, Jonathan
 1987 Pottery of the Pueblos of New Mexico, 1700-1940. Colorado Springs: Taylor Museum of the Colorado springs Fine Arts Center.
 1999 Clay People: Pueblo Indian Figurative Traditions. Santa Fe: Wheelwright Museum.

Benedict, Ruth
 1931 Tales of the Cochiti Indians. Washington, D.C.: Smithsonian Institution, Bureau of American Ethnology Bul. 98.

Benson, Nancy C.
 1986-1987 Pottery of the Pueblos. *Vista U.S.A.* 40.

Berger, Guy and Nancy Schiffer
 2000 Pueblo and Navajo Contemporary Pottery and Directory of Artists. Atglen, PA: Schiffer Publishing Ltd.

Bernstein, Bruce
 1994 Potters and Patrons: The Creation of Pueblo Art Pottery. *American Indian Art Magazine* 20(1).

Bloom, Lansing B. ed.
 1937 Acoma and Laguna. In "Bourke on the Southwest," *New Mexico Historical Review* 12(4):357-79.

Broder, Patricia Janis
 1981 American Indian Painting and Sculpture. New York: Abbeville Press.

Brody, J.J.
 1971 Indian Painters & White Patrons. Albuquerque: University of New Mexico Press.
 1977 Mimbres Painted Pottery. Santa Fe: School of American Research; Albuquerque: University of New Mexico Press.
 1990 Beauty from the Earth. Philadelphia: The University Museum of Archaeology and Anthropology, University of Pennsylvania.
 1992 A Bridge Across Cultures: Pueblo Painters in Santa Fe, 1910-1932. Santa Fe: Wheelwright Museum of the American Indian.

Brody, J.J., Catherine J. Scott, and Steven A. LeBlanc
 1983 Mimbres Pottery: Ancient Art of the American Southwest. New York, Hudson Hills Press with The American Federation of Arts.

Bunzel, Ruth L.
 1929, reprinted 1972 The Pueblo Potter: A Study of Creative Imagination. New York: Columbia University Press.

Burton, Henrietta K.
 1936 The Re-establishment of the Indians in Their Pueblo Life through the Revival of Their Traditional Crafts: A Study in Home Extension Education. New York: Columbia University, Teachers College.

Caraway, Caren
 1983 Southwest Indian Designs. Owings Mills, MD: Stemmer House Publishers, Inc.

Chapman, Kenneth M.
 1931 Indian Pottery. *Introduction to American Indian Art.* New York: Exposition of Indian Tribal Arts, Inc. Part II:3-11.
 1932 Indian Arts: America's Most Ancient Art. *Indian Arts.* Worcester, MA: The Davis Press, Inc.
 1933 Pueblo Indian Pottery. Nice, France: C. Czwedzicki, Vol. 1.
 1938 Pueblo Pottery of the Post-Spanish Period. Santa Fe: Laboratory of Anthropology, General Series, Bul. No. 4.

Chauvenet, Beatrice
 1983 Hewett and Friends: A Biography of Santa Fe's Vibrant Era. Santa Fe: Museum of New Mexico Press.

Clark, William
 1998 Eudora Montoya / Potter: Masters of the Art. *Indian Market Magazine* Santa Fe, 32.
Coe, Ralph
 1977 Sacred Circles: Two Thousand Years of Indian Art. Kansas City, MO: Nelson Gallery of Art-Atkins Museum of Fine Arts.
 1986 Lost and Found Traditions: Native American Art 1965-1985. New York: The American Federation of Arts. Clothbound edition published by University of Washington Press, Seattle, WA
Cohen, Lee, ed.
 1993 Art of Clay: Timeless Pottery of the Southwest. Santa Fe: Clearlight Publishers.
Congdon-Martin, Douglas
 1990 Storytellers and Other Figurative Pottery. West Chester, PA: Schiffer Publishing.
Curtis, Edward
 1926 The North American Indian. Norwood, MA: Plimpton Press.
Daniels, Barbara L., ed.
 1991 One Thousand Years of Clay. Albuquerque, NM: Acoma Museum.
Dedra, Don
 1985 Artistry in Clay. Flagstaff: Northland Press.
Dillingham, Rick
 1977 The Pottery of Acoma Pueblo. *American Indian Art Magazine* 2(4):44-51, 84.
 1992 Acoma & Laguna Pottery. Santa Fe, School of American Research
 1996 Fourteen Families in Pueblo Pottery. Albuquerque: University of New Mexico Press.
Dittert, Alfred E., and Fred Plog
 1980 Generations in Clay: Pueblo Pottery of the American Southwest. Flagstaff, AZ: Northland Publishing.
Dockstader, Frederick J.
 1961 Indian Art In America: The Arts & Crafts of the North American Indian. Greenwich, CT: New York Graphic Society.
 1973 Indian Art of the Americas. New York: Museum of the American Indian, Heye Foundation.
Dominguez
 1956 The Missions of New Mexico, 1776. Albuquerque: University of New Mexico Press.
Douglas, Frederick H.
 1930 Pueblo Indian Pottery Making. Denver: Denver Museum of Art, Department of Indian Art, Leaflet No.6.
 1933 Modern Pueblo Pottery Types. Denver: Denver Museum of Art, Department of Indian Art, Leaflet Nos. 53 and 54.
 1935 Pottery of the Southwestern Tribes. Denver: Denver Museum of Art, Department of Indian Art, Leaflet Nos. 69 and 70.
Douglas, Frederick H. and Rene D'Harnoncourt
 1941 Indian Art of the United States. New York: Museum of Modern Art.
Dozier, Edward P.
 1961 Rio Grande Pueblos: Perspectives in American Indian Culture Change. Edward H. Spicer, ed. Chicago: University of Chicago Press.
 1970 The Pueblo Indians of North America. New York: Holt Rinehart and Winston.
Drooker, Penelope Ballard & Patricia Capone
 1998 Makers and Markets: The Wright Collection of Twentieth-Century Native American Art. Cambridge, MA: Peabody Museum of Archaeology and Ethnology, Harvard University.
Dunn, Dorothy
 1968 American Indian Painting of the Southwest and Plains Areas. Albuquerque: University of New Mexico Press.
Dutton, Bertha P.
 1975 Indians of the American Southwest. Englewood Cliffs, New Jersey: Prentice-Hall, Inc.
Eaton, Linda B.
 1994 Tradition and Innovation: The Pottery of New

Mexico's Pueblos. *Plateau* 61(3).
Eddington, Patrick and Susan Makov
 1995 Trading Post Guidebook. Flagstaff, AZ: Northland Publishing.
Eggan, Fred
 1950 Social Organization of the Western Pueblos. Chicago: University of Chicago Press.
Eight Northern Indian Pueblos, Inc.
 1989-2001 Eight Northern Indian Pueblos Official Visitor's Guide. San Juan, NM
Fane, Diana
 1986 Curator's Choice: Indian Pottery of the American Southwest. *American Indian Art Magazine* 11(2).
Farrington, William
 1975 Prehistoric and Historic Pottery of the Southwest: A Bibliography. Santa Fe Sunstone Press.
Fawcett, David M., and Lee A. Callander
 1982 Native American Painting – Selections from the Museum of the American Indian. New York: Museum of the American Indian.
Feder, Norman
 1995 American Indian Art. New York: Abradale/Abrums.
Fewkes, Water
 1909 Antiquities of the Mesa Verde National Park: Spruce Tree House. *Bureau of American Ethnology Bulletin 41.* Washington, D.C.
 1989 The Mimbres: Art and Archaeology. A reprint of three essays, c. 1914-1924. Albuquerque: Avanyu Publishing, Inc.
Field, Clark
 1963 Indian Pottery of the Southwest: Post Spanish Period. Tulsa, OK: Philbrook Art Center.
Frank, Larry, and Francis H. Harlow
 1974 Historic Pottery of the Pueblo Indians, 1600-1880. West Chester, PA: Schiffer Publishing.
Fraser, Douglas
 1971 The Discovery of Primitive Art. *Anthropology and Art: Readings in Cross-cultural Aesthetics.* Charlotte M. Otten, ed. Garden City, NY: Natural History Press
Gault, Ramona
 1995 Artistry in Clay: A Buyer's Guide to Southwestern Indian Pottery. Santa Fe: Southwestern Association on Indian Affairs, 2nd edition.
Gifford, E. W.
 1928 Pottery Making in the Southwest. Berkeley: University of California 23:353-73.
Gill, Spencer and Jerry Jacka
 1976 Pottery Treasures. Portland: Graphic Arts Publishing Co.
Gilpen, Laura
 1941 The Pueblos: A Camera Chronicle. New York: Hastings House.
Goddard, Pliny Earle
 1931 Pottery of the Southwestern Indians. New York: American Museum of Natural History.
Golder, N
 1985 The Hunt and the Harvest: Pueblo Paintings from the Museum of the American Indian. Hamilton, NY: Gallery Association of New York.
Goldfrank, Esther Schiff
 1927 The Social and Ceremonial Organization of Cochiti. *Memoirs of the American Anthropological Association*, n. 33.
Gridley, Marion E.
 1971 Indians of Today. Chicago: Indian Council Fire Publications, Inc.
 1974 American Indian Women. New York: Hawthorn Books, Inc.
Halseth, Odd S.
 1926 The Revival of Pueblo Pottery Making. *El Palacio* (September 15) 21(6):135-54.
Hanson, James A.
 1994 Spirits in the Art: From the Plains and Southwest Indian Cultures. Kansas City, MO: Lowell Press, Inc.
Harlow, Frances H.
 1967 Historic Pueblo Indian Pottery: Painted Jars and Bowls of the Period 1600-1900. Los Alamos: The Monitor Press.

1973 Matte-Paint Pottery of the Tewa, Keres and Zuni Pueblos. Santa Fe, Museum of New Mexico Press.
1977 Modern Pueblo Pottery, 1880-1960. Flagstaff, AZ: Northland Press.
1990 Two Hundred Years of Historic Pueblo Pottery: The Gallegos Collection. Santa Fe, Morning Star Gallery.

Harvey, Byron, III.
1970 Ritual in Pueblo Art. New York: Museum of the American Indian.

Hawley, Florence
1936 Manual of Southwestern Pottery Types. Bulletin No. 291, Albuquerque: University of New Mexico Press.

Hayes, Allan & John Blom
1996 Southwestern Pottery: Anasazi to Zuni. Flagstaff, AZ: Northland Publishing.
1998 Collections of Southwestern Pottery: Candlesticks to Canteens, Frogs to Figurines. Flagstaff, AZ: Northland Publishing.

Hering, Michael
1987 Zia Matte-Paint Pottery: A 300-Year History. *American Indian Art Magazine* Autumn 12(4):38-45.

Hewett, Edgar L. and Bertha P. Dutton, eds.
1945 The Pueblo Indian World: Studies on the Natural History of the Rio Grande Valley in Relation to Pueblo Indian Culture. Albuquerque: University of New Mexico and School of American Research.

Highwater, Jamake
1976 Song of the Earth: American Indian Painting. Boston: New York Graphic Society.
1980 The Sweet Grass Lives On: Fifty Contemporary North American Indian Artists. New York: Lippincott & Crowell Publishers.
1983 Arts of the Indian Americas. New York: Harper & Row.

Hill, Rick
1992 Creativity is our Tradition: Three Decades of Contemporary Indian Art. Santa Fe: Institute of American Indian and Alaska Native Culture and Arts Development.

Hill, Tom, and Richard W. Hill, Sr., eds.
1995 Creation's Journey: Native American Identity and Belief. Washington, D.C.: Smithsonian Institution Press and National Museum of the American Indian.

Hodge, Frederick W.
1910 *Handbook of American Indians North of Mexico 2*
1935 Pueblo Names in the Oñate Documents. *New Mexico Historical Review* 10(1):36-47.

Hoffman, Gerhard, et. al.
1984 Indianische Kunst in 20 Jahrhundert. Münich, Germany.
1998 with Gisela Hoffman, Helen Cordero. in Roger Matuz, ed., Native North American Artists. Detroit, MI: St. James Press, 127-28.

Houlihan, Patrick T., Barbara Cortwright, John E. Collins, Mike Tharp, Maggie Wilson and Anita Da.
1974 Southwestern Pottery Today. *Arizona Highways* No. 5 Special Edition.

Houlihan, Patrick T., with Christopher Selser
1981 One Thousand Years of Southwestern Indian Ceramic Art. New York: ACA American Indian Arts.

Howard, Kathleen and Diana F. Pardue
1996 Inventing the Southwest. Flagstaff, AZ: Northland Publishing.

Howard, Richard M.
1975 Contemporary Pueblo Indian Pottery. *Ray Manley's Southwestern Indian Arts and Crafts* Tucson, AZ: Ray Manley Photography, Inc.:33-52.

Jacka, Lois (with photographs by Jerry Jacka)
May 1986 The New Individualists. *Arizona Highways*.
1988 Beyond Tradition: Contemporary American Indian Art and Its Evolution. Flagstaff: Northland Publishing.

Jacobson, Oscar B. and Jeanne D'Ucel
1950 American Indian Painters. Nice, France: C. Szwedzicki.

Karena, John with Allison Bird-Romero
1997 In the Spirit of the Ancestors. Pittsburgh, PA: Erie Art Museum and Four Winds Publishing Co.

LaFarge, Oliver
1956 A Pictorial History of the American Indian. New York: Crown Publishers.

Lester, Patrick
1995 The Biographical Directory of Native American Painters. Norman: University of Oklahoma Press, Tulsa, OK: SIR Publications.

Lister, Robert H., and Florence C. Lister
1978 Anasazi Pottery. Albuquerque: Maxwell Museum of Anthropology.

Marmor, Michael F. & James G. Ravin
1997 The Eye of the Artist. Mosby, NY.

Marshall, Ann
1999 Rain: Native Expressions from the American Southwest. Phoenix: Heard Museum.

Mateuz, Roger, ed.
1997 Native North American Artists. Detroit: St. James Press.

McCoy, Ron
1993 Helen Cordero in Cohen, Art of Clay. Santa Fe: Clearlight Publishers.

Mera, Harry P.
1933 A Proposed Revision of Rio Grande Glaze-paint Sequence. New Mexico Archaeological Survey, Laboratory of Anthropology Technical Series Bulletin 5. Santa Fe.
1935 Ceramic Clues to the Prehistory of North Central New Mexico. New Mexico Archaeological Survey, Laboratory of Anthropology Technical Series Bulletin 8. Santa Fe.
1938 reprinted 1970 Pueblo Designs: 176 Illustrations of the "Rain Bird." New York: Dover Publications, Inc.
1940 Population Changes in the Rio Grande Glaze-paint Area. New Mexico Archaeological Survey, Laboratory of Anthropology Technical Series Bulletin 9. Reprint 1991 Style Trends of Pueblo Pottery, 1500-1840. Albuquerque: Avanyu Publishing.

Mercer, Bill
1995 Singing the Clay: Pueblo Pottery of the Southwest Yesterday and Today. Cincinnati: Cincinnati Art Museum.

Monthan, Guy, and Doris Monthan
1975 Art and Indian Individualists. Flagstaff, AZ: Northland Press.
1977 Helen Cordero. *American Indian Art Magazine* 2(4):72-76.

Nahohai, Milford and Elisa Phelps
1995 Dialogues with Zuni Potters. Zuni, NM: Zuni A:shiwi Publishing.

New, Lloyd Kiva.
1981 American Indian Art in the 1980s. Niagara Falls: Native American Center for the Living Arts.

Nichols, Robert F.
The Tenorio Family. *Focus/Santa Fe* August/September 1994:20-21. Keeping Tradition Alive. *Focus/Santa Fe* October/December 1995:14-15.

Nyssen, Francoise
2001 Un Art Populaire. Cartier Foundation for Contemporary Art, Paris, France.

Oppelt, Norman T.
1991 Earth, Water and Fire: The Prehistoric Pottery of Mesa Verde. Boulder, CO: Johnson Publishing.

Ortiz, Alphonso
1972 ed., New Perspectives on the Pueblos. Albuquerque: University of New Mexico Press.
1979 editor, Handbook of North American Indians: Southwest (Washington, D.C., Smithsonian Institution), v. 9.

Parsons, Elsie Clews
1925 "The Pueblo of Jemez," *Papers of the Phillips Academy Southwestern Expedition 3*. New Haven, CT: Yale University Press.
1939, reprinted 1998 Pueblo Indian Religion. Chicago: University of Chicago Press 2 vols.

Peaster, Lillian
1997 Pueblo Pottery Families. West Chester, PA: Schiffer Publishing.

Peckham, Stewart
 1990 From This Earth: The Ancient Art of Pueblo Pottery. Santa Fe: Museum of New Mexico Press.
Peterson, Susan
 1997 Pottery by American Indian Women: The Legacy of Generations. New York: Abbeville Press.
Powell, John Wesley
 1900 Administrative Report: Field Research and Exploration. pp. xiii-xviii in *19th Annual Report of the Bureau of American Ethnology for the Years 1897-1898.* Pt.1. Washington, D.C.
Rushing, W. Jackson, with Bruce Berstein
 1996 Modern by Tradition: American Indian Painting in the Studio Style. Santa Fe: Museum of New Mexico.
Samuels, Peggy, and Harold Samuels
 1982 Contemporary Western Artists. New York: Bonanza Books.
 1985 Samuels' Encyclopedia of Artists of the American West. Secaucus, NJ: Castle/Book Sales, Inc.
Sando, Joe
 1974 The Pueblo Indian Book of History and Biographies. San Francisco: Indian Historian Press.
 1976 The Pueblo Indians. San Francisco: Indian Historian Press.
 1979 "Jemez Pueblo," *Handbook of Northern American Indians: Southwest* (Washington, D.C.: Smithsonian Institution, 1979) 9:428, fig. 11.
 1992 Pueblo Nations: Eight Centuries of Pueblo Indian History. Santa Fe: Clear Light Publishers.
Schaaf, Gregory
 1996 Ancient Ancestors of the Southwest. Portland, OR: Graphic Arts Center Publishing Co.
 1997a "C. Maurus Chino," *Native North American Artists,* Roger Matuez, ed., Detroit: St. James Press.
 1997b Honoring the Weavers. Santa Fe: Kiva Press.
 1997c Weaving Traditions: The Richness of Puebloan, Navajo, and Rio Grande Textiles. *Indian Artist* (Summer), 3(3):34-41.
 1998 Top Ten Points to Values in Indian Art. *Indian Market Magazine.* Santa Fe: Southwestern Association for Indian Arts and Starlight Publishing.
 1999a Hopi-Tewa Pottery: 500 Artist Biographies. Santa Fe: CIAC Press.
 1999b Pueblo Pottery Guide: Honoring Tradition & Innovation. *Indian Market Magazine.* Santa Fe: Southwestern Association for Indian Arts and Starlight Publishing.
 2000 Pueblo Indian Pottery: 750 Artist Biographies. Santa Fe: CIAC Press.
 2000b A Buyer's Guide to Navajo Weaving. *Indian Market Magazine.* Santa Fe: Southwestern Association for Indian Arts and Southwest Art; reprinted in *Southwest Magazine.* August: 178-81.
 2000c A Buyer's Guide to Kachina Dolls. *Indian Market Magazine.* Santa Fe: Southwestern Association for Indian Arts and Southwest Art: 182-86; reprinted in . *Southwest Magazine.* August: 182-86.
 2001 American Indian Textiles: 2,000 Artist Biographies. Santa Fe: CIAC Press.
Scully, Vincent
 1975 Pueblo: Mountain, Village, Dance. New York: Viking Press.
Sedgwick, Mrs. William T.
 1972 Acoma, The Sky City. Cambridge, MA: Harvard University Press.
Seymour, Tryntje Ban Ness
 1988 When the Rainbow Touches Down. Phoenix, AZ: Heard Museum.
Schiffer, Nancy
 1991d Miniature Arts of the Southwest. Atgalen, PA: Schiffer Publishing, Ltd.
Silberman, Arthur
 1978 100 Years of Native American Painting. Oklahoma City: The Oklahoma Museum of Art.
Sloan, John and Oliver LaFarge
 Introduction to American Indian Art. New York: The Exposition of Indian Tribal Arts, Inc. 2 vols.
Snodgrass, Jean
 1968 American Indian Painters: A Biographical Dictionary. New York: Museum of the American Indian, Heye Foundation.
Spicer, Edward
 1962 Cycles of Conquest: The Impact of Spain, Mexico, and the United States on the Indians of the Southwest, 1530-1960. Tucson: University of Arizona Press.
Stevenson, James
 1883 Illustrated Catalogue of the Collections Obtained from the Indians of New Mexico and Arizona in 1879. *Second Annual Report of the Bureau of American Ethnology.* Smithsonian Institution, 1880-81 (Washington, D.C.: U.S. Government Printing Office).
Tanner, Clara
 1968 Southwest Indian Craft Arts. Tucson: University of Arizona Press.
 1973 Southwest Indian Painting: A Changing Art. Tucson: University of Arizona Press.
 1976 ed. Arizona Highways Indian Arts and Crafts. Phoenix: Arizona Highways. Articles by Jerold Collings, Joe Ben Wheat, Barton Allen Wright, Richard L. Spivey, David L. Neumann, Robert Ashton and Sharon Ashton.
Toulouse, Betty
 1977 Pueblo Pottery of the New Mexico Indians. Santa Fe: Museum of New Mexico Press.
Toyk, Sheila
 1993 Santa Fe Indian Market: Showcase of Native American Art. Santa Fe: Tierra Publications.
Trimble, Stephen
 1987 Talking with Clay: The Art of Pueblo Pottery. Santa Fe, School of American Research Press.
Tryk, Sheila
 1993 Santa Fe Indian Market: Showcase of Native American Art. Santa Fe: Tierra Publications.
Tucker, Toba Pato
 1998 Pueblo Artists Portraits. Santa Fe: Museum of New Mexico Press.
Underhill, Ruth
 1944 Pueblo Crafts. Washington D.C.: U.S. Department of Interior, Bureau of Indian Affairs.
Washburn, Dorothy K., Ben Elkus, John Adair, Joe Ben Wheat and J.J. Brody
 1984 The Elkus Collection. San Francisco: The California Academy of Sciences.
Weigle, Marta & Barbara Babcock, eds.
 The Great Southwest of the Fred Harvey Company and the Santa Fe Railway.
Whiteford, Andrew Hunter et al.
 1989 I Am Here: Two Thousand Years of Southwest Indian Arts and Culture. Santa Fe: Museum of New Mexico Press.
Williams, Jean Sherrod, ed.
 1990 American Indian Artists in the Avery Collection and the McNay Permanent Collection. San Antonio, TX: Koogler McNay Art Museum.
Wilson, Olive
 1920 The Survival of an Ancient Art. *Art and Archaeology* (January) 9(1):24-29.
Wormington, H.M.
 1951 The Story of Pueblo Pottery. Museum Pictorial No. 2. Denver: Denver Museum of Natural History.
Wormington, H.M. and Arminta Neal
 1974 The Story of Pueblo Pottery. Denver: Denver Museum of Natural History.
Wright, Barton
 1989, 2000 Hallmarks of the Southwest. Atglen, PA: Schiffer Publishing Ltd.
Wycokoff, Lydia L.
 1996 Vision + Voices: Native American Painting. Tulsa, OK: Philbrrok Museum.